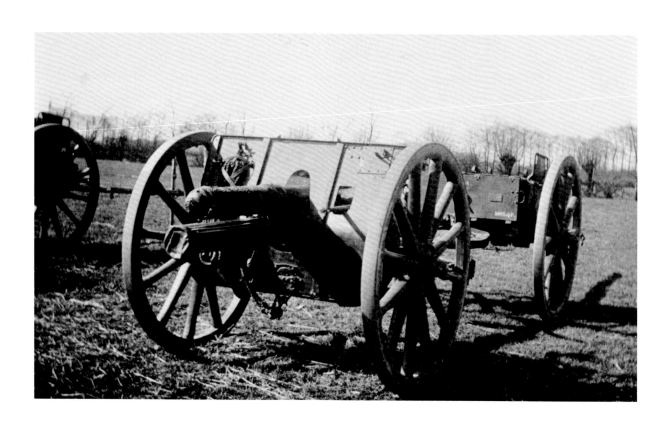

MAJOR J. F. NOBLE, Royal Horse Artillery, personal photograph
No. 4 Gun, 13-pounder (Quick Firing) Mk I horse artillery gun, E Battery, near Cologne, Germany, 1919
*The first British gun to come into action on the Western Front opened fire near Mons
at 9.30 a.m., 22 August 1914. It was also one of the last guns to cease fire a few miles
south of its original position on Armistice Day*

EDITED BY MARK HOLBORN

HISTORICAL TEXTS AND CHRONOLOGIES BY HILARY ROBERTS,
IMPERIAL WAR MUSEUMS

IMPERIAL WAR MUSEUMS

THE GREAT WAR

JONATHAN CAPE
LONDON

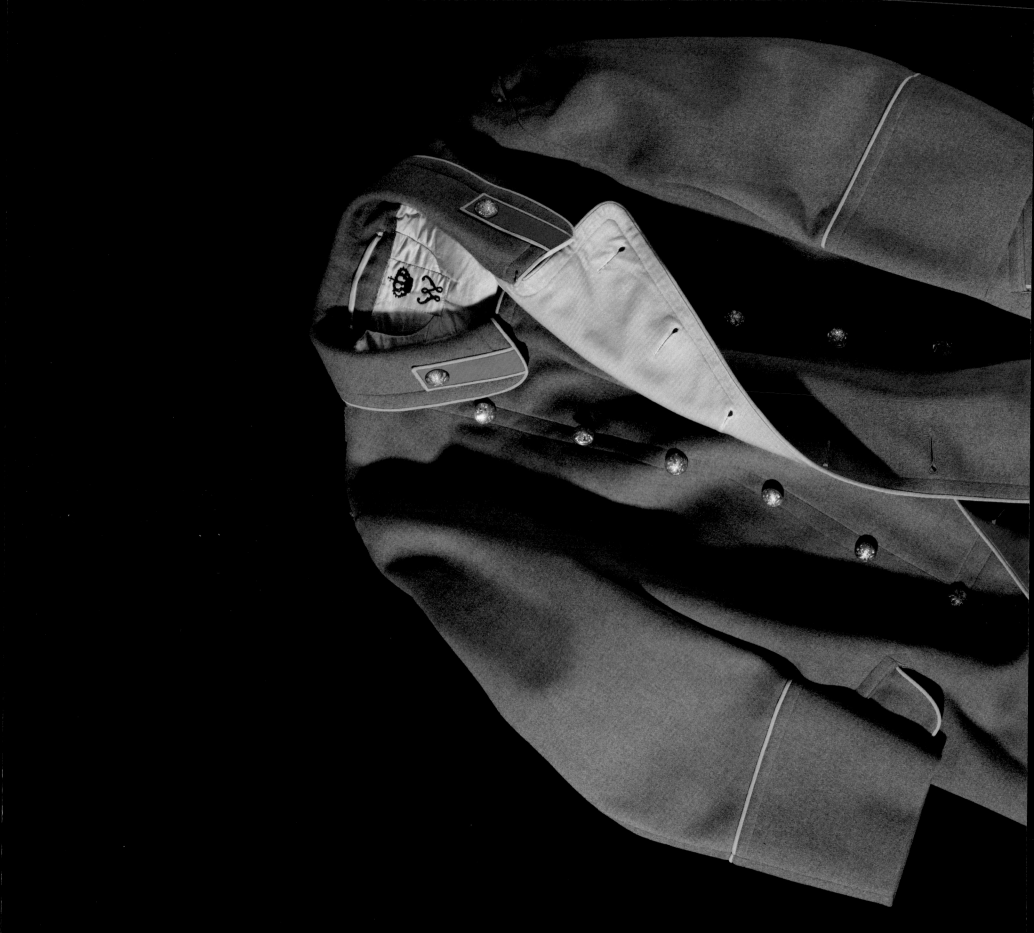

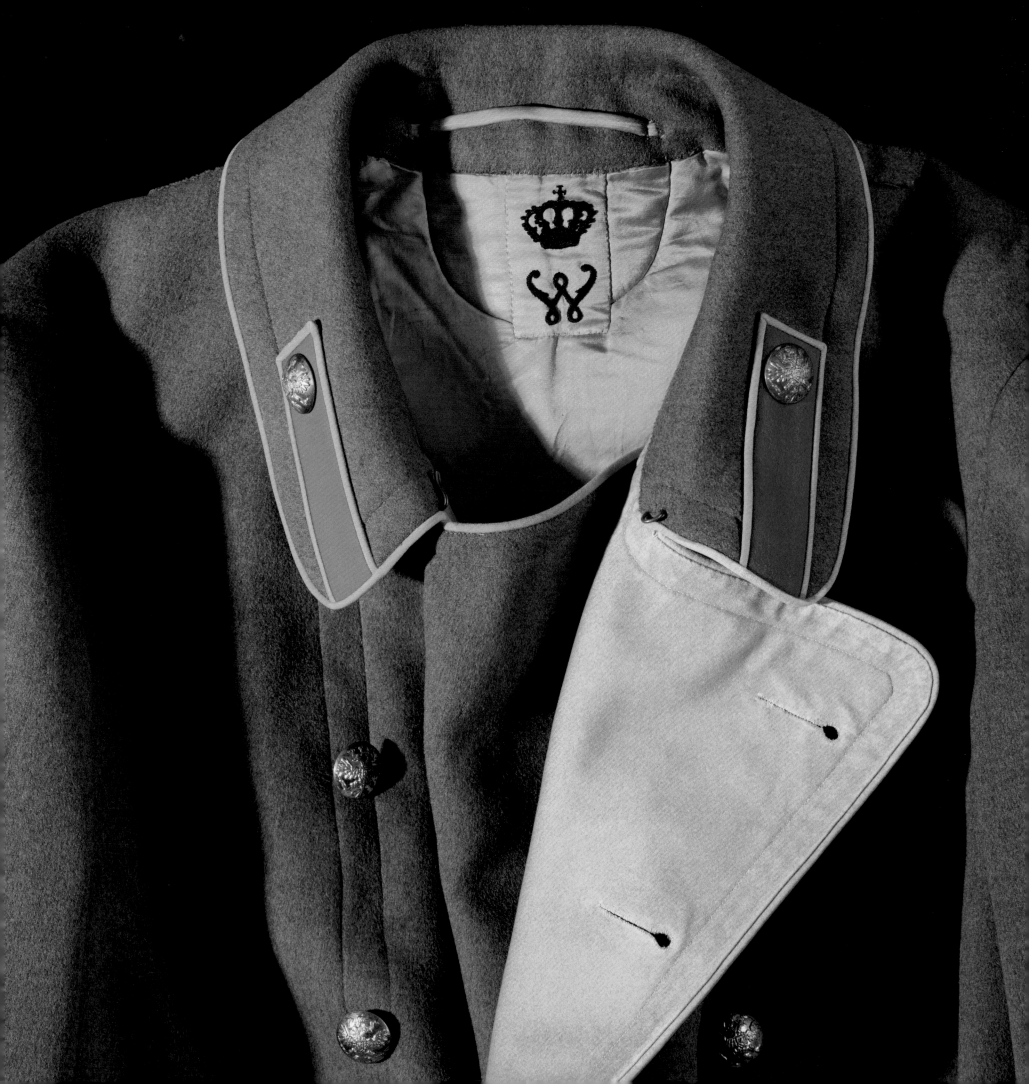

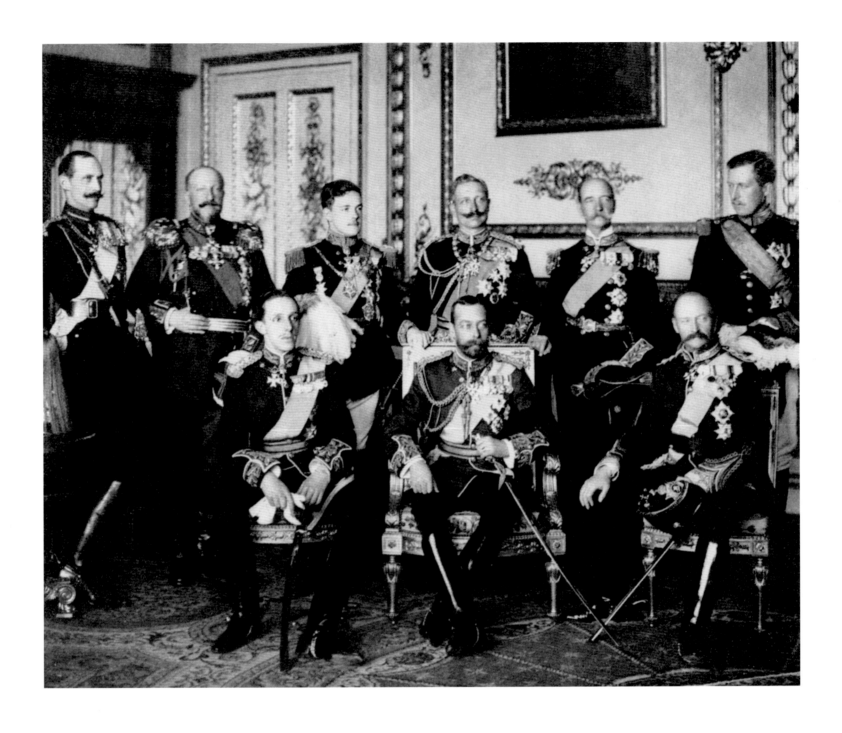

Left & pages 4–5: IWM collection
Russian cavalry officer's greatcoat worn by Kaiser Wilhelm II as colonel-in-chief of the 13th Narvski Hussars in pre-war Russia
Its provenance is confirmed by the imperial 'W' on the inside lining beneath the collar and by the fact that one sleeve was shorter than the other. Photographers and tailors were required to disguise the Kaiser's withered left arm, the result of an accident at birth

Above: W. & D. DOWNEY, London, commercial photograph
Gathering of European royalty, all related by birth or marriage, at the funeral of King Edward VII, Windsor Castle, 20 May 1910
Left to right, standing: King Haakon VII of Norway, King Ferdinand of Bulgaria, King Manuel II of Portugal, Kaiser Wilhelm II, King George I of Greece, King Albert I of Belgium. Seated: King Alfonso X111 of Spain, King George V and King Frederick VII of Denmark

Unknown commercial photographer
HMS *Dreadnought*, on sea trials, British waters, *c*. October 1906

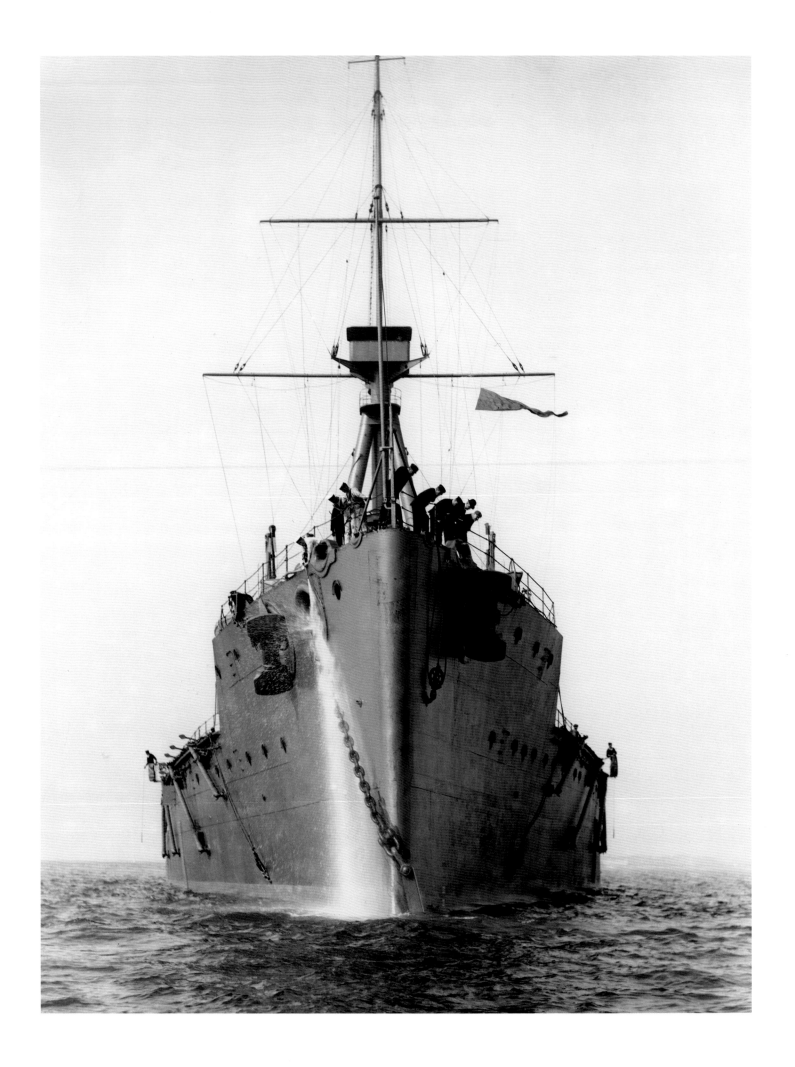

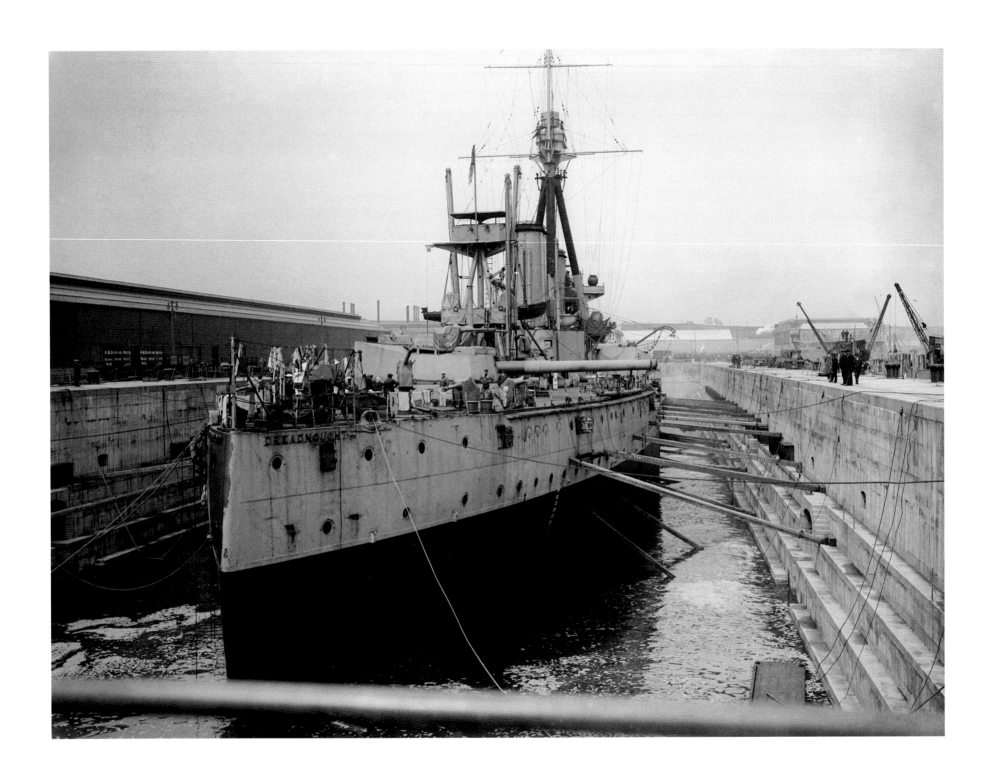

Royal Navy photographer
HMS *Dreadnought* in dry dock, Portsmouth, April 1916
*An icon of British pre-war naval power, HMS Dreadnought's only significant
wartime action was to ram and sink a German submarine, U29, in March 1915.
She was scrapped in 1921*

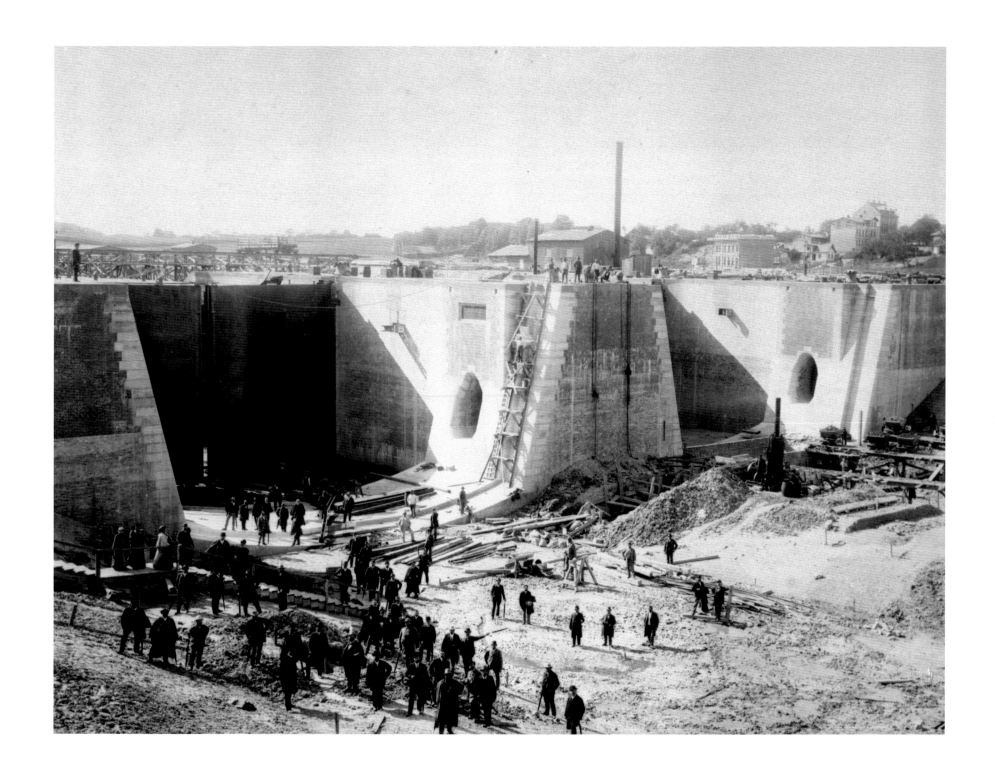

German official photographer
**A vast sea lock under construction. The lock controlled maritime access between the
Baltic Sea and the Kiel Canal, Kiel-Holtenau, Germany,** *c.* **1890**

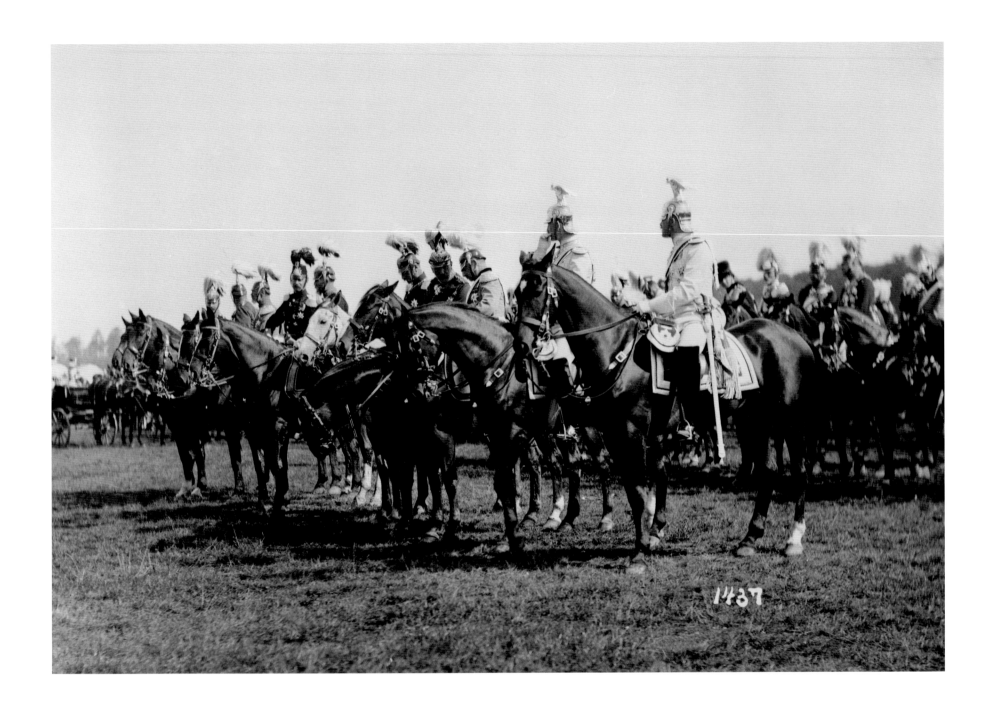

Unknown German court photographer
Kaiser Wilhelm II (third from right) and German princes awaiting the start of the Kaiser
Parade during the annual Kaisermanöver, near Stuttgart, Germany, 1899

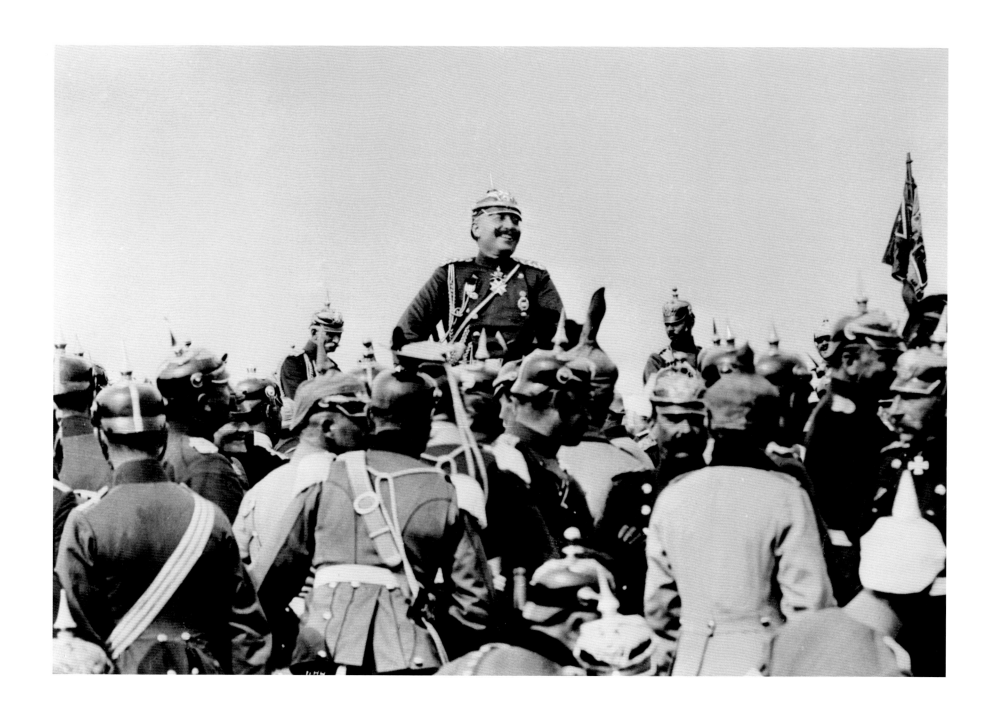

OSCAR TELLGMAN, official German court photographer
Kaiser Wilhelm II on horseback with his officers at the annual Kaisermanöver, Taunus Mountains, Germany, September 1905
The Kaiser exploited the propaganda value of the photograph and this became an important image in the First World War

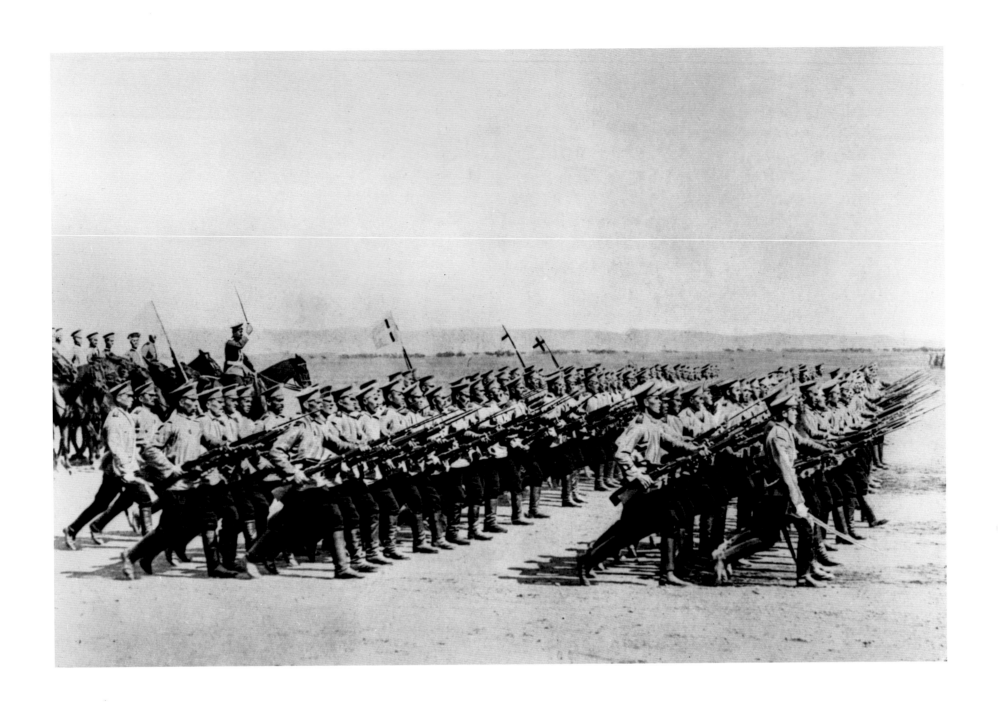

KARL VON GHAN (presumably), Russian court photographer
Russian infantry parade in review order during the state visit of President Poincaré of France, Tsarskoe Selo, Russia, 20–23 July 1914
The President's visit, intended to cement Franco-Russian military ties, occurred at the height of the crisis following the assassination of Archduke Franz Ferdinand in Sarajevo. Austria-Hungary's ultimatum to Serbia on 23 July was timed to coincide with Poincaré's journey home, minimising his chances of conferring with his allies. Austria-Hungary's declaration of war on Serbia triggered partial Russian mobilisation on 28 July. Four days later Germany declared war on Russia

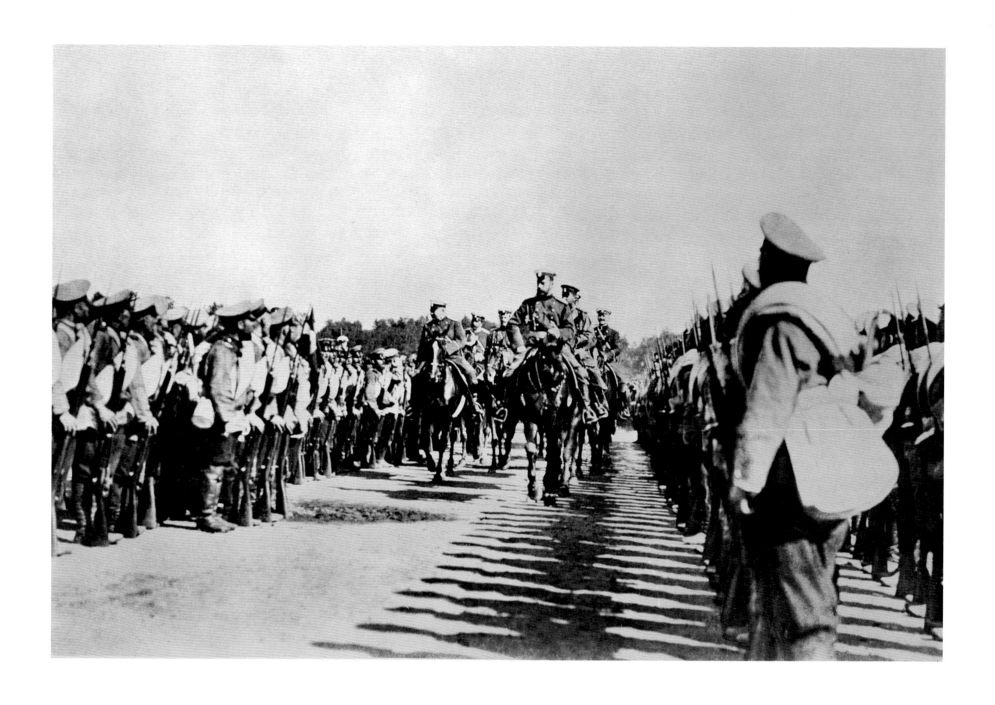

KARL VON GHAN (presumably), Russian court photographer
Tsar Nicholas II inspecting his troops during partial Russian mobilisation,
Tsarskoe Selo, Russia, 28–30 July 1914

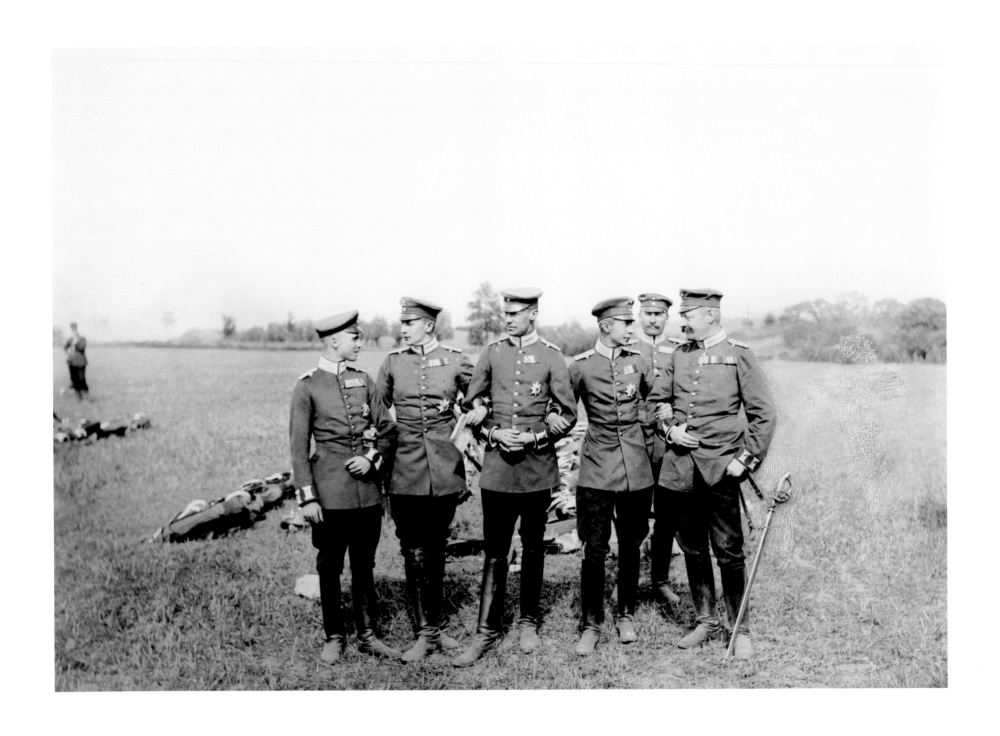

Unknown German court photographer
Crown Prince Wilhelm (second from right), the Kaiser's eldest son and commanding officer of 2nd Company, 1st Guards Regiment, with his officers at the annual Kaisermanöver, Altona, near Hamburg, Germany, 1904

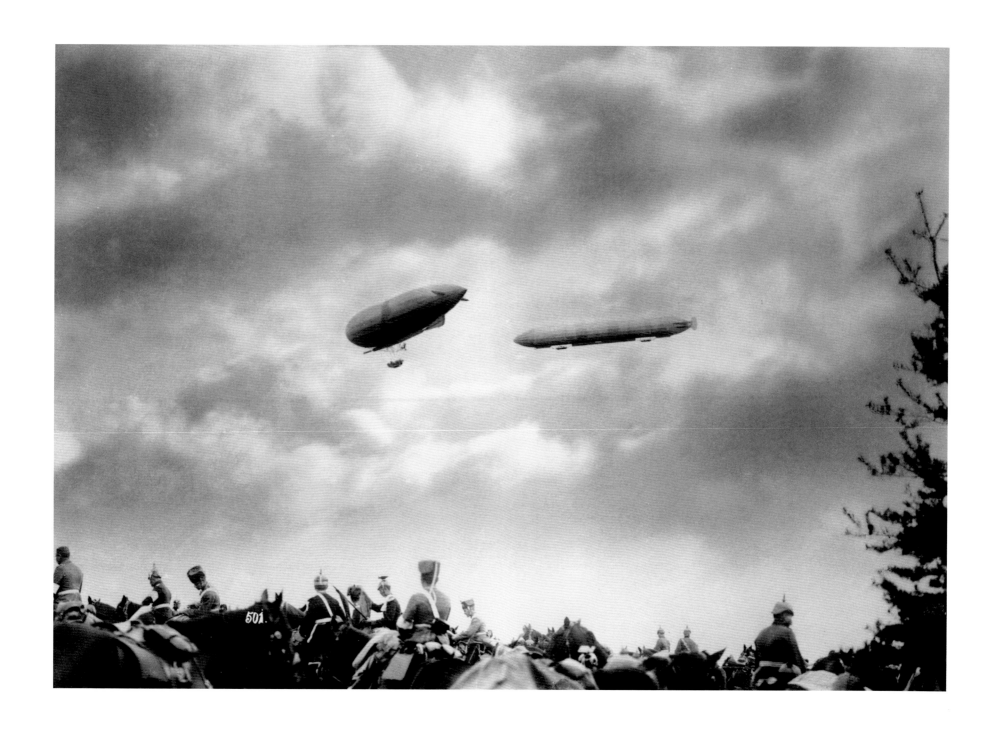

OSCAR TELLGMANN, German court photographer, photomontage
Zeppelin LZ3 and Parseval military airship PL2 at the annual Kaisermanöver,
Altona, near Hamburg, Germany, 1912
Germany dominated military airship design before the First World War.
The photomontage was created for propaganda purposes

Mark Holborn

We live in an age of seemingly endless warfare. There is a constant and immediate traffic in the resulting imagery. One campaign follows another. One conflict is settled, another is declared. History, of course, is not a progression of disparate events, but a continuous flow. An accumulation of forces, or what could be described as the 'wheel' of history, rolls forward to be ignited by an atrocity, a border incident, a single act of protest or an assassination.

A hundred years ago, in 1914, an old world that stretched back as far as the Napoleonic era or beyond was about to be dispatched. Cavalry charges were to become an anachronism. Plumed helmets and the glitter of the parade ground were to be replaced for ever on the battlefield by the practicalities of khaki or grey cloth and the refinements of camouflage. The furnaces roared to meet the demands of urgent and colossal military supply. At Spithead in July 1914 the warships were assembled with mechanical precision in lines stretching as far as the eye could see. A battleship of the new Dreadnought class, plated in massive armour, weighed nearly 18,000 tons. The science of ballistics advanced the muzzle velocity of artillery. It was an age of more deadly explosives, smokeless propellants and the quick-firing gun. Poison gas was to be released. The tank was to loom monstrously over trenches. Landmarks were eradicated and trees vanished. For the first time the conflict was also fought in the air. Battle was observed from the sky. Today we view the images of bombing patterns as abstractions devoid of human life. The machine age was harnessed in the service of 'industrial' warfare.

I am looking at a chart of the descendants and ancestry of Queen Victoria, who was born four years after Waterloo and died in 1901 on the threshold of the twentieth century. The chart unfolds over seven pages. At the time of, say, the outbreak of the American Revolutionary War her grandfather, George III, was in his thirties. Among her numerous grandchildren were both King George V and Kaiser Wilhelm. Tsar Nicholas II was married to their cousin Alix. It is a long span between those ancestors and these descendants. At the beginning of the twentieth century Queen Victoria was the matriarch at the centre of pre-war Europe. What unfolded in 1914 could be described as a family affair. The empires of old Europe that had encased the world like vast but shifting tectonic plates had at last collided. At the Versailles peace treaty of 1919 the maps were to be redrawn, the colours changed.

The Great War was indeed a world war. The images of the trenches of the Somme and Passchendaele on the Western Front came to symbolise the entire war. But the battles stretched from the Balkans and the Dardanelles to the Eastern Front, through the Middle East, Asia and Africa, and as far as the South Atlantic. The ANZAC forces as well as the Allies reached Gallipoli. General Allenby entered Jerusalem. Lawrence rode into Aqaba and fought for the liberation of Damascus. Troops came from all corners of the globe in the service of Empire. They enlisted in the West Indies and the Cameroons. Bengal cavalry pranced through the mud of France. Sikhs wandered in the mists of Belgium, and Zulus appeared on a ridge on the Western Front. There are photographs to confirm their incongruous presence.

Before hostilities ceased, new patterns in the global order were emerging. In 1917 in Russia the Tsar was swept away by the Bolshevik revolution, and Balfour, the British Foreign Secretary, declared his support for a Jewish homeland in Palestine. A climate of national humiliation in Germany was to help nourish extremism. Another undreamed-of catastrophe followed in the wake of this unimaginable war. The shadow of the Great War stretches through the entire century.

No parties were spared the immeasurable grief. The acts of remembrance and the construction of memorials followed. The Cenotaph was unveiled in Whitehall in 1920. Edwin Lutyens' monument was mathematically ingenious since it contained no right angles. The verticals would meet at a hypothetical point 1,000 feet in the air. The horizontals follow the curve of a sphere, the centre of which is 900 feet below the ground. The monument is in effect completed through these vast invisible dimensions. What is visible is only a fraction of what is represented. What remains defined but unseen would dwarf our habitable world.

From the outset the war itself had been made visible, though sparingly so, with the employment of photography. By the 1890s the halftone printing technique enabled both photographs and text to be reproduced in a single process. Illustrated magazines had proliferated. In Britain at the turn of the century the events of the Boer War were the subject of a new kind of illustrated popular publishing. *With the Flag to Pretoria*, edited by H. W. Wilson, included narrative texts combined with numerous photographs and somewhat imaginative sketches. The formula was immediately adopted in 1914. On 25 August, only three weeks after the declaration of war, *The Times* newspaper announced it was publishing its *History of the War* as the most authoritative popular publication. Each instalment went on sale weekly for seven pence. Thirteen instalments would then constitute a volume, for which the newspaper would provide three different kinds of binding to be sold by booksellers. At the beginning there was no knowing how long the enterprise would last. Each volume ran to around 500 pages and there were eventually twenty-two volumes, the final edition appearing on 27 July 1920 and the index volume in 1921. One volume even contained an atlas of the war. Many thousands of photographs were reproduced. *The Times* was not alone. A parallel project with the Amalgamated Press, *The Great War*, ran to twelve volumes, including hundreds of halftone photographs, action sketches and tipped-in photogravures. *The War Illustrated*, published by William Berry, the owner of the *Daily Telegraph*, was reported to reach a circulation of 750,000. From 1916 the *Illustrated London News* produced its own *Illustrated War News* on the same principle. The nation was saturated with visual records. The publications served a patriotic as well as a descriptive purpose. They provided portraits of leading figures, generals and heroes and relieved the density of the texts with pictures of locations, barracks, transport facilities and bomb damage. The volume of information and imagery is overwhelming but the horror was almost unstated visually. As in most wars, the reporting was mediated.

In contrast, in 1926 the German archives in Berlin published *Der Weltkrieg in Bild* in three volumes. One volume was almost entirely text, a second was photographic with a single sepia gravure plate of a German photograph per page, laid out perfectly beneath tissue paper, and the third was drawn entirely from the archives of the Entente – Britain and France. The quality of the Leipzig plates was gorgeous, but the choice of material was relentlessly unsparing. The Germans not only photographed their dead, but a decade later they were prepared to print those pictures. If the German material had been published alone, one might well have suspected some propagandist angle on the national suffering. The addition of the volume of British and French material, however, suggests some formal neutrality. Perhaps here you see the roots of the objectivity of the time, the *Neue Sachlichkeit*, a photographic cataloguing of the entire visual world for which death would be no exception. The original German photographs would almost certainly have been destroyed in the following war, and the books themselves are rare.

A century later there are evident shifts. Whatever economic tensions dominate public discourse, we live in an age of European reconciliation. The occasion and the purpose of publishing are neither patriotic nor unpatriotic. The losses are mutual. In the years since the emergence of modern photojournalism and television the nature of presentation has changed dramatically. The balance between the written word and the image as represented in those vast multi-volume popular histories has altered completely. The modern camera has allowed the photographer a different proximity. Robert Capa's picture of the falling Republican during the Spanish Civil War, despite questions on its authenticity, plants the actual moment of death in our imagination. After the millions of photographs of the Second World War we experienced the imagery of the Vietnam years, when the magazine story was published in its fullest and most considered form. We learned to read the picture long ago. A new visual narrative has to be driven first by the image. It is then substantiated by the information in caption, chronology or summary. This has been the route we have planned. We have been balancing the power of individual pictures with the overriding need to serve the narrative. This is not an anthology of the greatest photographs of the war, though it may indeed contain them.

I am aware that this act of editing from the immense archives of this museum into a single 500-page edition is an act of reduction. There will be inevitable omissions, but the sequence will reflect all the patterns I have described. It too will be both accessible and authoritative. This would not have been possible without the immense compilation of captions, chronologies and introductory summaries by Hilary Roberts. The details of every picture and the accuracy of the sequence have been rigorously checked by the museum's historians. To them all I am most grateful, as I am to the museum for allowing me into the realm of the unseen, unknown and unpublished, and for educating me.

My grandfather's generation served in the First World War, my father's in the Second. I grew up with the imagery of both conflicts unleashed in my childhood imagination. My son's generation has no such residual imagery. It is for them that we should engage with this material. We have a responsibility to pass it on. But they will have already learned with some certainty in their recent passage into adulthood that there never was, and never will be, a war to end all wars.

Above: SERGEANT FREDERICK LAWS, Photographic Section,
No. I Squadron, Royal Flying Corps
British Army mobilisation trials, Netheravon Camp, Wiltshire, June 1914
*Laws was a pioneer of aerial photography. His examination of this particular
photograph led to the development of aerial photographic interpretation, which would
play a vital part in the war, particularly on the Western Front*

Page 24: Heeresgeschichtliche Museum collection, Vienna
**The tunic worn by Archduke Franz Ferdinand when he was assassinated by Gavrilo
Princip, Sarajevo, Serbia, 28 June 1914**

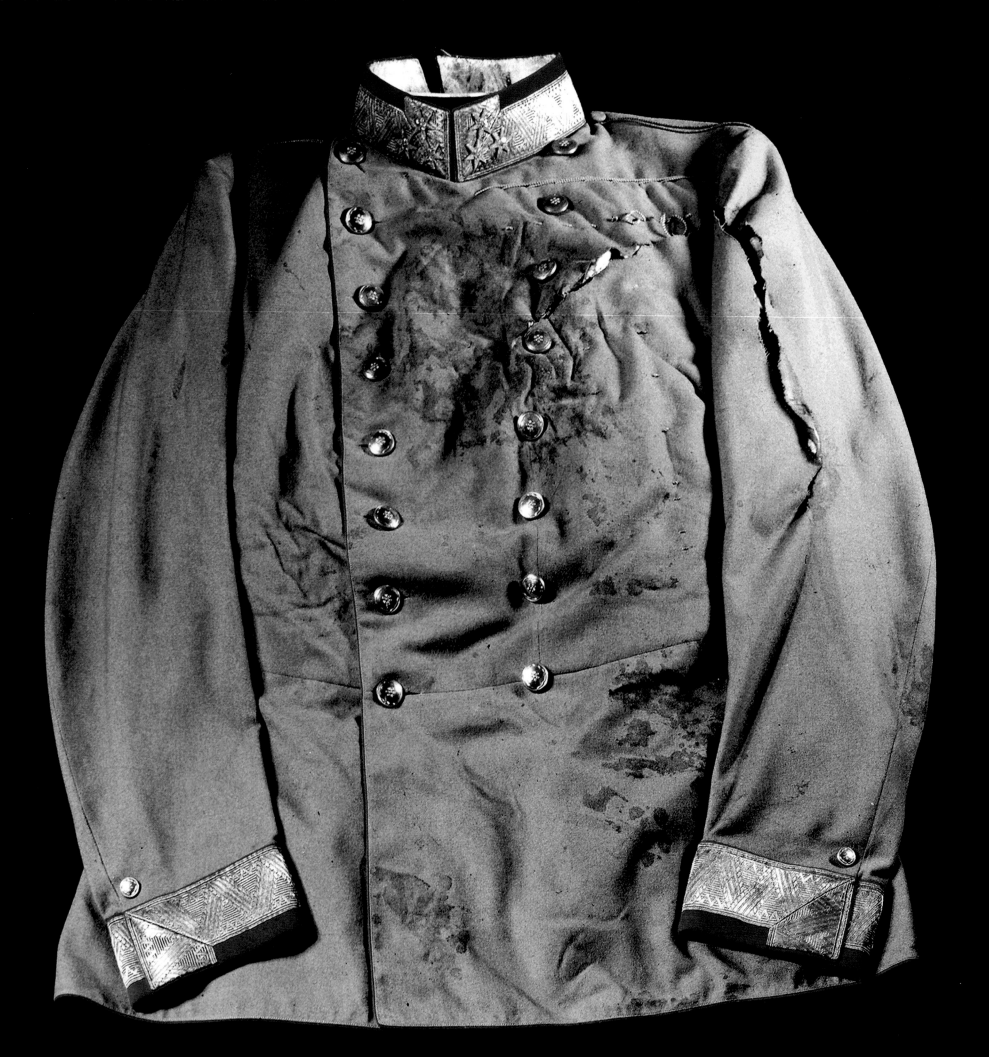

I

JUNE 1914 – DECEMBER 1914

YEAR	MASS MEDIA AND TECHNOLOGY	WAR PHOTOGRAPHY	WORLD EVENTS
1888	• George Eastman registers trademark Kodak. First Kodak camera goes on sale, United States	• Felice Beato, one of the first commercial war photographers, covers last campaign, Burma	• June: Kaiser Wilhelm II ascends to Imperial German throne
1898	• Kodak introduces Panoram camera, capable of generating panoramic photographs with a single exposure, United States	• Court photographers' annual coverage of Kaisermanöver re-orientated to showcase military power as political propaganda spectacle, Germany	• March: Germany challenges British naval supremacy by passing legislation to accelerate warship construction
1900	• George Eastman introduces Kodak Box Brownie camera for children	• Military, commercial and amateur photographers document 2nd Boer War & Boxer Rebellion	• 2nd Boer War, South Africa Boxer Rebellion, China
1901		• Horace Nicholls wins landmark court case to establish legal copyright in his Boer War photographs, Britain	• January: Death of Queen Victoria. Edward VII becomes King, Britain
1902			• January: Anglo-Japanese alliance ends Britain's 'Splendid Isolation'
1903	• Christina Broom becomes one of the first women to work as a professional press photographer, London. Olive Edis, another female professional photographer, opens studio in Norfolk, Britain		• December: Wright Brothers make first successful powered flight, United States
1904	• The *Daily Mirror* becomes first British daily newspaper to publish photographs regularly, employing Ernest Brooks, William Ivor Castle, William Rider-Rider and the Grant brothers (Tom, Horace and Bernard)	• Christina Broom becomes the first woman photographer to cover the British Army	• April: Entente Cordiale between Britain and France signed
1905		• Bulla & Sons Agency, St Petersburg document October Revolution, Russia	• December: Count Alfred von Schlieffen devises military plan to enable Germany to wage war on France and Russia simultaneously
1906	• Introduction of rotary offset lithographic printing technology. Lithographic printing, using metal plates, will become the principal printing process of the twentieth century	• First military vertical and oblique aerial photographs taken of Stonehenge by Lt P. H. Sharpe in a Royal Engineers military balloon, Britain	• February: Launch of HMS *Dreadnought* triggers international naval arms race • June: First powered flight in Europe. First radio broadcast and first feature film
1907	• Lumière Brothers introduce autochrome plates, the first genuine colour photographic process to be commercially viable, France		• August: Signature of Anglo-Russian Entente creates Triple Entente of France, Britain and Russia to form counterweight to Triple Alliance of Germany, Austria-Hungary & Italy
1908	• Amateurfotografenverband founded, Germany • Hilton DeWitt Girdwood, a Canadian, founds stereo photographic company Realistic Travels, Britain	• Royal Engineers photograph Samuel F. Cody's experiments in powered flight, Farnborough, Britain	• April: British Territorial Army founded, Britain • July: Revolution breaks out in Macedonia, Ottoman Empire

YEAR	MASS MEDIA AND TECHNOLOGY	WAR PHOTOGRAPHY	WORLD EVENTS
1909	• First known photograph to be taken from an aircraft (piloted by Wilbur Wright), Centocelli, Italy	• Tom Grant, *Daily Mirror*, covers overthrow of the Ottoman Emperor	• June: Construction of Dreadnought-class battleships begins in Russia • 28 June: Assassination of Archduke Franz Ferdinand and his wife Sophie, Sarajevo, Serbia. Austria-Hungary blames Serbia for supporting terrorist attack
1910	• Max Aitken, Canadian businessman, moves to Britain and begins to build newspaper empire		• May: Death of King Edward VII. George V becomes King
1912	• Communist Party launches *Pravda* newspaper in St Petersburg, Russia • Kodak's Vest Pocket Autographic camera introduced • Armando Console, *Daily Mirror* photographer, crosses the Alps in a balloon. He is briefly arrested by German authorities on suspicion of being a spy	• Sgt Frederick Laws, a keen photographer, transfers to Royal Flying Corps from Coldstream Guards. He takes command of the Photographic Section of No. 1 Squadron RFC	• May: Formation of Royal Flying Corps, Britain • October: 1st Balkan War starts
1913	• Herbert Baldwin publishes *A War Photographer in Thrace*, one of the earliest accounts of modern war photography, based on his coverage of the Balkan Wars, Britain	• RFC Experimental Flight at Farnborough begins using aerial photography for reconnaissance, Britain. Royal Navy assumes military responsibility for airships and balloons	• May: End of 1st Balkan War • June–September 2nd Balkan War
1914 JULY	• Austro-Hungarian Army kaiserlich und königliche Kriegspressequartier (KPQ), commanded by General Major Max Ritter von Hoen, established to manage wartime propaganda, Austria-Hungary		• 5 July: Germany supports Austria-Hungary in confrontation with Serbia • 21 July: Austria-Hungary issues ultimatum to Serbia • 28 July: Austria-Hungary declares war on Serbia • 29 July: Partial mobilisation in Russia
1914 AUGUST	• George Eastman of Kodak arrives in London to manage the impact of events on his business concerns, shortly before Britain declares war. He reports loss of communication with all Kodak continental branches, with the exception of Paris, and the layoff of most of his Harrow workforce in Britain • Defence of the Realm Act gives Government widespread powers over people's lives. War Propaganda Bureau (aka Wellington House), a subsidiary of the Foreign Office, established under direction of Liberal MP Charles F. G. Masterman, Britain	• European powers ban civilian press photographers in the front line of the Western Front on security grounds. Newspapers fall back on illustrations drawn from artist impressions, personal photographs and stiffly posed press photographs taken behind the lines • British servicemen are barred from carrying personal cameras. Ban is widely disregarded. German servicemen are permitted to carry personal cameras, but not use them in combat • Tom Grant, *Daily Mirror* photographer, documents Belgian Army resistance to German invasion, Western Front	• 1 August: Germany declares war on Russia • 2 August: Germany invades Luxembourg and demands permission to advance through Belgium, which asserts its neutrality • 3 August: Germany declares war on France • 4 August: Germany declares war on Belgium and invades. Britain declares war on Germany • 6 August: Austria-Hungary declares war on Russia • 7–16 August: British Expeditionary Force lands in France

YEAR	MASS MEDIA AND TECHNOLOGY	WAR PHOTOGRAPHY	WORLD EVENTS
1914 AUGUST	• Launch of *The War Illustrated: A Pictorial Record of the Conflict of the Nations*, edited by J. A. Hammerton and published by William Berry, owner of the *Daily Telegraph*. The magazine becomes one of the most successful wartime publications, achieving a circulation of 750,000, Britain • Frank Hurley appointed official photographer to Shackleton Expedition • Francis J. Mortimer, photographic artist and editor of *Amateur Photographer* and *Photogram* magazines, serves as Photographic Intelligence Officer & Special Constable, Britain. Edward Steichen, artist and photographer, returns to the United States from Paris • Topical Press photographer John Warwick Brooke enlists and joins 2nd King Edward's Horse as a signaller • Britain severs transatlantic telecommunication cables between Germany & United States	• Royal Engineers Photographic Reconnaissance Section begins military operational (survey) photography. No. 4 Squadron RFC starts aerial reconnaissance flights, Western Front • André Kertész enlists as a soldier with the Austro-Hungarian Army and starts taking personal photographs, Eastern Front • Viktor Bulla, Florence Farmborough and others photograph Eastern Front • Sgt Christopher Pilkington, Lt Richard Money and others take personal photographs of events on the Western Front. Some act as semi-official photographers on behalf of their unit. Lt Richard Money photographs troops under fire, Battle of the Marne • 19 German court photographers, including Hans Hildenbrand, are accredited as official war photographers • KPQ assumes responsibility for wartime film and photography, Austria-Hungary. 33,000 official photographs are taken during the war	• 7 August: Lord Kitchener appointed Secretary of State for War; Allies launch campaigns in German African colonies • 12 August: Britain & France declare war on Austria-Hungary • 13 August: Austria-Hungary invades Serbia • 14–19 August: Russia invades East Prussia; St Petersburg renamed Petrograd • 20 August: German forces occupy Brussels, Western Front • 20–25 August: Battle of the Ardennes and the Sambre, Western Front: French forces retreat with severe losses • 23 August: Battle of Mons, the first major action involving British forces. BEF forced into retreat, Western Front • 24 August: First Indian Army contingent departs for France • 26–30 August: Battle of Tannenburg, Eastern Front; rearguard action by British forces covers the retreat from Mons, Western Front
1914 SEPTEMBER	• War Propaganda Bureau begins operations, pursuing a policy known as propaganda of the facts, Britain. The Bureau's initial approach, to disseminate propaganda through literature, ignores the potential of imagery and mass media • Newspapers agree to collaborate with the Government to coordinate the release of official news in exchange for assurances that censorship would be minimal, Britain • Australia appoints Charles E. W. Bean Official Correspondent to the Australian Expeditionary Force • Matthew B. Claussen, Advertising Director for the Hamburg-Amerika Shipping Line, establishes German Information Service to supply US newspapers with pro-German stories, United States	• Lt G. F. Pretyman, No. 3 Squadron RFC, uses handheld civilian camera to take first British operational aerial photographs of German dispositions during the Battle of the Aisne on 15 September. Results are considered inferior to those of the French Air Force • Royal Engineers Photographic Reconnaissance Section begins military operational (survey) photography, Western Front • Tom Grant, *Daily Mirror*, covers Belgian Army in Battle of Hofstade, Western Front • Horace Grant, *Daily Mirror*, covers arrival of Indian troops in South of France	• 3–15 September: 2nd Battle of Lemberg and Battle of Masurian Lake, Eastern Front • 6–10 September: Battle of the Marne, Western Front • 13–28 September: Battle of the Aisne, Western Front • 17 September–16 October: 'Race to the Sea', Western Front • 26 September: First Indian troops arrive in Marseilles, France

YEAR	MASS MEDIA AND TECHNOLOGY	WAR PHOTOGRAPHY	WORLD EVENTS
1914 OCTOBER	• Germany and Austria-Hungary begin their attempts to confiscate Kodak branches within their territories	• Tom Grant, *Daily Mirror*, circumvents military ban on frontline photography to cover the Royal Naval Division's Royal Marine Brigade during defence of Antwerp, Western Front	• 3 October: Canadian Expeditionary Force departs for Britain • 10 October: German forces occupy Antwerp • 16 October: Indian Army expeditionary force leaves for Mesopotamia • 19 October–22 November: 1st Battle of Ypres • 29 October: Turkey enters war
1914 NOVEMBER		• US journalist Edward Lyall Fox and photographer/cinematographer Albert K. Dawson leave US for Germany via Copenhagen to document the German war in Europe. Dawson's photographs, taken on a freelance basis, are to be distributed by Underwood & Underwood. On arrival in Berlin, accreditation and access to the front is initially denied in line with standard German policy	• 1 November: Departure of first Australian/NZ troops for Britain; Royal Navy defeat at Battle of Coronel • 2 November: Russia declares war on Turkey. Britain launches naval blockade of Germany • 5 November: Britain & France declare war on Turkey • 6 November: Anglo Indian Force lands in Mesopotamia to protect UK oil interests in Persia
1914 DECEMBER	• Emil O. Hoppé, photographer and founder of the London Salon of Photography, designs the Penrose Annual of printing processes for 1915, making no concessions to the war to demonstrate that 'one British industry could still proudly lift up its head amid the clash of arms'	• Commandant of Berlin, General von Lowenfeld, grants Albert K. Dawson permission to take photographs of French Moroccan POWs in Zossen prison camp • British and German soldiers use personal cameras to photograph the Christmas Truce, Western Front • British and German seamen use personal cameras to photograph the Battle of the Falkland Islands • Horace W. Nicholls, former Boer War photographer, covers the British Home Front as a freelance commercial photographer • Starting with *The Elements at War*, Francis J. Mortimer begins to produce a series of artistic photomontages and pictorialist works on wartime	• 2 December: Austria-Hungary captures Belgrade, capital of Serbia. Serbian forces retake it on the 15th • 3 December: Australian/NZ Army Corps (ANZAC) diverted to Egypt • 8 December: German East Asia Squadron defeated, Battle of the Falkland Islands • 16 December: German naval bombardment of Scarborough, Hartlepool & Whitby, Britain • 17 December–18 January 1915: Turkey attacks Russia, Caucasus • 25 December: Christmas Truce, Western Front

Page 31: Unknown press photographer
An officer announces the mobilisation of the Imperial German Army after Germany declares war on Russia, Berlin, 1 August 1914
The events of August 1914 were covered by the first generation of international press photographers and circulated in both newspapers and illustrated magazines

When Kaiser Wilhelm II, grandson of Queen Victoria, became Emperor of Germany in 1888, he became leader of a country which, although at the heart of Europe, was not yet twenty years old and was surrounded by Russia, France and Austria-Hungary, all long-established European powers. By contrast, Britain, a small island detached from mainland Europe, was unrivalled as the world's superpower. Fully industrialised, wealthy and urbanised, Britain controlled a vast trading empire protected by the Royal Navy. Queen Victoria had been on the throne for more than fifty years, could count most European monarchs as relatives and was held in regard internationally.

Although unrivalled, Britain's position was not unchallenged. During the first twenty-five years of the Kaiser's reign, the major European powers sought to protect and extend their power. Rivalry between the world's most technologically advanced countries fuelled an atmosphere of mistrust and fear, which in turn led to the emergence of two opposing power blocs: the Triple Alliance of Germany, Austria-Hungary and Italy, and the Triple Entente of France, Britain and Russia.

The Kaiser, whose insecure, impetuous, tactless and grandiose personality was shaped by the need to overcome a highly visible birth defect, bears much of the responsibility for initiating the events that led to war in 1914. His government's aggressive foreign policy and development of the German armed forces created international alarm, fostering a situation in which global war was possible. However, the responsibility for the outbreak of war itself lies elsewhere.

The struggle of the Austro-Hungarian and Ottoman Empires to contain nationalism amongst their Slav and Arab peoples had already caused isolated outbreaks of violence, when, on 28 June 1914, Archduke Franz Ferdinand, heir presumptive to the Austro-Hungarian Emperor, was assassinated in Sarajevo by Gavrilo Princip of the Black Hand Serbian nationalist group. The assassination triggered a sequence of fast-moving events that culminated in war. The network of international alliances ensured that all the major European powers and their overseas dominions were drawn into the conflict.

Of all the nations, Germany was the most prepared. Following a plan of rapid attack developed by Count Alfred von Schlieffen in an attempt to avoid fighting a war on two fronts, German forces mobilised and invaded Belgium. They intended to defeat France before the vast Russian Army could take the field. However, German violation of Belgian neutrality brought Britain into the war, while Russia mobilised more quickly than expected. The German advance was stemmed on the Western Front in a series of desperate battles, giving way to the stagnation of trench warfare. On the Eastern Front, Russian forces achieved early success in Galicia.

At sea, the German fleet harassed British shipping before being confronted and defeated in the Battle of the Falkland Islands. 1914 ended with another ominous development when, for the first time, British civilians came under fire from the German Navy. The nature of this war was also being shaped by technology in the form of aviation, motorised transport and modern weapons as well as by the use of improved communications and media, including photography.

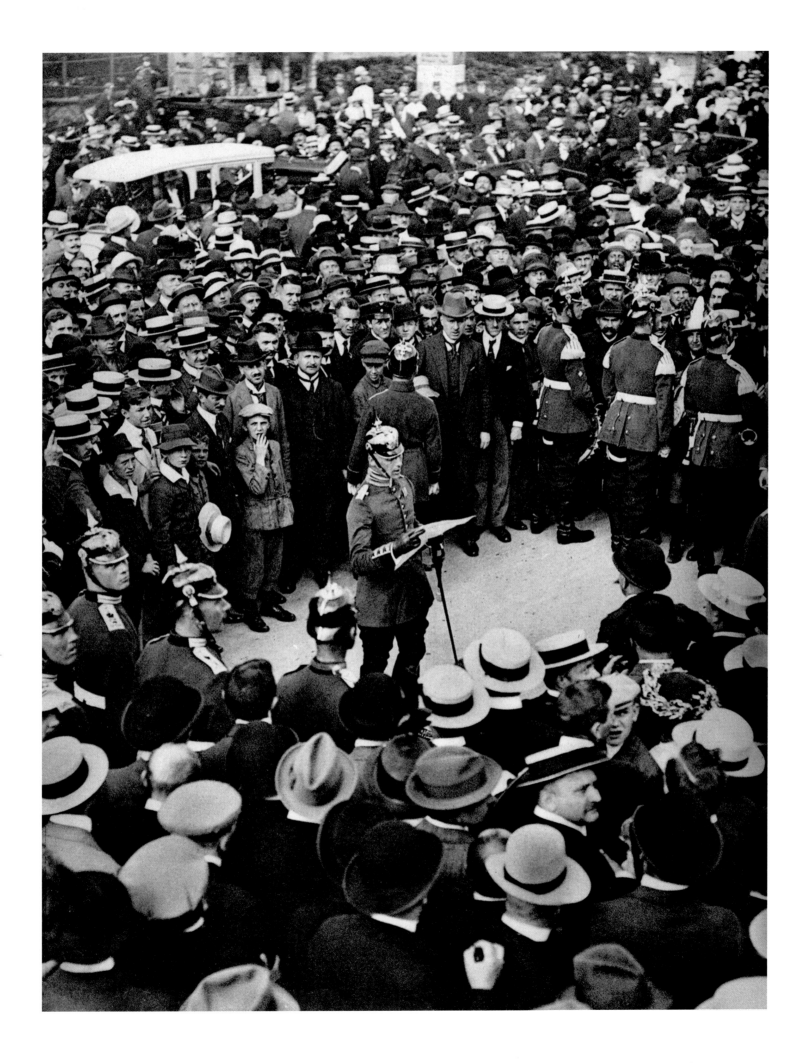

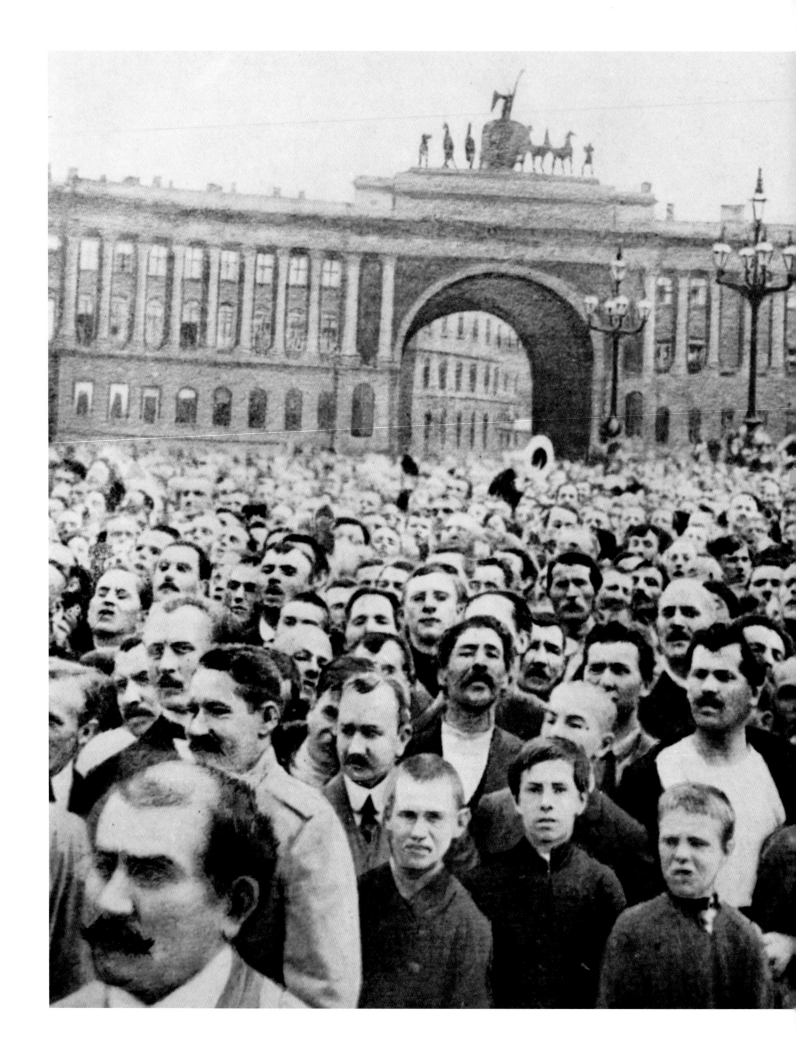

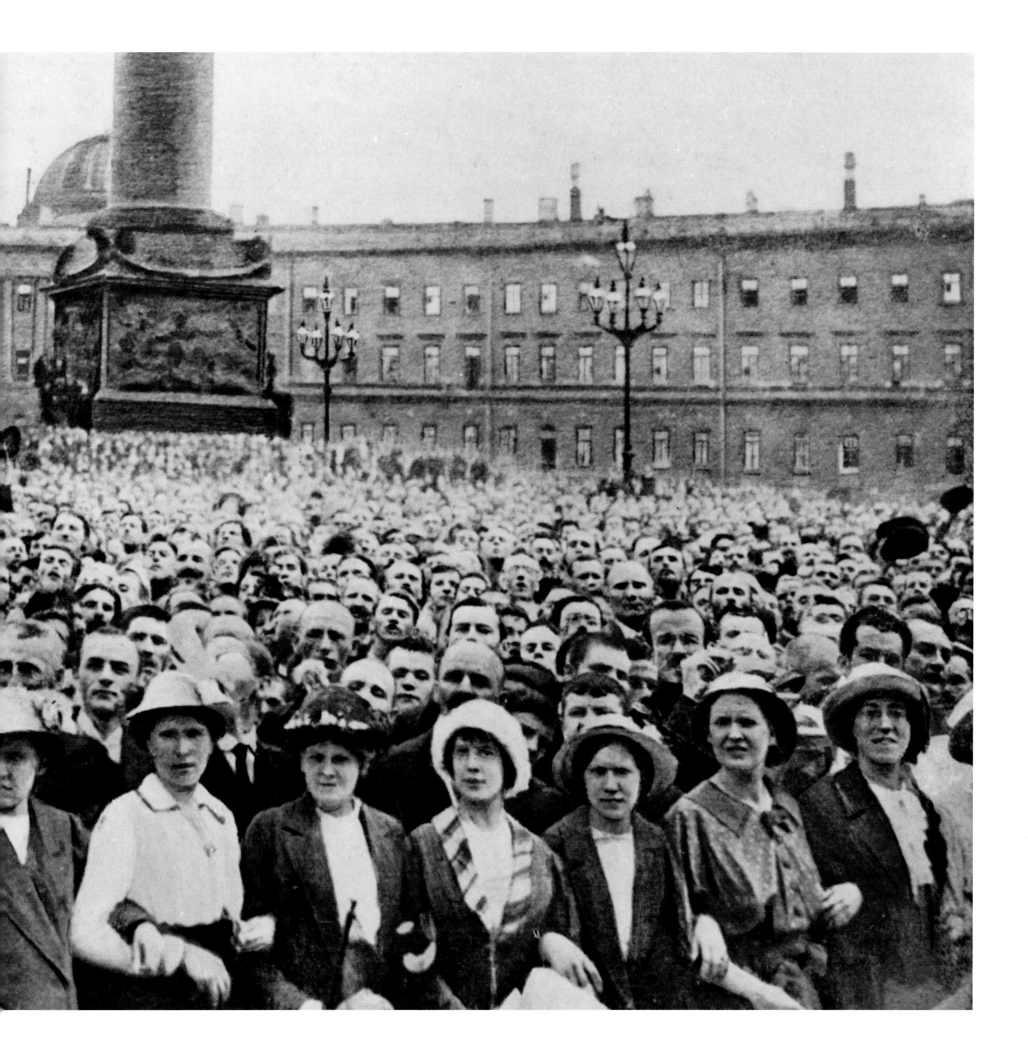

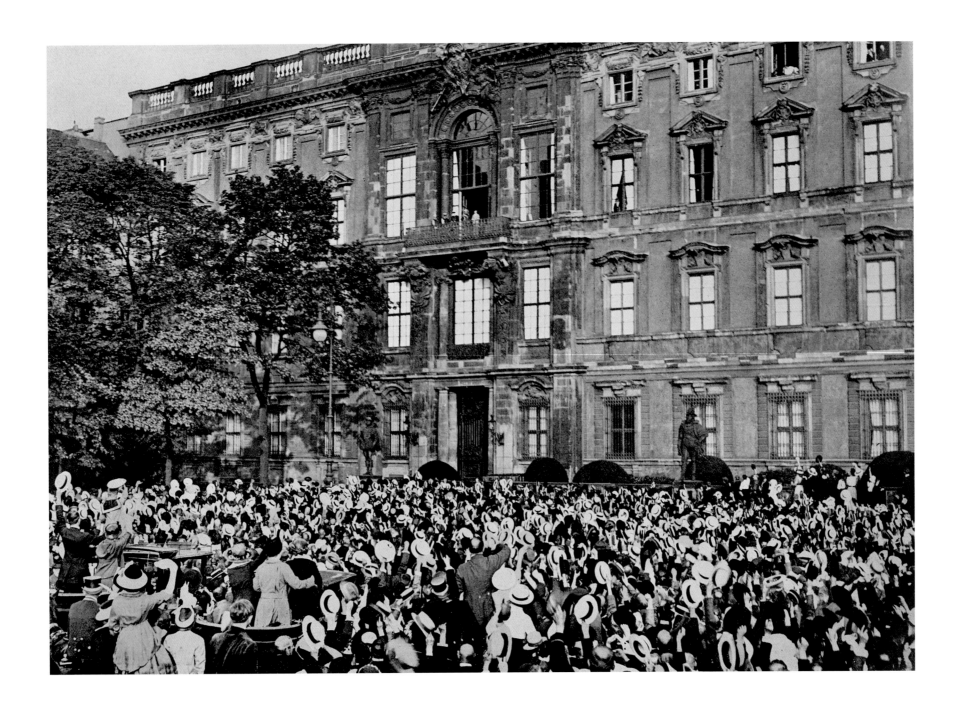

Pages 32–3: Unknown press photographer
Sombre Russian crowds wait for news on the eve of war, the Winter Palace, St Petersburg, 31 July 1914

Above: Unknown press photographer
Crowds cheer the Kaiser on the balcony of the Berliner Schloss, following Germany's declaration of war on Russia, Berlin, 1 August 1914
These patriotic scenes occurred across Europe, but the press photographers were limited by their lack of long-range lenses

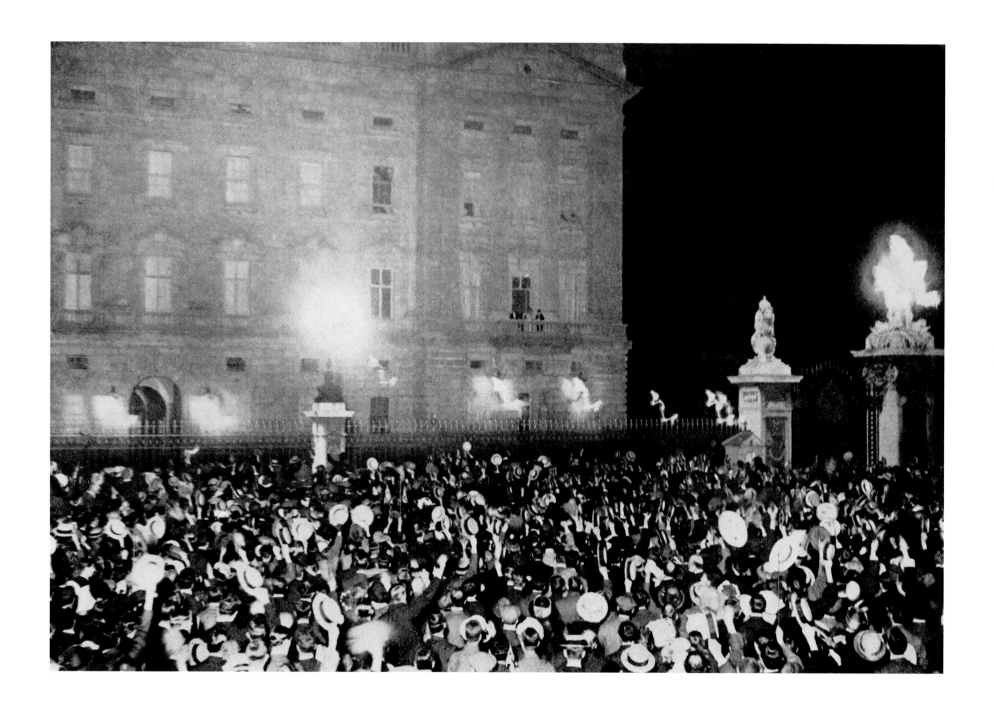

Unknown press photographer
**Crowds cheer King George, Queen Mary and the Prince of Wales on the balcony of
Buckingham Palace, London, after Britain declares war on Germany, 4 August 1914**

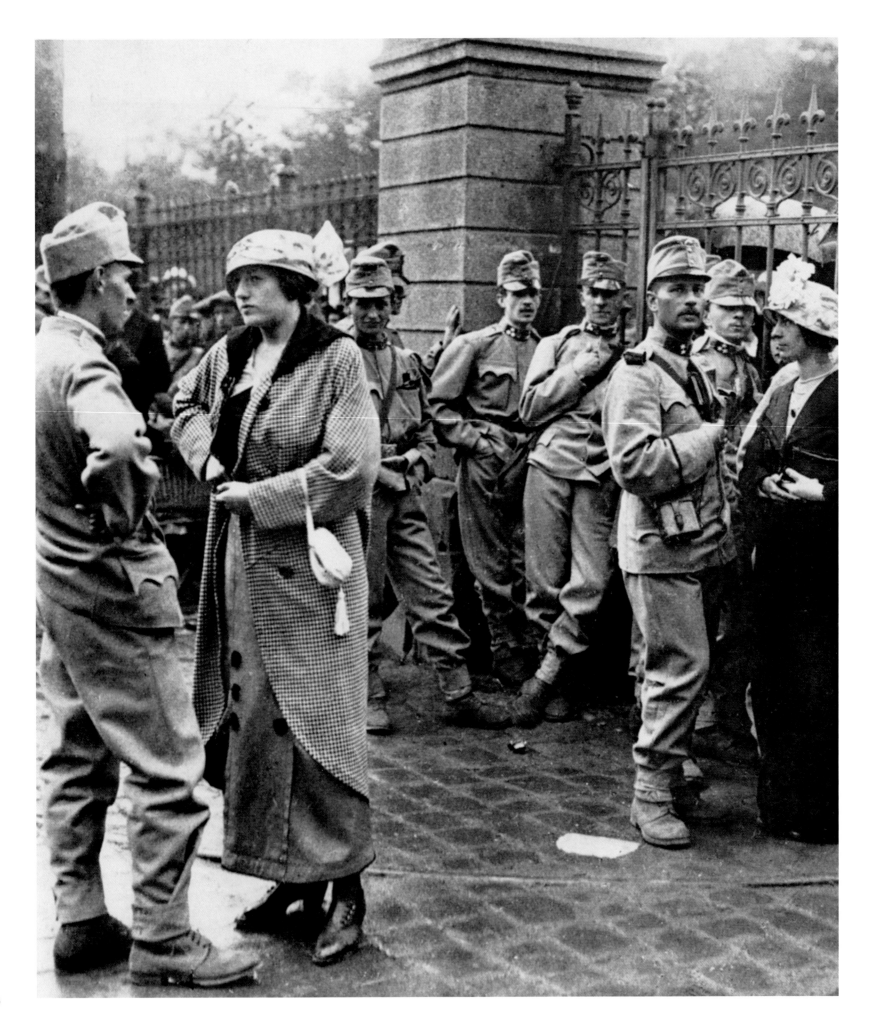

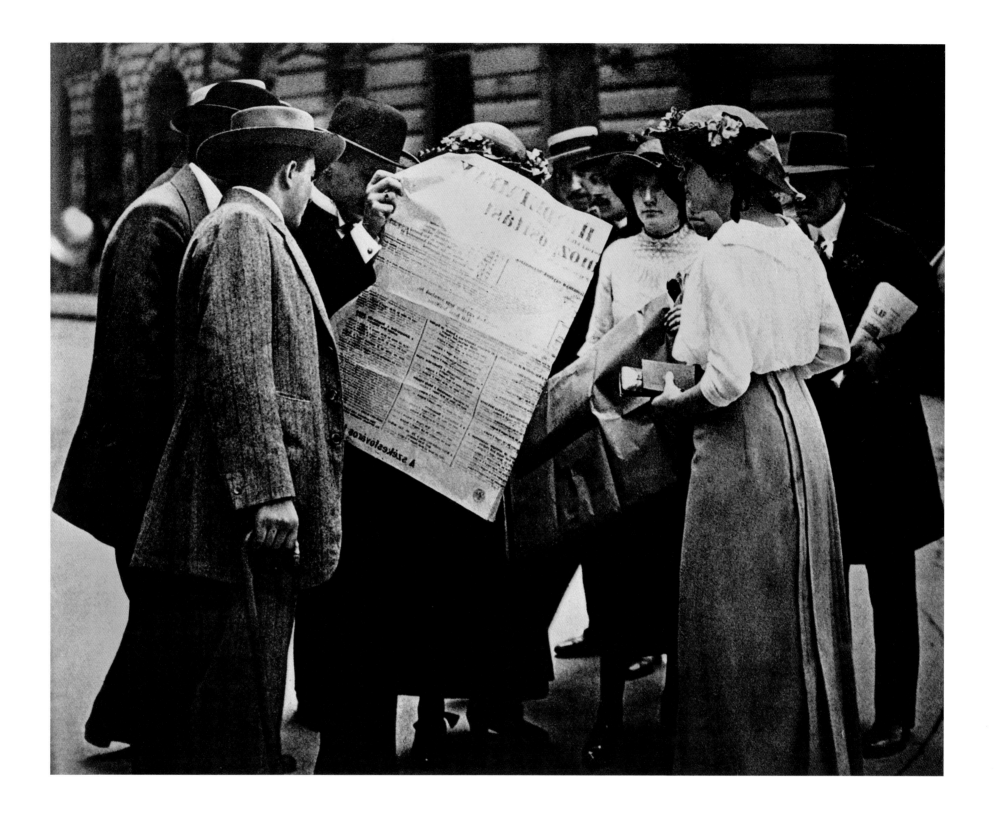

Left: Unknown press photographer
Czech troops prepare to leave for the front after Austria-Hungary has declared war on Serbia, Prague (then part of Austria-Hungary), *c.* 30 July 1914
A history of unrest among the ethinc Slavs in the Austro-Hungarian Empire caused press photographs suggesting Slav loyalty in the war against Serbia to be used as propaganda by the Austro-Hungarian Empire

Above: Unknown press photographer
Hungarians receive news of the mobilisation of the Austro-Hungarian Army, Budapest, Austria-Hungary, 30 July 1914

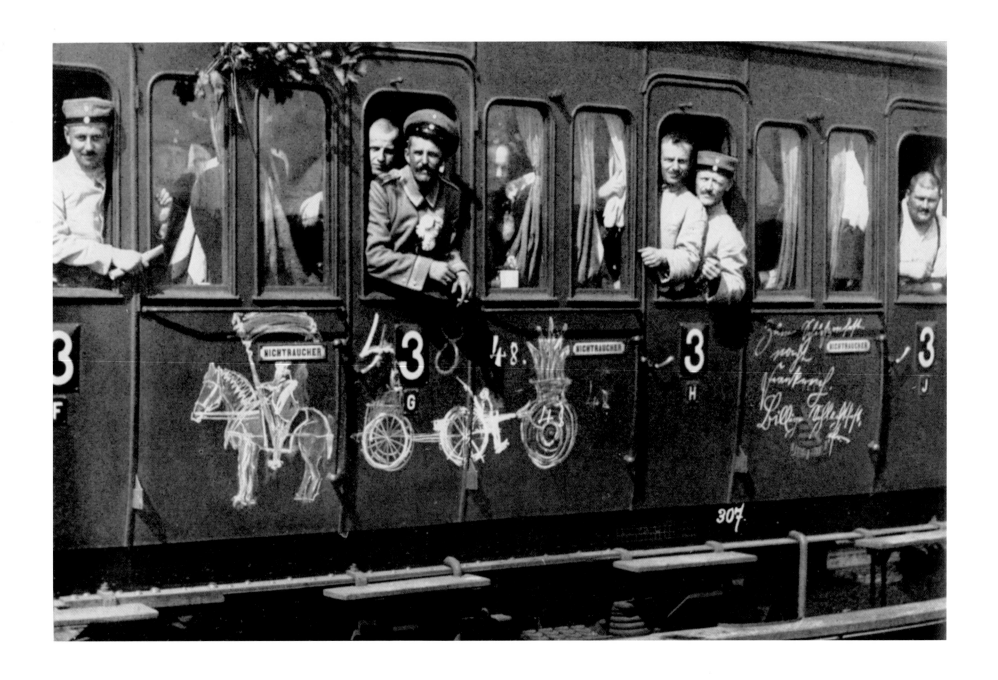

Unknown press photographer
A German troop train, decorated with patriotic slogans, departs for the front,
Germany, August 1914
German mobilisation proceeded rapidly. Civilian press photographers covered troop
departures, but had no access to the front line

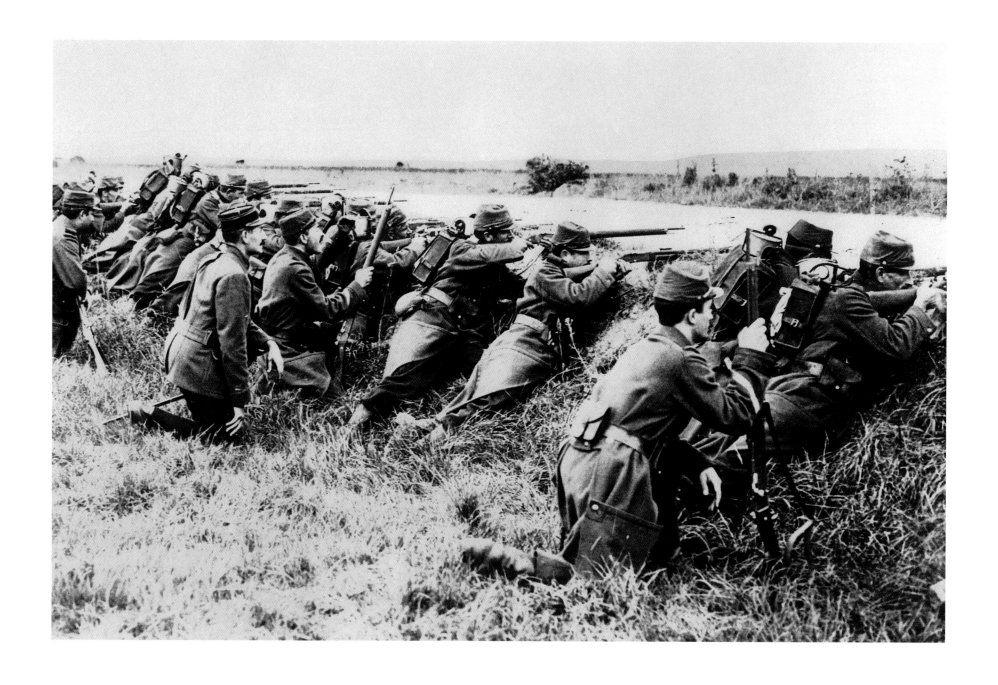

Unknown press photographer
**French infantry poised for action in the first French offensive during what was to be
the Battle of the Frontiers, Alsace-Lorraine, 7–10 August 1914**
*The press photographers were forced to work far behind the actual front lines,
resulting in stiffly posed photographs that convinced neither the newspaper proprietors
nor their readers*

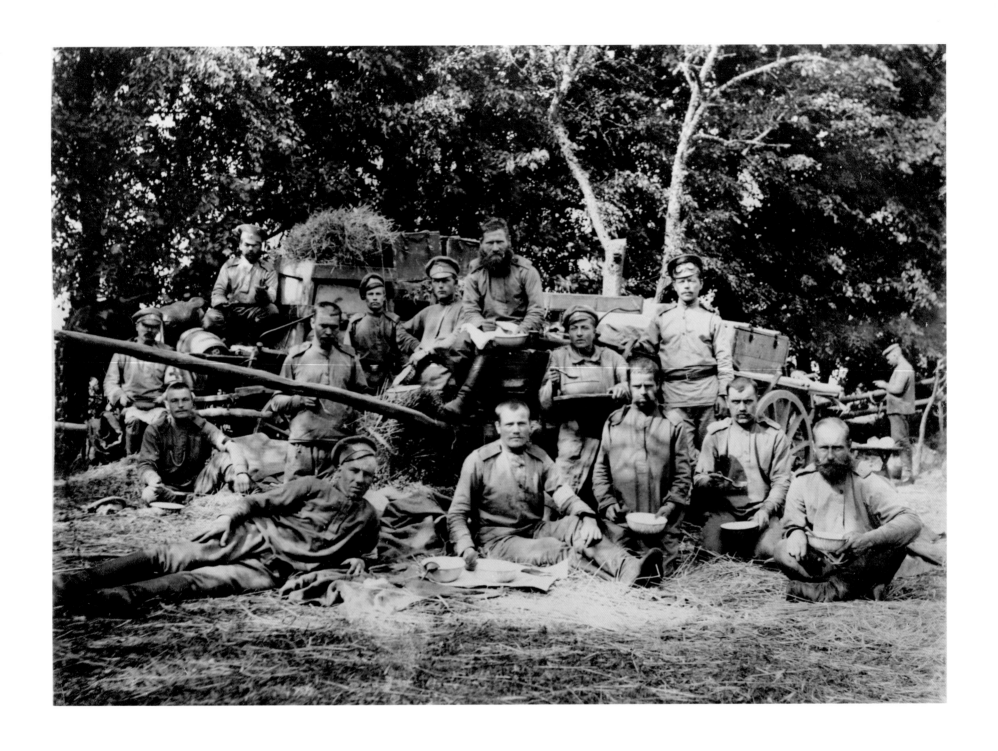

FLORENCE FARMBOROUGH, Red Cross, personal photograph
Russian soldiers attached to a Red Cross unit pause for a meal, on the Eastern Front,
near Grodzisko, East Galicia, Austria-Hungary (now Poland), August 1914
Farmborough, a British teacher working in Moscow, accompanied the Imperial
Russian Army to the front as a Red Cross nurse. A keen amateur photographer, she
produced a number of photographs of the Eastern Front

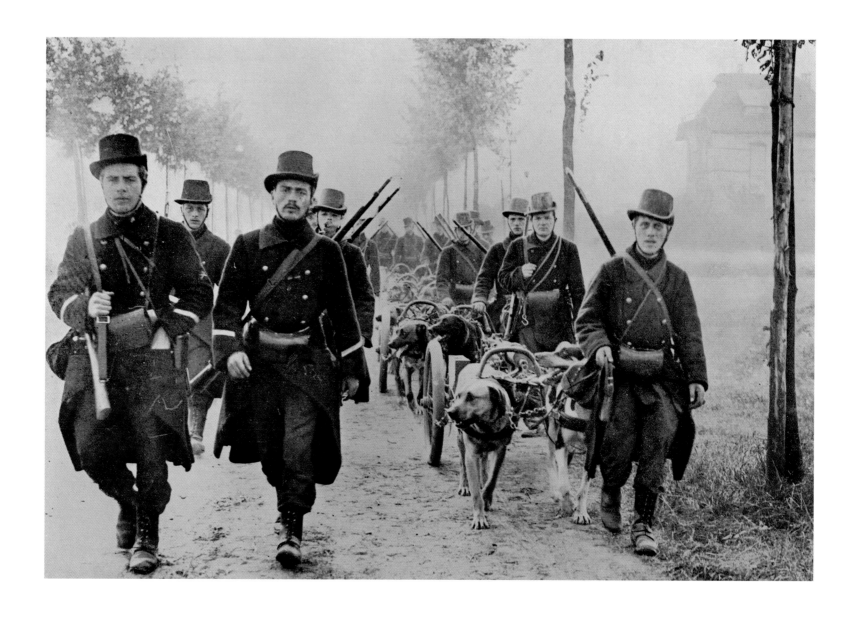

Above: Unknown press photographer
Belgian Carabiniers with dog-drawn machine-gun carts retreat from the German invasion towards Antwerp, Belgium, 20 August 1914
Desperate for support, the Belgian Army welcomed international press photographers to report their struggle

Pages 42–3: Unknown photographer, Sport & General commercial news agency
Troops of the 2nd London Regiment (Royal Fusiliers) wait for a troop train to Southampton, Waterloo Station, London, August 1914
The British Army, comprising a mixture of regular and reserve (territorial) battalions, deployed around the world. This regiment was posted to Malta

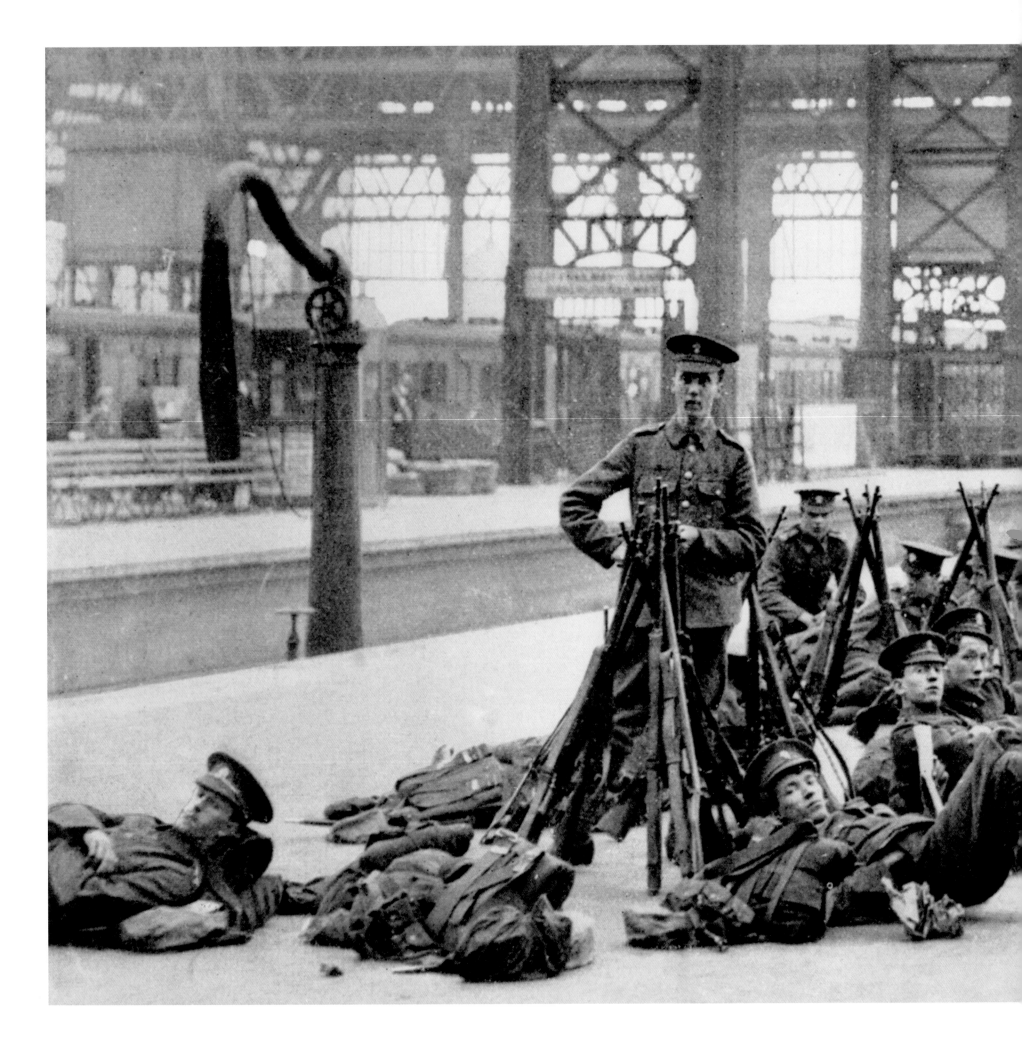

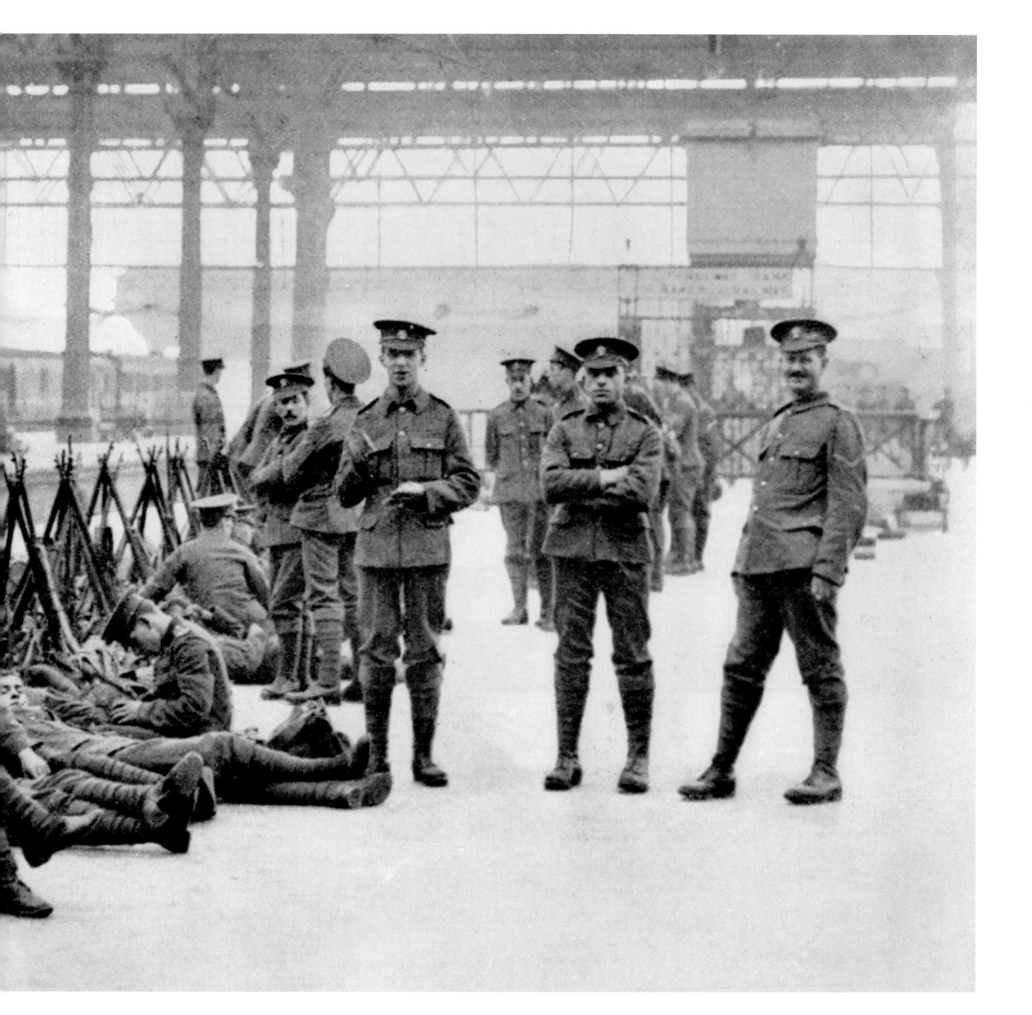

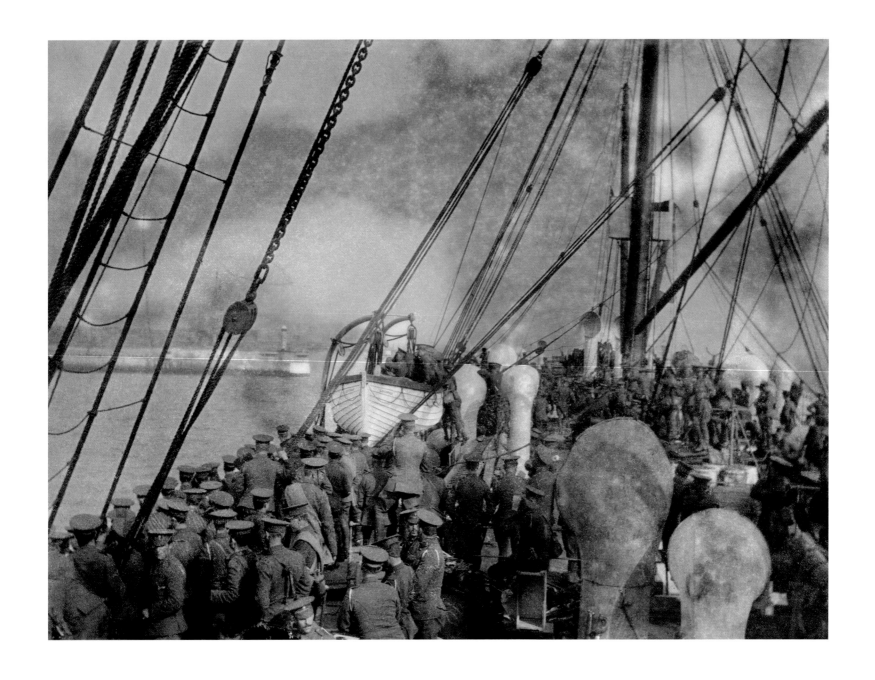

COLONEL THOMAS T. PITMAN, 11th Hussars, BEF, personal photograph
A troop ship of the British Expeditionary Force with the 11th Hussars on board approaches Le Havre, France, 16 August 1914
The British Expeditionary Force, a small, highly trained army of regular soldiers, which was deployed to the Western Front, was dismissed by the Kaiser as a 'contemptible little army'

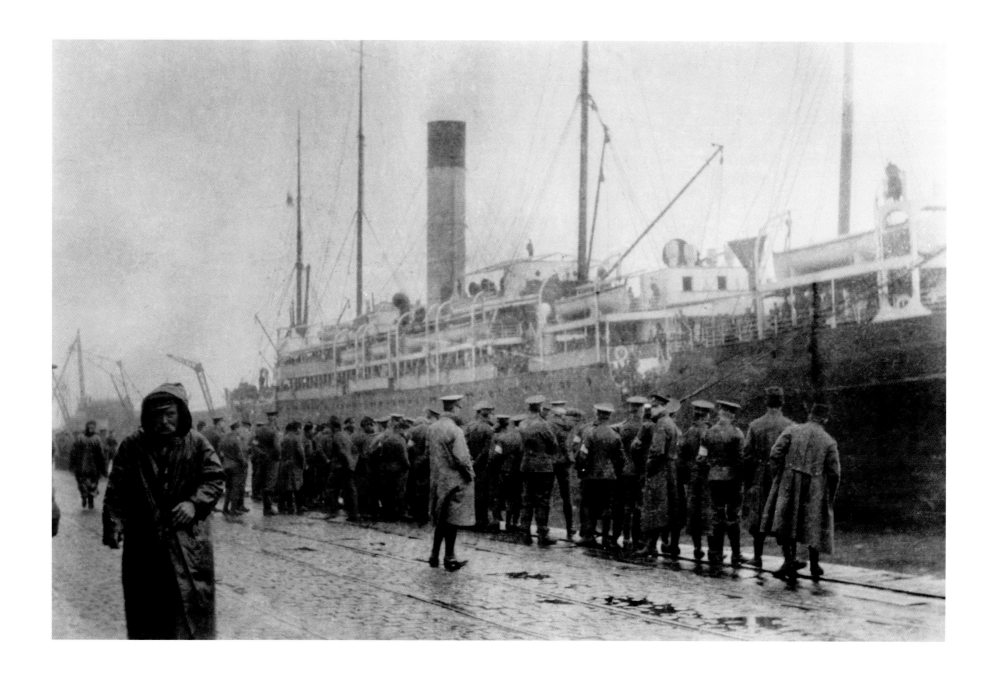

LIEUTENANT RICHARD MONEY, 1st Cameronians, BEF, personal photograph
**1st Cameronians having disembarked from the *Caledonia* as part of the British
Expeditionary Force, Le Havre, France, 16 August 1914**

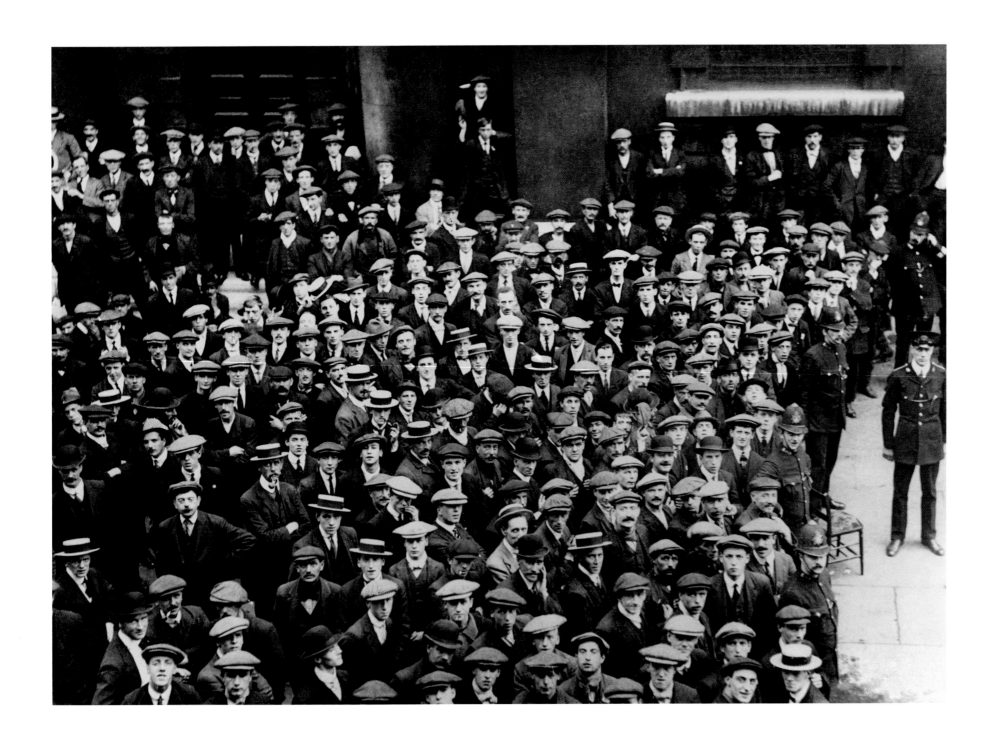

Unknown photographer, Sport & General commercial news agency
British Army reservists waiting for their pay in the churchyard of St Martin-in-the-Fields,
Trafalgar Square, London, August 1914

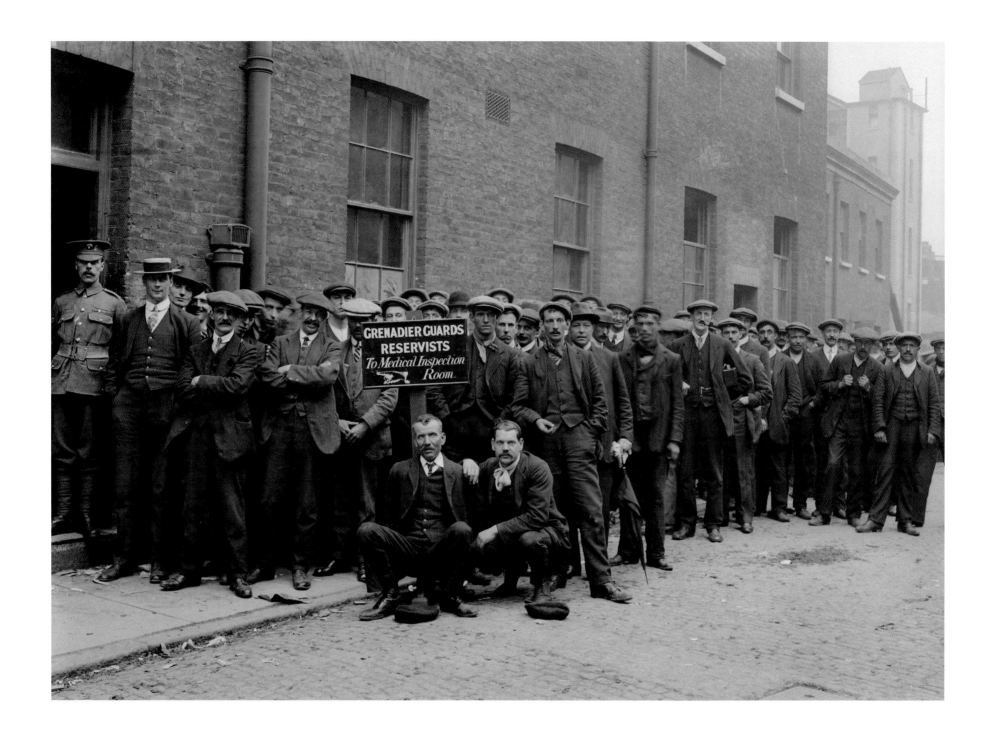

CHRISTINA BROOM, Household Division, British Army
**Reservists of the Grenadier Guards queue for medical inspection, Wellington Barracks,
Chelsea, London, August 1914**
*Mrs Albert Broom, one of the few women professional photographers, was appointed
to the Household Division in 1904 and photographed them in their London barracks
throughout the war*

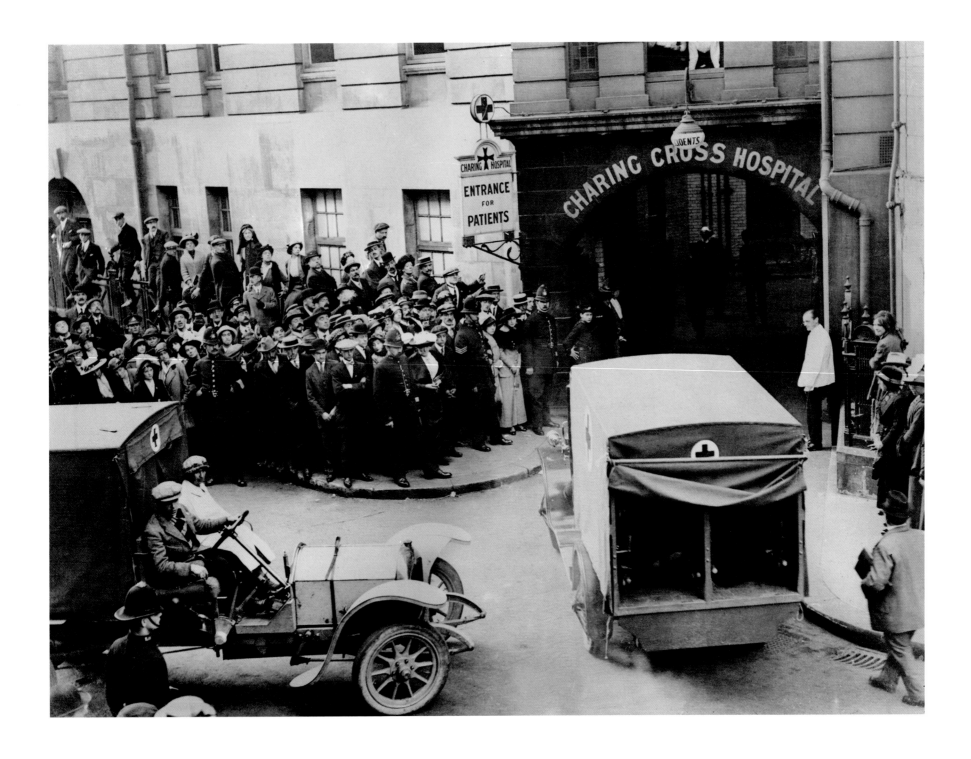

Unknown photographer, Sport & General commercial news agency
In an increasingly sombre national mood one of the first convoys of wounded arrives,
Charing Cross Hospital, London, September 1914

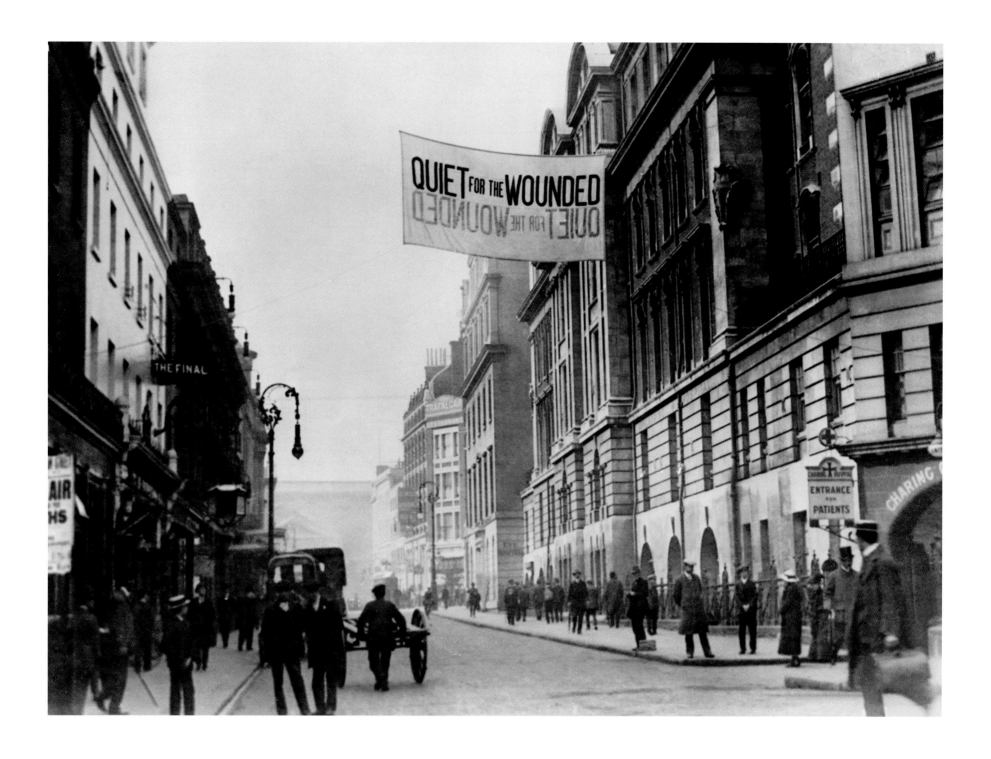

Above: Unknown photographer, Sport & General commercial news agency
Near Charing Cross Hospital, London, September 1914

Pages 50–51: Unknown photographer, Sport & General commercial news agency
British Army recruits train in Regent's Park, London, September 1914
The need for recruits was urgent and a lack of uniforms and equipment forced them to train in civilian clothes without weapons

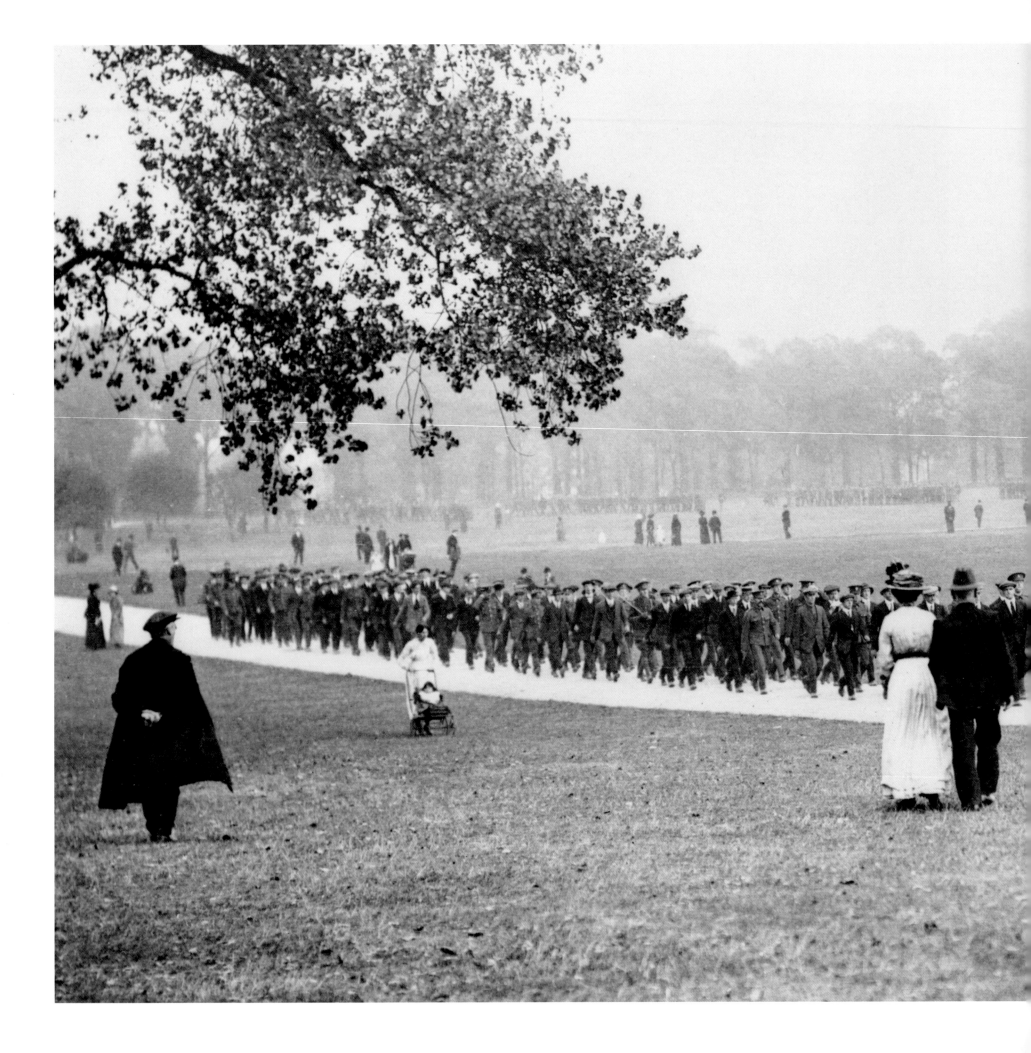

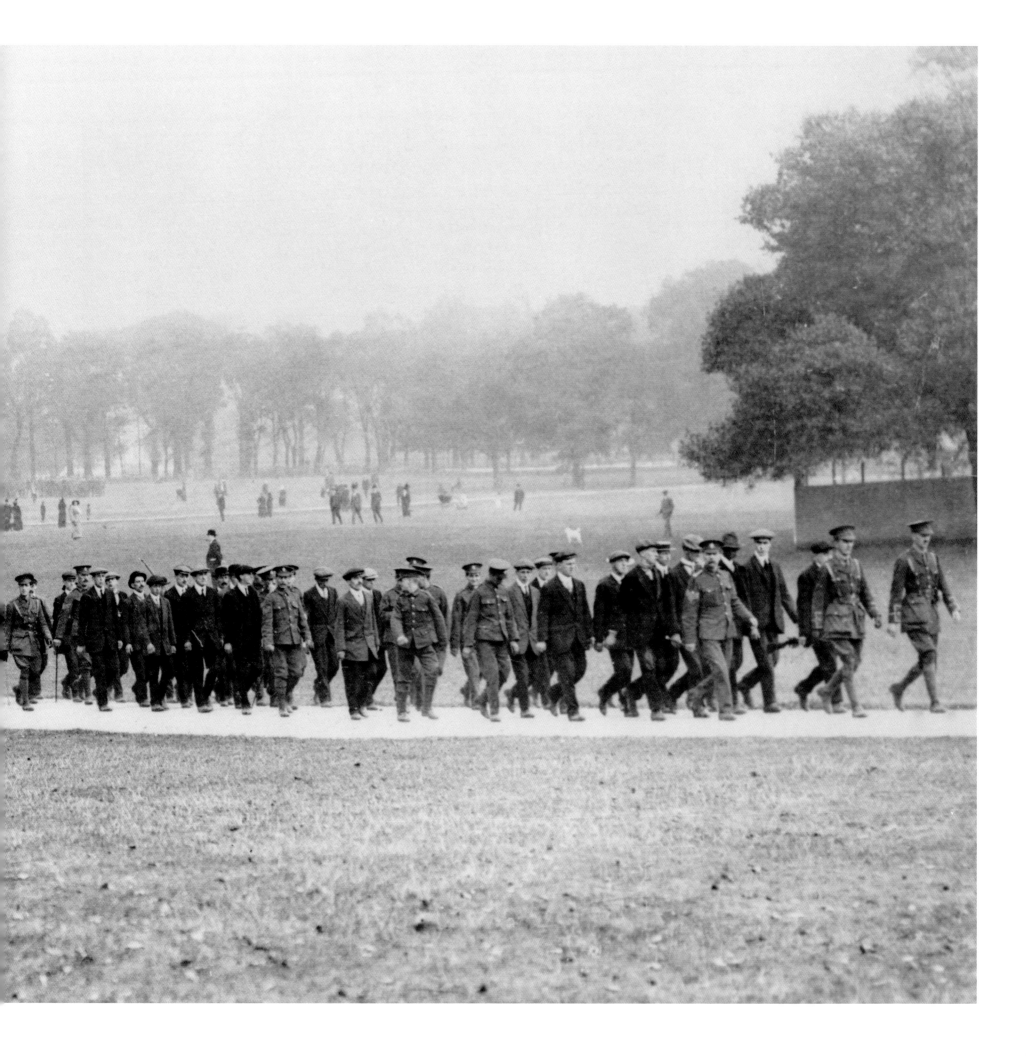

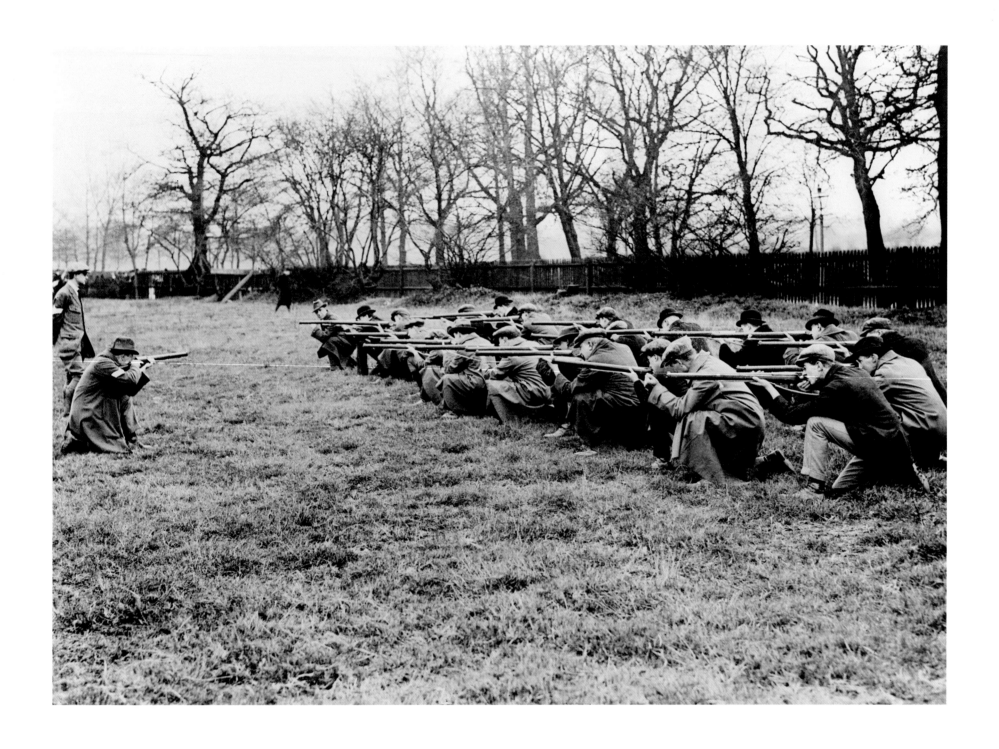

Unknown photographer, Sport & General commercial news agency
The Wandsworth Home Defence Battalion undergoes musketry training,
Wandsworth Common, London, 30 November 1914
As fear of invasion grew in Britain with the advance of the German Army through Europe,
men who had not been accepted for military service formed Home Defence units

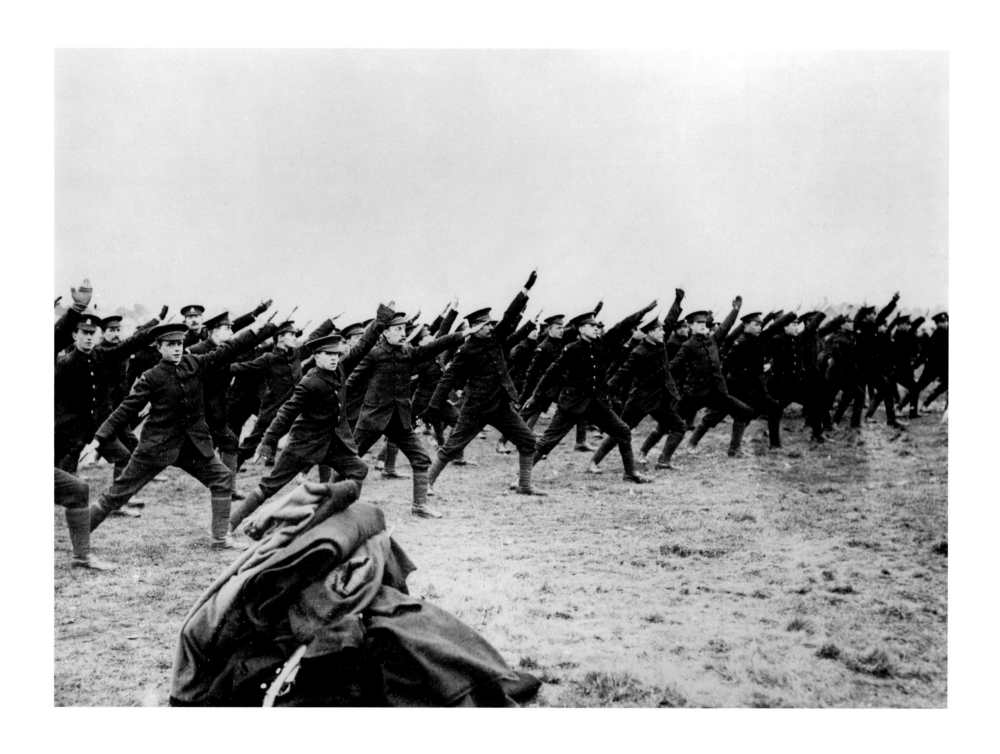

Unknown photographer, Sport & General commercial news agency
Physical training for recruits for the New Army, Branksome, near Bournemouth, Hampshire, January 1915
*The New Army, also known as Kitchener's Army after the Secretary of State for
War, was to provide troops for a long war. More than two million volunteered,
many forming 'Pals' Battalions'*

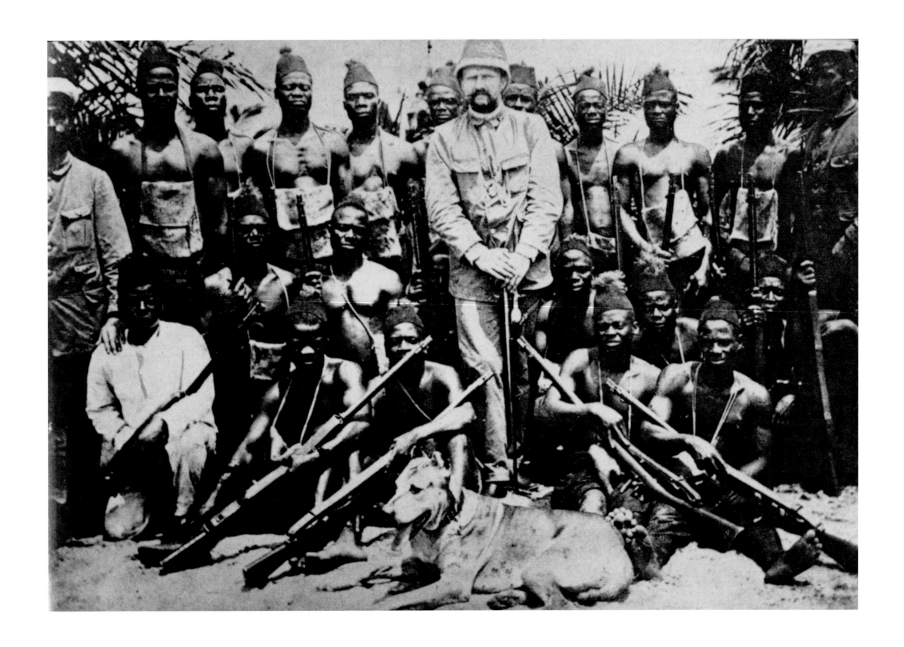

Unknown German photographer, personal photograph
Lieutenant Steinhausen of the Imperial German Army with recruits to a newly formed
local militia in the German colony of Cameroon, *c.* **1901**
German colonial ambitions fuelled international tension before the war

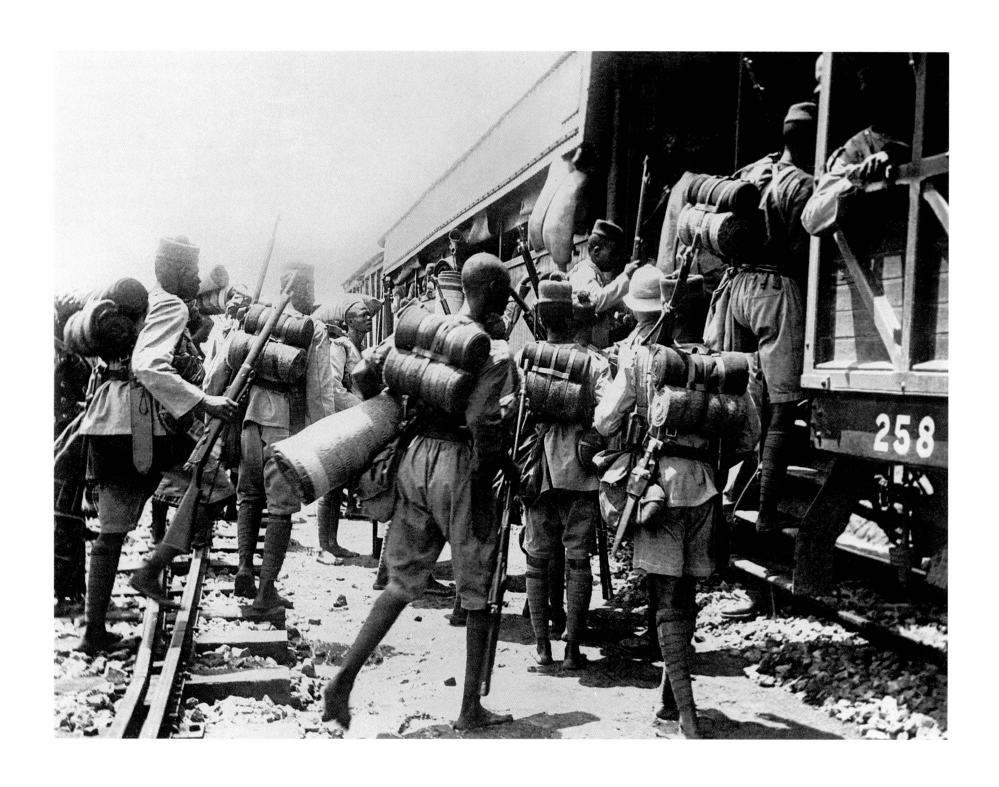

E. S. DOUBLEDAY, 1st Nigeria Regiment, Royal West African Frontier Force, personal photograph
1st Nigeria Regiment entrains to join the campaign in German Cameroon, Kaduna, Nigeria, 6 August 1914
Britain and France immediately acted to deprive Germany of support from its African colonies.
The subsequent campaign in German Cameroon, lasting eighteen months, was recorded entirely by
the soldiers' personal photographs

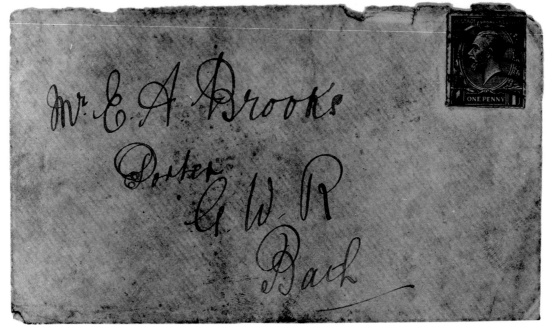

IWM collection
A letter sent to E. A. Brooks, a Great Western Railway porter, Bath, Somerset, *c.* 1914
Social pressures to join the armed forces were great. Those not in uniform risked being branded as cowards

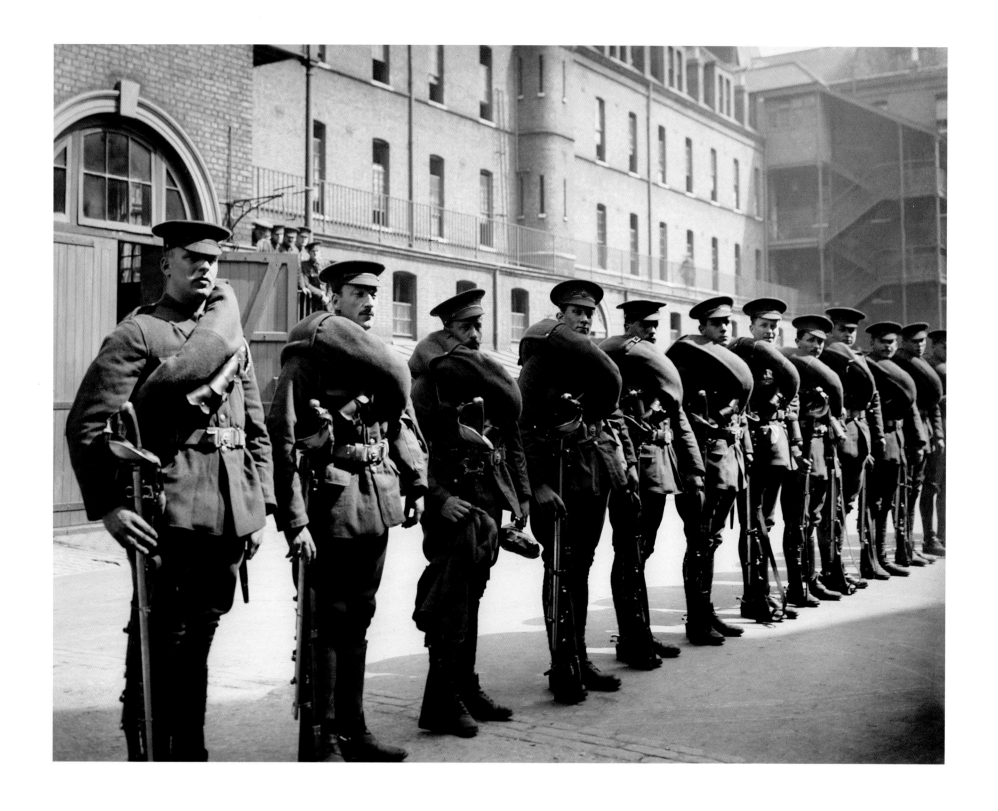

CHRISTINA BROOM, Household Division, British Army
1st Life Guards parade before leaving for the front, Chelsea Barracks, London, August 1914

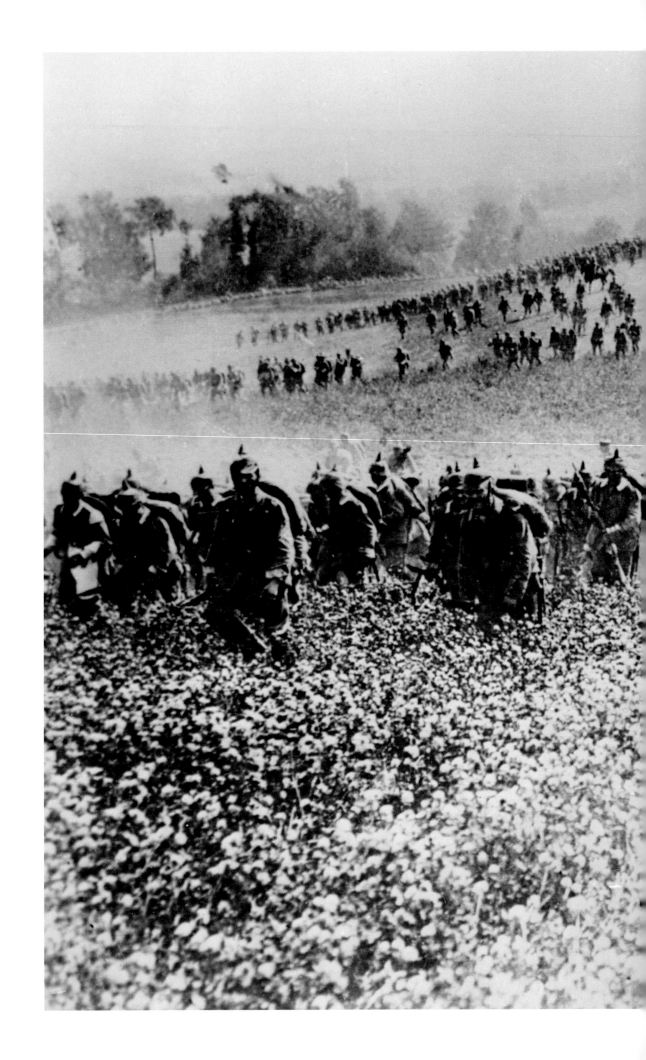

Unknown photographer, Sport & General commercial news agency
This photograph of the Imperial German Army may pre-date the war, but subsequently became an enduring symbol of the German advance to the River Marne, France, August 1914

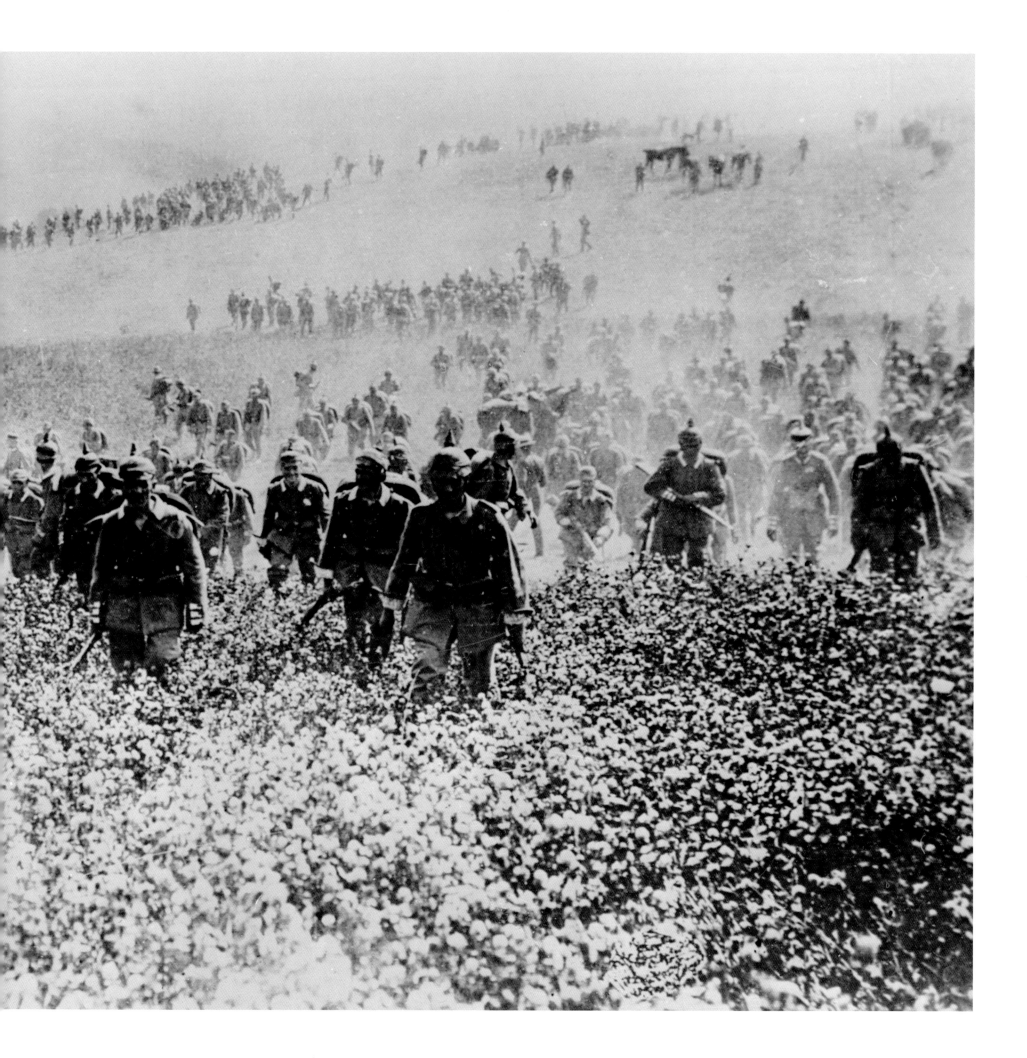

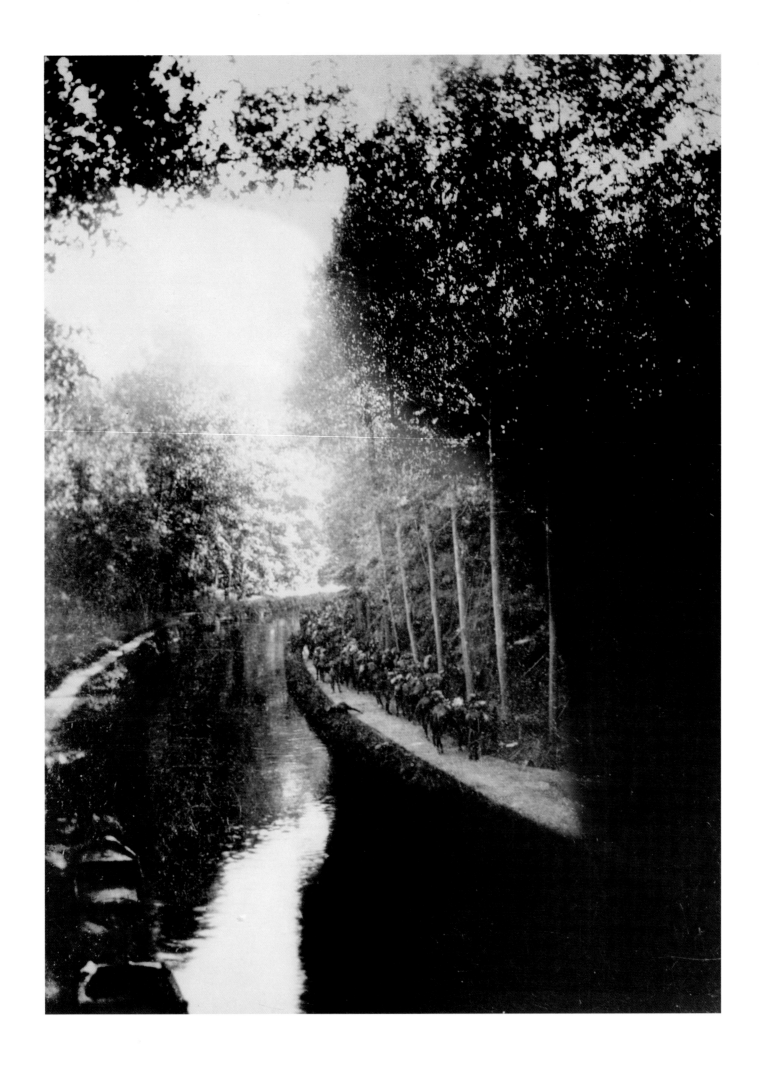

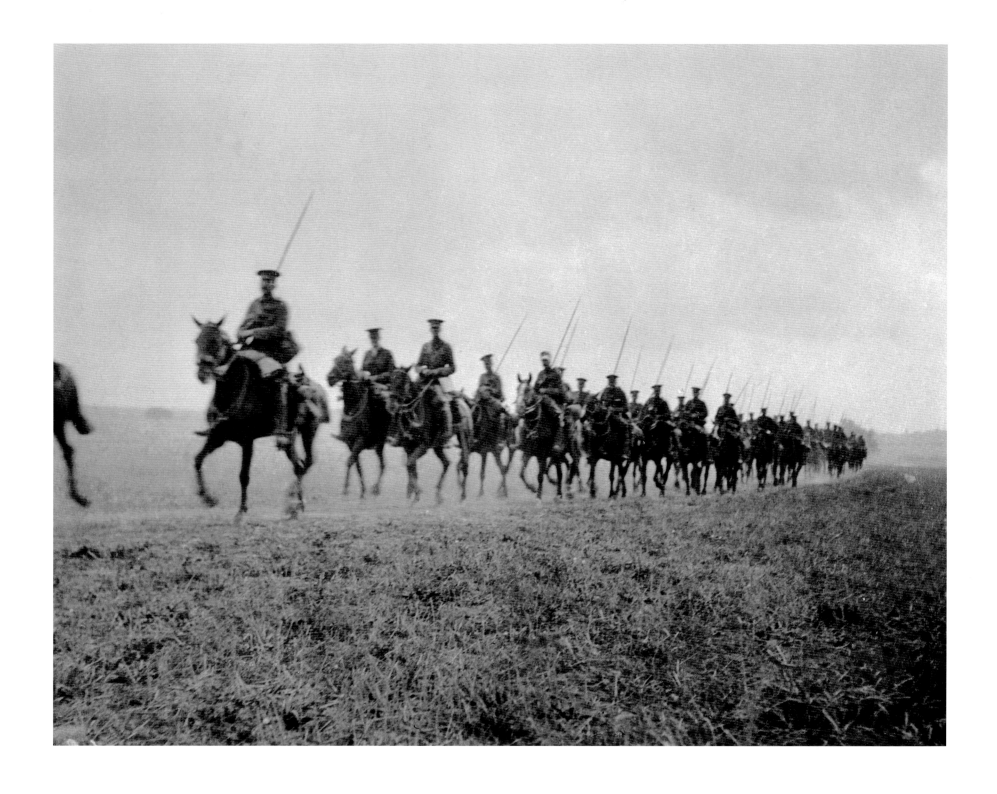

Left: COLONEL THOMAS T. PITMAN, 11th Hussars, BEF, personal photograph
11th Hussars (Prince Albert's Own) water their horses during the retreat from Mons, Canal de l'Ourcq, near Mitry, France, 3 September 1914
The British Expeditionary Force fought its first battle at Mons, Belgium, on 23 August. Despite inflicting heavy casualties it was outnumbered and forced to retreat

Above: PAUL LUCIEN MAZE, French Army interpreter attached to the Royal Scots Greys, personal photograph
2nd Cavalry Division in retreat, France, August 1914
Maze, an artist, later worked for French intelligence

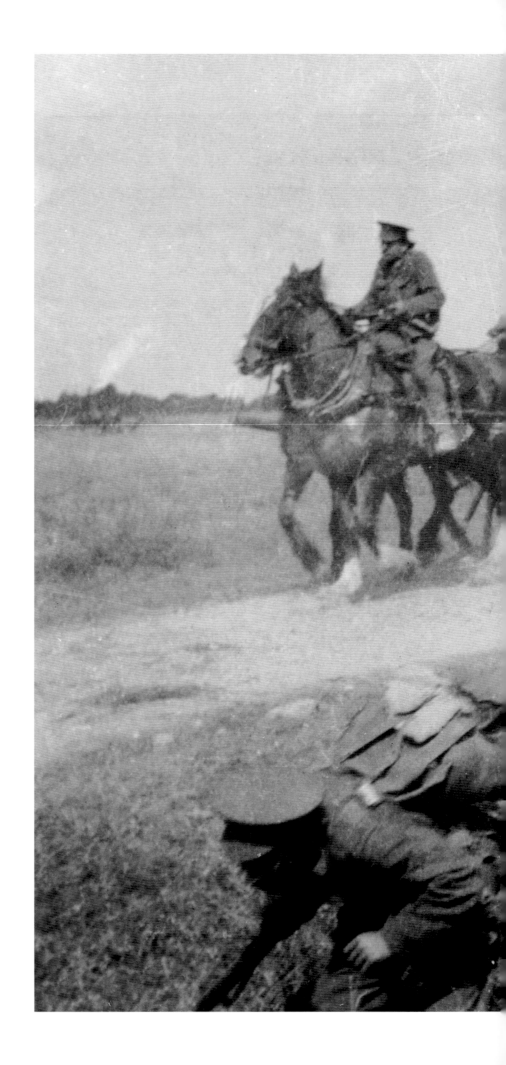

LIEUTENANT RICHARD MONEY, 1st Cameronians, BEF, personal photograph
**A transport column of the 1st Middlesex Regiment under shrapnel fire during the
Battle of the Marne, Signy-Signets road, France, 8 September 1914**
*The battle halted the German advance 30 miles from Paris. This was one of the first
photographs taken under fire and was widely published in Britain. Nine horses were
killed. The man in the centre of the photograph has just suffered a serious head wound*

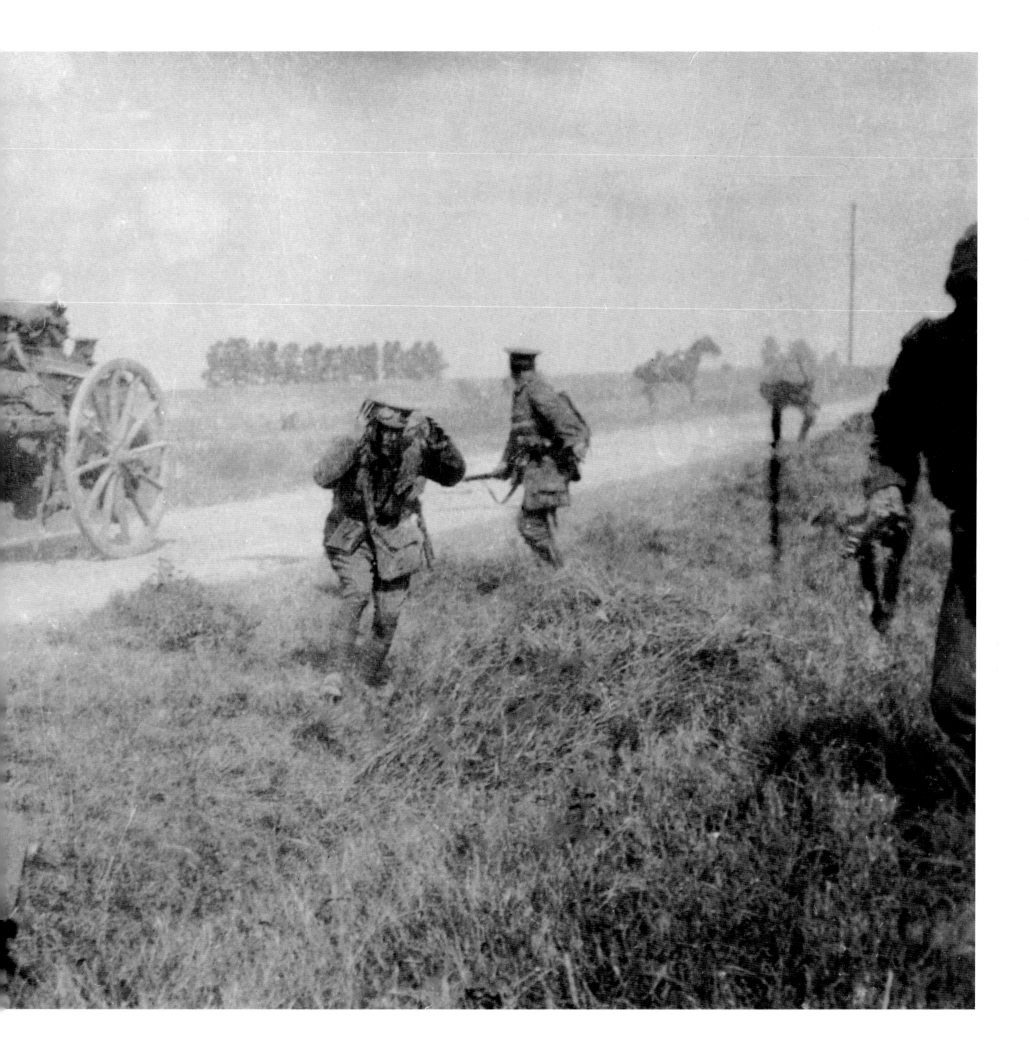

Unknown photographer, Sport & General commercial news agency
In a rearguard action intended to delay the German advance, a Belgian infantry unit defends a railway bridge while engineers prepare to destroy it, Termode, near Ghent, Belgium, 18 September 1914

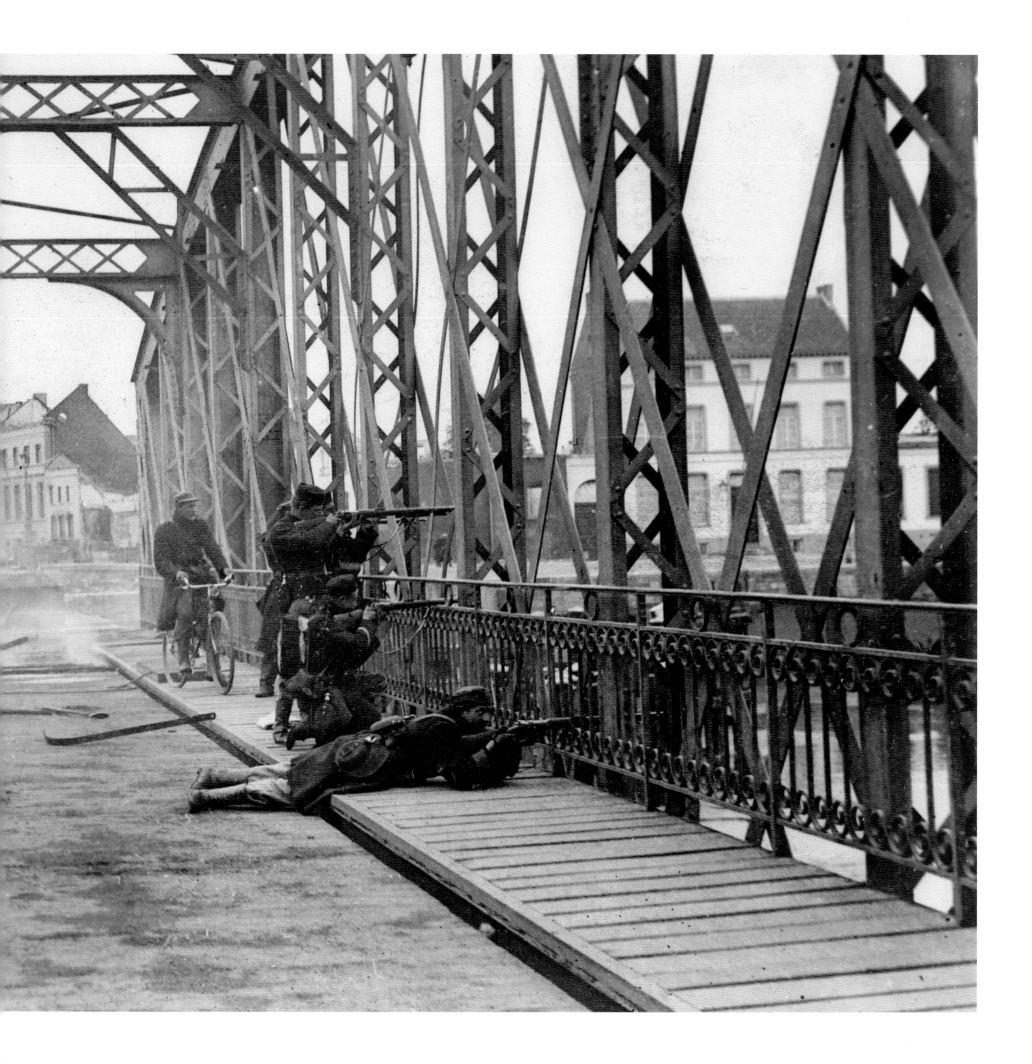

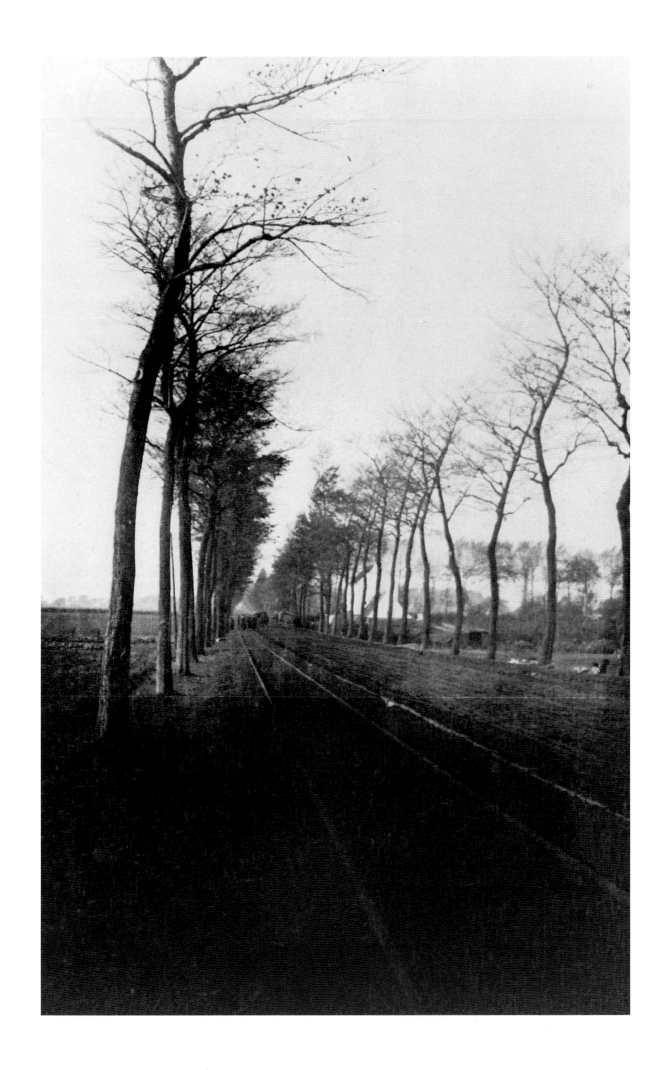

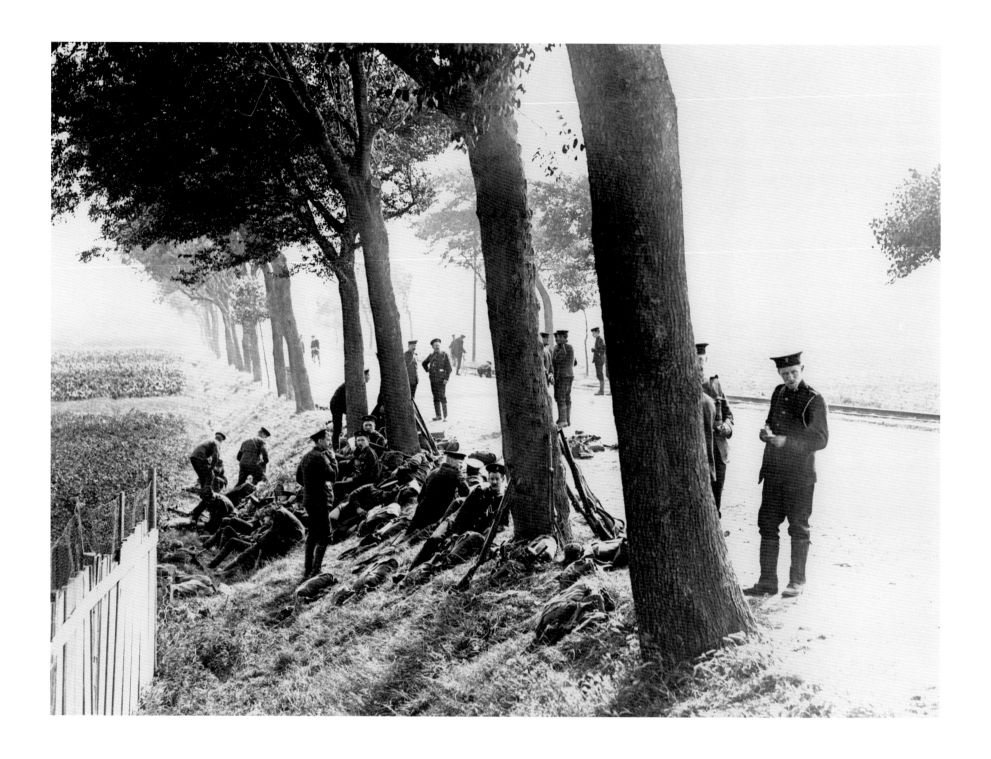

Left: CAPTAIN THE HON. HAROLD BURGE ROBSON, Northumberland Hussars, BEF, personal photograph
The Ypres–Menin road looking towards the dangerous intersection, which British troops would later call 'Hell-Fire Corner', Belgium, 11 November 1914
After the Battle of the Marne the opposing armies moved northwest in a series of attempts to outflank each other. 'The Race to the Sea' sought control of the Channel ports, on which Britain's security depended

Above: Unknown photographer, Sport & General commercial news agency
Men of the Royal Marine Brigade, part of a force mobilised by the Admiralty to defend the Channel ports, Ostend, Belgium, *c*. 28 August 1914
German forces occupied Ostend on 15 October 1914, increasing the threat to the French ports of Calais, Dunkirk and Boulogne

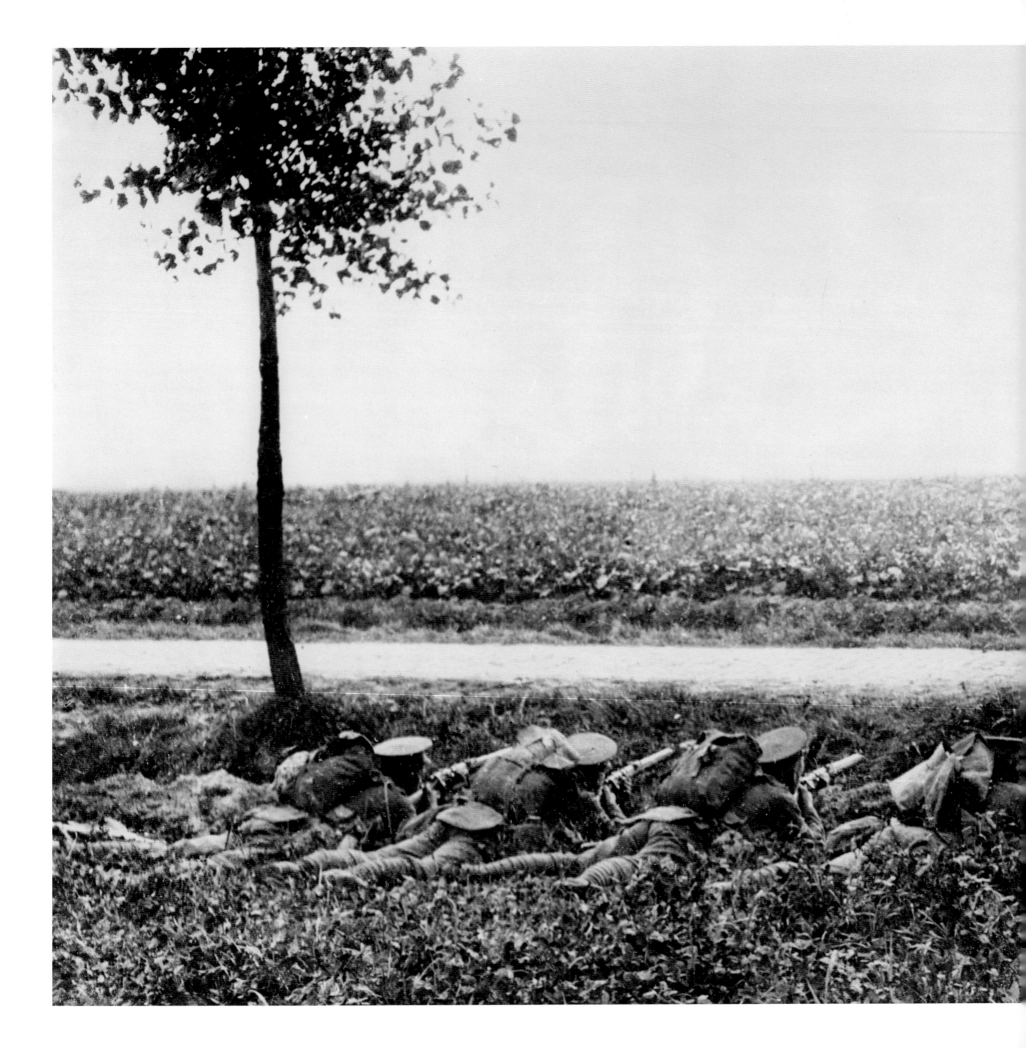

Unknown photographer, Sport & General commercial news agency
British infantry defend a roadside ditch, Belgium, 13 October 1914
*As the German advance was halted, trenches began to evolve on the Western Front.
Entrenching tools were scarce, so early trenches often evolved from existing ditches
and embankments*

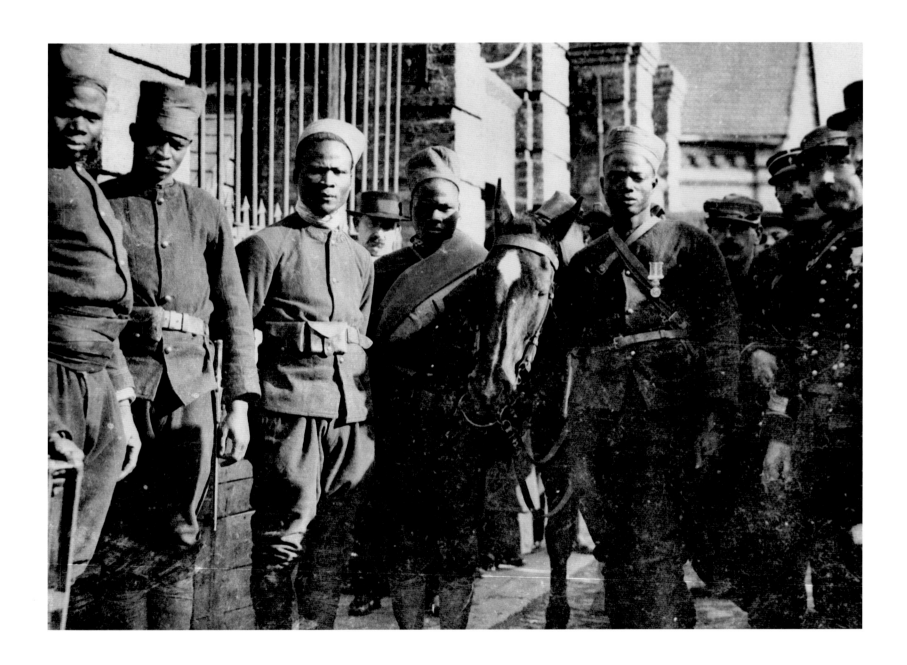

Unknown photographer, Sport & General commercial news agency
Senegalese Tirailleurs serving with the French Army, Dunkirk, France, November 1914
French and British colonial troops started to arrive on the Western Front in October
1914 and played an important part in the First Battle of Ypres

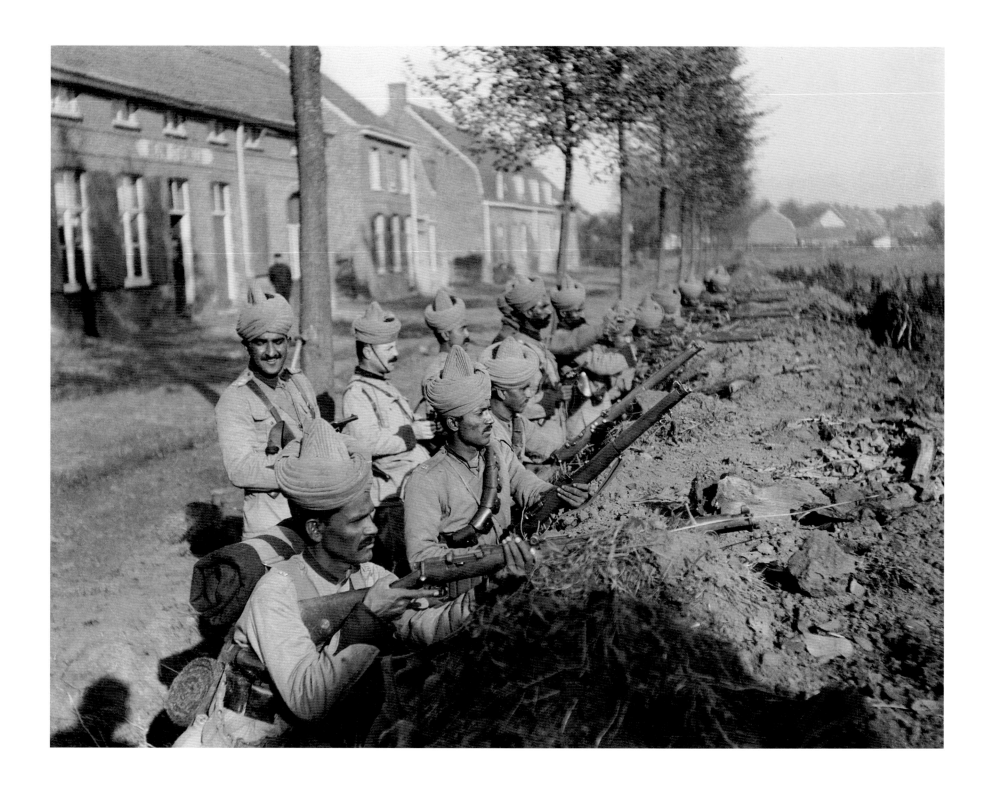

PAUL LUCIEN MAZE, French Army interpreter attached to the Royal Scots Greys
**Indian troops of 129th (Duke of Connaught's Own) Baluchis man defences on the outskirts of
Wytschaete, Belgium, October 1914**

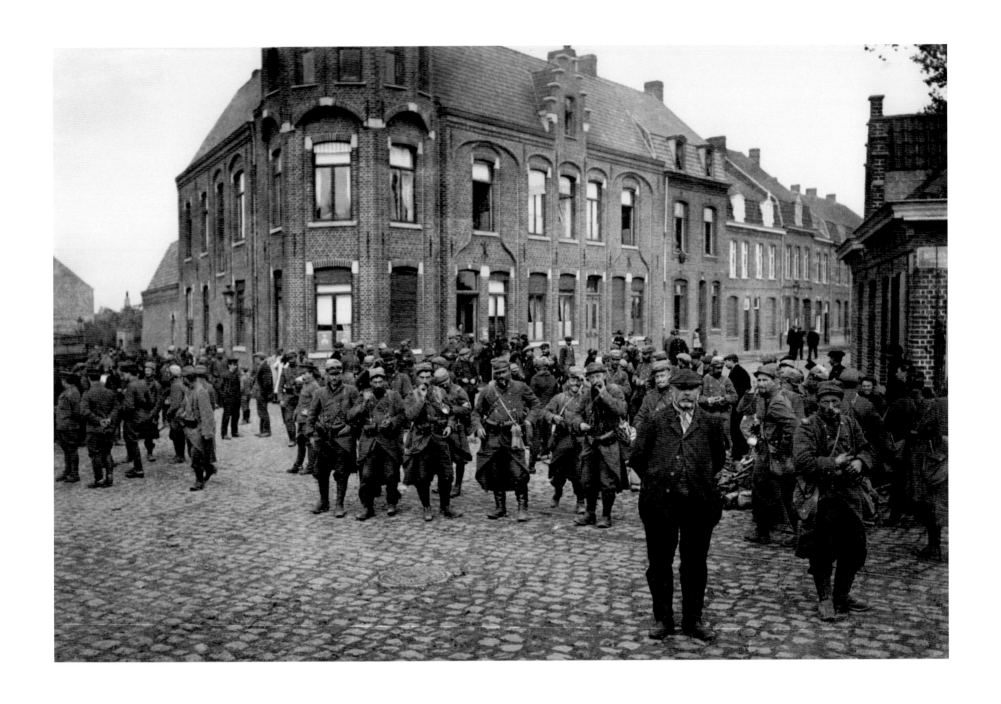

SERGEANT CHRISTOPHER PILKINGTON, 2nd Scots Guards, BEF, personal photograph
French troops assemble on the outskirts of Ypres, Belgium, October 1914
Control of Ypres ensured access to Calais, Dunkirk, Boulogne and the Flanders plain.
In mid-October 1914 the Allies took up position around the city, forming a small
salient. This could be defended from a ridge to the east, but was surrounded by higher
ground occupied by the Germans

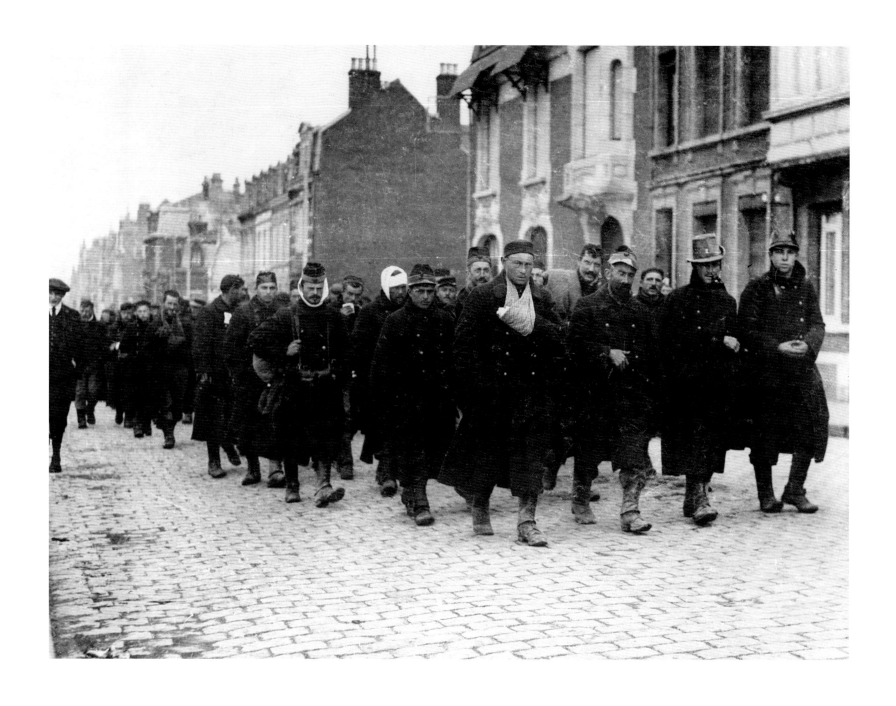

Unknown photographer, Sport & General commercial news agency
Wounded Belgian soldiers marching through Calais, France, 11 November 1914

Unknown photographer, Sport & General commercial news agency
Indian soldiers of 129th (Duke of Connaught's Own) Baluchis, survivors of the defence of Hollebeke, First Battle of Ypres, Gheluvelt (possibly), Belgium, 31 October 1914
The Baluchis, though outnumbered and suffering heavy casualties, did much to prevent the Germans breaking through to the Channel ports. Sepoy Khudadad Khan became the first Indian soldier of the war to receive the Victoria Cross

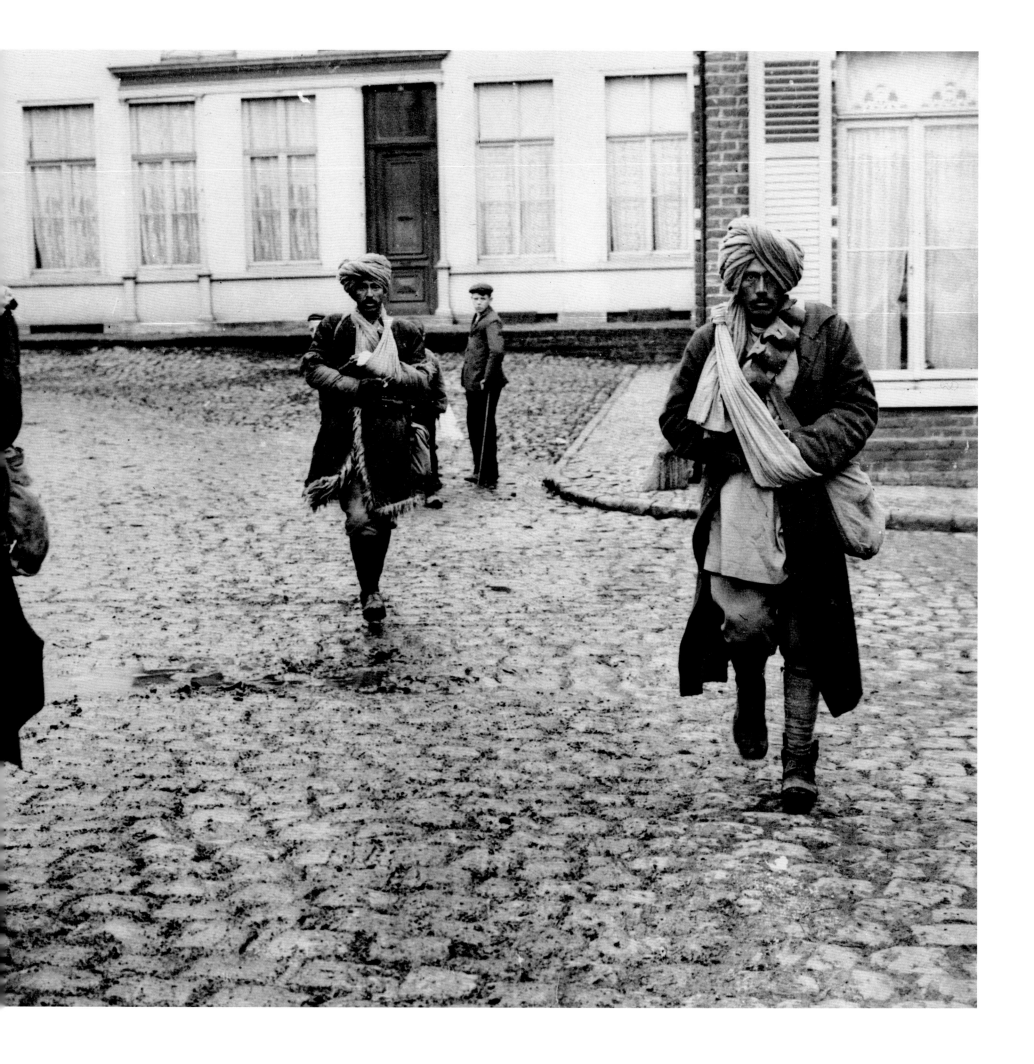

Unknown photographer, Sport & General commercial news agency
Refugees flee the city during the First Battle of Ypres, Belgium, 2 November 1914
*Atrocities perpetrated by German forces on Belgian civilians caused international outrage
and fuelled Allied propaganda*

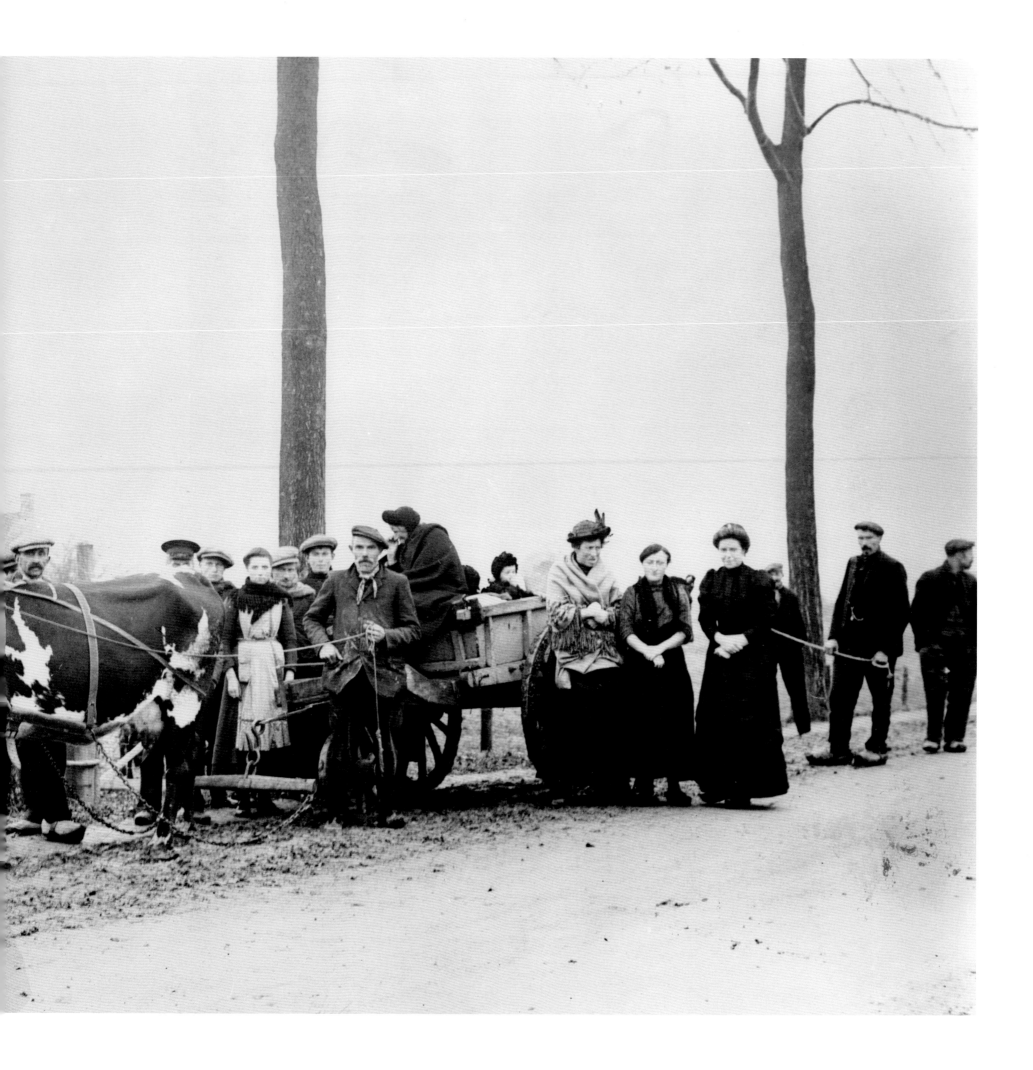

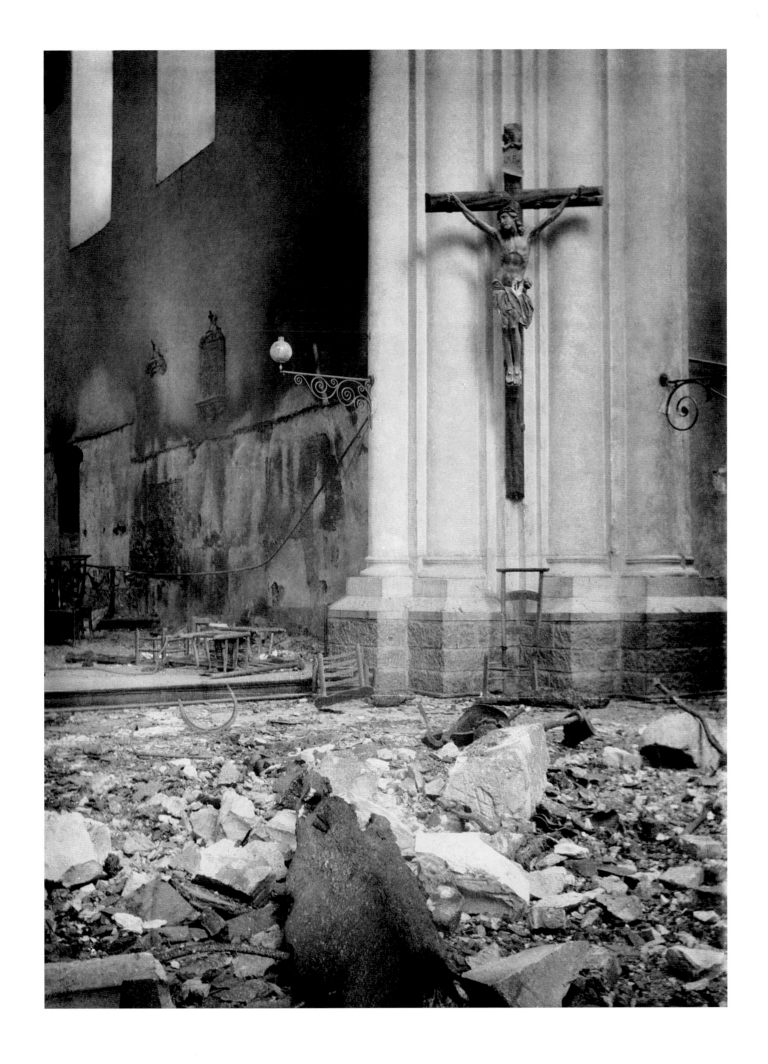

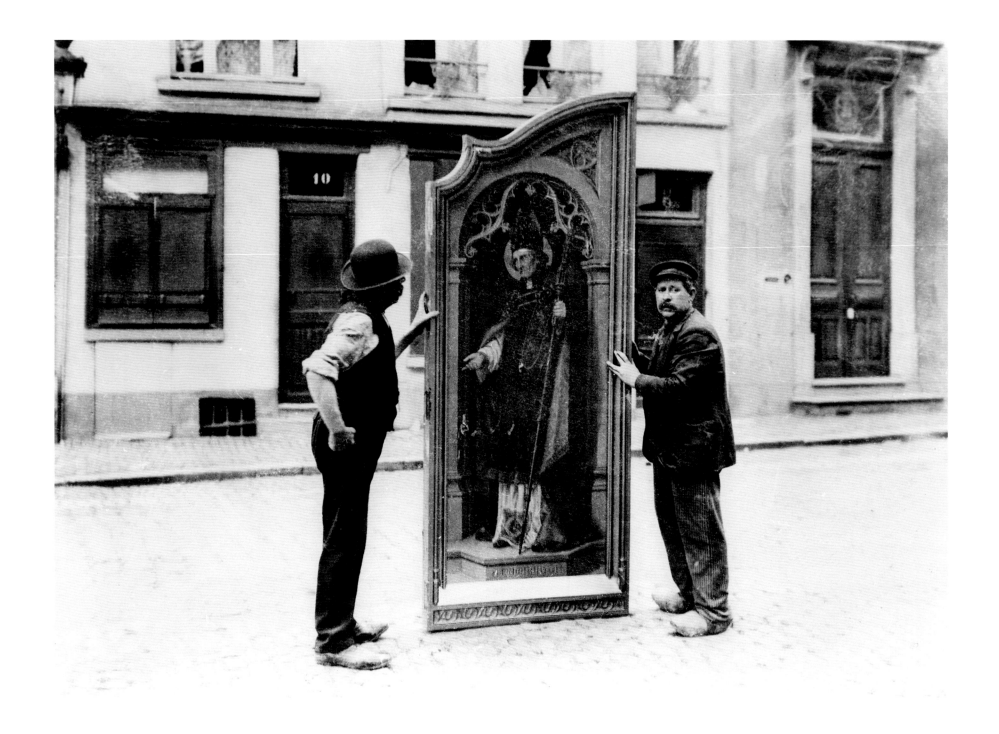

Left: COLONEL THOMAS T. PITMAN, 11th Hussars, BEF, personal photograph
The ruins of a church, with cross intact, destroyed by German artillery, during the First Battle of Ypres, Messines, near Ypres, Belgium, 28 October 1914

Above: Unknown photographer, Sport & General commercial news agency
The rescue of a painting from St Rumbold's Cathedral, Malines, shortly before the town was occupied by German forces, Belgium, 1 September 1914

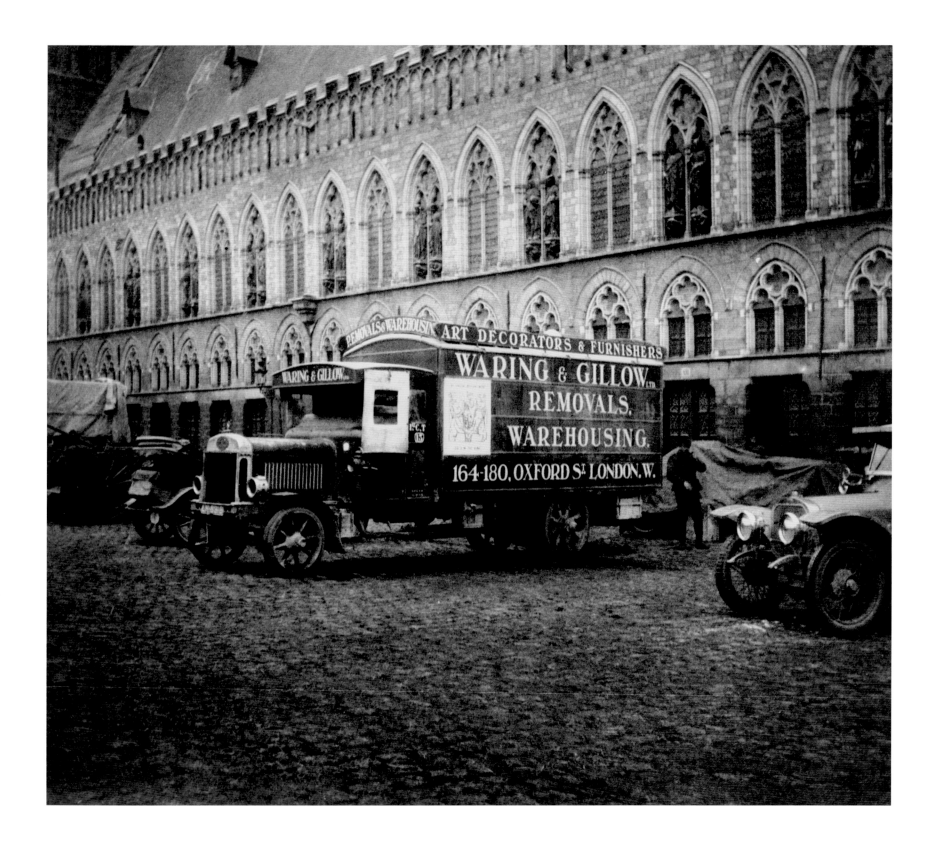

SERGEANT CHRISTOPHER PILKINGTON, 2nd Scots Guards, BEF, personal photograph
**A British-requisitioned removal lorry during the First Battle of Ypres, the Cloth Hall
(Lakenhalle), Ypres, Belgium, October 1914**
*The incongruous sight of such vehicles in the war zone proved irresistible to
photographers. Due to the serious transport shortage on the Western Front,
civilian vehicles were requisitioned by the War Office*

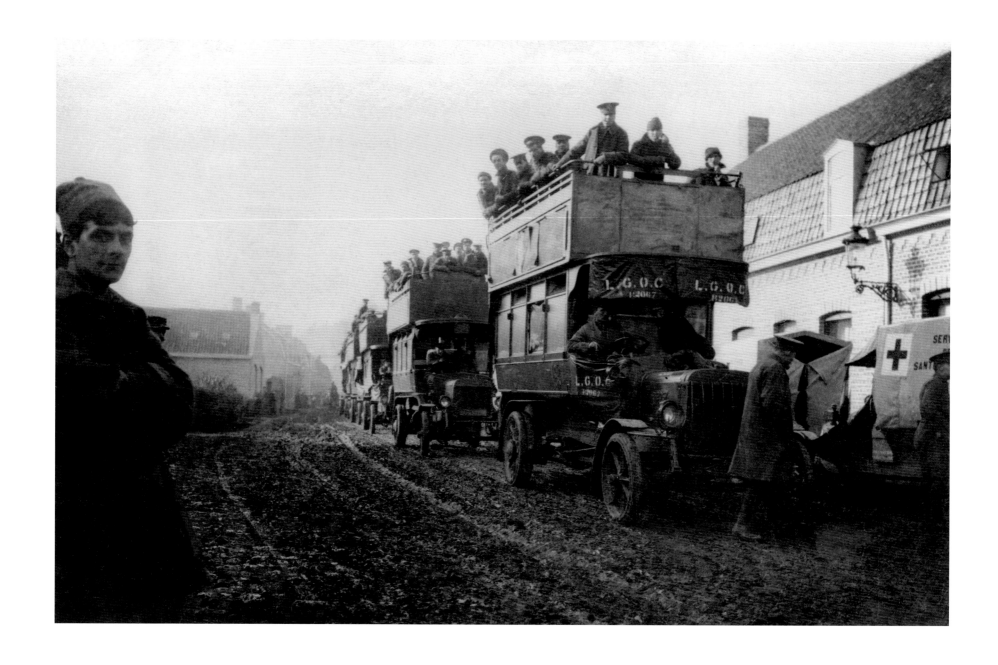

SERGEANT CHRISTOPHER PILKINGTON, 2nd Scots Guards, BEF, personal photograph
**London buses transport men of 2nd Royal Warwickshire Regiment to Ypres during the
First Battle of Ypres, Dickebusch, Belgium, 6 November 1914**

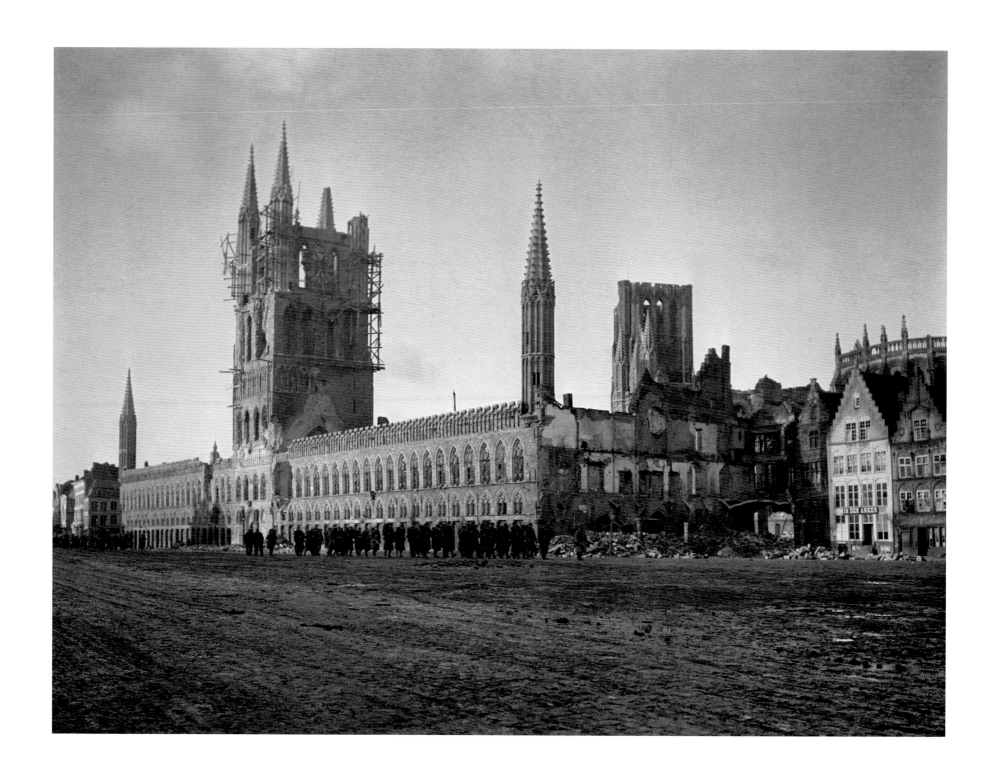

SERGEANT CHRISTOPHER PILKINGTON, 2nd Scots Guards, BEF, personal photograph
The Cloth Hall (Lakenhalle) showing damage caused by German shellfire during the
First Battle of Ypres, Ypres, Belgium, November 1914
The eleventh-century hall had just been restored when it was first hit by German shells
on 5 November 1914

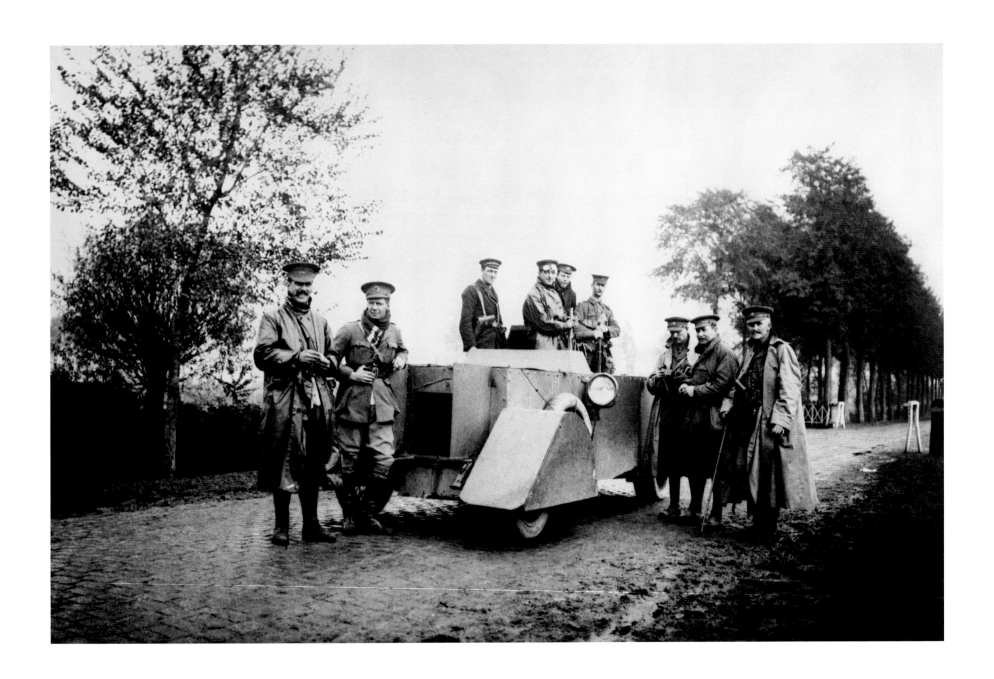

SERGEANT CHRISTOPHER PILKINGTON, 2nd Scots Guards, BEF, personal photograph
A Rolls-Royce armoured car, operated by the Royal Naval Air Service, after an operation at 'Hell-Fire Corner' on the Ypres–Menin road, near Ypres, Belgium, 14 October 1914
The air arm of the Royal Navy was established in 1912 and its armoured cars were initially used to pick up stranded airmen. It was a raiding unit during the retreat from Antwerp, but its operations on the Western Front ceased after trench warfare developed

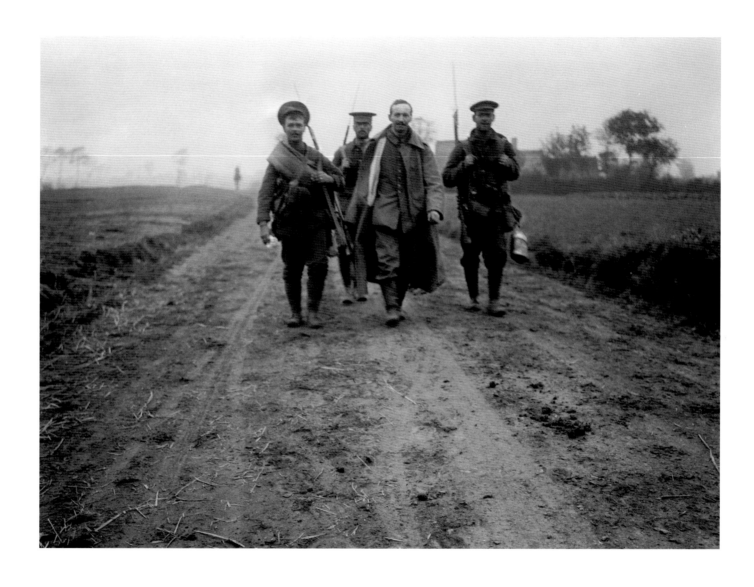

SERGEANT CHRISTOPHER PILKINGTON, 2nd Scots Guards, BEF, personal photograph
2nd Scots Guards escort a prisoner to a holding following a major battle at Gheluvelt during the First Battle of Ypres, Belgium, 29–31 October 1914
Gheluvelt was the scene of heavy fighting. It was eventually captured by the Germans, but the momentum of the German advance on Ypres was broken

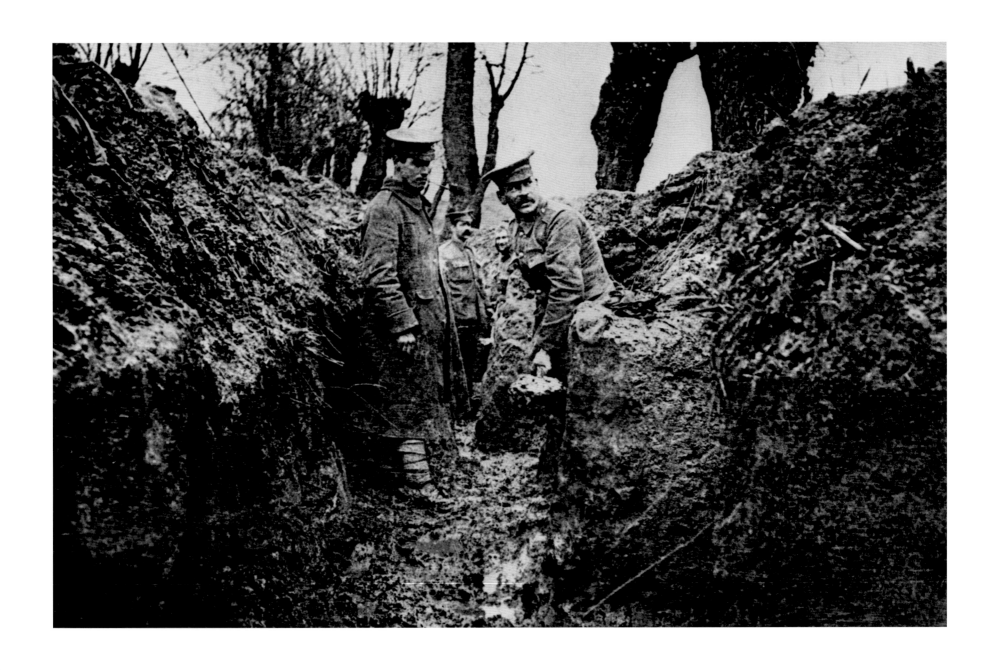

SERGEANT CHRISTOPHER PILKINGTON, 2nd Scots Guards, BEF, personal photograph
2nd Scots Guards excavate a trench near rue Petillon, Fleurbaix, Pas de Calais, France, 19 November 1914
Early trenches were highly improvised and lacked shelter and drainage. Collapses and floods
were common. Soldiers' photographs from this period reveal appalling conditions

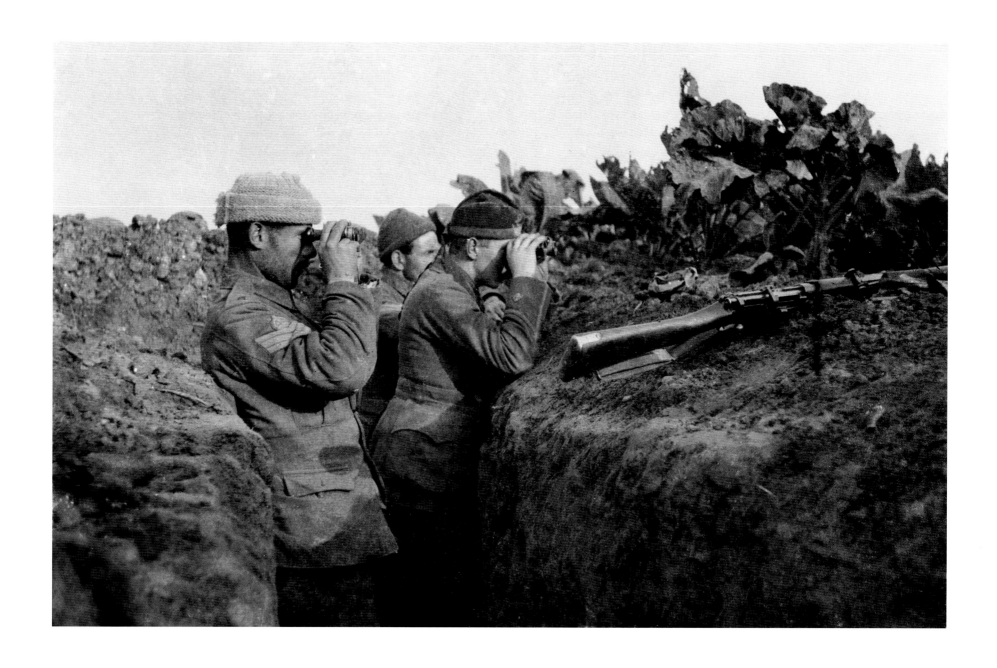

LIEUTENANT RICHARD MOONEY, 1st Cameronians, BEF, personal photograph
**1st Cameronians watching for snipers, 'Cabbage Patch Trench', Rouges Bancs –
La Boutilliére sector, Pas de Calais, 5 November 1914**
*Snipers caused many British casualties in the early days of trench warfare. Steel helmets
were not issued generally until 1916*

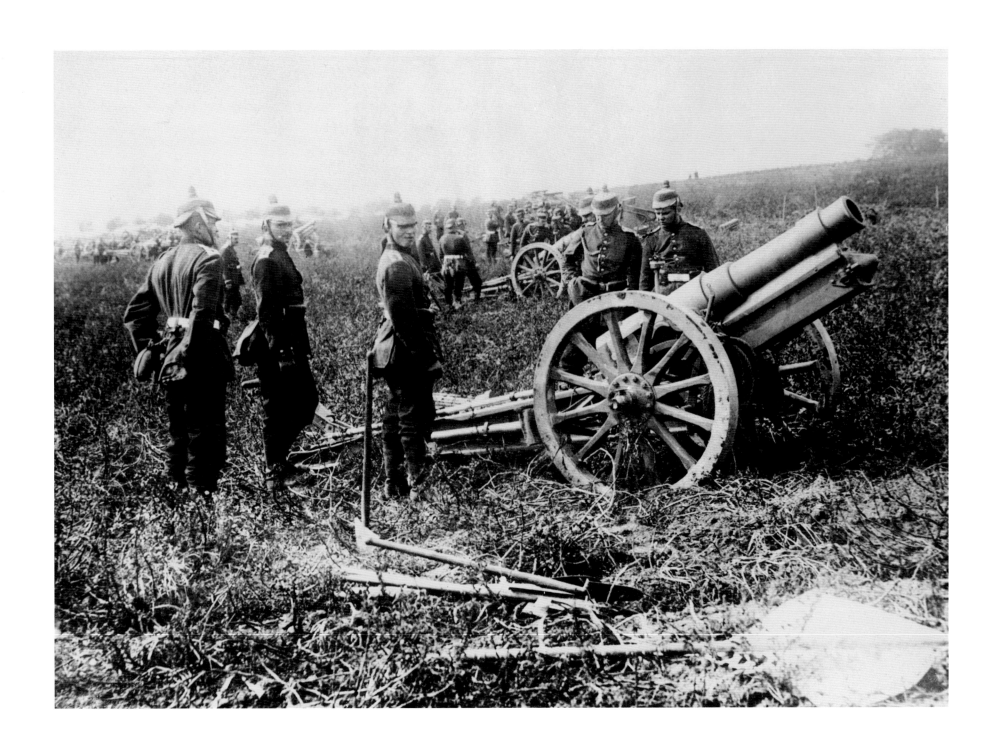

Unknown photographer, Sport & General commercial news agency
A German 15cm Heavy Field Howitzer battery
Though this picture may pre-date the war, it was used by the British press to explain
the impact of German artillery on the Ypres Salient on 14 November 1914. This gun
was particularly unpopular with British troops

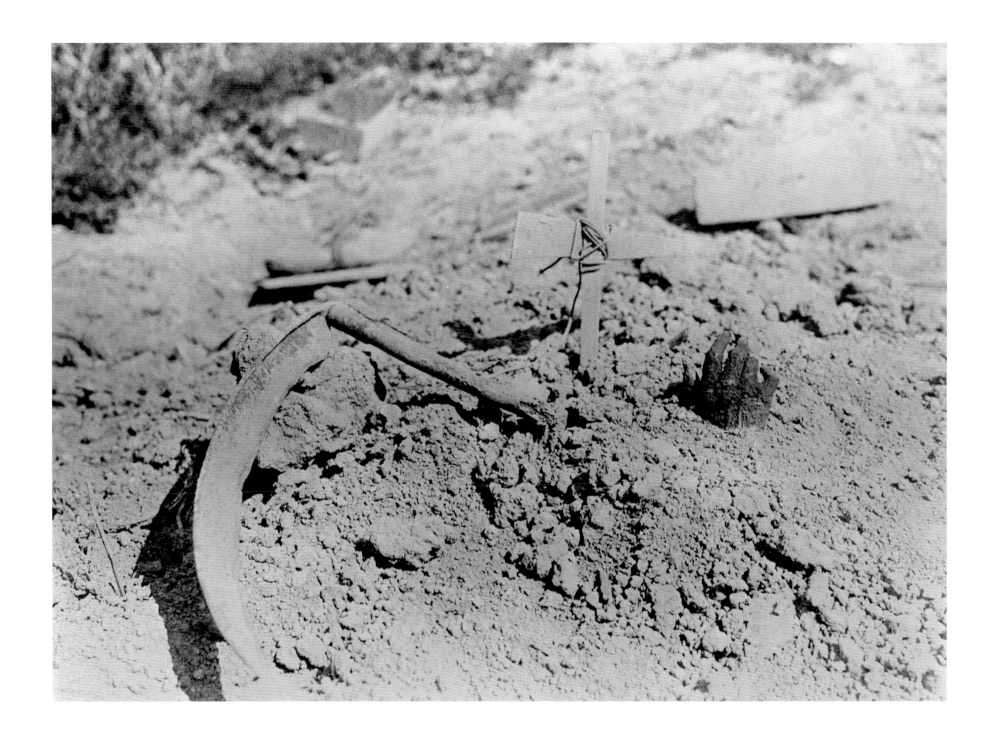

Unknown photographer, Sport & General commercial news agency
**The decomposing hand of a Belgian soldier protrudes from his makeshift grave in a
shell hole, Belgium, 20 November 1914**
*One of a number of photographs by unidentified German photographers that reached
British news agencies via neutral countries in the early stages of the war. The British
press published this picture as an example of German callousness*

Left: LIEUTENANT RICHARD MONEY, 1st Cameronians, BEF, personal photograph
C Company, 1st Cameronians in the line at Houplines, France, December 1914

Above: LIEUTENANT RICHARD MONEY, 1st Cameronians, BEF, personal photograph
Crew of a Royal Artillery 18-pounder Field Gun at their posts, Armentiéres sector, France, 7 December 1914
Soldiers relied on a supply of knitted garments from home. British troops were also issued with goat and sheepskin jerkins nicknamed 'Stinkers'

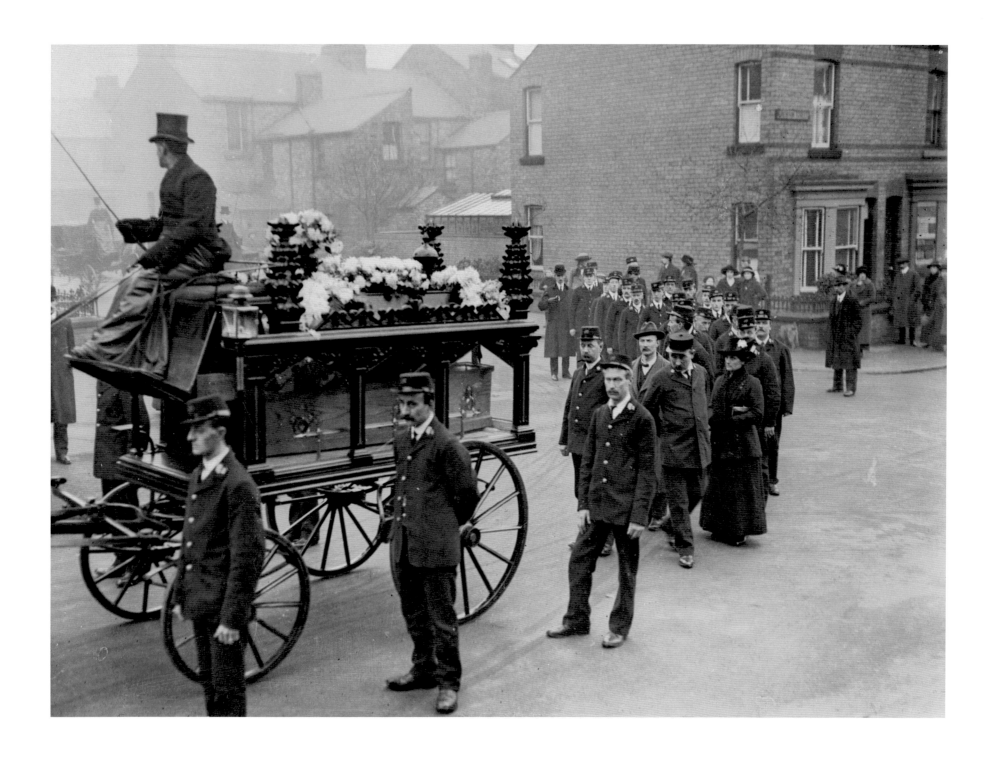

Above: Unknown photographer, Sport & General commercial news agency
The funeral cortége of postman Alfred Beal, killed in the naval bombardment of Scarborough on 16 December 1914
The German naval bombardment of Whitby, Scarborough and Hartlepool on 16 December 1914, the first attack on British civilians, killed 137 people and shocked the nation, fuelling more propaganda

Right: Unknown photographer, Sport & General commercial news agency
Damage to the ruins of Whitby Abbey caused by the naval bombardment on 16 December 1914

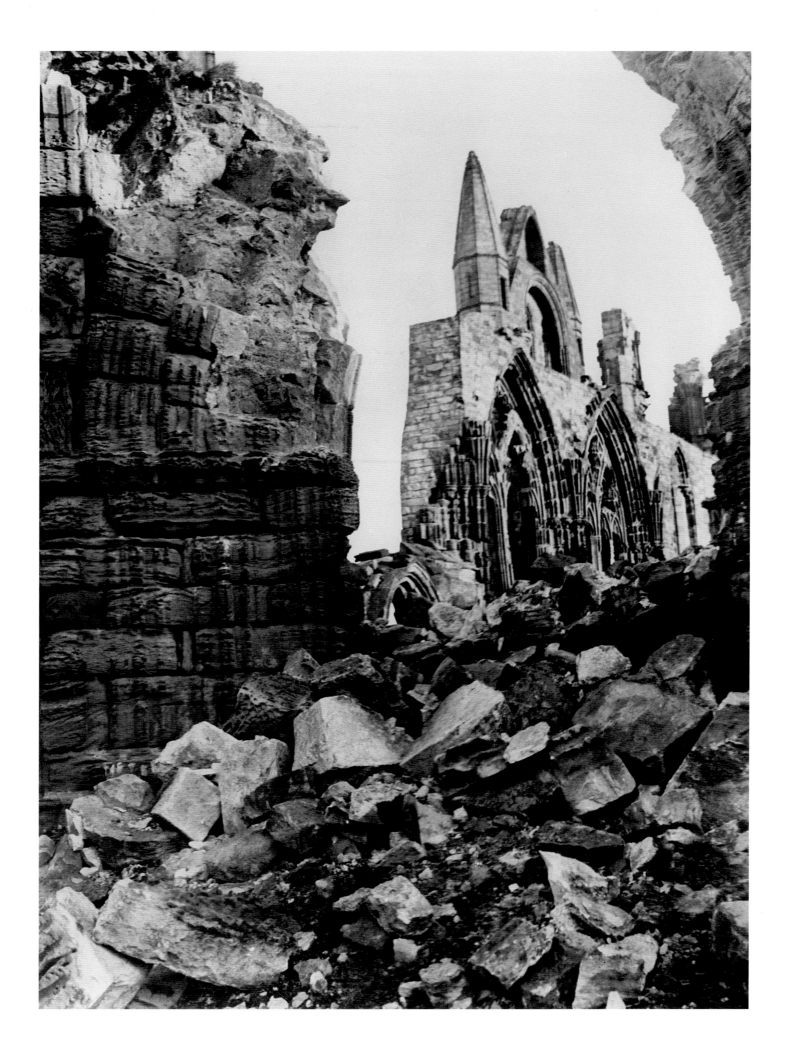

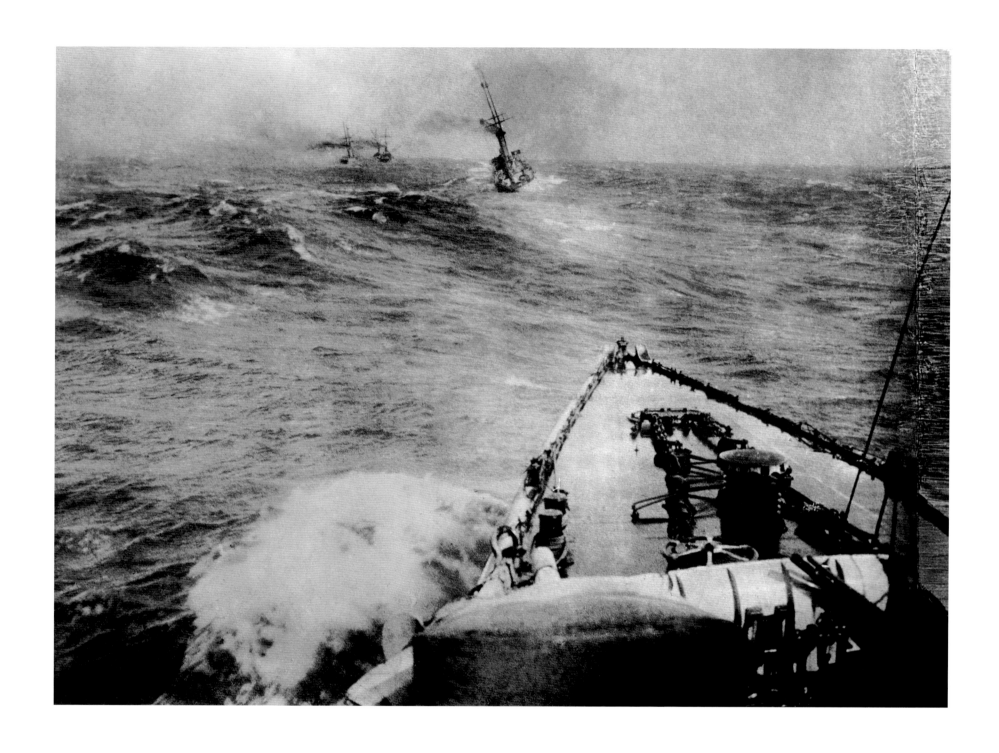

Unknown German seaman, German East Asia Squadron, personal photograph
**The German East Asia Squadron commanded by Admiral Maximilian von Spee sails
south after the Battle of Coronel, South Pacific, 26–9 November 1914**
*Von Spee's squadron caused havoc with British merchant shipping in the early weeks
of the war and inflicted a serious defeat on the Royal Navy at Coronel, off the coast of
Chile, on 1 November 1914*

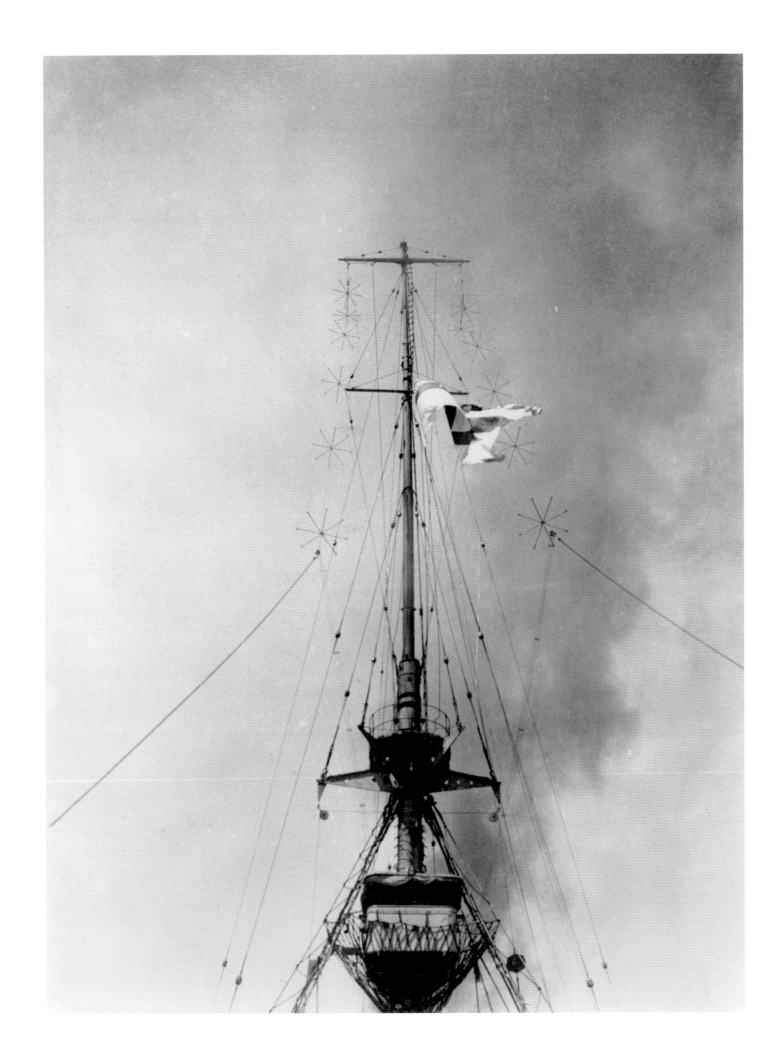

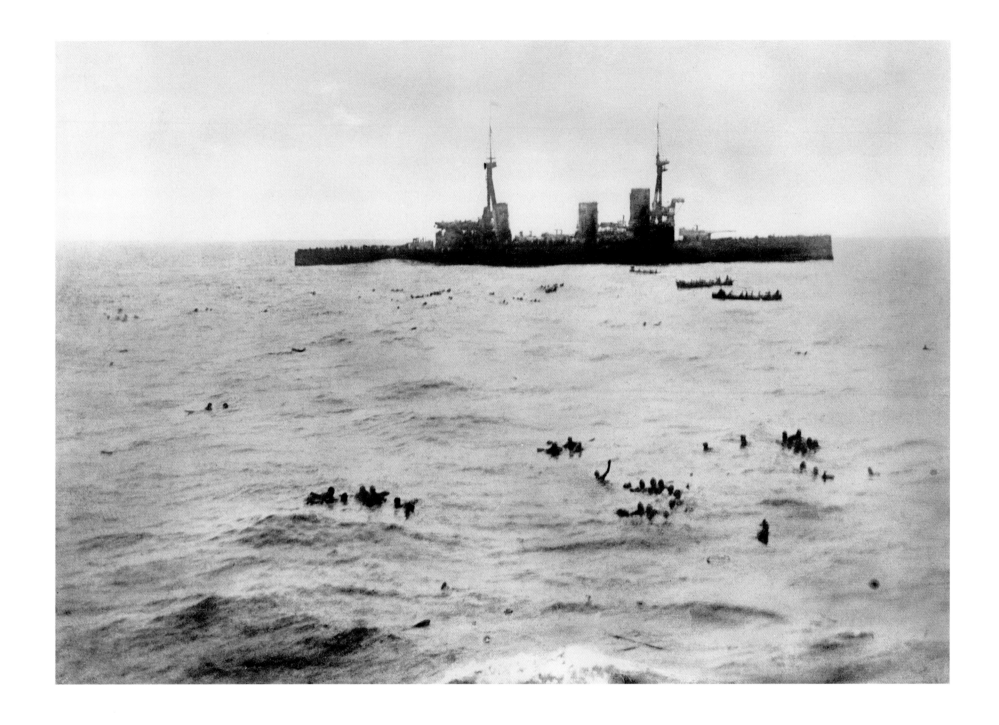

Left: COMMANDER S. ANDREWS, RN, HMS *Kent*, personal photograph
The County Ensign flies from the mainmast of HMS *Kent* at the start of the Battle of the Falkland Islands, South Atlantic, 8 December 1914
After Coronel, von Spee attempted to attack Port Stanley on the Falkland Islands, but was stopped by a British squadron under Rear Admiral Sir Doveton Sturdee

Above: SUB LIEUTENANT ARTHUR DYCE, RN, HMS *Invincible*, personal photograph
HMS *Inflexible* stands by to pick up survivors from SMS *Gneisenau*, the Battle of the Falkland Islands, South Atlantic, 8 December 1914
The German squadron, with the exception of SMS Dresden, *was destroyed with great loss of life. Von Spee was lost with his flagship, SMS* Scharmhorst

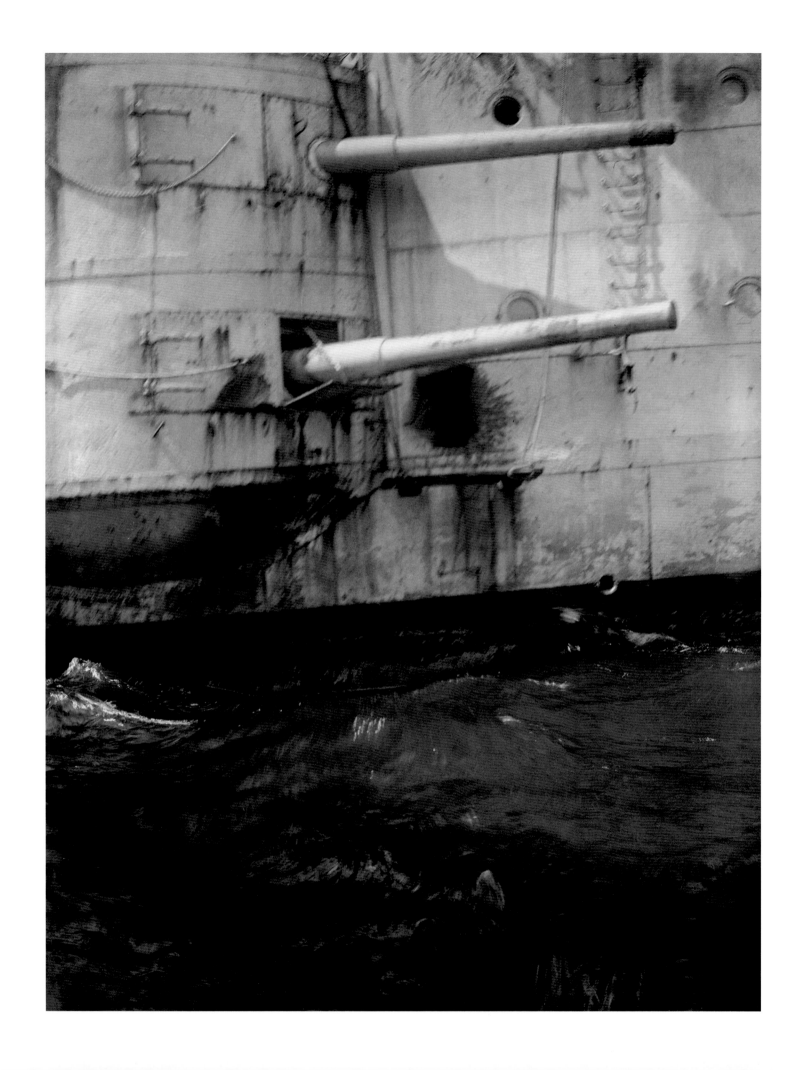

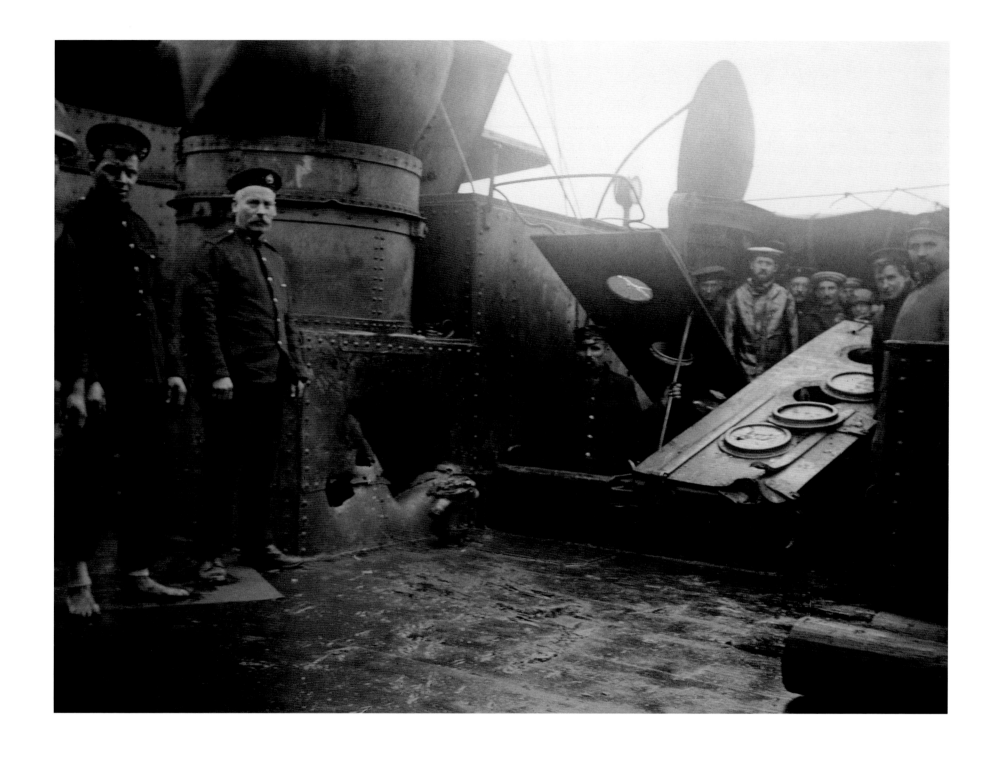

Left: COMMANDER S. G. ANDREWS, RN, HMS *Kent*, personal photograph
Damage to HMS *Kent* caused by 4.1-inch shell from SMS *Nürnberg*, Battle of the
Falkland Islands, South Atlantic, 8 December 1914
HMS Kent *was hit by thirty-eight shells, during a ninety-minute gunnery battle with SMS*
Nürnberg, *which sank with the loss of almost all its crew, including von Spee's son, Otto*

Above: COMMANDER S. G. ANDREWS, RN, HMS *Kent*, personal photograph
Damage to HMS *Kent* caused by shells from SMS *Nürnberg*, Battle of the Falkland
Islands, South Atlantic, 8 December 1914
Sgt Charles Mayes, Royal Marines (second left), extinguished a serious fire in HMS
Kent's *magazine and was awarded the Conspicuous Gallantry Medal*

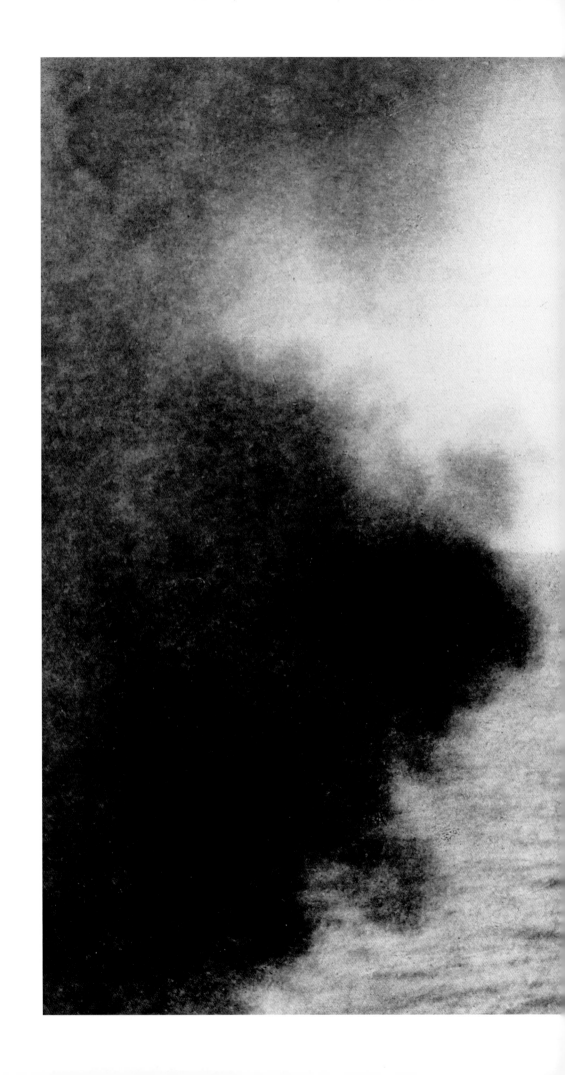

SUB LIEUTENANT ARTHUR DYCE, RN, HMS *Invincible*, personal photograph
**Sturdee's squadron overhauls von Spee's squadron as it seeks to escape,
Battle of the Falkland Islands, South Atlantic, 8 December 1914**
Smoke from the German ships can be seen on the horizon

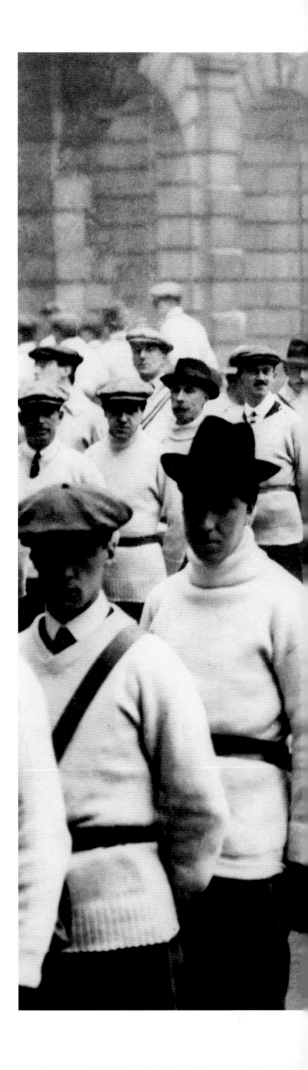

HORACE NICHOLLS, freelance commercial photographer
The United Arts Home Defence Force, comprising actors, artists and writers who
were barred from military service, parade, Burlington House, Piccadilly, London,
December 1914

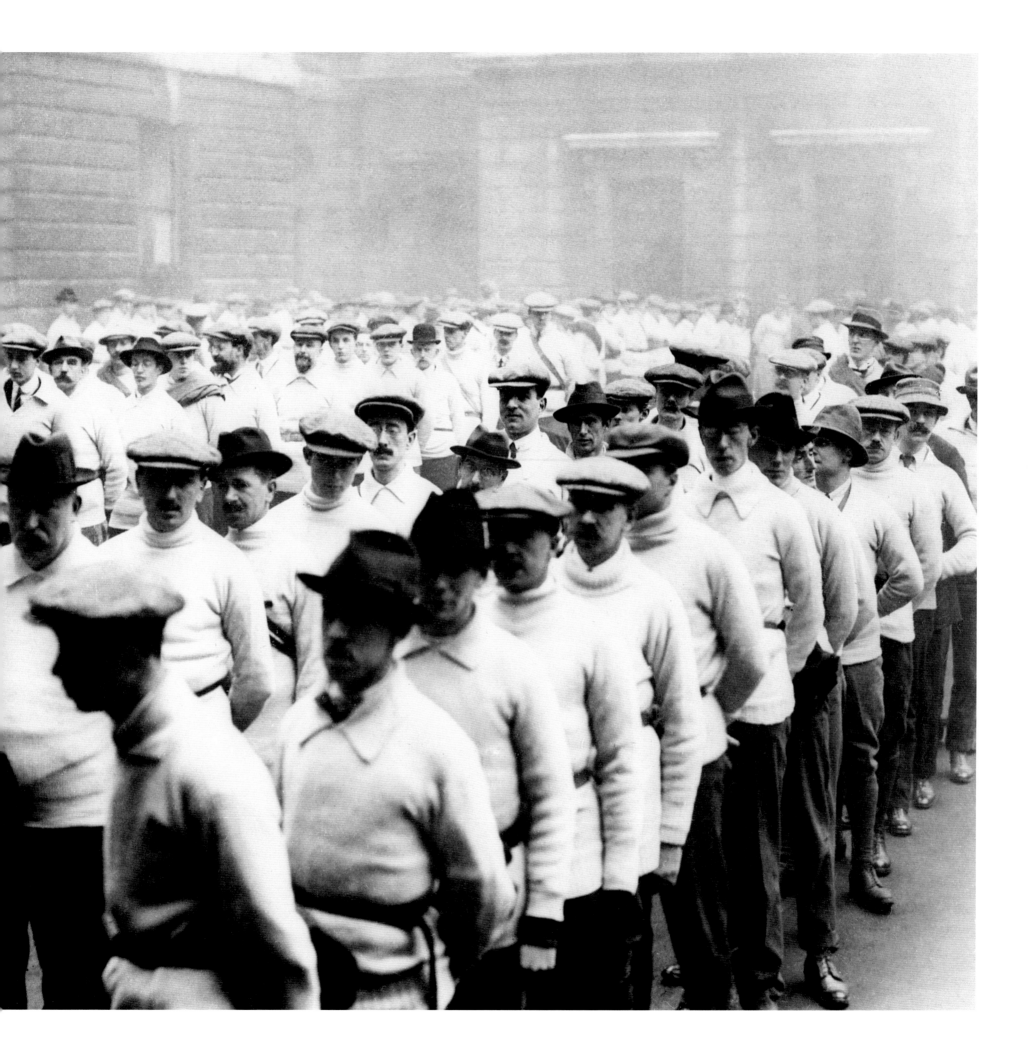

RIFLEMAN R. W. TURNER, London Rifle Brigade, BEF, personal photograph
Troops of London Rifle Brigade fraternise with German soldiers in No Man's Land during the unofficial Christmas Truce, Ploegsteert, Belgium, 25 December 1914
Soldiers' photographs convinced a sceptical public that early reports of the truce were true

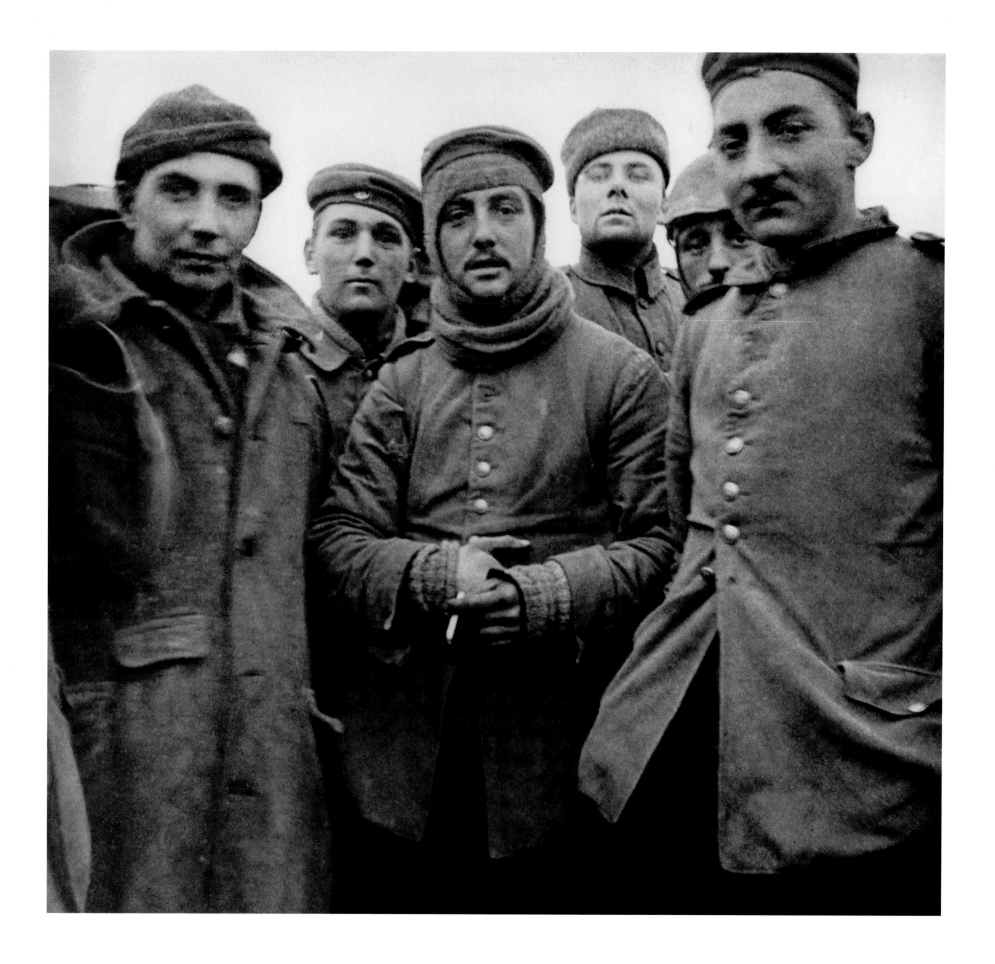

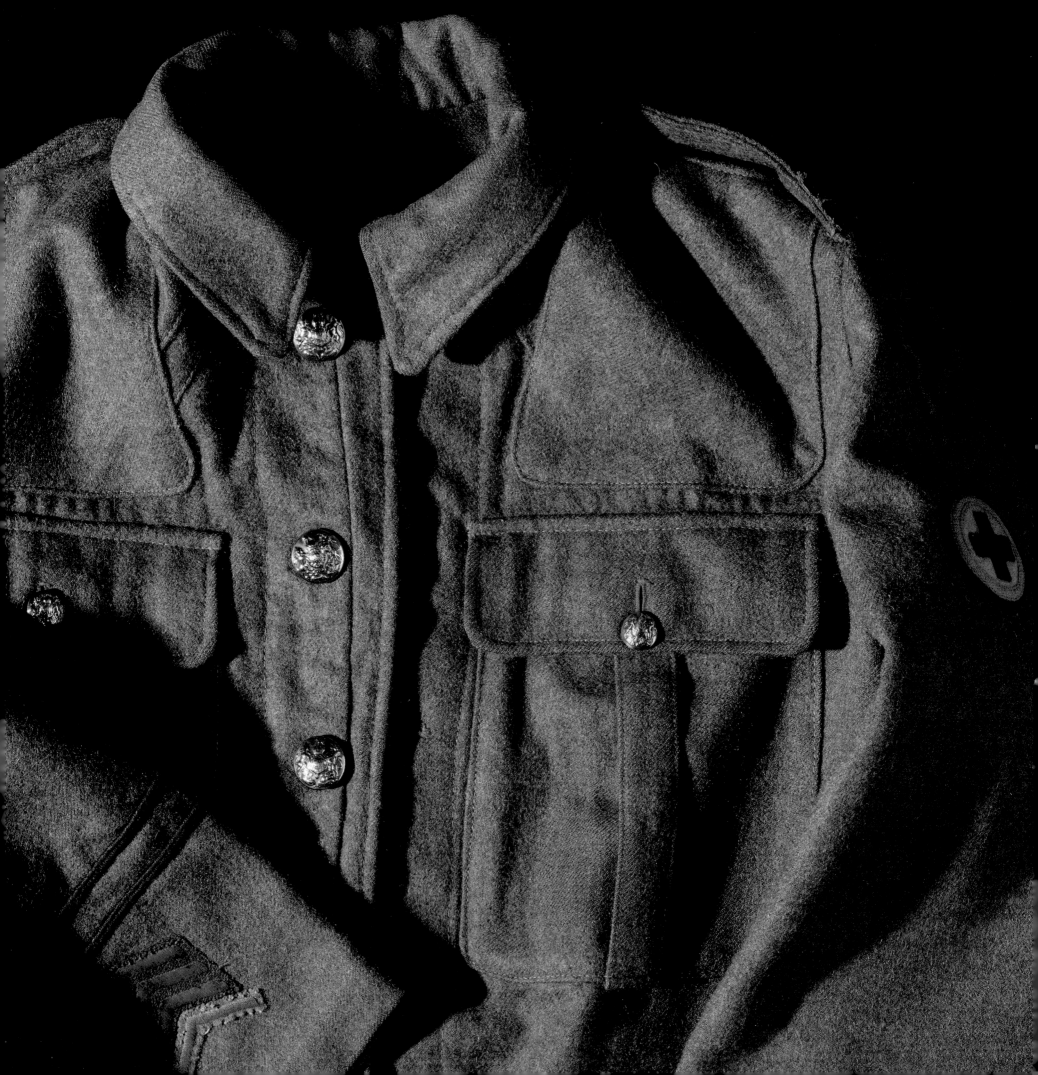

II

YEAR	MASS MEDIA AND TECHNOLOGY	WAR PHOTOGRAPHY	WORLD EVENTS
1915 JANUARY	• Ilford Daylight Loading Roll film introduced • Ernest Brooks, British royal photographer, joins Royal Naval Volunteer Reserve	• Albert K. Dawson, US freelance photographer, photographs German forces on the Western Front for three months. Photographs are published in German-language magazine *Deutsch-Amerika*, United States • British and German servicemen continue to use personal cameras in the front line, at sea and in the air, with or without permission. Cameras capture dramatic sinking of SMS *Blücher* at Dogger Bank • YMCA launches Snapshots from Home League, a morale-boosting voluntary scheme, which spreads throughout the British Empire. Volunteers, mostly amateur, photograph families of servicemen serving overseas on request • Sgt Major Frederick Laws begins to organise Royal Flying Corps provision for aerial photography. Sets up three photographic sections, one for each RFC wing. First aerial photograph mosaic created by Lt Darley	• 19 January: German airships raid Great Yarmouth and King's Lynn, killing 5 • 24 January: Battle of Dogger Bank • 31 January: First German use of poison gas, Battle of Bolimov, Eastern Front
1915 FEBRUARY	• Stieglitz's publication *Camera Work* struggles. Costs of production rise as subscribers fall to 37	• André Kertész falls ill with typhoid and is then wounded while serving as a soldier with the Austro-Hungarian Army, Ukraine. He spends the rest of the war as a convalescent • Underwood & Underwood publish first set of stereo war photographs, taken primarily by Albert K. Hibbard and Albert K. Dawson in Serbia and France during 1914 • Hans Hildenbrand, German official photographer, uses autochromes to take only official colour photographs of the German Army (in Alsace, the Vosges and Champagne) • RFC First Wing photographs entire German trench system in front of British First Army	• 3 February: Turkey attacks Suez Canal • 4 February: Germany announces unrestricted U-boat campaign on Allied and neutral shipping • 8–22 February: Battle of Masuria, Eastern Front • 19 February: Royal Navy bombards entrance to Dardanelles Straights
1915 MARCH	• Harold Harmsworth (Lord Rothermere) launches *Sunday Pictorial* newspaper (later the *Sunday Mirror*). A series of articles by Winston Churchill boosts circulation • Sir George Riddell, Newspaper Proprietors' Association, appointed Press Representative to the War Office and Admiralty with a remit to receive and circulate informal briefings to newspaper editors	• First significant operational use of aerial photography by RFC, Battle of Neuve Chapelle. Observers use handheld cameras while pilots fly at 800 feet under fire • Lt Bingham of 11 Squadron RFC uses civilian camera purchased in Amiens to make first stereo aerial photographs of Western Front • First RFC use of A-type aerial camera, the first purpose-built camera for military aerial photography, Western Front	• 10 March–2 April: Battle of Neuve Chapelle, Western Front • 18 March: British and French warships try to force entry to Narrows in Dardanelles, but sustain heavy losses • 21 March: German airships raid Paris, France • 22 March: Russia captures Przemyśl, Eastern Front

YEAR	MASS MEDIA AND TECHNOLOGY	WAR PHOTOGRAPHY	WORLD EVENTS
1915 APRIL	• Matthew Bynes Claussen establishes American Correspondent Film Company, United States. Funded by the German Government, its brief is to provide visual report of Germany's war for US audiences • German use of poison gas is reported by William Shepherd, first US war correspondent to be accredited to the BEF and only war correspondent at the front during 2nd Ypres Battle • Baron Herbert de Reuter, Head of Reuters News Agency, commits suicide following the failure of Reuters Bank. Roderick Jones takes over, Britain	• French Section photographique de l'Armée established to take photographs for news, propaganda and the historical record, France. The new section initially employs staff photographers supplied by commercial photographic firms Henri Manuel, Gorce, Vaillant, Vitry and Vallois • With the endorsement of Winston Churchill, Ernest Brooks, RNVR, appointed Admiralty official photographer (without rank) to cover Gallipoli landings on behalf of Royal Navy. Brooks is based on HMS *Queen Elizabeth*. He takes many memorable photographs, but some, controversially, are staged • Australian Official Correspondent Charles Bean lands with ANZAC forces at Gallipoli. During the subsequent campaign he takes *c.* 700 photographs to supplement his reports	• 22 April–27 May: 2nd Battle of Ypres; first German use of poison gas on Western Front • 25 April: Gallipoli landings
1915 MAY	• Lord Bryce's *Report of the Committee on Alleged German Outrages* circulated as a propaganda weapon by War Propaganda Bureau, fuelling public outrage about (subsequently unsubstantiated) German atrocities perpetrated on Belgian civilians, Britain • *Daily Mail* blames Lord Kitchener, Secretary of State for War, for the British armed forces' catastrophic shortage of munitions on the Western Front, Britain • British press begins to publish casualty lists. German press banned from mentioning losses or gains in colonies	• Albert K. Dawson moves to Eastern Front where he photographs the Austro-German offensive, the retaking of Przemyśl and the Austro-Hungarian campaign in Galicia. Finds glass-plate press camera too cumbersome and changes to 5x3-format roll-film camera • Some French photographers (Jean Baptiste Tournassoud of the French Army, Leon Gimpel, Jules Gervais-Courtellement, Paul Castelnau, Fernand Cuville, Albert Samama-Chikli and L. Aubert) work in colour, using the autochrome process. Their work is occasionally published in *L'Illustration*	• 2 May: Battle of Gorlice-Tarnów; Russia retreats from Poland • 7 May: RMS *Lusitania* sunk off Irish coast • 9 May: Kitchener's New Army begins overseas deployment • 9–10 May: Battle of Aubers Ridge, Western Front • 9 May–18 June: 2nd Battle of Artois, Western Front • 15–25 May: Battle of Festubert, Western Front • 23 May: Italy declares war on Austria-Hungary • 25 May: British Coalition Government formed under Asquith. Lloyd George appointed Minister of Munitions with brief to address shell shortage • 31 May: 1st German airship raid on London; 7 killed
1915 JUNE	• Lowell Thomas, journalist, undertakes film and photography assignment in Alaska, US	• First RFFC use of C-Type aerial camera with semi automatic plate-changing device • Kodak supplies film and cameras to the British Army & Navy for potential use in aerial photography	• 22 June: Austria-Hungary recaptures Lemberg, Eastern Front • 23 June–7 July: 1st Battle of the Isonzo, Italian Front

YEAR	MASS MEDIA AND TECHNOLOGY	WAR PHOTOGRAPHY	WORLD EVENTS
1915 JULY		• Hilton DeWitt Girdwood appointed Indian official photographer and cameraman on the Western Front, but barred from the trenches on security grounds	• 9 July: German forces surrender to General Botha, German South-West Africa • 18 July: 2nd Battle of the Isonzo, Italian Front
1915 AUGUST	• Press banned from acknowledging censorship in public, Germany • *Daily Mirror* publishes German pre-war photograph taken in June 1914, claiming it shows German soldiers looting in Poland	• British Army establishes topographical sections to maximise benefit of aerial photography • Charles Bean, Australian war correspondent, shot in leg by Turkish sniper during 2nd landing at Anzac Cove, Gallipoli • Albert K. Dawson's first cine film, *The Battle and Fall of Przemyśl*, is premiered in New York to an enthusiastic response. Dawson leaves the Eastern Front after the Fall of Warsaw	• 5 August: German Army occupies Warsaw, Eastern Front • 6 August: 2nd landing at Gallipoli • 16 August: German U-boat shells Whitehaven, Britain • 25 August: German & Austro-Hungarian forces capture Brest-Litovsk, Eastern Front
1915 SEPTEMBER	• German Army Kriegspresseamt (War Press Office) established under Oberstleutnant A. D. Deutelmoser, Germany. Kriegspresseamt goes on to publish *Deutsche Kriegsnachrichten, Nachrichten der Auslandspresse* and *Deutsche Kriegswochenschau*	• Hilton DeWitt Girdwood concludes his assignment on the Western Front • Frederick Laws returns from Western Front. Starts RFC School of Photography at Farnborough, Britain • Albert K. Dawson moves to the Balkan Front	• 25 September: British & French offensive on Western Front results in 2nd Battle of Champagne, 3rd Battle of Artois and Battle of Loos
1915 OCTOBER		• German authorities introduce system of identity photography, Poland, Eastern Front	• 1 October: German Fokker fighter aircraft deploy, Western Front • 5 October: British and French landings in Salonika • 7 October: Joint German-Austro-Hungarian invasion of Serbia • 9 October: Austria-Hungary captures Belgrade • 12 October: Execution of Nurse Edith Cavell, Brussels, Belgium • 14 October: Bulgaria declares war on Serbia • 15 October: General Sir Charles Monro replaces General Sir Ian Hamilton, Gallipoli
1915 NOVEMBER		• Frederick Laws receives a commission and is appointed Commandant of RFC School of Photography, Britain	• 10 November: Indian forces begin transfer from France to Mesopotamia • 22 November: Serbian forces defeated by Germany, Austria-Hungary and Bulgaria. They retreat through Albania to Adriatic coast; Battle of Ctesiphon, Mesopotamia

YEAR	MASS MEDIA AND TECHNOLOGY	WAR PHOTOGRAPHY	WORLD EVENTS
1915 DECEMBER	• Emil O. Hoppé designs *Penrose Annual* of printing processes for 1916. The design is far more restrained, reflecting prevailing shortages of dyes and other materials traditionally sourced from Germany for photogravure and halftone printing, Britain	• Charles Bean evacuated from Gallipoli • F. J. Mortimer publishes *The Birth of a Battleship* in Photogram • Reverend Harold Spooner, Major A. S. Kane and Major P. C. Saunders use personal cameras to record Siege of Kut	• 7 December: Siege of Kut begins, Mesopotamia • 19 December: General Sir Douglas Haig replaces Field Marshal Sir John French as commander of BEF • 20 December: Gallipoli evacuation begins
1916 JANUARY	• Max Aitken establishes Canadian War Records Office in London, Britain. He works to ensure Canadian contribution acknowledged in the press and publishes *Canada in Flanders*, a book about the achievements of Canadian soldiers based on his visits to the Western Front as an honorary colonel of the Canadian Army • Increasing conflict between Government and Army regarding handling of the press, Germany	• Ernest Brooks works briefly as an official photographer in Salonika • To ease overstretched resources, RFC squadrons are attached to each corps of British Army. Corps issue photo-reconnaissance tasking up to depth of 5,000 yards of the front line, Western Front	• 9 January: Gallipoli evacuation complete • 24 January: British Government pass First Military Service Act. Single men aged 19–41 eligible for conscription

Page 106: IWM collection
British Army khaki service dress jacket, which was worn on the Western Front by Private Leonard Stagg, a Royal Army Medical Corps nursing orderly
Pte Stagg volunteered in 1914 and spent most of 1915 in training as part of the New Army. He then served on the Western Front with 2/3 South Midland Field Ambulance from 1916 to 1918

In 1915, any lingering illusions about the scale, duration and nature of the war were dispelled. Throughout the year, the Central Powers held the strategic upper hand, resisting the Entente's repeated attempts to gain the advantage on land, in the air and even at sea.

The size, efficiency, disposition and equipment of the Imperial German Army enabled the Central Powers to retain or gain the advantage on the Western and Eastern Fronts. Britain's small peacetime army had been all but eliminated in the battles of 1914. Until its 'New Army', made up of volunteers, was ready, Britain had to rely on Empire forces to defend the Western Front and support its campaigns elsewhere.

On the Western Front, both sides made repeated attempts to break the stalemate of trench warfare, while struggling to understand its requirements. New weapons or new techniques, such as poison gas or aerial reconnaissance, were neutralised by the swift development of countermeasures. Crucially, neither side had the firepower required to achieve a breakthrough.

Stalemate on the Western Front persuaded both sides to attempt to eliminate their most vulnerable enemy. Germany turned its attention to the Eastern Front, where a war of movement was still possible. Despite inflicting costly defeats on the Russian Army, the Central Powers could not achieve victory. The Tsar, in an ill-advised response, took personal command of his armies, thereby personally associating himself with events on the front line. The Triple Entente gained some relief when Italy joined the war and opened another front by invading Austria-Hungary, but Bulgaria's entry into the war enabled the Central Powers to inflict a crushing defeat on Serbia in the Balkans.

Britain and France attempted to break the deadlock by launching campaigns in Mesopotamia and Gallipoli in an effort to eliminate Turkey from the war. Strong Turkish resistance, poor military leadership and dreadful fighting conditions resulted in humiliating and costly failure. Public dissatisfaction with the Government and with military leaders in Britain and France became increasingly outspoken.

Civilians were targeted relentlessly by Germany and Austria-Hungary. Zeppelin airships launched the world's first strategic bombing campaign on Britain, while indiscriminate attacks on civilian passenger ships such as the *Lusitania* by German submarines caused heavy loss of life. These events, and the execution of a British nurse, Edith Cavell, in Belgium, caused international outrage, reinforced public perceptions of German brutality and offered Britain a propaganda advantage that it would exploit for the rest of the war.

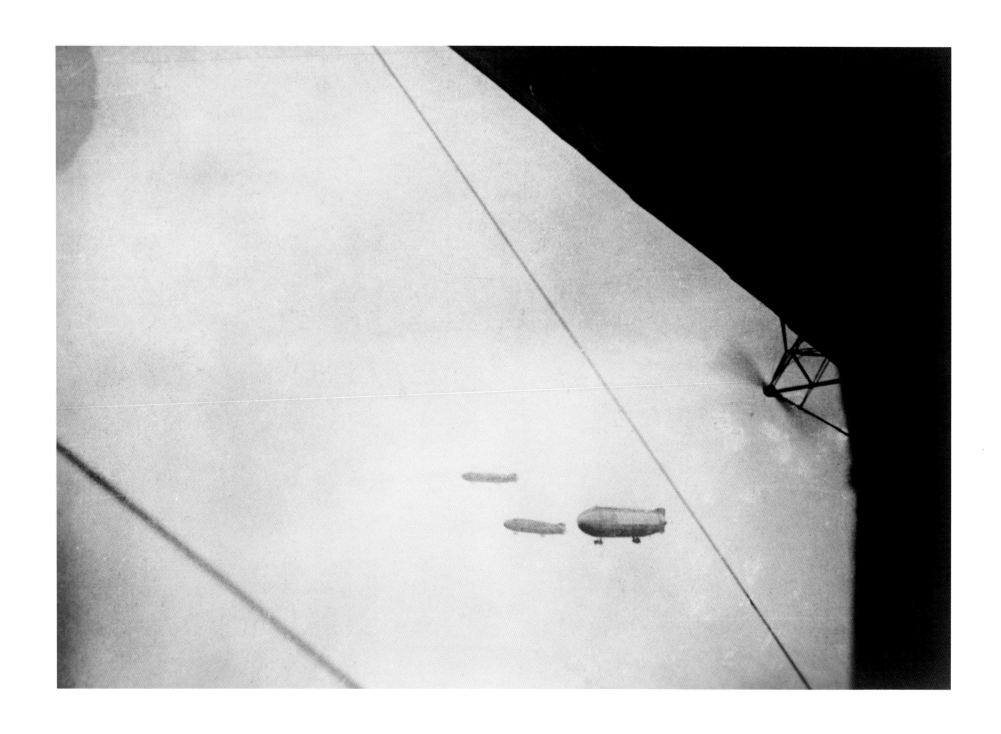

Unknown crew member of German Zeppelin L12, personal photograph
German Zeppelins on their way to bomb England, early August 1915
Zeppelins launched the world's first strategic bombing campaign against targets in Britain in early 1915. The raids had little military impact, but terrorised the civilian population

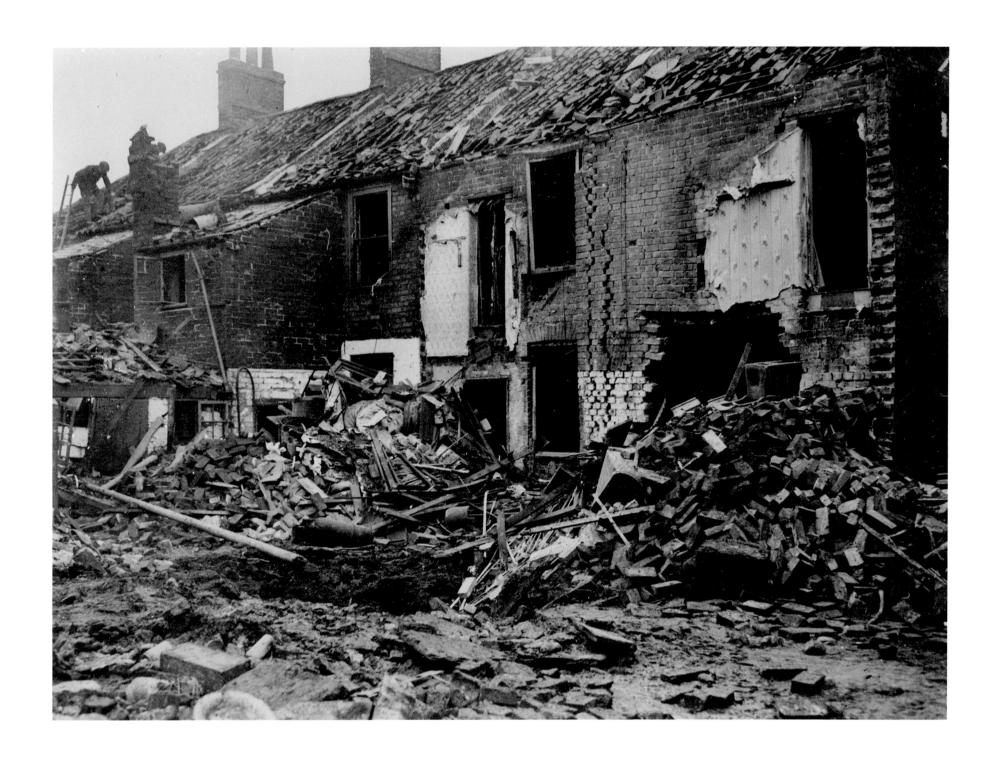

Unknown photographer, Sport & General commercial news agency
Damage caused by the first Zeppelin raid to Albert Street, King's Lynn, Norfolk, 20 January 1915
Three Imperial German Navy Zeppelins attacked the Norfolk coast on the night of
19–20 January 1915, killing four and injuring sixteen

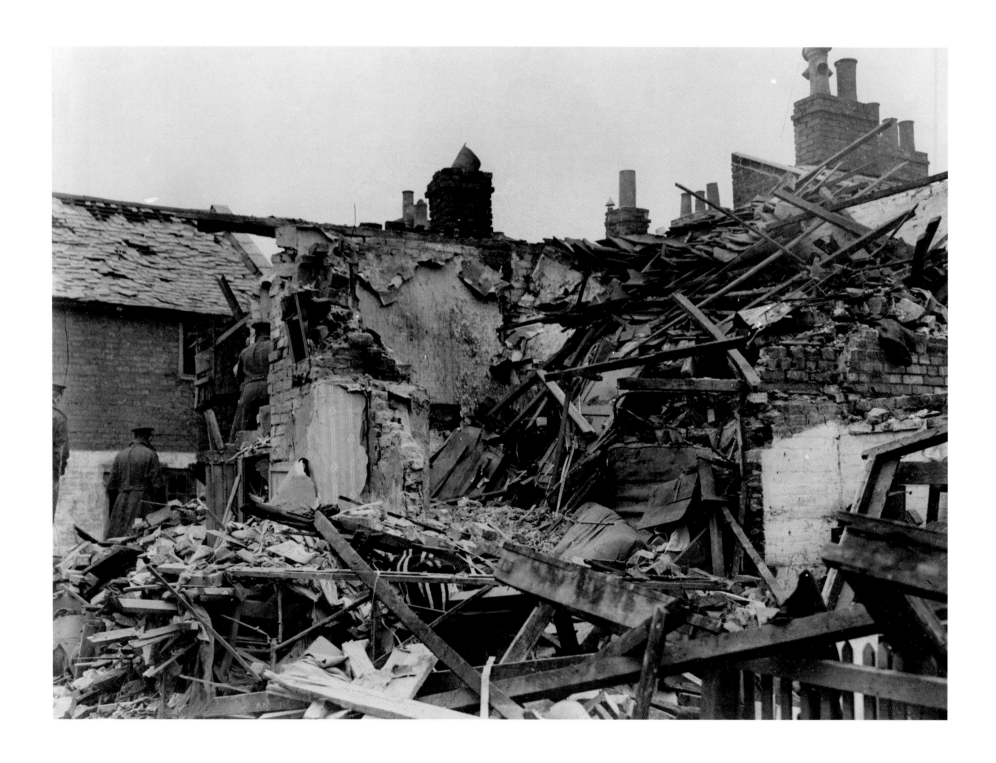

Unknown photographer, Sport & General commercial news agency
Damage caused by the first Zeppelin air raid to Bentinck Street, King's Lynn, Norfolk, 20 January, 1915
The bomb that destroyed Bentinck Street also killed Percy Goate,
aged four and Mrs Alice Gazley, aged twenty-six

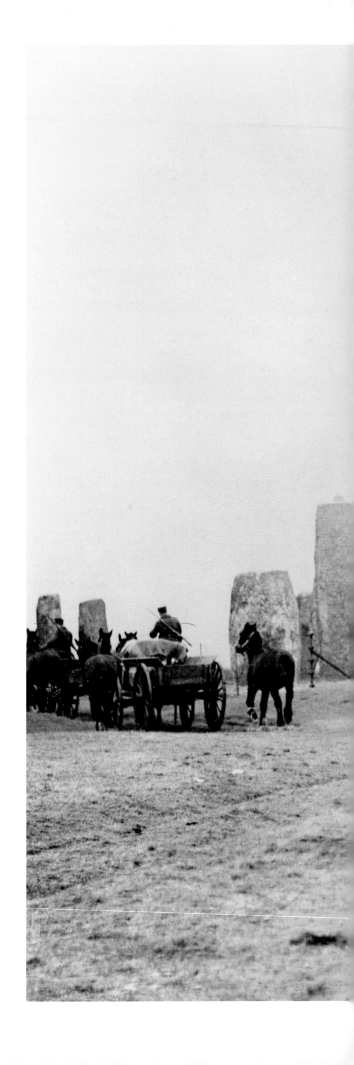

Unknown photographer, Sport & General commercial news agency
Transport wagons of 10th Canadian Rifles, Stonehenge, Salisbury Plain, Wiltshire, 28 January 1915
The Canadian Expeditionary Force arrived in Britain in late 1914 and spent four
months training on Salisbury Plain. They deployed to the Western Front in February
1915, and were soon engaged in the Second Battle of Ypres

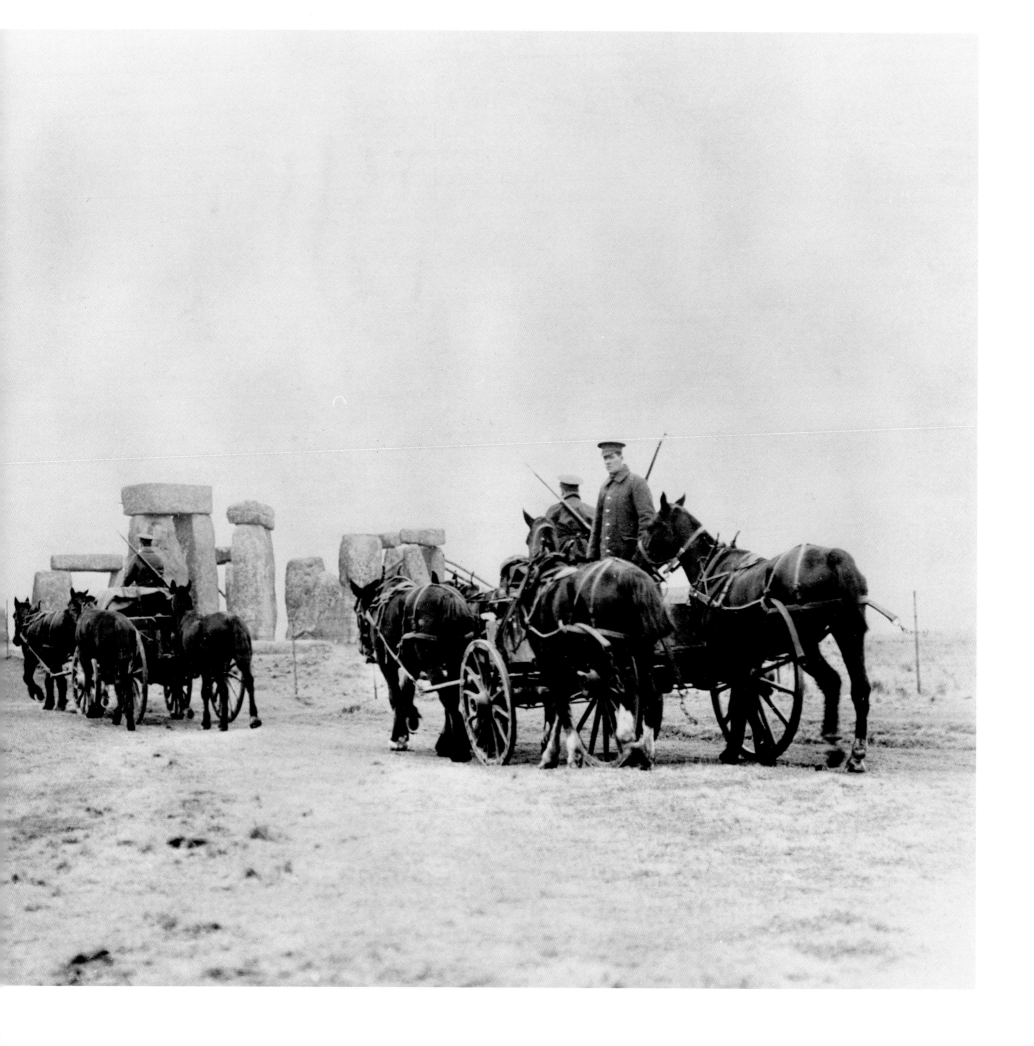

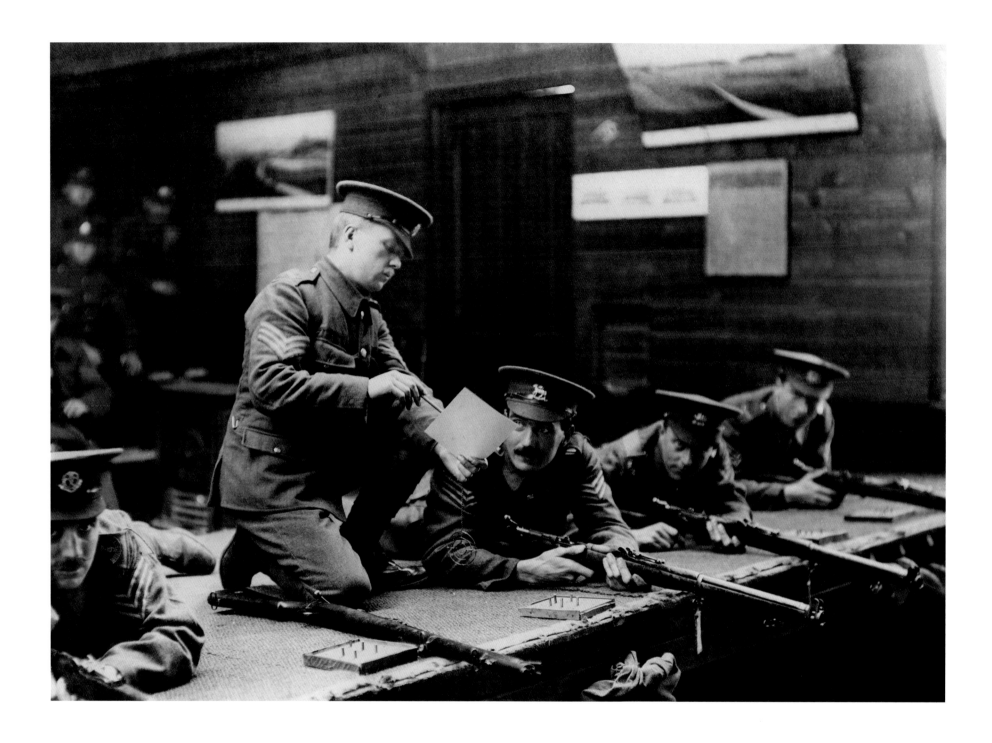

Left: Unknown photographer, Sport & General commercial news agency
A British cavalry sniper during training, Richmond Park, London, 10 February 1915

Above: Unknown photographer, Sport & General commercial news agency
An instructor evaluates target shooting on the miniature rifle range, British Army School of Musketry, Hythe, Kent, 21 January 1915
Training of the New Army was hampered by lack of instructors. Most were either at the front or had already been killed

Pages 120–21: Unknown photographer
The German battle cruiser SMS *Blücher* capsizes and sinks during the Battle of Dogger Bank, North Sea, 24 January 1915
The battle was the first major naval action of 1915 and resulted in huge loss of life. 792 German sailors died when SMS Blücher sank. The battle was the first naval action to be recorded by commercial photographers and newsreel cameramen

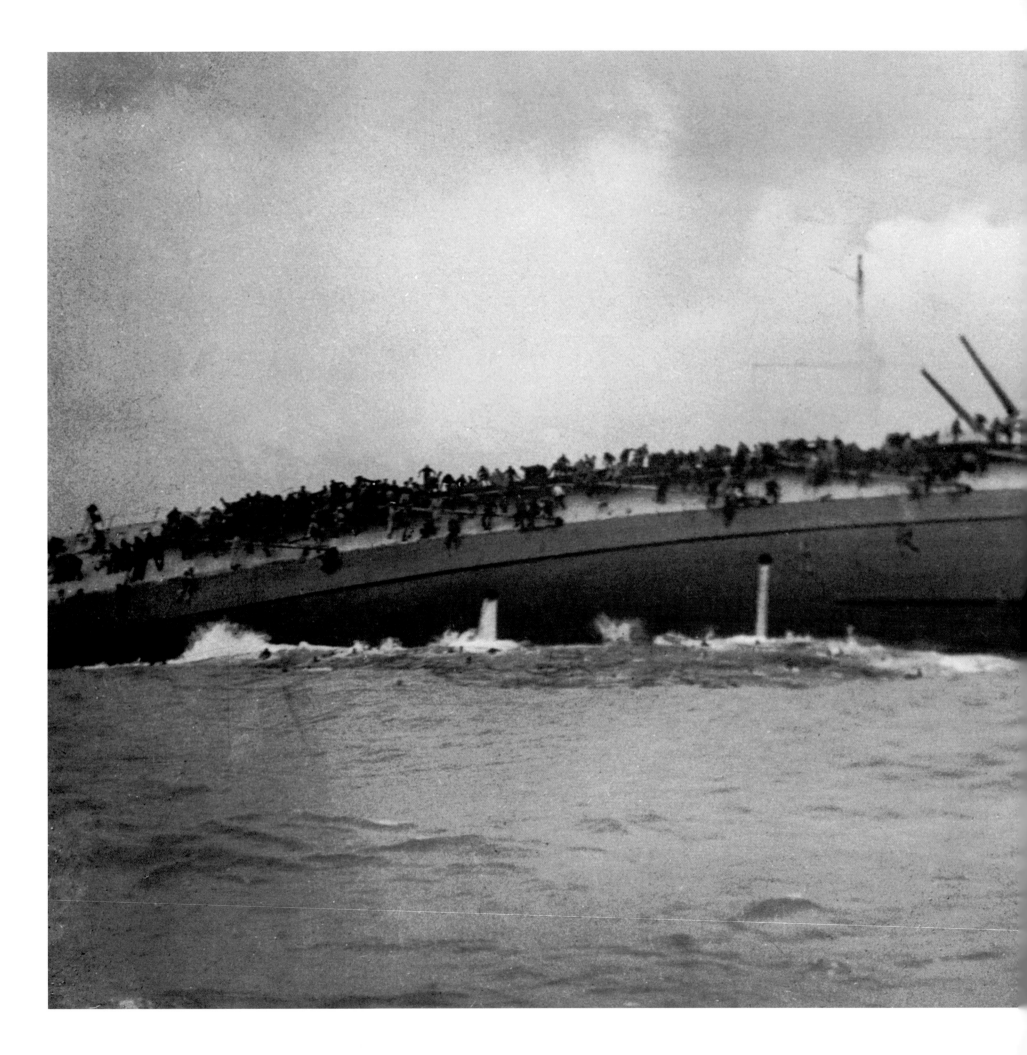

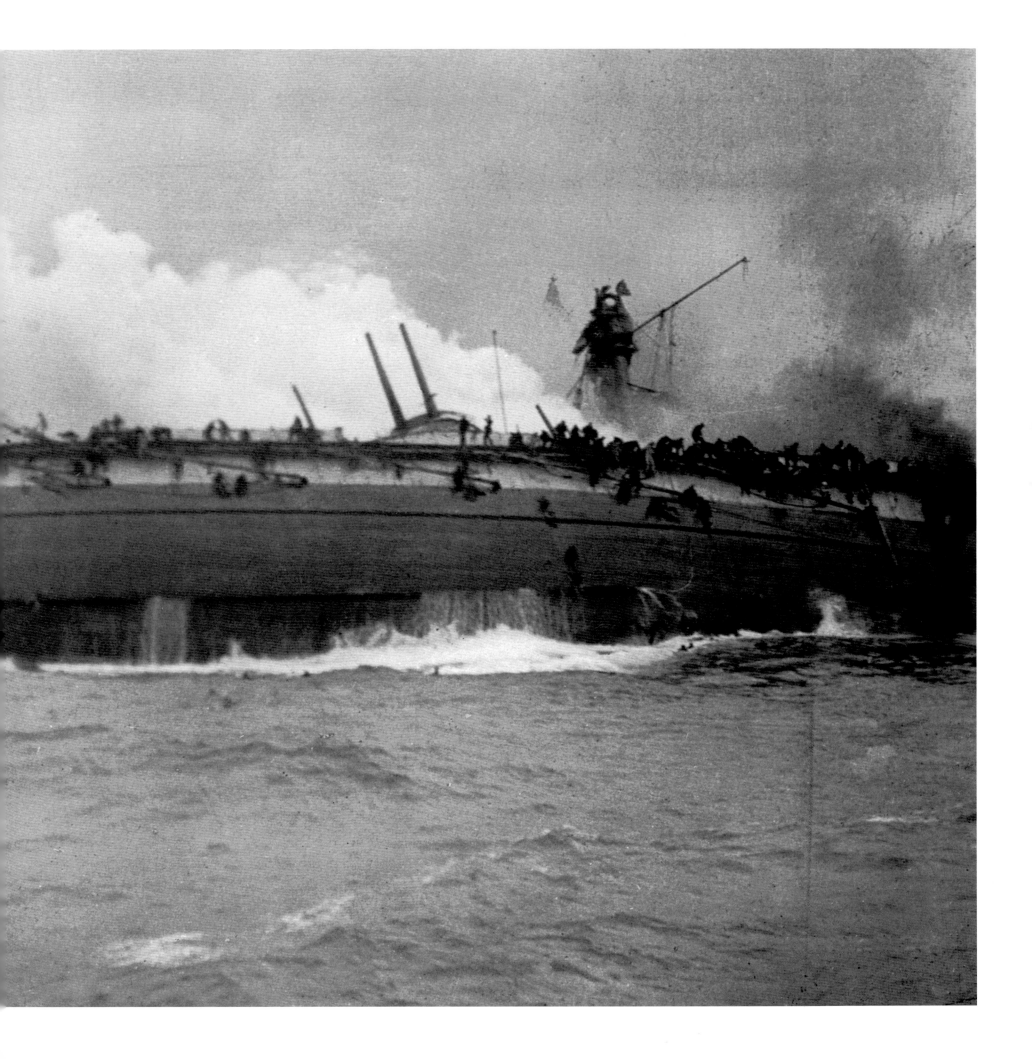

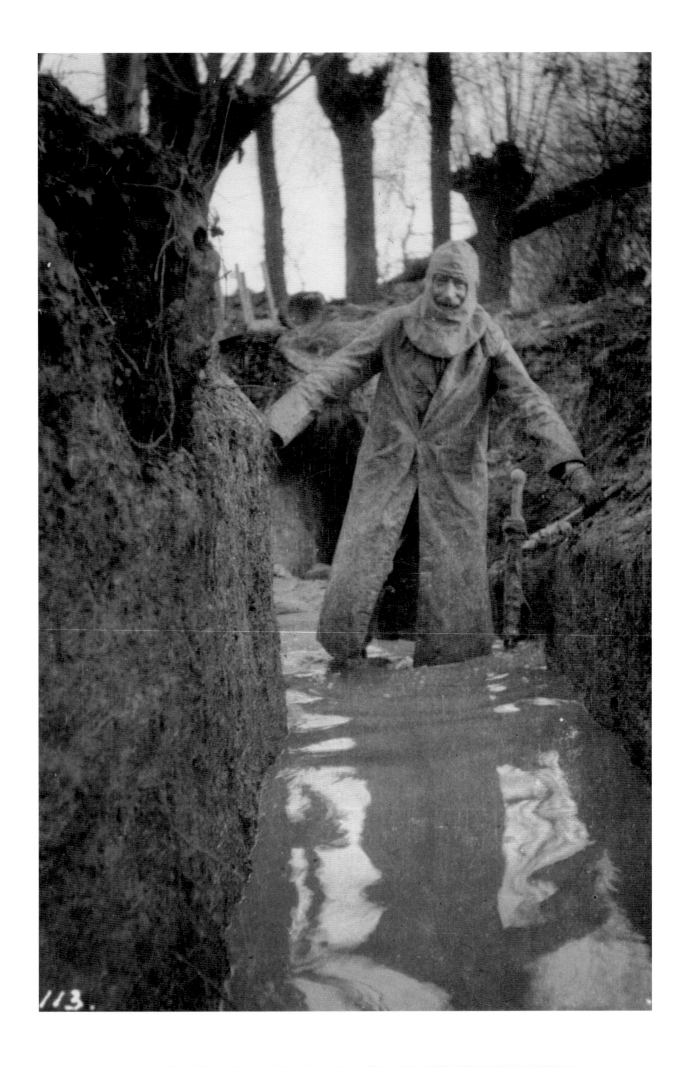

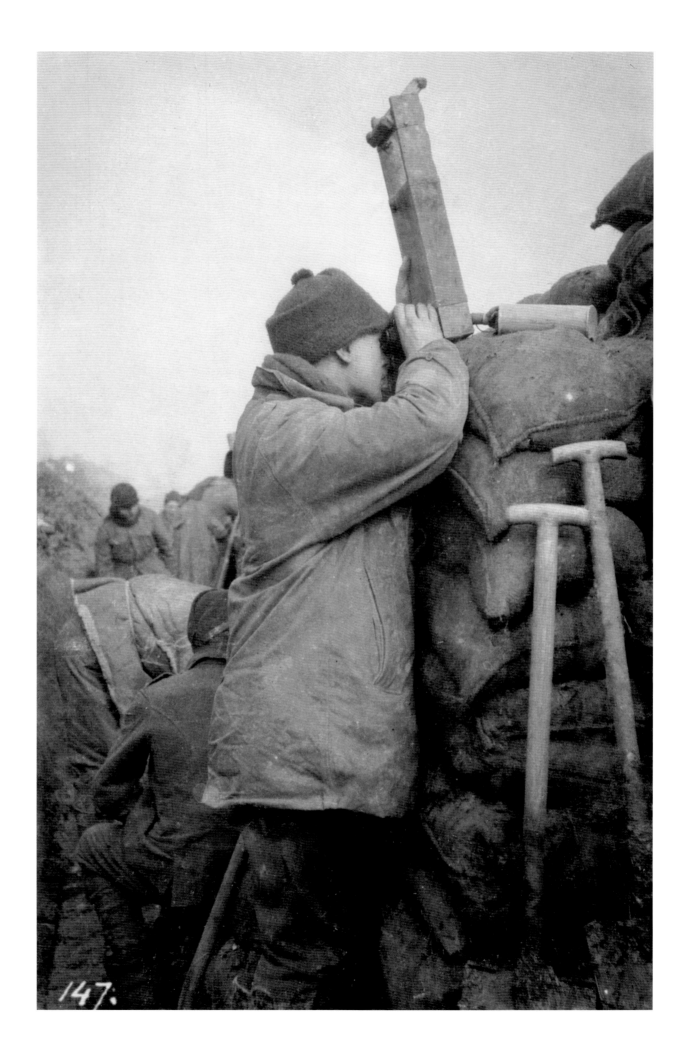

147.

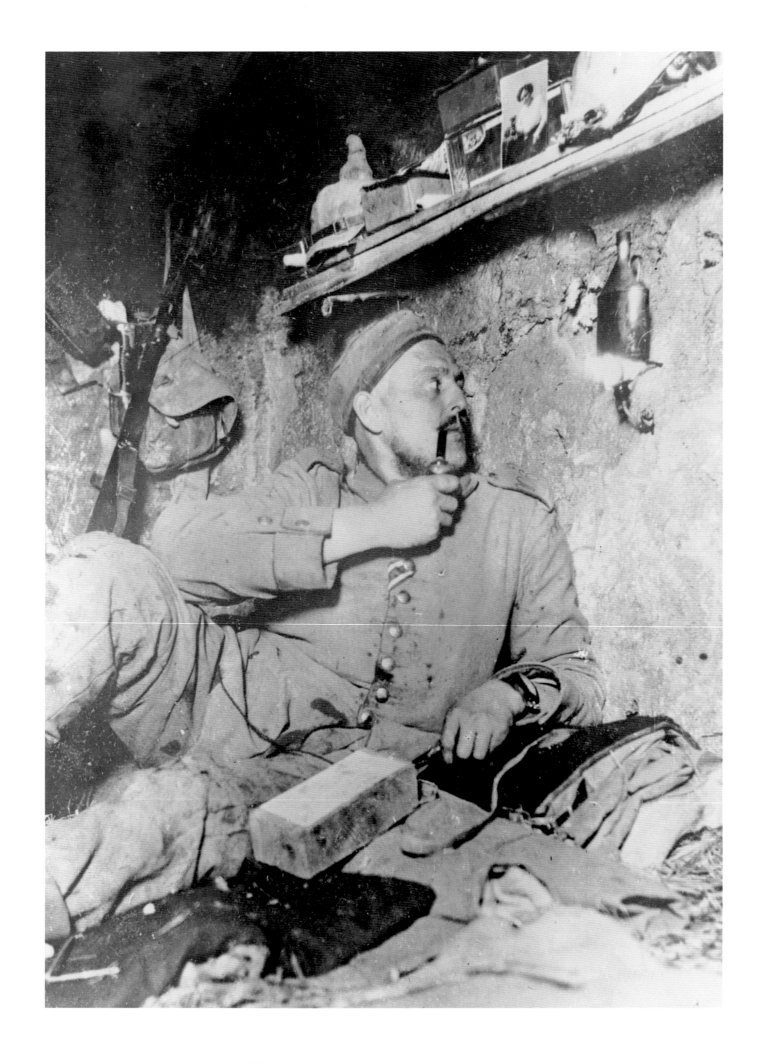

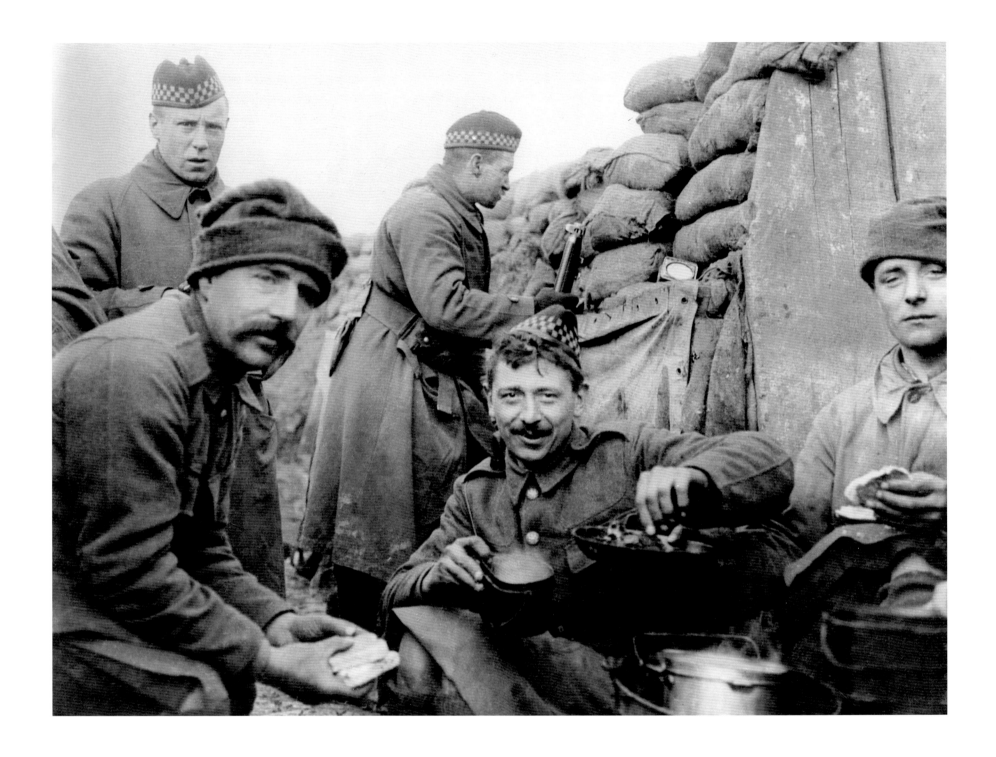

Page 122: LIEUTENANT RICHARD MONEY, 1st Cameronians, BEF, personal photograph
Colonel Philip R. Robertson, 1st Cameronians, inspects his battalion's waterlogged trench, Bois-Grenier sector, Nord, France, January 1915
Soldiers' own photographs continued to document the hardship of winter in the trenches. Frostbite and hypothermia were common. 20,000 British soldiers suffered trench-foot

Page 123: LIEUTENANT RICHARD MONEY, 1st Cameronians, BEF, personal photograph
2nd Lieutenant L. J. Barley, 1st Cameronians, uses a trench periscope to observe German positions, Grande Flamengrie Farm, Bois-Grenier sector, Nord, France, February 1915

Left: Unknown German photographer, personal photograph, Sport & General commercial news agency
A German soldier relaxes in an underground dugout, Rheims sector, France, 1915

Above: CAPTAIN ALBERT M. BANKIER, 2nd Argyll and Sutherland Highlanders, BEF, personal photograph
2nd Argyll and Sutherland Highlanders prepare a hot meal in a frontline trench, Bois-Grenier sector, Nord, France, March 1915

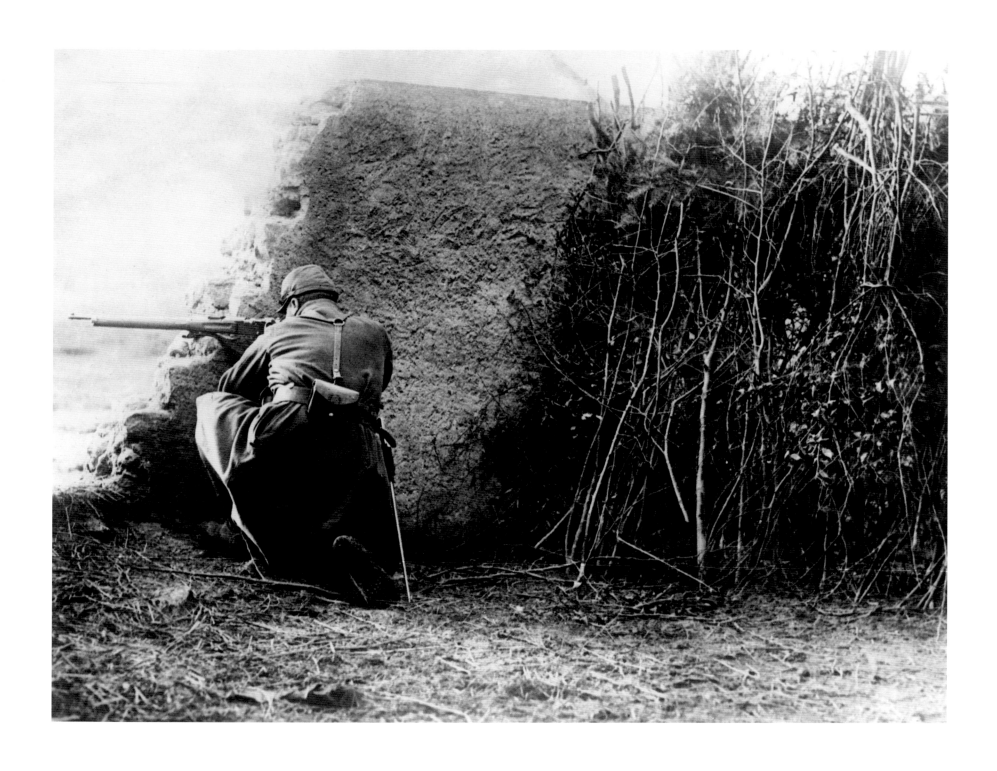

SPA photographer, French Army
A carefully posed photograph of a French marksman on the Western Front, 1915
The French War Ministry founded the Section photographique de l'Armée (SPA) to provide images for propaganda, information and historical and artistic purposes in April 1915

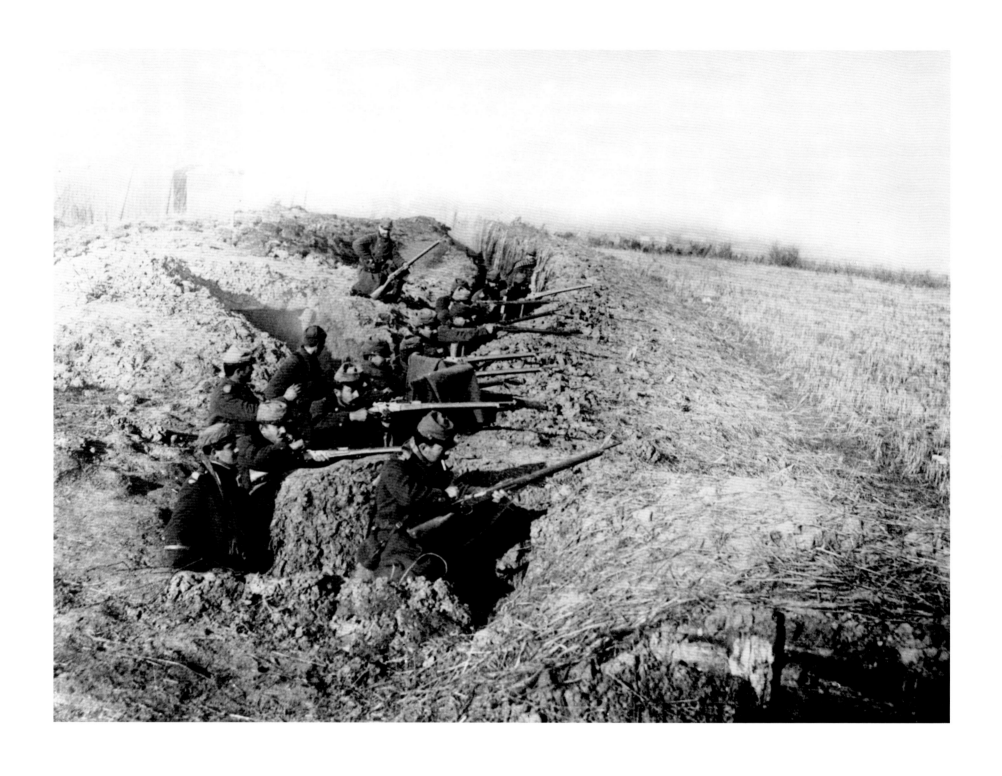

SPA photograph, French Army
French troops man an advanced trench, Alsace-Lorraine Front, January 1915

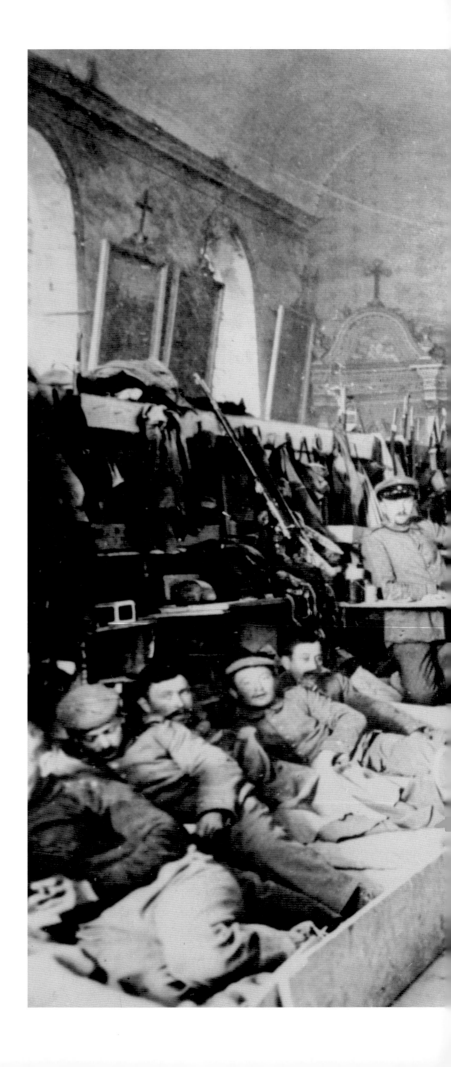

Unknown photographer, Imperial German Army, personal photograph
German troops billeted in a church, Second Battle of Ypres, France, May 1915
On 22 April 1915, the Imperial German Army launched a major offensive against the
Ypres Salient using poison gas, a terrifying new weapon. Canadian and French colonial
troops were among the casualties

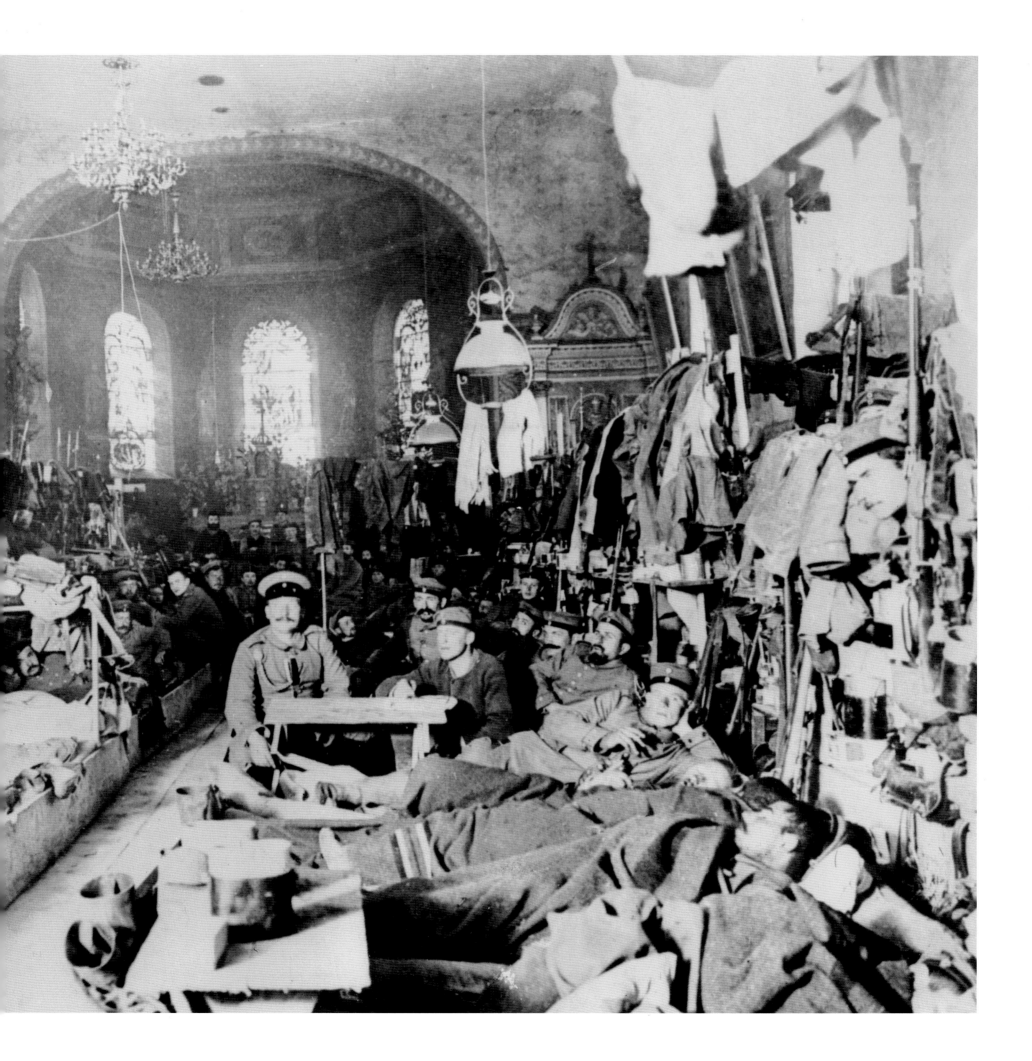

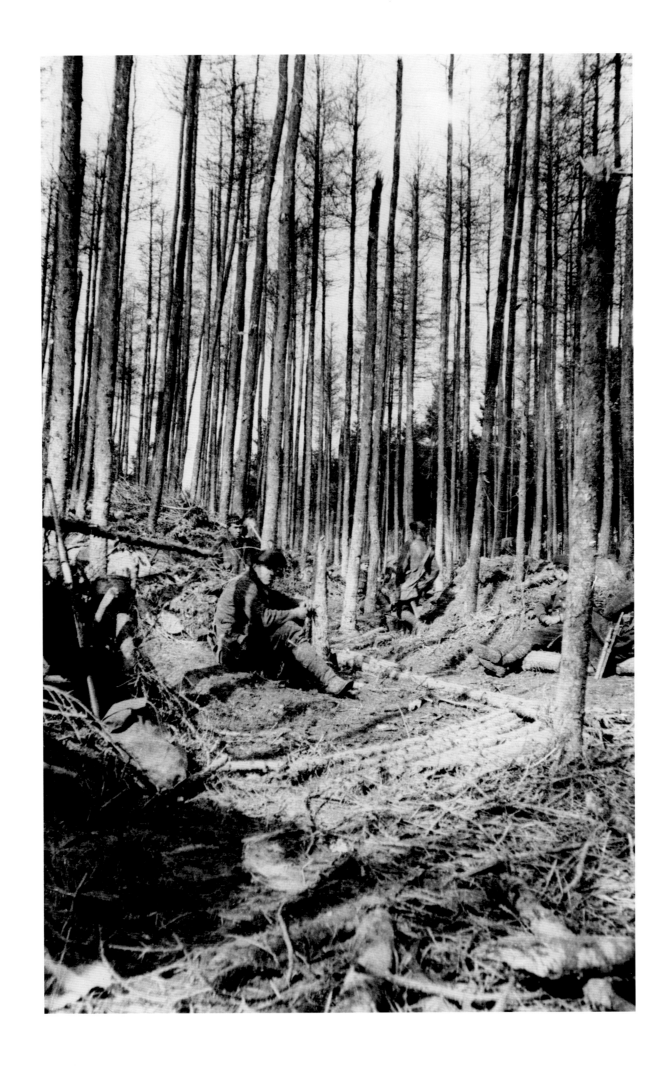

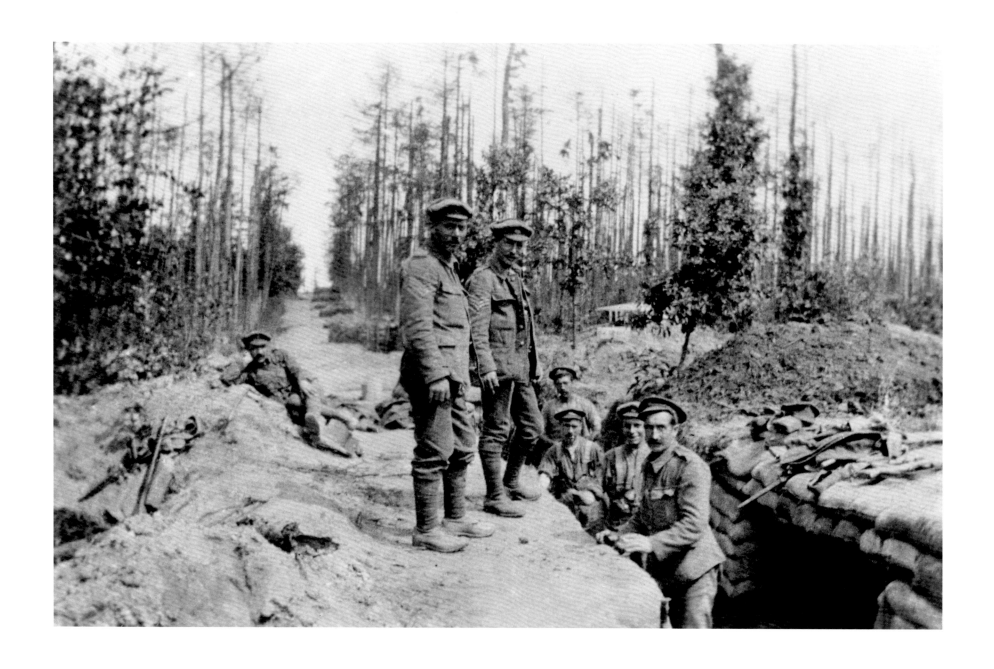

Left: LIEUTENANT BARCLAY, 1st King's Liverpool Regiment, BEF, personal photograph
British dugouts near Blauwepoort Farm, Second Battle of Ypres, Belgium, April 1915
Allied forces withstood the German assault, despite heavy casualties. Lt Barclay, fearing possible court martial, disposed of his camera shortly after taking this photograph

Above: CAPTAIN WYNDHAM HIGGINS, 2nd Suffolk Regiment, BEF, personal photograph
Soldiers of the 2nd Suffolk Regiment man dugouts in Bellyache Wood, near Spoilbank, Ypres Salient, Belgium, July–August 1915

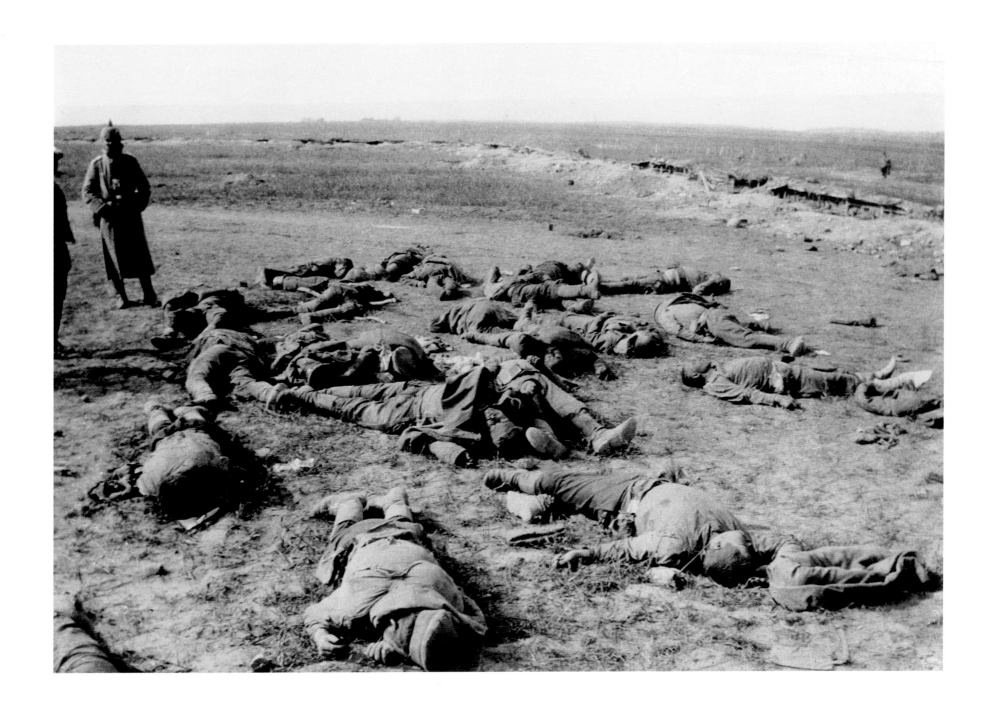

LIEUTENANT GUSTAV LACHMANN, Leib-Dragoner-Regiment Nr. 24, Imperial German
Army, personal photograph
**German soldiers inspect enemy casualties after capturing a Russian position on the
Eastern Front, near Lavgole, Russia (now Lithuania), 4 June 1915**
*Gustav Lachmann, a cavalry officer, was one of many experienced German soldiers
transferred from the Western Front in early 1915*

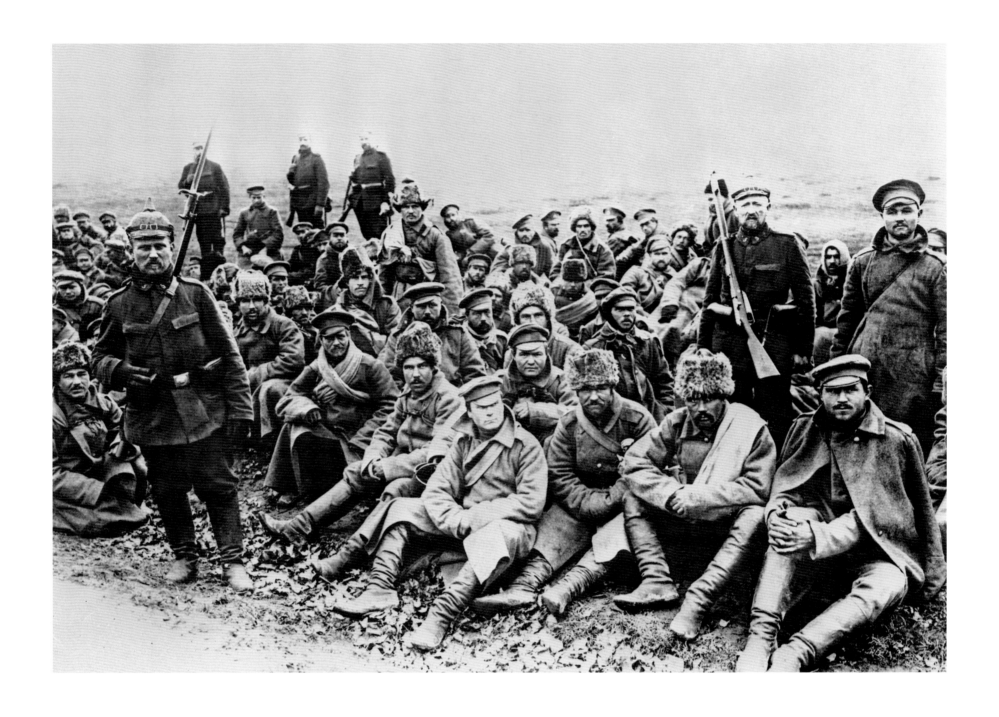

Unknown German photographer, personal photograph, from Sport & General commercial news agency
German reserve troops guard Russian prisoners near Łódź, Russia (now Poland), *c.* **October 1915**
With the assistance of seasoned reinforcements from the Western Front, German forces
gradually gained control of present-day Poland

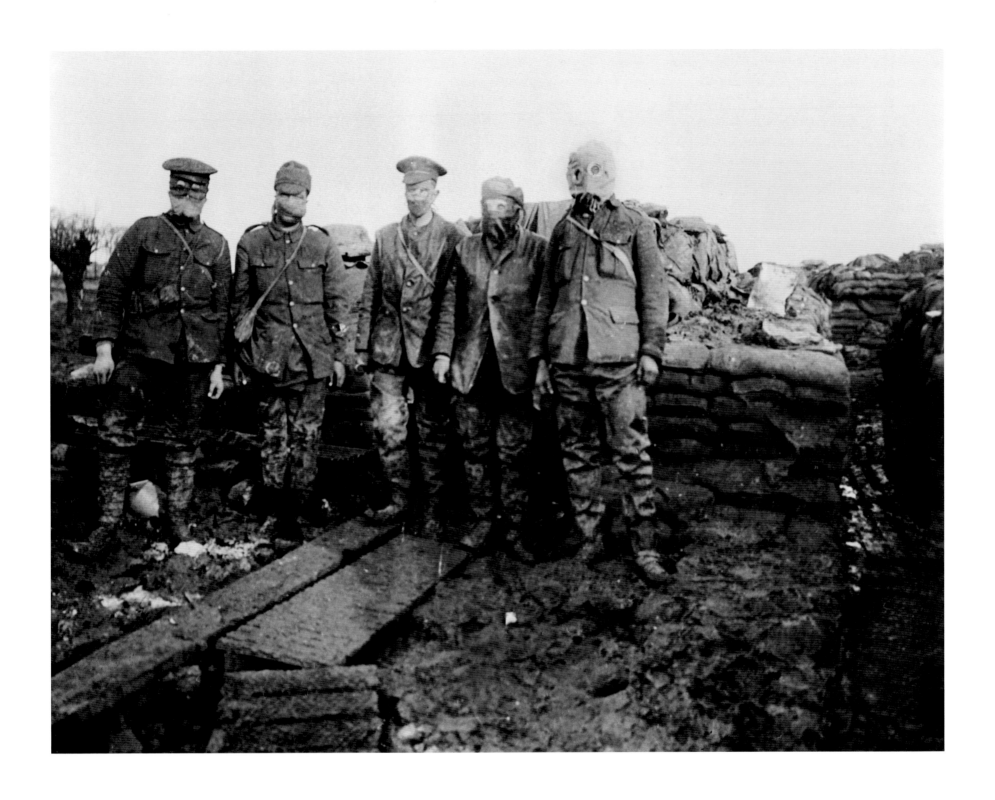

Unknown soldier, 1st Scots Guards, BEF, personal photograph
Men of the Scots Guards wearing crude early gas masks, Western Front, December 1915
As gas attacks escalated, primitive masks of various designs were rushed to the Western Front. They offered little protection and Allied casualties mounted

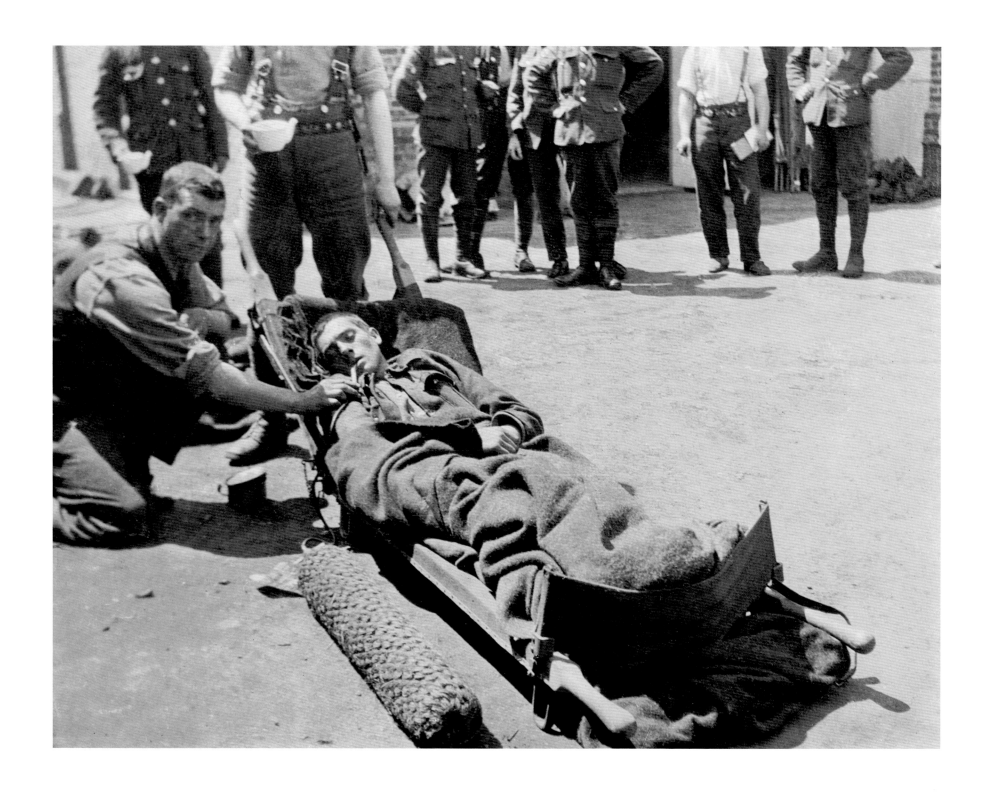

LIEUTENANT COLONEL JOHN F. CROMBIE, Royal Army Medical Corps, BEF, personal photograph
A medical orderly of North Midland Field Ambulance gives oxygen to a badly gassed soldier,
Hazebrouck, France, June 1915

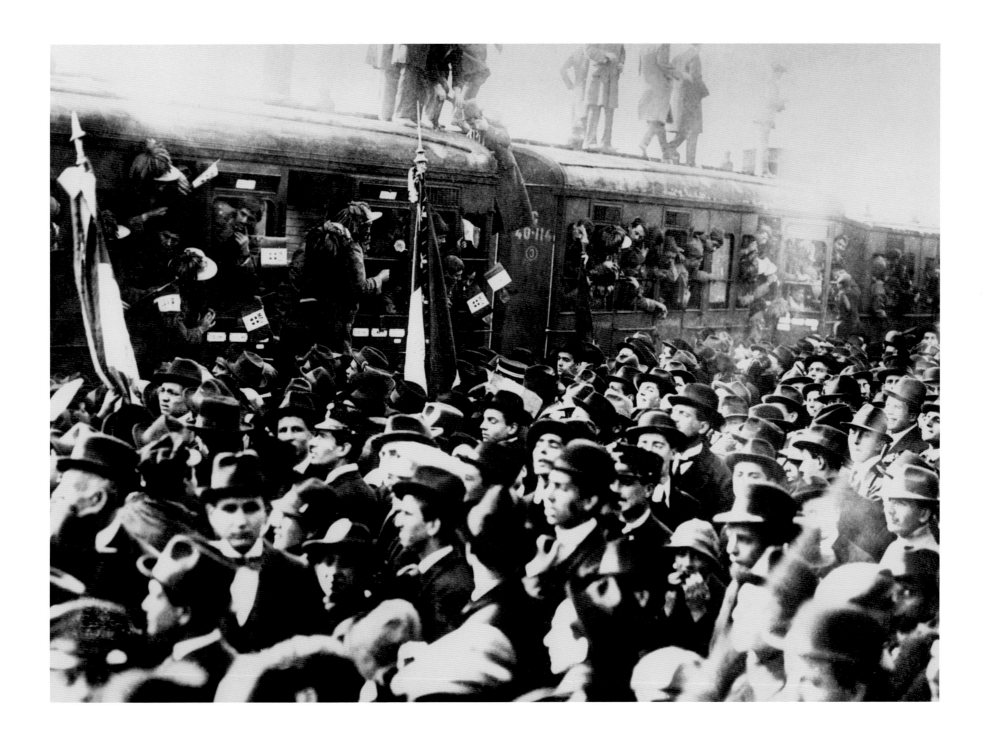

Above: Unknown Italian photographer, Sport & General commercial news agency
Bersaglieri troops depart for the front, Rome, Italy, May 1915
Italy declared war on Austria-Hungary on 25 May 1915. The elite Italian Bersaglieri regiments suffered 82,000 casualties in the war

Right: Unknown Italian photographer, Sport & General commercial news agency
An Italian soldier demonstrates one of the first gas masks, 1915

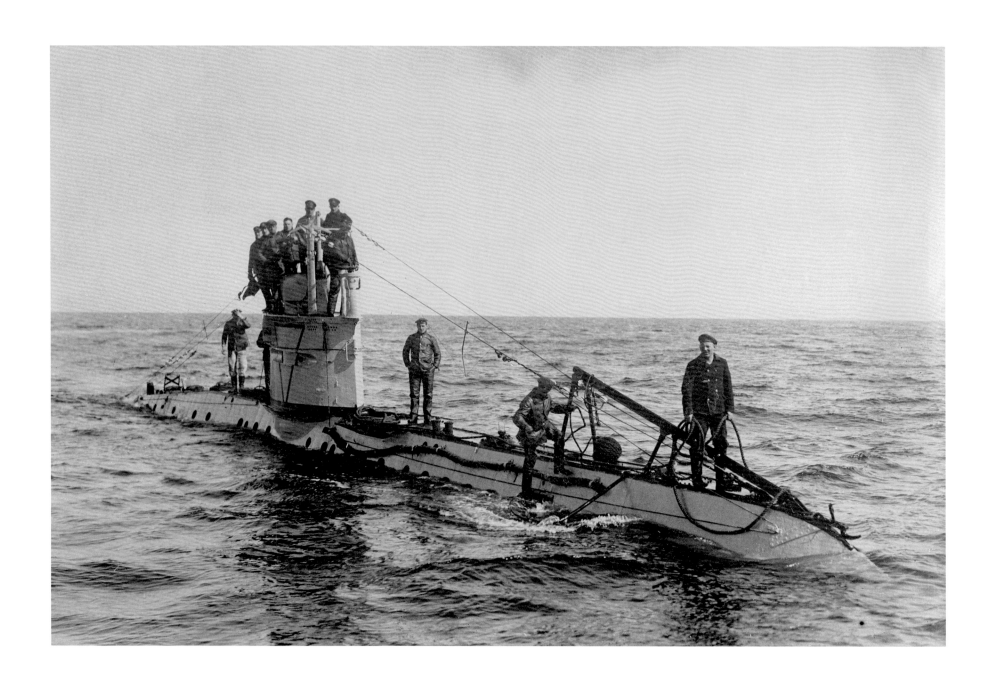

Unknown German naval photographer
A German UC-1-class submarine and its crew, German coastal waters, *c.* 1915
German submarines, or U-boats, posed a serious threat to shipping throughout the war. On 4 February 1915, Germany announced the start of unrestricted submarine warfare against Allied and neutral ships, ostensibly in response to the Allied naval blockade of Germany

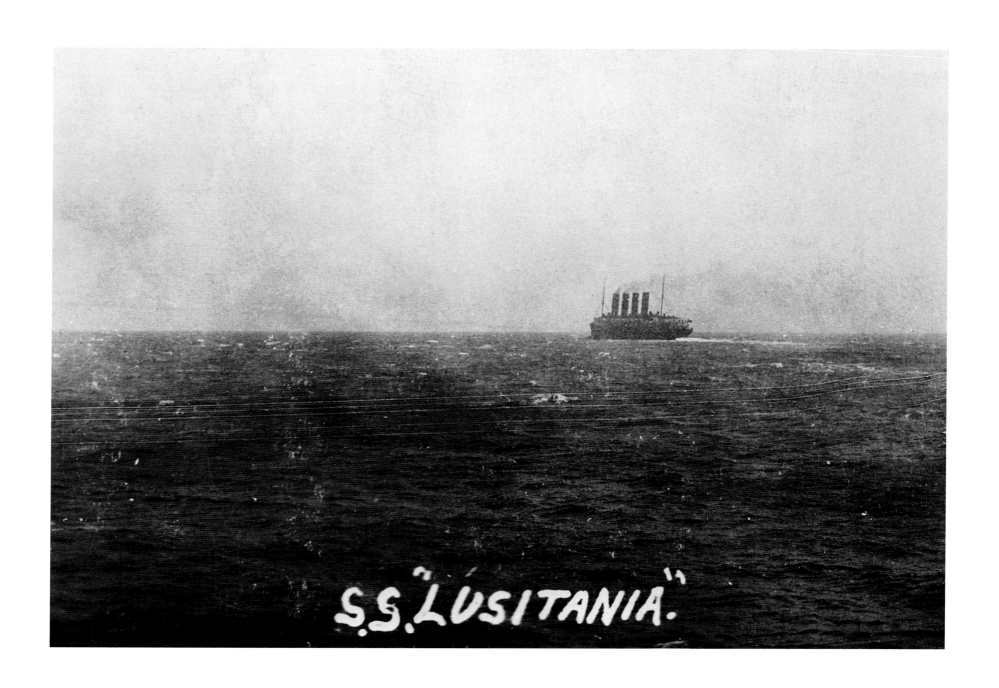

Unknown photographer, from the collection of G. R. Rance
**The last photograph of the British passenger liner RMS _Lusitania_, taken as she left
New York on her final transatlantic voyage, 1 May 1915**
_1,198 passengers and crew died when RMS Lusitania was torpedoed and sunk by German
submarine U-20 off Queenstown, Southern Ireland, 7 May 1915. The sinking shocked
America and created another important propaganda weapon for Britain_

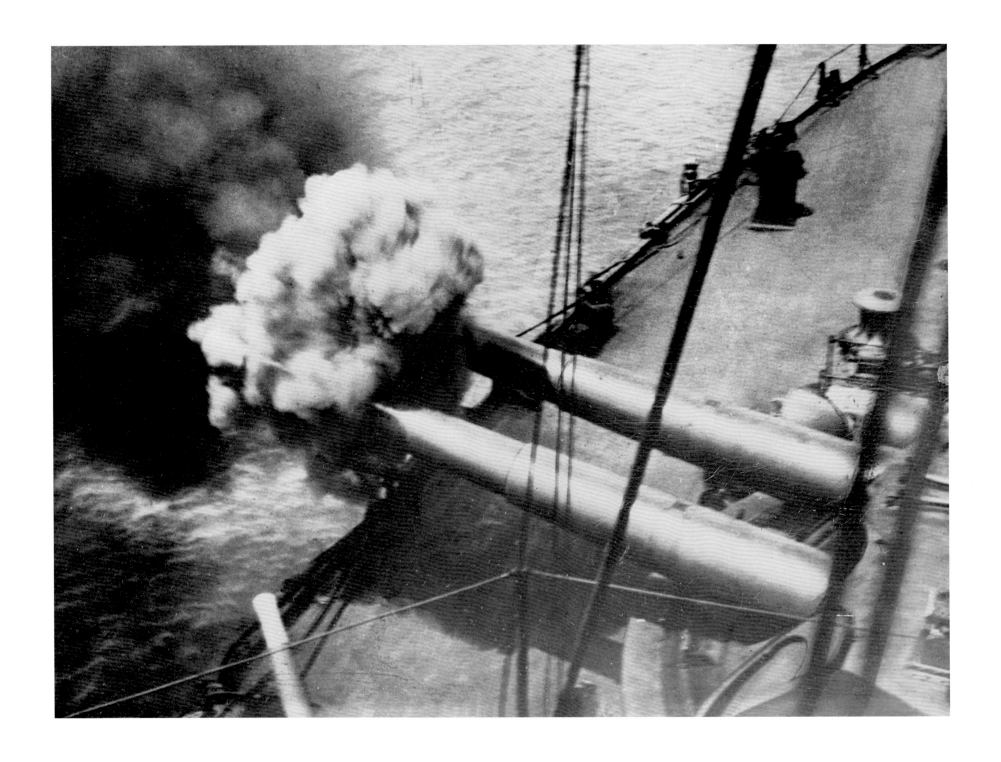

ERNEST BROOKS, Admiralty photographer
**A British battleship fires its 12-inch guns at Turkish forts defending the entrance to the
Dardanelle Straits, March 1915**
*The Dardanelles Campaign, conceived by Winston Churchill, First Lord of the Admiralty,
began with a massive, but ultimately ineffective, naval bombardment of Turkish
defences in an attempt to gain control of the straits*

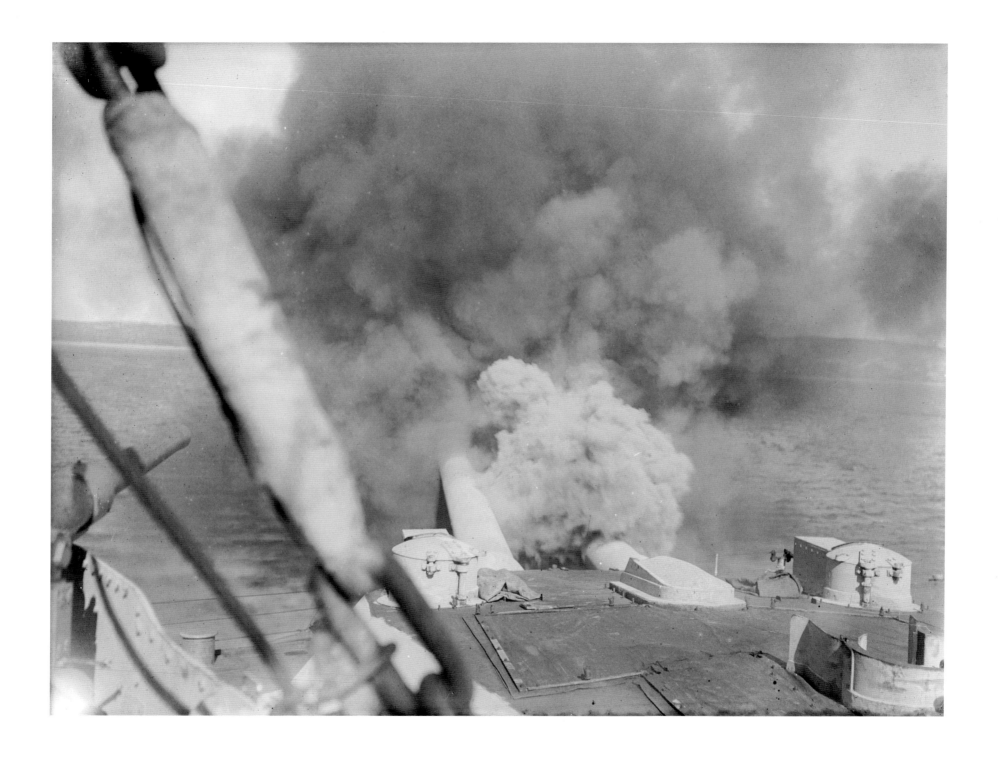

ERNEST BROOKS, Admiralty photographer
The 12-inch guns of HMS *Canopus* bombard Turkish forts at the entrance to the Dardanelle Straits, March 1915
Following successful press coverage of the Battle of Dogger Bank, the Admiralty appointed Ernest Brooks, a former royal photographer serving with the Royal Naval Volunteer Reserve, as official photographer. He was based on HMS Queen Elizabeth, *but moved around freely*

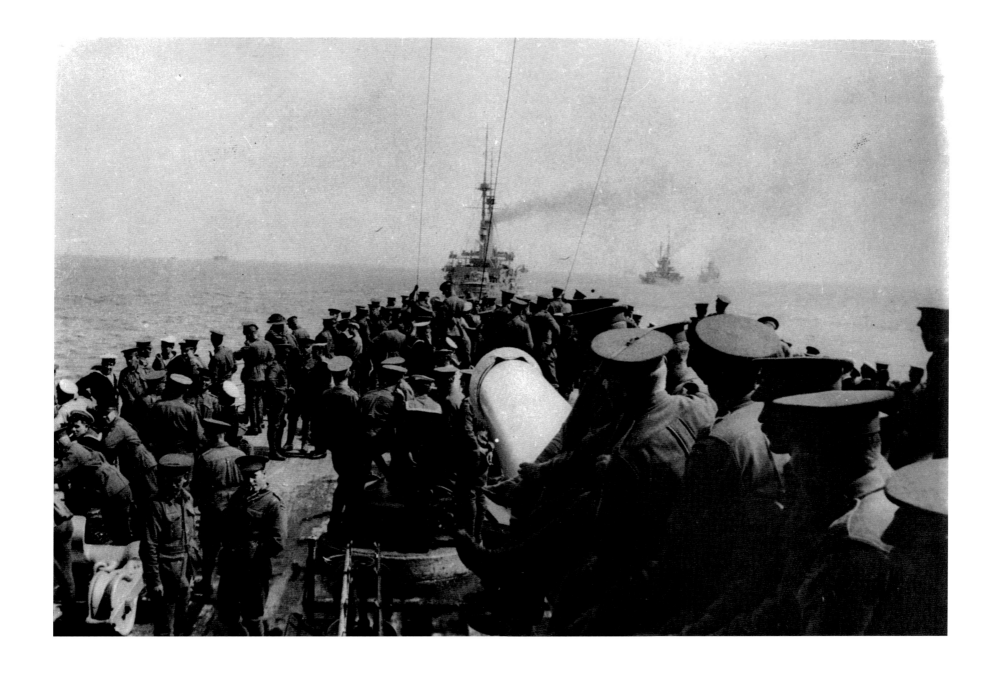

Left: Unknown photographer, personal photograph, from the collection of E. B. Clark
**1,500 men of 3rd Australian Brigade prepare to disembark from HMS *Prince of Wales*
off the coast of Gallipoli, 25 April 1915**
*In its first action of the war, the Australian and New Zealand Army Corps landed at
what became known as Anzac Cove*

Above: ELLIS ASHMEAD-BARTLETT, British official war correspondent
**HMS *Baccante* leads HMS *London*, carrying men of 111th Australian Battalion and
1st Field Company Australian Engineers during the voyage from Lemnos to Gallipoli,
24 April 1915**
*In a new development, the Gallipoli landings were also photographed by official war
correspondents, including Ashmead-Bartlett and the Australian, Charles Bean*

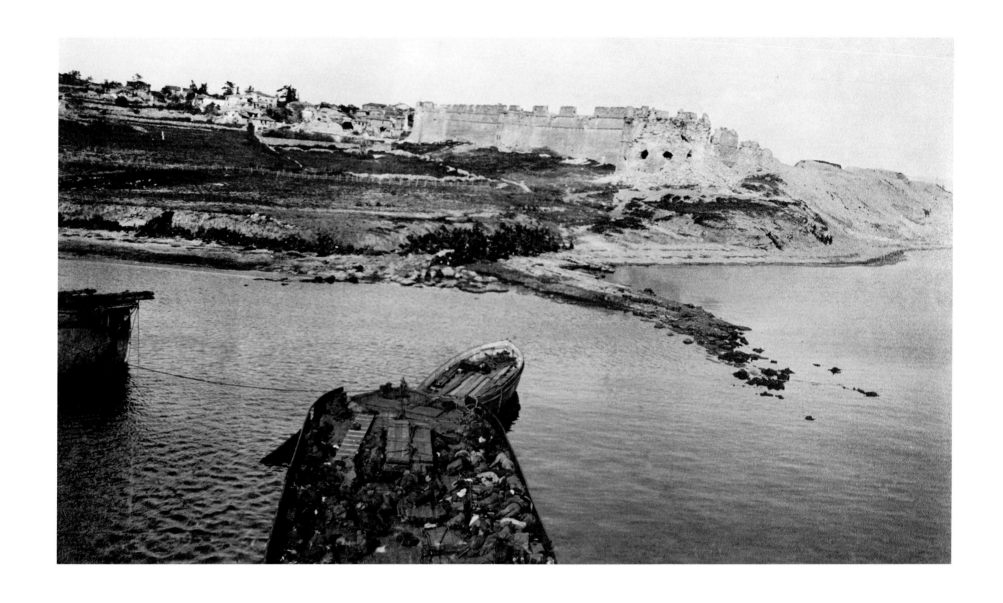

LIEUTENANT C. N. GRAHAM, RN (presumably), personal photograph
The landings at V Beach as seen from SS *River Clyde*, Sedd el Bahr, Cape Helles, Gallipoli, 25 April 1915
In the distance the Dublin Fusiliers are pinned down as devastating Turkish fire enfilades the beach. In the foreground a landing barge contains the bodies of Munster Fusiliers who were killed or wounded before they could get ashore. An estimated 6,500 British troops became casualties at V Beach

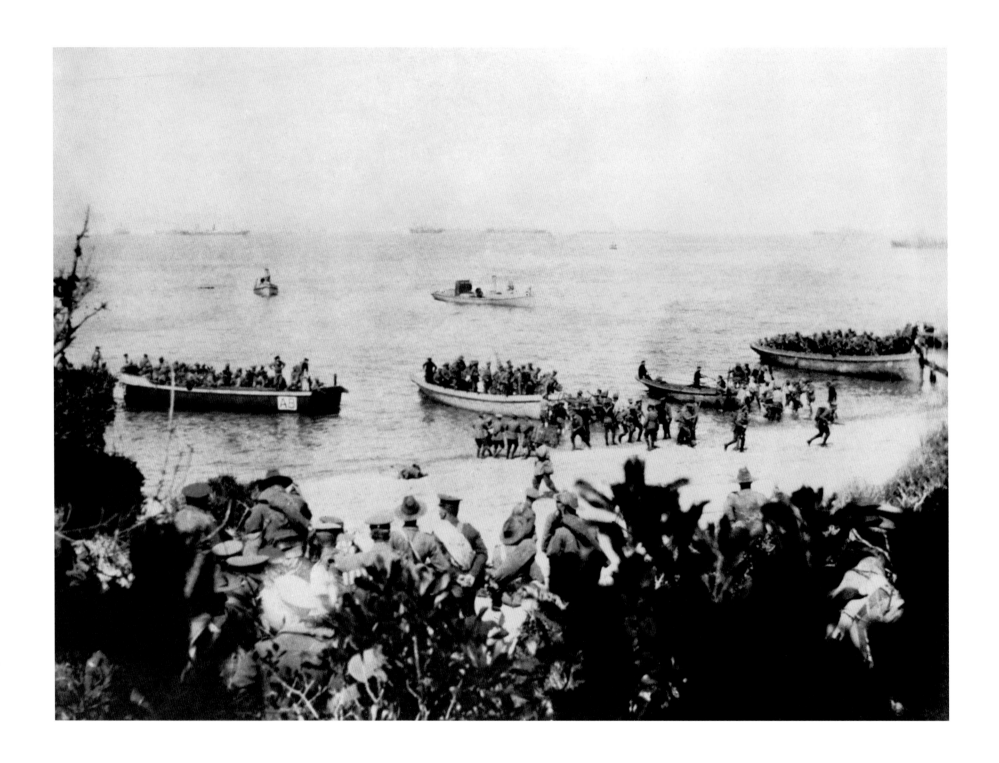

LANCE CORPORAL A. R. H. JOYNER, 1st Australian Divisional Signal Company,
Australian Imperial Force, personal photograph
Z Beach, Anzac Cove, Gallipoli, 8 a.m., 25 April 1915
*The staff of Colonel H. N. MacLaurin, 1st Australian Infantry Brigade, are visible in the
foreground. At the water's edge lies the body of Sapper R. Reynolds, the first Australian
casualty of the war. The photographer, Lance Corporal Joyner, was killed at Bazentin,
France, on 4 December 1916*

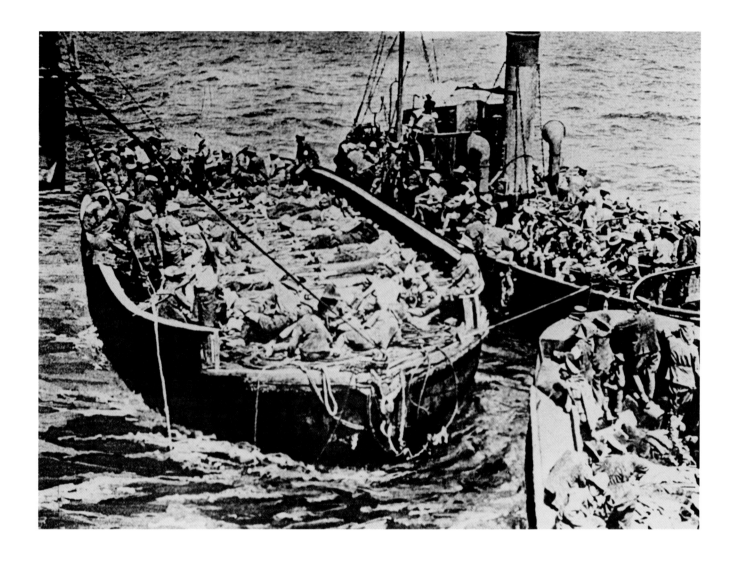

Above: Unknown photographer, personal photograph, from the collection of Chaplain Colonel Ernest N. Merrington, Australian Chaplain's Corps, Australian Imperial Force
Evacuation of wounded from Z Beach, Anzac Cove, Gallipoli, 25 April 1915
Steam launch Keraunos *transports walking wounded while stretcher cases are evacuated by barge*

Pages *148–9*: ERNEST BROOKS, Admiralty photographer
Panorama of the British camp at W Beach, Cape Helles, Gallipoli, *c*. May 1915
W Beach subsequently became known as Lancashire Landing, since it was here that 1st Lancashire Fusiliers fought their way ashore in an action for which six Victoria Crosses were awarded

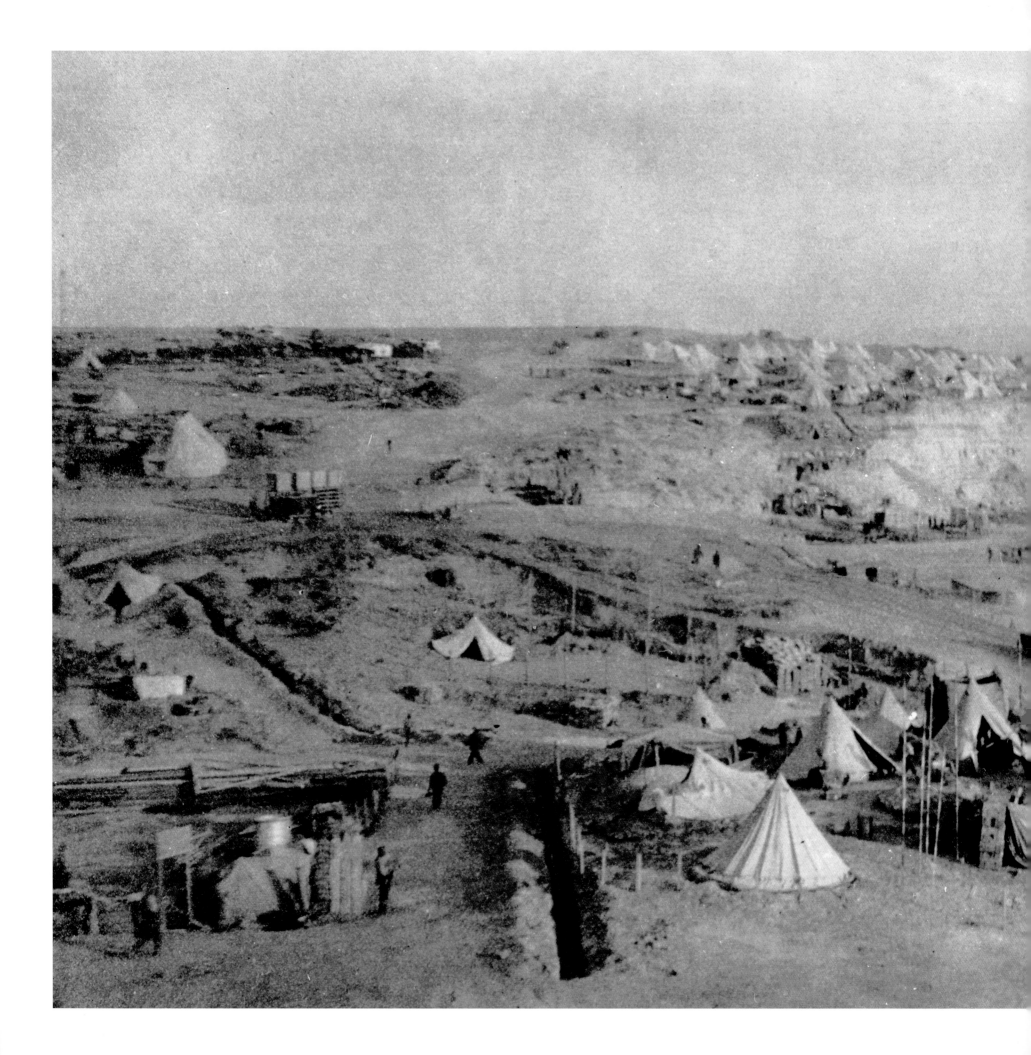

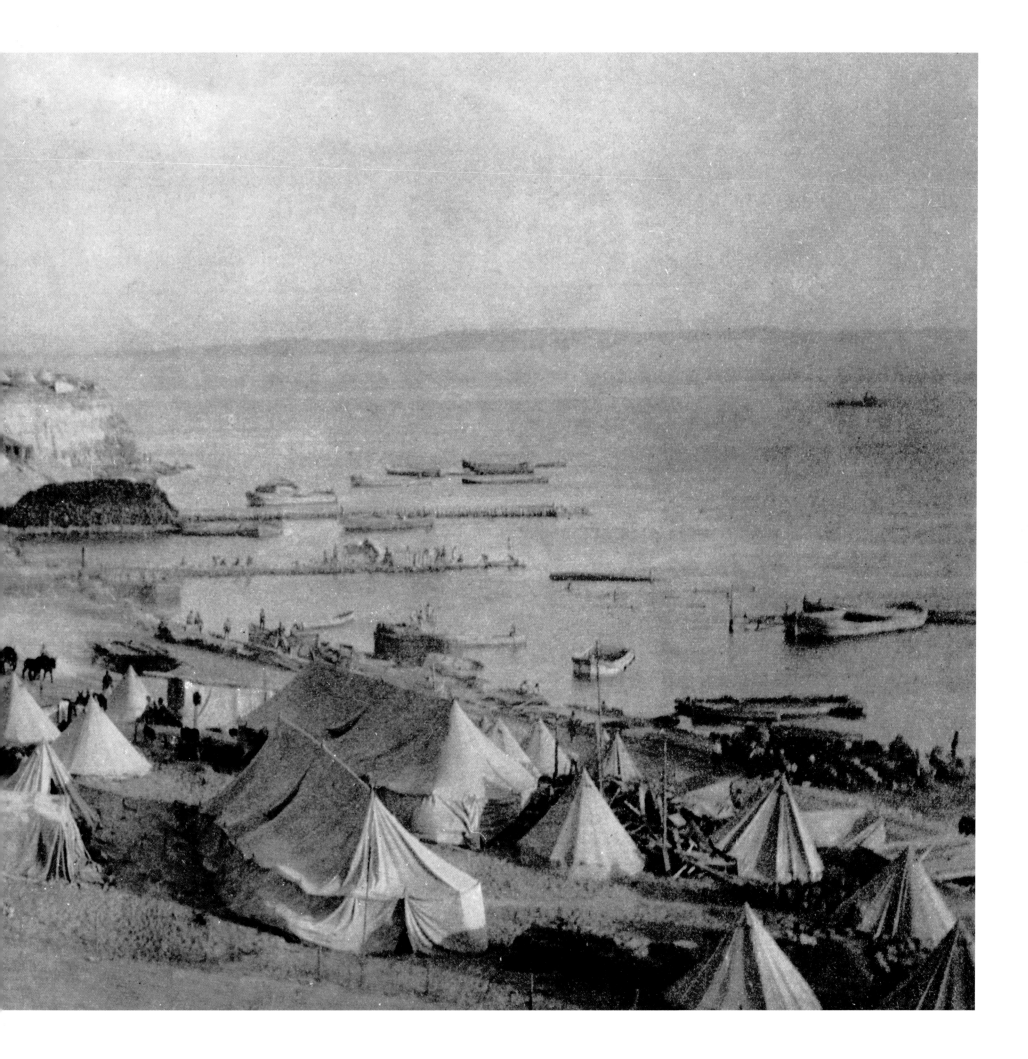

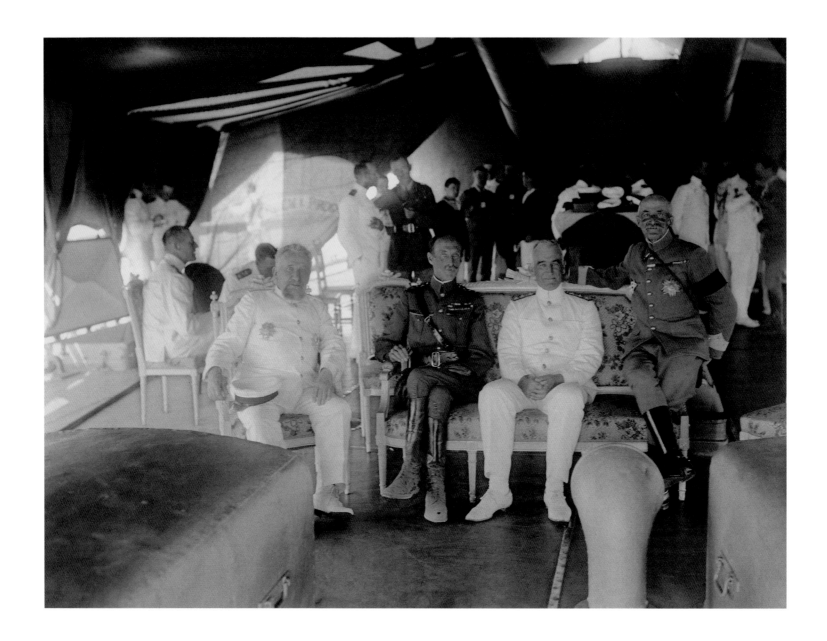

ERNEST BROOKS, Admiralty photographer
Allied Commanders-in-Chief meet to confer on board HMS *Queen Elizabeth*, moored off the island of Tenedos, 22 March 1915
Allied commanders remained remote and out of touch from events at the front. Left to right: Vice Admiral A. Boué de Lapeyrère, Commander-in-Chief French Mediterranean Fleet; General Sir Ian Hamilton, Commander Mediterranean Expeditionary Force; Vice Admiral John M. de Robeck, naval commander; and General Bailloud, General Officer Commanding Corps Expeditionaire d'Orient

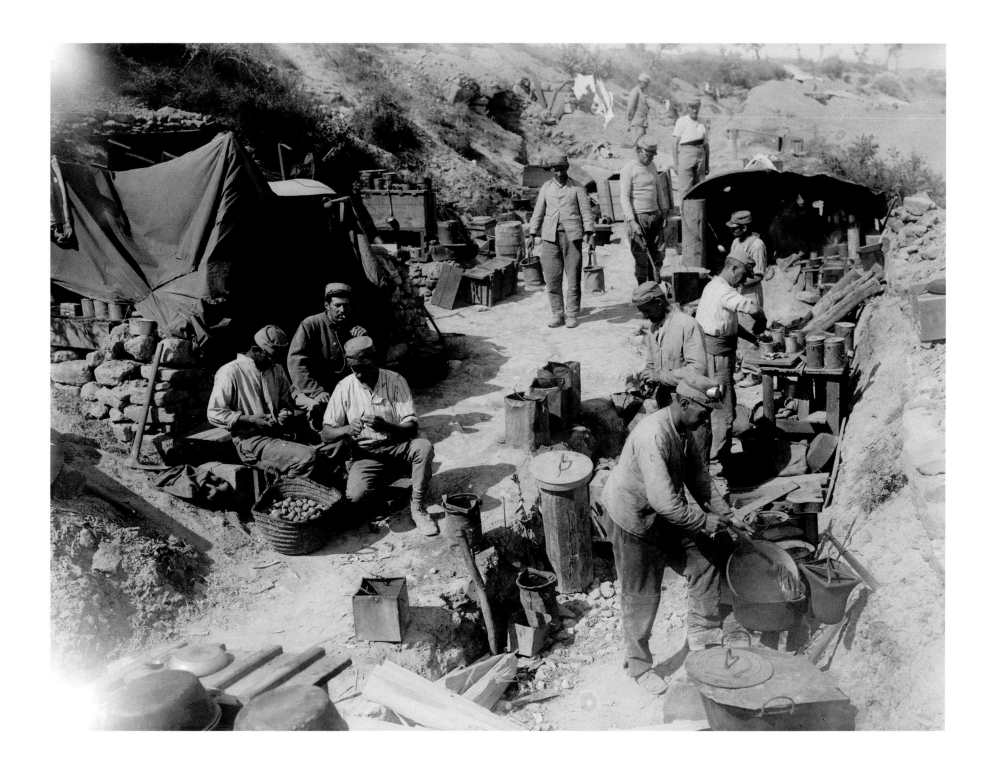

Above: ERNEST BROOKS, Admiralty photographer
A French field kitchen half a mile from the Turkish lines, Cape Helles, Gallipoli, Autumn 1915
A lack of fresh food combined with a plague of flies, poor sanitation and the gruelling climate caused high levels of disease among Allied soldiers in Gallipoli. Dysentery was rife

Pages 152–3: ERNEST BROOKS, Admiralty photographer
Panorama of Gully Ravine, Cape Helles, Gallipoli, September 1915
This ravine was the scene of fierce fighting in June and July

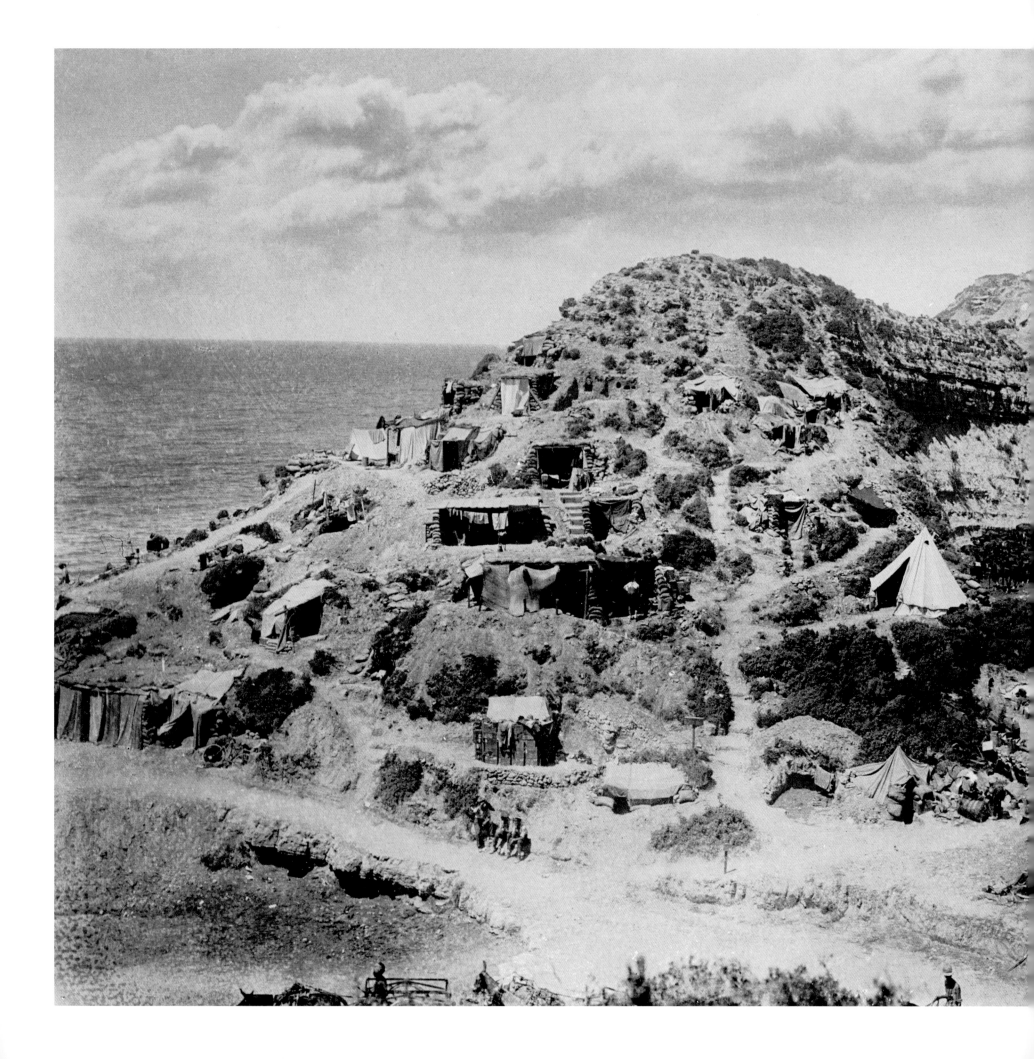

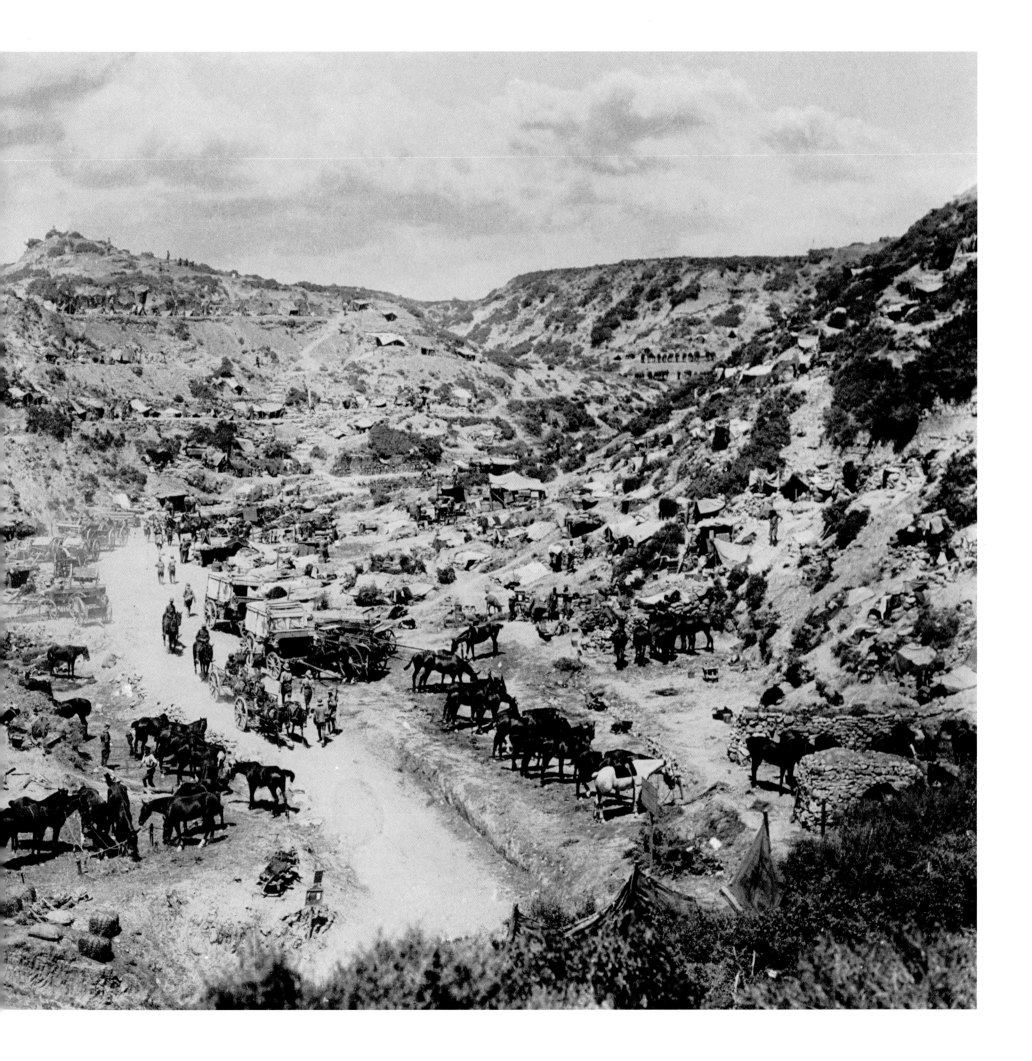

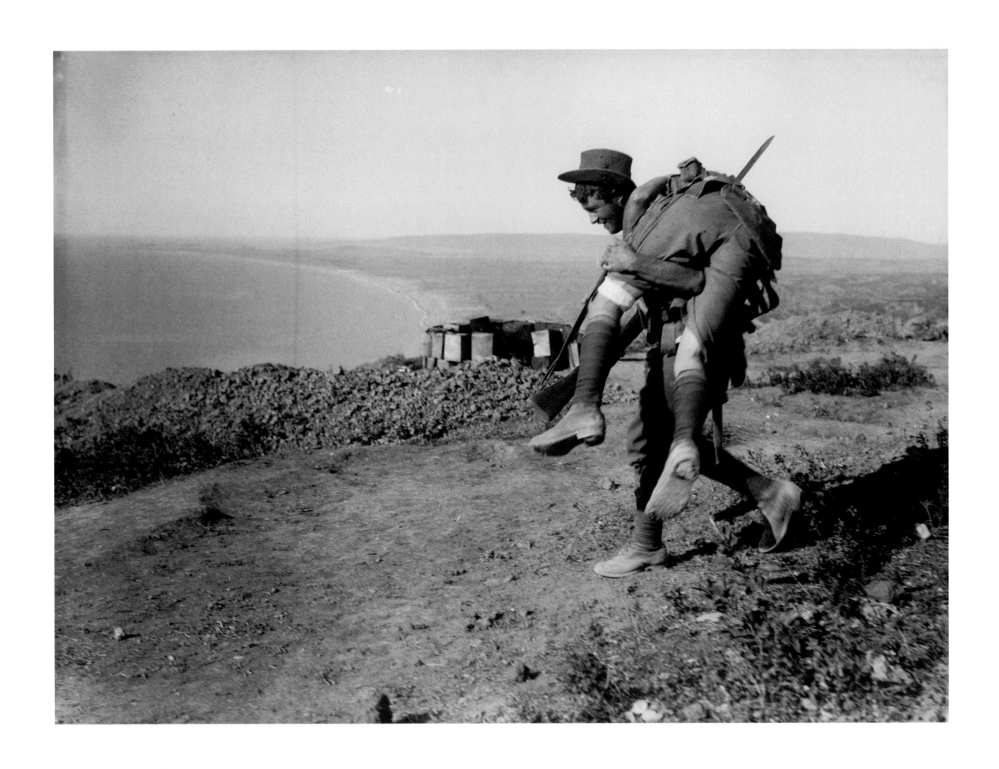

ERNEST BROOKS, Admiralty photographer
An Australian soldier carries a wounded comrade down to the beach for treatment,
Walker's Ridge, Suvla, Gallipoli, 1915
This photograph, now an icon of the Australian experience at Gallipoli, is believed
to have been staged for the camera

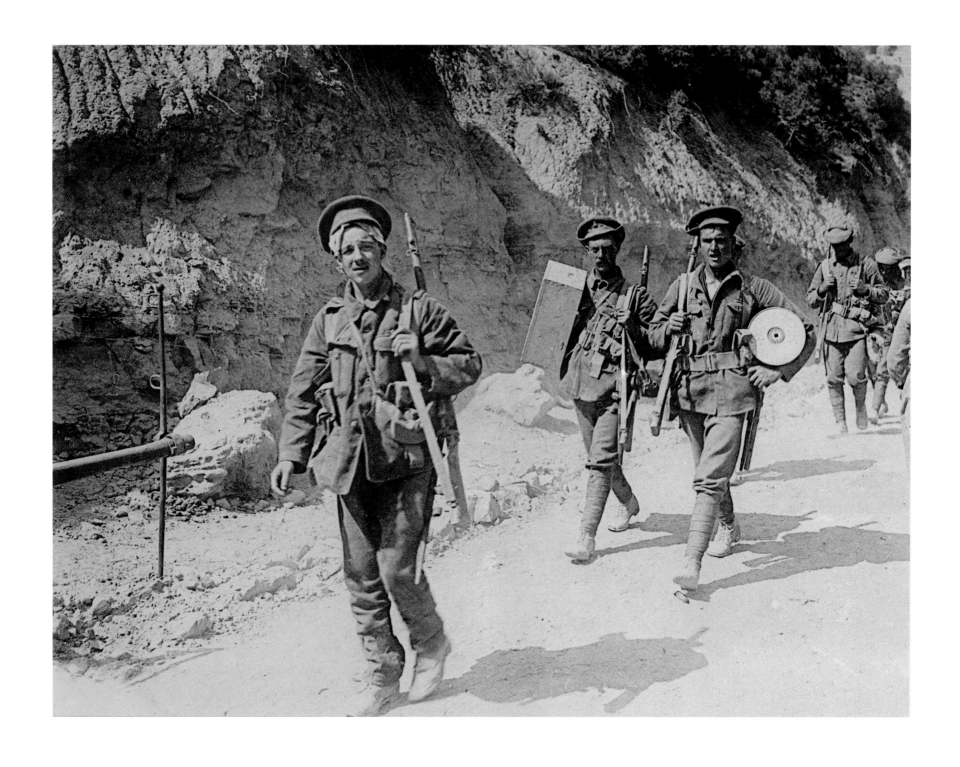

ERNEST BROOKS, Admiralty photographer
Royal Fusiliers return from the trenches through Gully Ravine, Cape Helles, Gallipoli, Summer 1915
The climate, ranging from soaring temperatures in summer to bitter cold in winter,
continually undermined the efficiency of the Allied forces

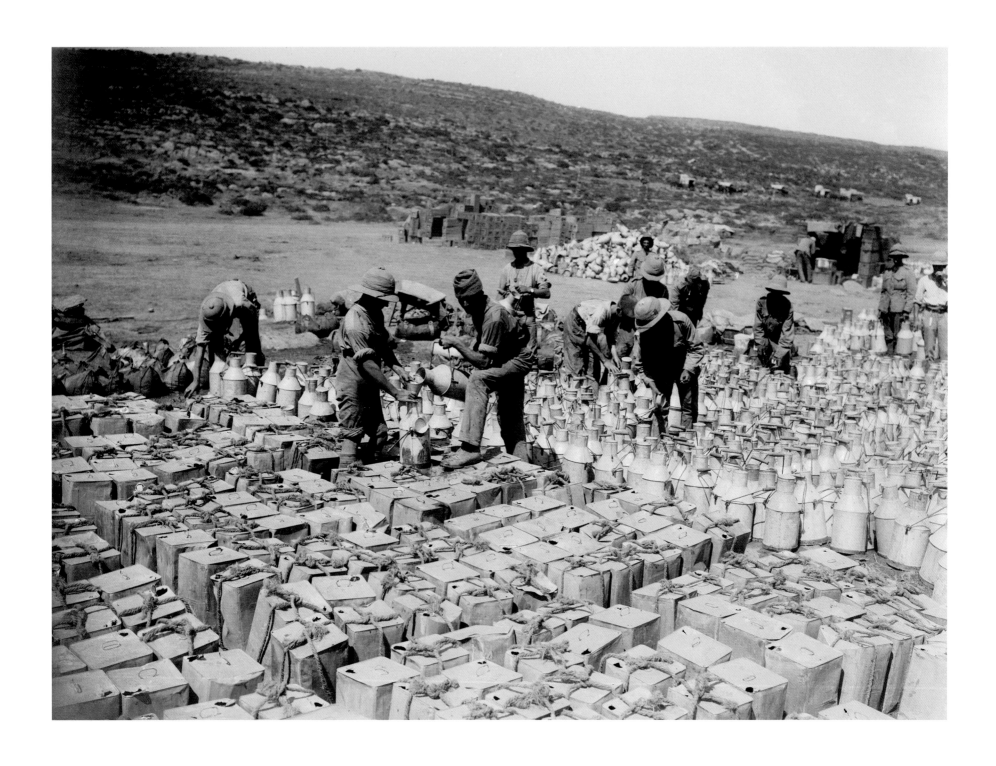

ERNEST BROOKS, Admiralty photographer
Water is filtered before being put into covered cans, Cape Helles, Gallipoli, Summer 1915
*Shortage of water and containers increased the suffering of the Allied troops in the
summer months*

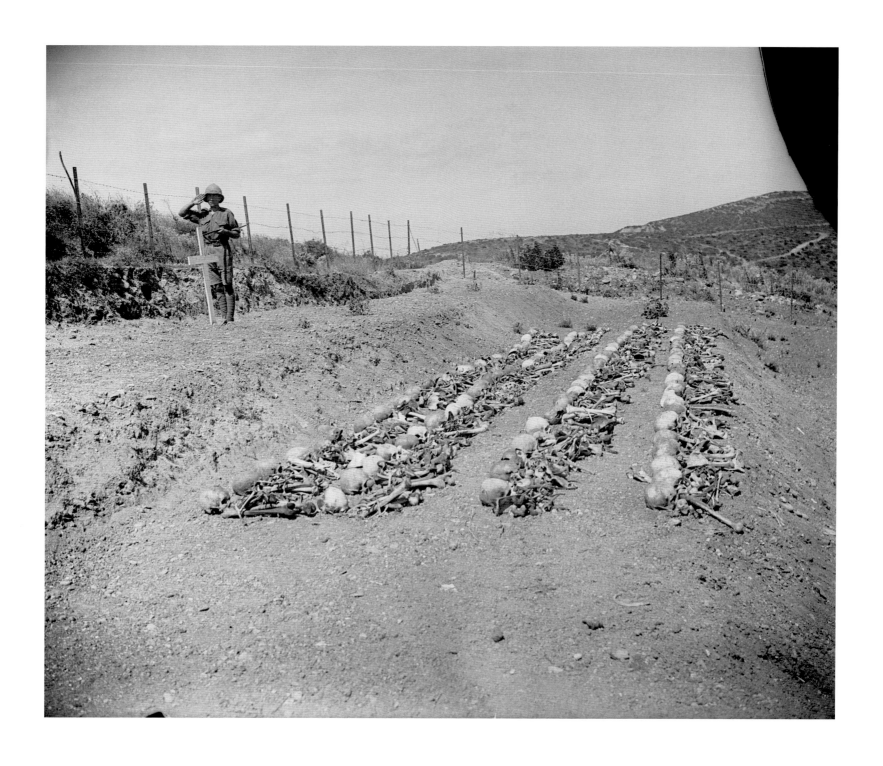

WILLIAM J. BRUNELL, Ministry of Information photographer
A mass grave prepared for the remains of New Zealand soldiers who died at Chunuk Bair during the Battle of Sari Bair on 8 August 1915
The grave was dug at the easternmost point reached by ANZAC forces during the Gallipoli Campaign. The photograph was taken during the clearing of the battlefield in 1918

ERNEST BROOKS, Admiralty photographer
A group of Australian soldiers, including a father and son, in a trench on Walker's Ridge, Suvla, Gallipoli, May 1915
Trooper Andrew Yeates, 9th Light Horse (with pipe), died, aged fifty-four, of wounds sustained at Lone Pine on 30 August 1915. In the foreground is his son, Private James Yeates, 3rd Australian General Hospital. Both had enlisted in 1914

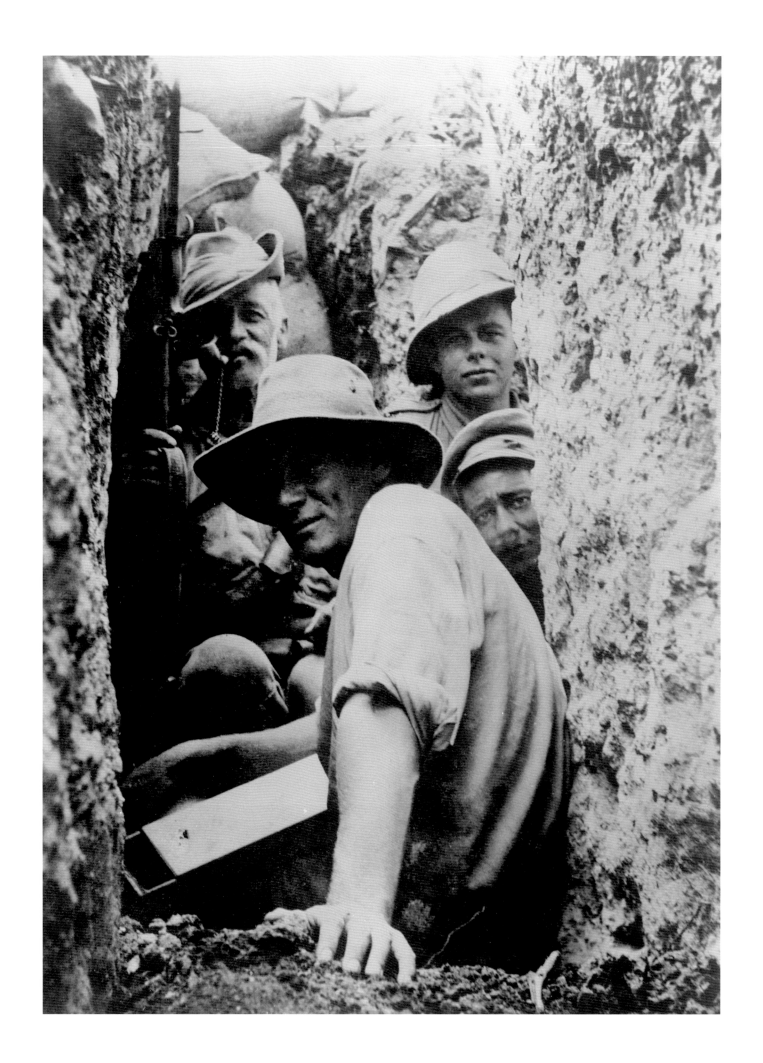

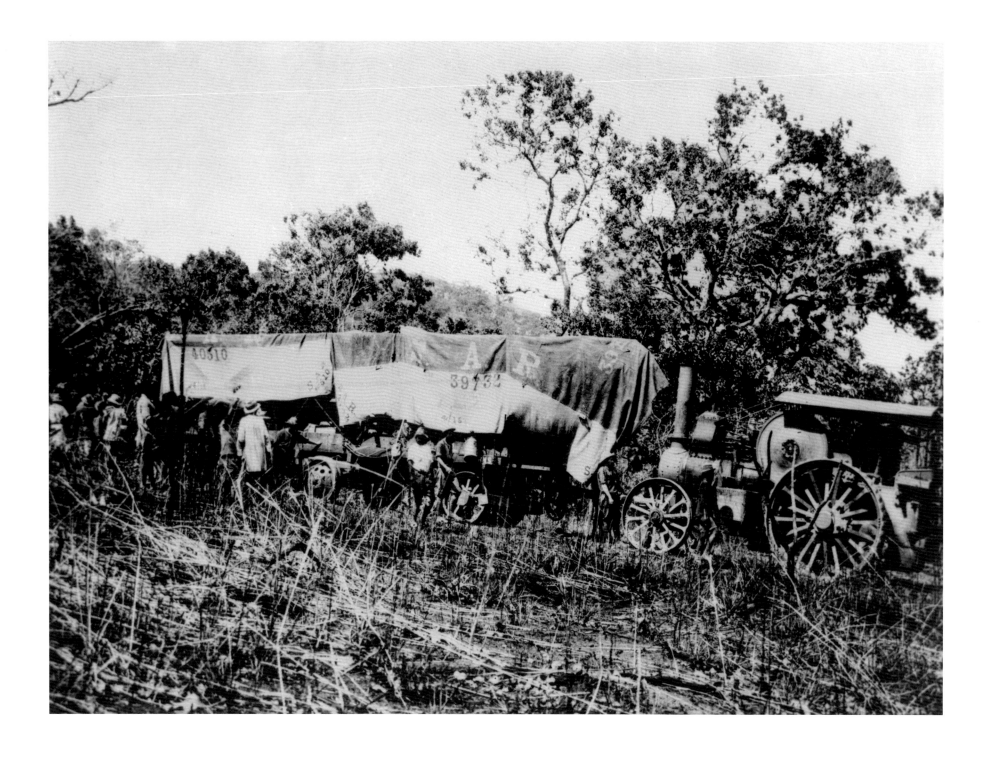

Above: LIEUTENANT COMMANDER GEOFFREY SPICER-SIMSON, RN,
personal photograph
Steam tractors haul trailers bearing two naval gunboats, HMS *Mimi* and HMS *Tou-Tou*, through jungle during the Tanganyika expedition that culminated in the Battle of Lake Tanganyika, Africa, September–October 1915
Spicer-Simson led a successful British expedition to wrest control of the lake from the Imperial German Navy in 1915. The gunboats were transported to the lake from South Africa via 138 miles of jungle. They went into action in December, overcoming a superior force of three German vessels

Pages 162–3: Unknown photographer, personal photograph, from the collection of Joseph Granville Squiers, East African Mounted Rifles
A patrol of East African Mounted Rifles monitor activity in the bush during the campaign in German East Africa, Bisil, near Kajiado, Kenya, July–August 1915

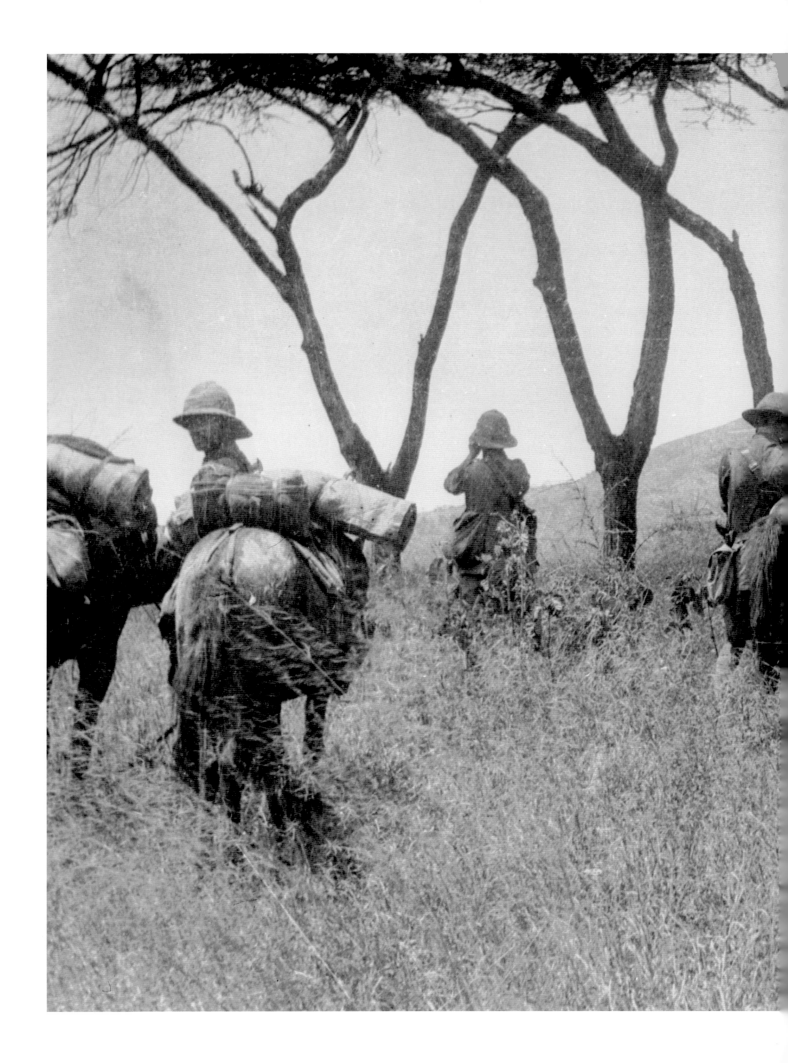

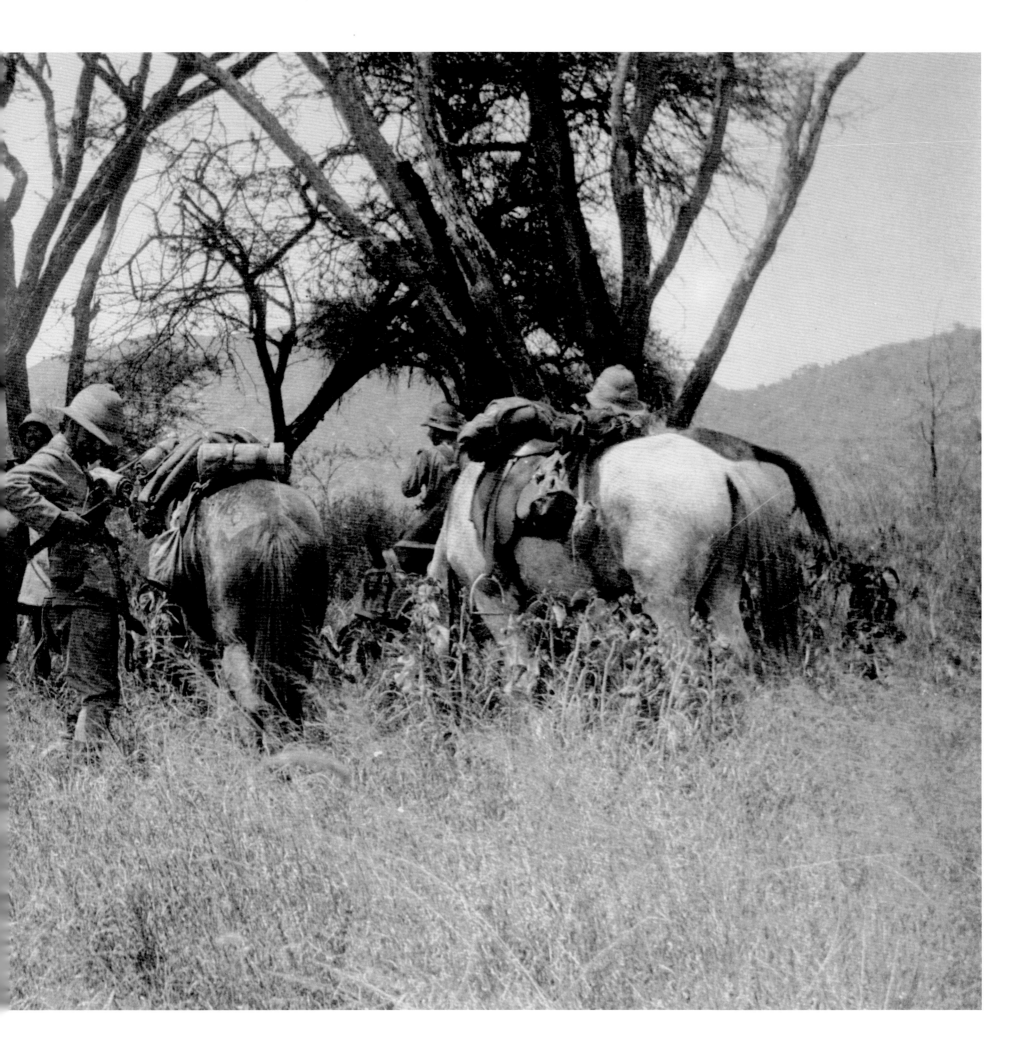

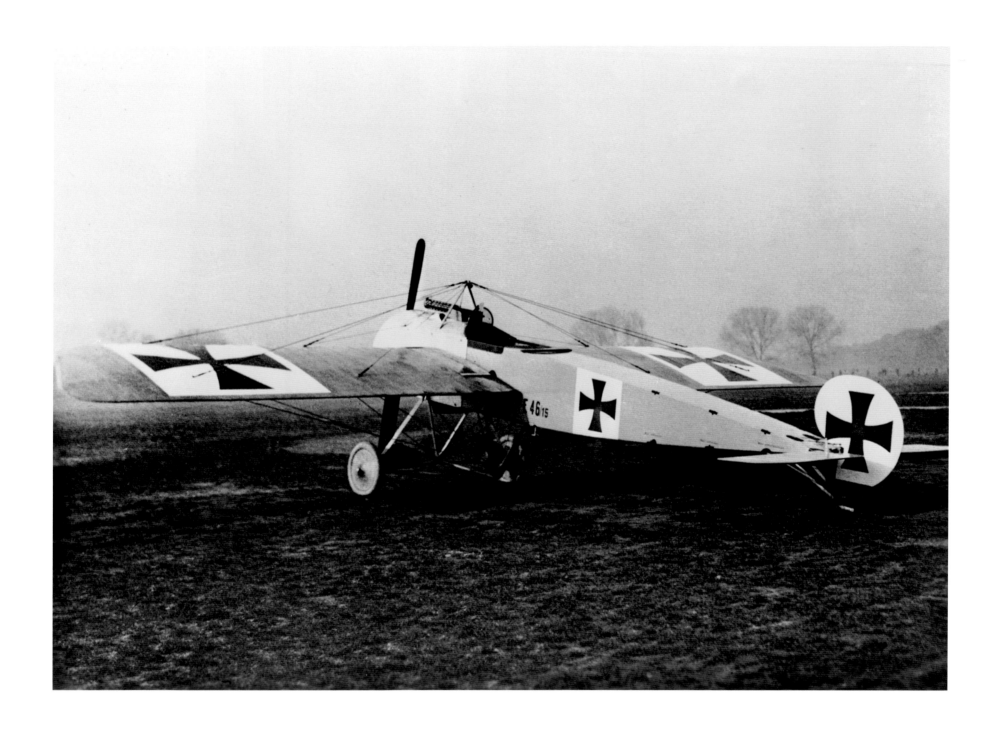

Unknown German photographer, from the collection of Hans and Botho von Romer
Fokker E (Eindekker) Scout single-seat monoplane, *c.* April 1915
Armed fighter aircraft evolved to support and maintain the flow of intelligence from
aerial photography on the Western Front in April 1915. The innovatory interrupter
gear (enabling a machine gun to be fired forwards through the propeller) gave the
Fokker absolute air superiority over the Western Front during 1915

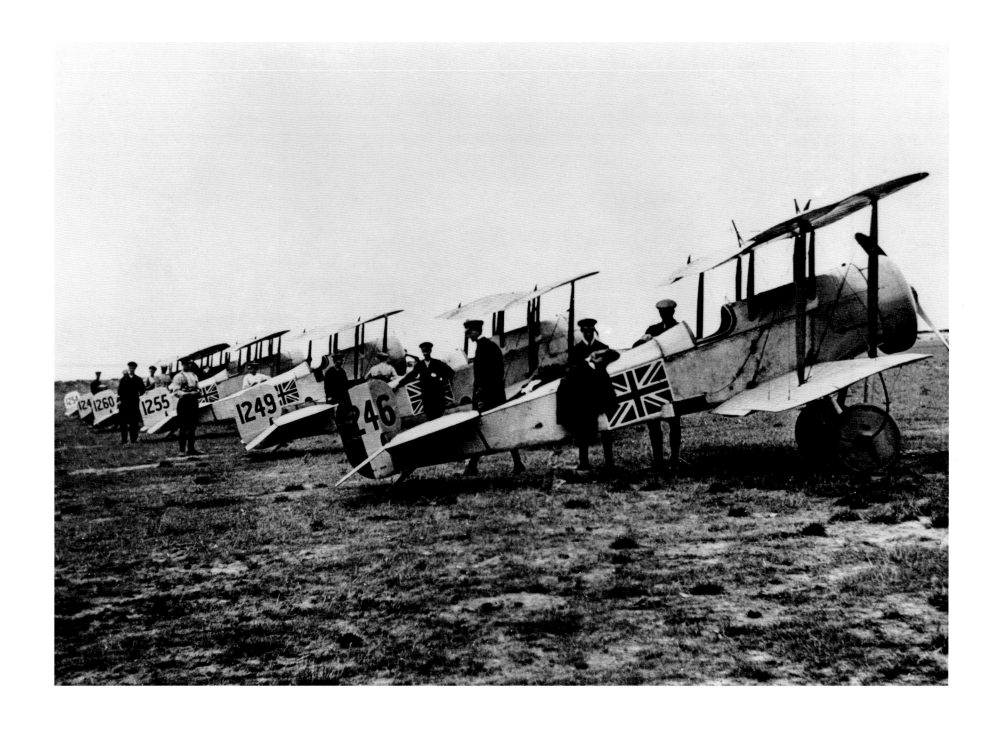

Unknown photographer, Sport & General commercial news agency
Bristol Scouts of the Royal Naval Air Service, Eastchurch Naval Air Station,
Isle of Sheppey, Kent, 1915
Although the Bristol Scouts performed well, they were outclassed by the forward firing
capability of the Fokker. In 1915, British pilots referred to themselves as 'Fokker Fodder'

Unknown soldier, London Rifle Brigade, BEF, personal photograph
British troops advance through a cloud of poison gas on the opening day of the Battle of Loos, Loos-Artois Offensive, France, 25 September 1915
The photograph shows the first British use of poison gas on the Western Front.
The attack failed when the wind blew the gas back towards the British front lines

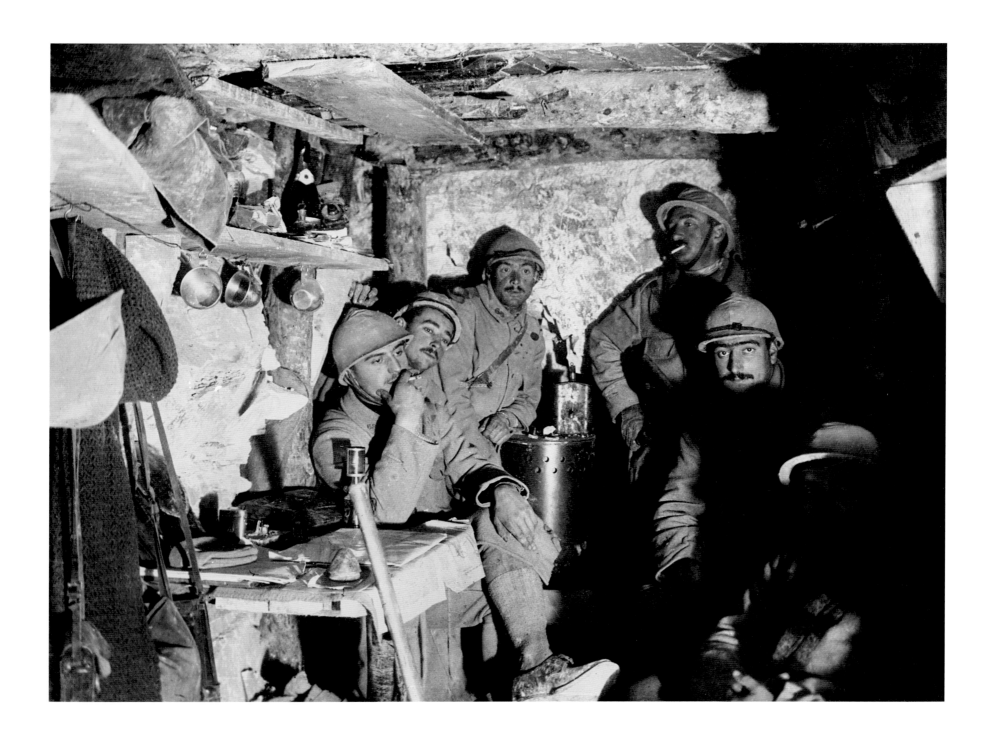

Above: SPA photographer, French Army
Soldiers of 68th French Infantry Regiment rest in a frontline trench dugout, Ravin de Souchez, near Arras, Pas de Calais, France, October 1915

Right: Unknown soldier, 1st Scots Guards, BEF, personal photograph
B Company, 1st Scots Guards, fuse grenades (also known as Mills Bombs) in Big Willy Trench during the Loos-Artois Offensive, Hohenzollern Redoubt, near Auchy-les-Mines, France, October 1915
Big Willy Trench was the scene of fierce fighting during a battle for control of the Hohenzollern Redoubt. British troops used more than 5,000 grenades in the battle, but this was not sufficient to hold the redoubt

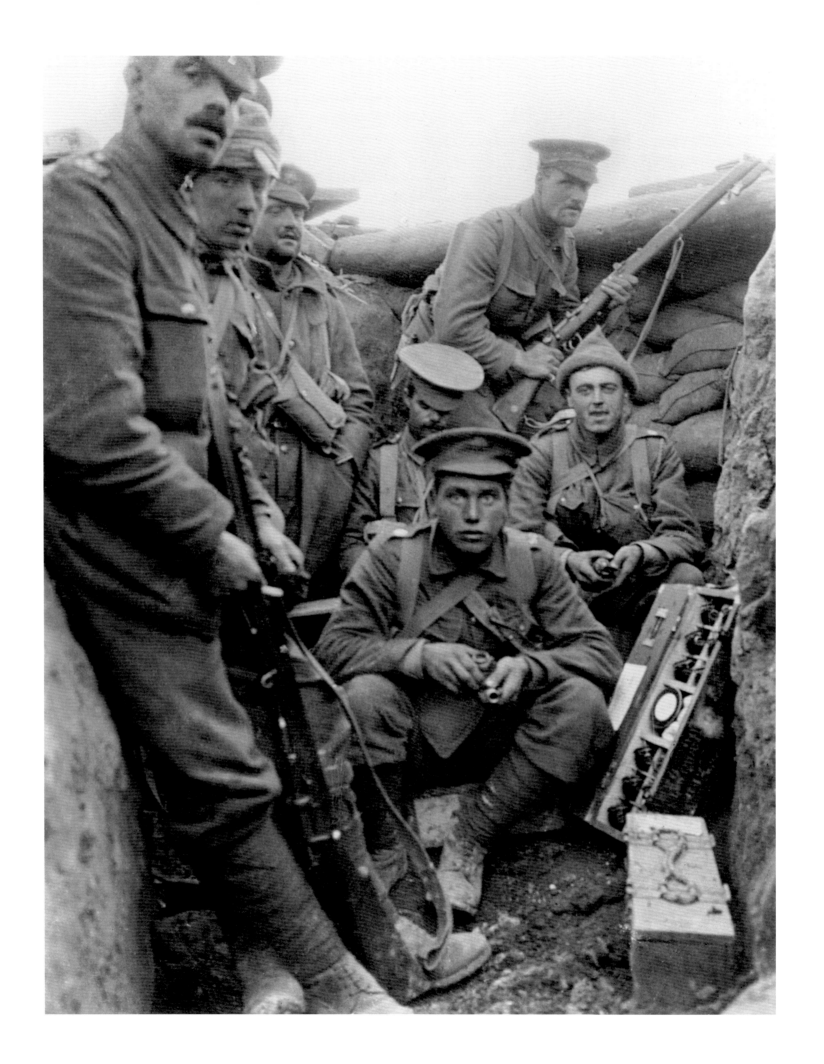

PROCLAMATION

———◆———

Le Tribunal du Conseil de Guerre Impérial Allemand siègant à Bruxelles a prononcé les condamnations suivantes :

Sont condamnés à mort pour trahison en bande organisée :

Edith CAVELL, Institutrice à Bruxelles.

Philippe BANCQ, Architecte à Bruxelles.

Jeanne de BELLEVILLE, de Montignies.

Louise THUILIEZ, Professeur à Lille.

Louis SEVERIN, Pharmacien à Bruxelles.

Albert LIBIEZ, Avocat à Mons.

Pour le même motif, ont été condamnés à quinze ans de travaux forcés :

Hermann CAPIAU, Ingénieur à Wasmes. — Ada BODART, à Bruxelles. — Georges DERVEAU, Pharmacien à Pâturages. — Mary de CROY, à Bellignies.

Dans sa même séance, le Conseil de Guerre a prononcé contre dix-sept autres accusés de trahison envers les Armées Impériales, des condamnations de travaux forcés et de prison variant entre deux ans et huit ans.

En ce qui concerne BANCQ et Edith CAVELL, le jugement a déjà reçu pleine exécution.

Le Général Gouverneur de Bruxelles porte ces faits à la connaissance du public pour qu'ils servent d'avertissement.

Bruxelles le 12 Octobre 1915

Le Gouverneur de la Ville,

Général VON BISSING

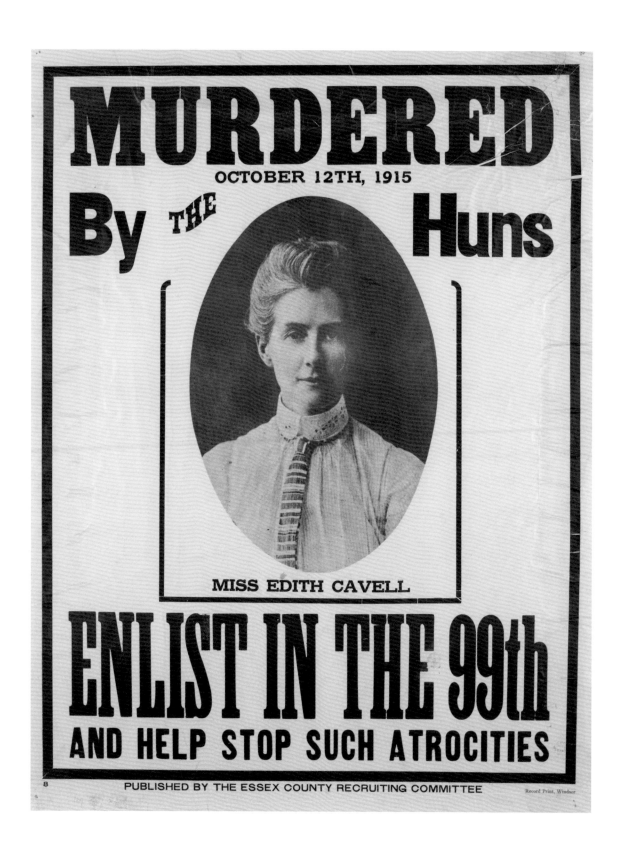

Left: IWM collection

German proclamation announcing the conviction and execution of Edith Cavell, a British nurse and matron of a Belgian Nursing School, Brussels, Belgium, 12 October 1915

Edith Cavell joined the Red Cross at the outbreak of war and continued to work in Brussels, caring for the wounded of both sides, when the city came under German control. She was arrested in August 1915 and charged with aiding the escape of Allied soldiers to neutral Holland. Her execution by firing squad on 12 October 1915 caused an international outcry

Above: IWM collection

British recruiting poster evoking the memory of Edith Cavell, published in Essex, late 1915

Edith Cavell was the subject of much Allied propaganda. Her death was cited as an example of German brutality

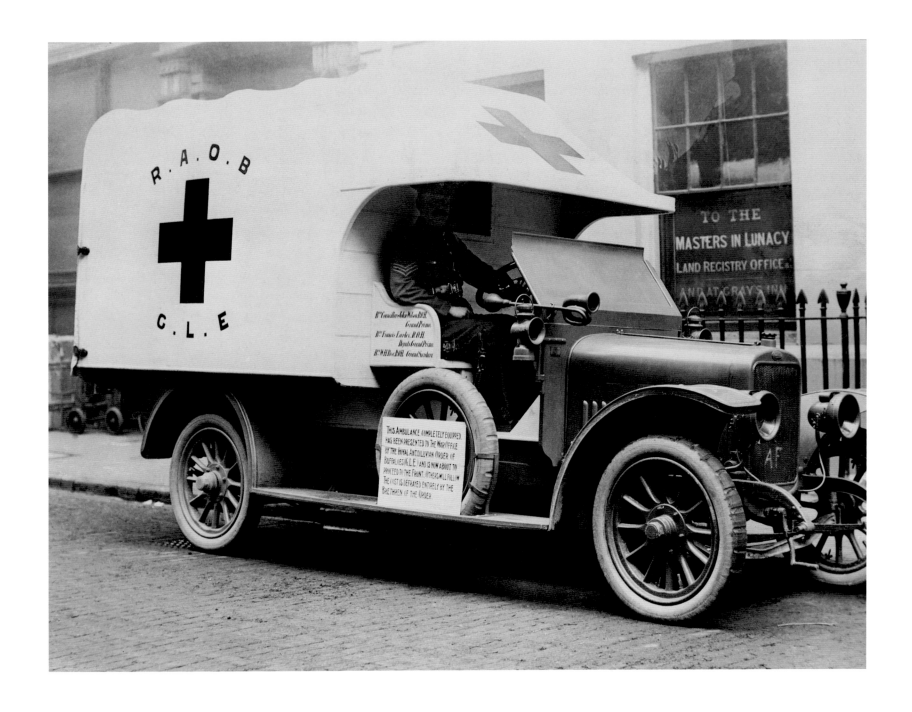

Unknown photographer, Sport & General commercial news agency
The first of six motor ambulances presented to the Red Cross by the Royal Antediluvian
Order of Buffaloes, London, 25 January 1915
The Order of Buffaloes, a British fraternal society, was one of many organisations that
raised funds for ambulances to be sent to the Western Front. Ambulance No. 1 and its
driver, George Pearce, subsequently operated in the Ypres Salient

Above: W. H. EDWARDS, personal photograph
The remains of a London General Omnibus Company bus, Willesden Bus Garage, London, September 1915
The bus was badly damaged during a Zeppelin raid at Norton Folgate, East London, on the night of 8–9 September 1915

Pages 174–5: ARIEL VARGES, Mesopotamian Expeditionary Force photographer
The Taq-I Kisra, also known as the Arch of Ctesiphon, 1917
The monument marked the furthest point of the Allied advance in Mesopotamia (now Iraq) in November 1915. The Allied campaign in Mesopotamia aimed to prevent Ottoman forces securing the region's oil fields. British and Indian forces commanded by Major General Sir Charles Townsend advanced from Basra towards Baghdad, but were blocked by a strong Turkish force at Ctesiphon on 22 November 1915. After two days of battle the Allied forces retreated south towards the city of Kut al Amara

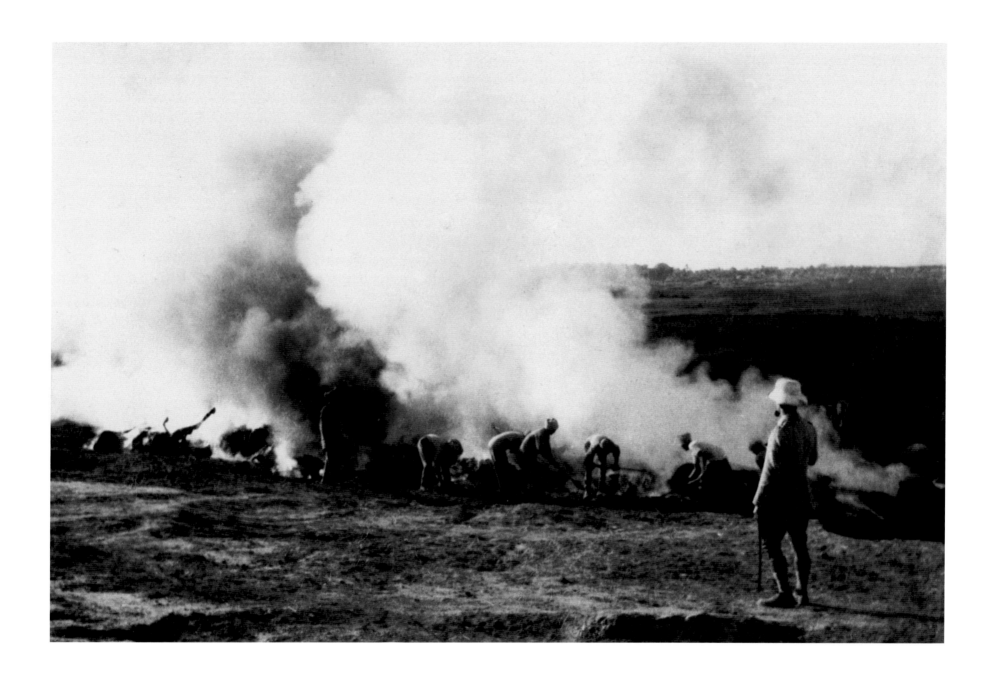

MAJOR A. S. CANE, Royal Army Medical Corps, Mesopotamian Expeditionary Force, personal photograph
British troops destroy surplus animal carcasses during the early stages of the Siege of Kut, Kut al Amara, Mesopotamia, December 1915
The Allied force reached Kut on 3 December and was immediately besieged by Turkish forces. A belief that the siege would be lifted within six weeks meant that little effort was made to conserve supplies at the outset

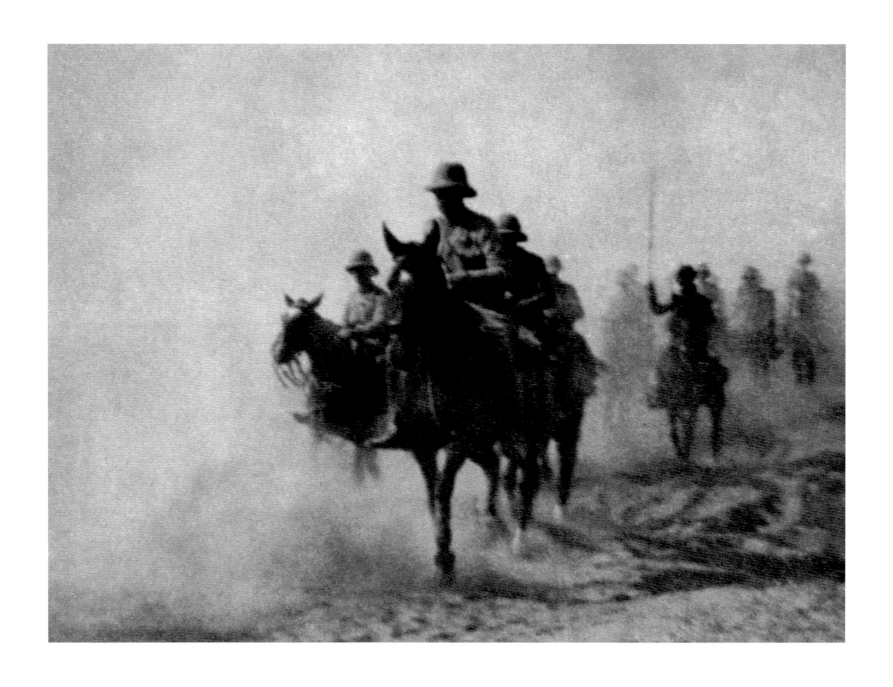

MAJOR A. S. CANE, Royal Army Medical Corps, Mesopotamian Expeditionary Force, personal photograph
Allied forces retreat through the desert towards Kut al Amara, Mesopotamia,
25 November–3 December 1915

Unknown photographer, personal photograph, from the collection of Lieutenant
Colonel Henry F. N. Jourdain, 5th Connaught Rangers, British Salonika Force
View from Allied positions on Kosturino Ridge, Salonika, 30 November 1915
*A Franco-British force landed at Salonika in a belated and ill-fated attempt to support
the Serbian Army in October 1915. They confronted the Bulgarian Army at Kosturino
Ridge on 7 December and were forced to retreat*

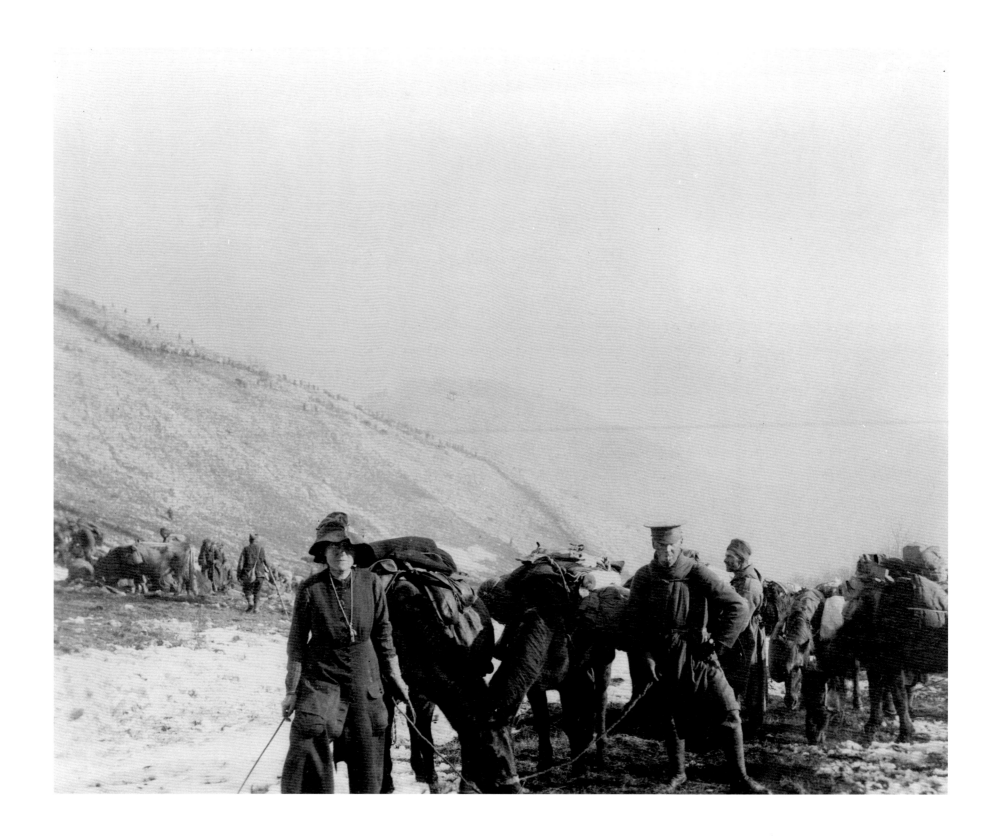

Unknown photographer, personal photograph, from the collection of Mrs St Claire Stobart
Mabel St Clair Stobart, head of the Serbian Relief Fund's Front Line Field Hospital in Serbia, leads her column of medical staff as they accompany the Serbian Army in its retreat through the Albanian mountains, near Roshai, 7 December 1915
The Serbian Army was defeated by Austro-Hungarian, German and Bulgarian forces, resulting in a retreat through the mountains in harsh winter conditions

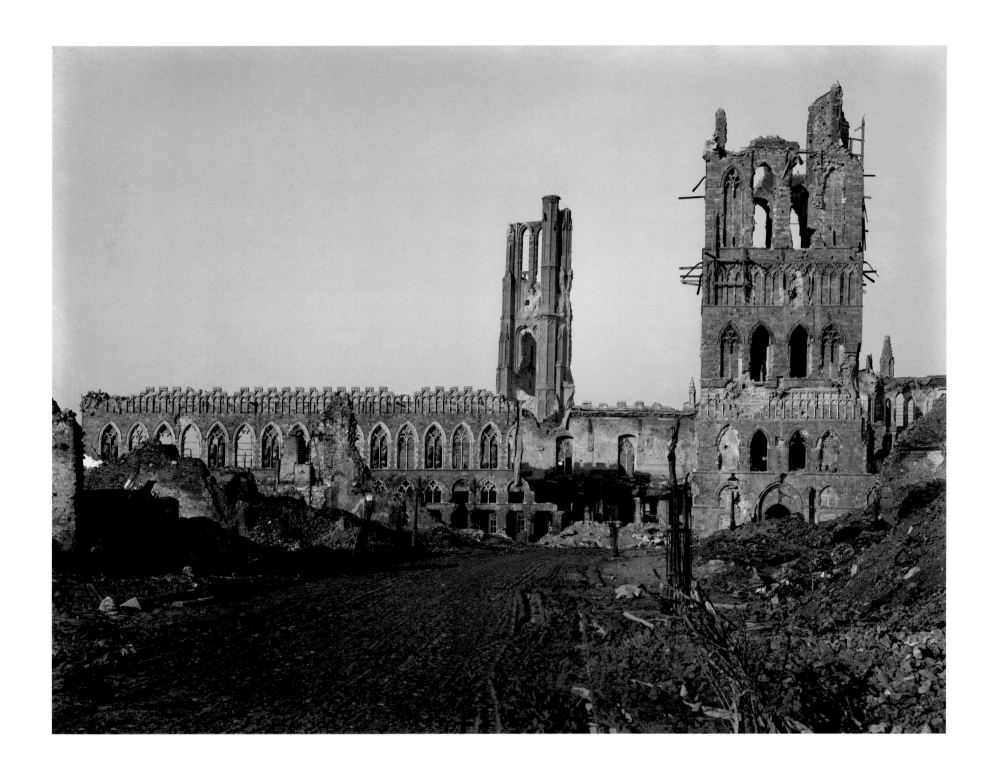

Above and right: Unknown photographer, Royal Engineers
Ruins of the Cloth Hall (Lakenhalle), Ypres, Belgium, 23 January 1916

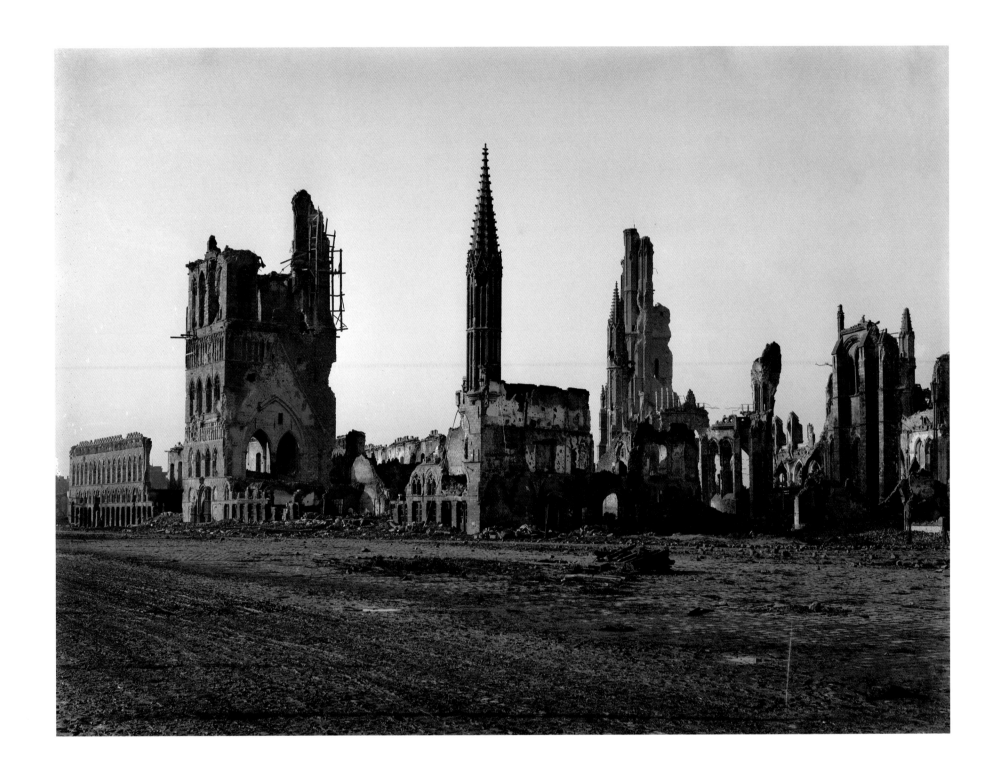

Pages 182–3: ERNEST BROOKS, Admiralty photographer
Stores burn on the beach as the last Allied troops to leave Suvla are evacuated on board HMS *Cornwallis*, 20 December 1915
In November 1915, Field Marshal Lord Kitchener recommended that the campaign in Gallipoli be abandoned. The evacuation was completed on 9 January 1916 in what was regarded as the only successful Allied operation of the whole Dardanelles Campaign

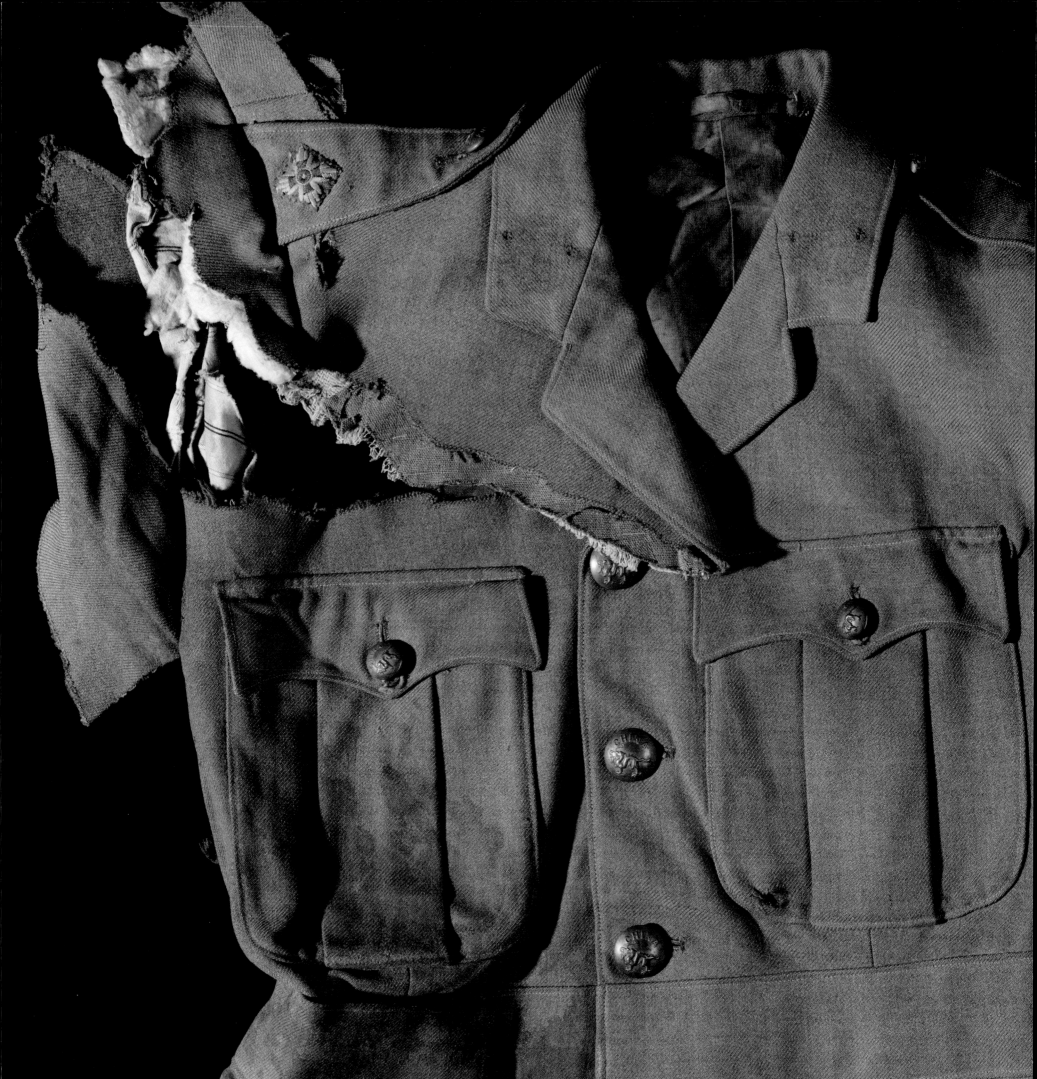

FEBRUARY 1916 – DECEMBER 1916

YEAR	MASS MEDIA AND TECHNOLOGY	WAR PHOTOGRAPHY	WORLD EVENTS
1916 FEBRUARY	• French Cabinet Minister Philippe Berthelot establishes Maison de la Presse to coordinate wartime propaganda, France • Pre-censorship of articles relating to United States introduced, Germany	• Military Section of the Maison de la Presse assumes responsibility for French official photography and film	• 18 February: German forces in Cameroons surrender to British • 21 February–18 December: Battle of Verdun, Western Front
1916 MARCH	• Sgt John Warwick Brooke awarded DCM for repairing phone cables under heavy fire, Western Front	• Ernest Brooks appointed first British Army official photographer, attached to Intelligence Department at GHQ on the Western Front. He is accorded the rank of honorary 2nd Lieutenant • The Royal Navy, deprived of Brooks' services, press for an official photographer to be permanently assigned to them, but are refused. They are granted access to Brooks and Ivor Castle, when they can be spared from the Western Front	• 1 March: Resumption of German U-boat attacks on shipping • 9 March: Germany declares war on Portugal
1916 APRIL	• The Shackleton Expedition takes to open boats after their ship *Endurance* is crushed by ice in Antarctica. Frank Hurley and others await rescue on Elephant Island for four months while Shackleton sails 750 miles to South Georgia in search of rescue	• First Canadian official photographer, Captain Harry Knobel, appointed to the Western Front and takes 650 photographs. Health fails after two months	• 24 April–1 May: Easter Rising, Dublin • 29 April: Siege of Kut ends with surrender of British-Indian garrison, Mesopotamia
1916 MAY	• George Eastman questions a potential ban by the British Government on import of cine film • Admiralty withholds public announcement of Battle of Jutland, but commissions Winston Churchill to write an account for the press, based on written reports, several months later	• Tom Grant (*Daily Mirror*) works as British official photographer in Mesopotamia • American Film Correspondent Company fails due to high expenditure and lack of good frontline footage	• 14 May–10 June: Battle of Asiago, Italian Front • 16 May: Conscription extended to married men, Britain • 21 May: Introduction of Daylight Saving Time to increase factory working hours, Britain • 31 May: Battle of Jutland, North Sea
1916 JUNE		• Bernard Grant (*Daily Mirror*) joins the Royal Naval Air Service as an official photographer	• 4 June–17 August: Brusilov Offensive (Russia's major battle of the war), Eastern Front • 5 June: HMS *Hampshire* sunk. Field Marshal Lord Kitchener, Secretary of State for War, drowned; start of Arab Revolt, Middle East

YEAR	MASS MEDIA AND TECHNOLOGY	WAR PHOTOGRAPHY	WORLD EVENTS
1916 JULY	• Karl Bulla retires, passing management of his St Petersburg photographic agency to sons Viktor & Andrei, Russia. He dies in exile in the 1930s	• Royal Engineers, Ernest Brooks & Geoffrey Malins cover opening day of the Battle of the Somme • John Warwick Brooke (Topical Press) appointed 2nd British official photographer on the Western Front with rank of 2nd Lt (Hon) • *Daily Express* recommends Armando Console as an official photographer. War Propaganda Bureau rejects Console on medical grounds • RFC generate *c.* 19, 000 aerial photographs of the Somme battlefield. 400 RFC aircraft are lost while engaged on aerial photographic missions. First guide to interpretation of aerial photography produced	• 1 July–18 November: Battle of the Somme, Western Front • 7 July: David Lloyd George replaces Lord Kitchener as Secretary of State for War, Britain • 11 July: Germans suspend attacks at Verdun to support action on the Somme, Western Front • 14 July: Battle of Bazentin Ridge, Somme, Western Front • 19 July: Battle of Fromelles, Western Front
1916 AUGUST	• Frank Hurley and others of Shackleton expedition rescued on Whale Island and hear first news of the ongoing war • Newspapers reduced to half of pre-war size due to paper shortage, Germany	• Captain Ivor Castle (*Daily Mirror*) replaces Knobel as Canadian official photographer. Lt Oscar Bovill appointed Canadian official cine cameraman • Indian official photographer Girdwood's film & photographs discovered to comprise large number of 'fake' scenes. They are withheld by censors who are concerned about the 'potential effect on schoolboys', Britain	• Battle of the Somme continues • 4 August: Battle of Romani, Sinai, Middle East, leads to start of Turkish retreat towards Palestine • 6–17 August: Battle of the Isonzo, Italian Front • 27 August: Romania enters war on Allied side but is quickly invaded by the Central Powers, Eastern Front • 28 August: Italy declares war on Germany • 29 August: Field Marshal von Hindenburg replaces von Falkenhayn as German Chief of General Staff. General von Ludendorff appointed Quartermaster General
1916 SEPTEMBER	• Launch of *Vogue* magazine, Britain. Emil O. Hoppé contributes editorial and society portraits to early issues	• RFC School of Aerial Photography, Mapping & Reconnaissance established, Farnborough, Britain	• Battle of the Somme continues • 3 September: First German airship shot down over Britain • 4 September: British forces take Dar-es-Salaam, German East Africa • 15 September: First use of tanks on the Somme, Western Front
1916 OCTOBER	• Kriegspresseamt introduces twice-daily news briefings for journalists, Germany	• British Army Printing and Stationary Service (AP&SS) produces up to 5,000 photographic prints a day, Amiens, France	• Battle of the Somme continues • 5 October: Adolf Hitler wounded, Western Front • 24 October–18 December: Nivelle Offensive at Verdun, Western Front

YEAR	MASS MEDIA AND TECHNOLOGY	WAR PHOTOGRAPHY	WORLD EVENTS
1916 NOVEMBER	• Max Aitken buys *Daily Express* newspaper, Britain. Establishes Canadian War Memorials Fund to support employment of Canadian war artists • Frank Hurley arrives in England from Antarctica • News Division of German Foreign Office launches Militärischen Film – und Fotostelle (Military Film & Photographic Unit) to generate official photography and film using photographic materials supplied by Agfa	• British photographer Herbert Baldwin (Central Press Agency) appointed first Australian official photographer, Western Front • First use of E-Type metal aerial camera, to address focus problems caused by (temperature-change-induced) distortion to wooden camera bodies, by RFC • BEF armies equipped with photographic printing sections	• 7 November: Woodrow Wilson re-elected as President, United States • 13 November: Battle of the Ancre; start of final action on the Somme, Western Front • 19 November: Bad weather ends Battle of the Somme, Western Front; Allied forces liberate Monastir, Serbia
1916 DECEMBER	• Department of Information set up under C. H. Montgomery of the Foreign Office, Britain	• Lt Ernest Brooks protests to War Propaganda Bureau about Canadian official photographer Ivor Castle's staged photographs. Brooks is loaned to Admiralty to cover Grand Fleet during winter lull on Western Front • Sgt George Westmoreland, a professional photographer serving with the Queen's (Royal West Surrey) Regiment, tasked to take official photographs in Palestine • F. J. Mortimer publishes *The Trail of the Huns* in *Photogram*	• 6 December: Fall of Bucharest, Eastern Front • 9 December: Romania signs Armistice with Central Powers, Eastern Front • 7 December: David Lloyd George becomes Prime Minister, Britain • 8 December: General Nivelle replaces Joffre as commander of French armies, Western Front • 12–31 December: German 'Peace Note' and US request for statement of war aims fail to initiate peace negotiations • 19 December: End of Battle of Verdun, Western Front

The year of 1916 was one of change and transition as the major powers absorbed the lessons of failures, including those of Kut, where the surrender of the Anglo-Indian garrison to Turkish forces after a five-month siege delivered a severe blow to British prestige. There was now an acceptance that the war could not be won without victory on the Western Front and that full economic and industrial mobilisation was needed to achieve this.

In Britain, this led to the introduction of conscription, the mobilisation of the civilian workforce, the nationalisation of the munitions industry and, finally, a different government led by David Lloyd George. A new propaganda strategy was initiated, employing war correspondents, photographers, cinematographers and artists on the front line.

The Royal Navy's blockade began to make a serious impact on the lives of German civilians. A German attempt to break the stranglehold culminated in the Battle of Jutland. In the most significant naval action of the war, the Royal Navy retained its supremacy despite suffering heavy losses.

The Allies planned coordinated offensives on all fronts. But they were pre-empted when Germany attempted to destroy the French Army at Verdun. Both sides suffered enormous casualties in one of the longest and most devastating battles of the war.

On the Eastern Front, a huge Russian offensive inflicted a massive defeat on the Austro-Hungarians in Galicia. The latter, weakened by deploying their best troops in an abortive offensive against Italy, could no longer fight without German military support.

Meanwhile, Britain's New Army took to the field with improved personal equipment, weapons and munitions, amidst hopes that a 'Big Push' alongside the French on the River Somme would deliver victory. French engagement at Verdun required British and Empire forces to bear the brunt of the offensive.

The Battle of the Somme opened with a seven-day bombardment intended to destroy the German defences. But the British firepower was too dispersed. The Germans' well-constructed defences survived to inflict terrible casualties on the British on the first day of the battle. Fierce fighting continued for four months, with all sides incurring heavy casualties for little apparent gain. The British deployed a new weapon, the tank, but to minimal effect. As winter approached, and conditions deteriorated, the offensive was finally called off. Victory had proved elusive, but the Germans had been shocked by the industrial warfare of the Somme.

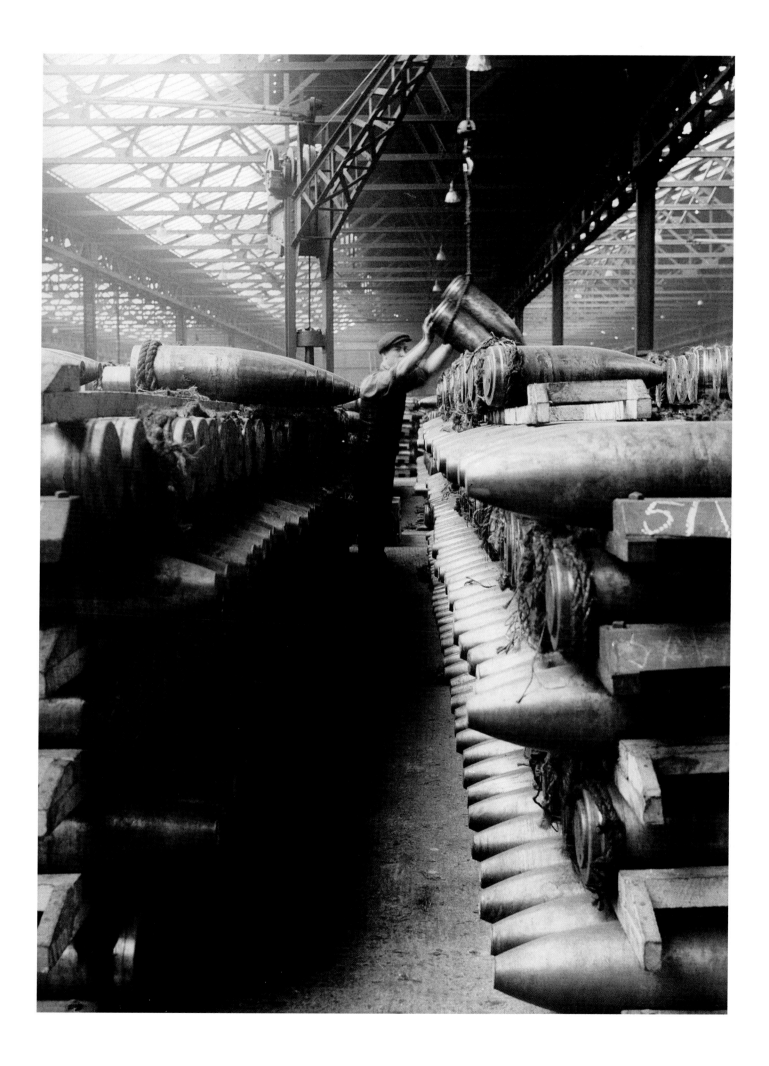

Unknown photographer, Royal Flying Corps
An aerial view of Kut al Amara on the banks of the River Tigris, Mesopotamia (now Iraq), *c.* **1916**
The Siege of Kut lasted 147 days. All efforts to relieve it, including an attempt to supply it from the air, failed. The garrison surrendered on 29 April 1916

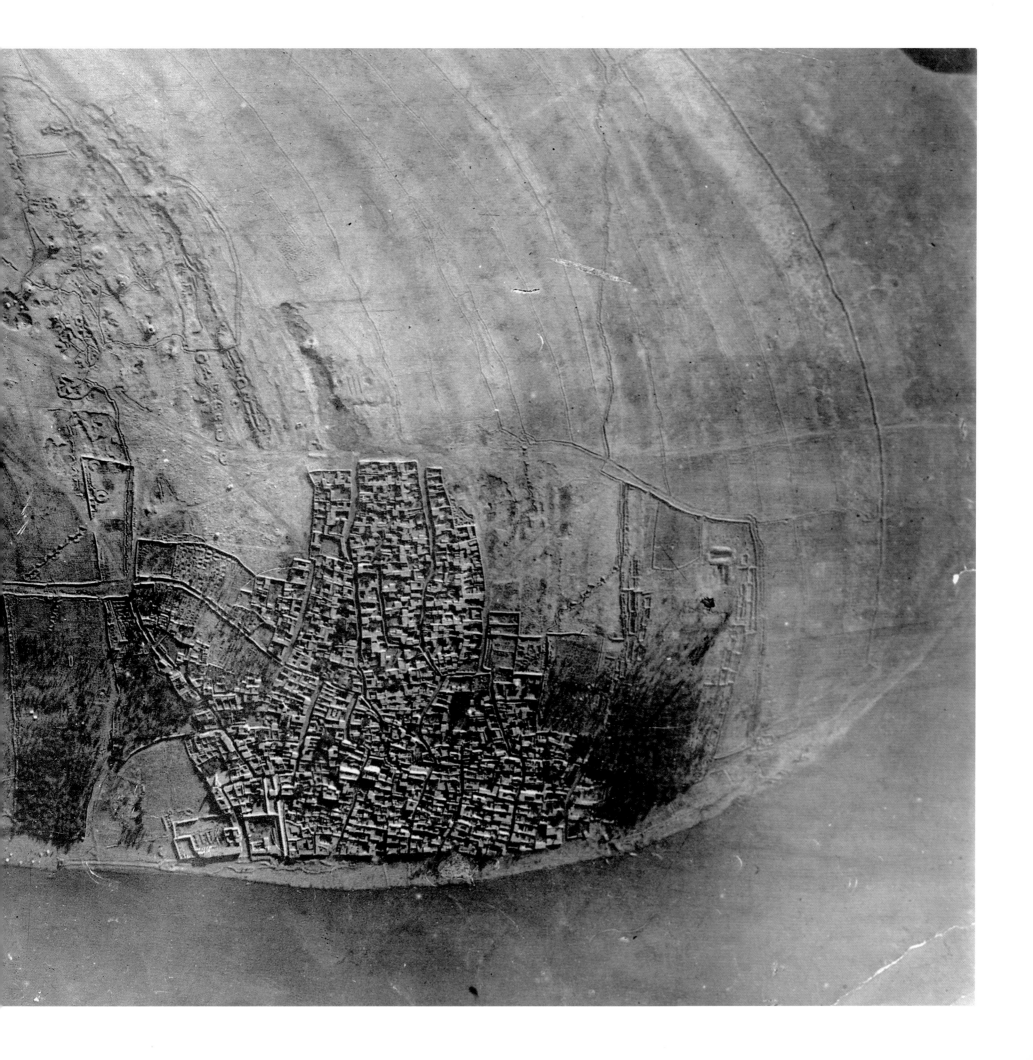

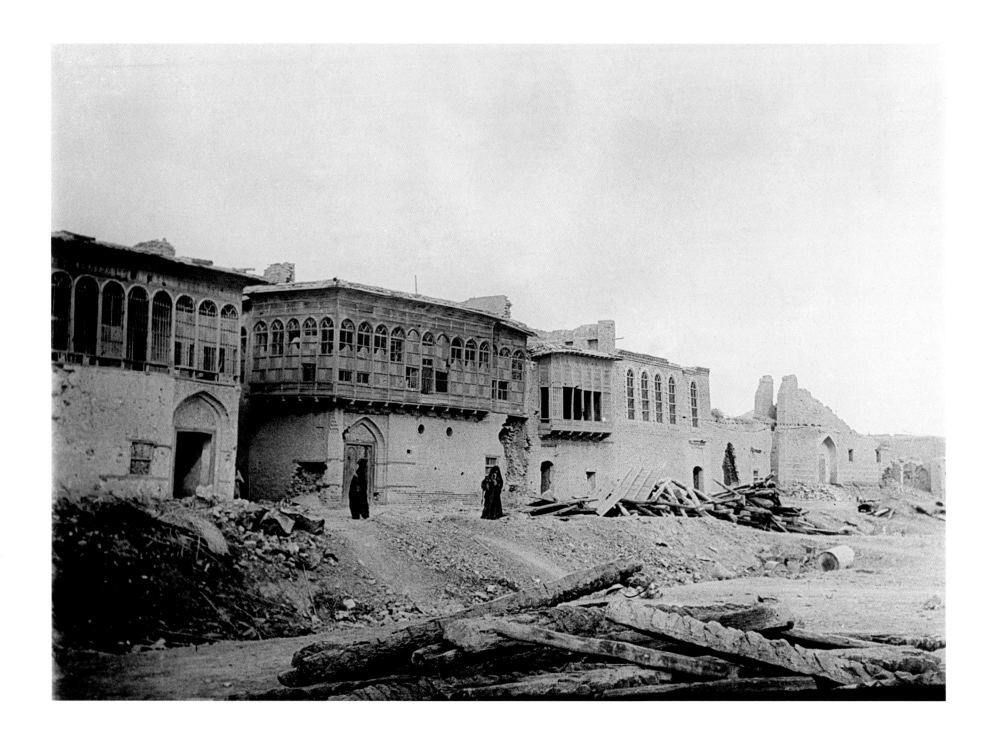

Above: Unknown photographer, personal photograph, from the collection of Captain E. Chard, Mesopotamian Expeditionary Force
The ruins of Kut al Amara, Mesopotamia, 1917

Right: Unknown photographer, personal photograph, from the collection of Lieutenant Roffly, Mesopotamian Expeditionary Force
The ruins of Kut al Amara, Mesopotamia, 1917

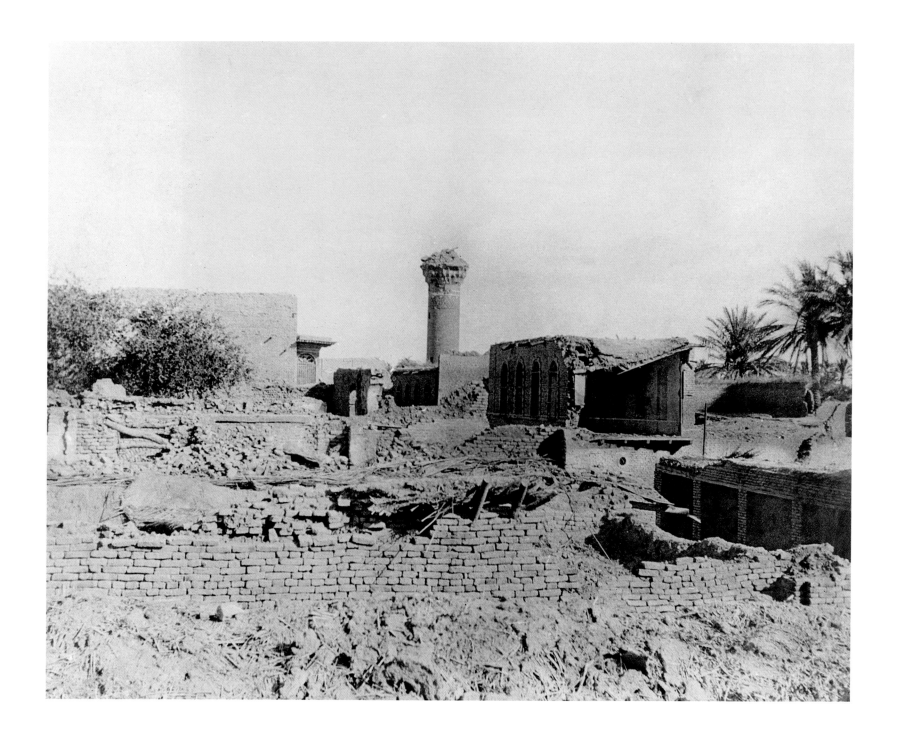

Page 196: Unknown soldier, personal photograph, Mesopotamian Expeditionary Force
A Gurkha mans a Lewis gun in a forward trench, Mesopotamia, 1916

Page 197: Unknown press photographer
An emaciated Indian sepoy who was captured at Kut on 29 April 1916 and then suffered extreme deprivation as a prisoner of war in Anatolia, *c*. July 1916
Indian troops formed two-thirds of the Kut Garrison. Only half survived the siege and subsequent imprisonment

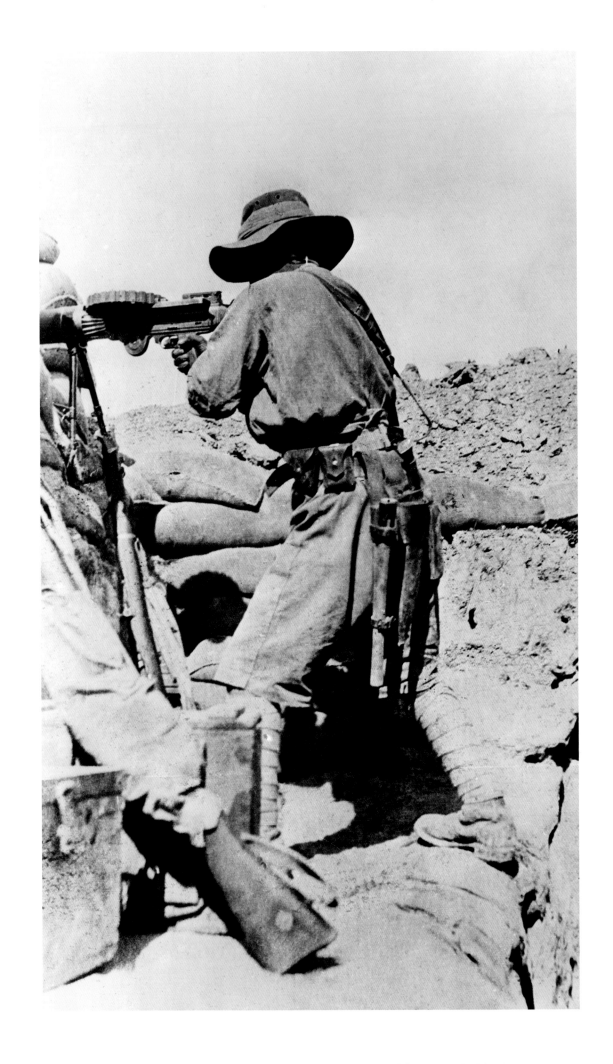

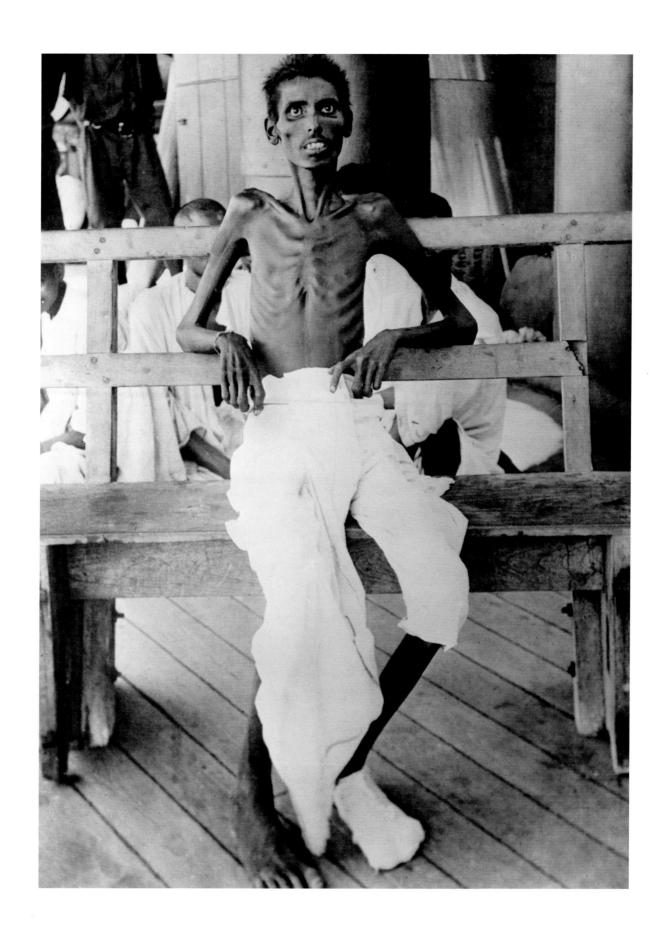

Admiral Sir John Jellicoe, Commander-in-Chief of the Grand Fleet, on board HMS *Iron Duke*, North Sea, 1916

The German High Seas Fleet tried to lure the British Battle Cruiser Fleet, commanded by Vice Admiral Sir David Beatty, into battle in order to break the British blockade of German ports. The strategy misfired when Jellicoe deployed the Grand Fleet in support of Beatty's cruisers

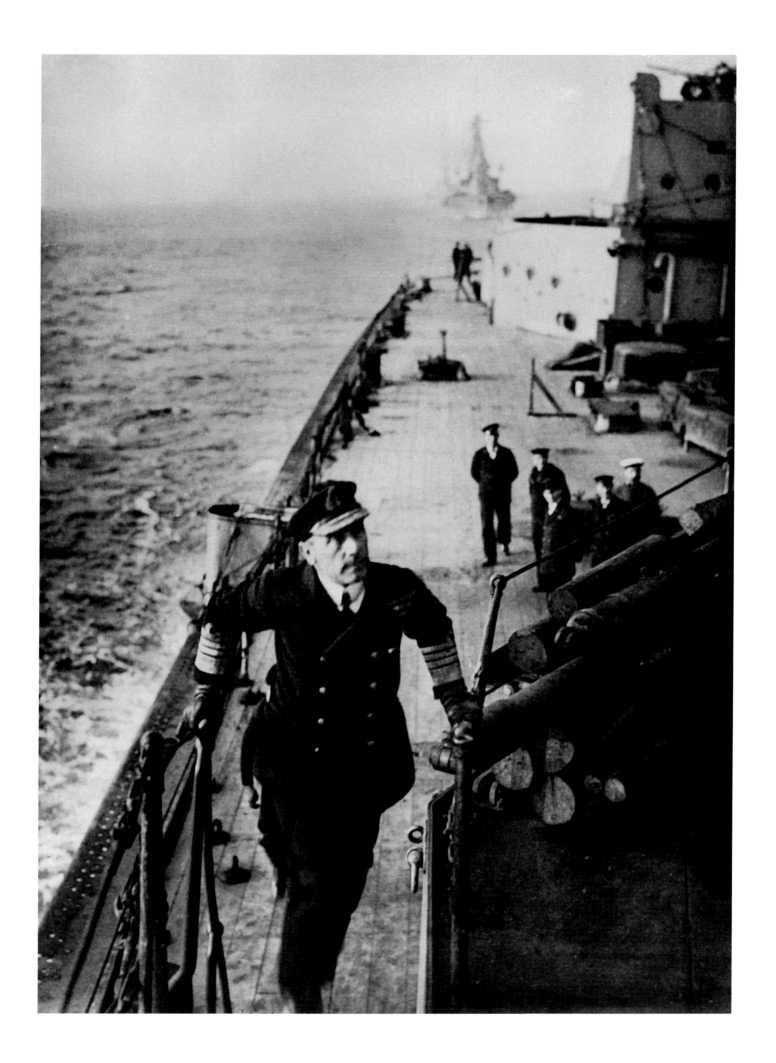

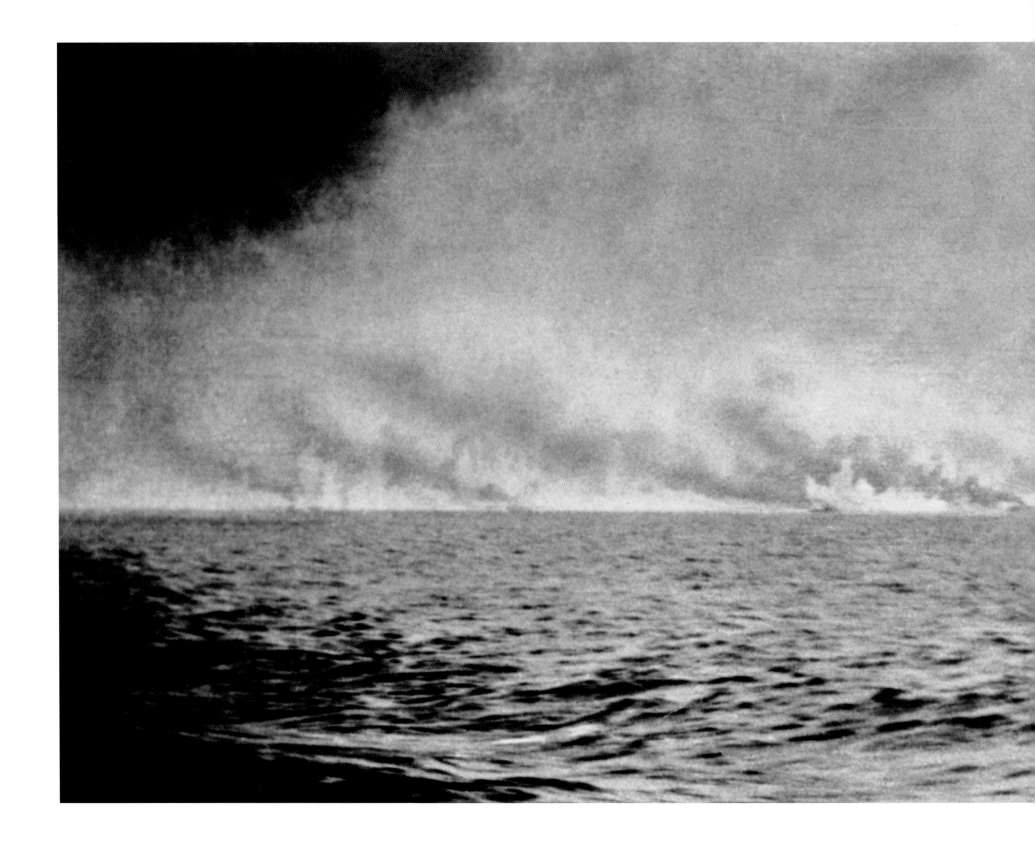

SUB LIEUTENANT ARTHUR DYCE DUCKWORTH, RN, HMS *Birmingham*, British 2nd
Light Cruiser Squadron, personal photograph
**On the horizon ships of Vice Admiral Sir David Beatty's Battle Cruiser Fleet fall into
line and move to action stations on receiving reports of German ships ahead, Battle of
Jutland, North Sea, 31 May 1916**
*The British and German fleets engaged off the Danish peninsula of Jutland in the most
significant naval action of the war. Although the outcome was inconclusive, the Royal
Navy maintained dominance of the North Sea*

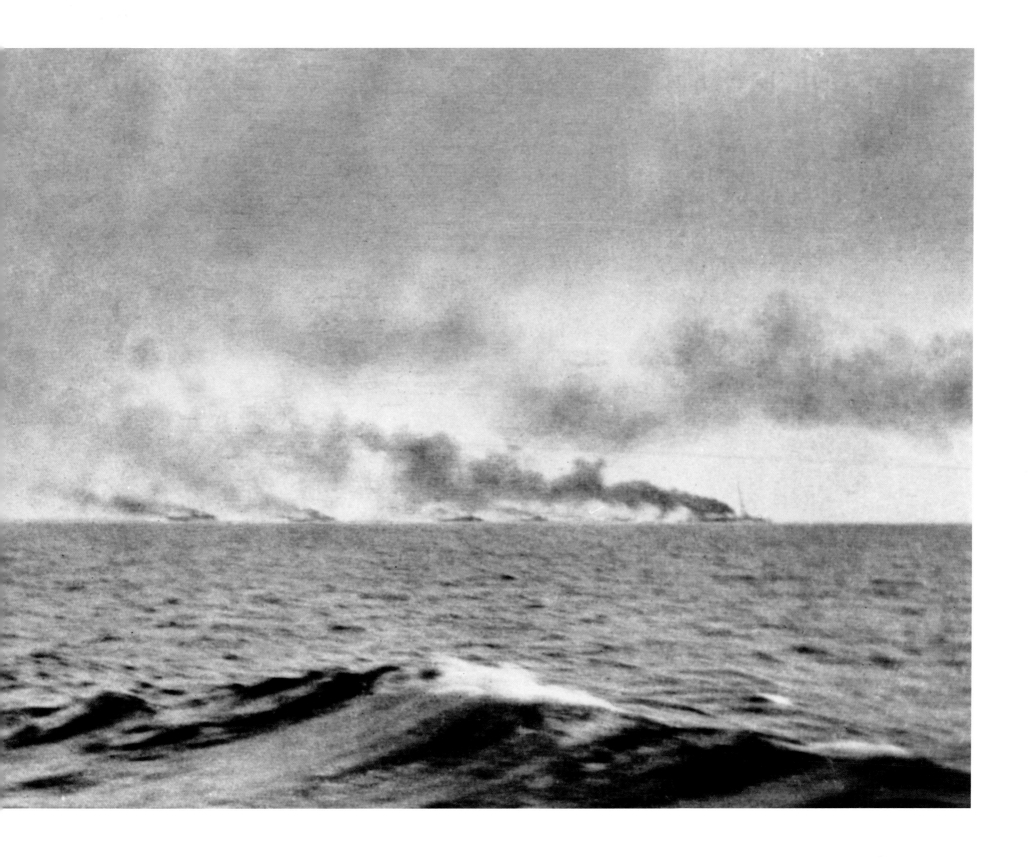

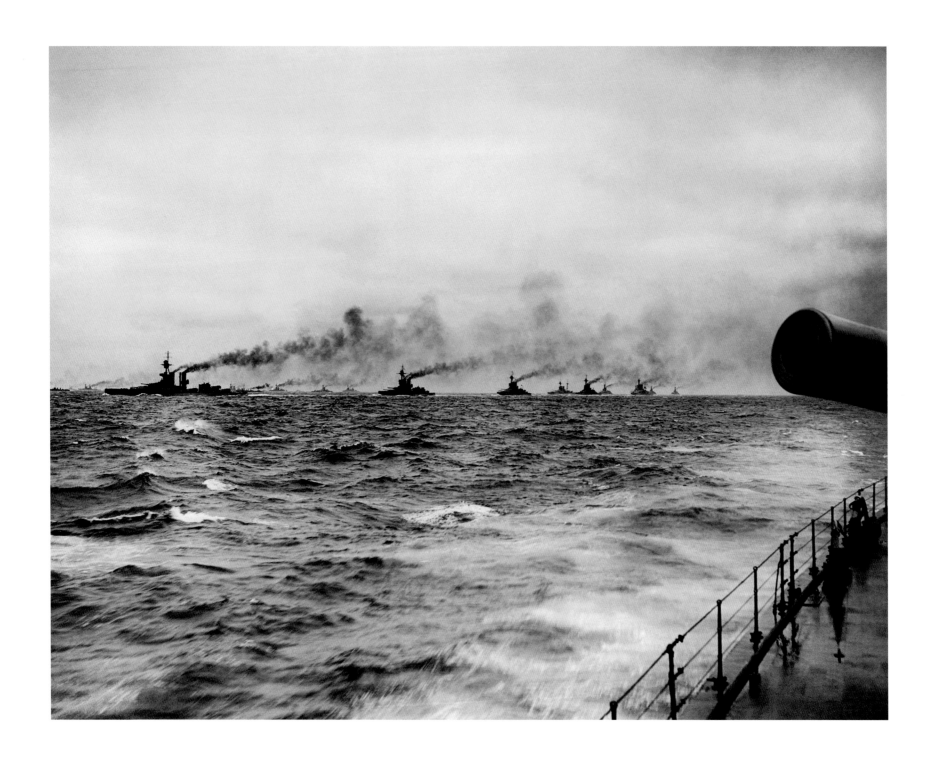

Unknown sailor, British Grand Fleet, personal photograph
**Battleships of the Grand Fleet move to engage the German High Seas Fleet off Jutland,
North Sea, May 1916**
*The photograph became a popular souvenir postcard in wartime Britain, with the title
'Jellicoe's Dash to Jutland'*

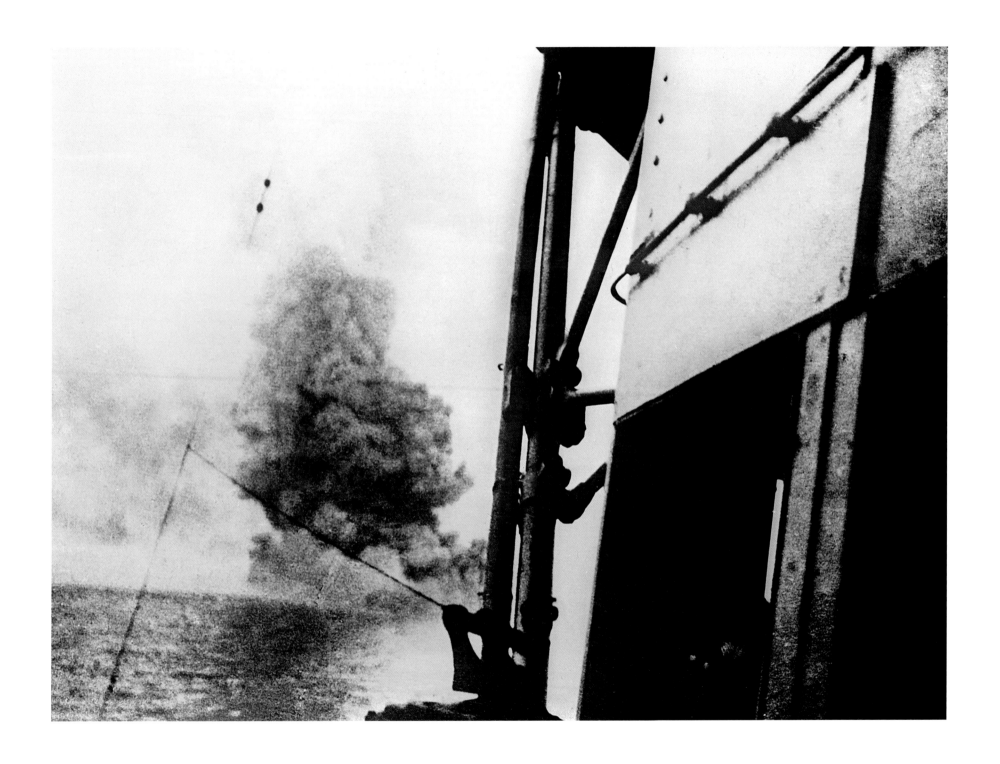

Unknown sailor, HMS *Inflexible*, British Grand Fleet, personal photograph
A magazine explosion destroys HMS *Invincible*, flagship of the 3rd Battle Cruiser Squadron, North Sea, 6.35 p.m., 31 May 1916
HMS Invincible *was struck simultaneously by shells from SMS* Derfflinger *and SMS* Lutzow. *Naval gunnery inflicted huge casualties, particularly on the British fleet*

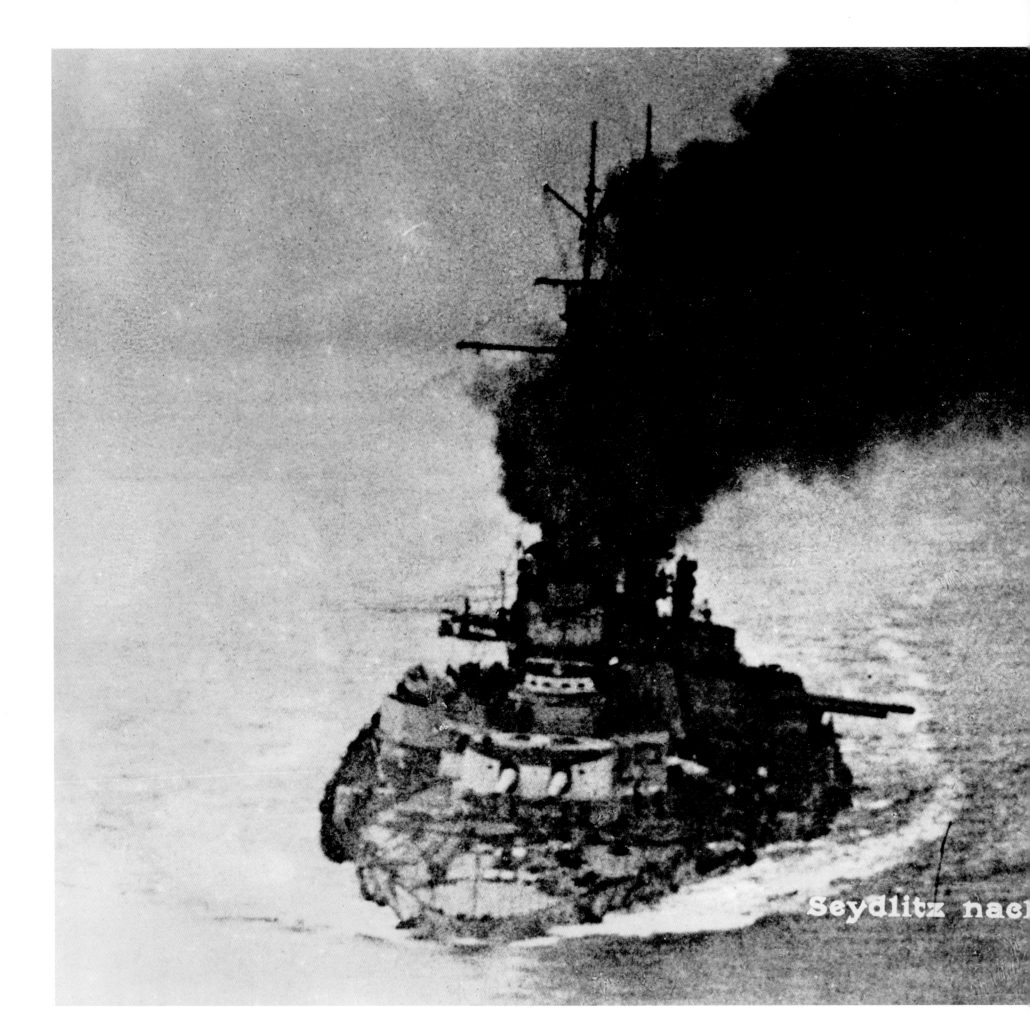

Seydlitz nach

der Skagerrack~Schlacht.

201

Unknown German photographer
An aerial view of the German battle cruiser SMS *Seydlitz*, on fire and taking on water, as she limps to Wilhelmshaven after escaping the battle, North Sea, 1 June 1916
SMS Seydlitz *was hit by twenty-two shells and a torpedo. Of her crew, ninety-eight were killed and fifty-five wounded*

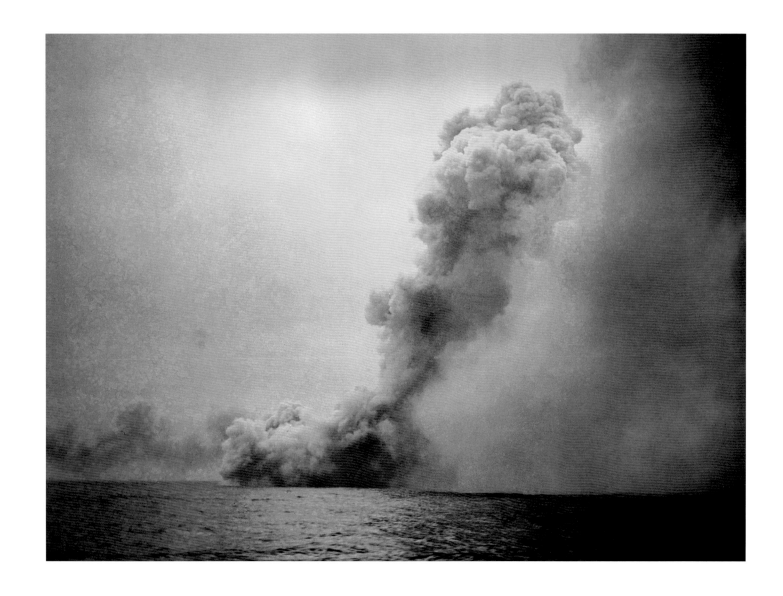

Above: Unknown sailor, HMS *Inflexible*, British Grand Fleet, personal photograph
HMS *Queen Mary*, a Royal Navy battle cruiser, is destroyed by a magazine explosion
after being struck by two shells from SMS *Derfflinger*, North Sea, 4.26 p.m., 31 May 1916
The explosion killed all but seven of the crew of 1,273

Right: Unknown sailor, HMS *Benbow*, British Grand Fleet, personal photograph
Destroyer HMS *Badger* searches for survivors from HMS *Invincible*, North Sea,
31 May 1916
The explosion on HMS Invincible killed all but six of the crew of 1,025, including
Rear Admiral Sir Horace Hood, Commander of 3rd Battle Cruiser Squadron

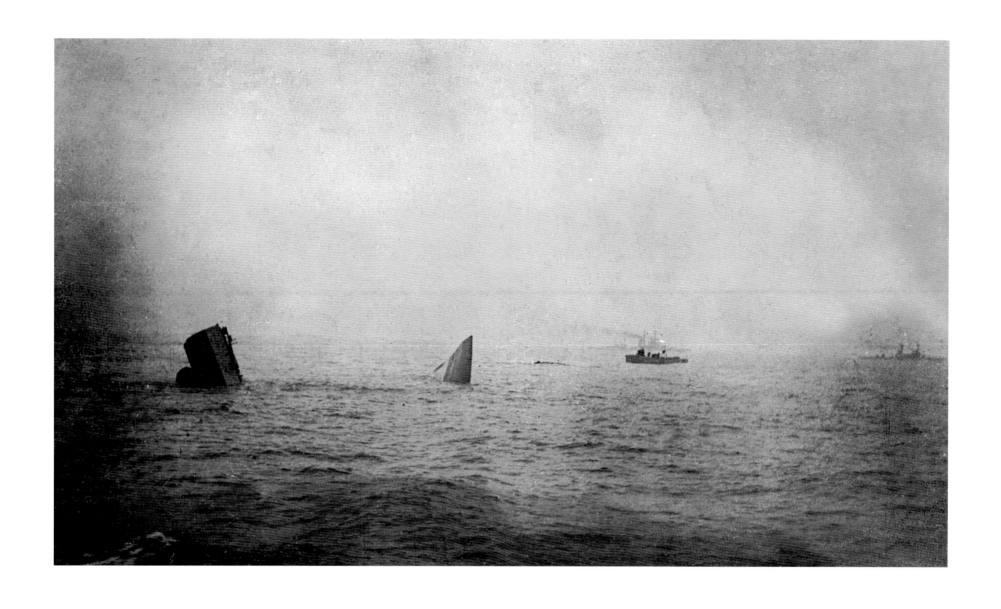

A shell hole in the side of the light cruiser HMS *Chester*, sustained during the Battle of Jutland and photographed after the ship returned to port, Grimsby, June 1916
HMS Chester was hit by seventeen shells. Twenty-nine of her crew were killed and forty-nine wounded. Some lost legs, due to poorly designed gun shields

Damage to the deck of HMS *Chester*, sustained during the Battle of Jutland and photographed after the ship returned to port, Grimsby, June 1916
The casualties included Boy (1st Class) Jack Travers Cornwell, who was posthumously awarded the Victoria Cross for remaining at his post on the ship's forward gun. The position was hit four times, killing all but Cornwell, who died of his wounds in Grimsby on 2 June 1916, aged fifteen

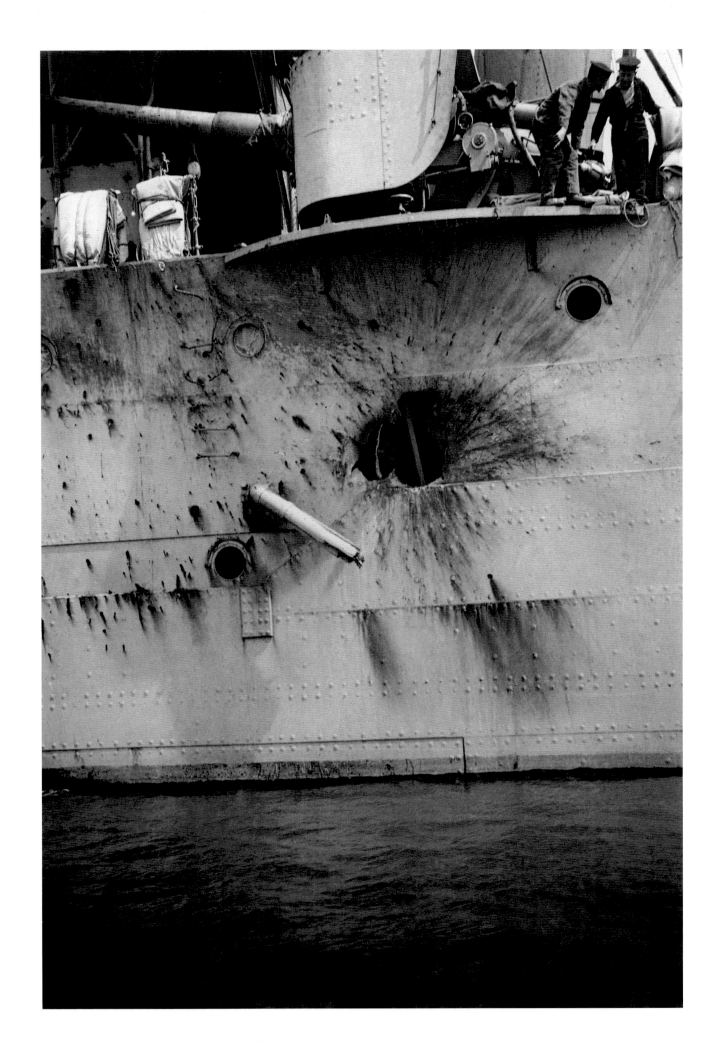

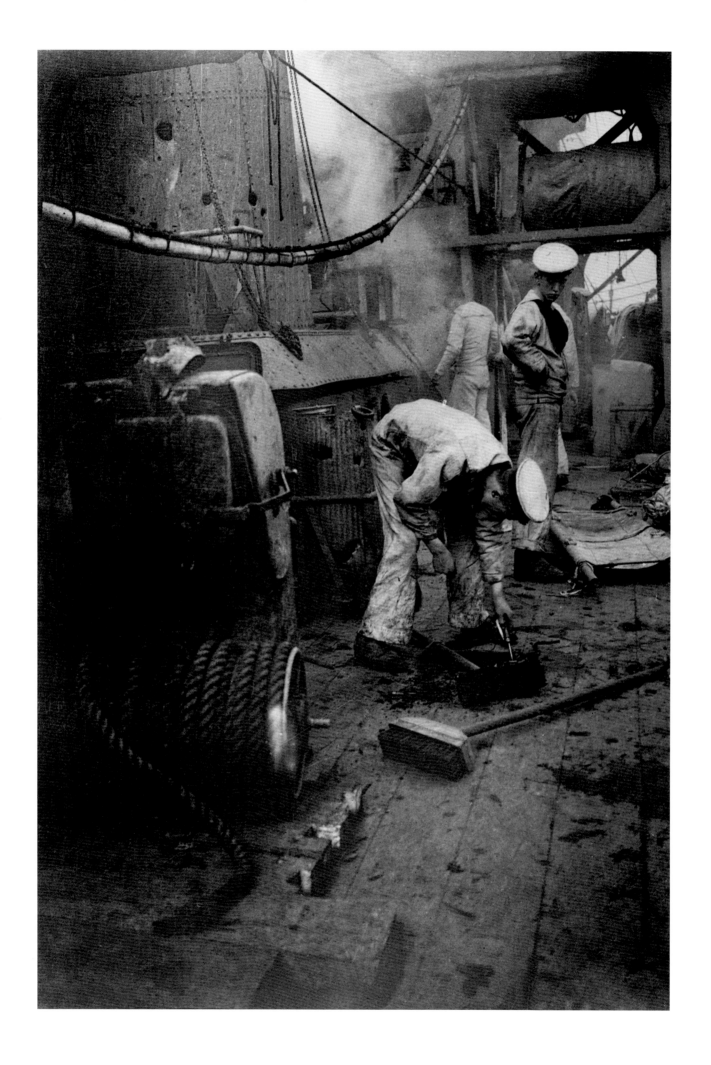

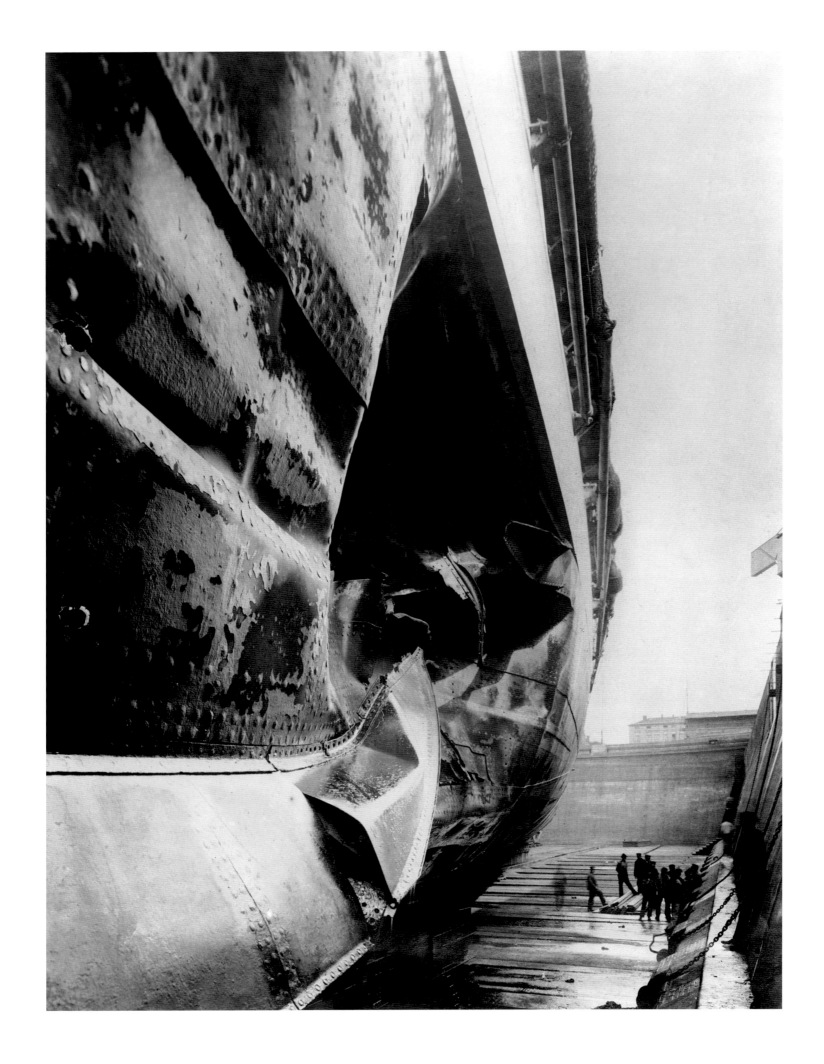

Bruchstücke der 38 cm Pzgr. Bdz. mit Schwarzpulverfüllung von Treffer 3
zum Vergleich 28 cm Pzgr. S.M.S. „Seydlitz".

Left: Unknown photographer, Imperial German Navy
Damage to the German battleship SMS *Ostfriesland*, sustained when she hit a mine leaving the Battle of Jutland, Wilhelmshaven, Germany, 3 June 1916

Above: Unknown photographer, Imperial German Navy
A display, comprising British shell fragments and a shell that failed to explode, on the quarterdeck of SMS *Seydlitz*, Wilhelmshaven, Germany, 3 June 1916

VERDUN WAS THE LONGEST BATTLE OF THE WAR. IT LASTED 298 DAYS.

AT LEAST 1,140,000 FRENCH SOLDIERS AND 1,250,000 GERMAN SOLDIERS
SERVED IN THE BATTLE.

THE GERMANS BROUGHT 2,500,000 SHELLS TO THE BATTLE ON 1,300 TRAINS.

IT IS ESTIMATED THAT THERE WERE 550,00 FRENCH CASUALTIES AND 434,000
GERMAN CASUALTIES. AT LEAST A THIRD OF ALL THESE WERE FATALITIES.

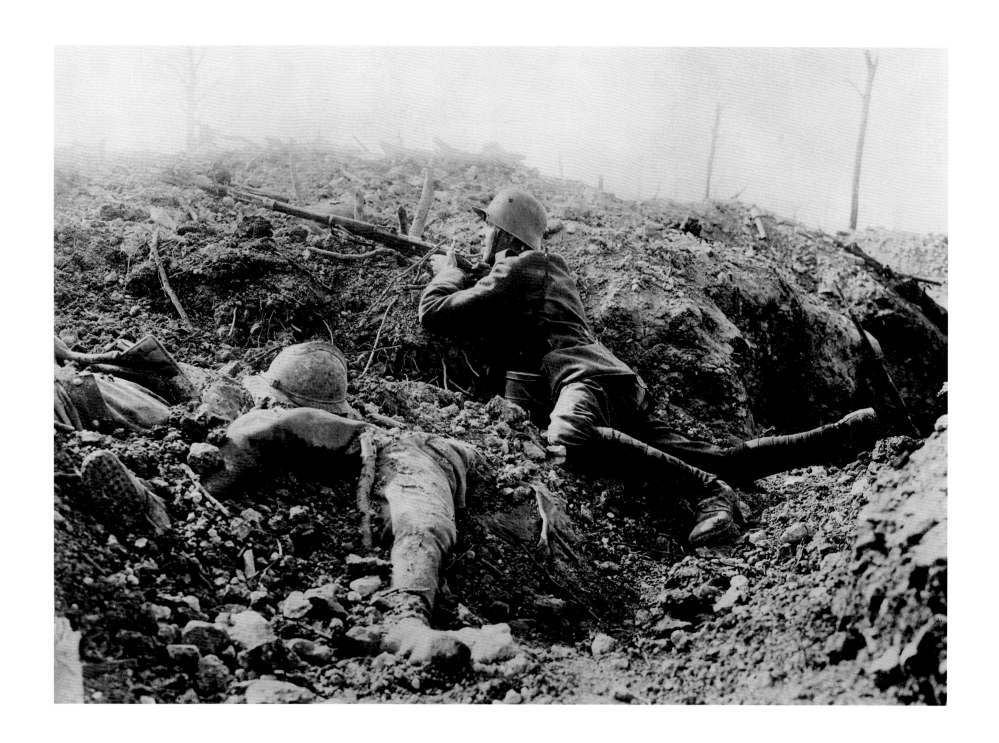

Unknown photographer, Imperial German Army
A posed propaganda photograph showing a German soldier guarding a shallow trench
near the remains of a French soldier, Fort Vaux, Verdun, France, 1916
The Imperial German Army attacked the French stronghold of Verdun on 21 February
1916 in an attempt to weaken the French and break a deadlock on the Western Front.
Fort Vaux was one of a series of heavily defended French forts on the Verdun Front. Two
months of bitter fighting ended when the Germans captured Fort Vaux on 7 July 1916

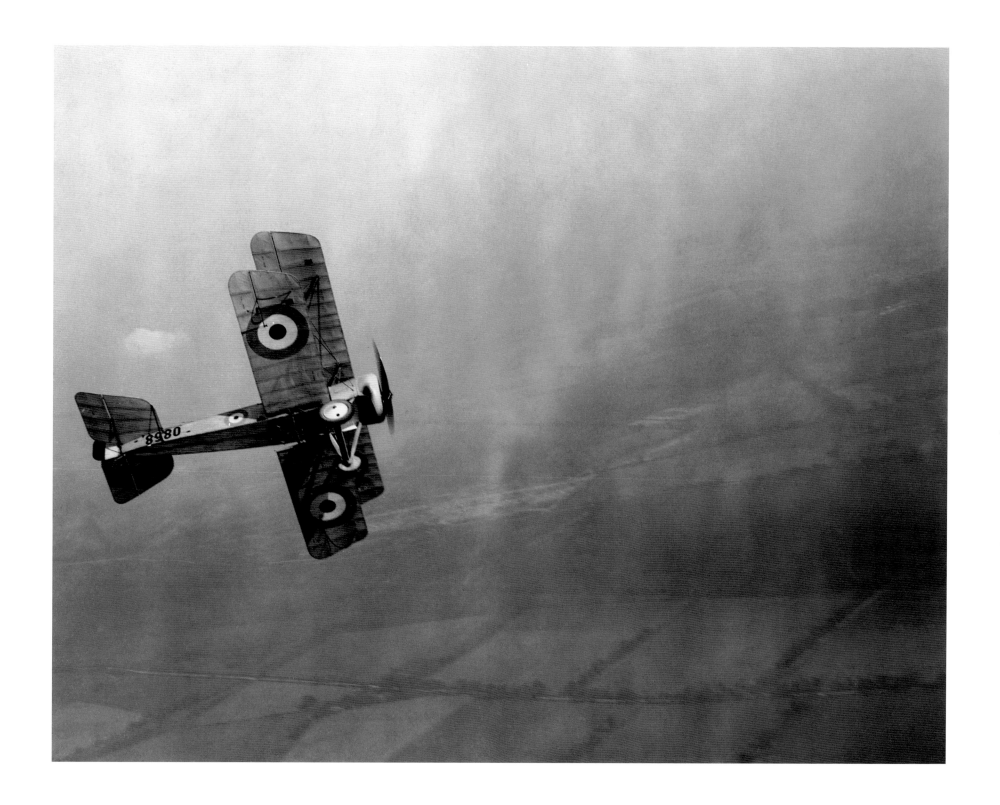

CHIEF PETTY OFFICER A. BLACKWELL, Royal Naval Air Service
**A Royal Naval Air Service Bristol Scout D during a reconnaissance mission over the
Western Front, February 1916**
*The Bristol Scout was one of the first British single-seater fighter aircraft, developed
primarily for scouting. It was fast and manoeuvrable. This aircraft was based on
HMS* Vindex, *a Royal Navy seaplane carrier operating in the North Sea*

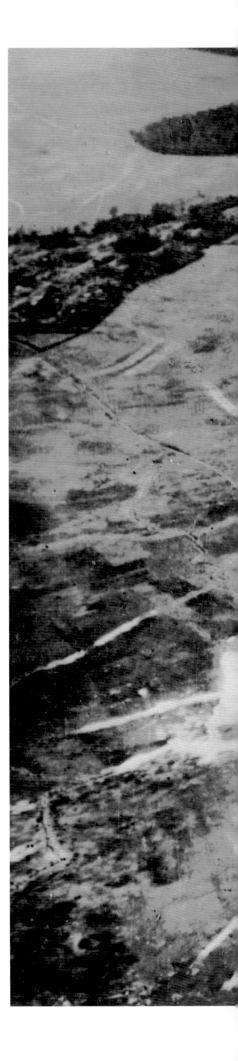

Unknown photographer, Royal Flying Corps
A rare aerial photograph of a British gas attack in progress between Carnoy and Montauban, France, shortly before the Somme Offensive, June 1916
The use of poison gas was well established on the Western Front by mid-1916

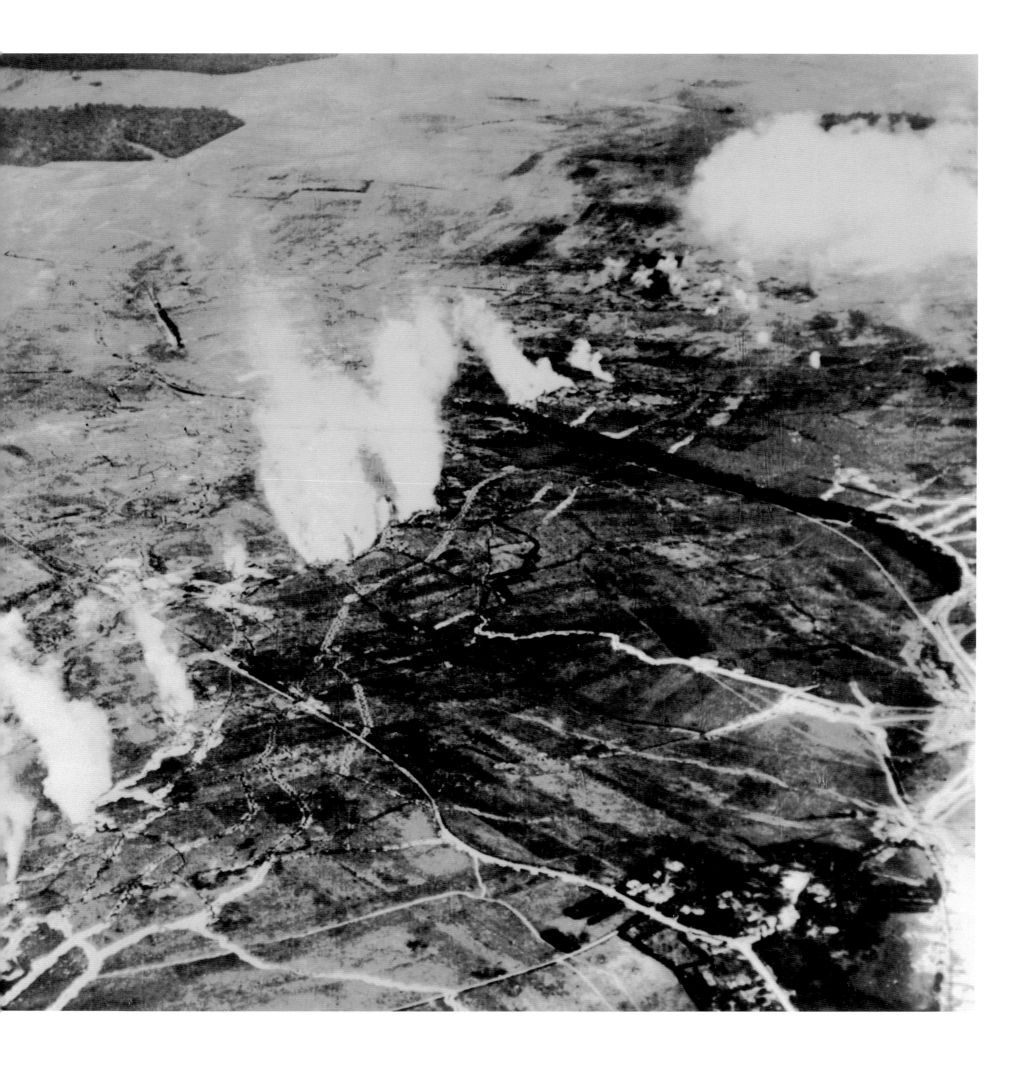

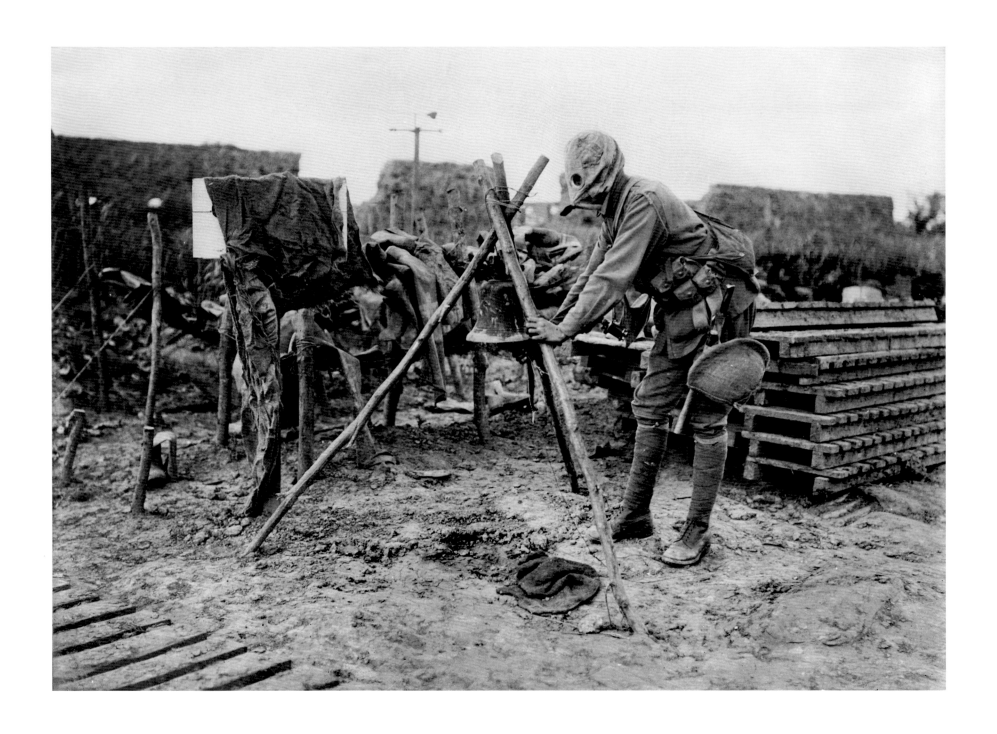

LIEUTENANT ERNEST BROOKS, British Army photographer
A gas sentry sounds the alarm, Fleurbaix, France, June 1916
Defences against gas attacks were rudimentary, but evolving

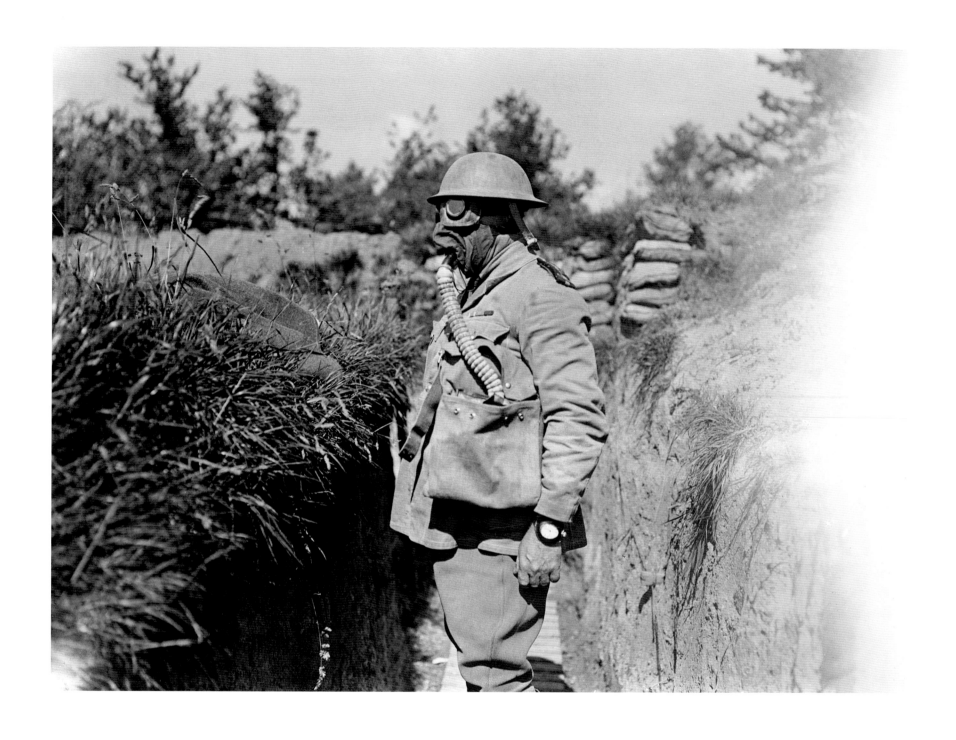

LIEUTENANT ERNEST BROOKS, British Army photographer
**An Australian Army Chaplain, possibly Walter Dexter, wears a box respirator in the
line, Fleurbaix, France, June 1916**

LIEUTENANT W. IVOR CASTLE, Canadian Army photographer
**A statue of the Madonna at a precarious angle on top of the Basilica of Notre-Dame
de Brebières, Albert, Somme, France, October 1916**
*The statue, designed by Albert Roze, slumped when it was hit by a German shell on
15 January 1915. 'The Leaning Virgin' became a familiar landmark, a target and the
subject of superstition for soldiers serving on the Somme. It was demolished in 1918*

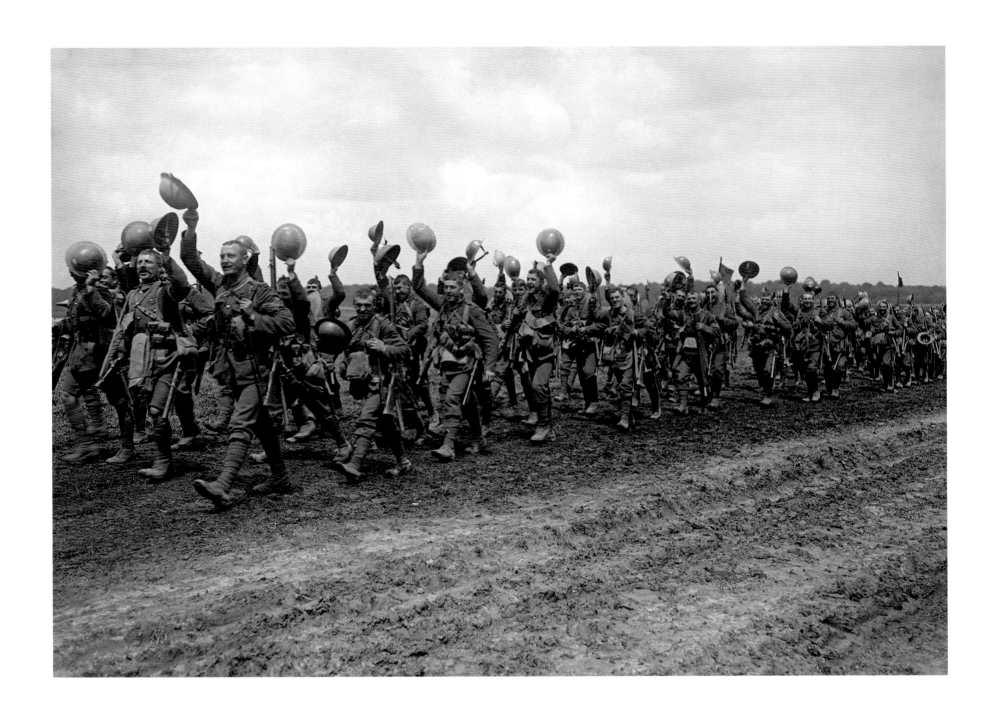

LIEUTENANT ERNEST BROOKS, British Army photographer
**Men of 4th Worcestershire Regiment wave newly issued steel helmets for the photographer
on their way to the trenches, Acheux, Somme, France, 28 June 1916**
*The Somme Offensive, a series of battles in a previously relatively undisturbed sector of the
Western Front, was intended to break the stalemate of trench warfare. As the French
were engaged at Verdun, British and Empire troops bore the brunt of the fighting*

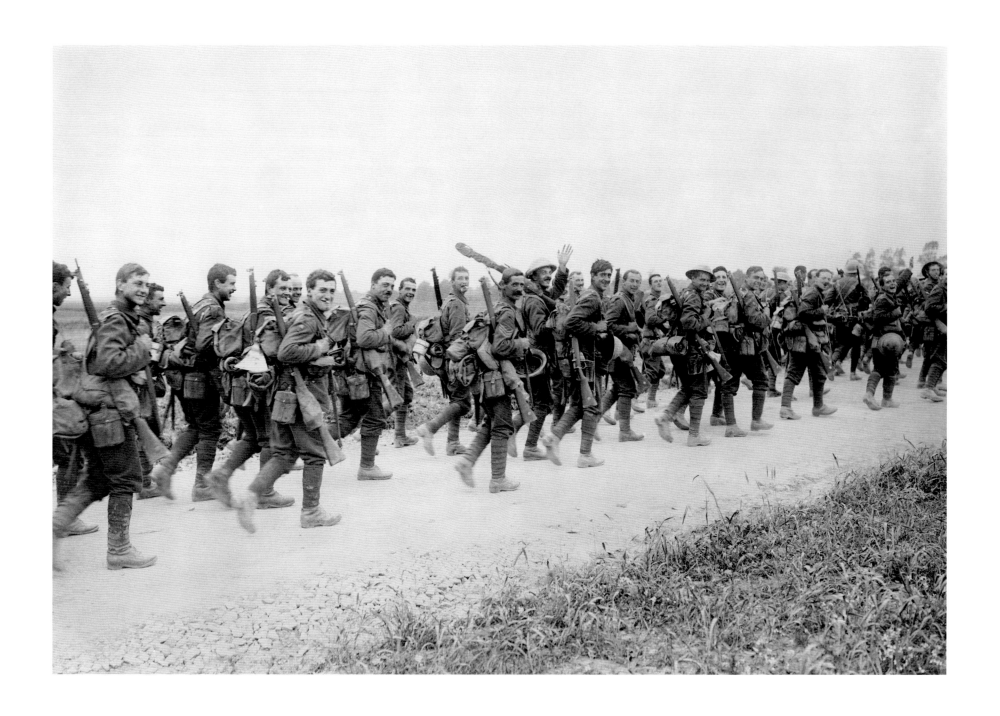

LIEUTENANT ERNEST BROOKS, British Army photographer
A 'Pals' Battalion', 10th (Hull Commercials) East Yorkshire Regiment, marches to the trenches, near Doullens, Somme, France, 3 July 1916
The Somme was the New Army's first major offensive and the most costly. Many 'Pals' Battalions' were decimated, with lasting consequences for their communities at home

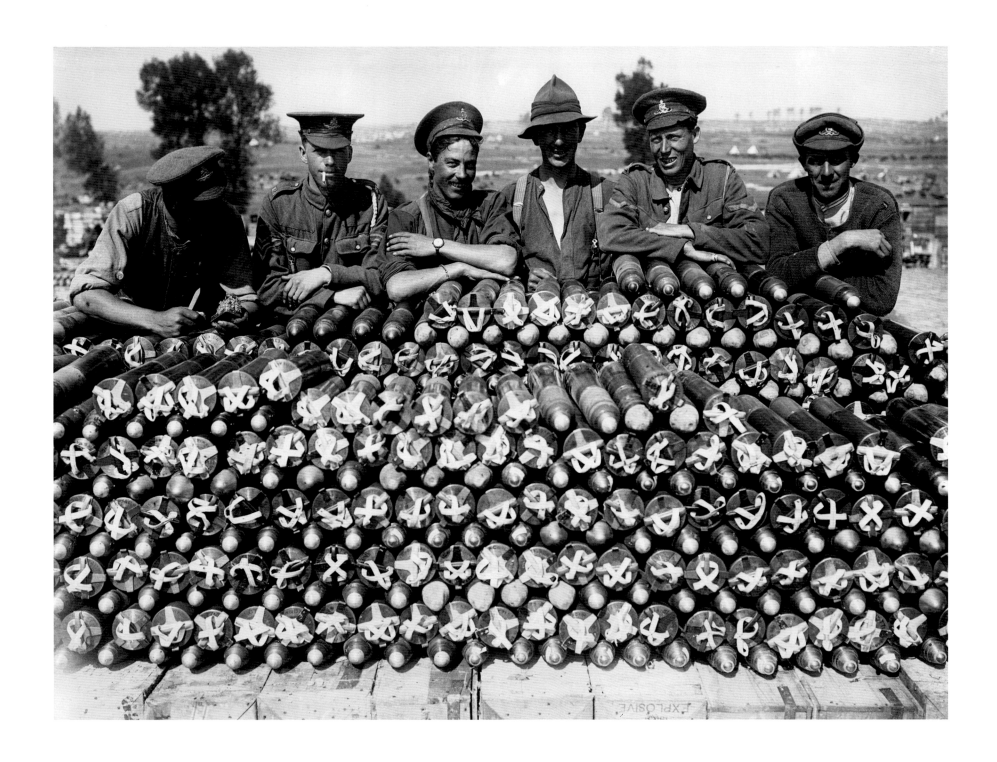

LIEUTENANT ERNEST BROOKS, British Army photographer
Soldiers display a stack of 18-pounder shells in a shell dump near Becourt Wood, near Albert, Somme, France, September 1916
Ernest Brooks, now a British Army official photographer on the Western Front with the rank of Lieutenant, was ordered to document the vast stockpiles of munitions in a campaign to alleviate public concern over shell shortages

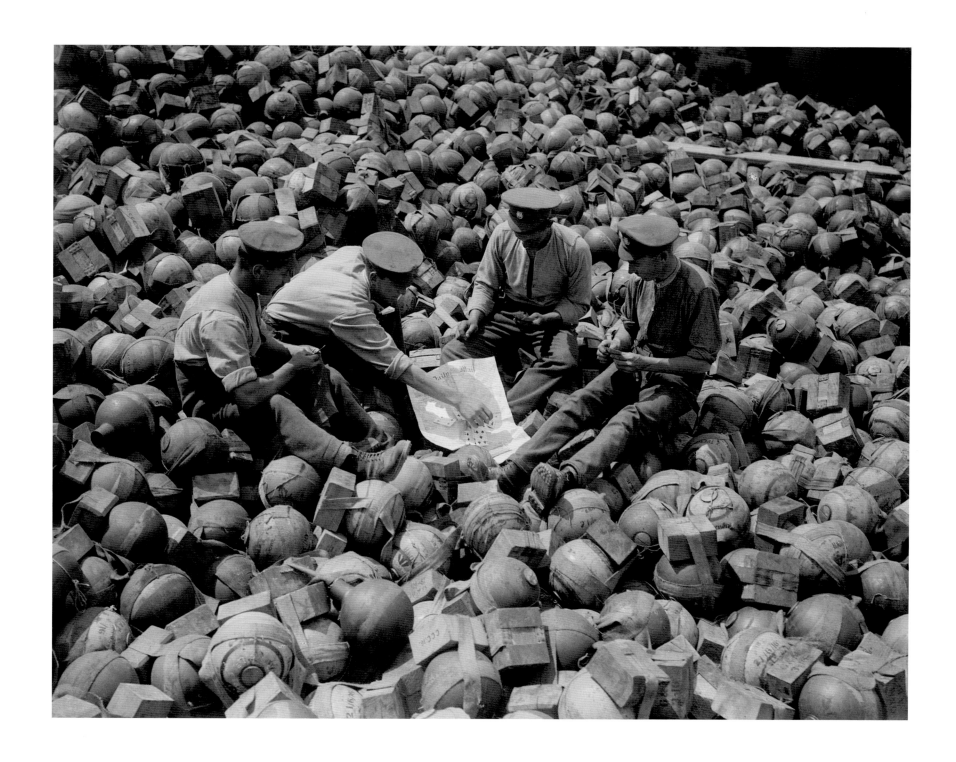

LIEUTENANT ERNEST BROOKS, British Army photographer
Men of the Royal Army Ordnance Corps play cards on top of a stockpile of trench
mortar shells (also known as 'Toffee Apples'), Acheux, Somme, France, July 1916

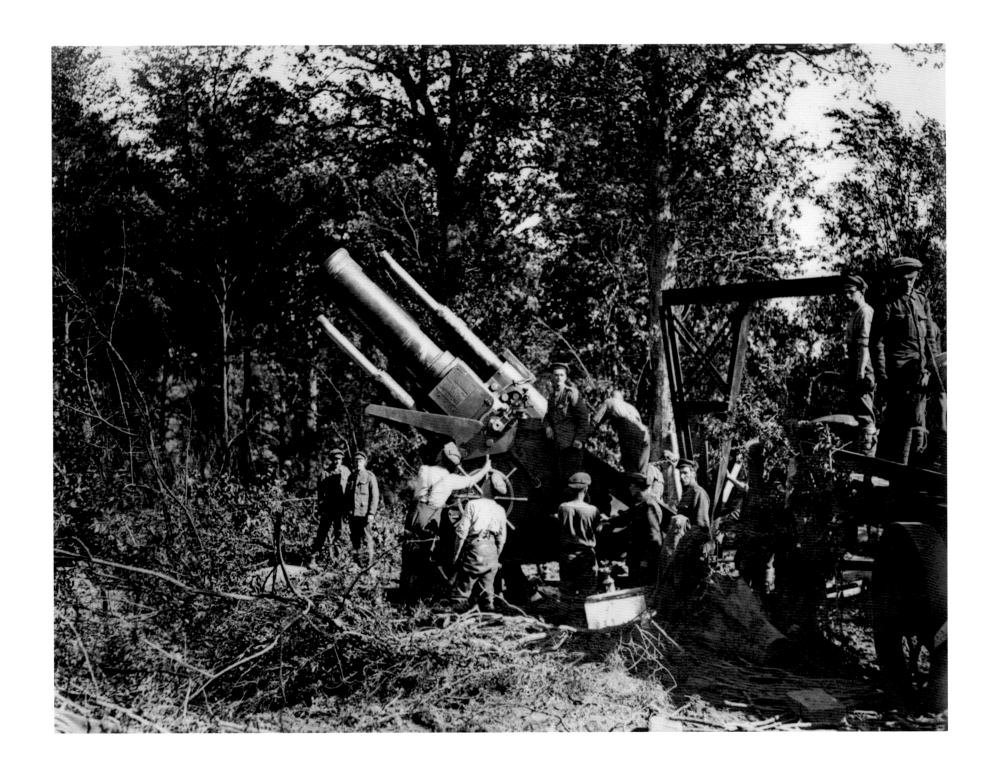

Unknown photographer, Royal Engineers No. 1 Printing Company, British Army
**A British 15-inch howitzer is elevated for firing at the start of the battle, Albert,
Somme, France, 1 July 1916**
*British artillery mounted an unprecedented bombardment to eliminate German
frontline defences, including the barbed-wire obstacles in No Man's Land*

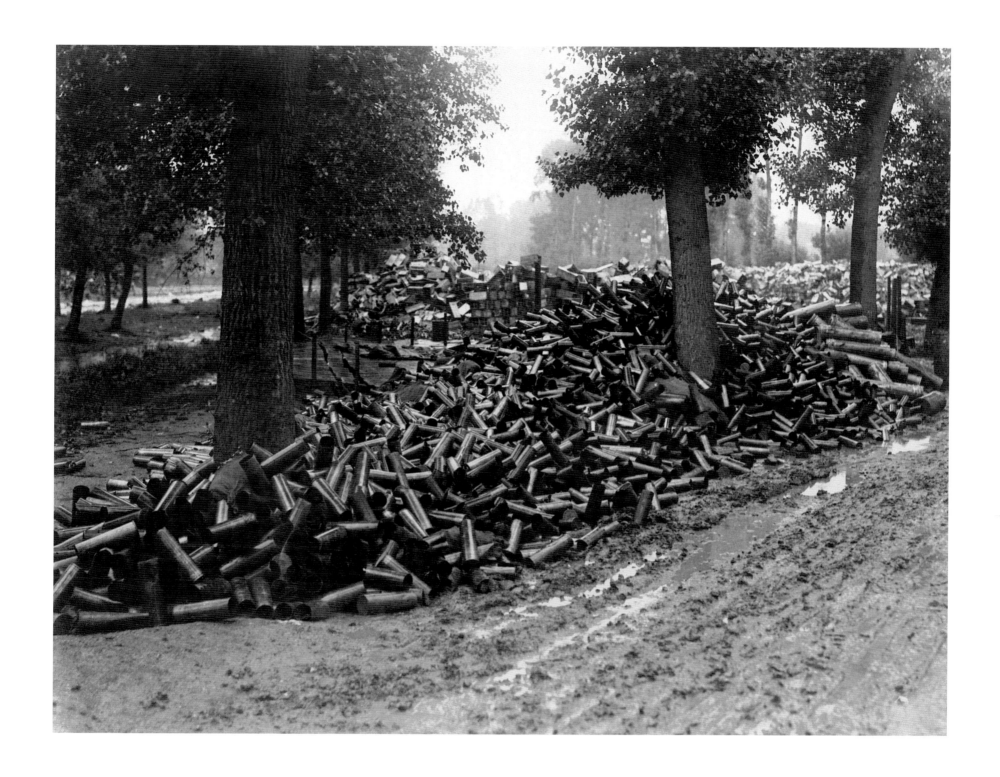

Unknown photographer, Royal Engineers No. 1 Printing Company, British Army
**Empty 18-pounder shell cases expended during the bombardment, Fricourt, Somme,
France, July 1916**

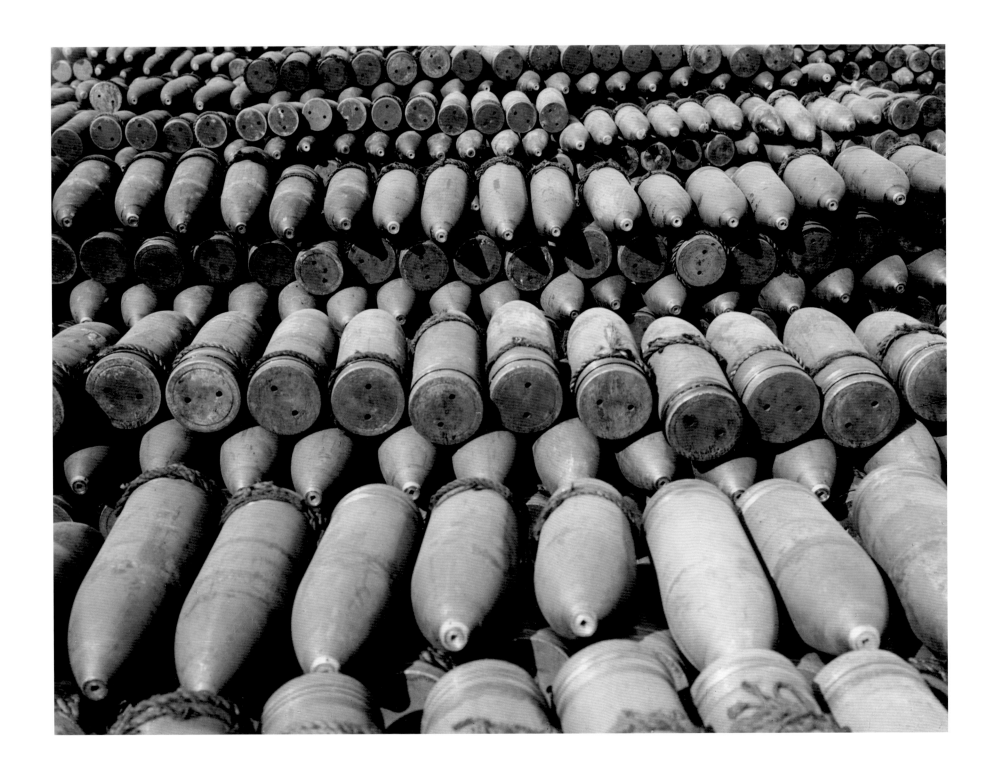

LIEUTENANT ERNEST BROOKS, British Army photographer
A stockpile of 9.2-inch howitzer shells, Carnoy, Somme, France, September 1916

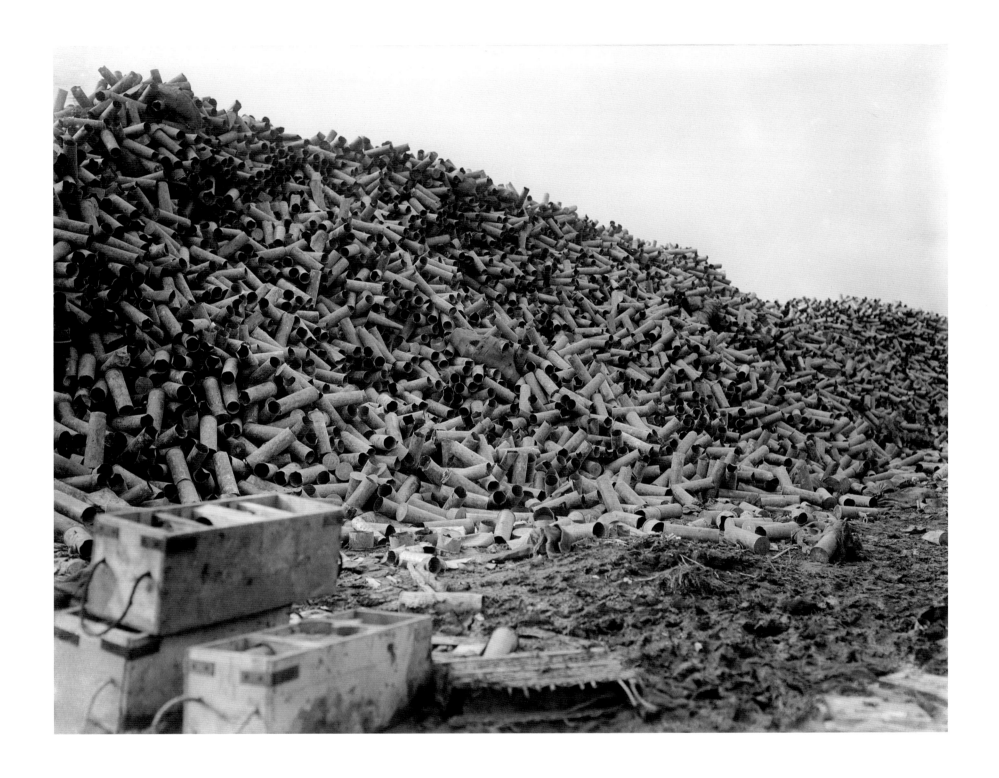

LIEUTENANT ERNEST BROOKS, British Army photographer
Empty shell cases, Fricourt, Somme, France, September 1916

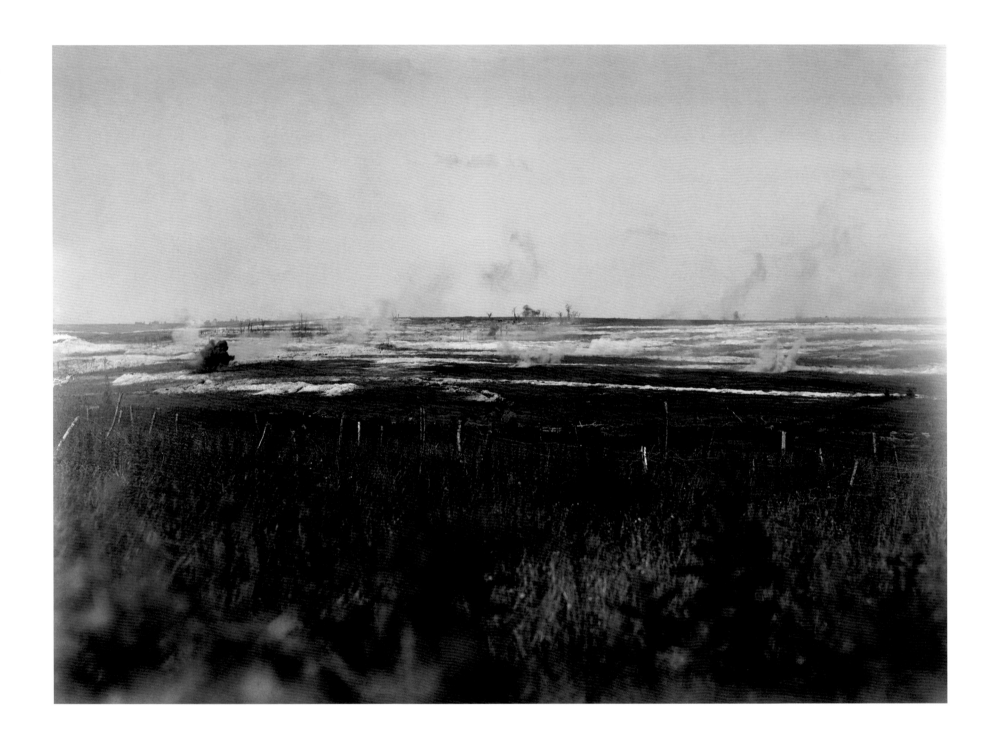

Above and right: Unknown photographer, Royal Engineers No. 1 Printing Company, British Army
British artillery bombards German trenches shortly before the infantry assault,
La Boisselle, Somme, France, 1 July 1916

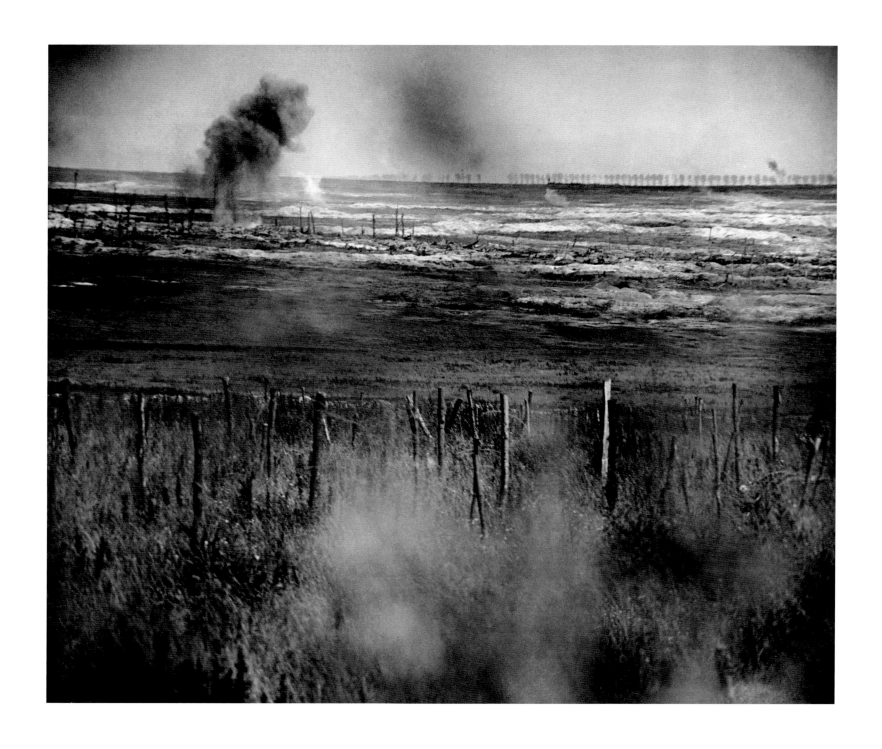

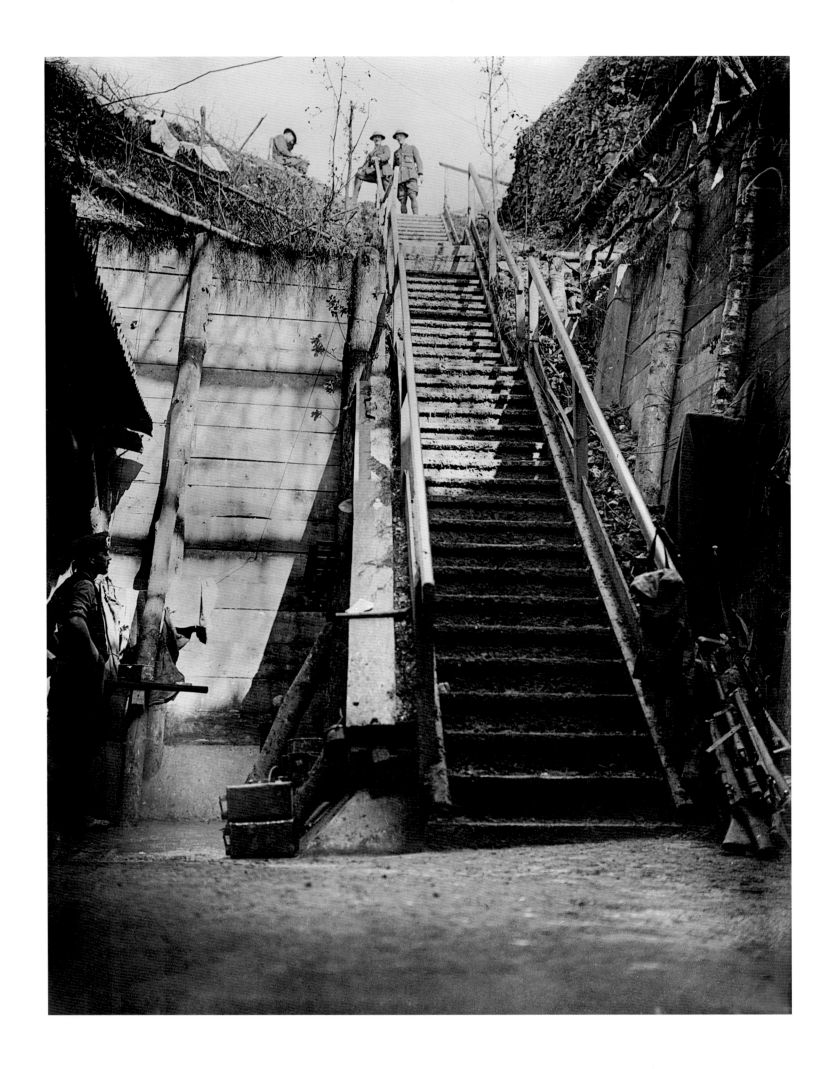

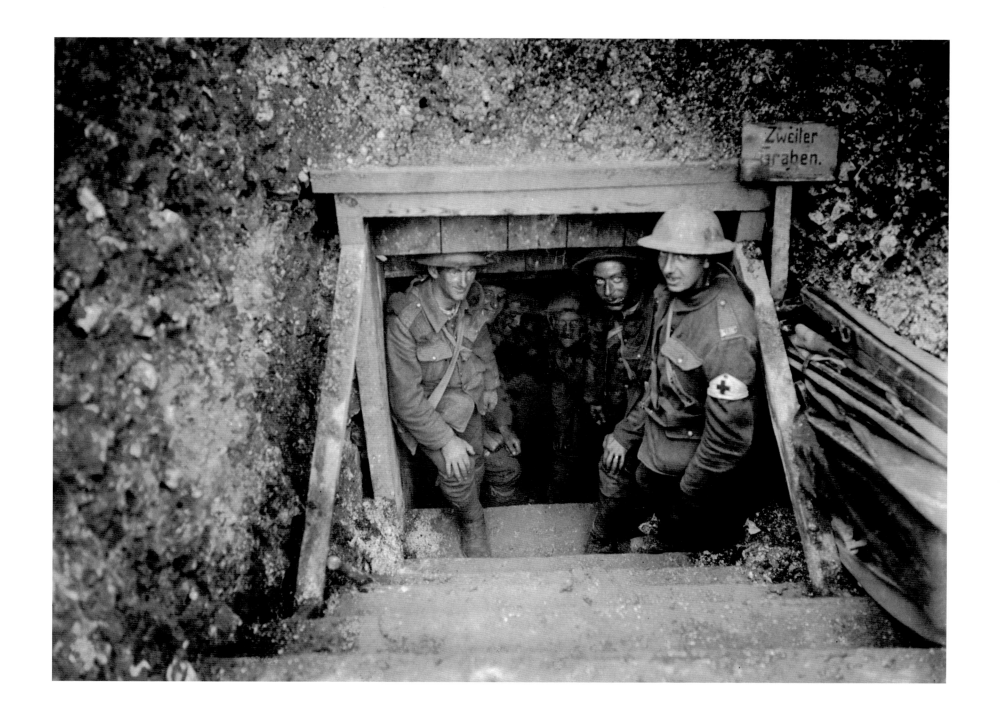

Left: LIEUTENANT JOHN WARWICK BROOKE, British Army photographer
The entrance to a well-constructed German bunker in a quarry near Bernafay Wood, Montauban, Somme, France, 3 July 1916
British intelligence underestimated the strength and quality of the German defences. Their bombardment had little effect and alerted the Germans to the imminent attack

Above: LIEUTENANT ERNEST BROOKS, British Army photographer
British troops inspect a deep German dugout in Dantzig Alley Trench, Mametz, Somme, France, July 1916
The trench was taken after fierce fighting on 1 July 1916

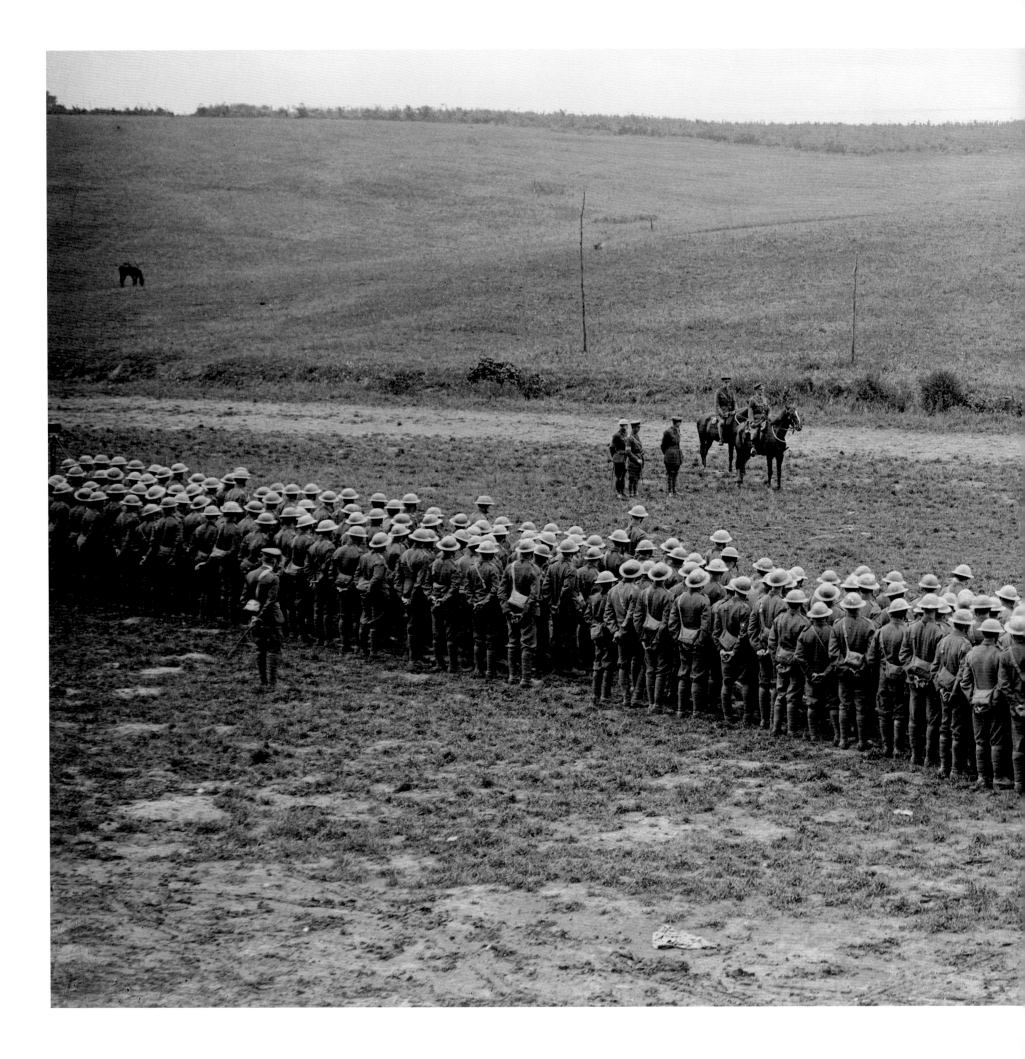

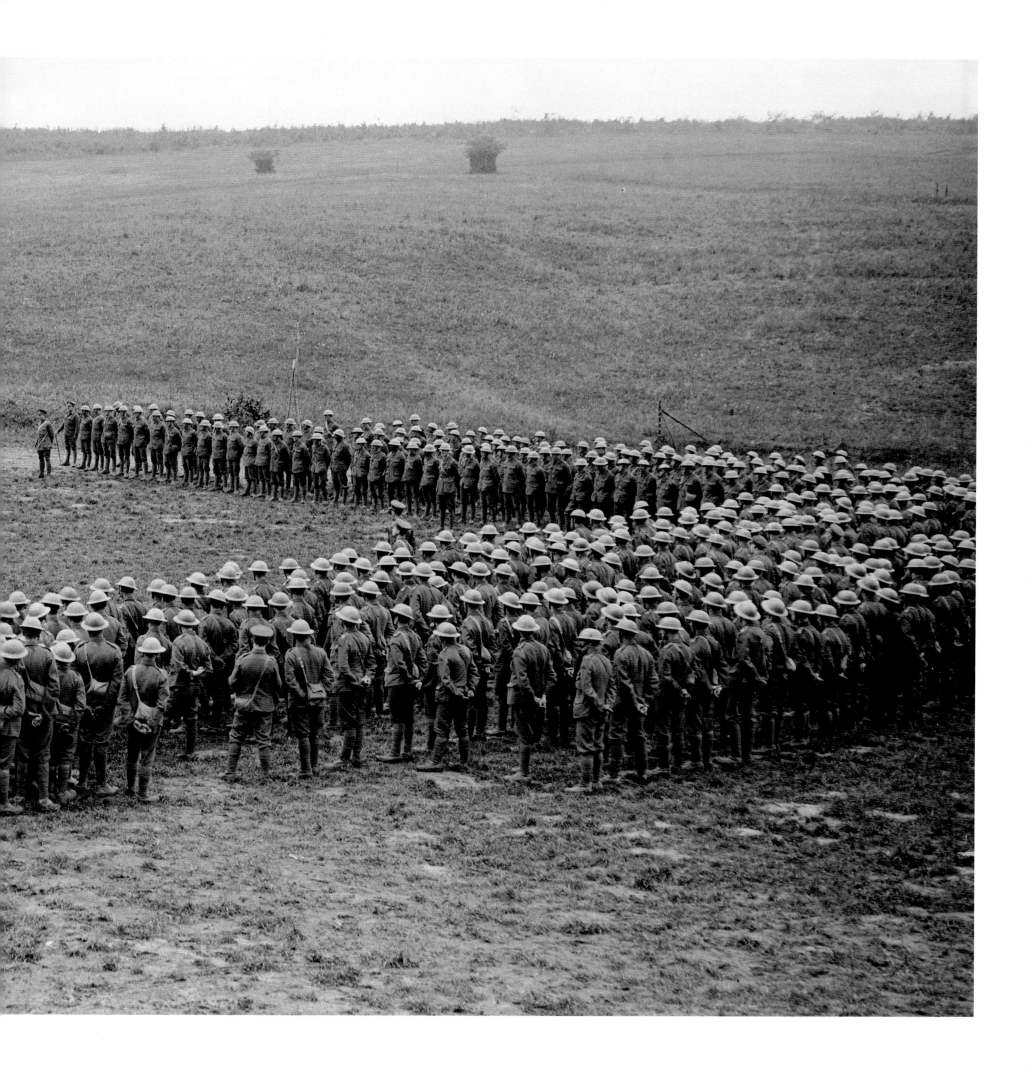

Pages 234–5: LIEUTENANT ERNEST BROOKS, British Army photographer
Major General Sir Henry de Beauvoir de Lisle, Commander of 29th British Division, addresses the massed ranks of 1st Lancashire Fusiliers shortly before battle, Mailly-Maillet, Somme, France, 29 June 1916
The infantry assault was scheduled to begin at 7.30 a.m. on 1 July 1916. The British High Command was confident of success. Frontline troops were less certain of their prospects

Right: Unknown photographer, Royal Engineers No. 1 Printing Company, British Army
British troops, with wire-cutters attached to their rifles, wait in a support trench for the order to advance, near Beaumont Hamel, Somme, France, 1 July 1916

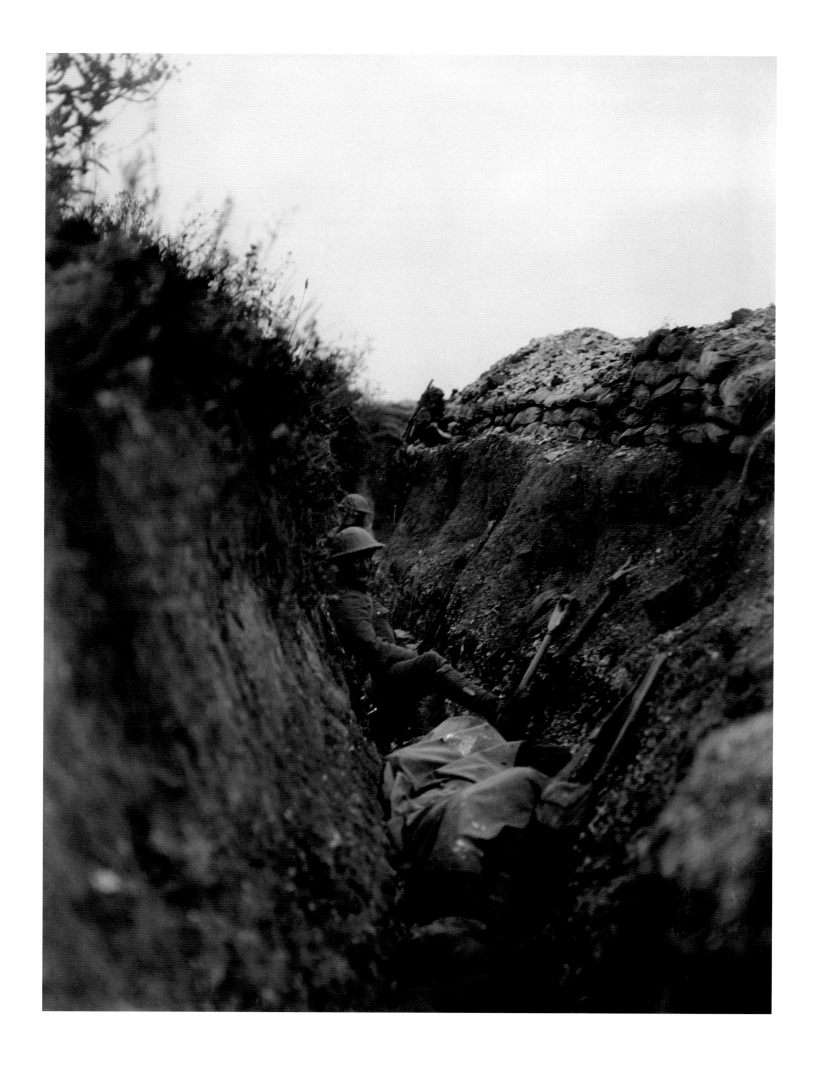

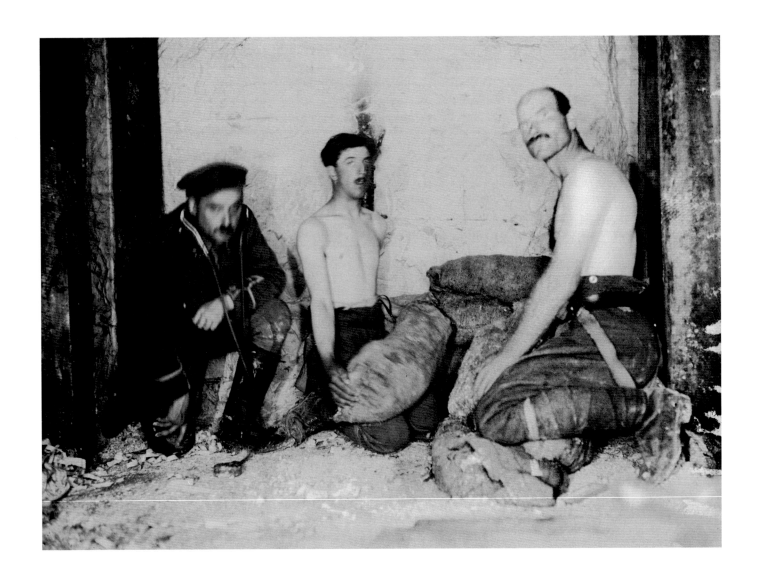

Unknown photographer, Royal Engineers No. 1 Printing Company, British Army
**British tunnelling engineers lay a charge in an underground mine chamber. The officer on
the left is using a geophone to listen for enemy underground activity, Somme, France,
June 1916**
*In a highly secret and dangerous operation, British engineers tunnelled under the
German lines to lay a series of huge mines*

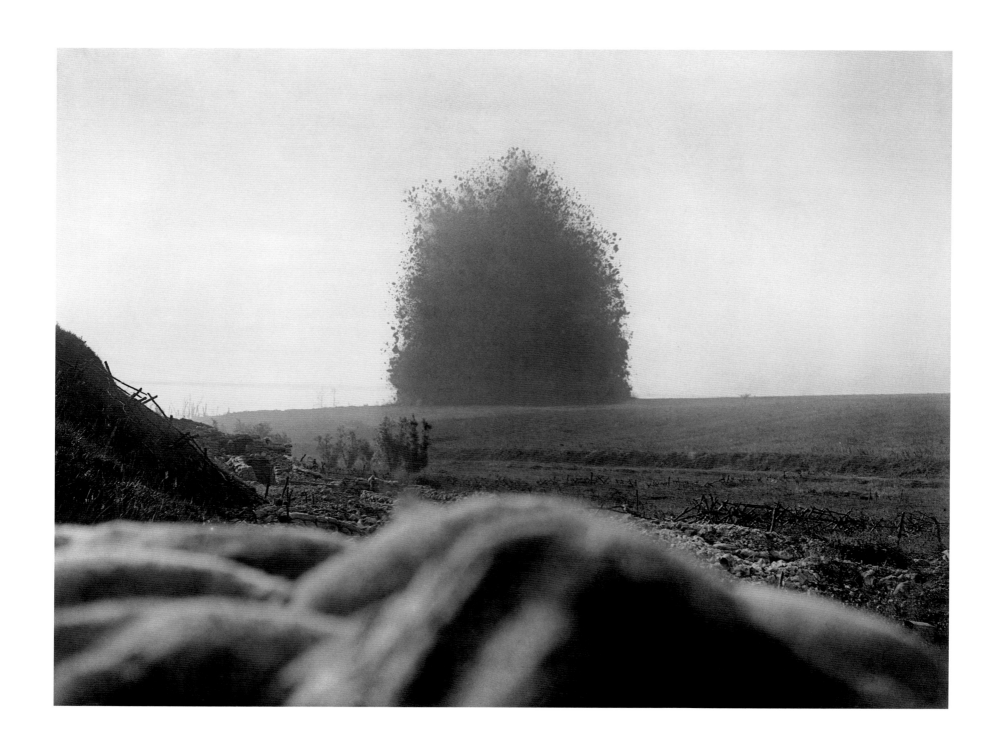

LIEUTENANT ERNEST BROOKS, British Army photographer
**A 45,000-pound mine is detonated under German frontline positions, Hawthorn
Redoubt, Beaumont Hamel, Somme, France, 7.20 a.m., 1 July 1916**
*Documenting the detonation of the mine was an important objective for Lt Brooks. He
worked alongside Geoffrey Malins, recently appointed British official cinematographer*

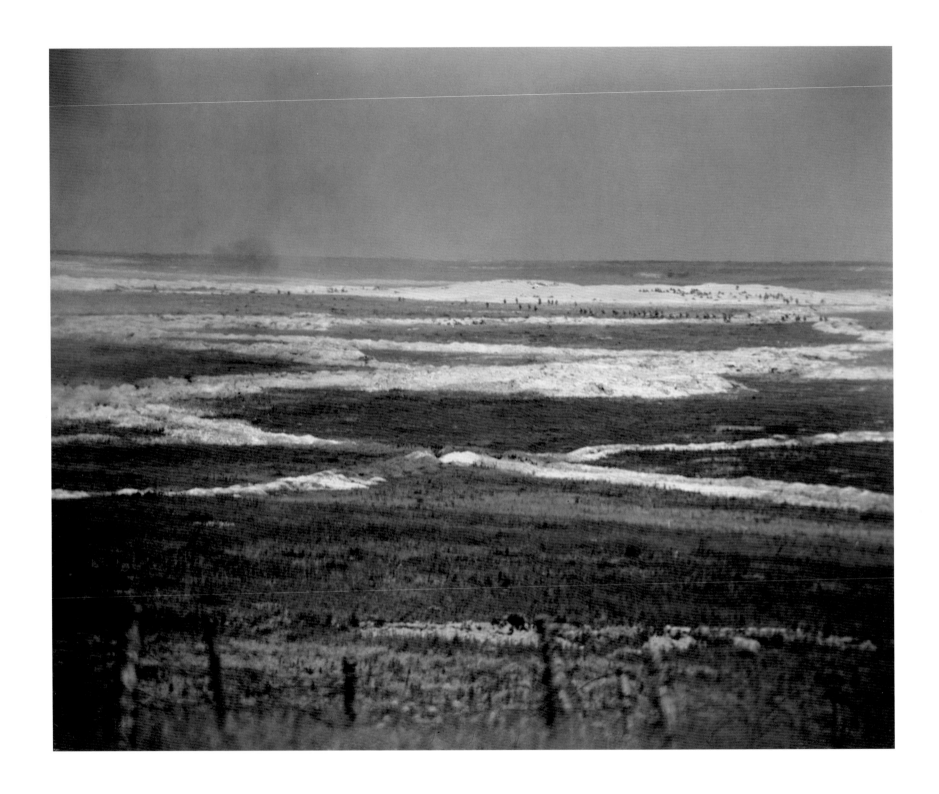

Unknown photographer, Royal Engineers No.1 Printing Company, British Army
British troops advance towards the German trenches, near Mametz, Somme, France,
1 July 1916
*German machine guns inflicted devastating casualties on the advancing infantry and
the attack failed in many areas. The British Army suffered nearly 60,000 casualties,
the highest ever recorded in a single day*

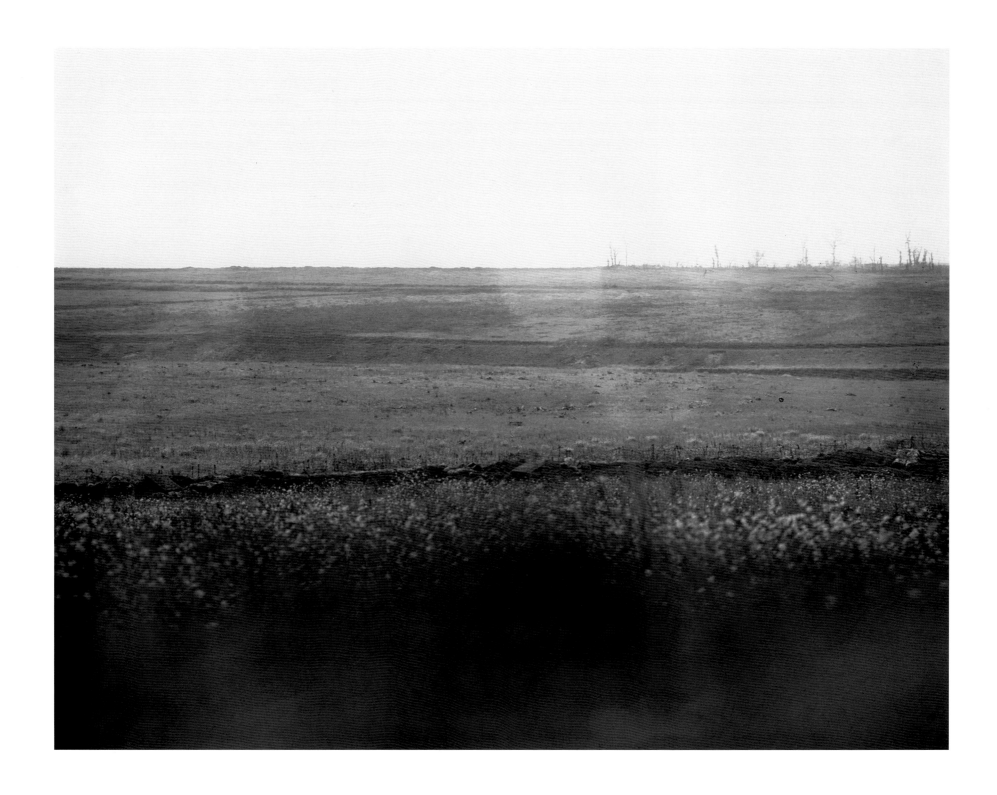

Unknown photographer, Royal Engineers No. 1 Printing Company, British Army
View of the battlefield from a British frontline trench sometime after the initial assault.
British casualties lie unburied in No Man's Land, La Boisselle, Somme, France, 1 July 1916

Unknown photographer, Imperial German Army
The body of a British soldier who died of thirst after being wounded in No Man's Land,
Combles, Somme, France, August 1916
Many wounded, unable to be rescued, died in No Man's Land

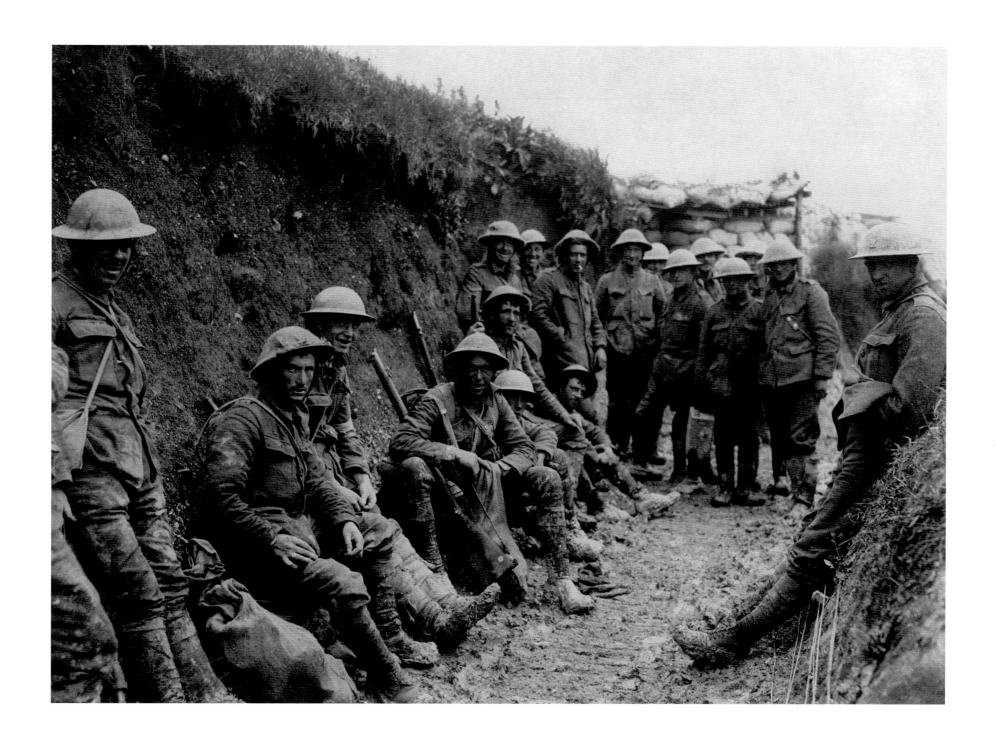

Unknown photographer, Royal Engineers No. 1 Printing Company, British Army
A Royal Irish Rifles ration party rests in a communication trench during the opening hours of the battle, Somme, France, 1 July 1916
The photograph became an icon of the British experience of the Western Front and is one of the most famous images of the war. Little is known about the circumstances in which it was taken

LIEUTENANT ERNEST BROOKS, British Army photographer
British troops watch a bombardment, Mametz, Somme, France, 4 July 1916
Savage fighting continued on the Somme for four months, incurring huge numbers of casualties but achieving little. The war of attrition on the Western Front continued

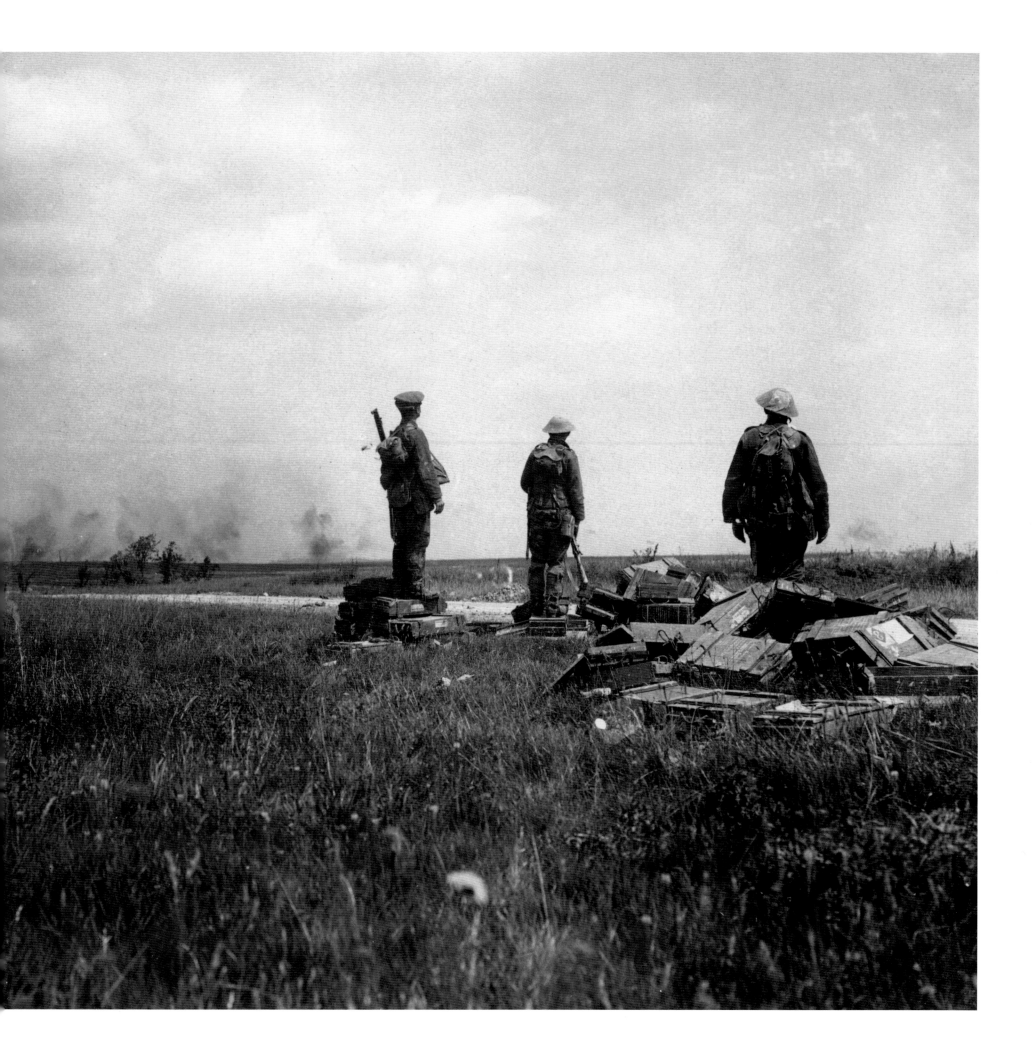

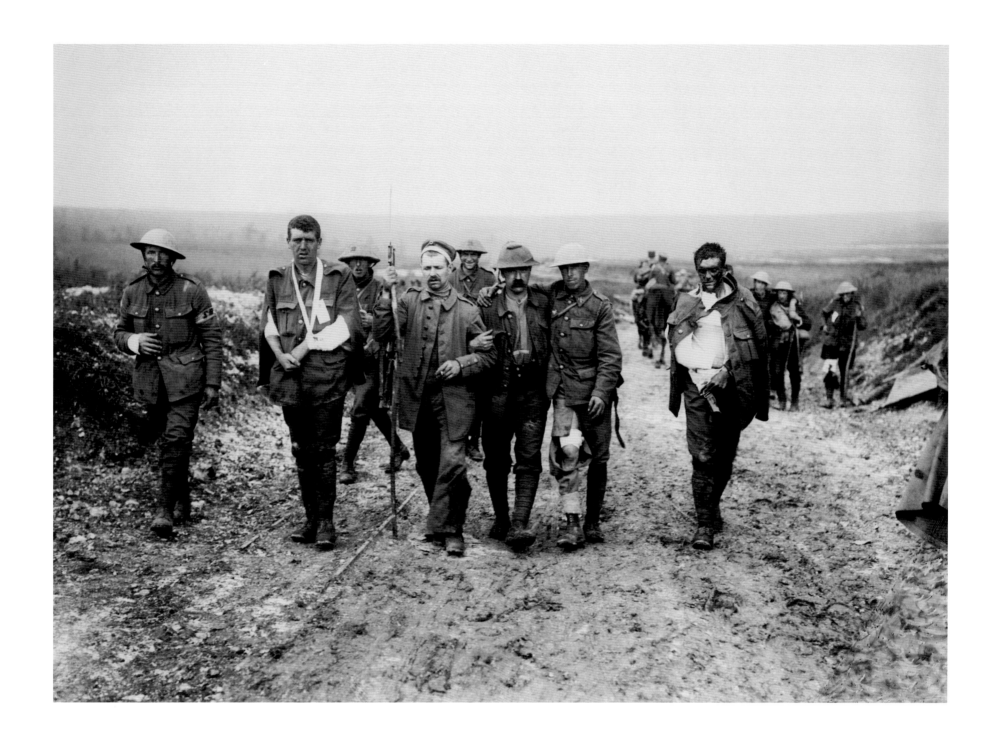

LIEUTENANT ERNEST BROOKS, British Army photographer
British and German troops, wounded during the fighting for Bazentin Ridge, move to
a dressing station, Bernafay Wood, Somme, France, 19 July 1916

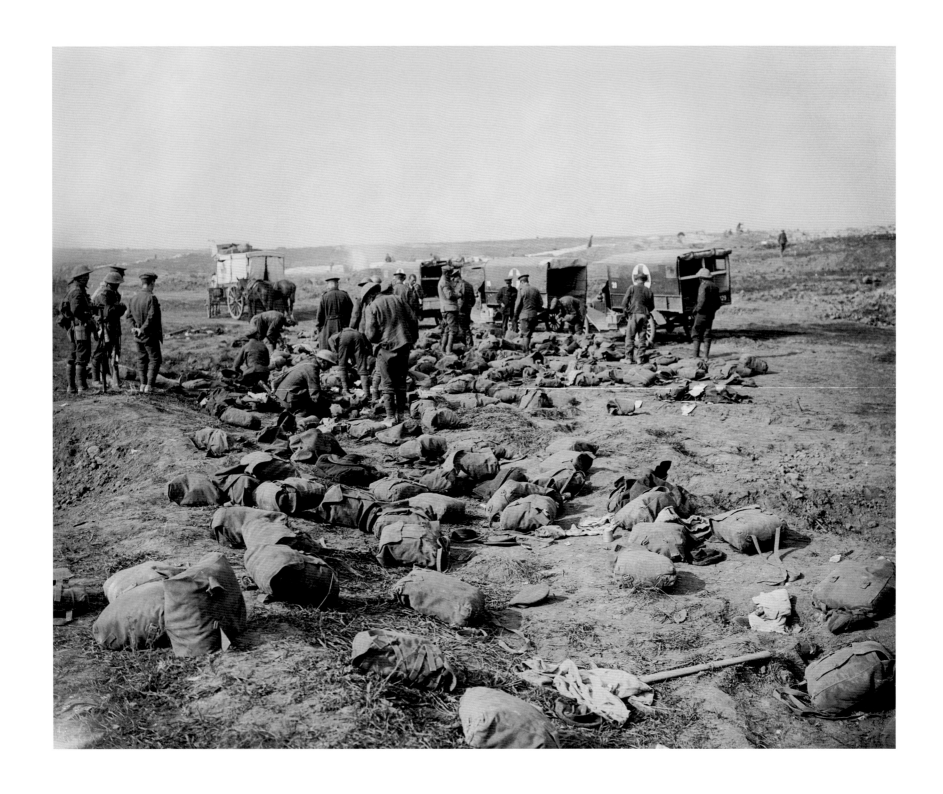

LIEUTENANT JOHN WARWICK BROOKE, British Army photographer
Men of the Royal Army Medical Corps search packs that had belonged to the dead for
letters and effects to be sent to relatives after the Battle of Guillemont, Western Front,
September 1916

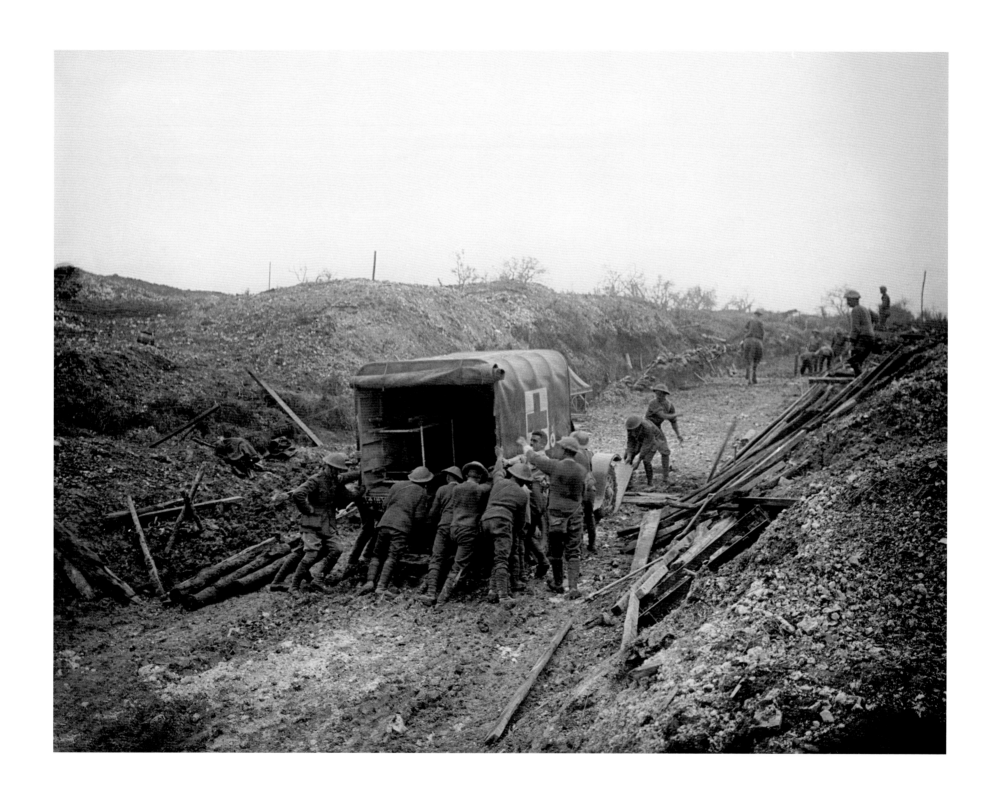

LIEUTENANT JOHN WARWICK BROOKE, British Army photographer
**An ambulance of 16th (Irish) Division struggles through the mud on its way to the
front line, Mametz Wood, Somme, France, July 1916**

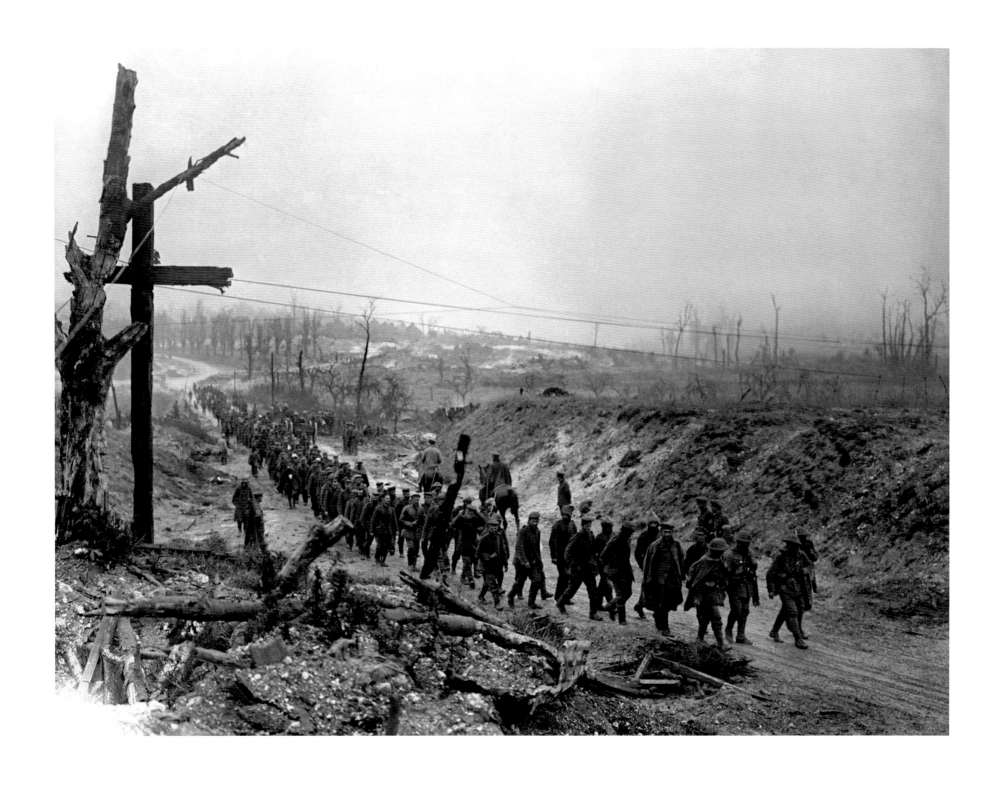

LIEUTENANT JOHN WARWICK BROOKE, British Army photographer
**German prisoners captured at Bazentin Ridge march into Fricourt, Somme, France,
14 July 1916**

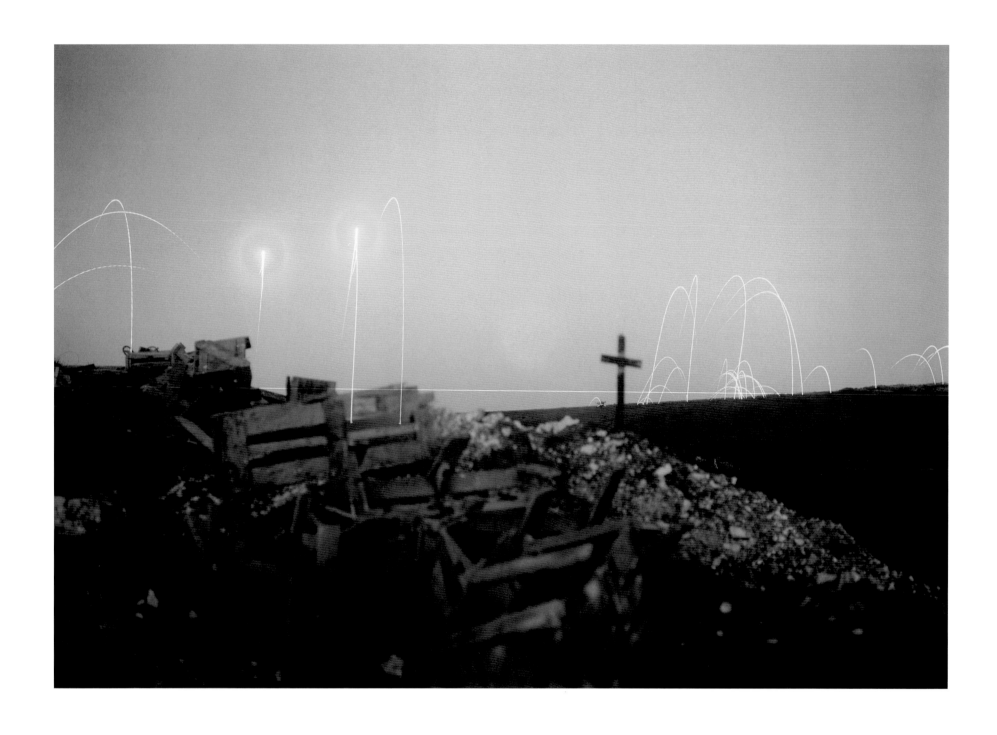

LIEUTENANT ERNEST BROOKS, British Army photographer
**Flares, known as Very lights, illuminate the battlefield at dusk after the attack on
Beaumont Hamel, Somme, France, 2 July 1916**

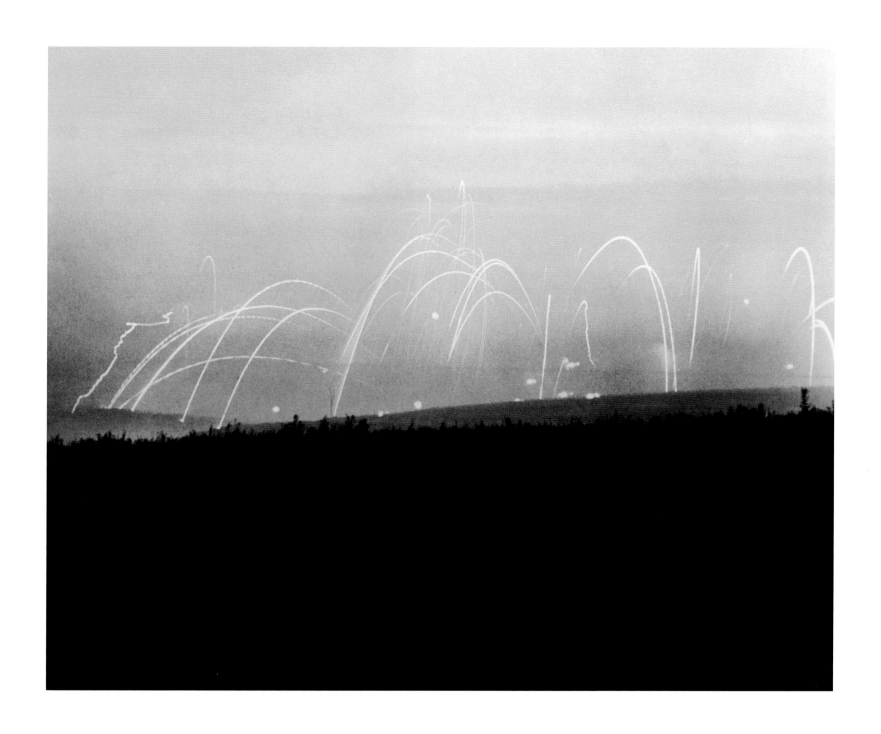

LIEUTENANT ERNEST BROOKS, British Army photographer
**British artillery bombards the German lines at dawn in the prelude to an assault on
Thiepval, Somme, France, 15 September 1916**

LIEUTENANT ERNEST BROOKS, British Army photographer
British night bombardment of Beaumont Hamel, Somme, France, 2 July 1916

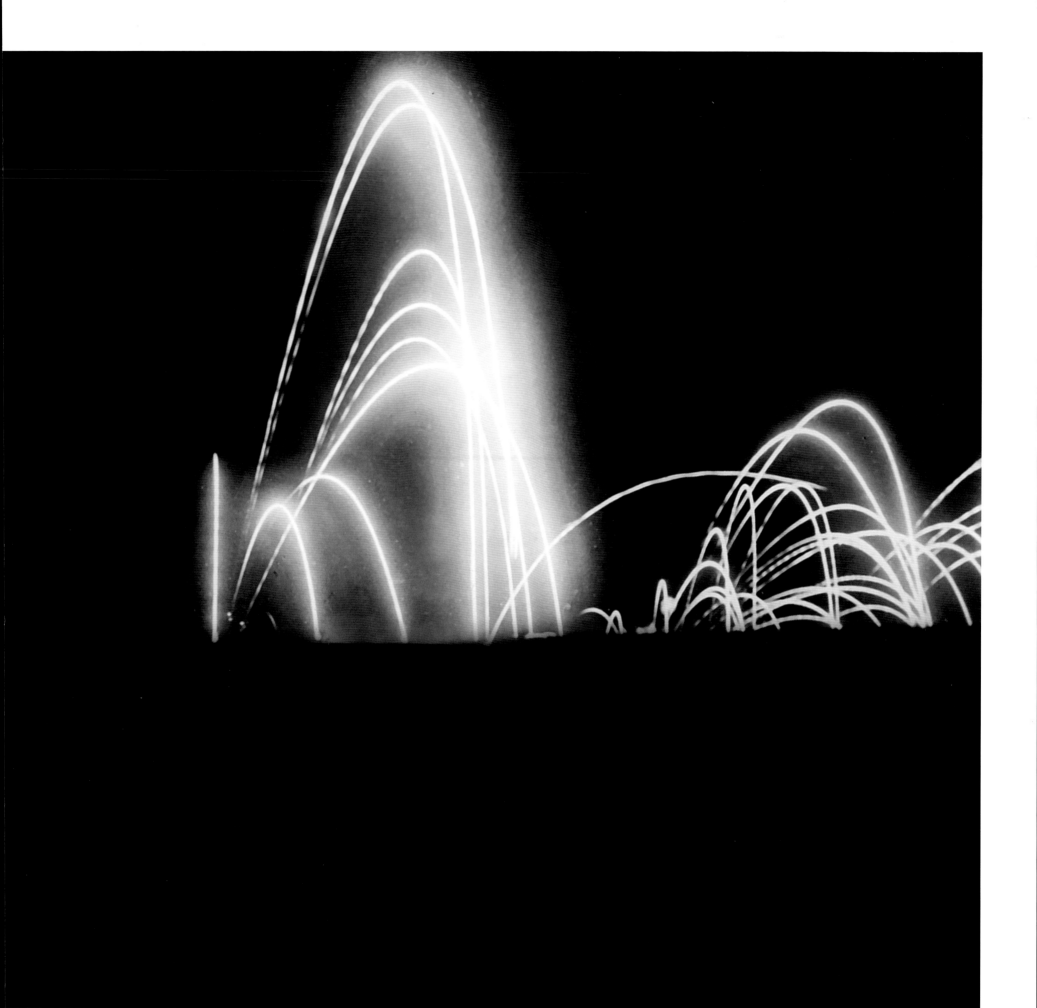

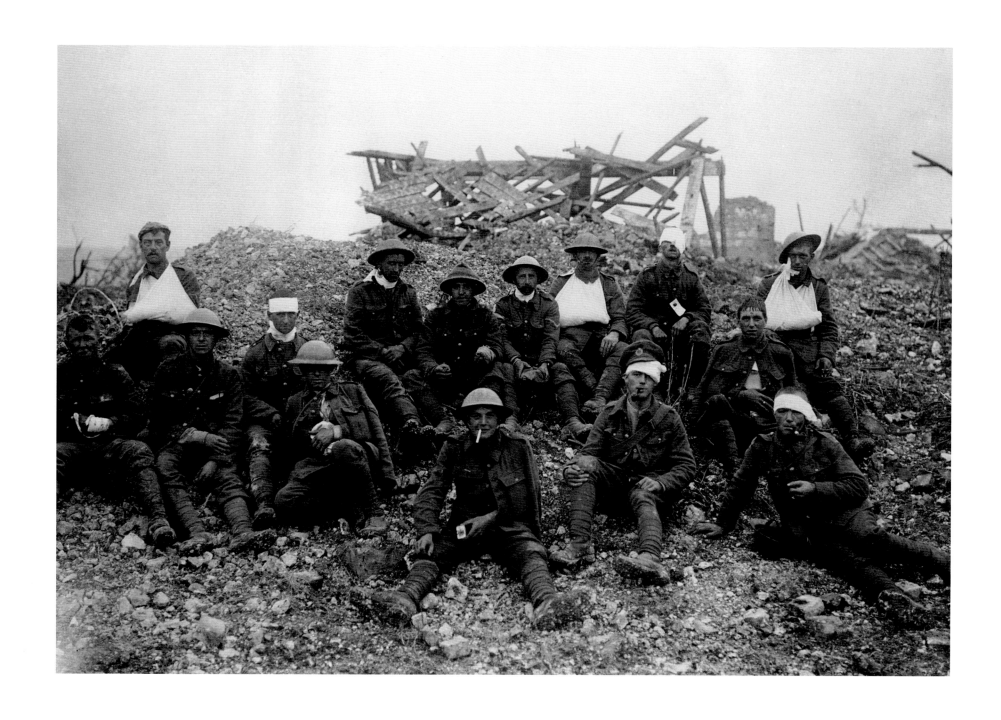

LIEUTENANT ERNEST BROOKS, British Army photographer
Wounded British troops at Mametz, Somme, France, July 1916

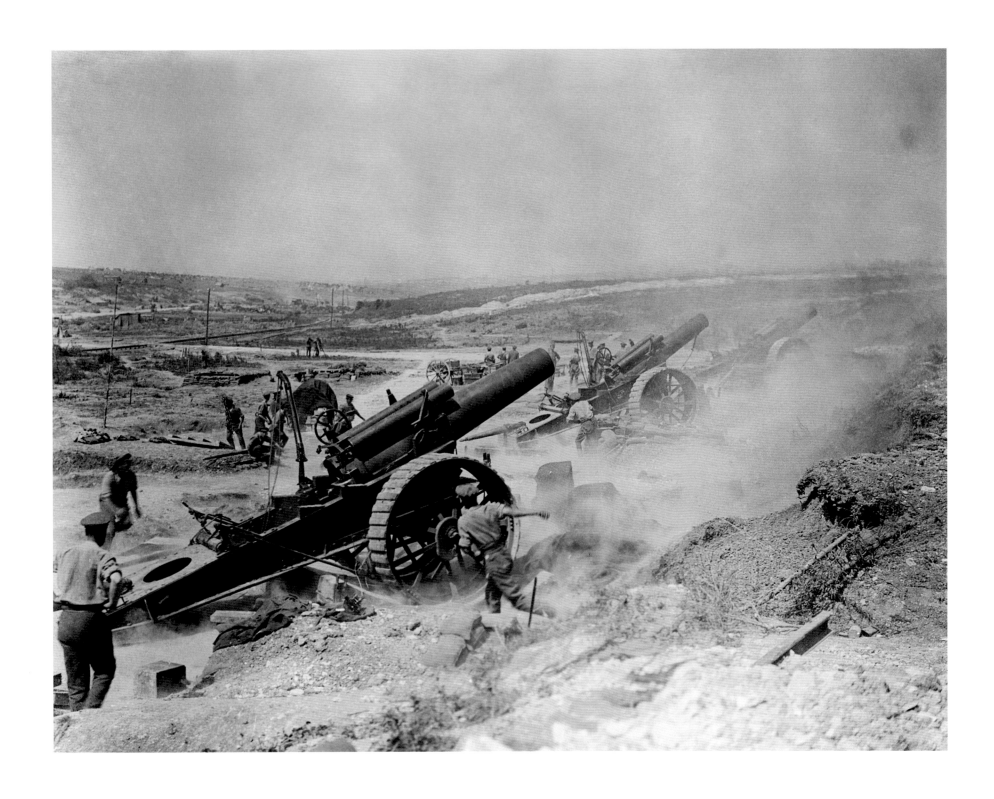

LIEUTENANT JOHN WARWICK BROOKE, British Army photographer
**8-inch howitzers of 39th Siege Battery, Royal Garrison Artillery in action,
Fricourt-Mametz Valley, Somme, France, August 1916**

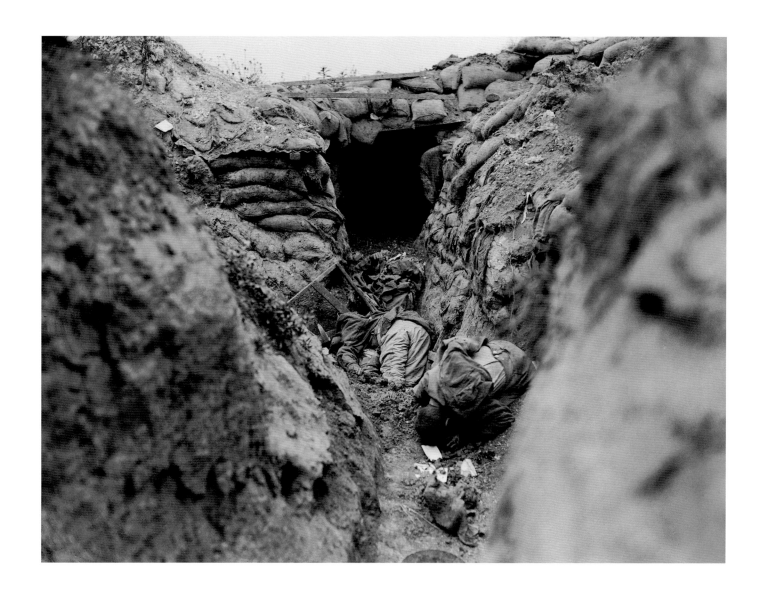

Unknown photographer, Royal Engineers No. 1 Printing Company, British Army
German dead in a frontline trench, near Albert, Somme, France, 1 July 1916

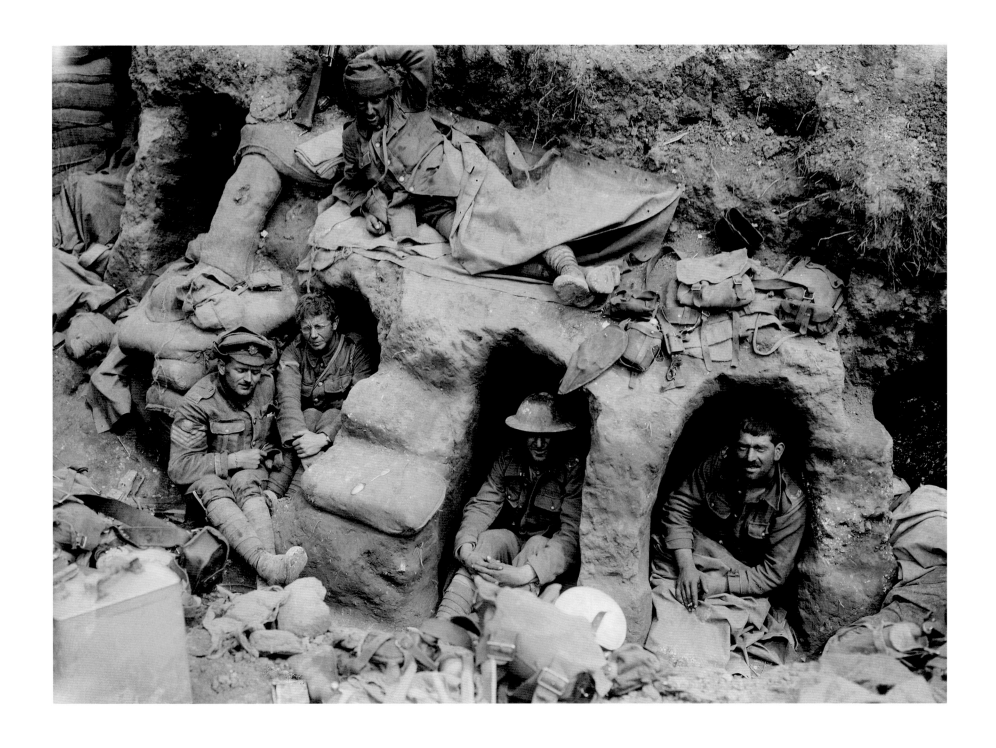

LIEUTENANT ERNEST BROOKS, British Army photographer
Sgt John W. Clarke (left) and soldiers of the Border Regiment rest in shallow dugouts
near Thiepval Wood, Somme, France, August 1916
Sgt Clarke was killed in action on 31 August 1916

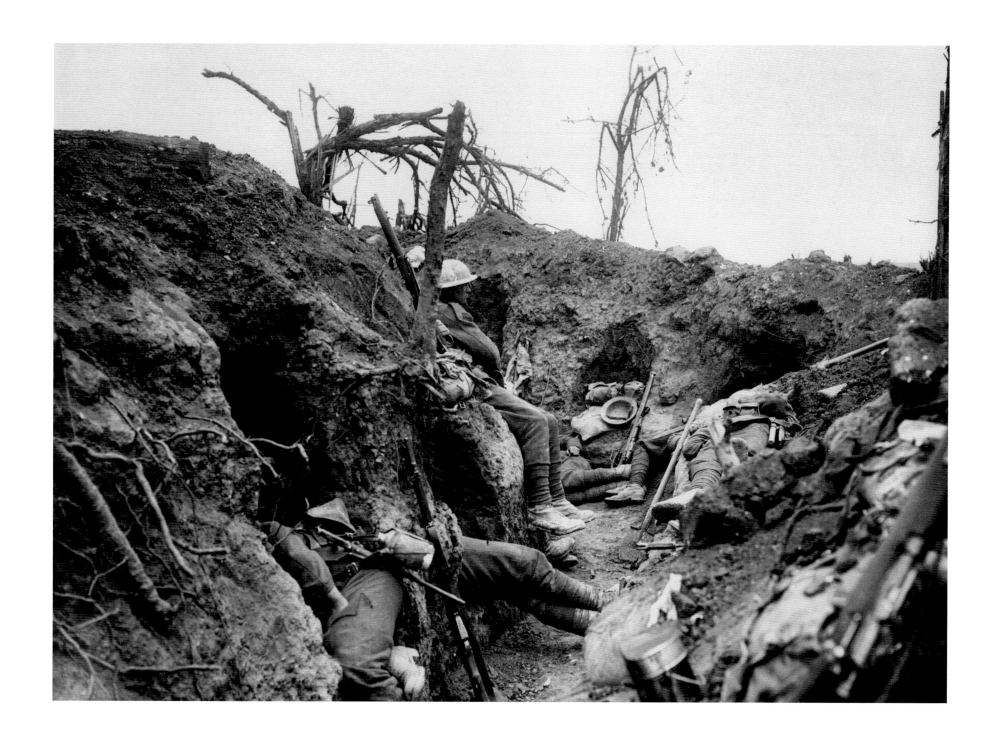

LIEUTENANT ERNEST BROOKS, British Army photographer
Men of the Border Regiment rest in a frontline trench, Thiepval Wood, Somme,
France, August 1916

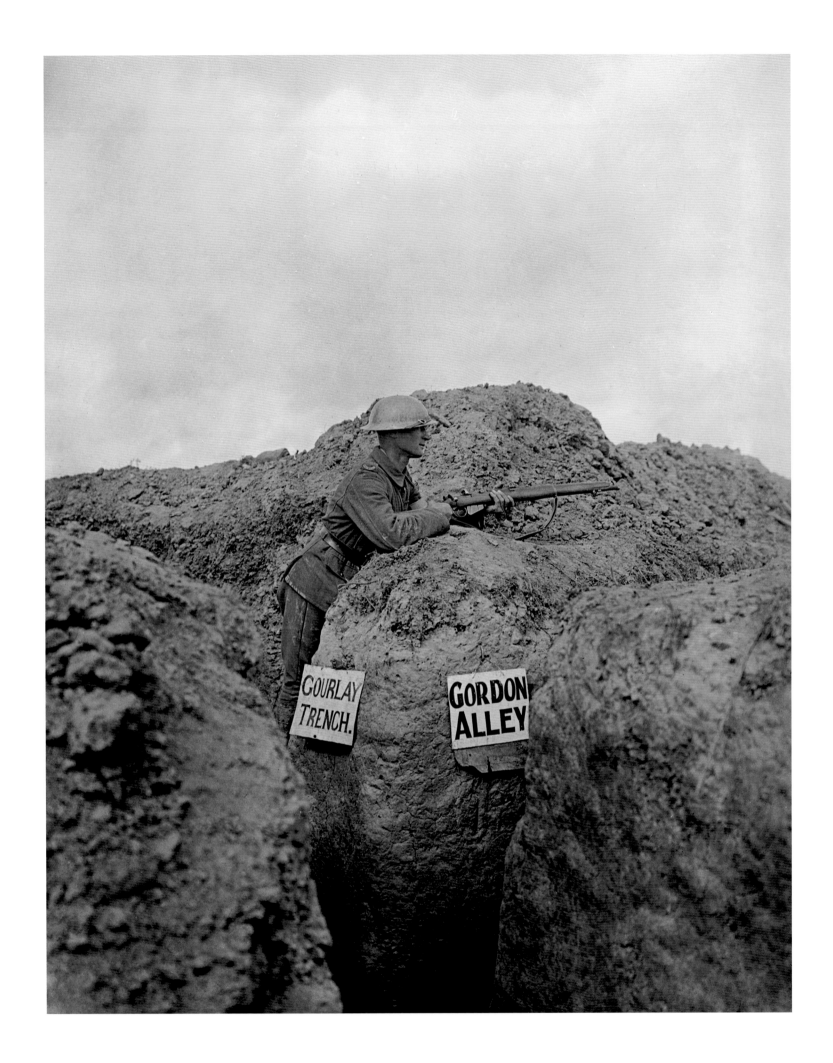

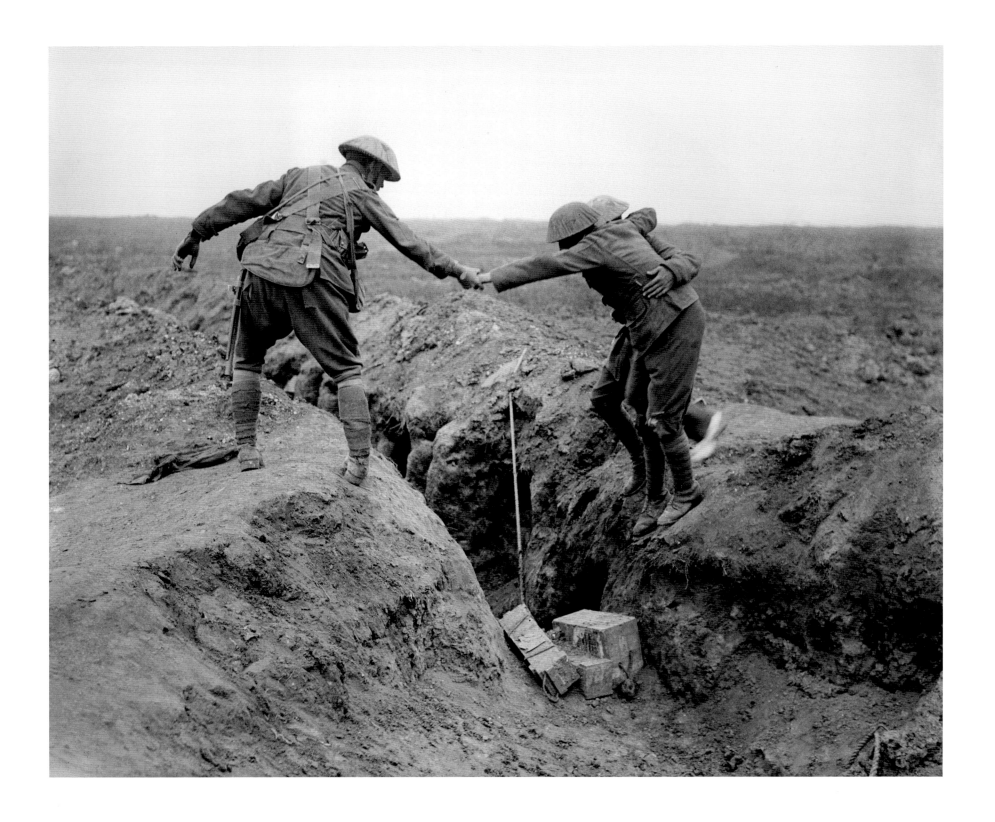

Left: LIEUTENANT JOHN WARWICK BROOKE, British Army photographer
A sentry of 10th Gordon Highlanders guards the junction of Gourlay Trench and Gordon Alley, Martinpuich, Somme, France, 28 August 1916

Above: LIEUTENANT JOHN WARWICK BROOKE, British Army photographer
British soldiers assist a wounded man, returning from the front line after the capture of Ginchy, Somme, France, 9 September 1916

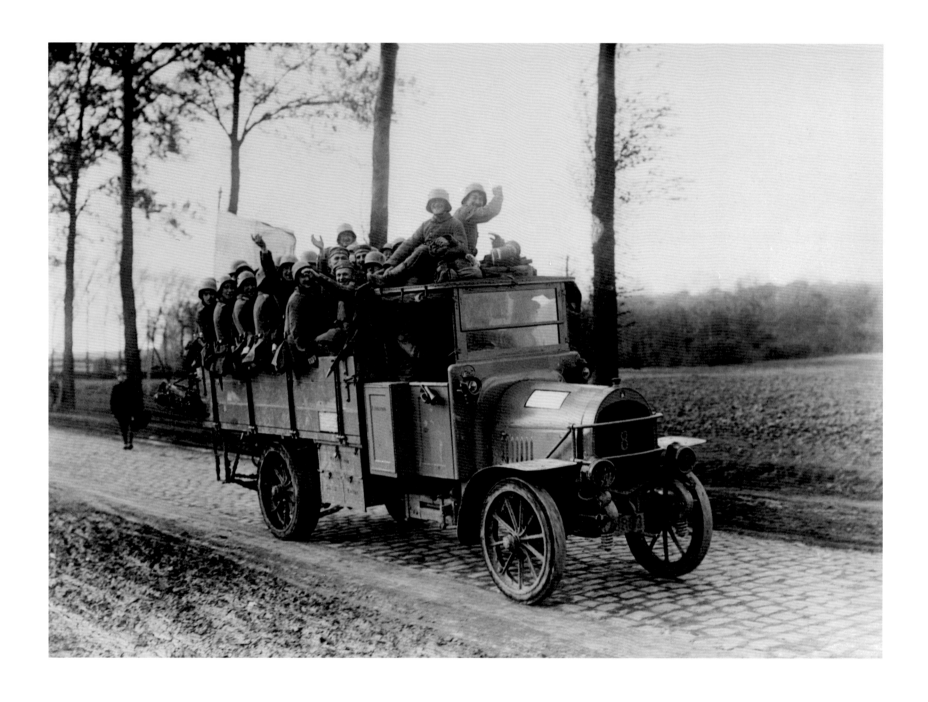

Unknown photographer, Imperial German Army
A lorry transports German infantry to the front line, Somme, France, 1916

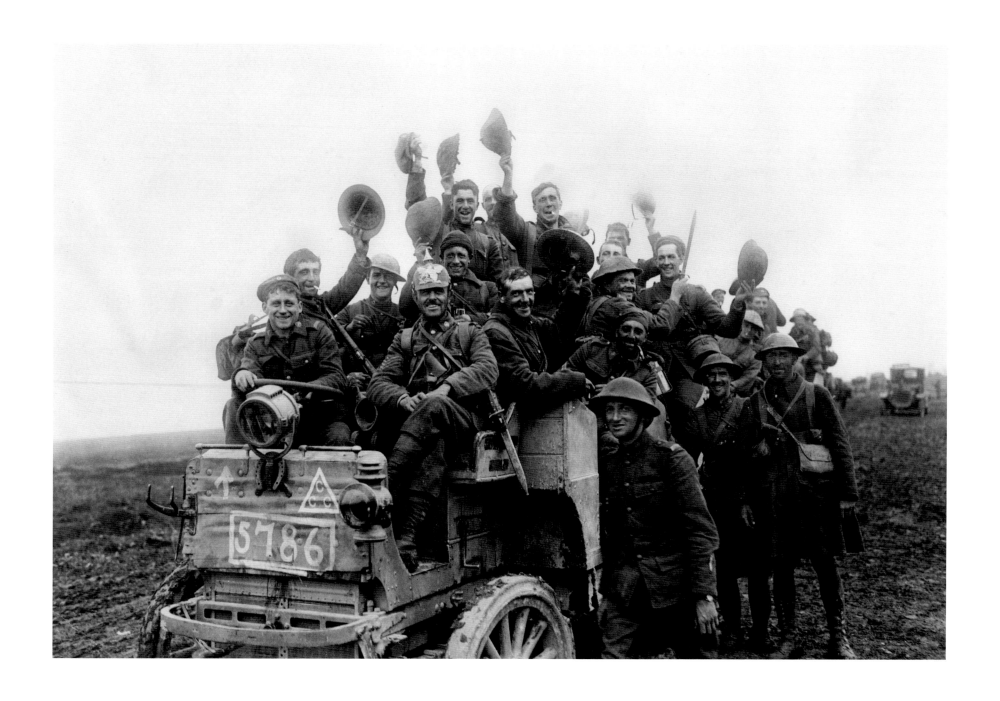

LIEUTENANT W. IVOR CASTLE, Canadian Army photographer
**Canadian troops just out of the line pose with their trophies on an Autocar UK21
30-cwt lorry, Courcelette, Somme, France, September 1916**

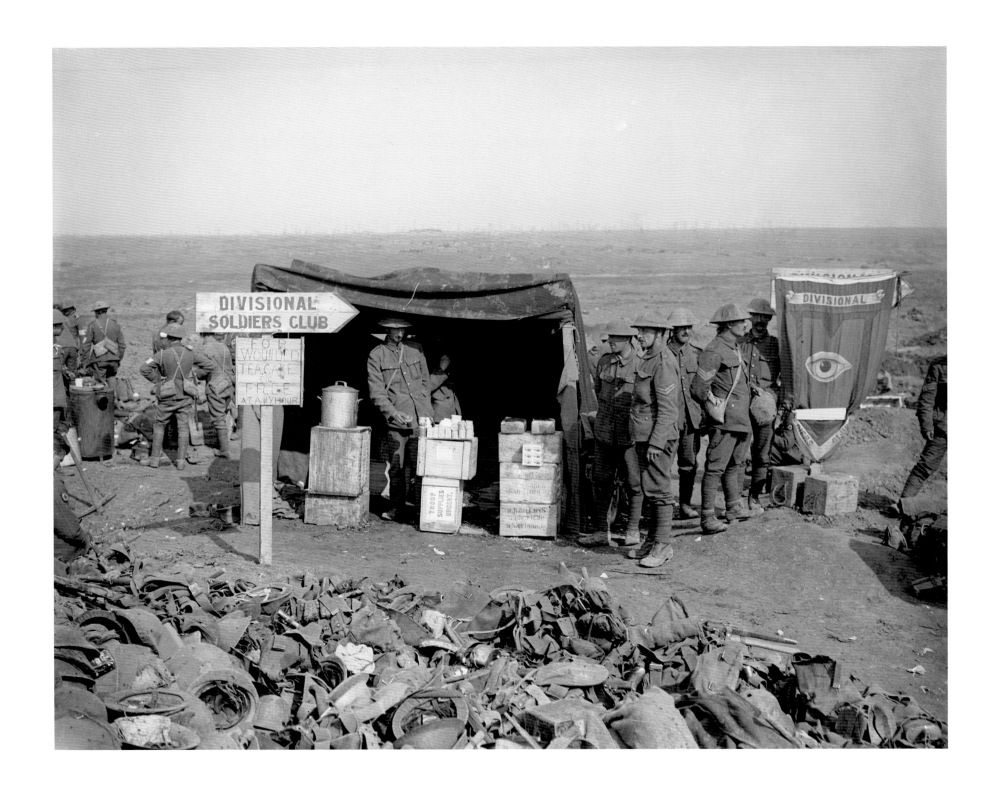

LIEUTENANT JOHN WARWICK BROOKE, British Army photographer
**The Guards Divisional Canteen offers free refreshments to the wounded, Guillemont,
Somme, France, September 1916**

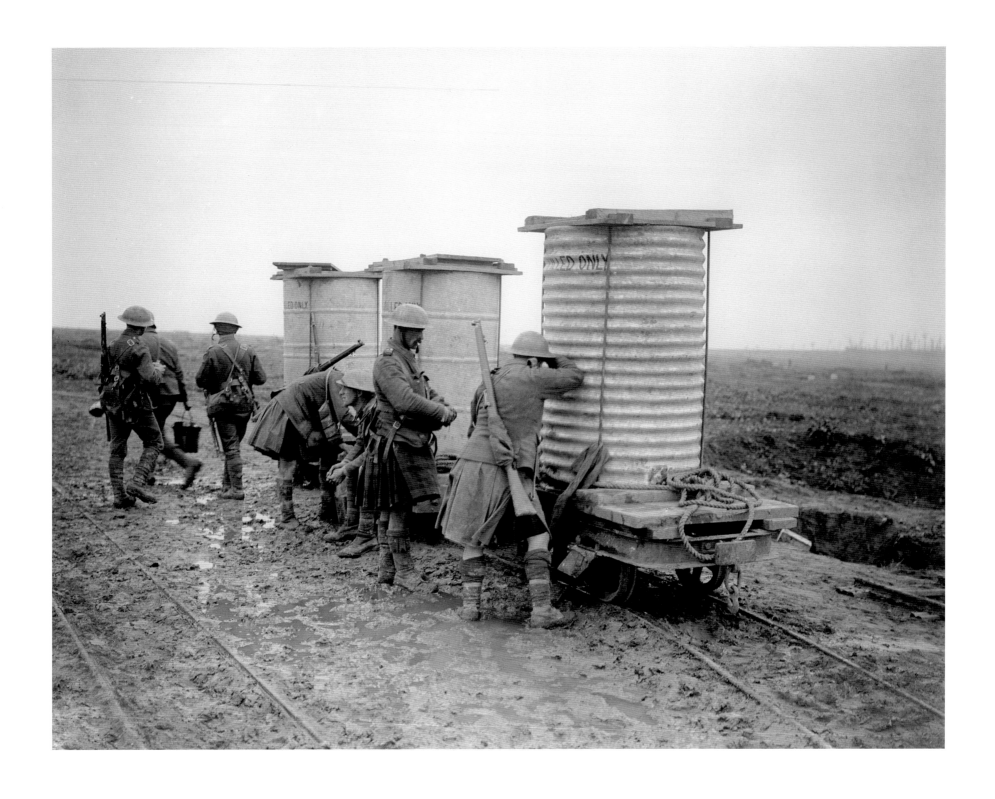

LIEUTENANT JOHN WARWICK BROOKE, British Army photographer
Water butts are moved forward on a trolley railway, near Pozières, Somme, France, October 1916

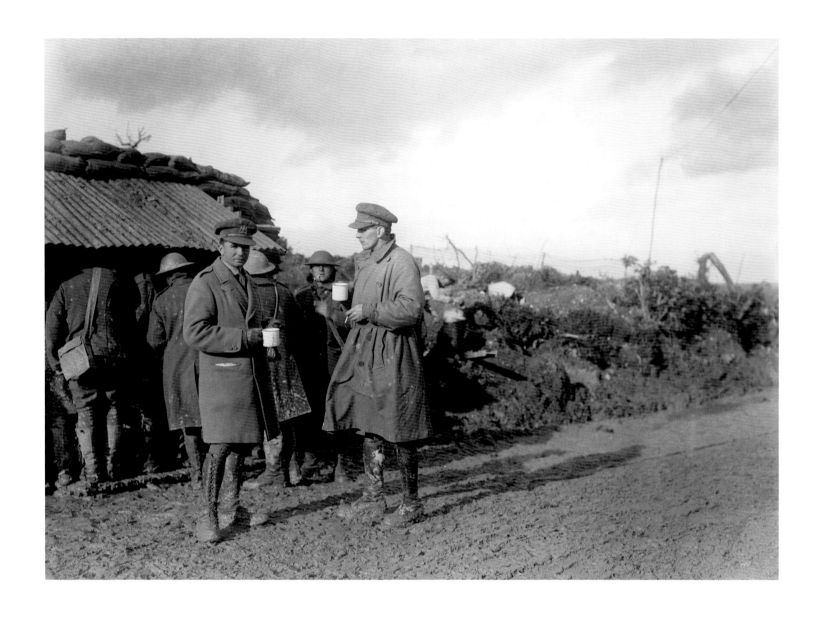

Unknown photographer, British Army
**Lt Ernest Brooks (left), British Army official photographer, and Lt Geoffrey Malins,
official cinematographer, photographed by an assistant at a coffee stall behind the
lines, Somme, France, September 1916**

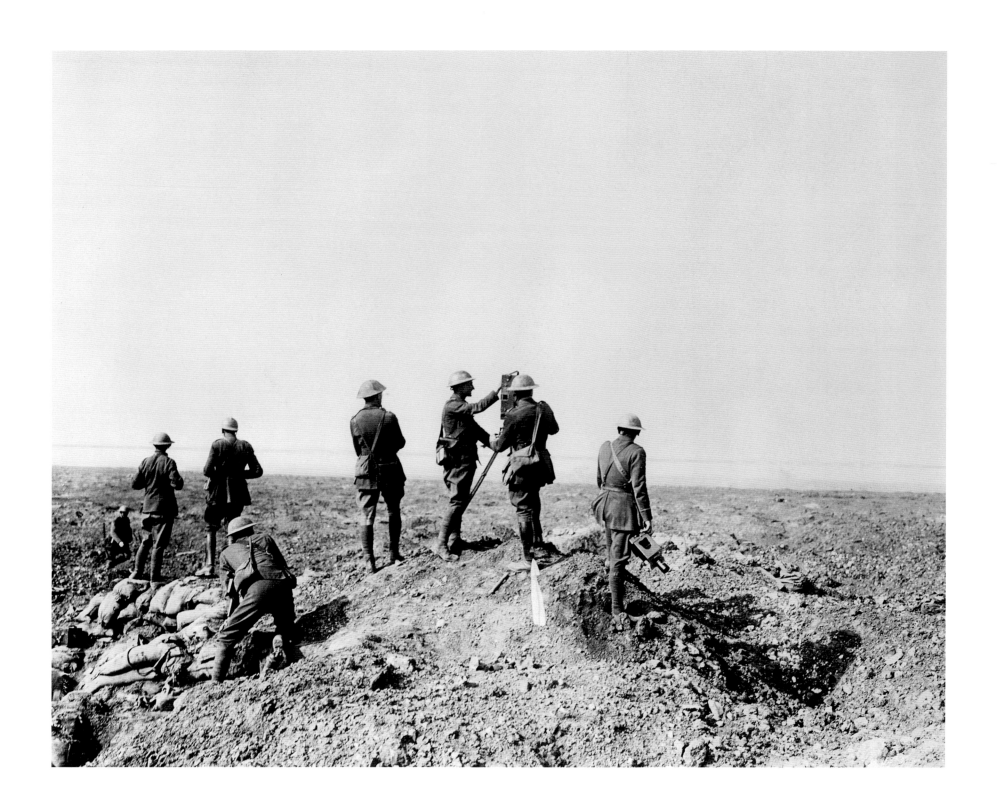

Unknown photographer, Canadian Army
Cpt Ivor Castle, Canadian Army official photographer (right with camera), with Lt Oscar Bovill, Canadian Army official cinematographer, records the bombardment of German positions at Courcelette, Somme, France, October 1916
Most British and Empire official photographers were Fleet Street professionals

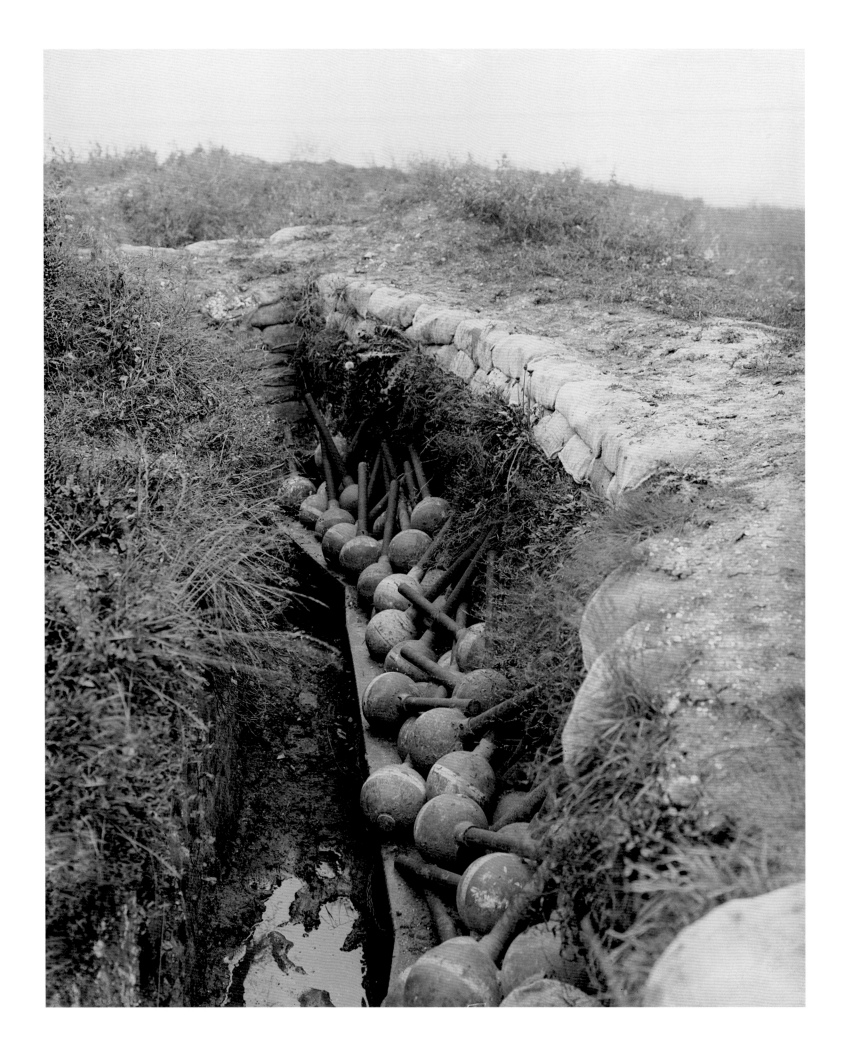

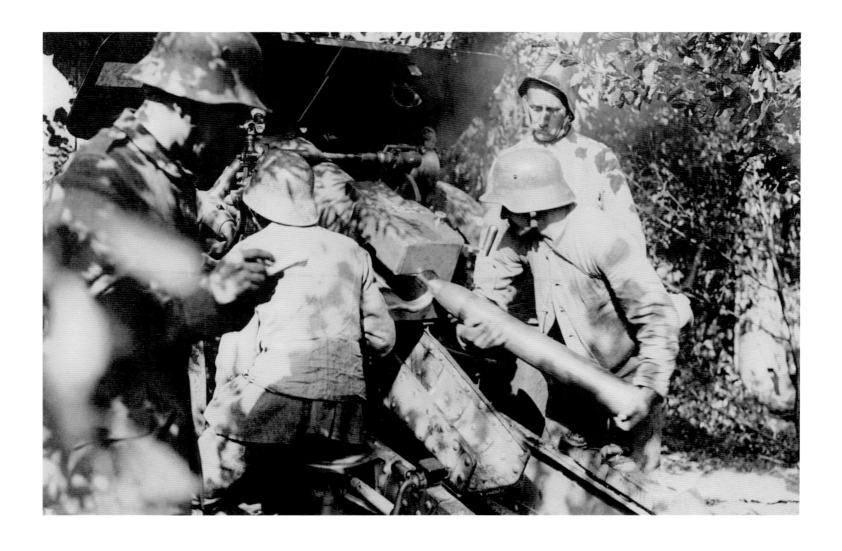

Left: LIEUTENANT JOHN WARWICK BROOKE, British Army photographer
Trench mortar bombs ready for use in a reserve trench, St George's Hill, near Fricourt, Somme, France, September 1916

Above: Unknown photographer, Imperial German Army
The crew of a German Foot Artillery battery load a 10-cm K14 Kanone, Somme, France, 1916

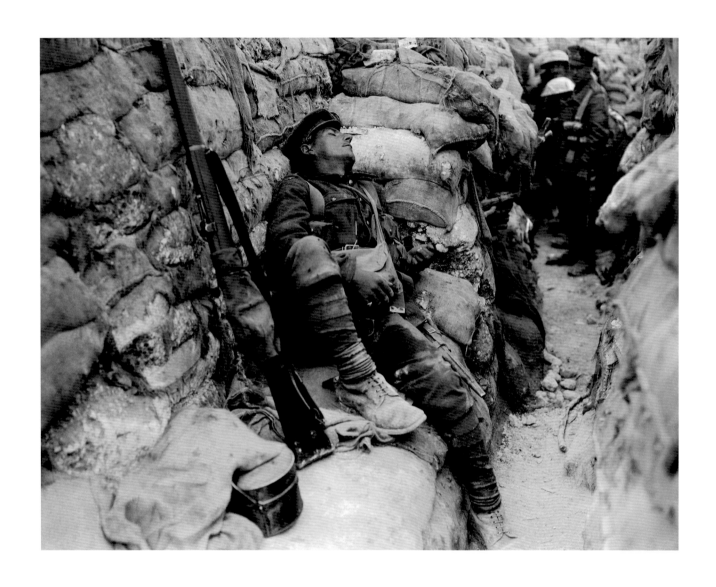

LIEUTENANT ERNEST BROOKS, British Army photographer
An exhausted soldier asleep in a frontline trench, Thiepval, Somme, France,
c. **26 September 1916**

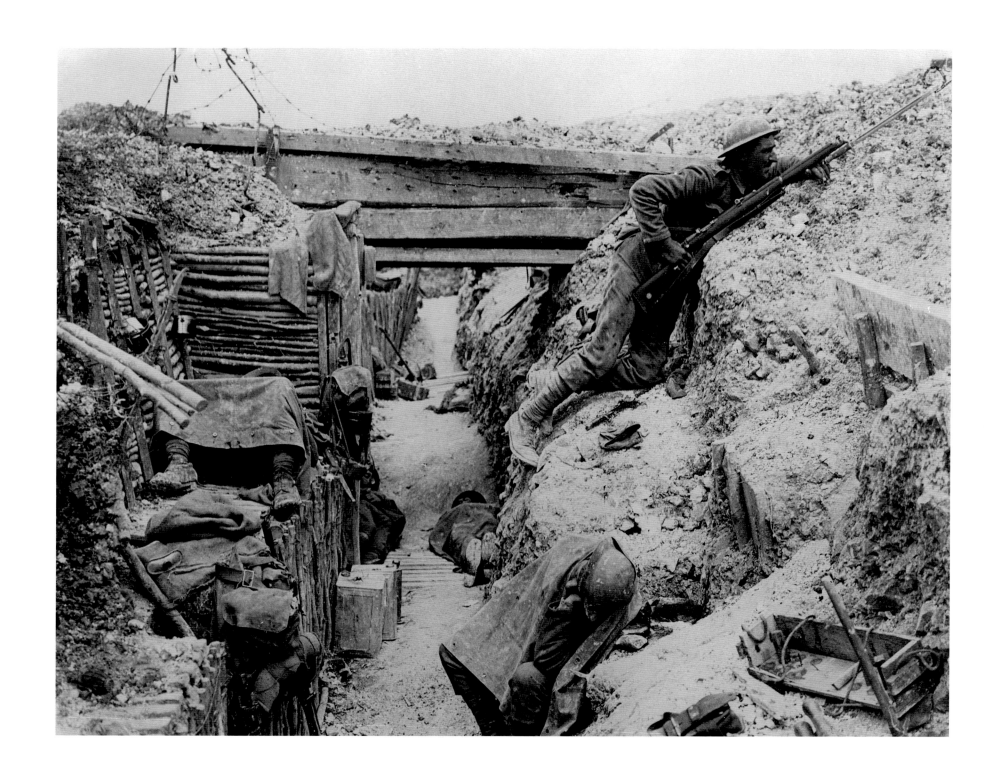

LIEUTENANT JOHN WARWICK BROOKE, British Army photographer
Soldiers of A Company, 11th Cheshire Regiment occupy a captured German trench.
A sentry stands guard on the fire step while his comrades sleep, Ovillers-la-Boisselle,
Somme, France, July 1916

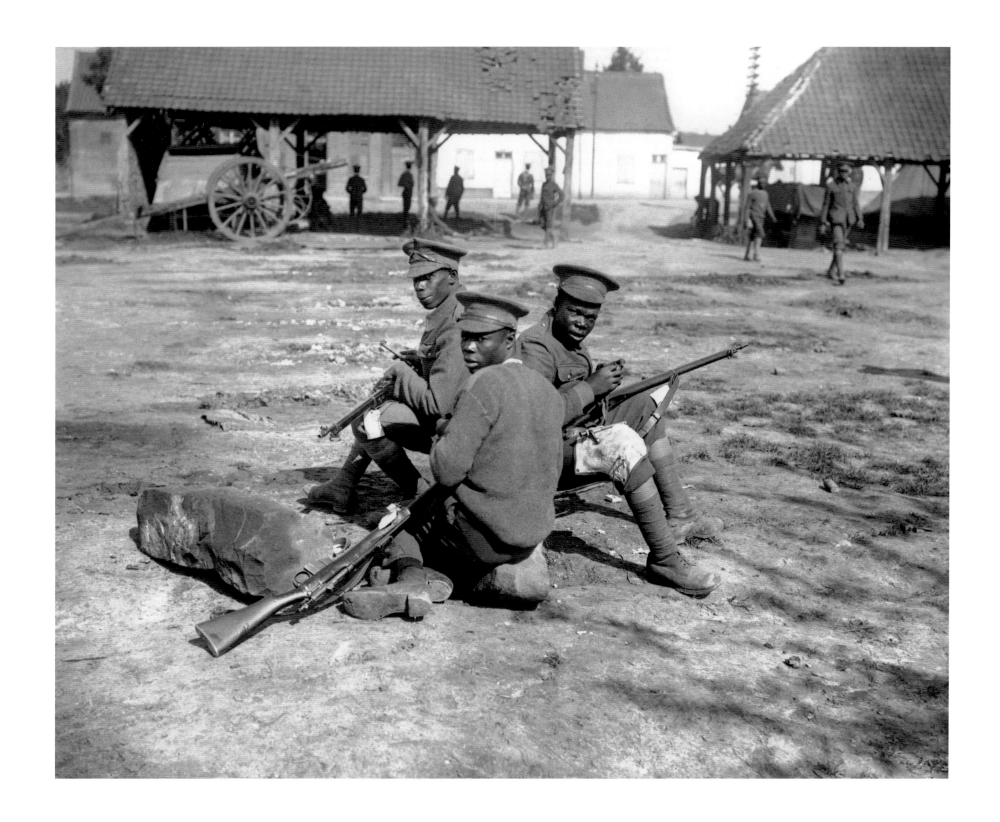

LIEUTENANT ERNEST BROOKS, British Army photographer
Soldiers of the British West Indies Regiment clean their rifles in a farmyard on the
Albert–Amiens road, Somme, France, September 1916

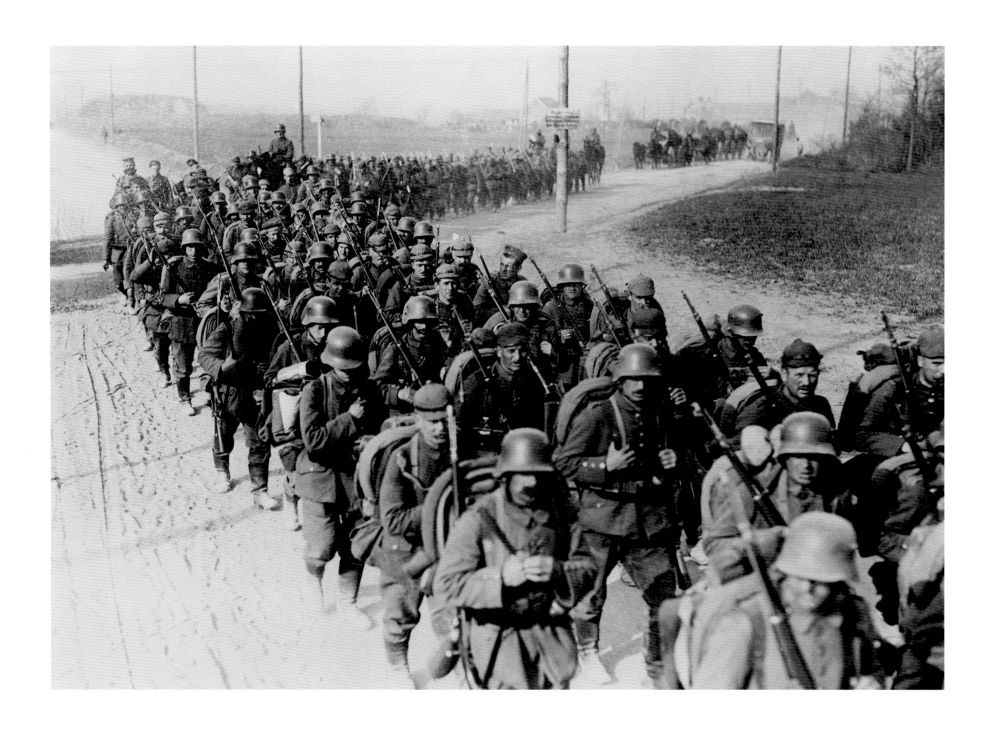

Unknown photographer, Imperial German Army
German troops on the march, Somme, France, 1916

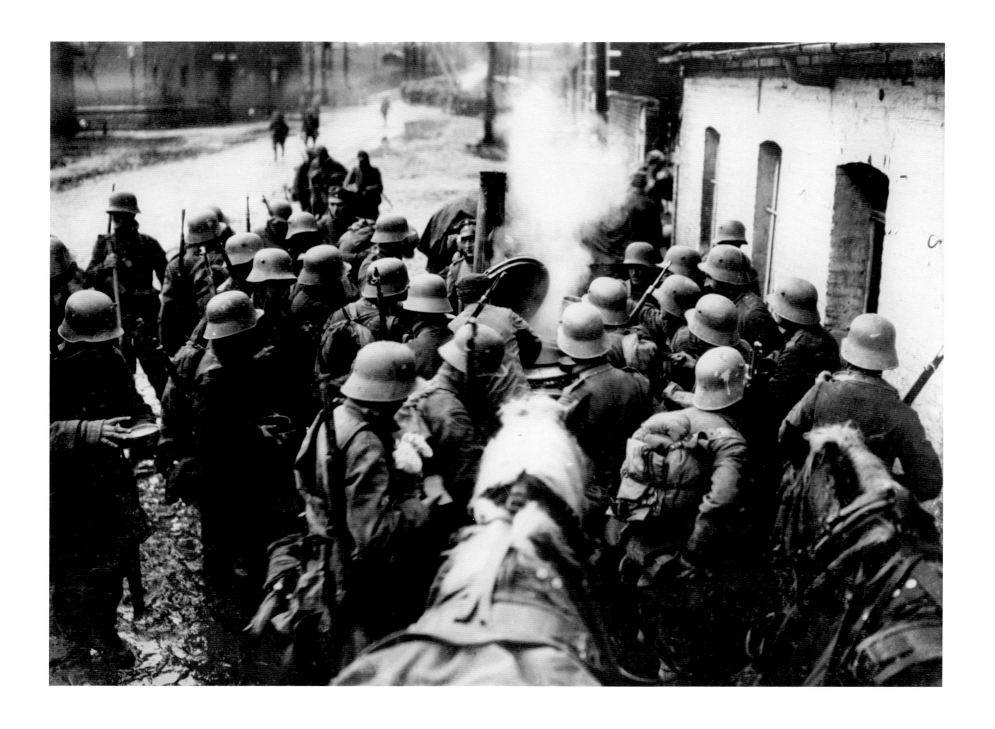

Unknown photographer, Imperial German Army
German assault troops gather round a field kitchen, Somme, France, 1916

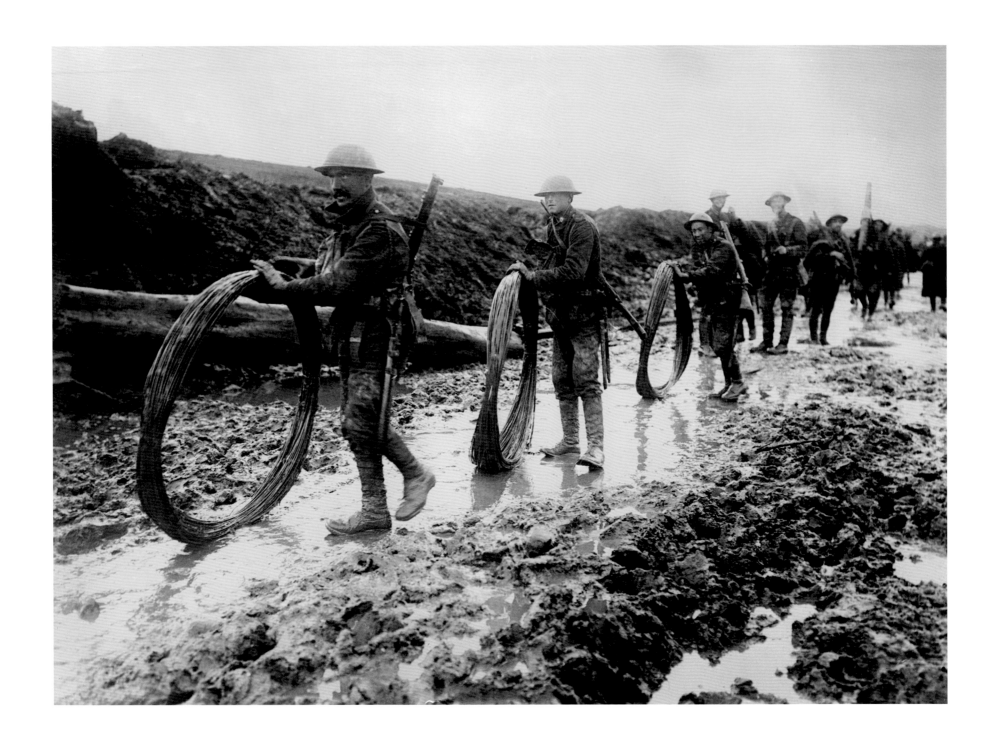

LIEUTENANT ERNEST BROOKS, British Army photographer
**British troops move reels of wire up to the front line, near Le Hamel, Somme, France,
September 1916**

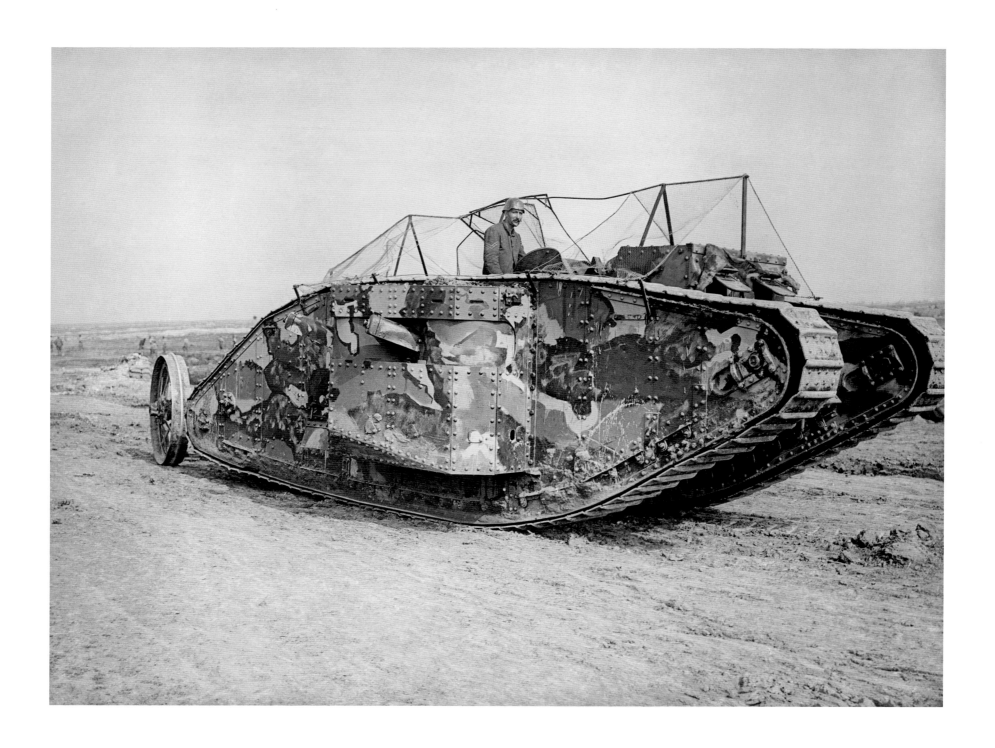

LIEUTENANT ERNEST BROOKS, British Army photographer
**The first official photograph of a British tank going into action, Flers-Courcelette,
Somme, France, 15 September 1915**
*Two months into the battle, the British deployed a new weapon: the tank. Although
most broke down or failed to reach their objective, their potential was clear*

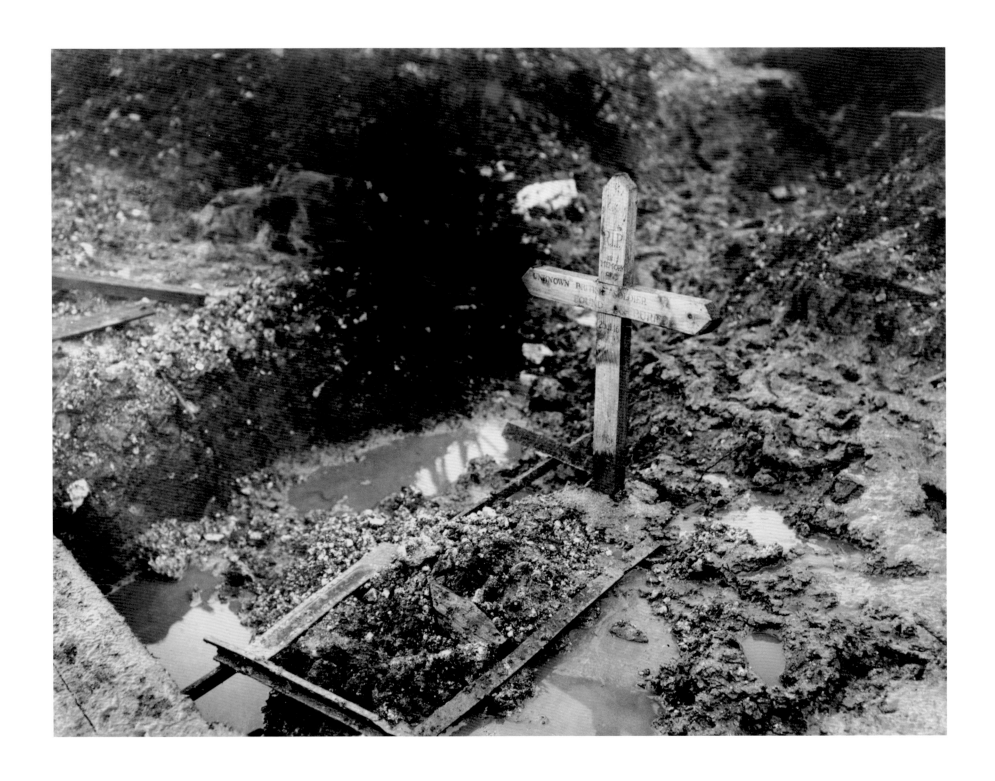

LIEUTENANT ERNEST BROOKS, British Army photographer
The grave of an unknown British soldier, Thiepval, Somme, France, September 1916
The battlefield degenerated into a quagmire as autumn set in

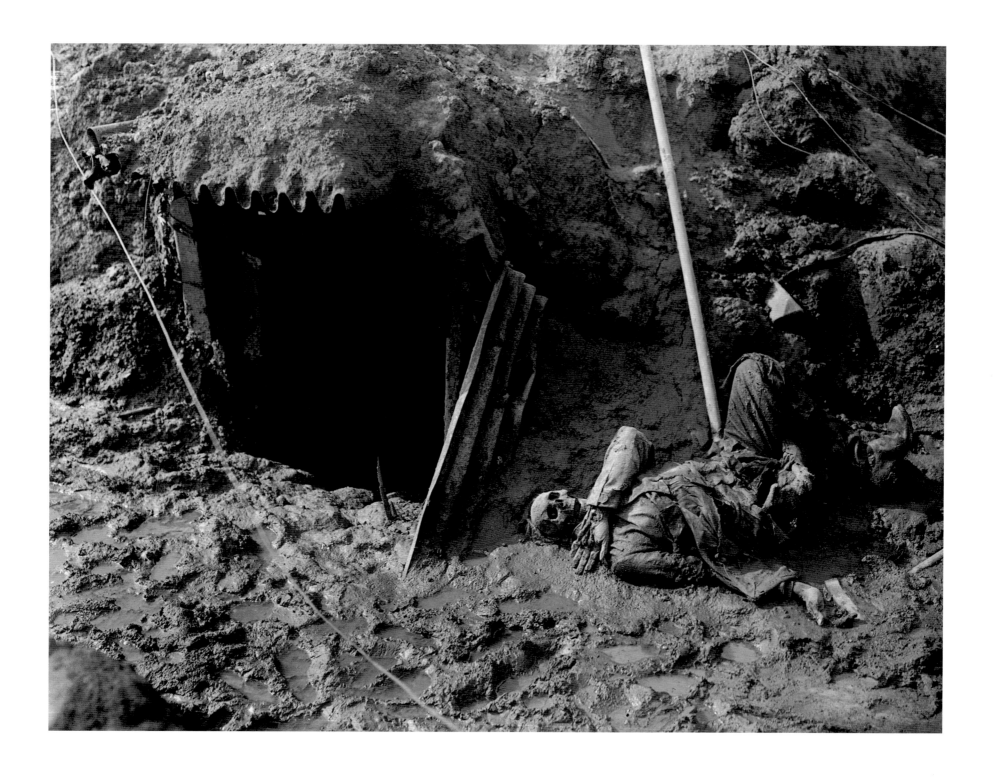

LIEUTENANT ERNEST BROOKS, British Army photographer
The decomposed body of a German soldier, killed at the entrance to his dugout,
Beaumont Hamel, Somme, France, November 1916

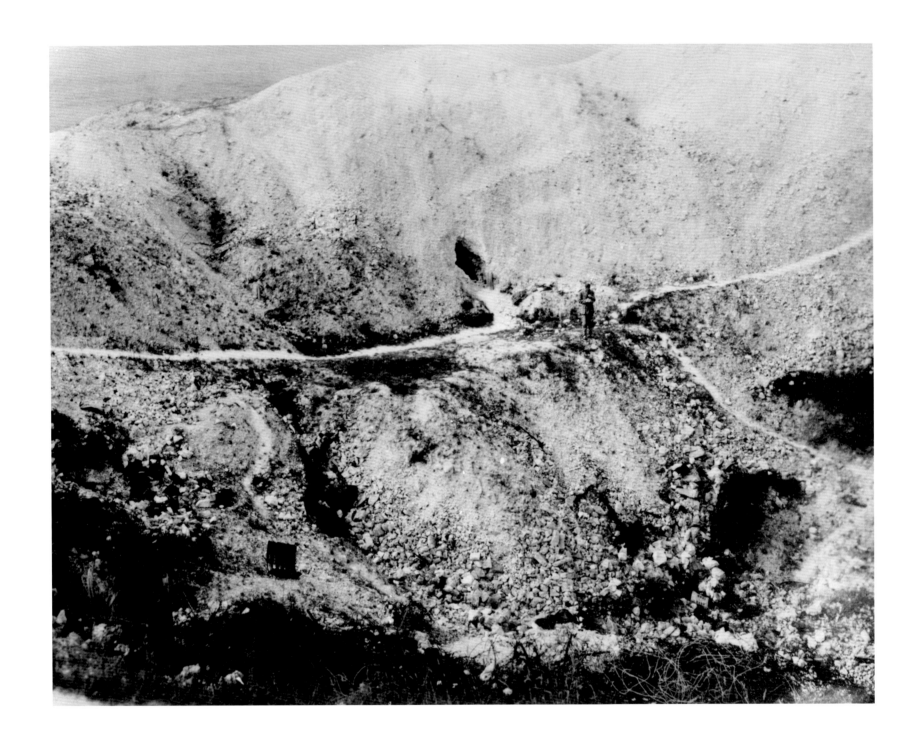

MISS KATHLEEN LAMB, personal photograph
The Lochnagar Crater, created by one of the mines detonated on 1 July 1916, became
a point of pilgrimage after the war, La Boisselle, Somme, France, July 1921

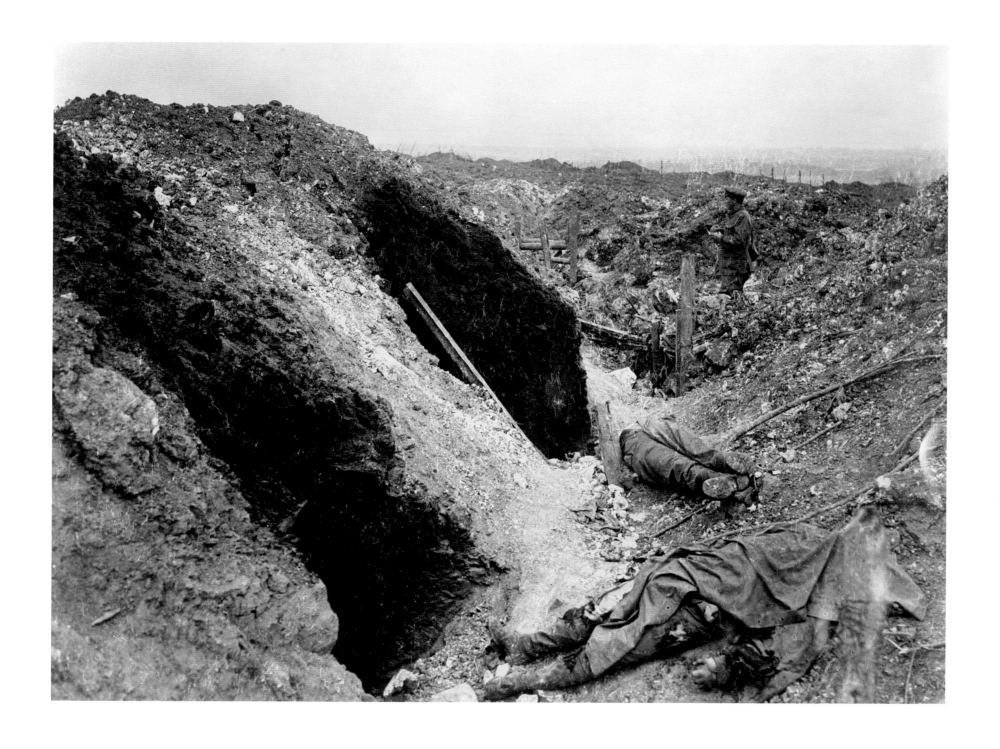

CAPTAIN HENRY KNOBEL, Canadian Army photographer
The bodies of two German soldiers lie in a trench badly damaged by artillery fire, near
Mametz, Somme, France, July 1916

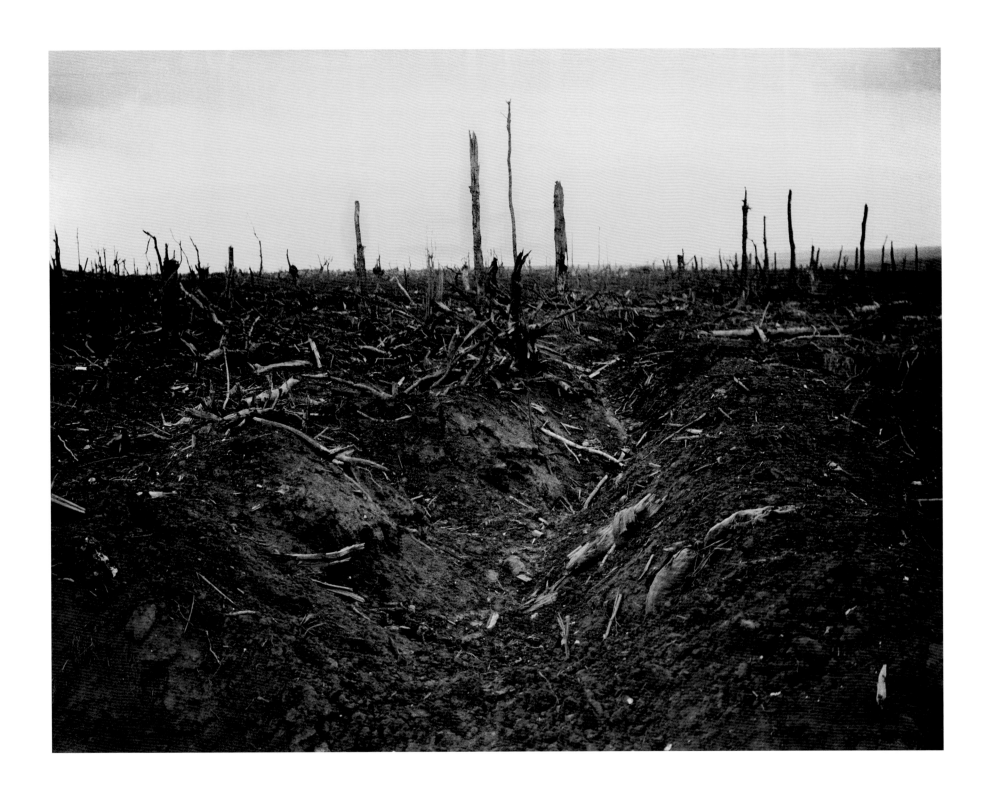

LIEUTENANT ERNEST BROOKS, British Army photographer
**The remains of a wood destroyed by shellfire, near Guillemont, Somme, France,
September 1916**

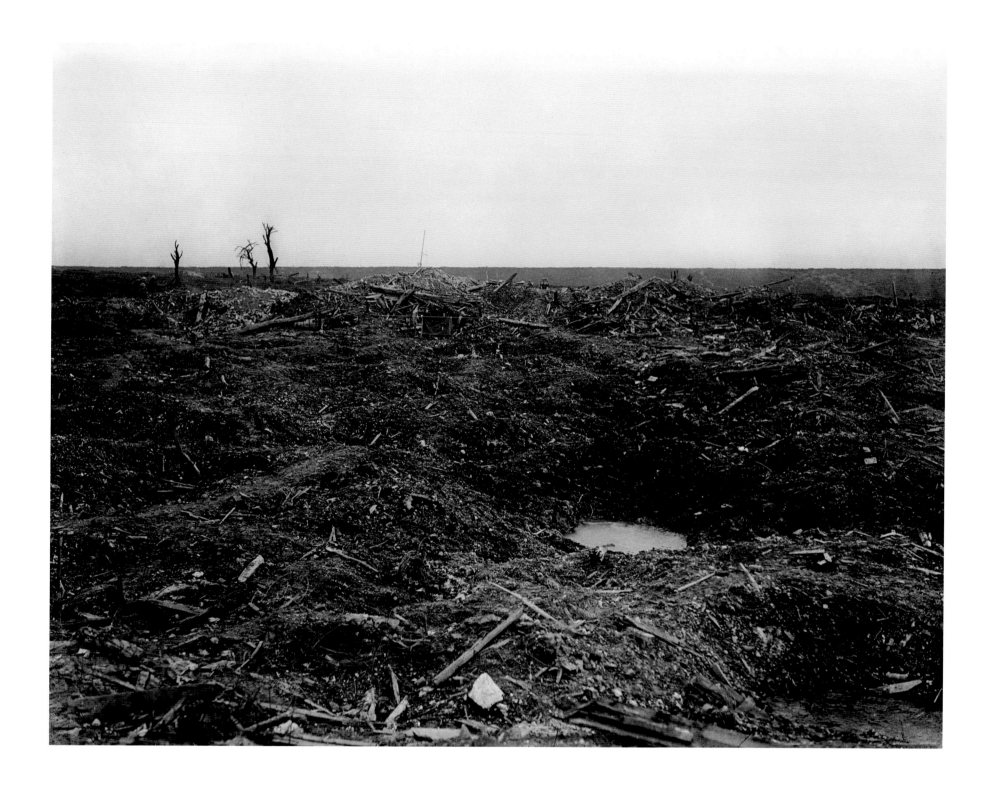

CAPTAIN HERBERT F. BALDWIN, Australian Army photographer
**The remains of a German strongpoint, Mouquet Farm, near Pozières, Somme, France,
November 1916**

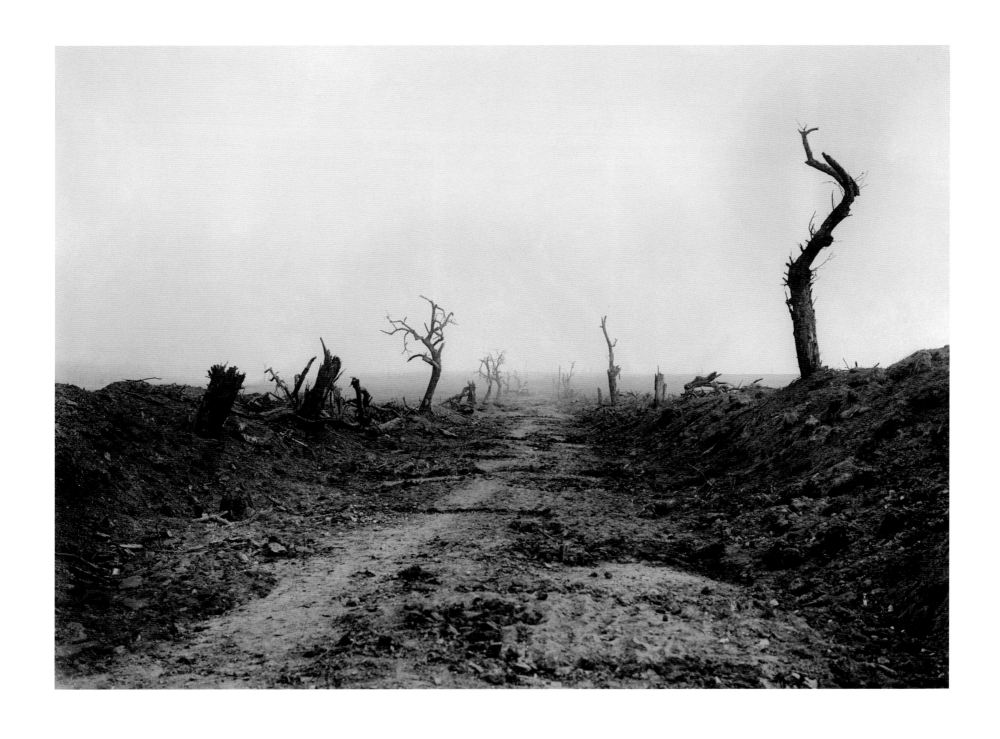

LIEUTENANT ERNEST BROOKS, British Army photographer
**Devastation caused by bitter fighting (not artillery fire), Waterlot Farm, near Guillemont,
Somme, France, 11 September 1916**

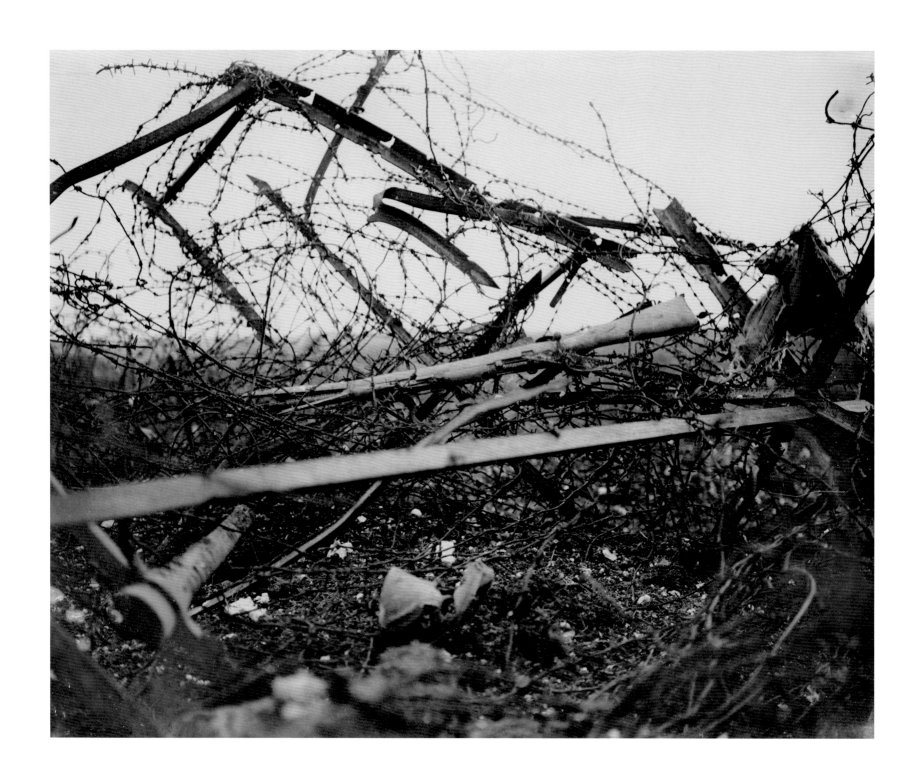

LIEUTENANT JOHN WARWICK BROOKE, British Army photographer
Study of German barbed-wire entanglement after troops of 63rd (Royal Naval)
Division captured the village of Beaucourt-sur-Ancre during the closing phase of the
Somme Offensive, Somme, France, 14 November 1916
The offensive was finally called off on 18 November 1916

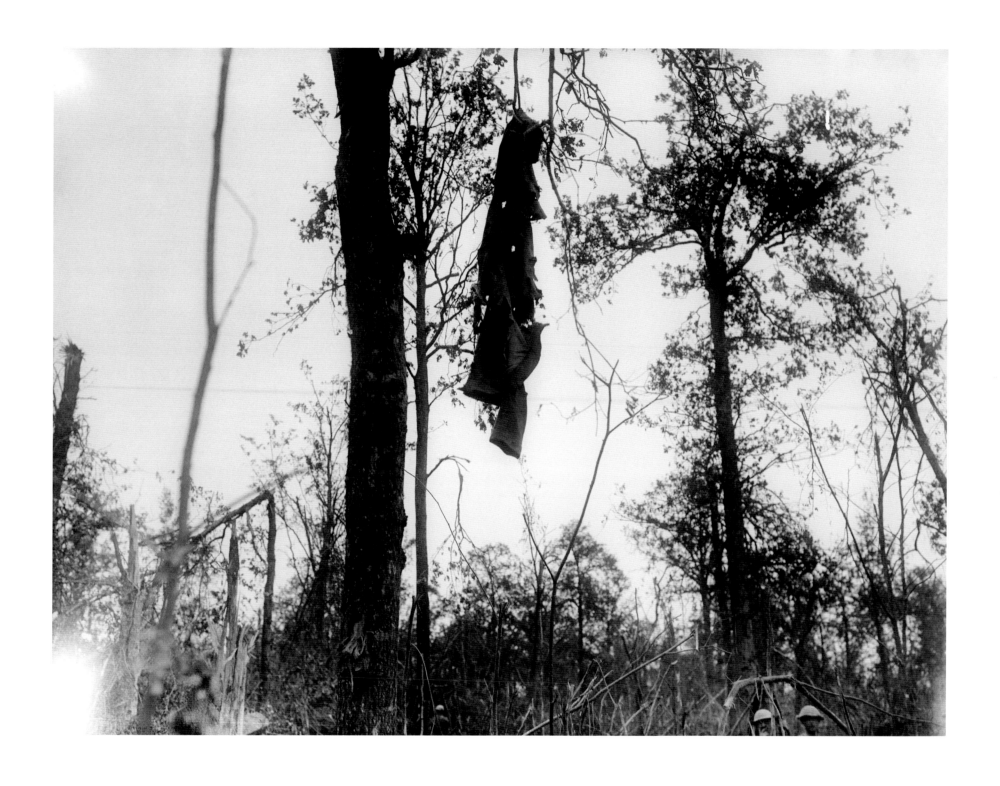

LIEUTENANT ERNEST BROOKS, British Army photographer
**A German soldier's overcoat blown into a tree by shellfire, Mametz Wood, Somme,
France, August 1916**

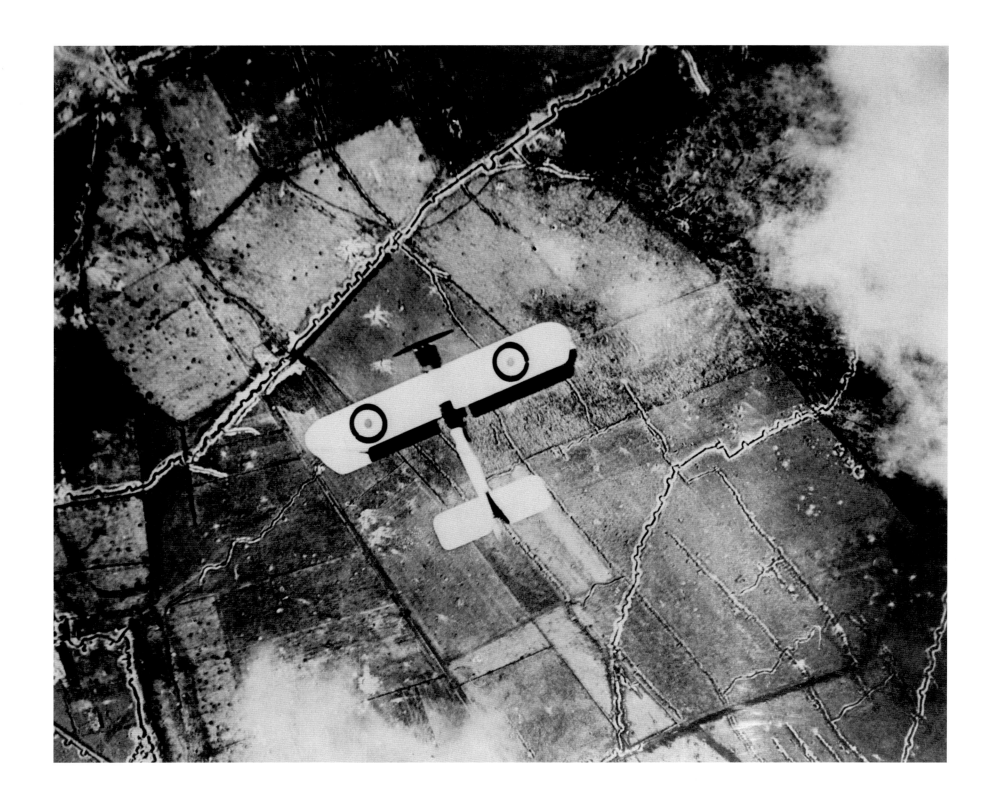

Unknown Royal Flying Corps photographer
A Royal Flying Corps BE 2C aircraft on an aerial photographic reconnaissance mission over trench lines in the Grand Bois area, near Wytschaete, Ypres, Belgium
The stability of the BE 2C made it an ideal photographic platform for the Royal Flying Corps, but its lack of speed and manoeuvrability made it particularly vulnerable. Forced to operate at high altitudes, most of these aircraft were accompanied by at least three fighters

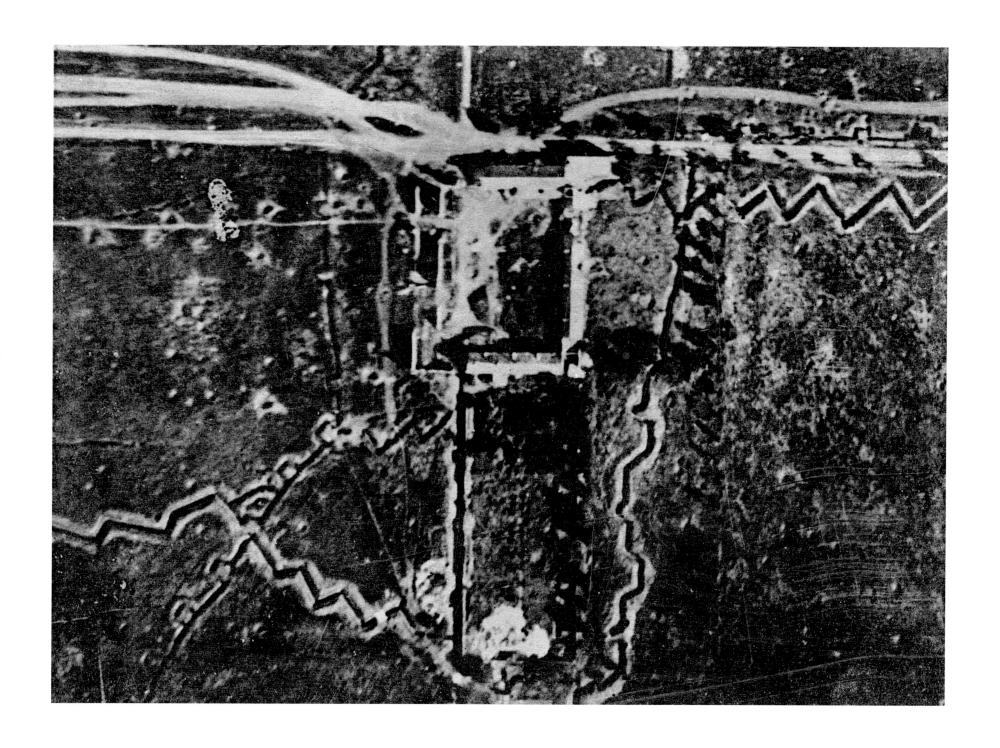

Unknown Royal Flying Corps photographer
Aerial view of Mouquet Farm, a German strongpoint, near Thiepval, Somme, France before the offensive, *c.* June 1916
Mouquet Farm served as advanced headquarters for German forces manning the second line of the trenches. Its capture proved difficult as the farm was surrounded by large underground dugouts and tunnels. British, Canadian and Australian forces repeatedly attempted to capture the farm, which held out until 26 September 1916

Right: Unknown Royal Flying Corps photographer
Aerial view of Mouquet Farm showing the effects of sustained artillery fire during the
Battle of the Somme, near Thiepval, Somme, France, September 1916

Pages 298–9: Zeppelin Company photographer, Friedrichshafen, Germany
German Zeppelin LZ 77 shortly before it was shot down at Revigny during the
opening phase of the Battle of Verdun, France, 21 February 1916

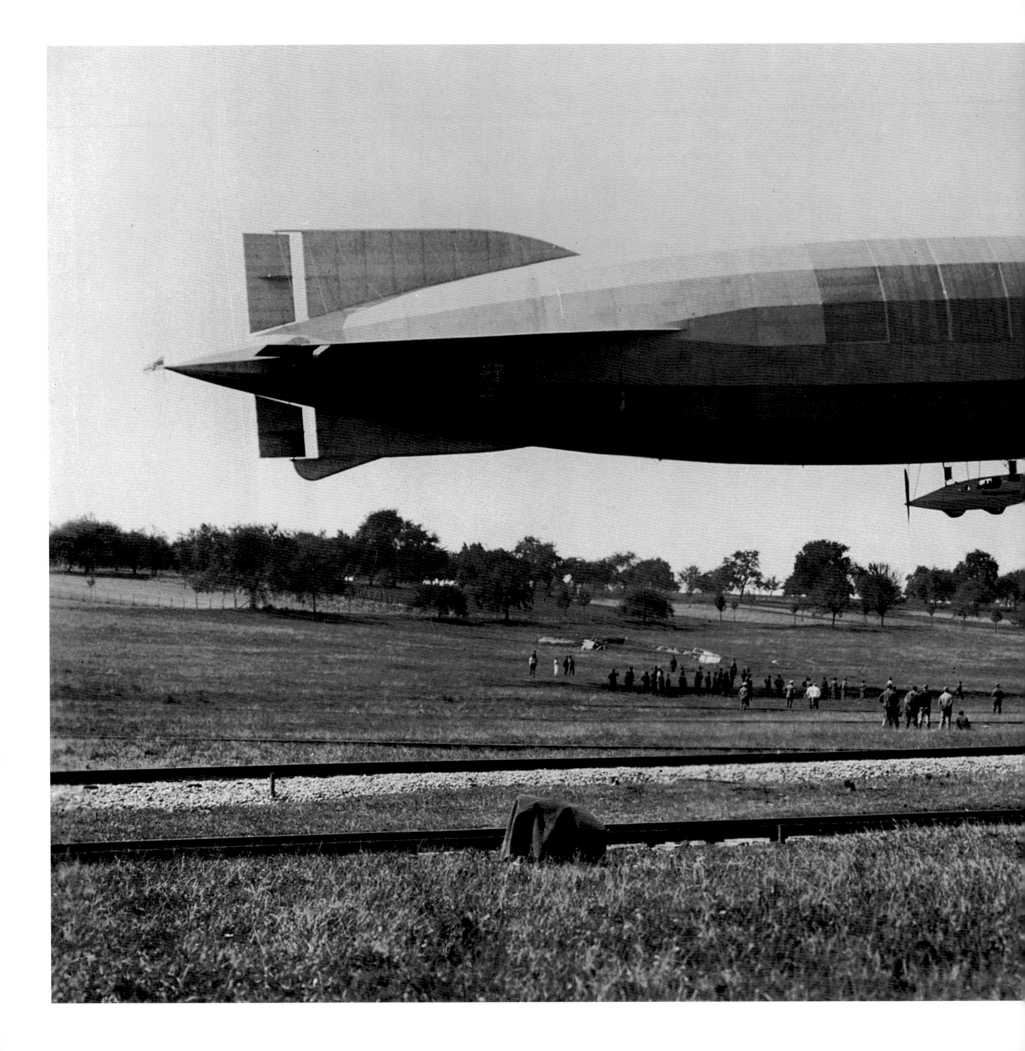

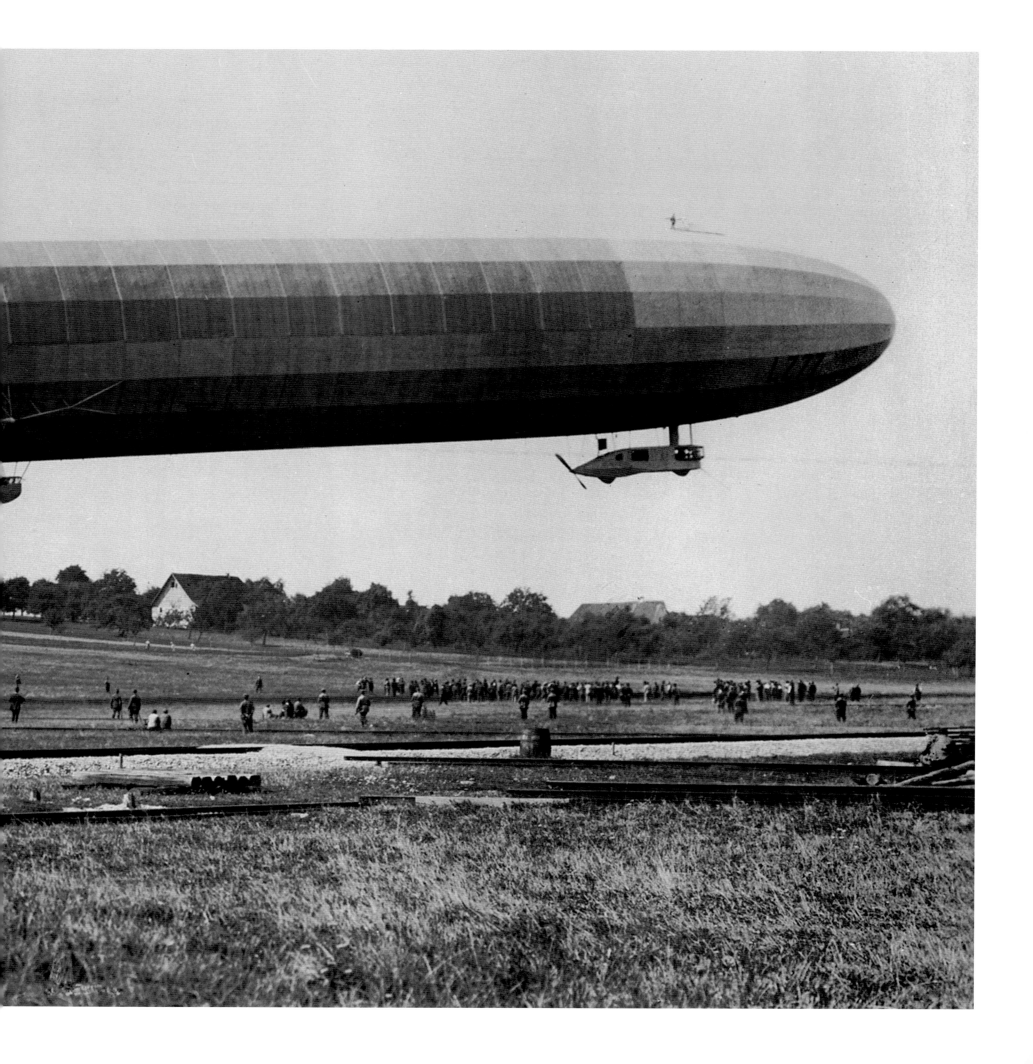

F. J. MORTIMER, FRPS, freelance commercial photographer, Editor of *Amateur Photographer* magazine, photomontage
'Gate of Goodbye', a montage depicting British soldiers bidding farewell to relatives, Victoria Station, London, 1916–17
This highly skilled montage was made up of at least twenty different photographs. Although fictional, the scene had such familiarity that it became an icon of the British public's experience of war on the Home Front

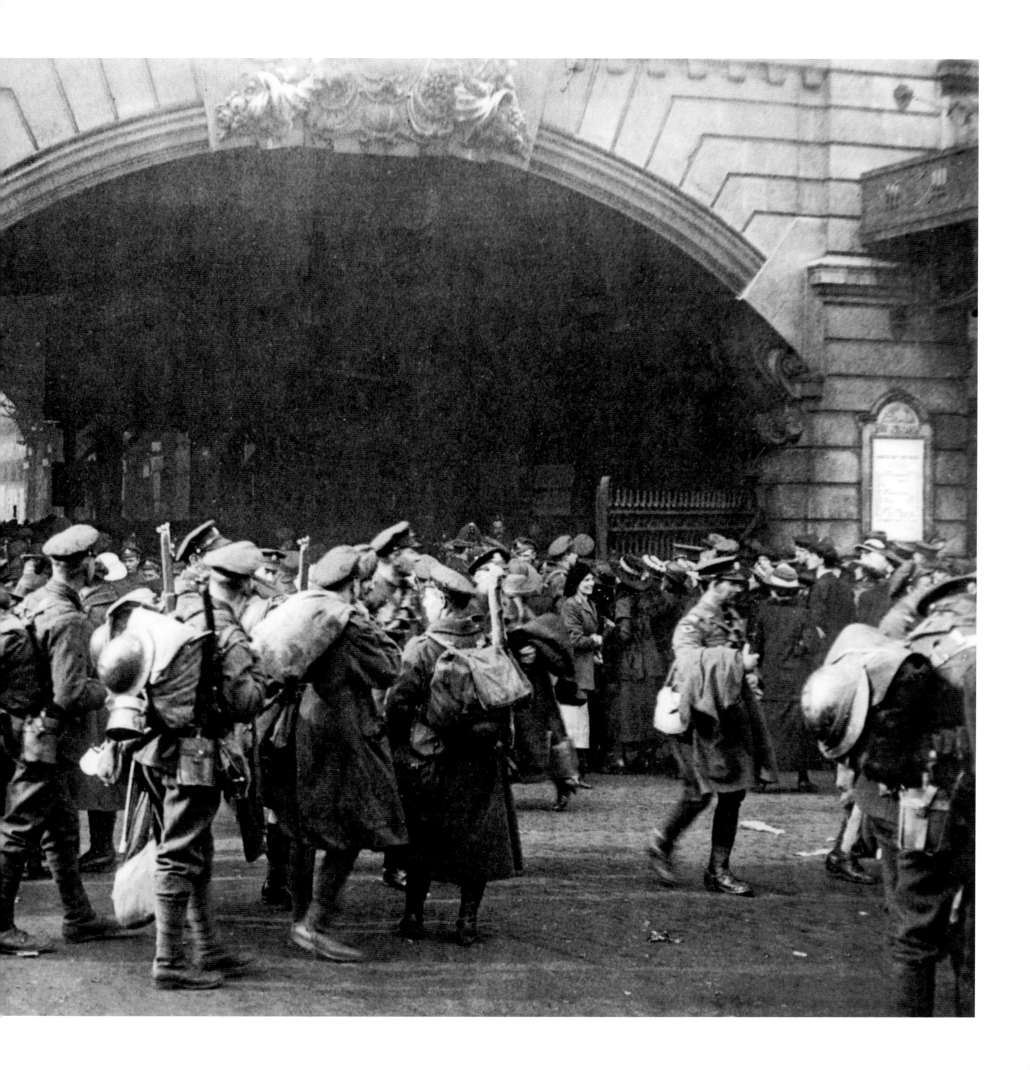

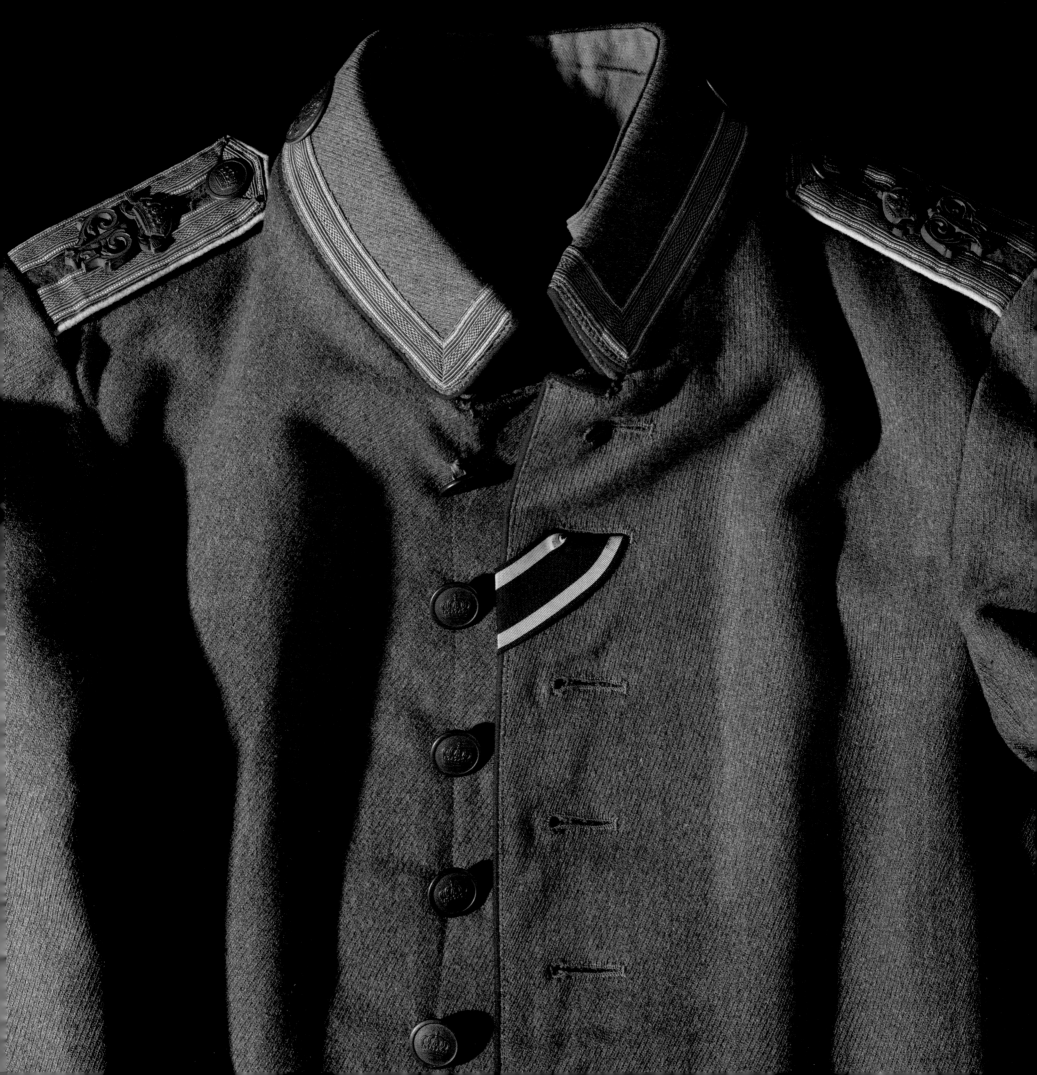

IV

YEAR	MASS MEDIA AND TECHNOLOGY	WAR PHOTOGRAPHY	WORLD EVENTS
1917 JANUARY	• Max Aitken accepts a peerage from Lloyd George and takes title Lord Beaverbrook, Britain. Lord Northcliffe and Lord Rothermere subsequently appointed viscounts. All appointments attract public controversy • Colonel John Buchan takes control of Department of Information, Britain. DoI Advisory Committee includes (at various times) Lord Northcliffe, Lord Burnham (*Daily Telegraph*), Robert Donald (*Daily Chronicle*), C. P. Scott (*Manchester Guardian*) & Sir George Riddell	• Introduction of L-Type aerial camera, the most sophisticated aerial camera used by the RFC during the war • In response to work of Allied official photographers, German Army establishes Bild und Film Amt (Bufa) [Photo & Film Office] to improve supply of propaganda imagery	• 19 January: Explosion at Silvertown munitions factory, Silvertown, London, Britain • January–April 'Turnip Winter', Germany
1917 FEBRUARY	• War Propaganda Bureau at Wellington House absorbed into Department of Information headed by Col John Buchan, Britain • Lowell Thomas presents his film and photography of Alaska to Franklin K. Lane, Secretary of State for the Interior, US		• 1 February: Germany recommences unrestricted submarine warfare • 3 February: British civilians urged to observe voluntary rationing to conserve food supplies • 3 February: US severs diplomatic relations with Germany in response to resumption of unrestricted submarine warfare • 24 February: British forces capture Kut al Amara, Mesopotamia • 25 February: German forces begin withdrawal to the Hindenburg Line, Western Front
1917 MARCH	• Launch of *Isvestia* newspaper, Russia. It quickly becomes the official voice of the Soviet Government	• Canadians use aerial photographs to build a scale model to plan their assault on Vimy Ridge • Ariel Varges, US photographer and cinematographer, appointed British official photographer in Mesopotamia and Salonika	• 5 March: British Government approves Alfred Mond's proposal for a National War Museum. Charles Ffoulkes, Curator of Royal Armouries, is appointed Curator, Britain • 11 March: British forces capture Baghdad, Mesopotamia • 12 March: Start of first Russian Revolution, Petrograd • 15 March: Tsar Nicholas II abdicates and a Provisional Government is formed, Russia • 26 March: 1st Battle of Gaza, Middle East • 28 March: Formation of Women's Auxiliary Army Corps (WAAC) allows women to serve with the armed forces for the first time • 31 March: First WAAC contingent arrives in France

1917 APRIL

MASS MEDIA AND TECHNOLOGY

- Horace W. Nicholls' son Arthur is killed in action on the Western Front

WAR PHOTOGRAPHY

- George Eastman puts Kodak resources at the disposal of the US Government. The War Department initially declines to base its school of aerial photography at Kodak's facility in Rochester, preferring to maintain its facilities at Langley Field, Fort Sill and Cornell

- Beaverbrook fires Canadian official cinematographer Lt Oscar Bovill, for faked coverage of Vimy Ridge

- Bert Underwood joins US Army Signal Corps and serves as Head of Special Services Division, Office of the Chief Signal Officer in the US War Department. His responsibilities include censoring the output of his own firm

- Alfred Dawson joins the US Army Signal Corps and serves as Captain in Charge of the Signal Corps' darkrooms

WORLD EVENTS

- 3 April: Vladimir Lenin, leader of Russian Bolshevik Party, returns to Russia from Switzerland, passing through Germany in a sealed train

- 6 April: US declares war on Germany

- 9 April–4 May: Battle of Arras; Canadians seize Vimy Ridge, Western Front

- 16 April: 2nd Battle of the Aisne; Nivelle Offensive, Western Front

- 17 April: 2nd Battle of Gaza, Middle East

- 24 April–22 May: 1st Battle of Doiran, Salonika

- 29 April–October: Mutinous outbreaks in the French Army, Western Front

1917 MAY

MASS MEDIA AND TECHNOLOGY

- Australian War Records Section established, London, Britain

- Hubert Wilkins returns from photographing the Canadian Arctic Expedition to the North Pole and applies to join Australian Flying Corps

WORLD EVENTS

- 10 May: Royal Navy introduces convoy system in response to German submarine warfare

- 15 May: General Pétain replaces General Nivelle in command of French armies, Western Front

- 18 May: US Congress passes war service legislation

- 21 May: Imperial War Graves Commission established

- 25 May: First daylight bombing raid on Britain by German Gotha aircraft

1917 JUNE

MASS MEDIA AND TECHNOLOGY

- Alfred Stieglitz publishes last edition of *Camera Work*

- At the request of General Pershing, Frederick Palmer, *New York Herald* chief correspondent in Europe, enlists as an officer with the American Expeditionary Force and accepts role as head of AEF press and censorship bureau. His role quickly proves incompatible with that of a journalist

WAR PHOTOGRAPHY

- Australian official photographer Herbert Baldwin's health fails as a consequence of his experience of the bombardment of Messines. RFC carries out daily aerial photography of Messines

- William Rider-Rider (*Daily Mirror*) takes over from William Ivor Castle as Canadian official photographer on the Western Front. Despite poor eyesight, he takes *c.* 4,000 photographs at the front

WORLD EVENTS

- 7–14 June: Battle of Messines, Western Front

- 10–29 June: Battle of Ortigara, Italian Front

- 13 June: Daylight raid on London by German Gotha bombers; 157 killed

- 17 June: First action involving Portuguese troops, Western Front

- 28 June: First contingent of US troops arrive in France; General Allenby assumes command of Egyptian Expeditionary Force, Middle East

- 29 June–18 July: Kerensky Offensive, Eastern Front

YEAR	MASS MEDIA AND TECHNOLOGY	WAR PHOTOGRAPHY	WORLD EVENTS
1917 JULY	• Nippon Kogaka KK (Nikon) established, Japan • Hubert Wilkins' application to Australian Flying Corps refused when he is discovered to be colour-blind	• UK Department of Information appoints Horace W. Nicholls first official photographer to Home Front in Britain. Nicholls and G. P. Lewis record contribution of women and civilian workers to the war effort • US Army Signal Corps assumes responsibility for US Army official photography	• 6 July: Arab force guided by T. E. Lawrence captures Aqaba, Jordan; Canada introduces conscription • 7 July: Daylight raid on London by German Gotha bombers; 57 killed • 14 July: George Michaelis replaces Theobald von Bethmann Hollweg as German Chancellor • 17 July: Royal Family changes name to Windsor (from Saxe-Coburg-Gotha) • 31 July–10 November: 3rd Battle of Ypres (Passchendaele), Western Front
1917 AUGUST	• George Eastman agrees that Kodak should forgo any profits on its products for the duration of the war, United States • Kriegspresseamt holds conference to consider weaknesses in German propaganda and methods of countering British propaganda successes. Concludes that German official propaganda has lost contact with public opinion, is insensitive, dull and consistently defensive	• Frank Hurley and Hubert Wilkins start work as Australian official photographers & cinematographers on the Western Front. Supervised by Charles Bean, they cover 3rd Battle of Ypres (Passchendaele) • US Army Signal Corps Photographic Division established with a complement of 25 • US Navy establishes School of Photography and Photographic Section • At suggestion of Franklin K. Lane, US Secretary of the Interior, Lowell Thomas and photographer Harry Chase depart to report war in Europe	• 3 August: German High Seas Fleet Mutiny, Wilhelmshaven • 6 August: Alexander Kerensky becomes Prime Minister of Russia • 20 August: French offensive at Verdun, Western Front
1917 SEPTEMBER		• Frank Hurley argues for permission to create composite photographs of scenes on the Western Front. He is opposed by Charles Bean, who believes this will undermine public faith in official war photography • RFC generate 15,837 aerial photographs	• 3 September: Germans capture Riga, Eastern Front • 20 September: Battle of Menin Road Ridge, Western Front • 29 September: First night raid on London by German Gothas
1917 OCTOBER	• Chancellor Bethmann-Hollweg refuses to create Ministry of Propaganda, fearing it will strengthen military power at the expense of the civilian government, Germany. Kriegspresseamt accused of wasteful use of resource	• Frustrated by being denied permission to create composite images, Hurley tenders his resignation as an official photographer. It is refused and he is given permission to create 6 composite images in the pictorialist style, including *Over The Top*. Also takes iconic image of Chateau Wood during Battle of Passchendaele • Tom Grant, returning home from working as an official photographer in Salonica, is a passenger on the French liner SS *Sontay* when it is torpedoed by German submarine, U-33. Grant retrieves his camera and photographs passengers and crew abandoning ship	• 6 October: Sinking of SS *Sontay* • 19 October: Last German airship raid on London • 24 October–10 November: Battle of Caporetto, Italian Front • 26 October: 2nd Battle of Passchendaele, Western Front • 31 October: 3rd Battle of Gaza, Middle East

YEAR	MASS MEDIA AND TECHNOLOGY	WAR PHOTOGRAPHY	WORLD EVENTS
1917 NOVEMBER	• Kenneth Mees, Head of Research at Kodak, provides a position paper for George Eastman, recommending that the Kodak Company should become a 'controlled' establishment and should be made responsible for the photographic technique of the United States Army	• Frank Hurley leaves Western Front for Palestine. George Wilkins continues to work on Western Front until end of war • Viktor Bulla covers October Revolution, Russia. Appointed Chief Photographer of the Leningrad Soviet • Ernest Brooks posted to Italian Front, where he is attached to Intelligence Section, GHQ Italy. Complains that photography is hampered by lack of car and bad weather	• 2 November: Balfour Declaration announces British Government's support for Jewish Homeland in Palestine • 7 November: Bolsheviks seize power in 2nd Russian Revolution • 10 November: Village of Passchendaele captured, ending 3rd Battle of Ypres, Western Front • 16 November: George Clemenceau becomes Prime Minister and Minister of War, France • 20–30 November: Battle of Cambrai; significant use of tank, Western Front
1917 DECEMBER	• André Kertész publishes first photographs while convalescing from his injuries, Hungary	• Official, press and amateur photographers cover Allenby's entry into Jerusalem. Sgt George Westmoreland's low rank hampers his coverage • F. J. Mortimer publishes his work *'All's Well': The Mine-sweeper and the Destroyer* in *Photogram* • General Pershing permits civilian press photographers to cover US troops in the front line • Austro-Hungarian Kriegspressequartier (KPQ) creates official photographic unit	• 9 December: British forces take Jerusalem, ending 673 years of Turkish rule, Middle East • 15th December: Bolshevik Government signs armistice with Germany, suspending hostilities on Eastern Front

By 1917, civilians were fully integrated in the war effort. While men served overseas, women assumed new roles in industry, agriculture and the armed forces. Although wages were good, appalling working conditions resulted in accidents and strikes. British civilians continued to endure air raids while the naval blockade caused serious shortages in Germany where the winter of 1916–17 became known as the 'Turnip Winter'. In retaliation, Germany resumed unrestricted submarine warfare, hoping to cut off Allied supply lines and starve Britain into submission. Shipping losses reached new heights and Britain faced the possibility of starvation. This was averted by the introduction of convoys, food conservation campaigns and improved domestic food production.

On the Western Front, the German Army, now commanded by Field Marshal Paul von Hindenburg and General Erich Ludendorff, executed a strategic retreat to its strongly fortified Hindenburg Line. Britain and France mounted another sequence of powerful offensives, involving more sophisticated use of artillery, tanks, mines and chemical weapons at Arras, the Aisne and finally at Ypres (also known as Passchendaele), but the German defences proved resilient. After the failure of the Aisne Offensives, mutinies temporarily weakened the French Army. Meanwhile German pilots, amongst them the charismatic Manfred von Richthofen, ruled the skies until a new generation of Allied aircraft challenged their superiority.

Fortunes fluctuated on other fronts. Anglo-Indian forces resumed their campaign in Mesopotamia, retaking Kut and entering Baghdad. In Palestine, General Sir Edmund Allenby mounted a successful campaign, capturing Jerusalem in December 1917. Arab tribes, encouraged by Colonel T. E. Lawrence, rose in revolt against the Turks. On the Italian Front, the Central Powers achieved a major success at Caporetto, which resulted in the near-collapse of the Italian Army.

Unrestricted submarine warfare proved a diplomatic disaster for Germany. The United States responded by severing diplomatic relations with Germany. The affair of the 'Zimmermann telegram', which exposed a proposal for a German and Mexican alliance against the United States, proved the final straw. In April 1917, the United States declared war on Germany. The relief of Britain and France was tempered by concern as revolution broke out in Russia. The Tsar was replaced by a Provisional Government, which in turn was overthrown in a second revolution led by Vladimir Lenin's Bolshevik Party. Hopes that Russia would continue to fight on the Eastern Front proved in vain. As 1917 drew to a close, Russia entered into peace negotiations with Germany.

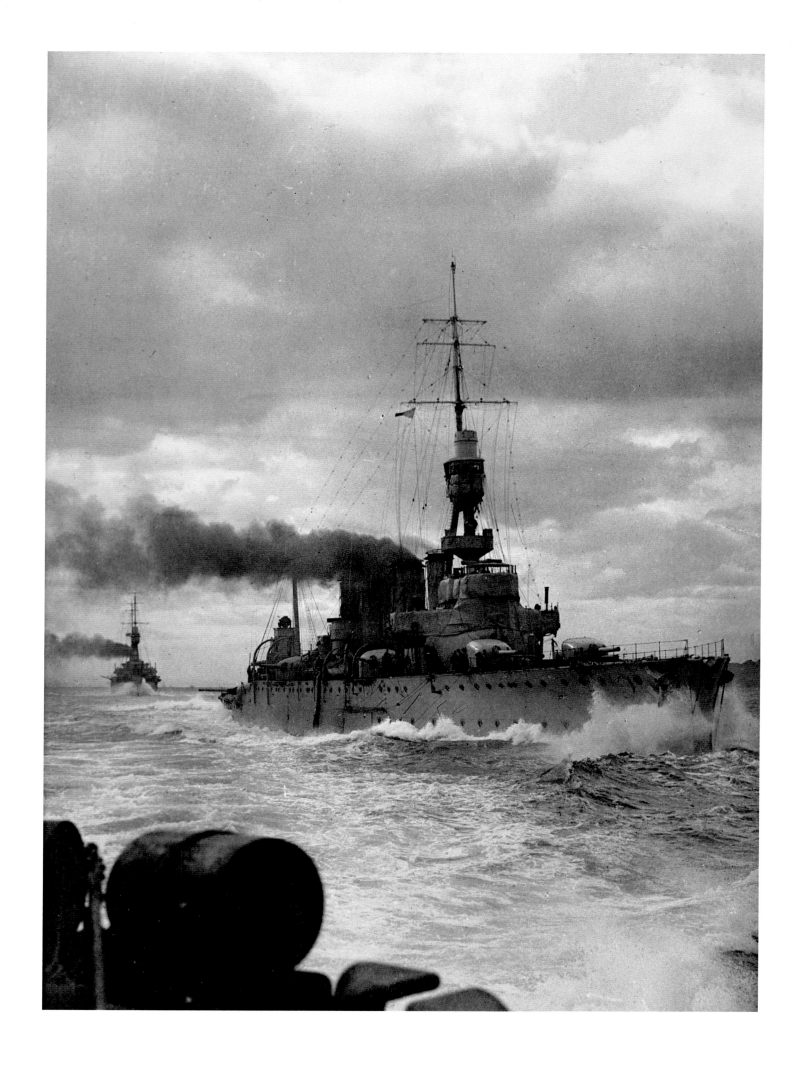

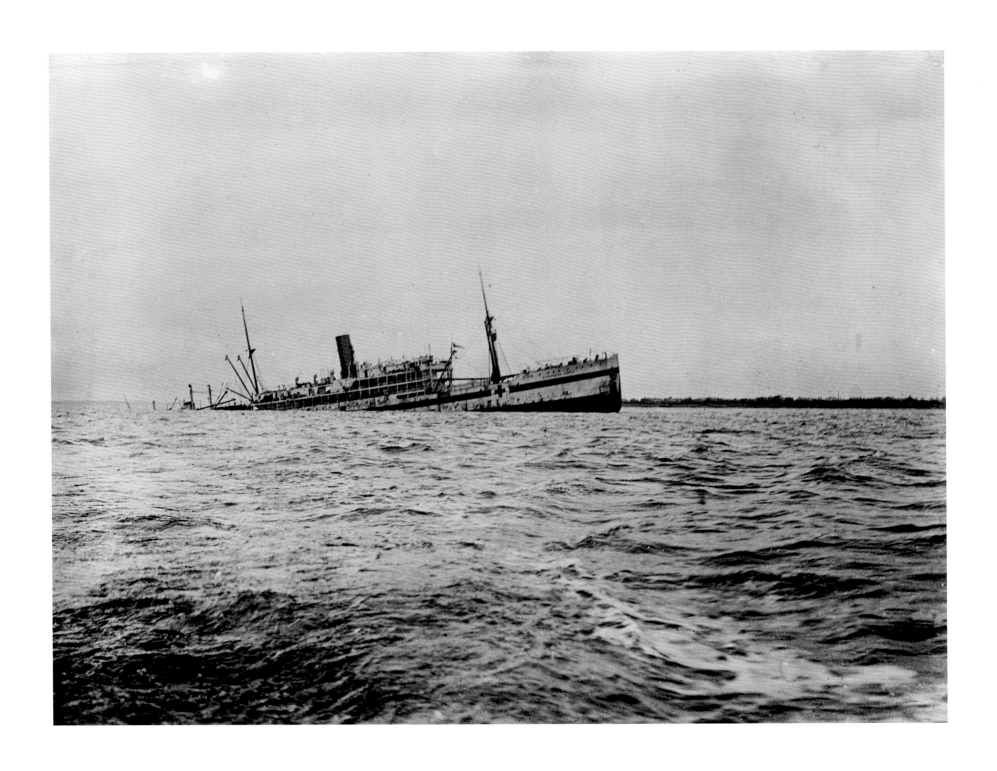

Unknown British photographer, personal photograph
**Hospital ship HMHS *Gloucester Castle* founders after being torpedoed by German
submarine UB-32 off the Isle of Wight, English Channel, 31 March 1917**
*An unprecedented 2,439 Allied and neutral ships were sunk by German submarines in
1917. Losses diminished following the introduction of the convoy system in June*

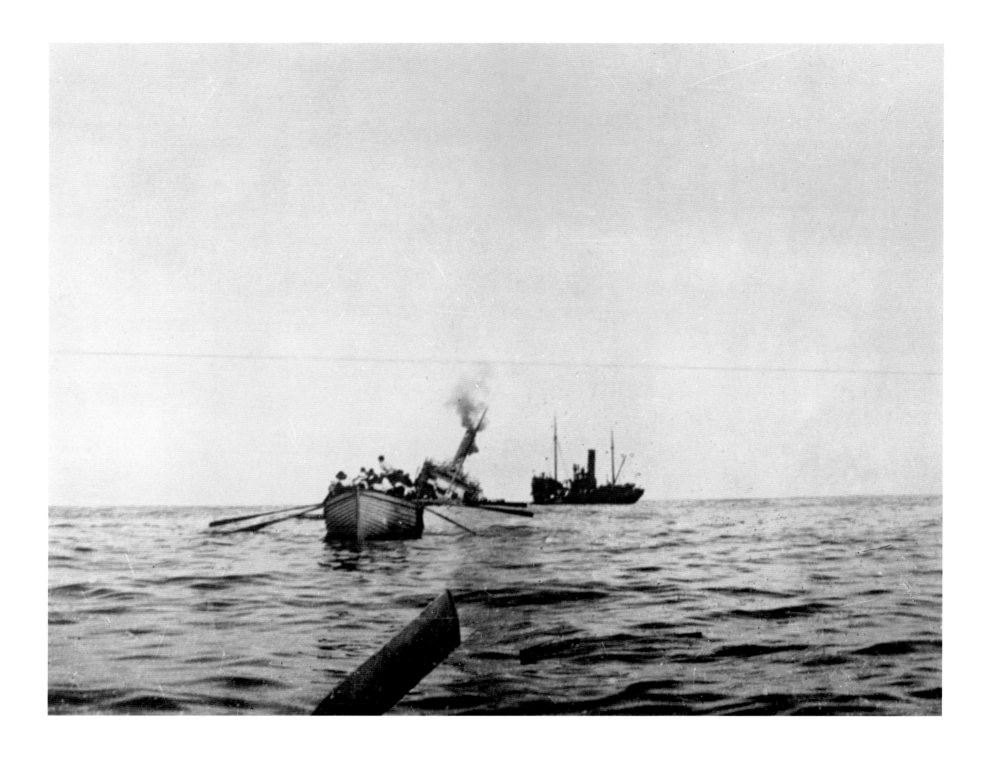

Above: Unknown British photographer, personal photograph
A lifeboat rows clear of troopship SS *Aragon* as she sinks with the loss of 610 lives after being torpedoed by German submarine U-34 off Alexandria, the Mediterranean, 30 December 1917
SS Aragon was carrying 2,700 troops from Marseilles to the Palestine Front. Two ships that came to the rescue were also torpedoed

Pages 312–13: Unknown British photographer, personal photograph
Passengers and crew use ropes to escape from the sinking British troopship HMT *Arcadian*, which had been torpedoed by German submarine UC-74 on passage from Salonika to Alexandria, Aegean Sea, 15 April 1917
Germany resumed unrestricted submarine warfare on 17 January 1917 in the hope of weakening the blockade and strangling British supply lines

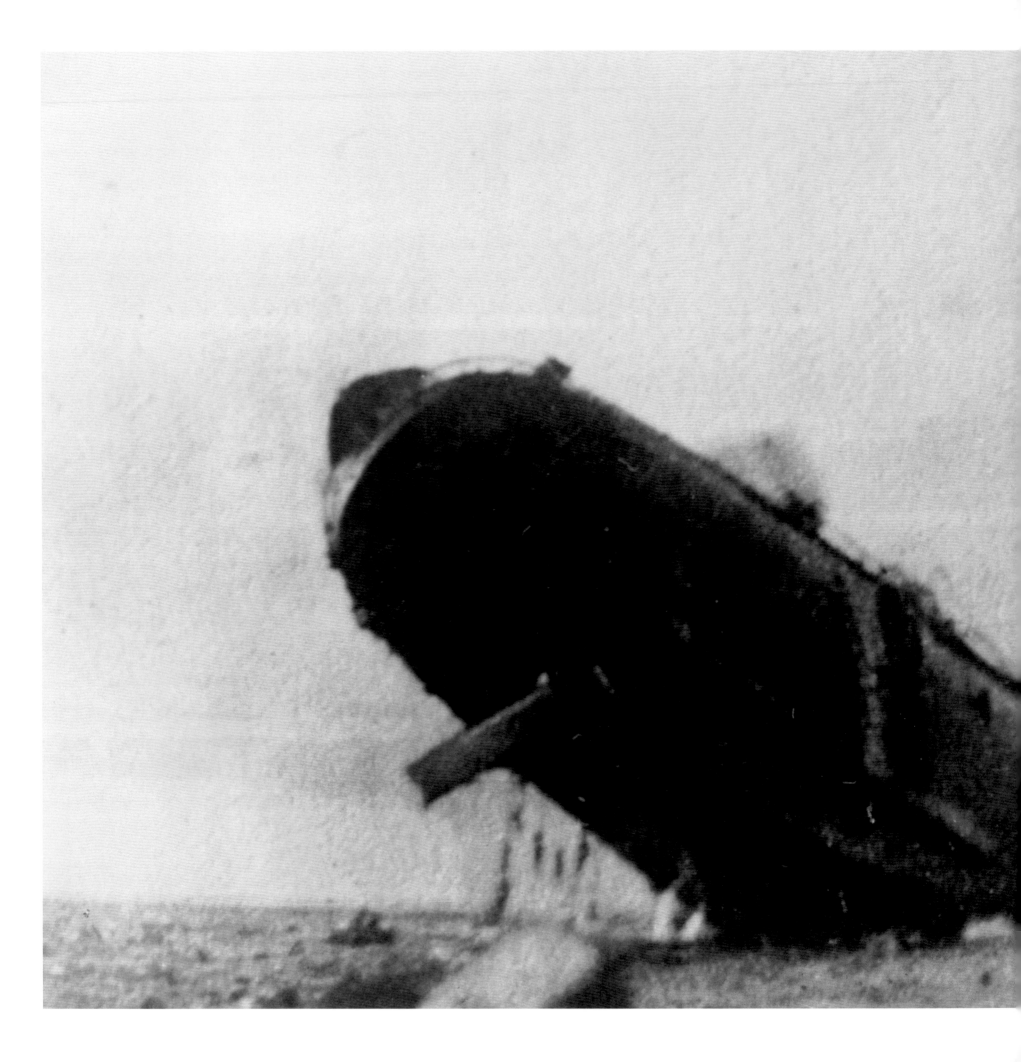

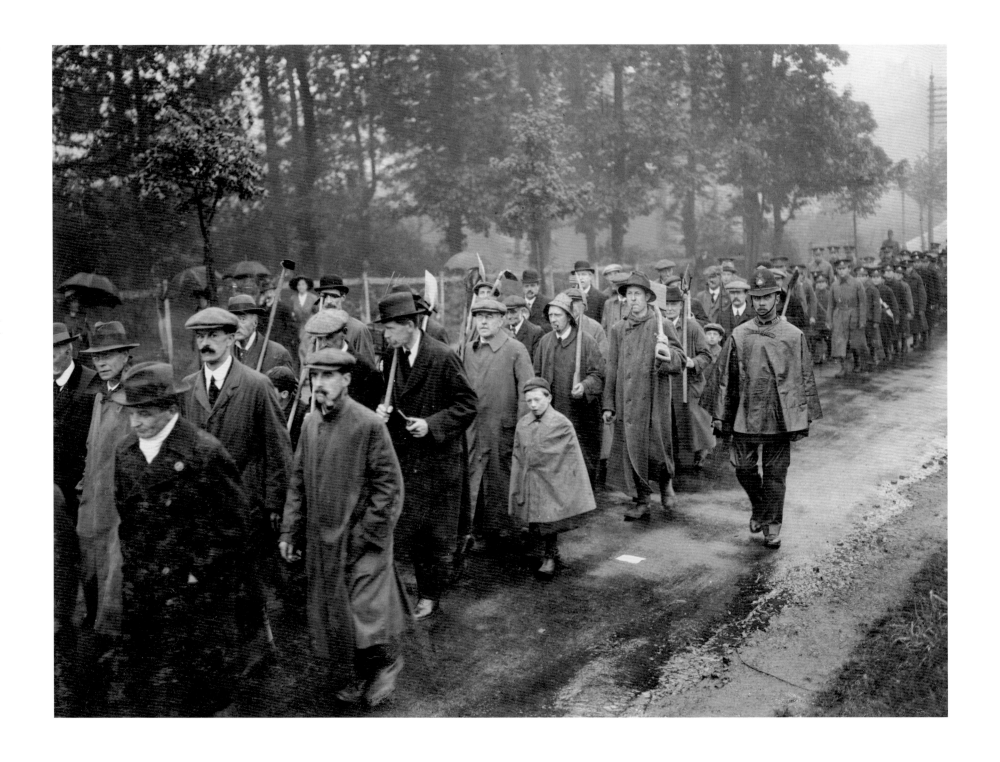

Unknown photographer, Sport & General commercial news agency
A procession of allotment holders, Britain, 19 November 1917
The success of the German submarine campaign threatened Britain with starvation in
April 1917. Although domestic food production increased dramatically, panic buying
led to shortages

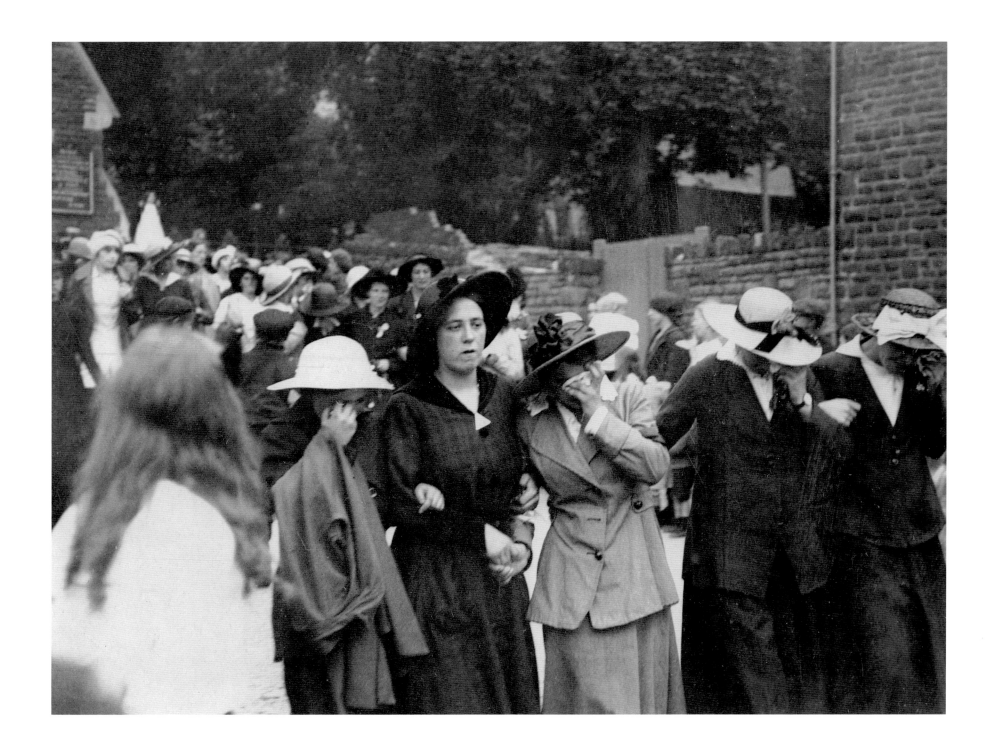

Unknown press photographer
Mourners at the funeral of a munitionette who was killed at an accident at the National Shell Factory, Swansea, Wales, 27 August 1917
British industry was by now fully geared to war production. Women formed 37 per cent of the workforce. Dangerous working conditions took a heavy toll and many munitions workers died from explosions or poisoning. Seventy-three were killed in an explosion at Silvertown, Essex, in January 1917

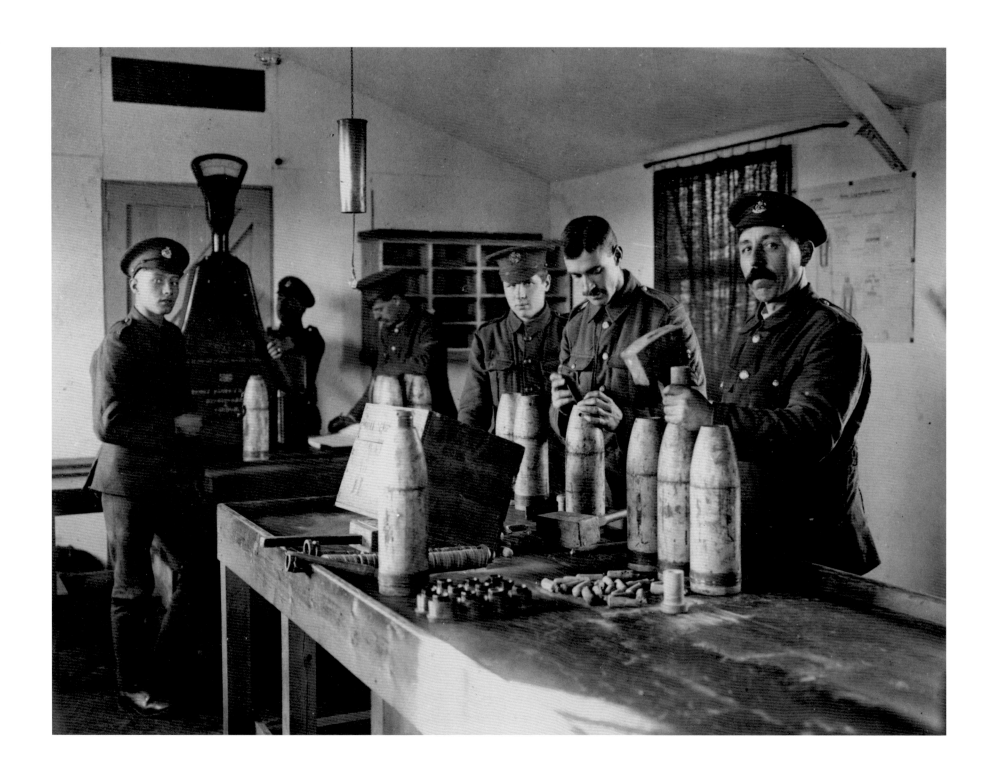

Unknown photographer, Royal Engineers Porton Down Photographic Section, British Army
Head-filling gas shells, North Magazine, Royal Engineers Experimental Station, Porton Down, Wiltshire, 1917
Gas shells were introduced in 1916. There were 1,296,853 casualties from poison gas during the war

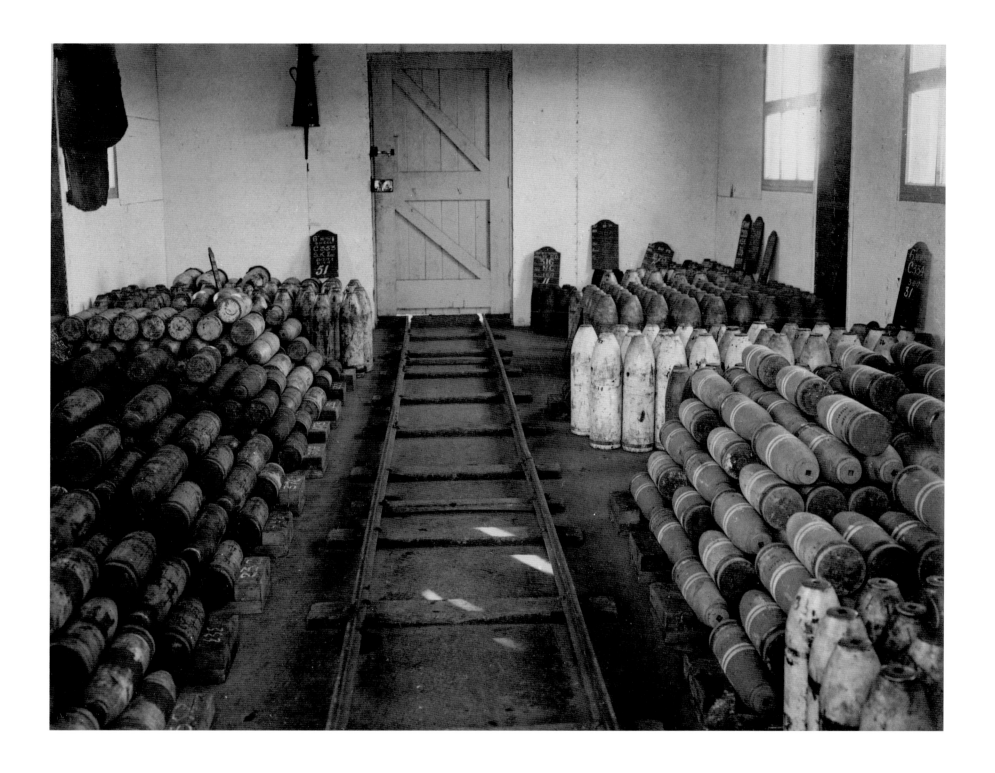

Unknown photographer, Royal Engineers, Porton Down Photographic Section, British Army
Stacks of gas shells, North Magazine, Royal Engineers Experimental Station,
Porton Down, Wiltshire, 1917
Mustard gas, a most persistent form of poison gas, which caused agonising burns and
temporary blindness, was first used by the German Army on the Western Front in
September 1917

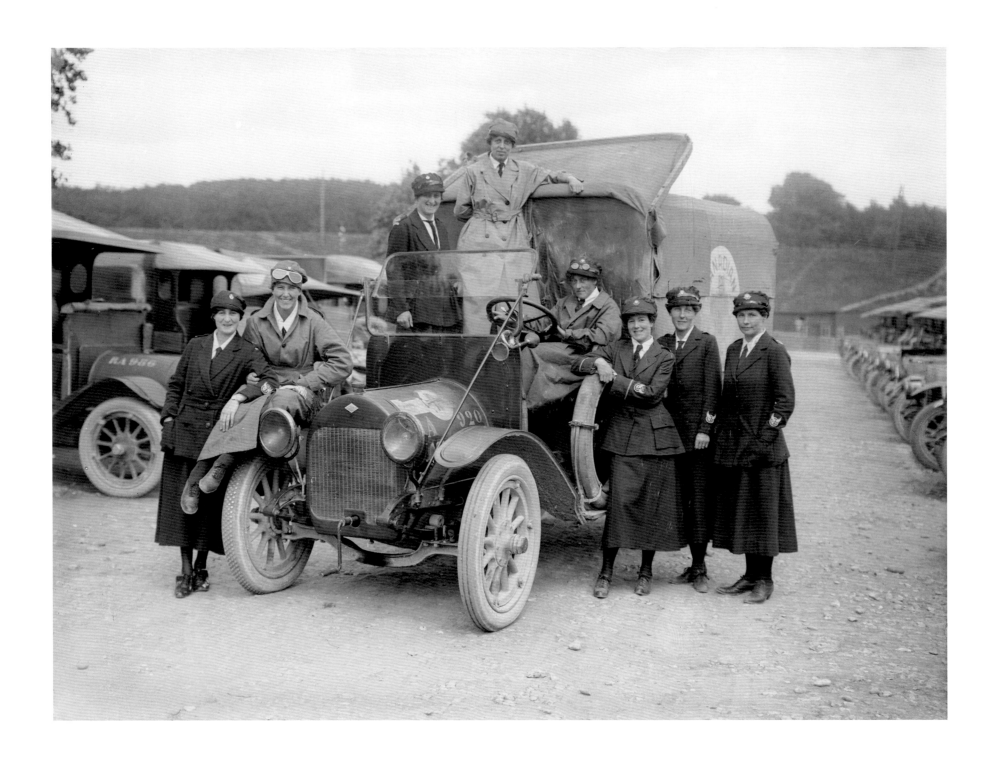

LIEUTENANT ERNEST BROOKS, British Army photographer
Women ambulance drivers of the Voluntary Aid Detachment (VAD), Étaples, France,
27 June 1917
Approximately 80,000 women served with the British armed forces in non-combatant
roles. Although not in the front line, they risked exposure to poison gas and air raids

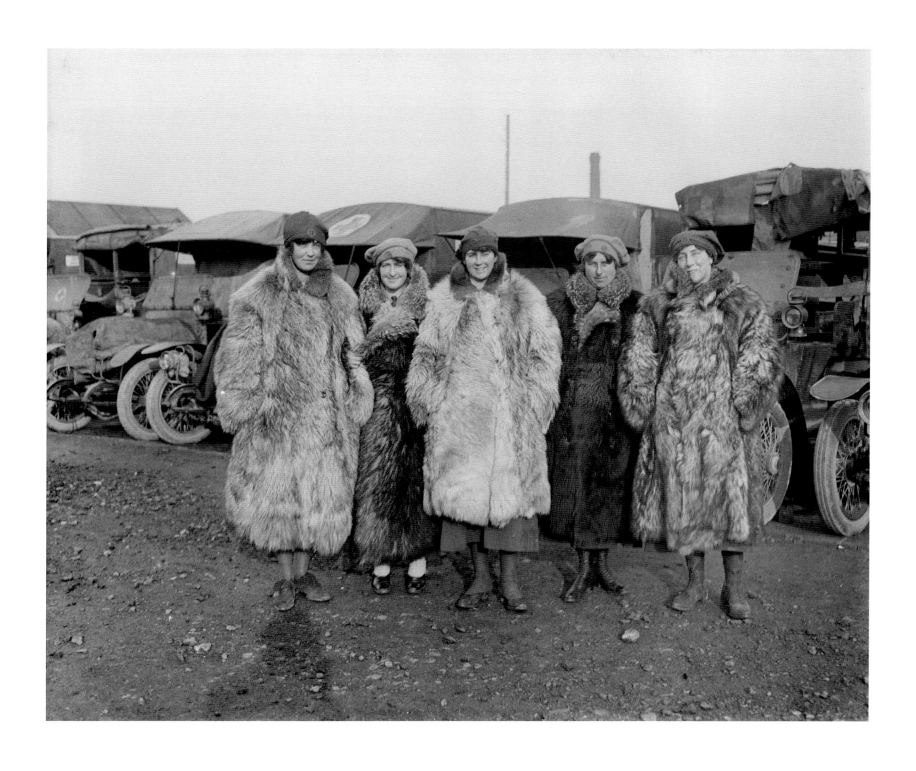

LIEUTENANT JOHN WARWICK BROOKE, British Army photographer
Women drivers of the First Aid Nursing Yeomanry, Calais, France, January 1917

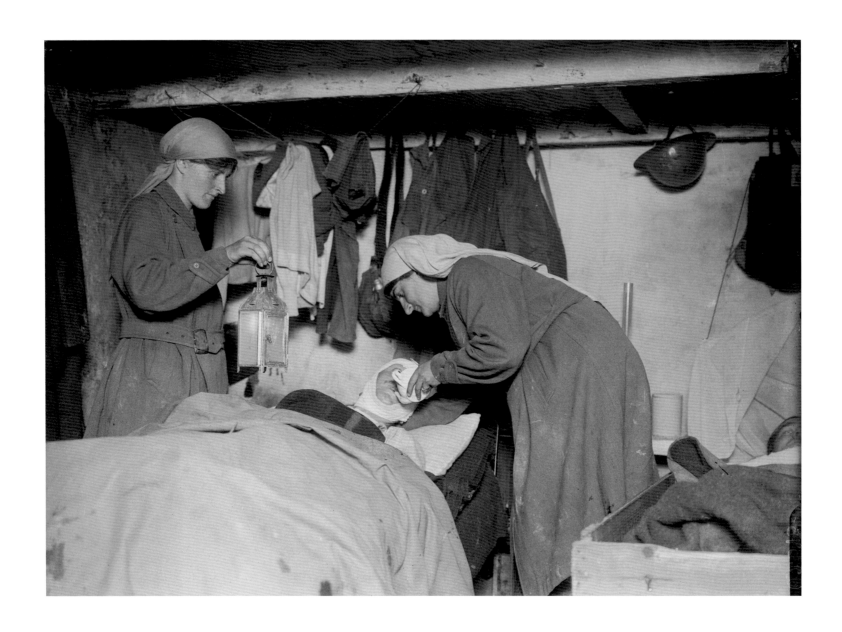

LIEUTENANT ERNEST BROOKS, British Army photographer
Mairi Chisholm (left) and Elsie Knocker, Baroness de T'Serclaes, care for a wounded
Belgian soldier in their advanced first-aid post, Pervyse, north of Ypres, Belgium,
6 August 1917
The British nurses, dubbed the 'Women of Pervyse', ran a series of first-aid posts in the
Belgian front line from 1914 until poison gas forced them to leave in 1918. They were
the only women to work in the very front line on the Western Front

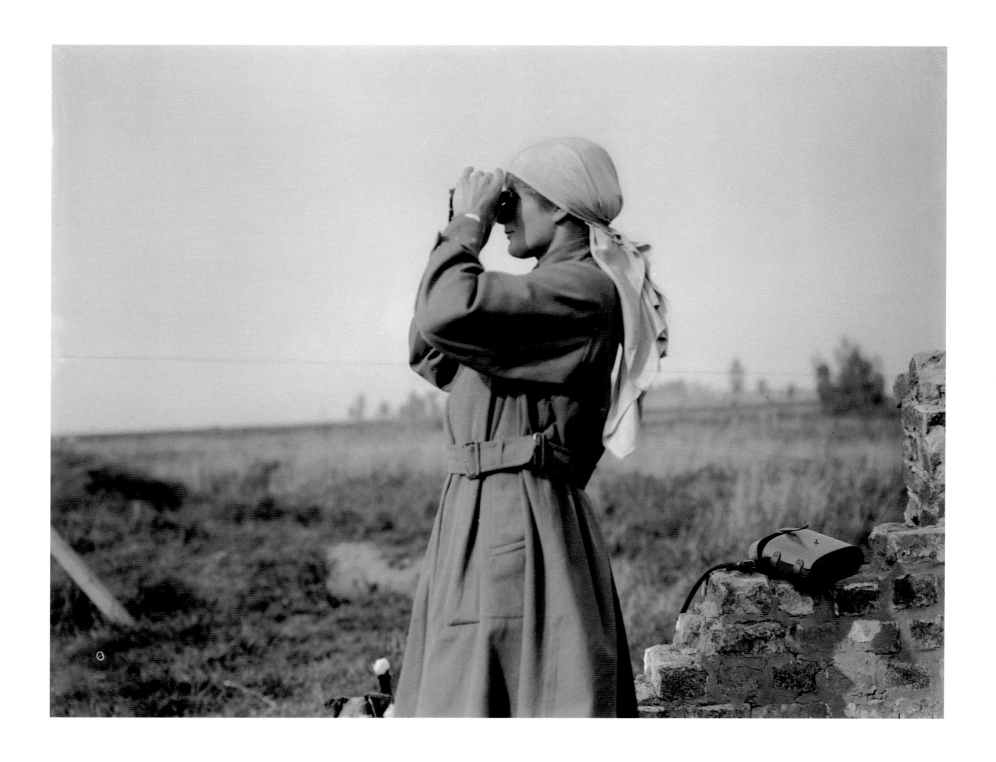

LIEUTENANT ERNEST BROOKS, British Army photographer
Mairi Chisholm monitors activity in the front line, 100 yards away from her first-aid post, Pervyse, Belgium, 11 September 1917
Press and official photographers often sought to glamorise the 'Women of Pervyse'.
Both were keen amateur photographers and their own pictures revealed more of life in
the frontline

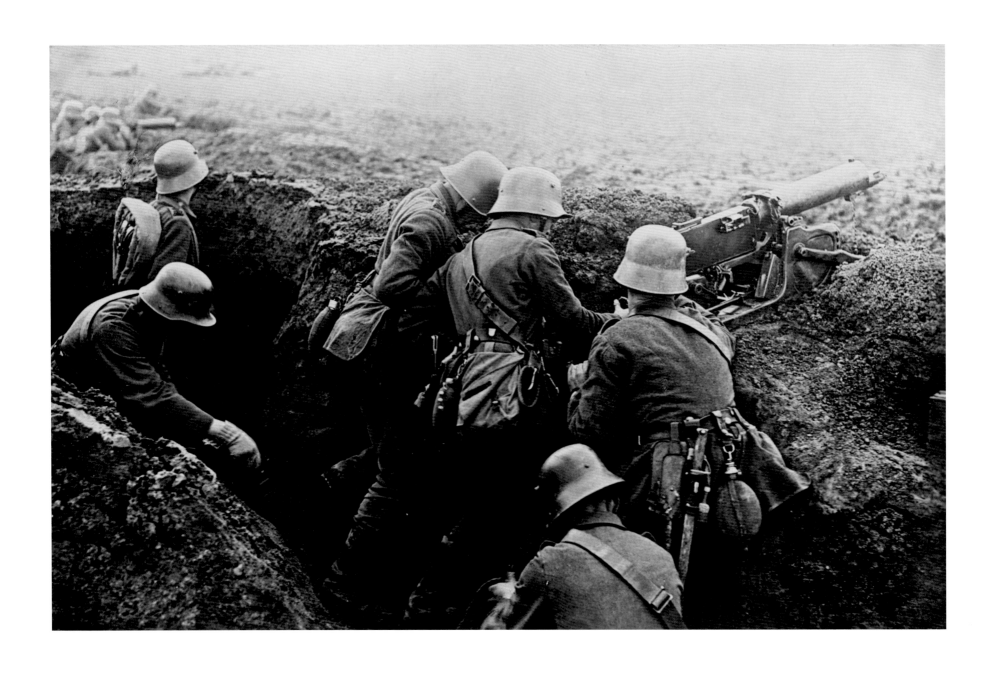

Unknown photographer, Imperial German Army
German machine gunners undergo training in a trench behind the front lines, France, February 1917
Depleted by the Verdun and Somme Offensives, the Imperial German Army carried out
a strategic retreat to the strongly fortified Hindenburg Line in March 1917

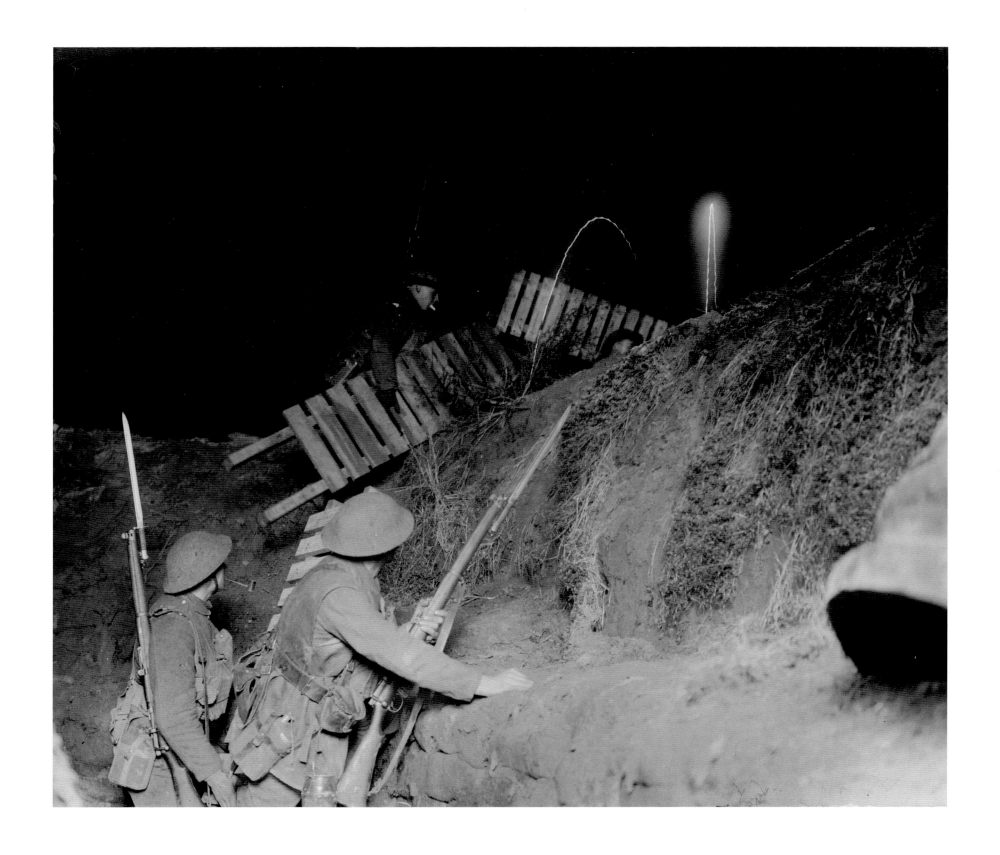

LIEUTENANT JOHN WARWICK BROOKE, British Army photographer
A British Army fatigue party carries duckboards up to the line, Cambrai, France, 12 January 1917
Despite the losses on the Somme, the British Army prepared to launch a new offensive
in the spring of 1917

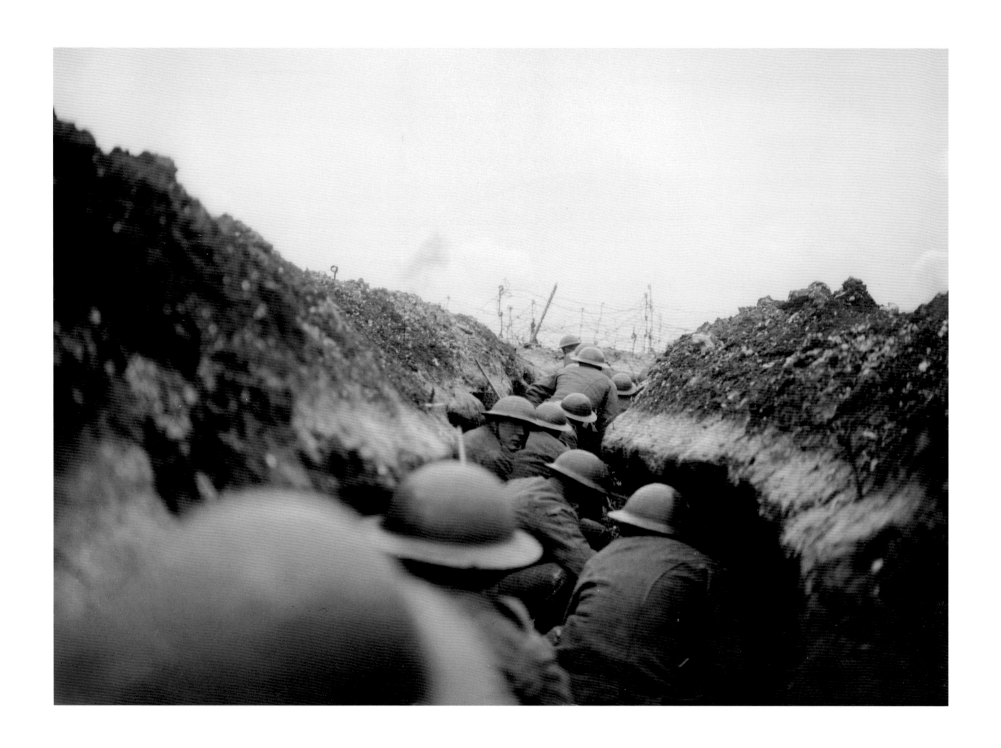

LIEUTENANT JOHN WARWICK BROOKE, British Army photographer
A daylight raiding party of 9th Cameronians (Scottish Rifles) waits for the signal to go over the top, near Arras, France, 24 March 1917
In April 1917, British and Empire forces launched a major offensive in the vicinity of Arras. French forces attacked German positions on the Aisne in what became known as the Nivelle Offensive. Its failure brought the French Army to the brink of mutiny

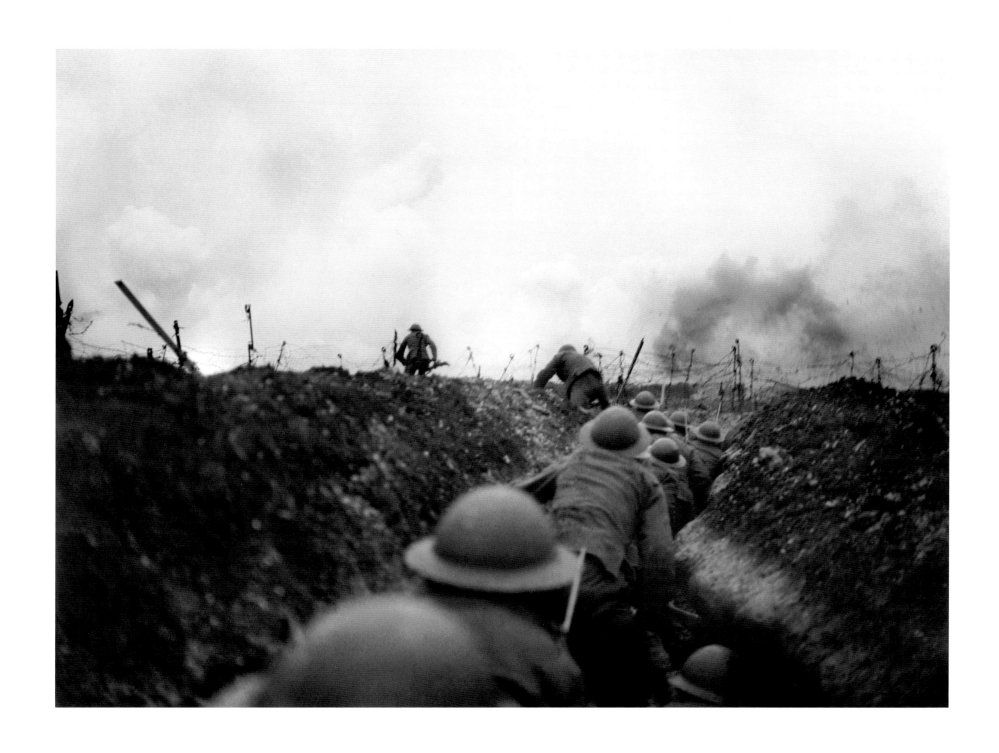

LIEUTENANT JOHN WARWICK BROOKE, British Army photographer
An officer leads 9th Cameronians (Scottish Rifles) daylight raiding party over the top
under cover of a creeping barrage, near Arras, France, 24 March 1917

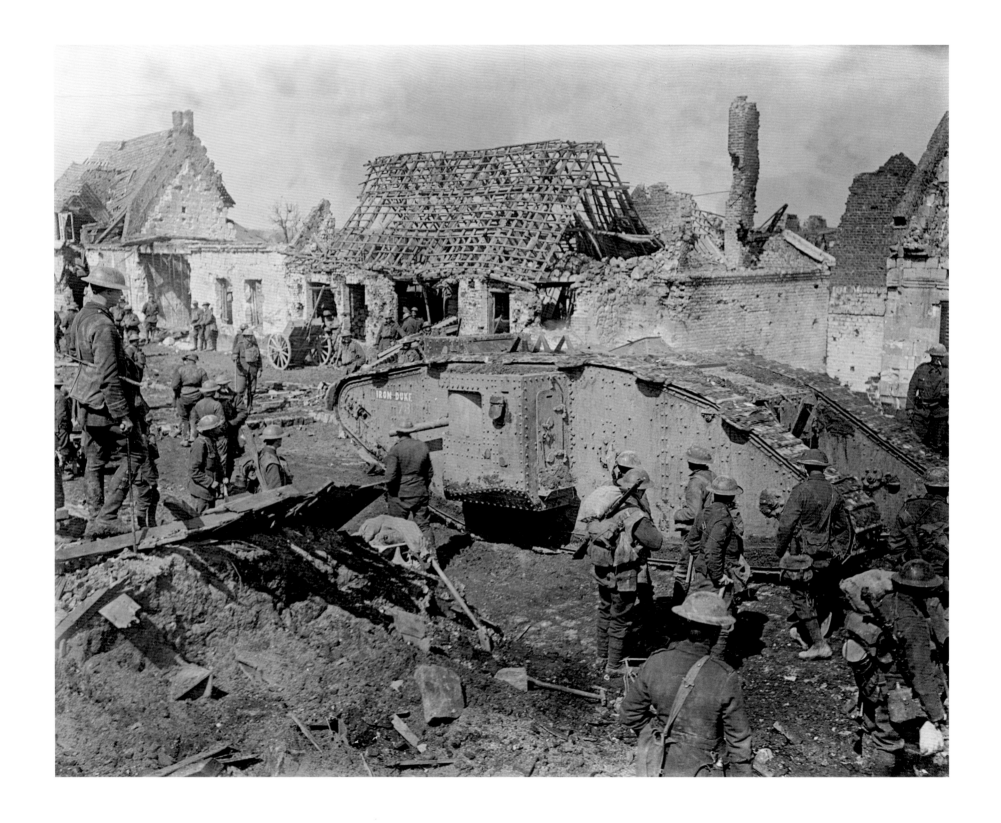

LIEUTENANT JOHN WARWICK BROOKE, British Army photographer
A British tank, *Iron Duke*, moves through the ruins of Arras on its way to the front
during the Battle of the Scarpe, Arras, Pas de Calais, France, 10 April 1917

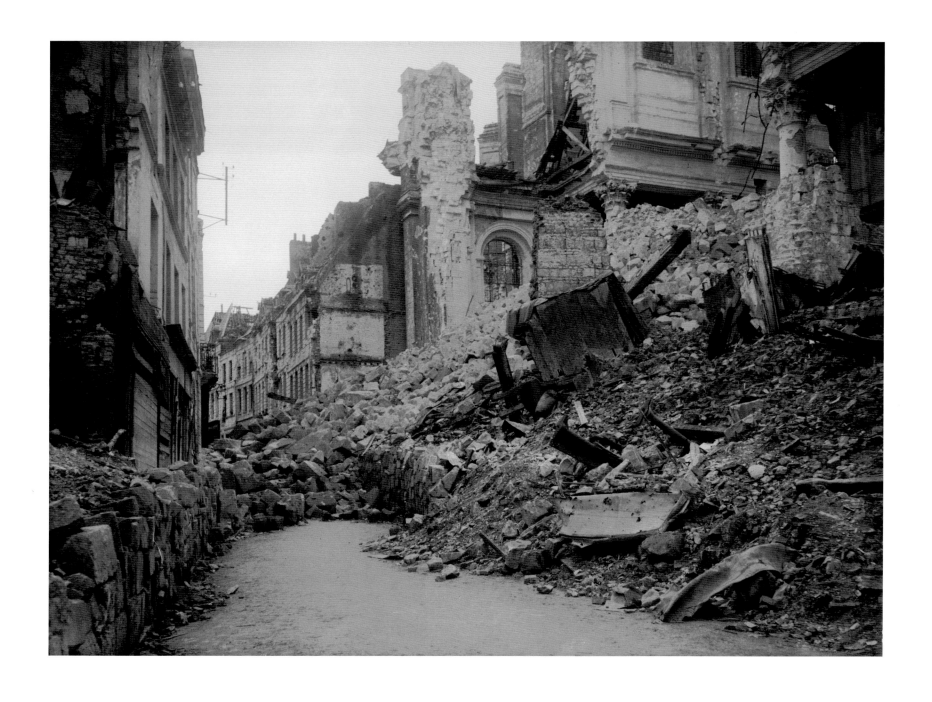

LIEUTENANT ERNEST BROOKS, British Army photographer
Destruction in the city of Arras, Pas de Calais, France, May 1917

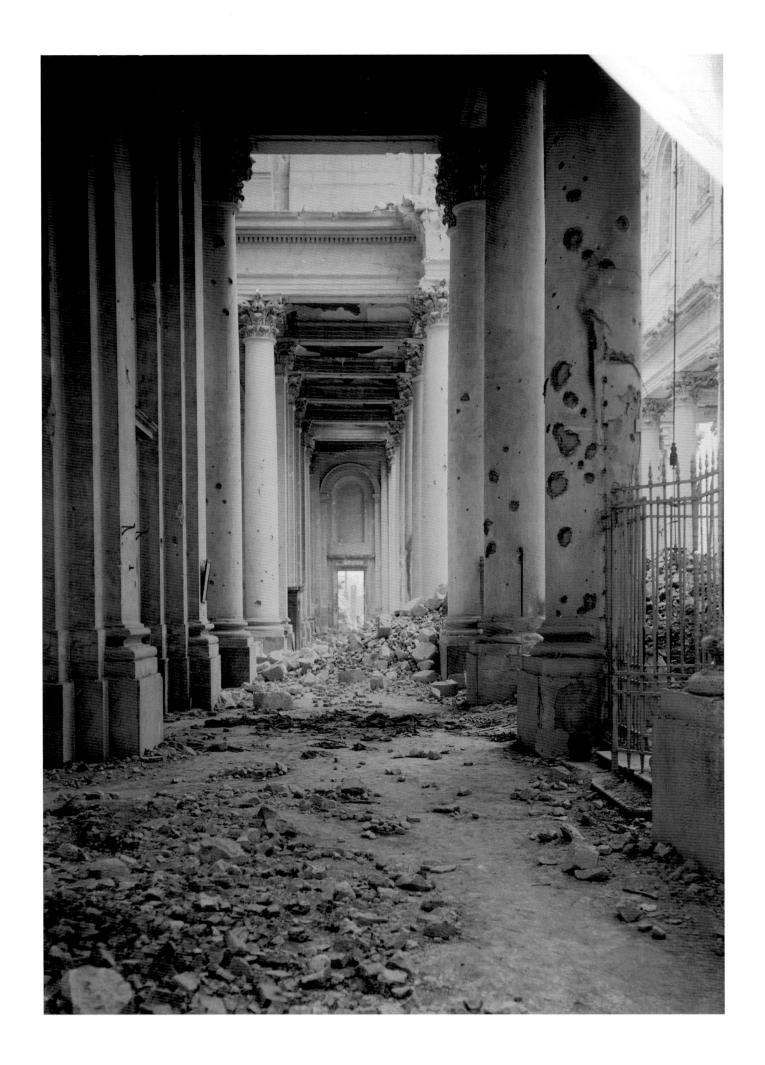

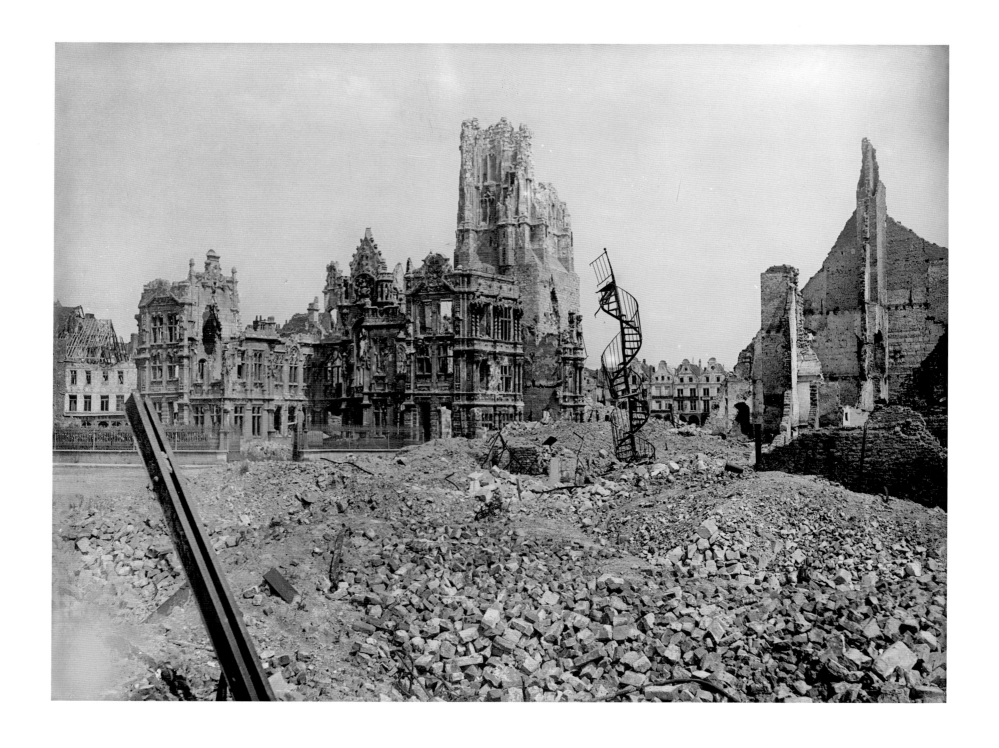

Left: LIEUTENANT ERNEST BROOKS, British Army photographer
Destruction to Arras Cathedral, Pas de Calais, France, May 1917

Above: LIEUTENANT ERNEST BROOKS, British Army photographer
Ruins near the Town Hall, Arras, Pas de Calais, France, May 1917

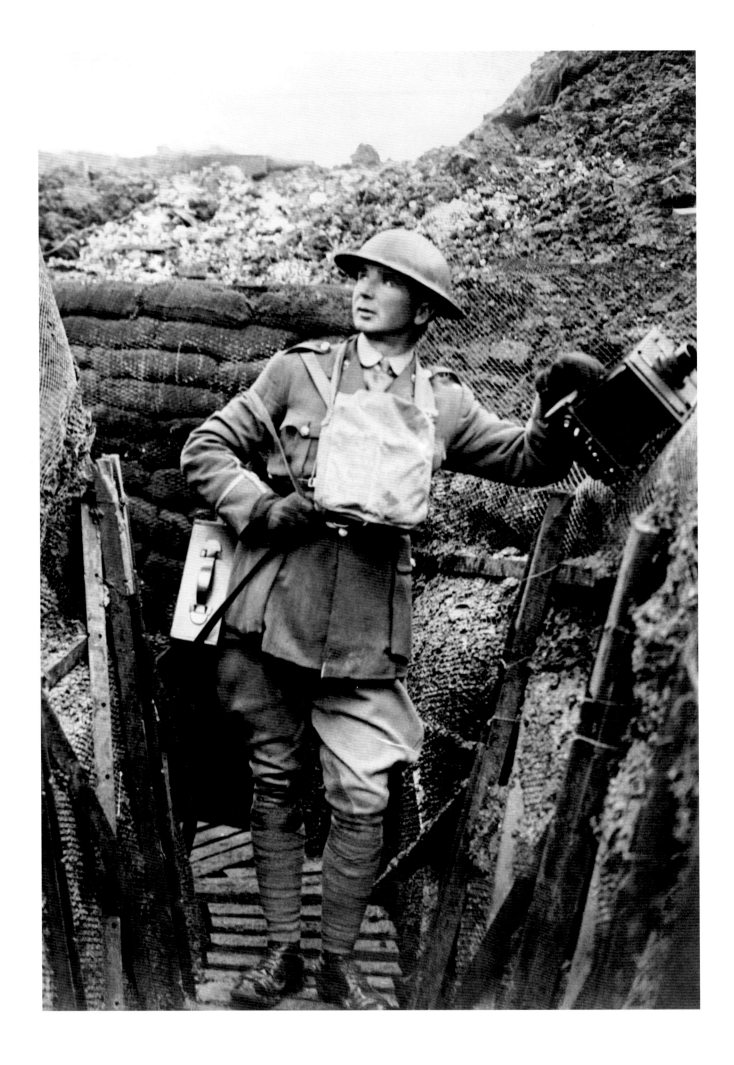

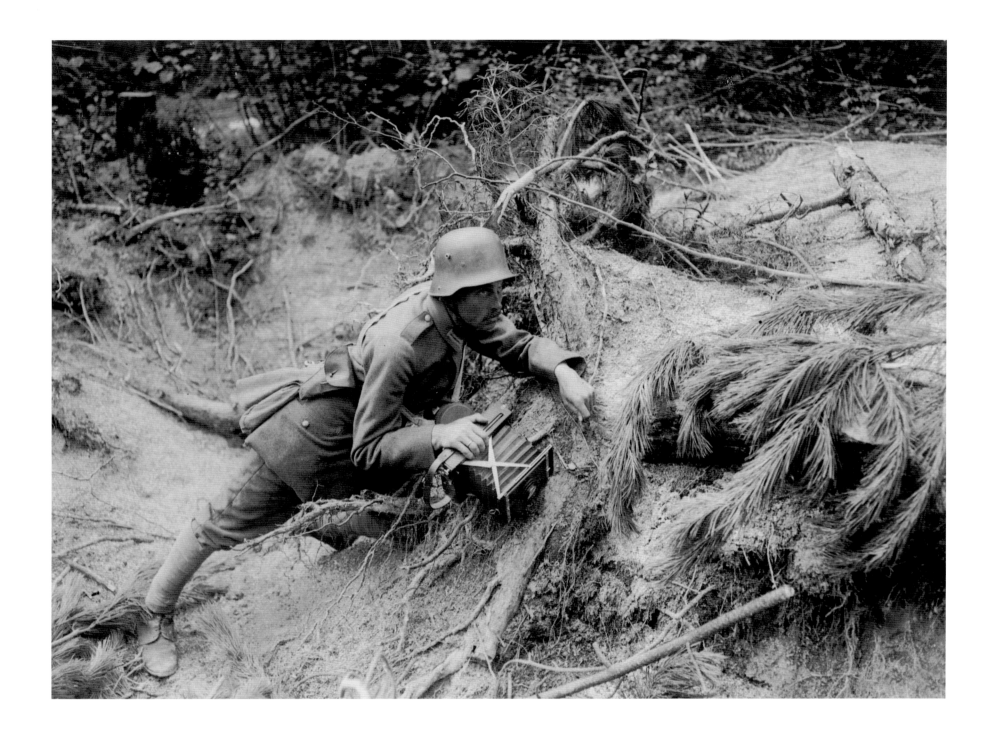

Left: Unknown photographer, British Army
Lt Ernest Brooks, British Army official photographer on the Western Front, with his camera in a trench, probably during the Arras Offensive, France, 1917
By 1917 the importance of photography in the creation of a visual record as well as for propaganda, news and operational work was clear to all nations, but there were too few photographers to meet the need. Ernest Brooks also covered the Italian Front and the Grand Fleet

Above: Unknown photographer, German Army Bild und Film Amt
An official German photographer at work on the Western Front, June 1917
The German Bild und Film Amt (Bufa) assumed responsibility for official photography and film in January 1917. Both British and German official photographers on the Western Front relied on the German Goerz Anschutz press camera

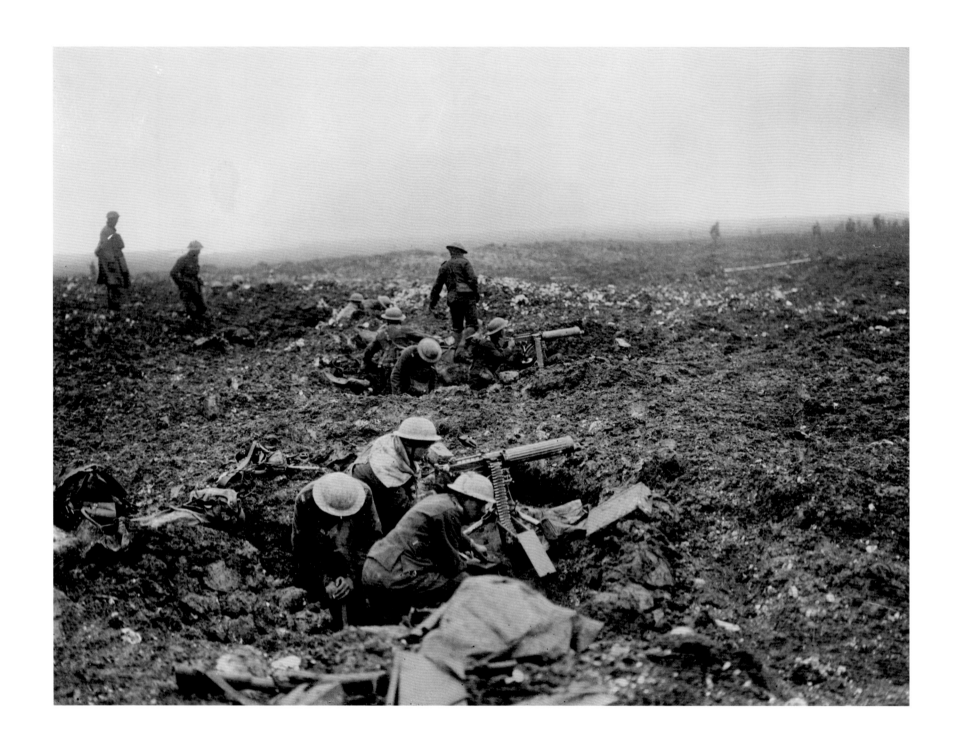

LIEUTENANT W. IVOR CASTLE, Canadian Army photographer
Canadian machine gunners dig in during the Arras Offensive, Vimy Ridge,
Pas de Calais, France, April 1917
Vimy Ridge, a 200-foot-high ridge near Arras, had been a German stronghold since
1914. The Canadians attacked the ridge on 9 April 1917

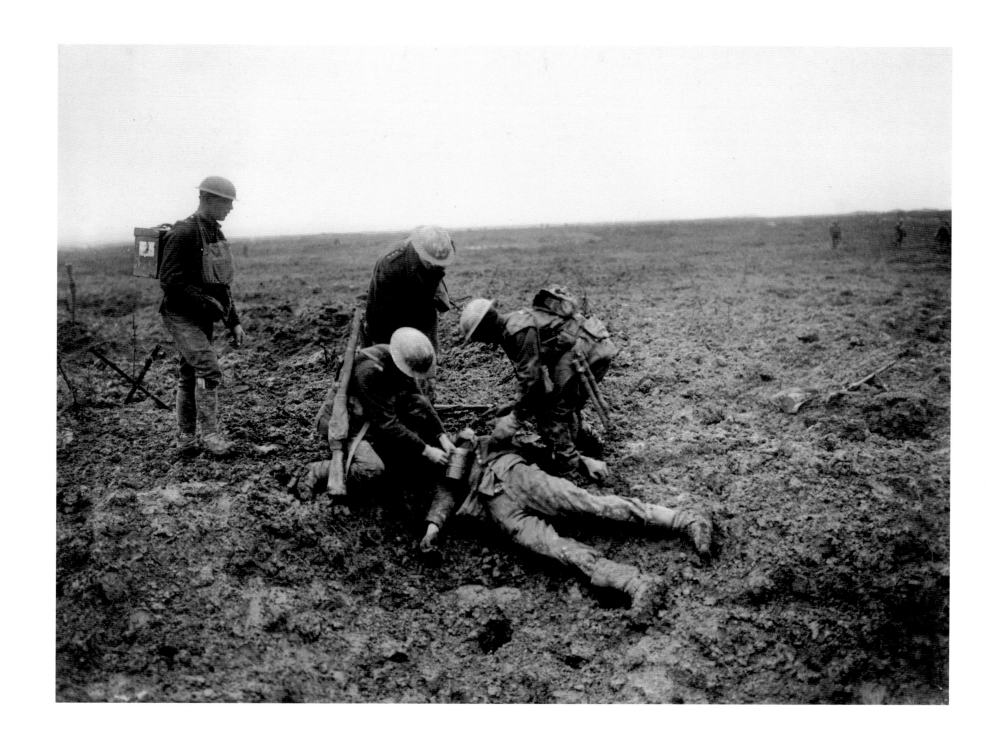

Above: LIEUTENANT W. IVOR CASTLE, Canadian Army photographer
Canadian troops tend a German casualty on Vimy Ridge, Pas de Calais, France, April 1917
Despite heavy casualties, the Canadians fought their way up the ridge, gaining control after three days

Pages 334–5: LIEUTENANT COLONEL S. C. BYRNE, 1/11 London Regiment (Finsbury Rifles), Allied Desert Column, personal photograph
The Allied Desert Column advances through scrub desert on a wire road between Bir el Mazar and Bardawil, Sinai, Egypt, February 1917
A combined force of British, Empire and Arab troops overran the Sinai Peninsula in early 1917 before converging on Gaza, gateway to Turkish-controlled Palestine

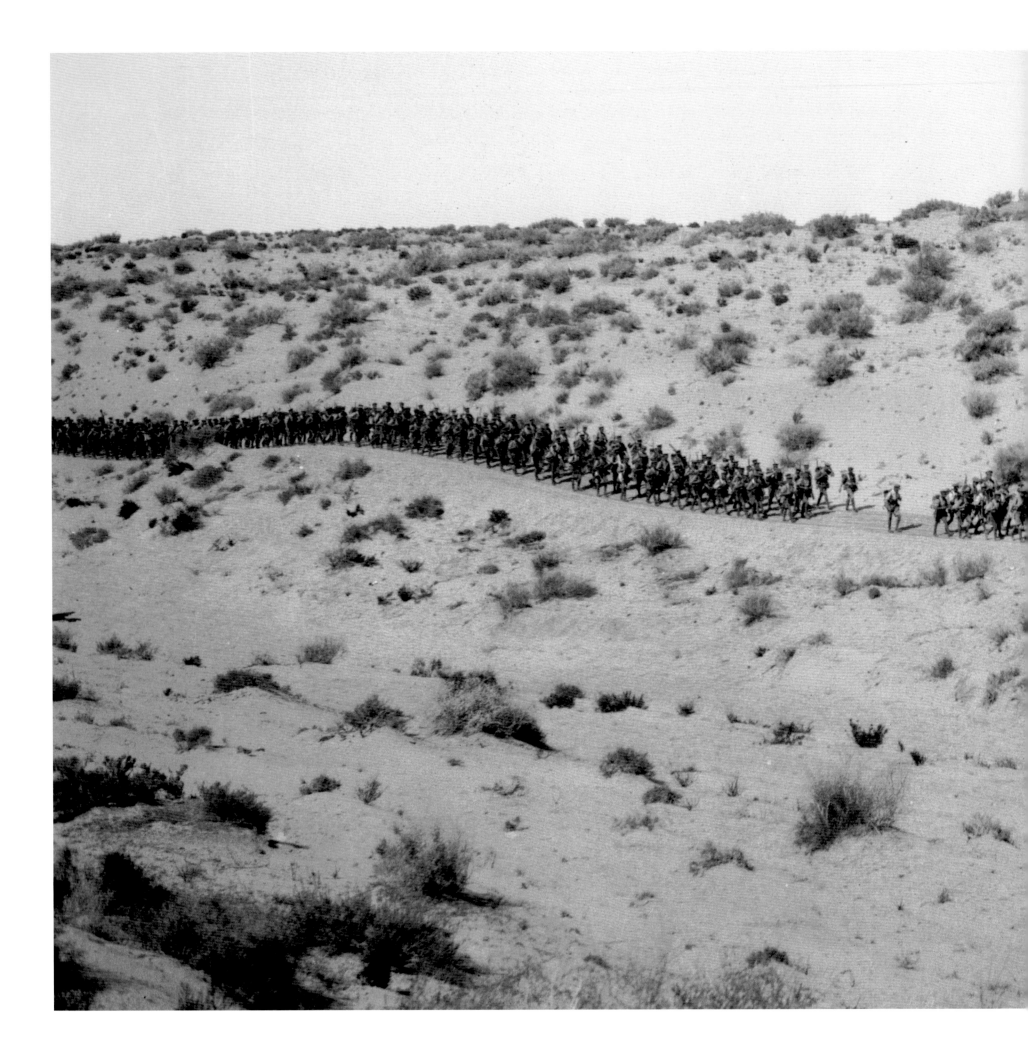

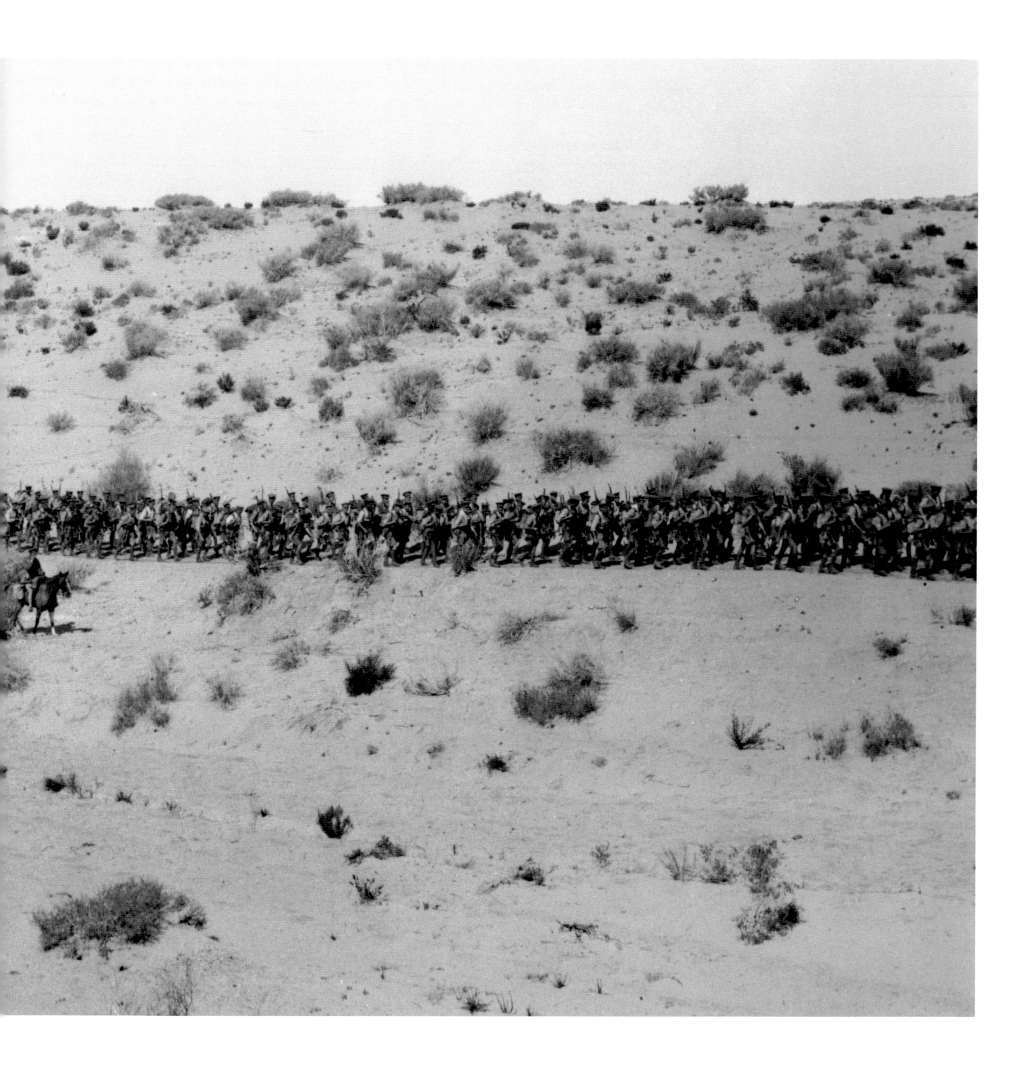

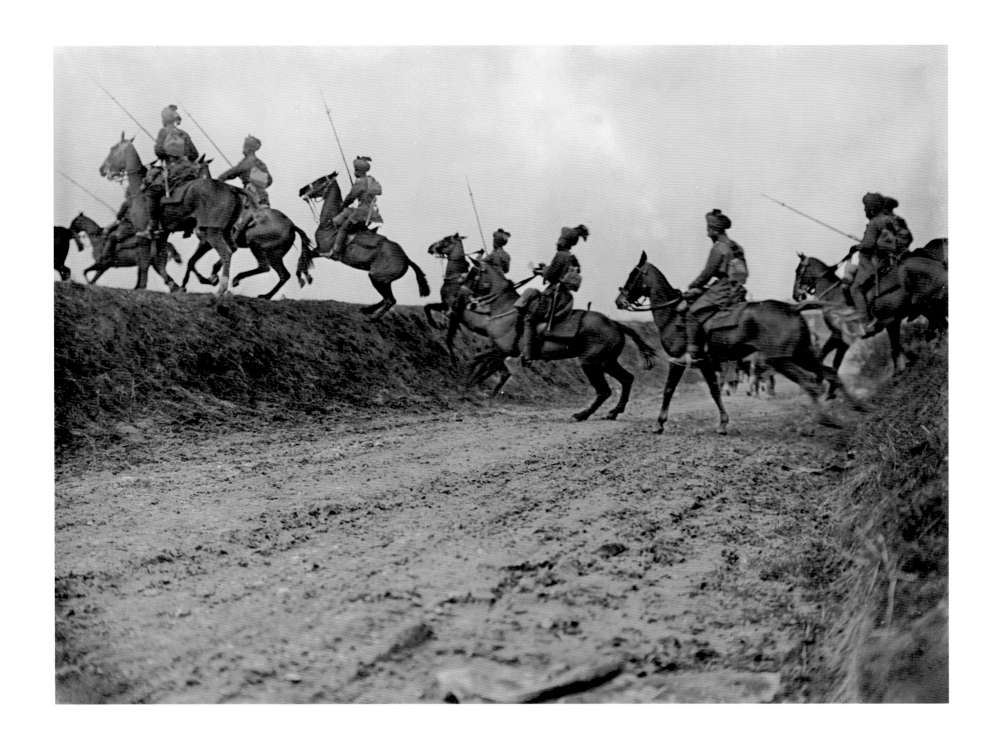

LIEUTENANT ERNEST BROOKS, British Army photographer
A troop of 9th Bengal Lancers (Hodson's Horse), near Vraignes-en-Vermandois, Somme, France, April 1917

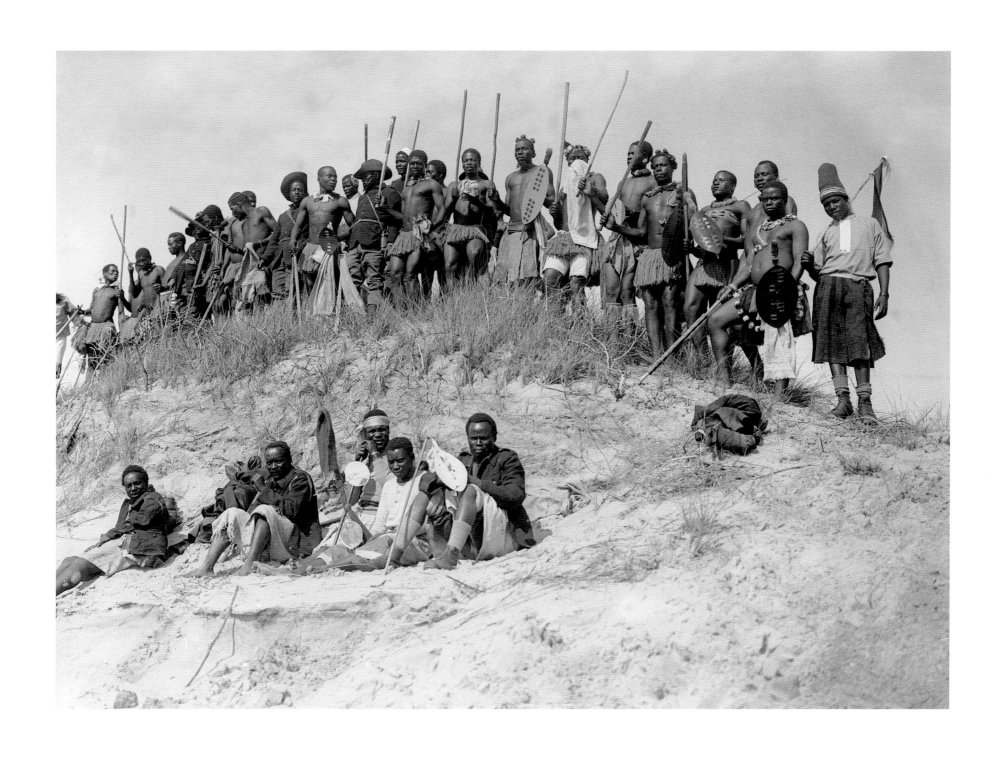

LIEUTENANT ERNEST BROOKS, British Army photographer
**Zulus of the South African Native Labour Corps prepare for a traditional war dance,
Dannes, Pas de Calais, France, 24 June 1917**

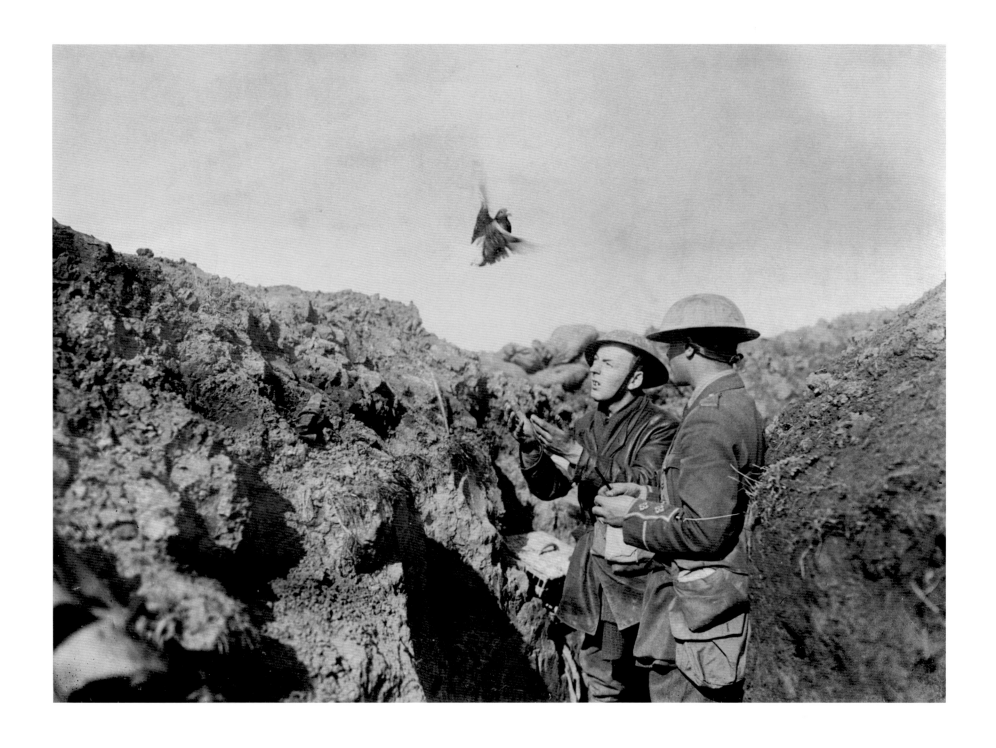

LIEUTENANT W. IVOR CASTLE, Canadian Army photographer
Canadian soldiers release a carrier pigeon from a trench, Western Front, May 1917
Trained dogs and carrier pigeons provided an alternative to the fragile telecommunications on the Western Front

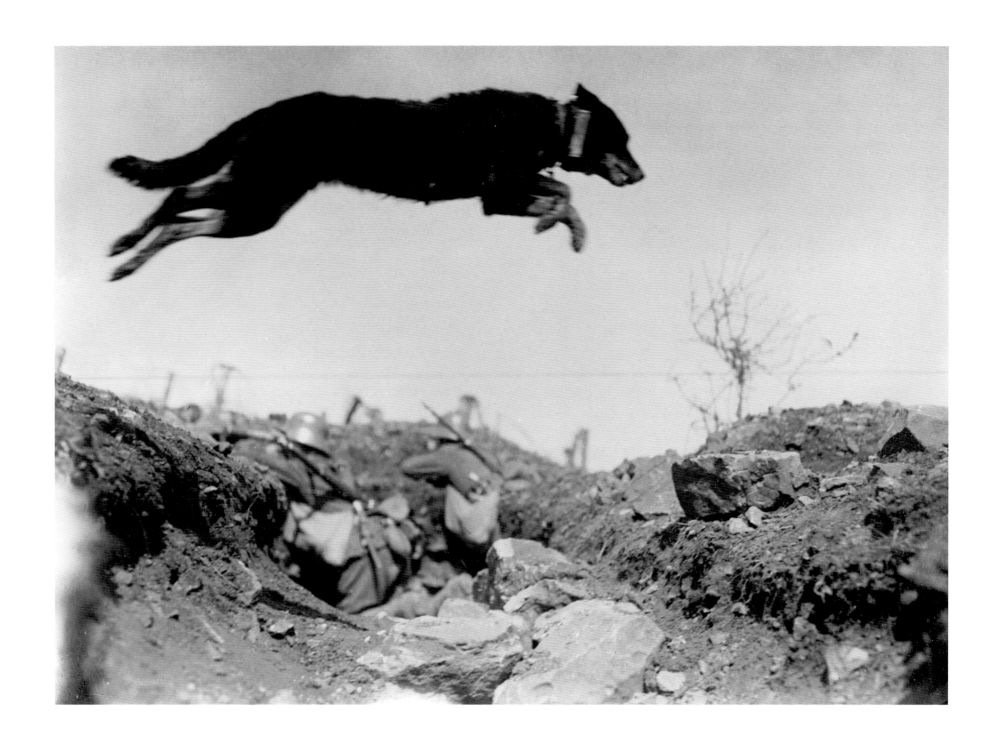

Unknown photographer, Imperial German Army
A German messenger dog leaps a trench, near Sedan, Ardennes, France, May 1917

Above: LIEUTENANT ERNEST BROOKS, British Army photographer
German barbed-wire entanglement, near Arras, France, 21 June 1917

Right: LIEUTENANT WILLIAM RIDER-RIDER, Canadian Army photographer
German observation post disguised as a tree trunk, Lens–Arras Road, France, September 1917

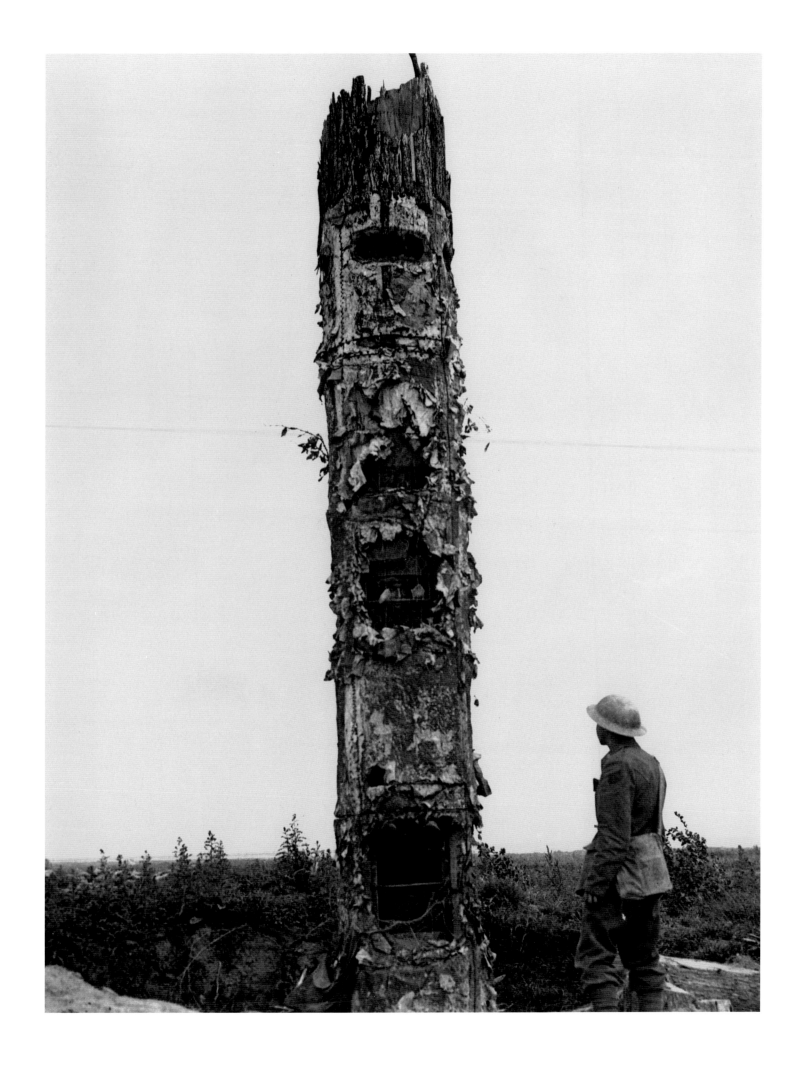

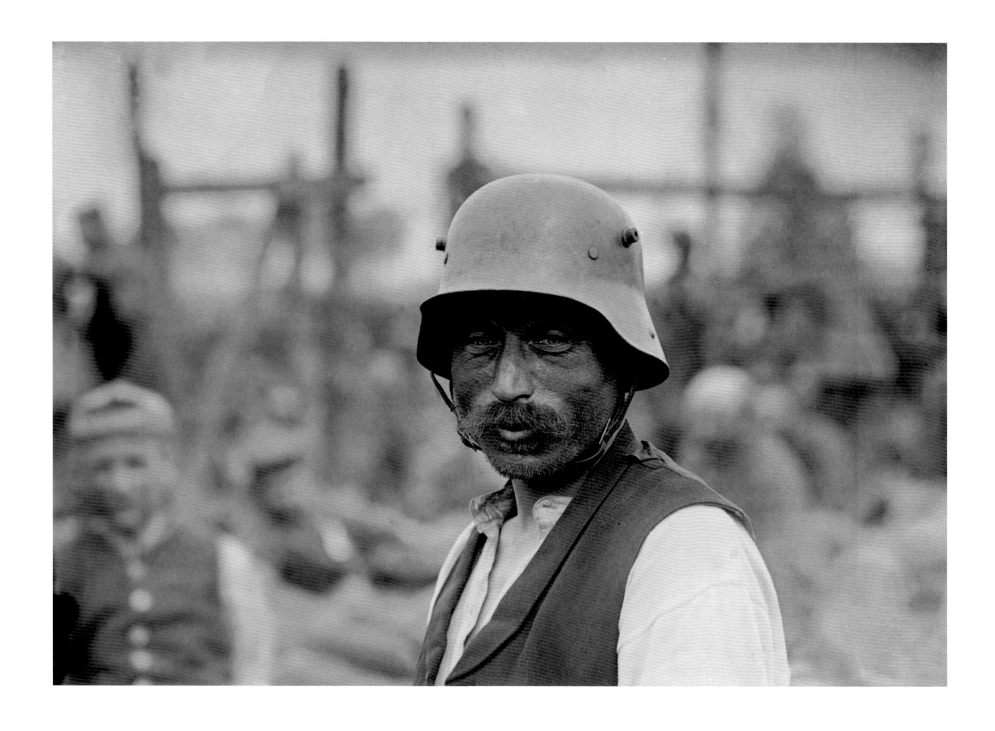

LIEUTENANT ERNEST BROOKS, British Army photographer
German prisoner captured in the Battle of Messines, near Ypres, Belgium, 8 June 1917
Photographers sought to highlight any apparent deficiency in military qualities,
combat fatigue and the impact of defeat in their coverage of prisoners

LIEUTENANT ERNEST BROOKS, British Army photographer
German prisoner captured in the Battle of Messines, near Ypres, Belgium, 8 June 1917
The Battle of Messines, an attempt to gain control of high ground overlooking Ypres,
was a prelude to the Third Battle of Ypres (Passchendaele). It opened with the detonation
of nineteen mines, followed by an infantry assault under cover of a creeping barrage

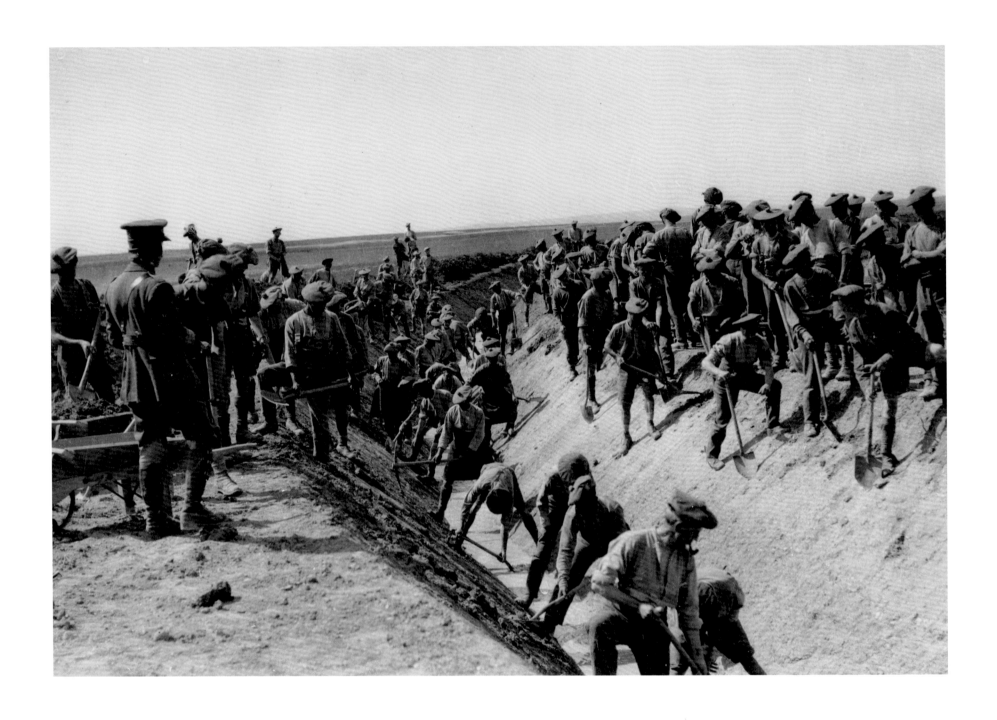

ARIEL VARGES, Mesopotamian Expeditionary Force photographer
Highland troops dig a drainage channel to destroy mosquito breeding grounds and reduce malaria, Daubratali Marshes, Salonika (now Macedonia), 1917
Ariel Varges, an American film cameraman working for the International Film Service in Salonika, was the sole official British photographer in Salonika and Mesopotamia

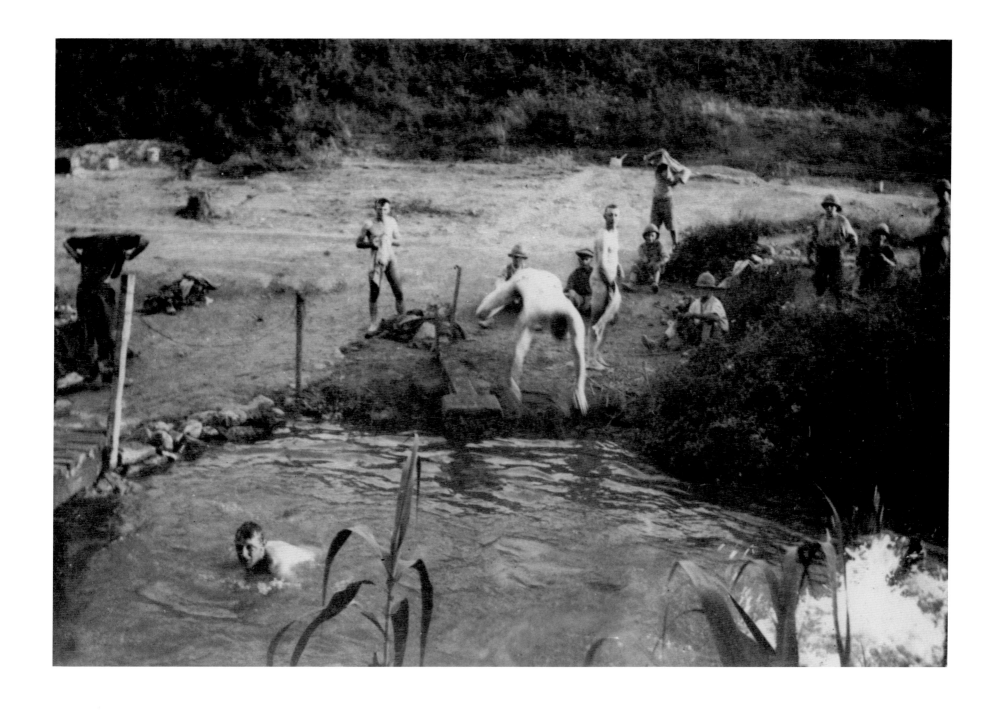

Above: LIEUTENANT J. S. JESS SPIER, 7 South Wales Borderers,
Salonika Expeditionary Force, personal photograph
**Soldiers of the South Wales Borderers enjoy a swim, near Lake Doiran, Salonika,
Summer 1917**
The ban on personal use of cameras was rigidly enforced on the Western Front after
1915. Elsewhere servicemen and women continued to take personal photographs

Pages 346–7: Unknown photographer, Imperial German Army
A German patrol fords the Black Drin, near Lake Ohrid, Struga, Salonika, *c.* 1917

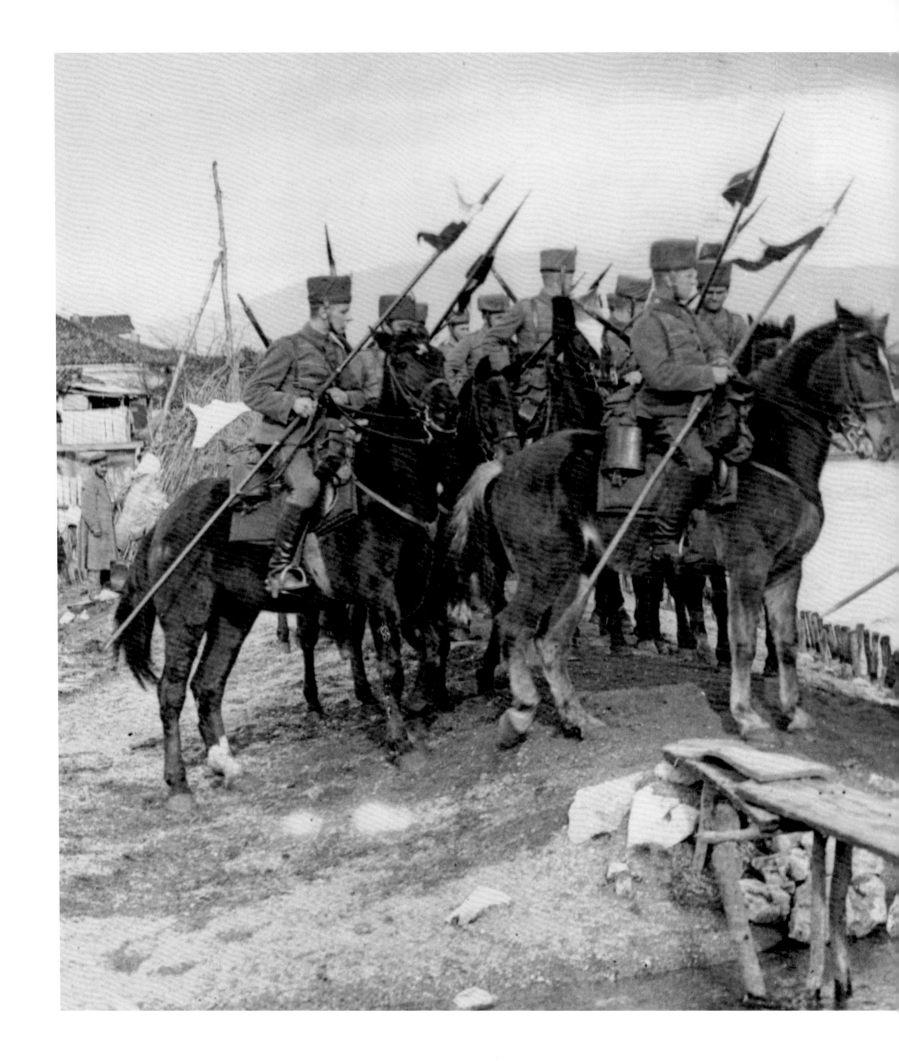

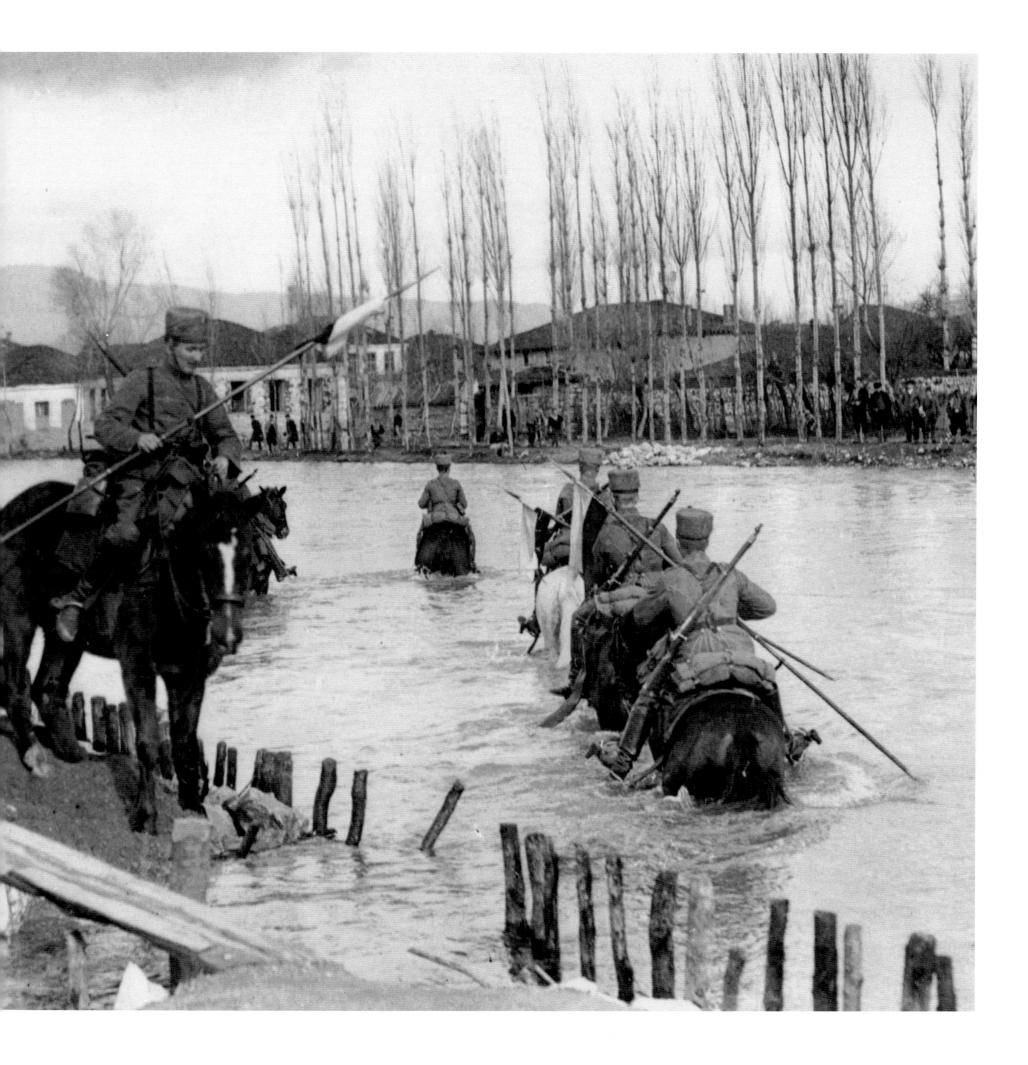

CAPTAIN THE REVEREND WILLIAM PASCOE, Chaplain, No. 28 Casualty Clearing
Station, Mesopotamian Expeditionary Force, personal photograph
**Pte G. Brown (8th Duke of Cornwall's Light Infantry), unofficial gravedigger at the
British Military Cemetery of Karasouli, Salonika, August 1917**

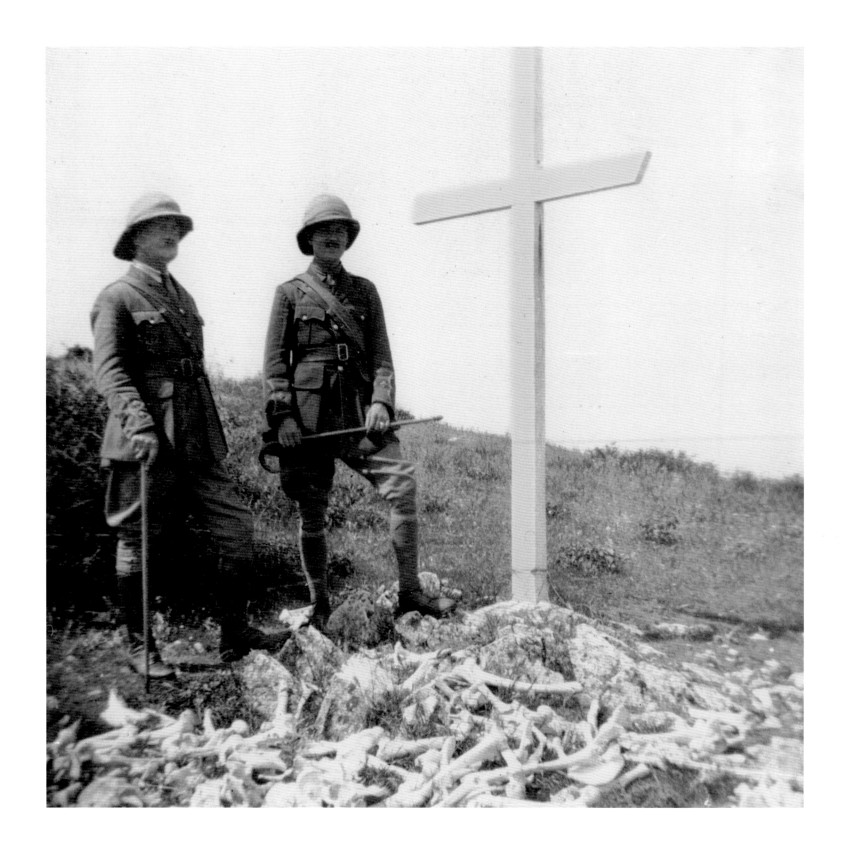

Above: MAJOR F. C. BENTLEY, 2/20 London Regiment, Salonika Expeditionary Force, personal photograph
Lieutenants Dark and Lovell, 2/20 London Regiment, visit a memorial to casualties of the 2nd Balkan War (1913), Mort Homme, Salonika, 1917
Some of the casualties' bones surround the cross

Pages 350–51: Unknown photographer, personal photograph, from the collection of G. Scott
Refugees with their salvaged possessions watch the Great Fire of Salonika destroy their homes and livelihoods
The fire started accidentally in a building housing war refugees. It destroyed two-thirds of the city of Salonika (now Thessaloniki)

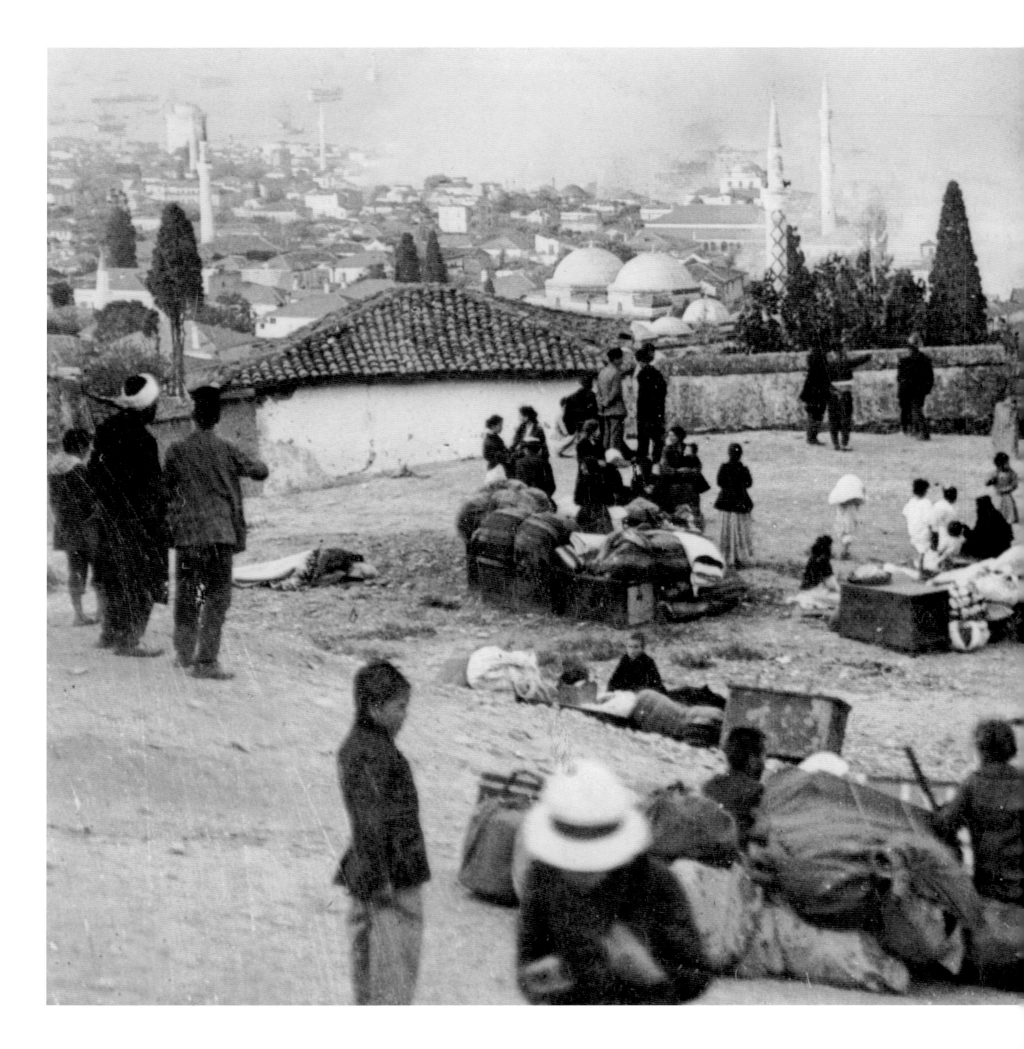

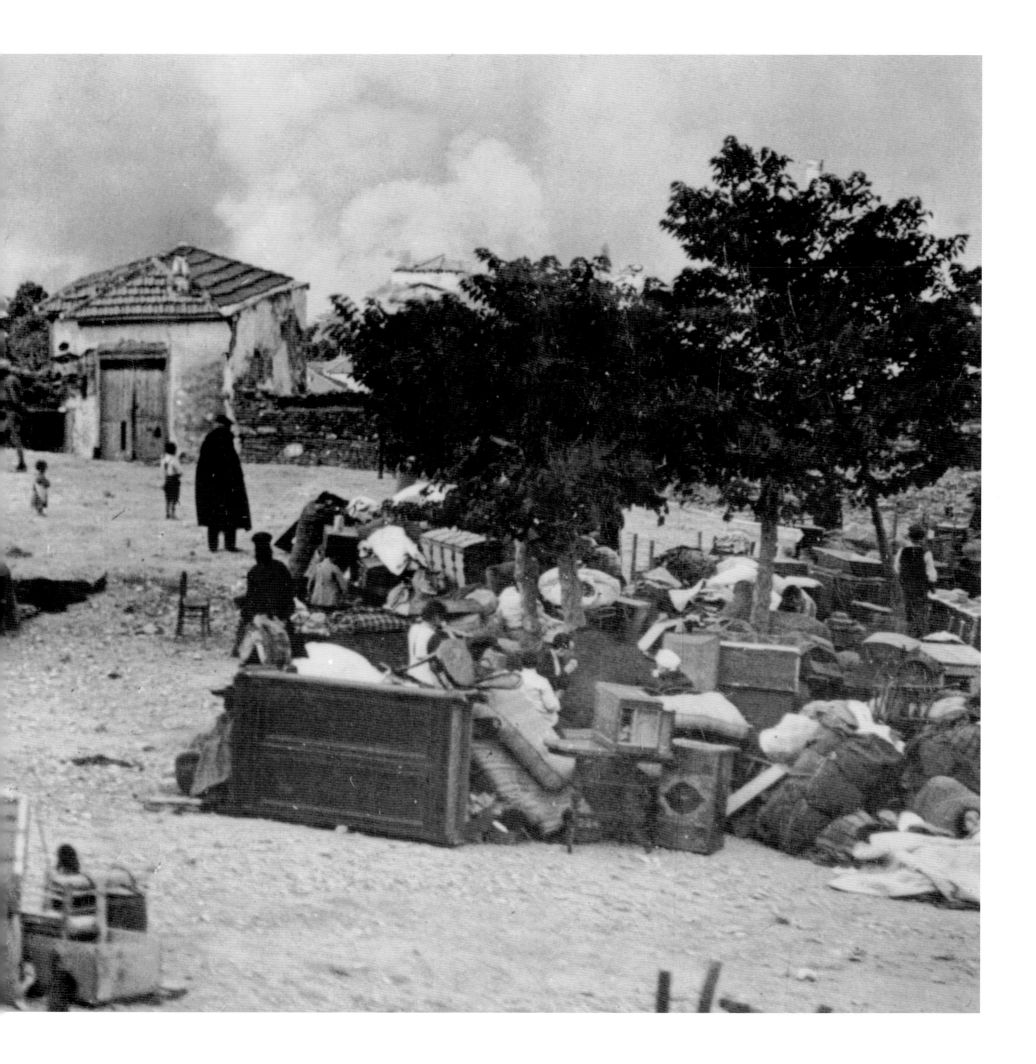

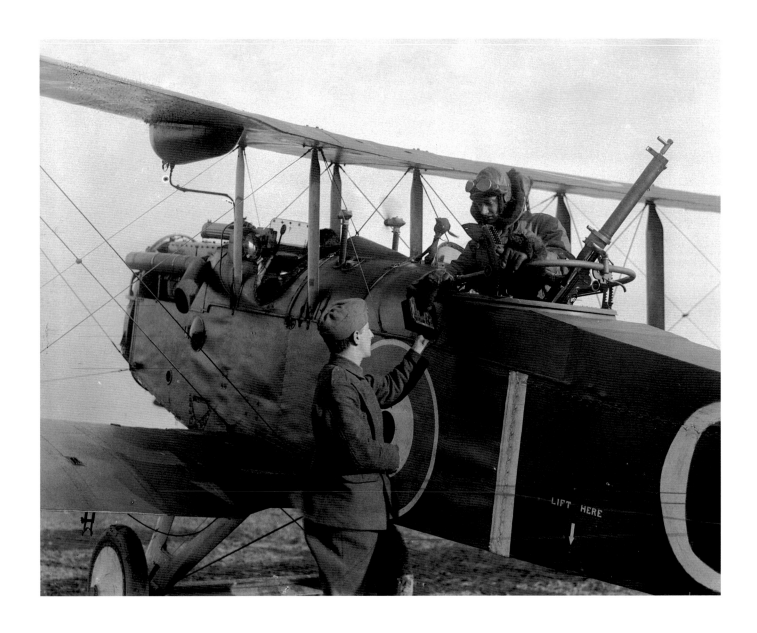

SECOND LIEUTENANT DAVID MCLELLAN, Royal Flying Corps photographer
**A Royal Flying Corps mechanic hands a set of photographic plates to the gunner
of a DH4 aircraft to record the results of a bombing mission, Serny Airfield, France,
17 February 1918**
In 1917 the Royal Flying Corps exposed 14,678 plates and made 347,000 prints

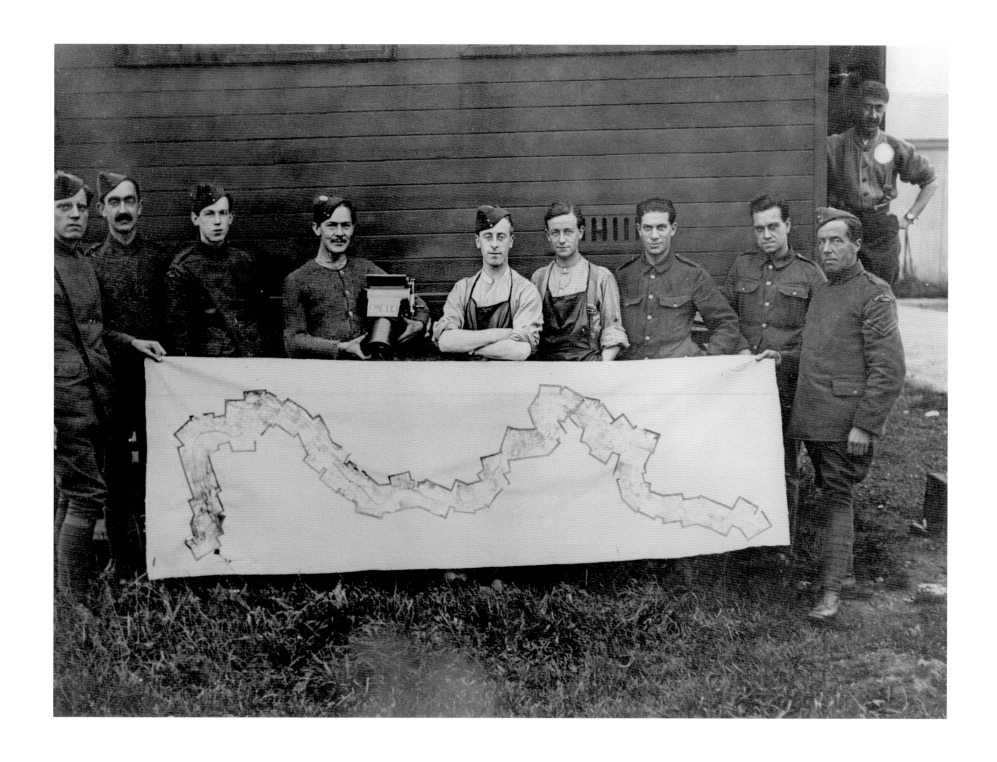

Unknown photographer, Royal Flying Corps, personal photograph
**A Royal Flying Corps Photographic Section displays a giant mosaic, showing a section
of the front line assembled from aerial photographs, outside their mobile darkroom,
Western Front, 18 September 1917**
Aerial photography kept Allied commanders informed about the development of the
Hindenburg Line

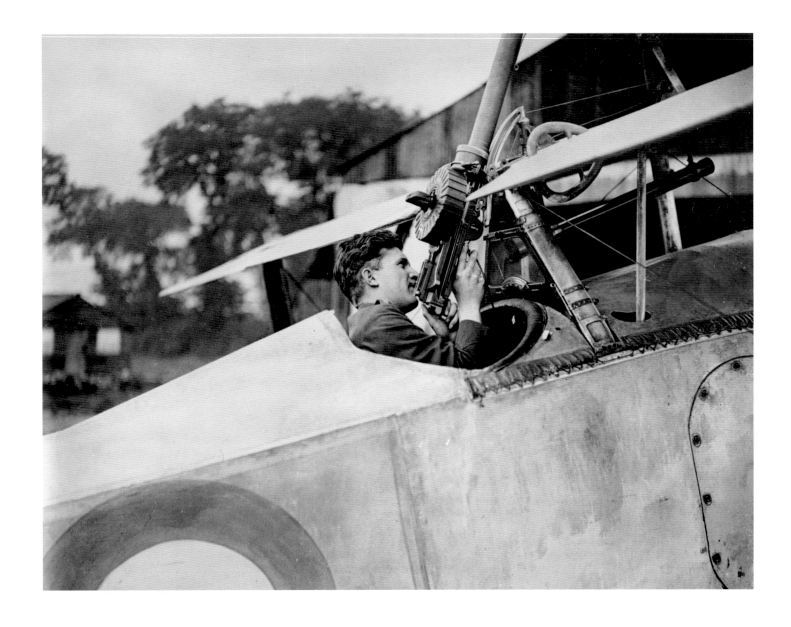

Above: LIEUTENANT WILLIAM RIDER-RIDER, Canadian Army photographer
Lieutenant Colonel William A. 'Billy' Bishop, VC, a Canadian air ace serving with No. 60 Squadron FRC, checks the Lewis gun in the cockpit of his Nieuport 17, Filescamp Farm, near Arras, France, August 1917
Pilots credited with shooting down five or more enemy aircraft became known as aces and were glamorised by the press for the risks they took. Most had a life expectancy of a few weeks. The casualty rate was heightened by a belief that it was cowardly to wear a parachute

Right: Unknown photographer, Imperial German Air Force
Trophies collected from aircraft shot down by Oberleutnant Manfred von Richthofen at his family home, Schweidnitz, Germany, May 1917
Von Richthofen, also known as the Red Baron after the colour of his aircraft, was Germany's leading fighter ace and a national hero

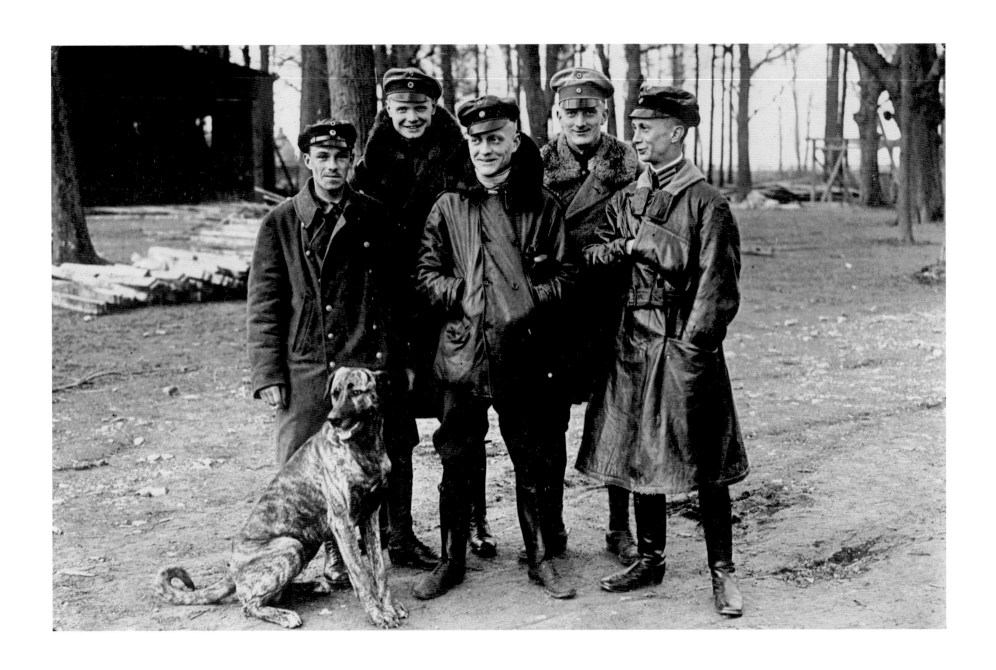

Unknown photographer, Imperial German Air Force
Oberleutnant Manfred von Richthofen, commander of Jasta 11, Imperial German Air Force, with his dog Moritz and fellow pilots: (left to right) Vizefeldwebel Sebastian Festner (twelve victories, killed 25 April 1917), Leutnant Karl-Emil Schaffer (thirty victories, killed 5 June 1917), Oberleutnant Manfred von Richthofen (eighty victories, killed 21 April 1918), his brother Leutnant Lothar von Ricthofen (forty victories) and Leutnant Kurt Wolff (thirty-three victories, killed 15 September 1917)
The success of Jasta 11 in April 1917 caused the Royal Flying Corps to designate it 'Bloody April'

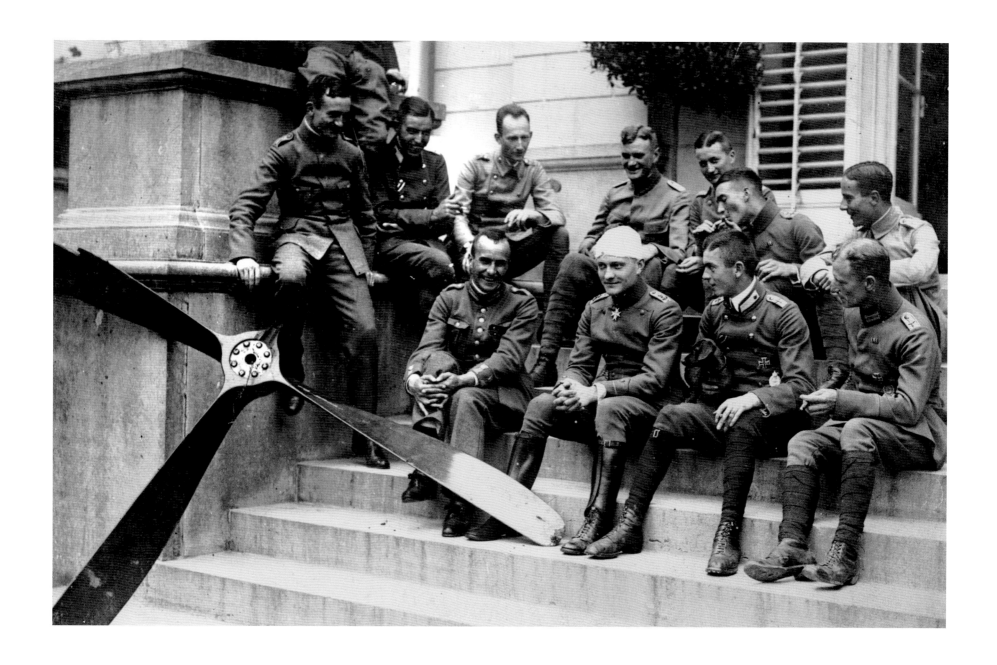

Unknown photographer, Imperial German Air Force
Pilots of Jagdgeschwader 11, known informally as the 'Flying Circus', visit their commander, von Richthofen, in hospital with a gift of a British aircraft propeller, 14 August 1917
Von Richthofen sustained a serious head wound while in combat with fighter aircraft of No. 20 Squadron Royal Flying Corps on 6 July 1917. He never fully recovered

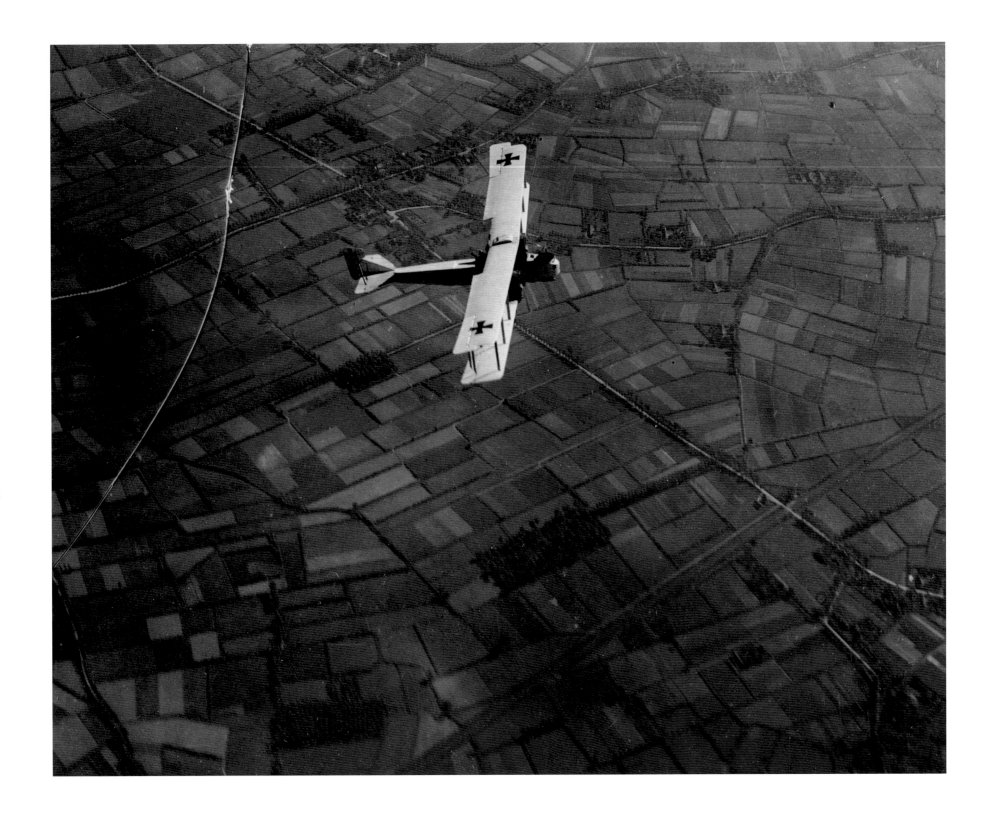

Squadron photographer, Imperial German Air Force
**An Imperial German Air Force Gotha G IV heavy bomber of Kampf-Geschwader No. 3
(England Squadron) over Belgium**
*The Gotha G IV was the first German aircraft capable of bombing England. The unit,
known informally as the England Squadron, carried out a series of raids on England
from German-occupied Belgium*

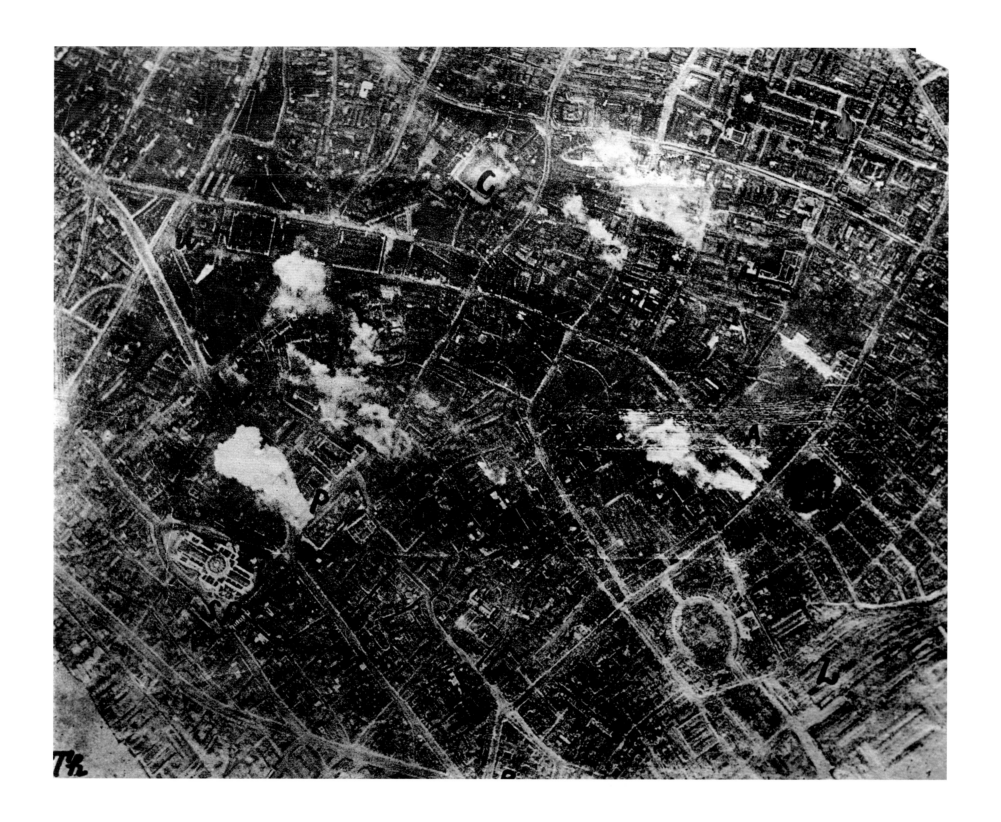

Unknown photographer, Imperial German Air Force
**Aerial view showing St Paul's Cathedral (left), taken during the second daylight raid on
London, 7 July 1917**
Gotha raids on London commenced in June 1917

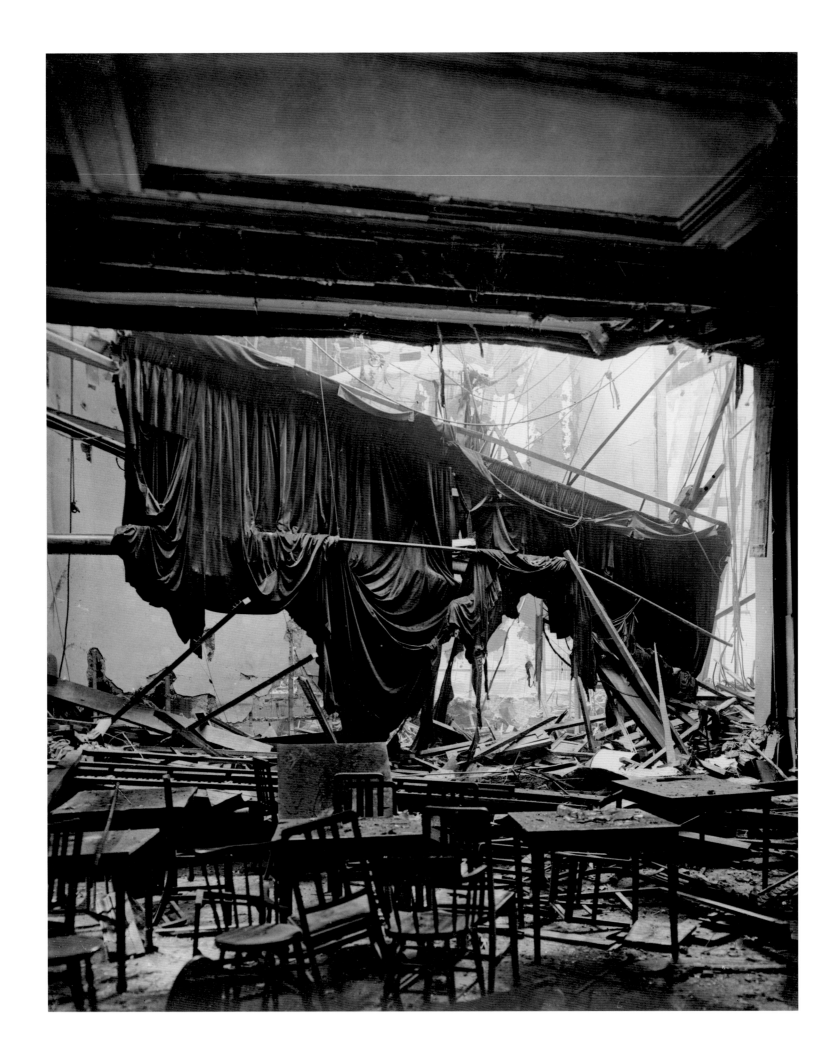

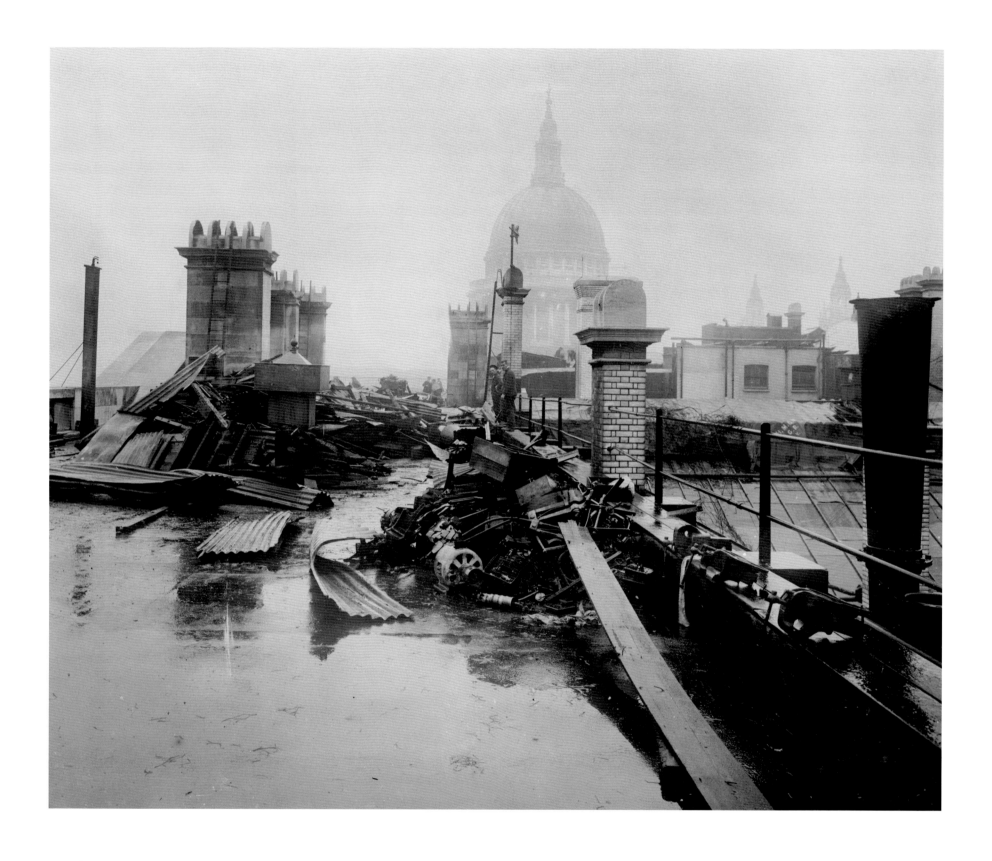

Left: Unknown photographer, Home Office
Damage to the Little Theatre after being hit by a 50-kg bomb during a German air raid, London, 4–5 September 1917

Above: Unknown photographer, Home Office
View of St Paul's Cathedral from the roof of the General Post Office, showing debris from the German daylight raid on London, 7 July 1917

CAPTAIN FRANK HURLEY, Australian Army photographer
An observer, wearing a parachute, disembarks from the basket of an Australian observation balloon, Ypres Salient, Belgium, 23 October 1917
Static observation balloons were primary targets on the Western Front. Observers, with a high fatality rate, were the only aviators routinely equipped with parachutes. The parachutes, developed in 1915, were unreliable and used only as a last resort

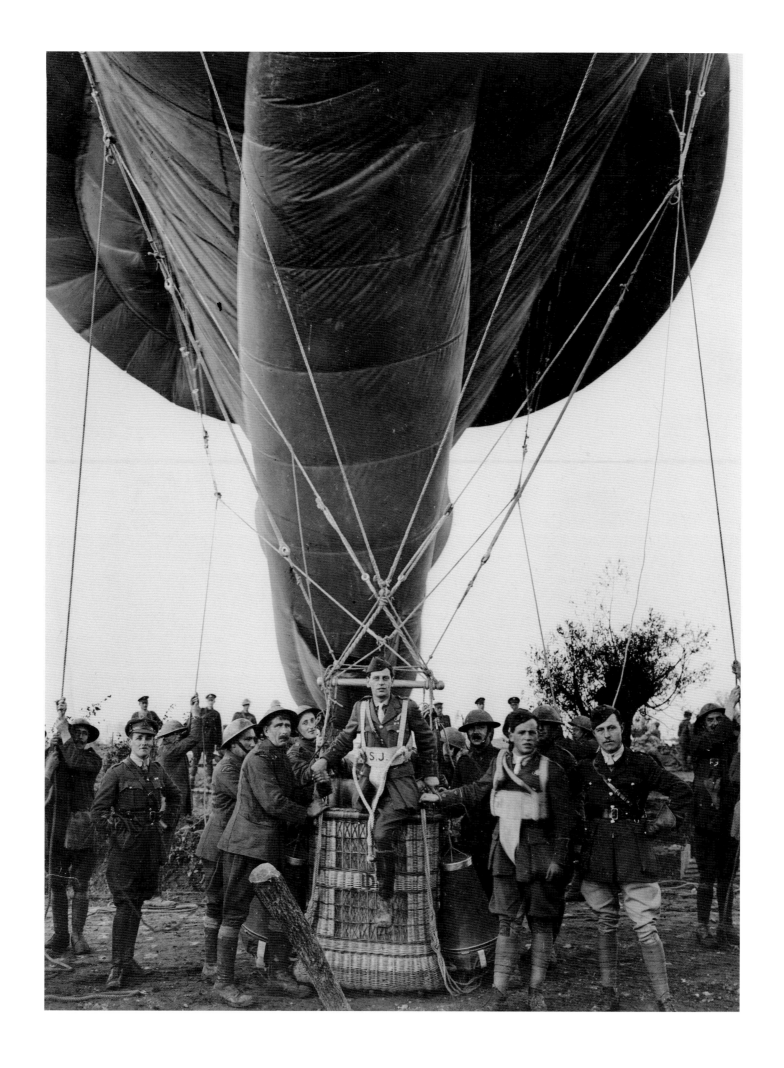

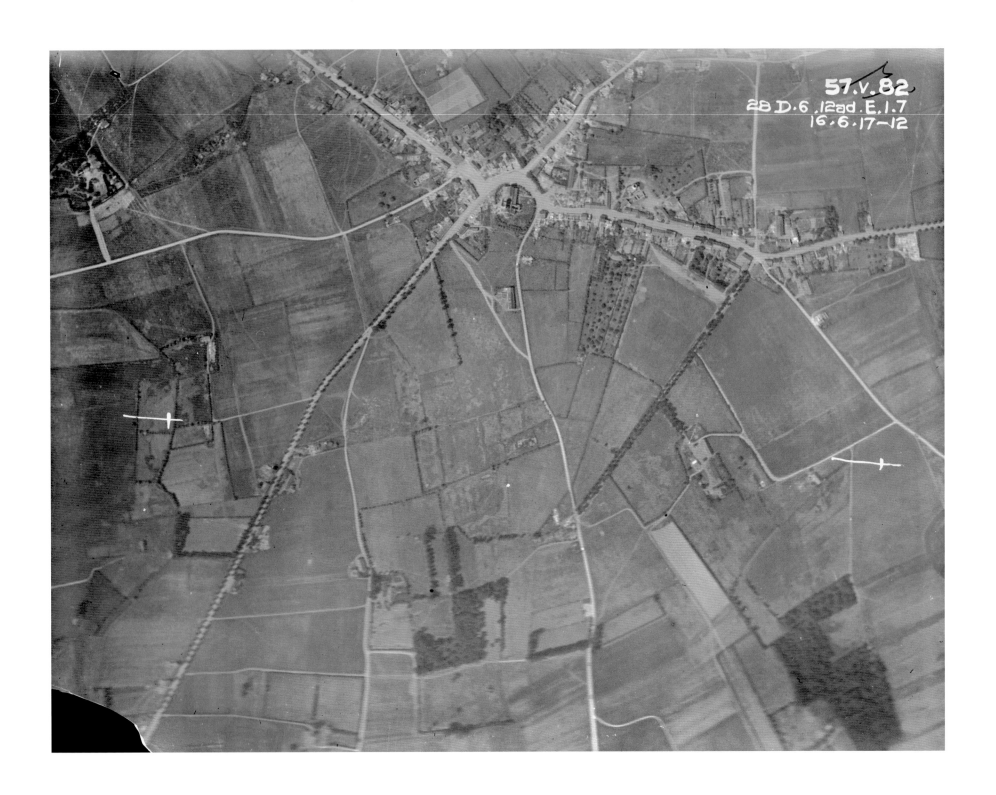

Unknown photographer, Royal Flying Corps
**Aerial view of the village of Passchendaele before the battle, Ypres Salient, Belgium,
16 June 1917**
*The Third Battle of Ypres, also known as Passchendaele after the village where it
ended, was a savage battle for control of the ground surrounding the city of Ypres*

Unknown photographer, Royal Flying Corps
Aerial view of the village of Passchendaele after the battle, Ypres Salient, Belgium,
16 June 1917
3,000 Allied guns fired 4.25 million shells in the opening artillery barrage, destroying
the battlefield

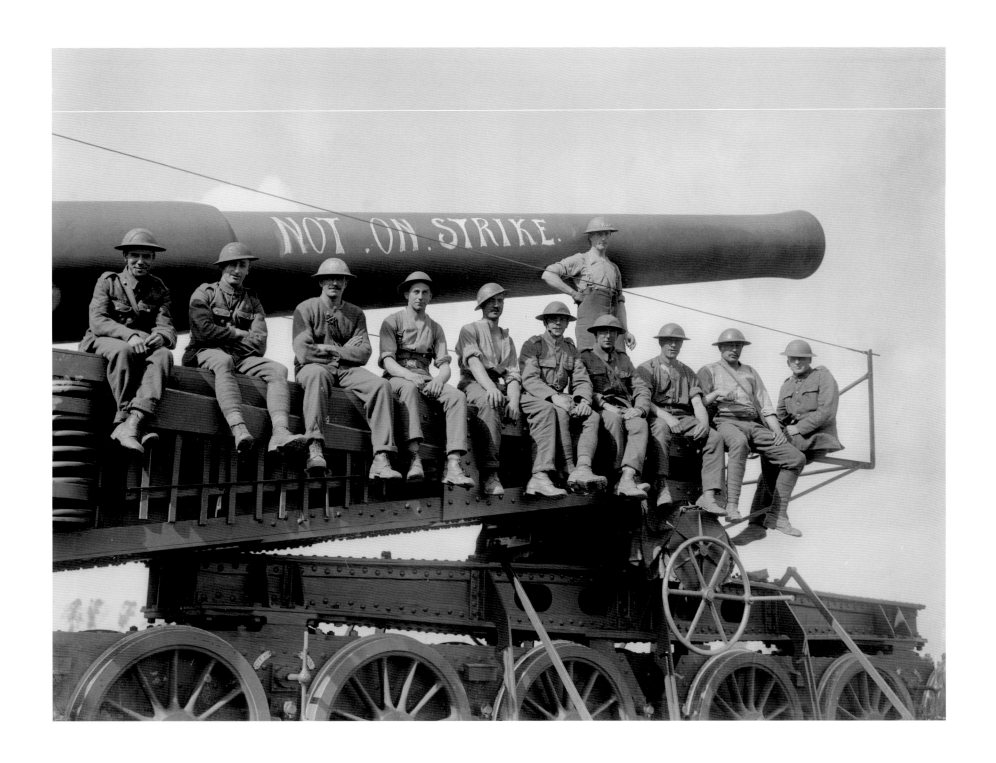

LIEUTENANT ERNEST BROOKS, British Army photographer
**The crew of a Royal Marine Artillery 12-inch gun send a message to striking workers
in Britain during the Battle of Langemarck, Woesten, Belgium, 24 August 1917**
*The new offensive did nothing to mitigate widespread industrial unrest arising from
difficult working conditions, escalating prices and shortages in Britain. Germany,
Russia and France were also affected by deteriorating industrial relations*

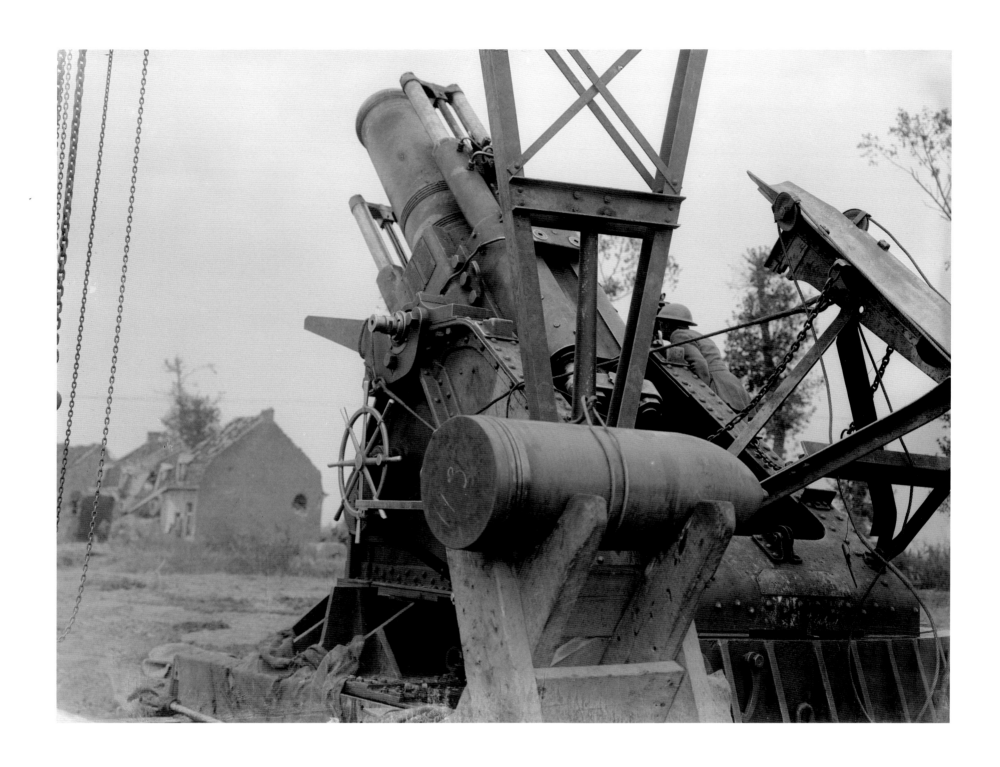

LIEUTENANT ERNEST BROOKS, British Army photographer
**A 15-inch howitzer is prepared for firing during the Battle of Polygon Wood, near
Ypres, Belgium, 27 September 1917**

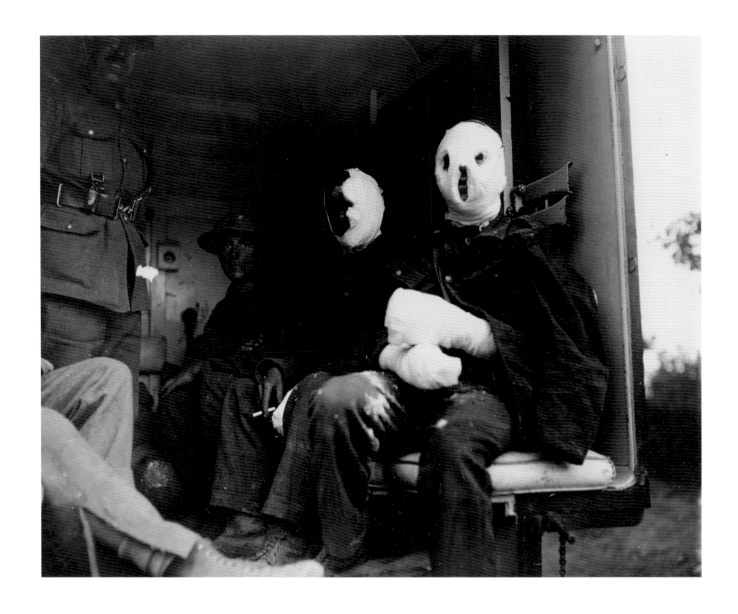

LIEUTENANT WILLIAM RIDER-RIDER, Canadian Army photographer
Canadian soldiers are evacuated after being badly injured in a German flame-thrower
attack, Lieven, Belgium, July 1917

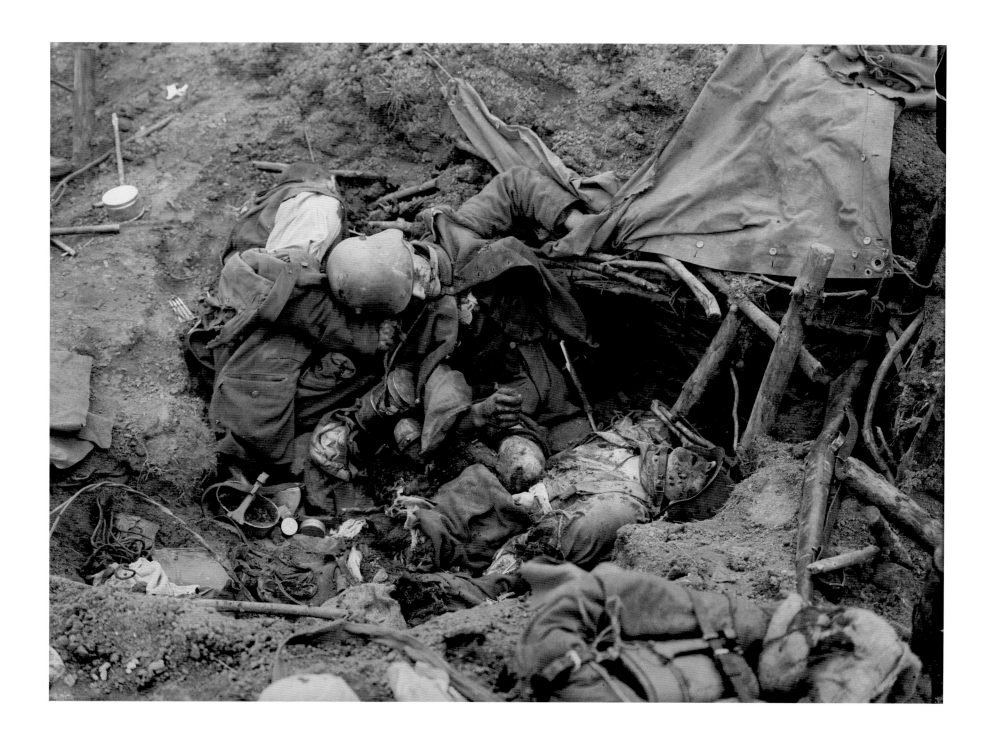

LIEUTENANT ERNEST BROOKS, British Army photographer
The bodies of three German soldiers, killed when a shell hit their dugout during the
Battle of Pilckem Ridge, Ypres Salient, Belgium, 31 July 1917

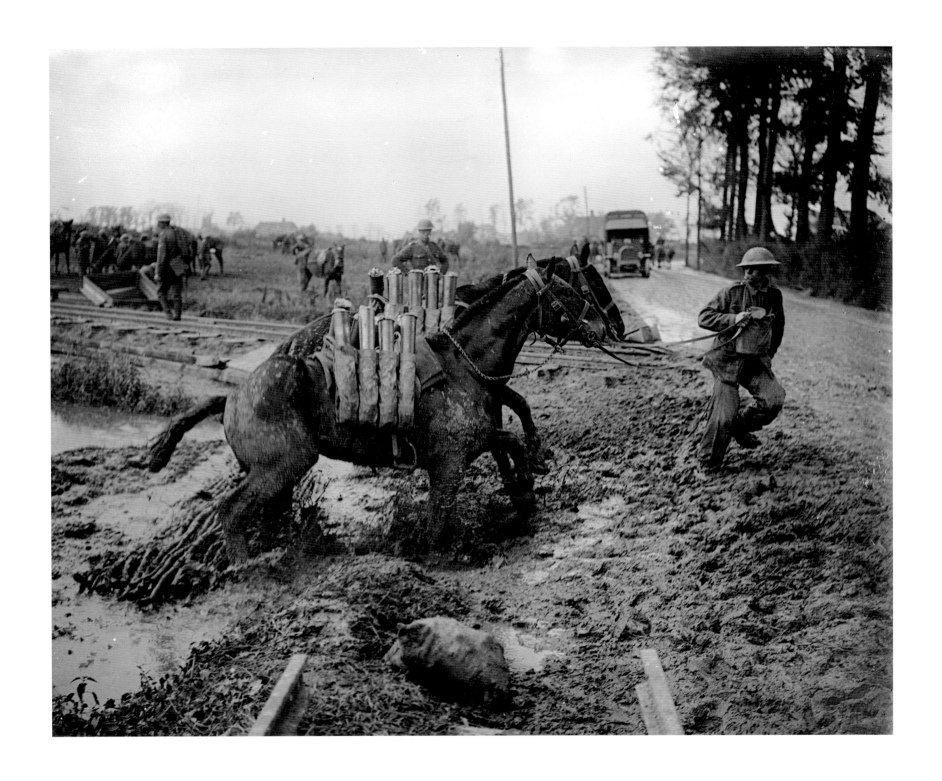

LIEUTENANT JOHN WARWICK BROOKE, British Army photographer
Pack mules struggle with a consignment of shells during the Battle of Pilckem Ridge,
Ypres Salient, 1 August 1917
Heavy rain combined with artillery fire turned the battlefield into a quagmire

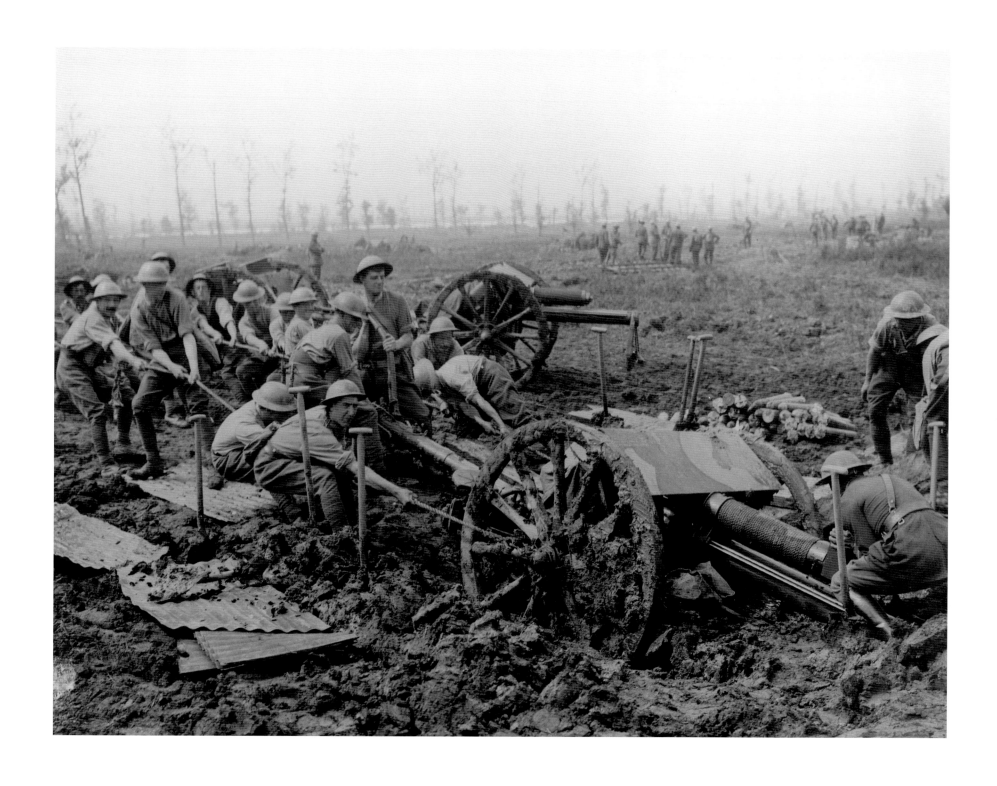

LIEUTENANT JOHN WARWICK BROOKE, British Army photographer
Gun crews, possibly of 149 Artillery Brigade, Royal Horse Artillery, haul an 18-pounder
field gun out of deep mud near Zillebeke, Ypres Salient, Belgium, 9 August 1917

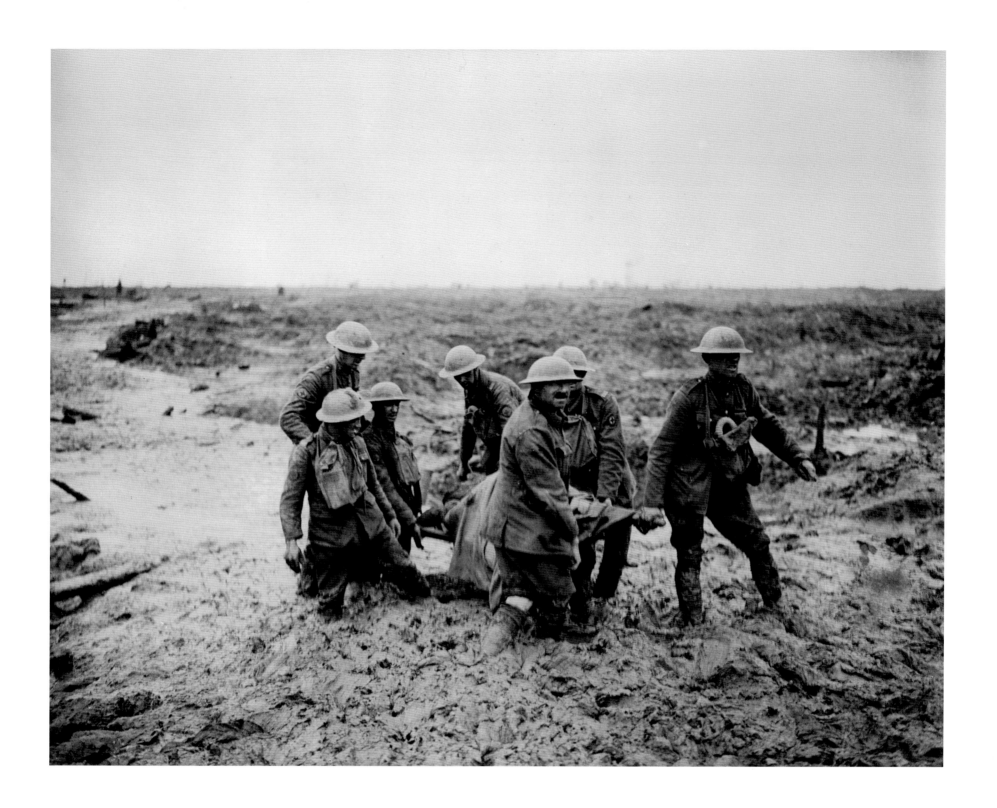

LIEUTENANT JOHN WARWICK BROOKE, British Army photographer
**Stretcher-bearers of the Field Ambulance Corps carry a wounded man through deep
mud, near Boesinghe, Ypres Salient, Belgium, 1 August 1917**
Passchendaele was the subject of some of the war's most iconic imagery

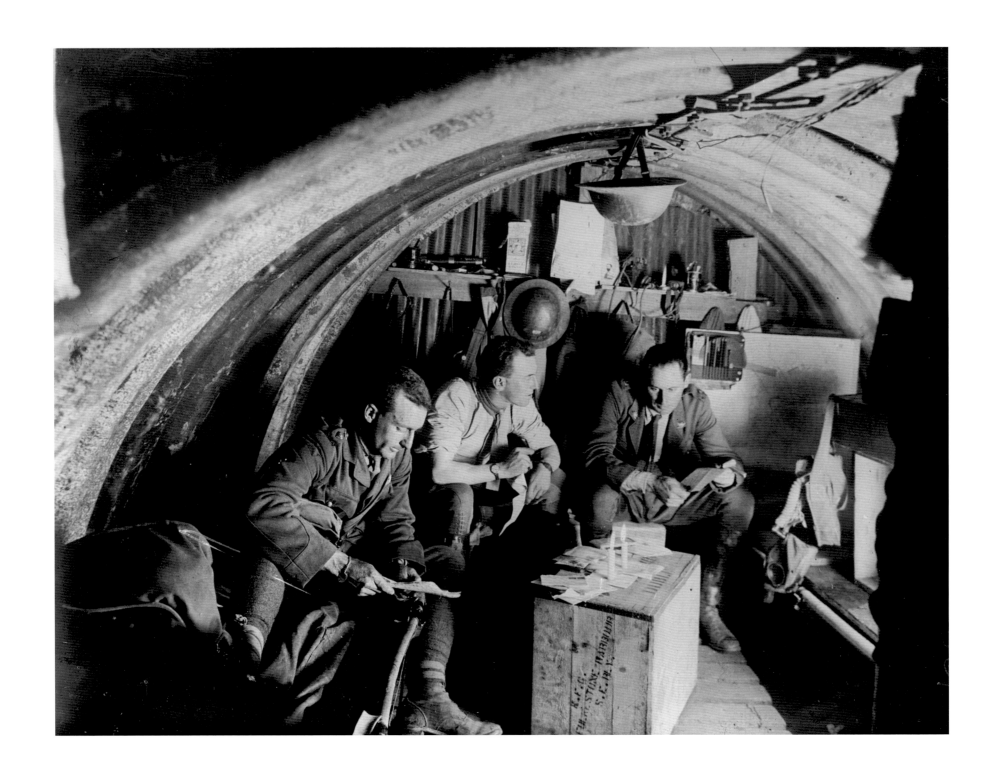

CAPTAIN FRANK HURLEY, Australian Army photographer
Officers of 105 Howitzer Battery, 4th Australian Brigade, in their dugout, near Hill 60,
Ypres Salient, Belgium, 27 August 1917

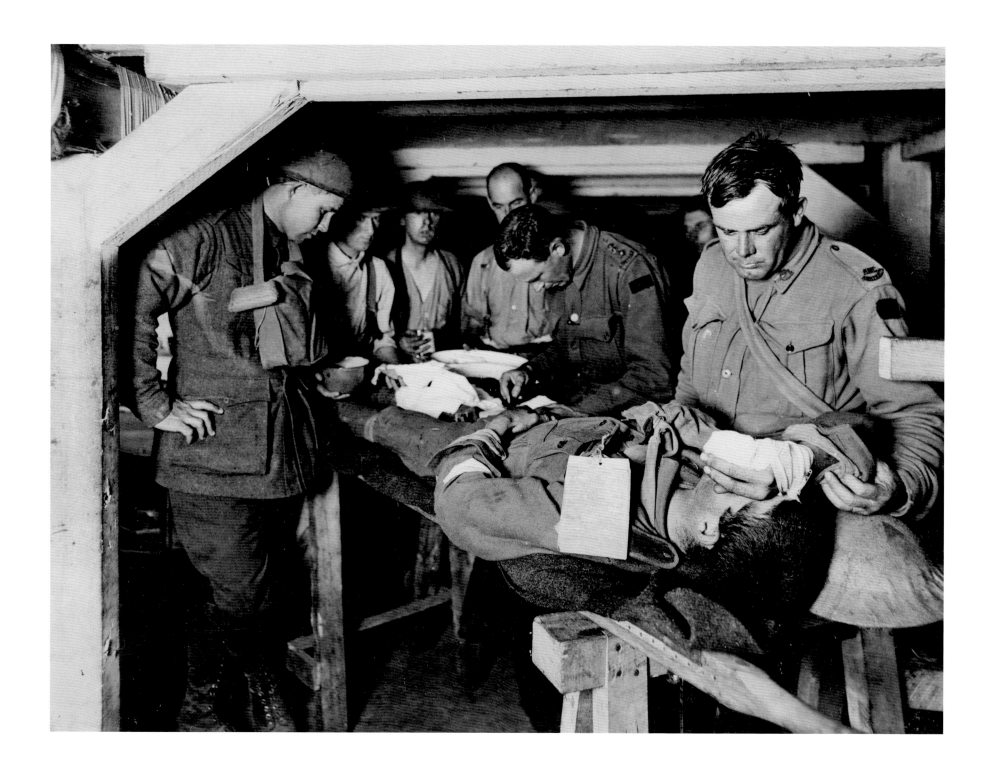

CAPTAIN FRANK HURLEY, Australian Army photographer
An Australian medical officer removes shrapnel from the leg of a wounded soldier,
3 Australian Brigade Advanced Dressing Station, Ypres Salient, Belgium, 20 September 1917

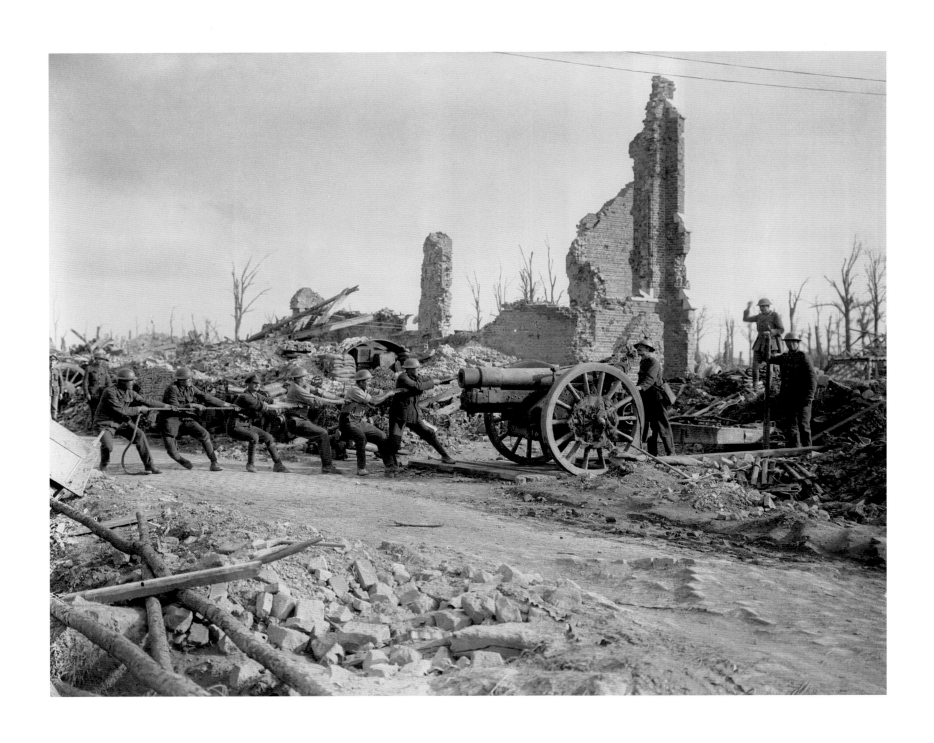

LIEUTENANT ERNEST BROOKS, British Army photographer
British gun crews haul a 6-inch howitzer forward to a new position during the Battle
of Langemarck, near Boesinghe, Ypres Salient, Belgium, 16 August 1917

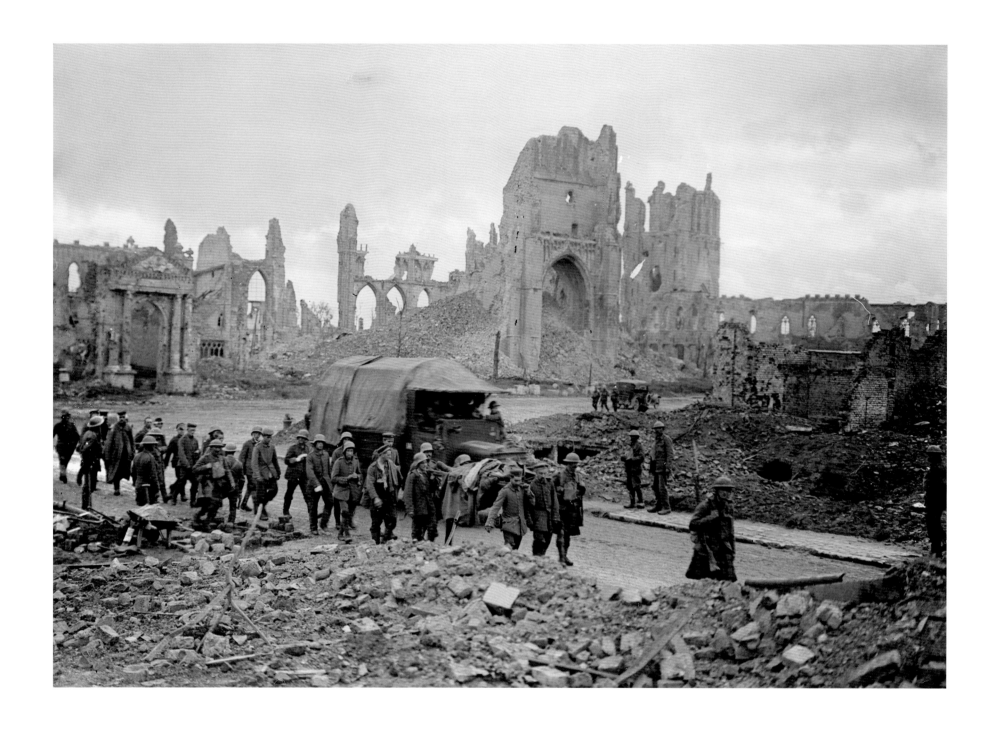

LIEUTENANT ERNEST BROOKS, British Army photographer
German prisoners, captured during the Battle for Menin Road Ridge, move through
the ruins of Cathedral Square, Ypres, Belgium, 20 September 1917

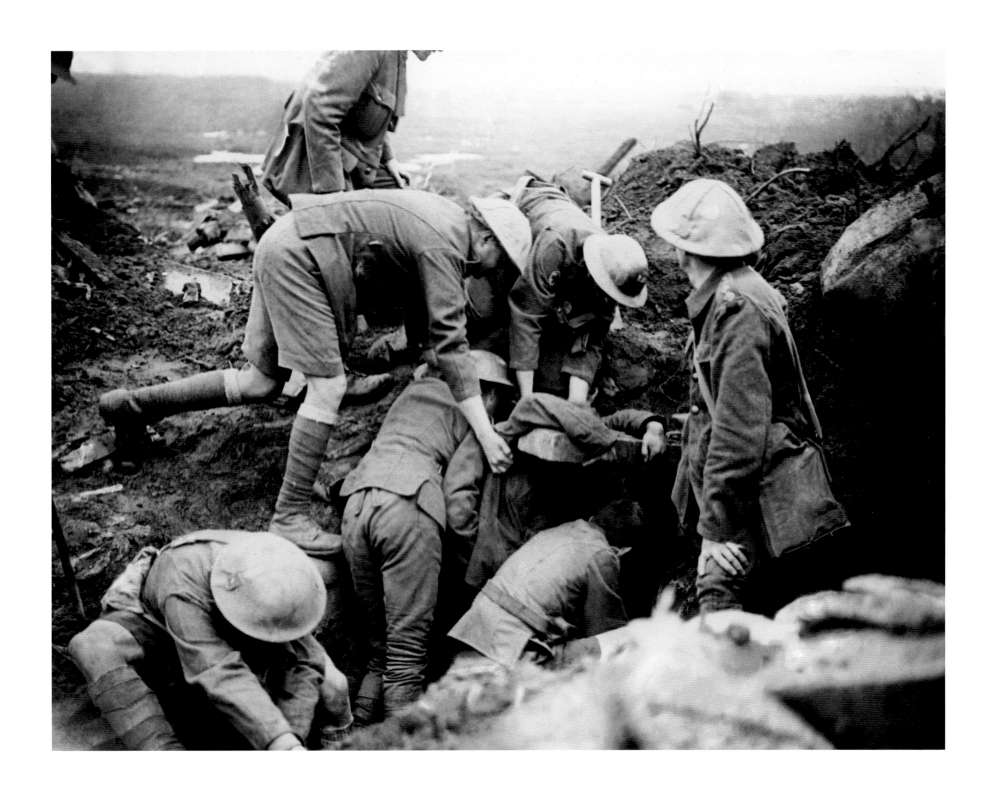

LIEUTENANT JOHN WARWICK BROOKE, British Army photographer
An injured man, buried alive, is rescued from the ruins of the Regimental Aid Post of
the 13th Durham Light Infantry after it was hit by a German shell, near Zillebeke,
Ypres Salient, Belgium, 20 September 1917

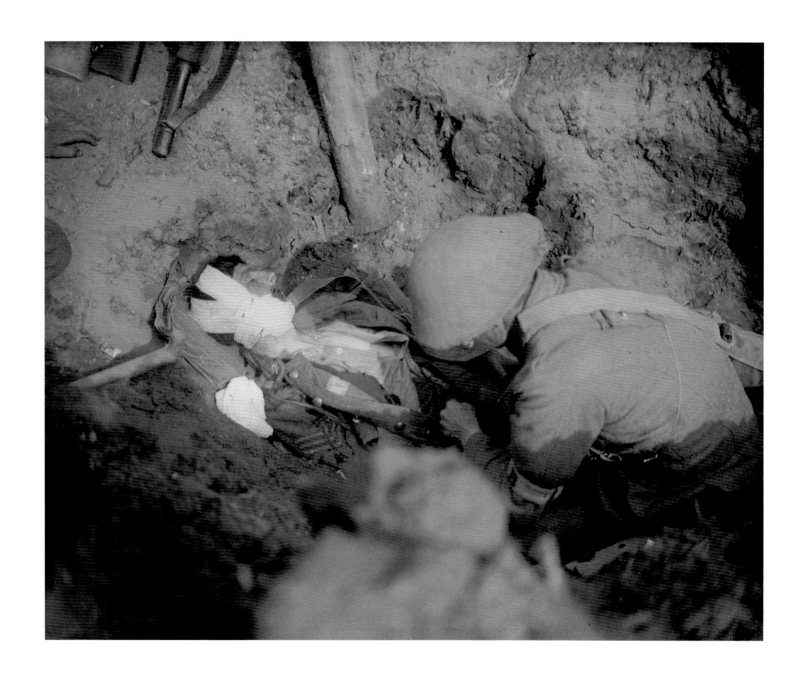

LIEUTENANT JOHN WARWICK BROOKE, British Army photographer
A stretcher-bearer gives first aid to a badly wounded sergeant of the Argyll and
Sutherland Highlanders in a trench at 'Clapham Junction' during the Battle of Polygon
Wood, Ypres Salient, 26 September 1917

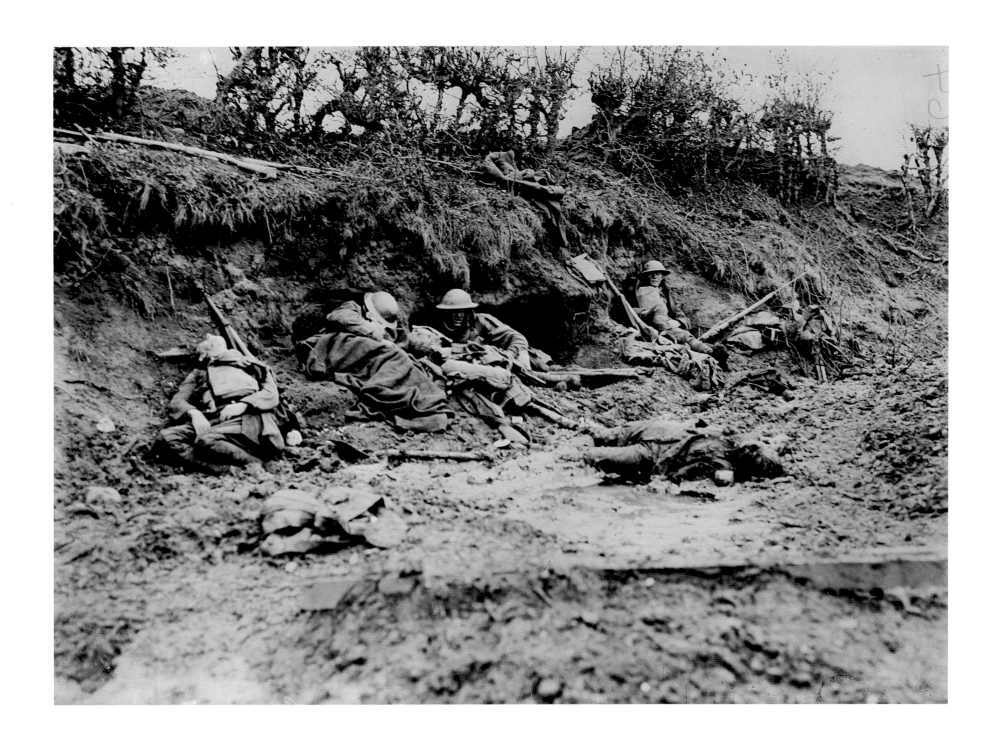

CAPTAIN FRANK HURLEY or CAPTAIN HUBERT WILKINS, Australian Army photographers
Australian soldiers, surrounded by the dead, huddle in 'funk holes' carved in the sides
of a railway cutting, Broodseinde Ridge, Ypres Salient, Belgium, 21 October 1917
Pte Austin G. Henderson, 38th Australian Battalion, is on the far right. Both Australian
photographers recorded this scene with different cameras. It is believed this picture is
by Hurley

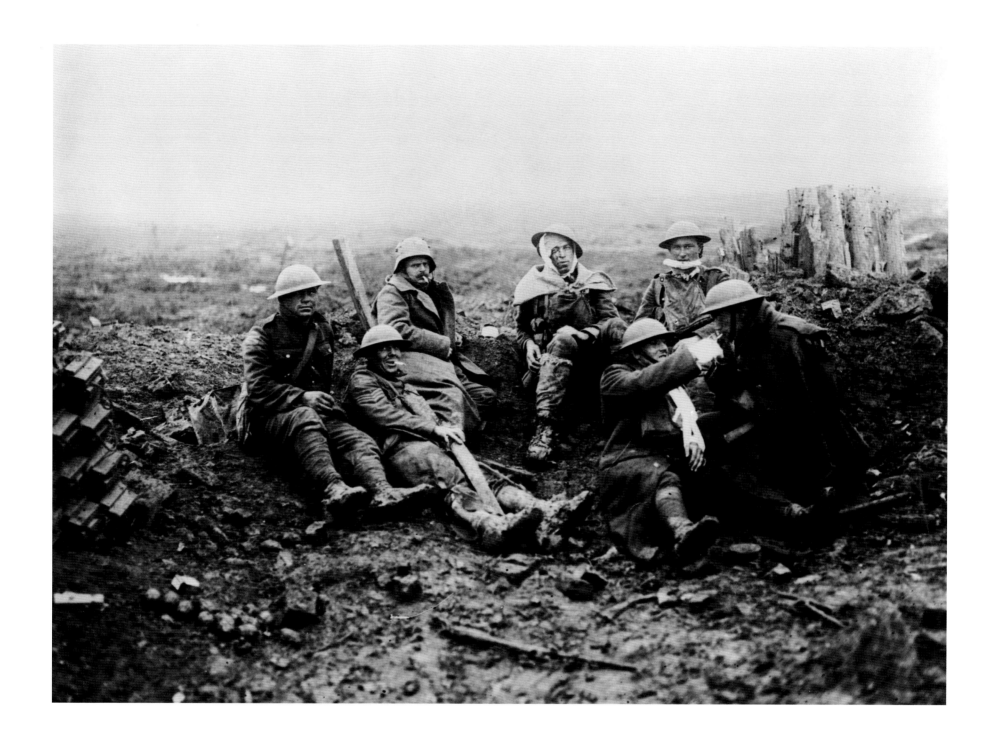

LIEUTENANT WILLIAM RIDER-RIDER, Canadian Army photographer
A group of Canadian walking wounded and a German prisoner pause for cigarettes
near Heine Pillbox during the assault on Passchendaele, Ypres Salient, Belgium,
November 1917

LIEUTENANT ERNEST BROOKS, British Army photographer
A German shell bursts within ten yards of the photographer, near Zonnebeke, Ypres Salient, Belgium, 22 September 1917

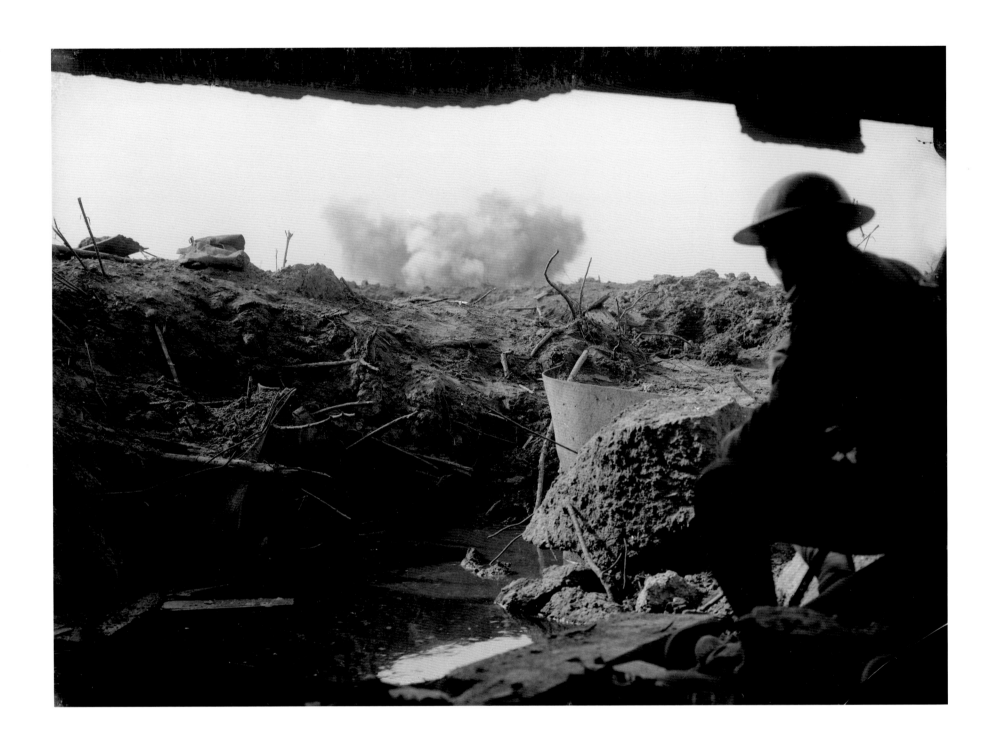

LIEUTENANT ERNEST BROOKS, British Army photographer
**A British soldier shelters from a German barrage in a captured German pillbox, near
the Wieltje–Gravenstafel Road (Rat Farm), Ypres Salient, Belgium, 27 September 1917**
*German defences in the Hindenburg Line relied on pillboxes made of thick, reinforced
concrete. They provided protection from flooding as well as from assaults*

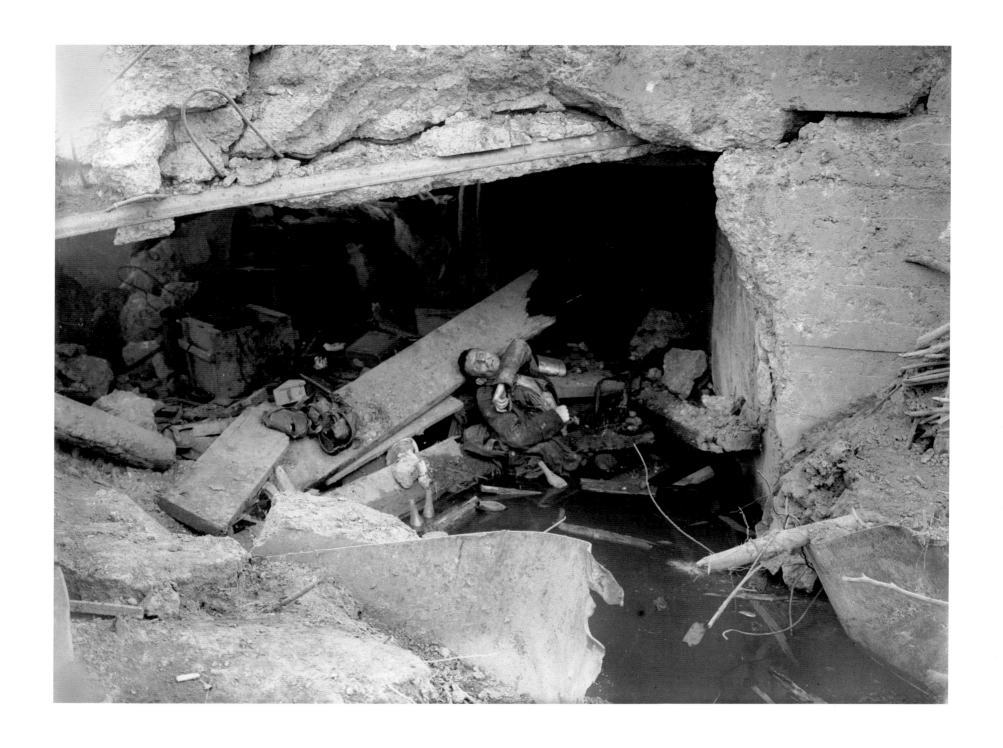

LIEUTENANT ERNEST BROOKS, British Army photographer
A dead German soldier in the flooded remains of a concrete gun emplacement
destroyed by heavy British shelling during the Battle for Menin Road Ridge,
near Zonnebeke, Ypres Salient, Belgium, 23 September 1917

LIEUTENANT ERNEST BROOKS, British Army photographer
A German prisoner captured in the attack on Vampire Farm by Scottish and South
African troops, near Potijze, Ypres Salient, Belgium, 20 September 1917

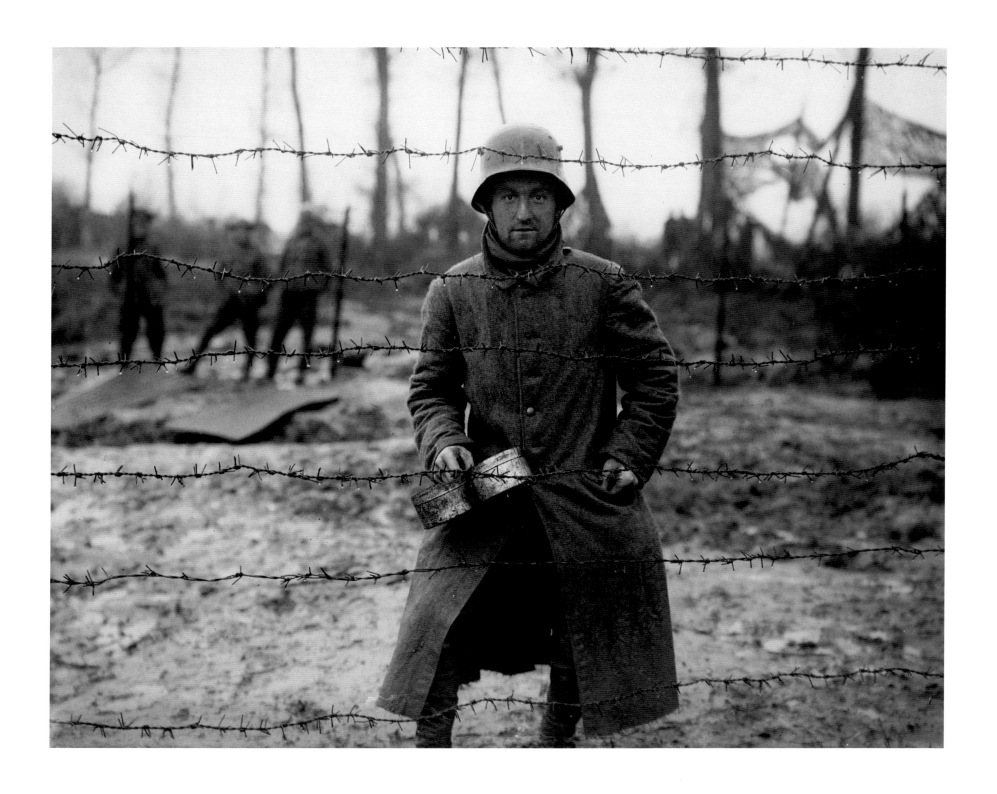

LIEUTENANT ERNEST BROOKS, British Army photographer
A German prisoner, mess tin in hand, waits for a meal in a prisoner-of-war cage,
Langemarck, Ypres Salient, Belgium, 26 September 1917

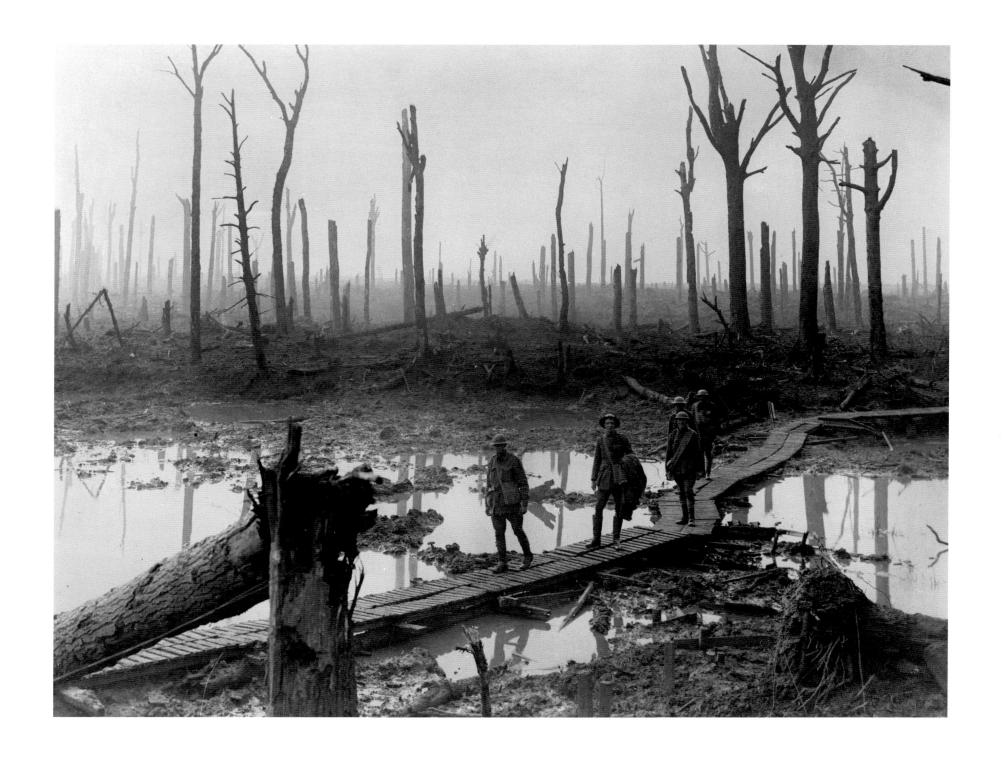

CAPTAIN FRANK HURLEY, Australian Army photographer
Australian troops walk through the remains of Chateau Wood, Ypres Salient, Belgium,
29 October 1917

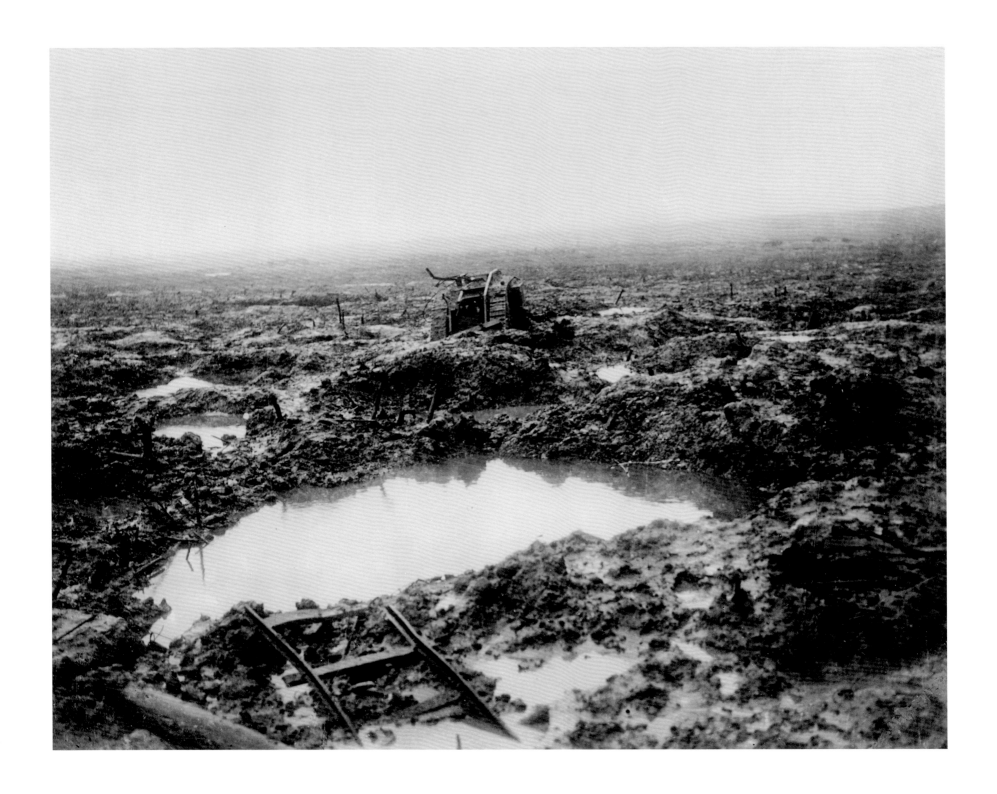

Above: LIEUTENANT WILLIAM RIDER-RIDER, Canadian Army photographer
A derelict British tank on the battlefield at Passchendaele, Ypres Salient, Belgium, November 1917

Right: LIEUTENANT WILLIAM RIDER-RIDER, Canadian Army photographer
16th Canadian Machine Gun Company holds the line in a desolate landscape of water-filled shell holes, Ypres Salient, Belgium, November 1917
The nearest machine gunner is Pte Reginald Le Brun

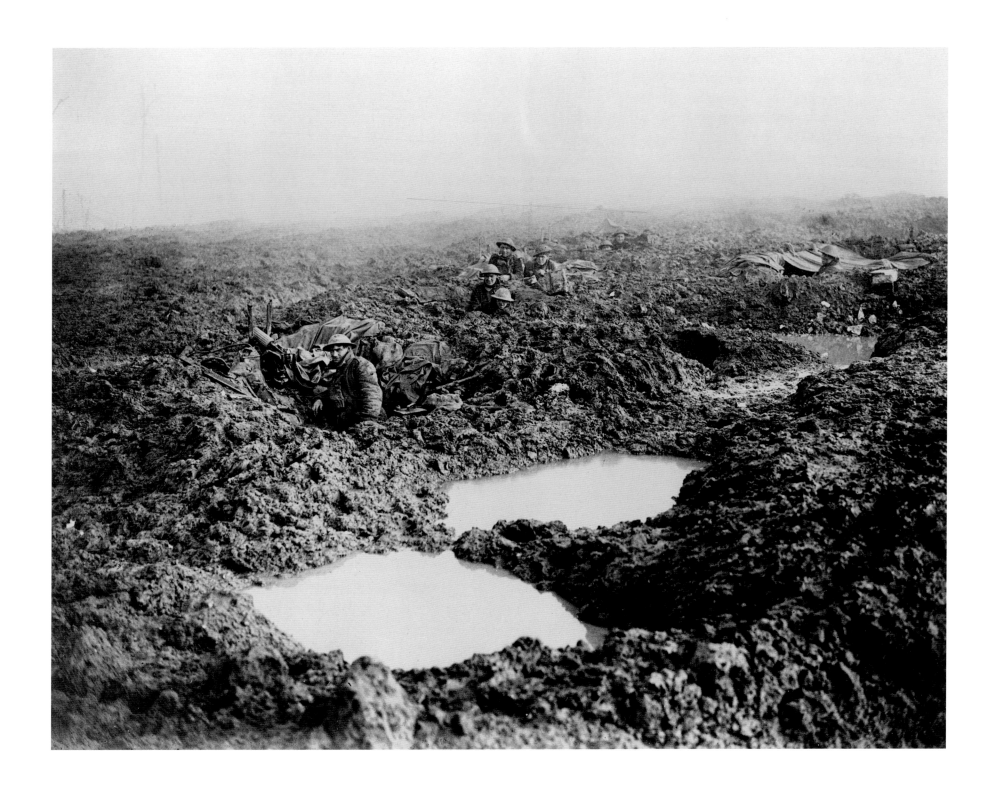

Pages 392–3: LIEUTENANT ERNEST BROOKS, British Army photographer
Trees felled by the German Army to hinder the advance of British tanks near
Havrincourt during the Battle of Cambrai, Pas de Calais, France, 20 November 1917

Pages 394–5: Unknown German Army photographer, Bild und Film Amt (Bufa)
Italian prisoners captured during the Battle of Caporetto on the Isonzo Front by
German and Austro-Hungarian forces, October 1917
The Central Powers inflicted a devastating defeat on Italy at Caporetto

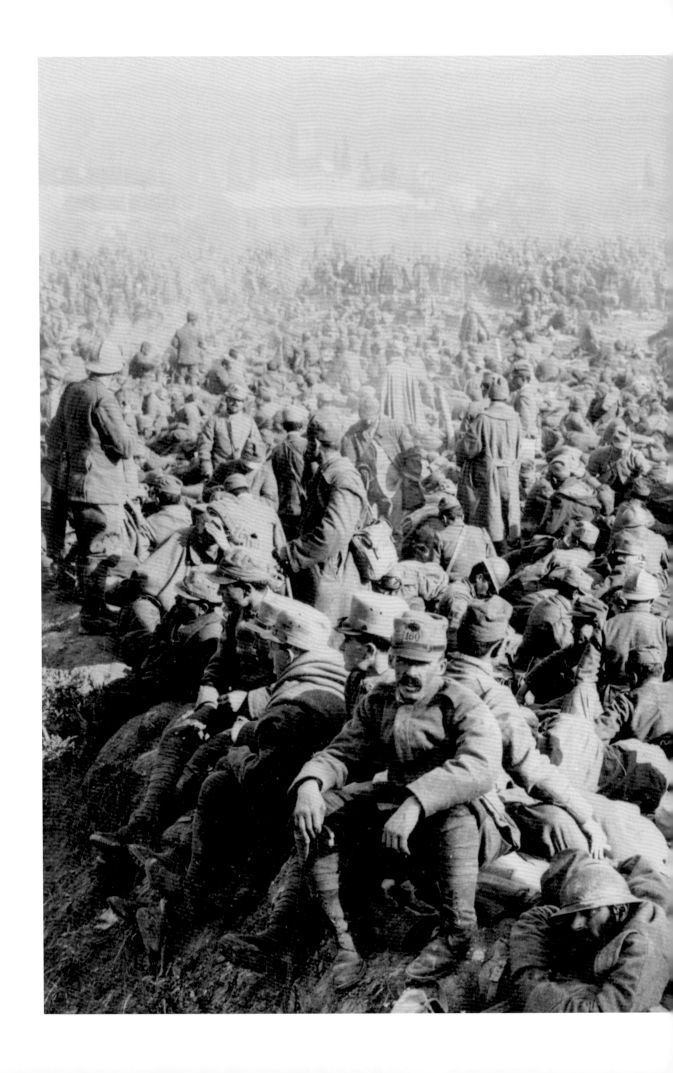

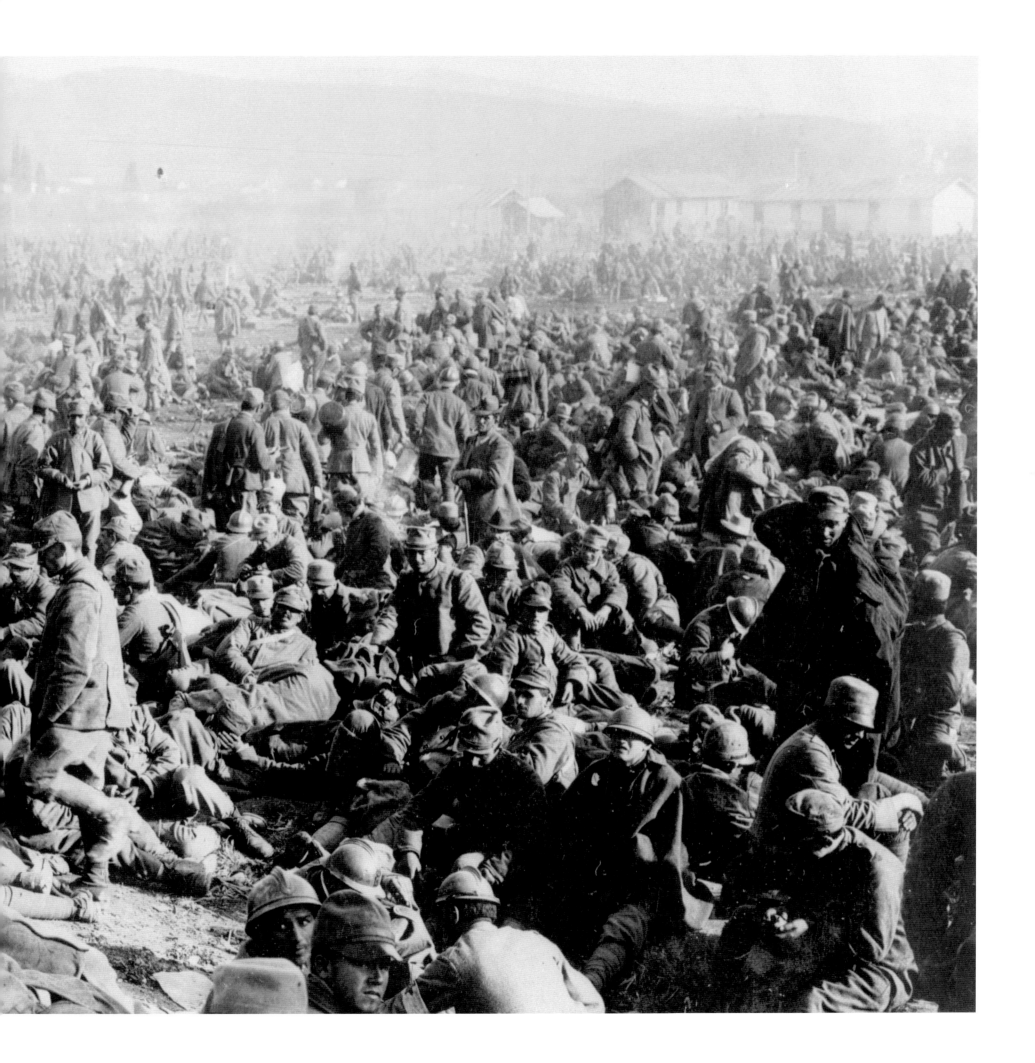

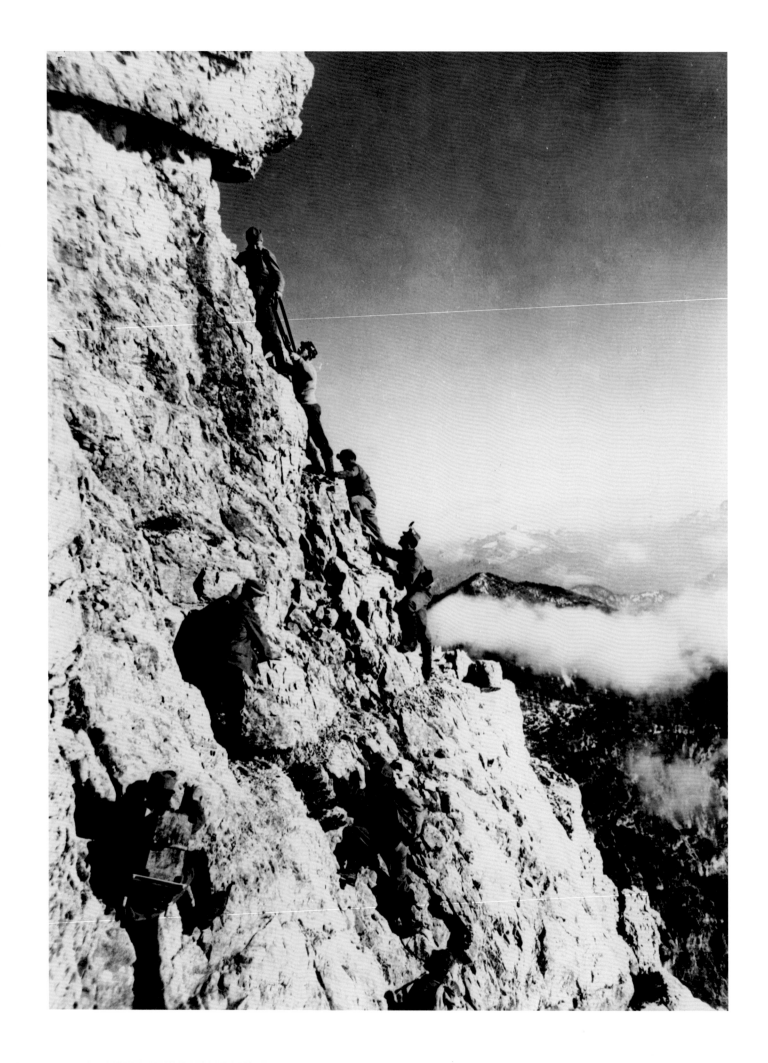

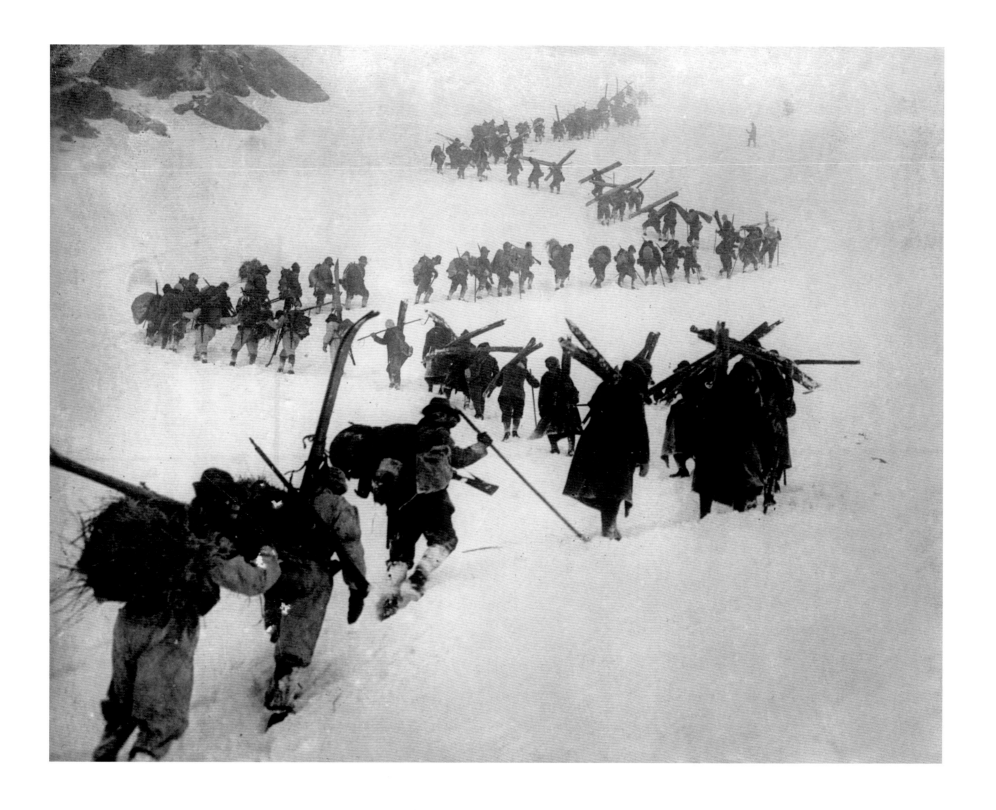

Left: Unknown photographer, Austro-Hungarian Army
Austro-Hungarian mountain patrol, the Alps, 1917

Above: Unknown photographer, Italian Army
Italian ski troops transport supplies through a mountain pass in a snow storm, Italy, 15 November 1917

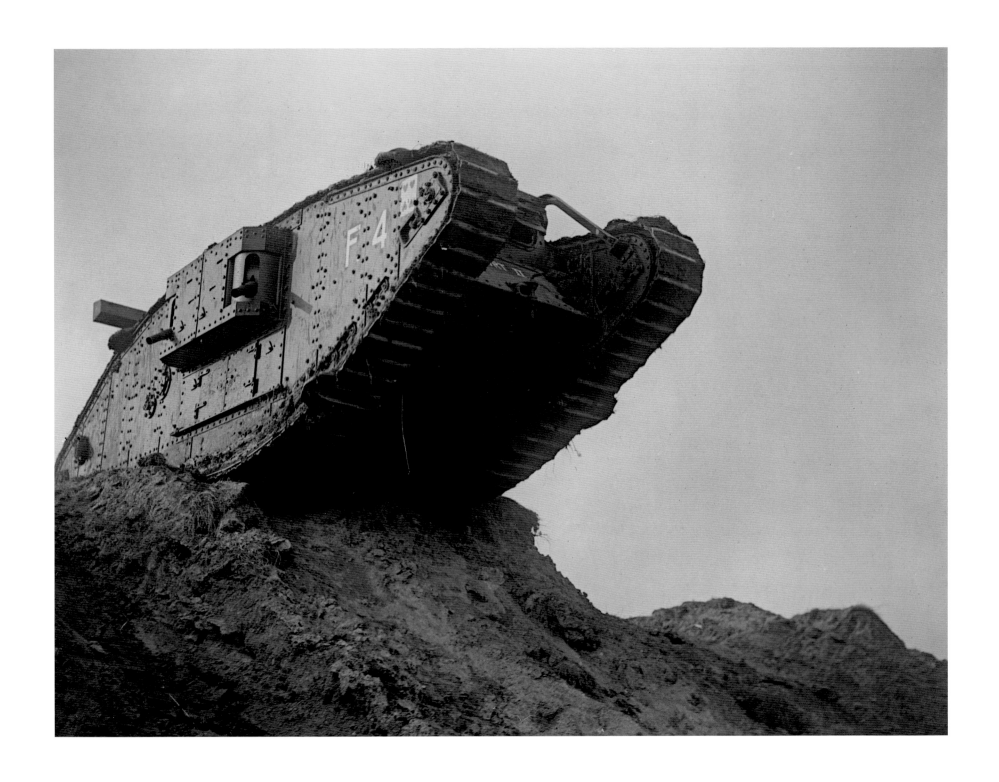

LIEUTENANT JOHN WARWICK BROOKE, British Army photographer
**A British Mk IV tank, *Flirt II*, during special training for the Battle of Cambrai,
Tank Driving School, Wally, near Arras, France, 21 October 1917**
*The British Army assembled a force of more than 400 tanks for the Battle of Cambrai.
Although unreliable, the tanks demonstrated their ability to break through the defences
of the Hindenburg Line*

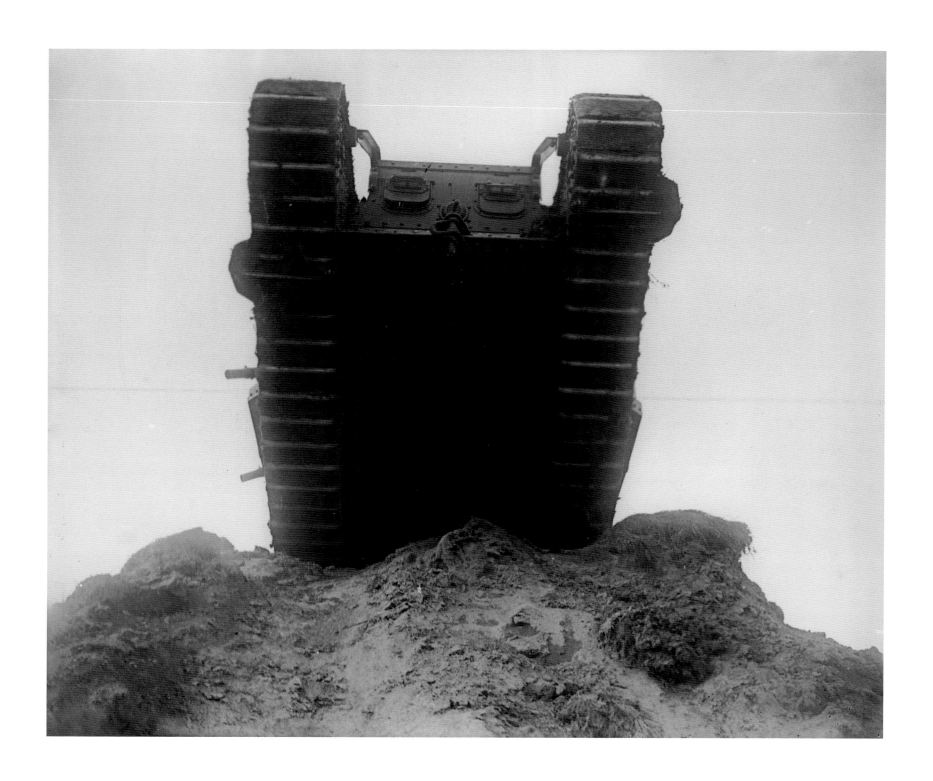

LIEUTENANT JOHN WARWICK BROOKE, British Army photographer
**A British Mk IV tank, *Flirt II*, during special training for the Battle of Cambrai,
Tank Driving School, Wally, near Arras, France, 21 October 1917**
*Brooke intended the photograph to represent a German soldier's view of a tank
surmounting his trench*

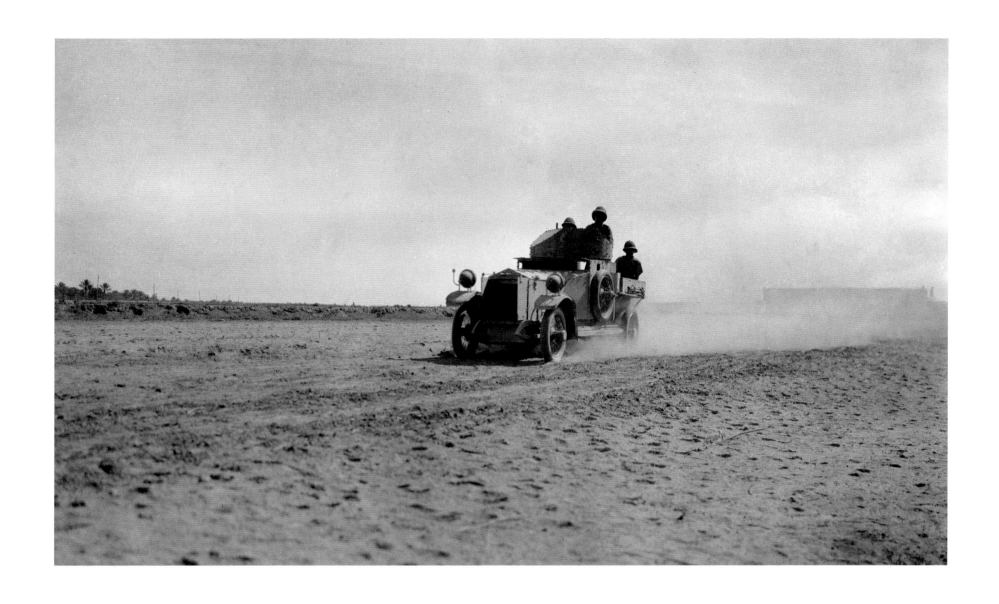

ARIEL VARGES, Mesopotamian Expeditionary Force photographer
A Rolls-Royce armoured car on patrol in the desert, Mesopotamia (now Iraq), *c.* **September 1917**
*The flat desert terrain enabled armoured cars to operate in the cavalry role that trench
warfare had denied them*

Above: Unknown photographer, personal photograph, from the collection of Colonel T. E. Lawrence

Lieutenant Colonel Stewart F. Newcombe, Chief of the British Military Mission in the Hejaz, with Arab forces in the desert, Hejaz, 1917

Emir Hussein, Sherif of Mecca, rebelled against Turkish rule in October 1916. With British support, his son Feisal led a successful campaign to attack Turkish supply routes in the Hejaz, including the Hejaz Railway and the port of Aqaba (now South Jordan)

Right: CAPTAIN RAYMOND GOSLETT (presumably), personal photograph, from the collection of Colonel T. E. Lawrence

Colonel T. E. Lawrence, British Liaison Officer to the Arab Revolt, shortly after the Arab forces had captured Aqaba, Hejaz, July 1917

Lawrence was appointed liaison officer to Feisal's forces in 1916. He compiled a visual record of the Arab Revolt from his own photographs and those of other British officers. The photographs, together with the journalism of Lowell Thomas, gave rise to the legend of Lawrence of Arabia

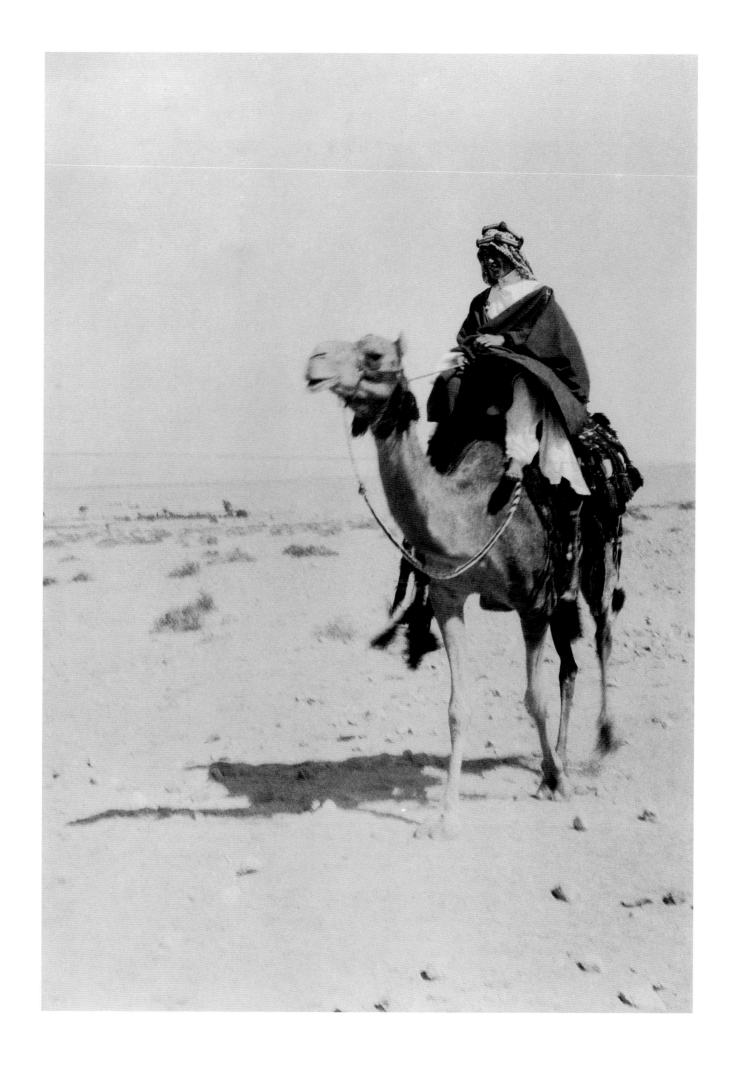

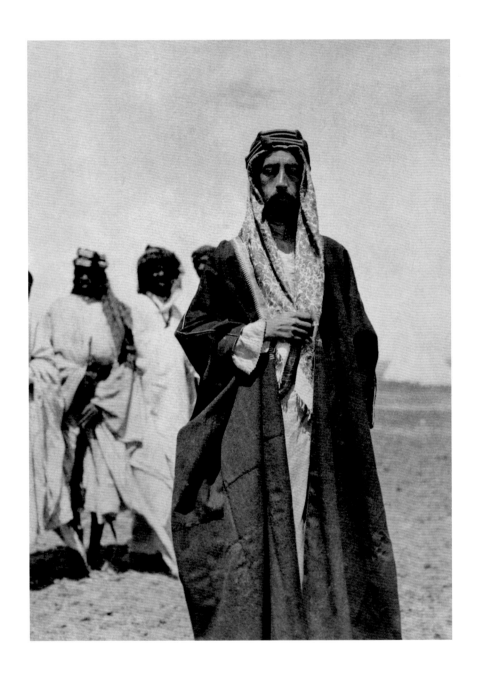

CAPTAIN EVAN MACRURY, personal photograph, from the collection of Colonel T. E. Lawrence
Emir Feisal bin Husain al-Hashimi, future King of Iraq, Wejh, Hejaz (now Saudi Arabia), March 1917

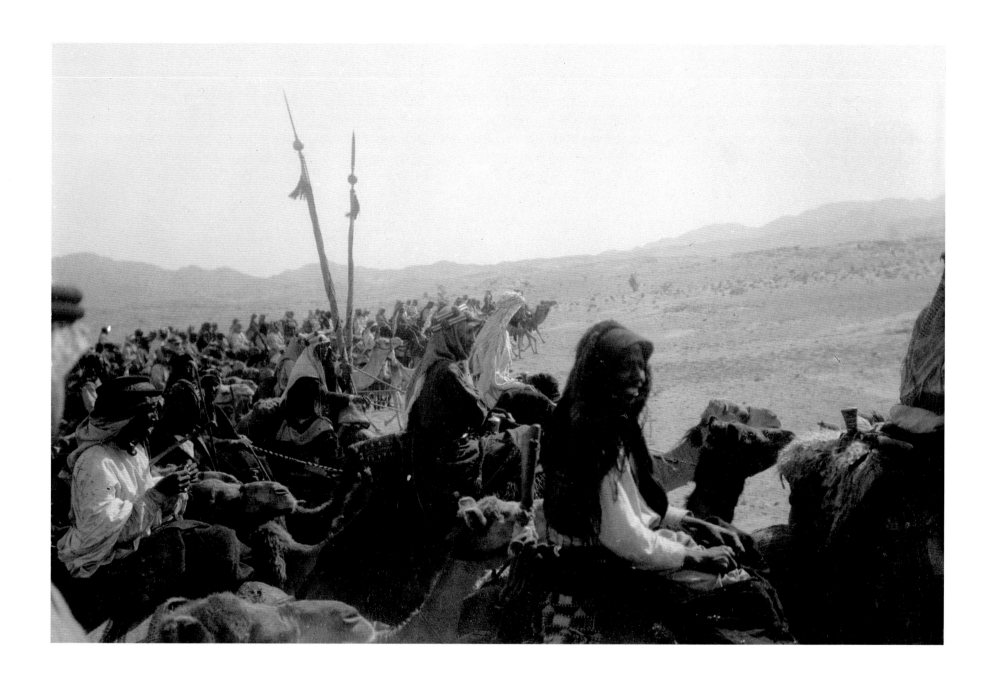

COLONEL T. E. LAWRENCE, personal photograph
**Emir Feisal bin Husain al-Hashimi and Sherif Sharraf lead the Ageyl bodyguard north
toward Wejh, Hejaz, 3 January 1917**

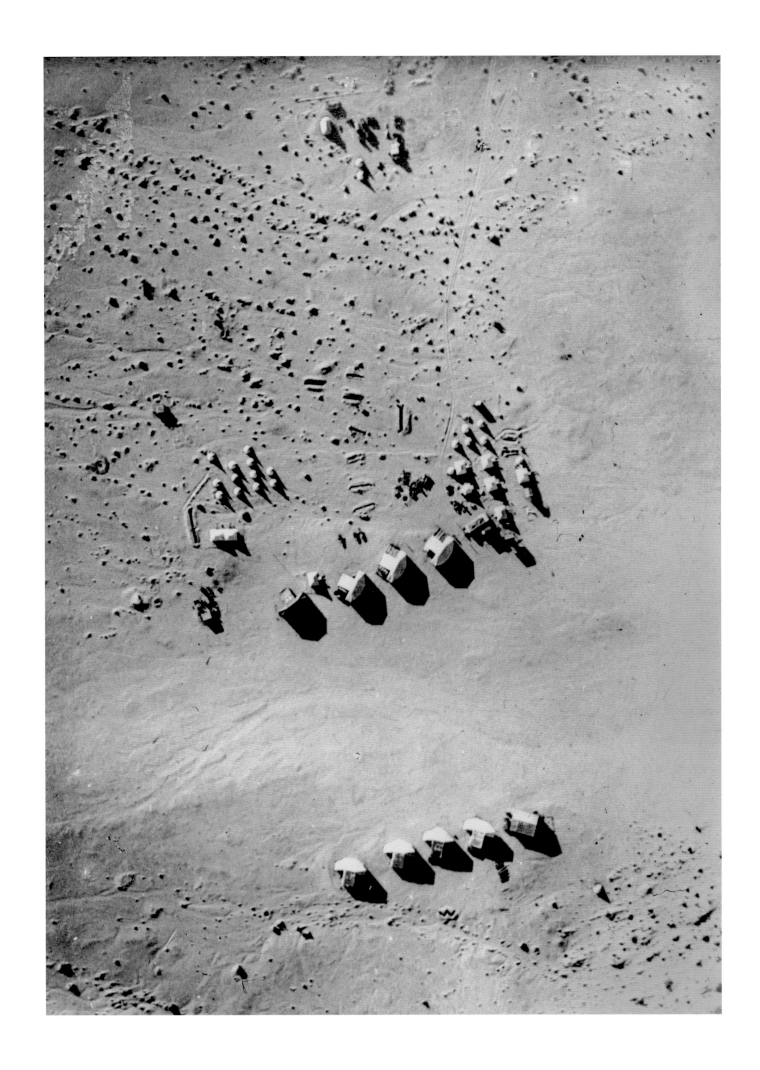

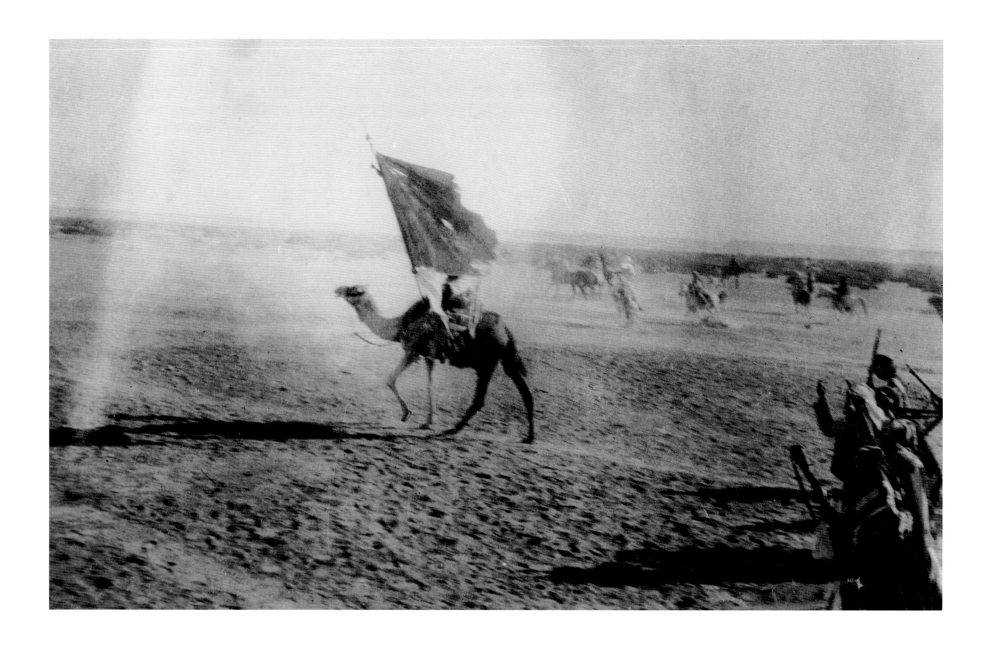

Left: Unknown photographer, Royal Flying Corps
Aerial view of a Royal Flying Corps camp, near Aqaba, Hejaz, 1917

Above: COLONEL T. E. LAWRENCE, personal photograph
Emir Feisal's standard-bearer leads the triumphal Arab entry into Aqaba, Hejaz, 6 July 1917

THE JEWISH NATIONAL MOVEMENT

DECLARATION BY
THE BRITISH GOVERNMENT

The Secretary of State for Foreign Affairs has transmitted to Lord Rothschild the following letter :—

FOREIGN OFFICE,
November 2nd, 1917

DEAR LORD ROTHSCHILD,

I have much pleasure in conveying to you, on behalf of His Majesty's Government, the following declaration of sympathy with Jewish Zionist aspirations which has been submitted to, and approved by, the Cabinet :—

"His Majesty's Government view with favour the establishment in Palestine of a national home for the Jewish people, and will use their best endeavours to facilitate the achievement of this object, it being clearly understood that nothing shall be done which may prejudice the civil and religious rights of existing non-Jewish communities in Palestine, or the rights and political status enjoyed by Jews in any other country."

I should be grateful if you would bring this declaration to the knowledge of the Zionist Federation.

Yours sincerely,

ARTHUR JAMES BALFOUR.

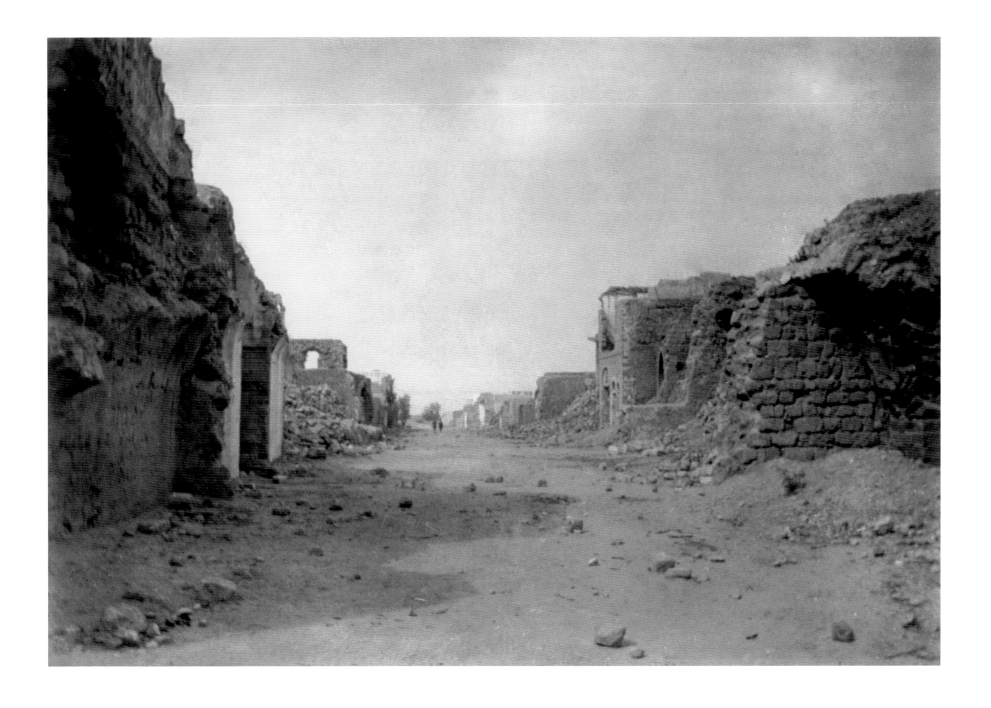

Left: IWM collection
A Jewish National Movement (Zionist) pamphlet quotes the Balfour Declaration of 2 November 1917
Arthur Balfour, British Foreign Secretary, wrote to Lord Rothschild declaring Britain's support for a Jewish state in Palestine on 2 November 1917. The Balfour Declaration laid the foundation for future conflict between Arabs and Jews

Above: Unknown photographer, Egyptian Expeditionary Force
Destruction in Gaza after its capture by the Egyptian Expeditionary Force under General Sir Edmund Allenby, Palestine, November 1917
Allenby was put in command of the force in May 1917 and ordered to revive its faltering campaign in Palestine

PROCLAMATION
OF MARTIAL LAW IN JERUSALEM.

To the inhabitants of Jerusalem the Blessed and the people dwelling in its vicinity.

The defeat inflicted upon the Turks by the troops under my command has resulted in the occupation of your City by my forces. I therefore here and now proclaim it to be under Martial Law, under which form of administration it will remain so long as military considerations make it necessary.

However, lest any of you should be alarmed by reason of your experiences at the hands of the enemy who has retired, I hereby inform you that it is my desire that every person should pursue his lawful business without fear of interruption. Furthermore, since your City is regarded with affection by the adherents of three of the great religions of mankind, and its soil has been consecrated by the prayers and pilgrimages of devout people of those three religions for many centuries, therefore do I make known to you that every sacred building, monument, holy spot, shrine, traditional site, endowment, pious bequest or customary place of prayer, of whatsoever form of the three religions, will be maintained and protected according to the existing customs and beliefs of those to whose faiths they are sacred.

December 1917. **EDMUND HENRY HYNMAN ALLENBY, General,**

Commander-in-Chief Egyptian Expeditionary Force.

PROCLAMATION
DE LA LOI MARTIALE A JÉRUSALEM.

Aux habitants de la sainte ville de Jérusalem et à la population des environs.

La défaite infligée aux Turcs par les troupes que je commande a abouti à l'occupation de votre Cité par mon armée. En conséquence, je la proclame d'ores et déjà sous le régime de la Loi Martiale, auquel elle demeurera soumise pour autant que les considérations militaires le rendront nécessaire.

Néanmoins, et afin qu'aucun de vous n'en conçoive quelque alarme du fait de vos expériences passées avec l'ennemi qui s'est retiré, je viens par la présente vous informer que mon désir est que chacun de vous poursuive son légitime travail sans crainte d'interruption. De plus, considérant que votre ville jouit de l'affection des adhérents des trois grandes religions de l'humanité et qu'au cours de plusieurs siècles son sol a été consacré par les prières et les pèlerinages des pieux fidèles de ces trois religions, je proclame conséquemment que tout édifice sacré, monument, lieu saint, sanctuaire, site traditionnel, dotation, legs pieux ou endroit habituel de prière, relevant de n'importe laquelle des trois religions précitées, sera maintenu et protégé conformément aux coutumes existantes et aux croyances des personnes au regard de qui ces lieux sont sacrés.

Décembre 1917. **EDMUND HENRY HYNMAN ALLENBY, Général,**

Commandant en Chef la Force Expéditionnaire d'Egypte.

PROCLAMAZIONE
DI LEGGE MARZIALE IN GERUSALEMME.

Agli abitanti di Gerusalemme la Sacra ed alla popolazione che vive nella sua vicinità.

La disfatta inflitta ai Turchi dall'armata sotto il mio comando ha avuto per risultato l'occupazione della Città vostra dalle mie truppe. Io per conseguenza dichiaro e la pongo sotto la Legge Marziale, e sotto tale forma verrà amministrata per tanto tempo quale le considerazioni militari lo considereranno necessario.

Tuttavia, se mai certuni si fossero allarmati per l'esperienza avuta sotto le mani del nemico che si è ritirato, io vi informo che è il mio desiderio che ogni persona prosegua ai suoi lavori ed affari senza interruzione.

Inoltre, siccome la Città vostra è considerata con affezione dagli aderenti da tre delle grandi religioni dell'umanità, ed il suo suolo è stato consacrato dalle preghiere ed i pellegrinaggi dei devoti popoli di queste tre religioni da parecchi secoli, proclamo che qualunque edifizio sacro, monumento, luogo santo, reliquiario, sito tradizionale, dotazione o pio luogo di culto o abituale di preghiera, di qualsiasi delle tre religioni precitate, saranno mantenuti e protetti conformemente agli usi esistenti ed alle credenze delle persone per le quali questi luoghi sono sacri.

Dicembre 1917. **EDMUND HENRI HYNMAN ALLENBY, Generale,**

Commandante in Capo la Forza di Spedizione d'Egitto.

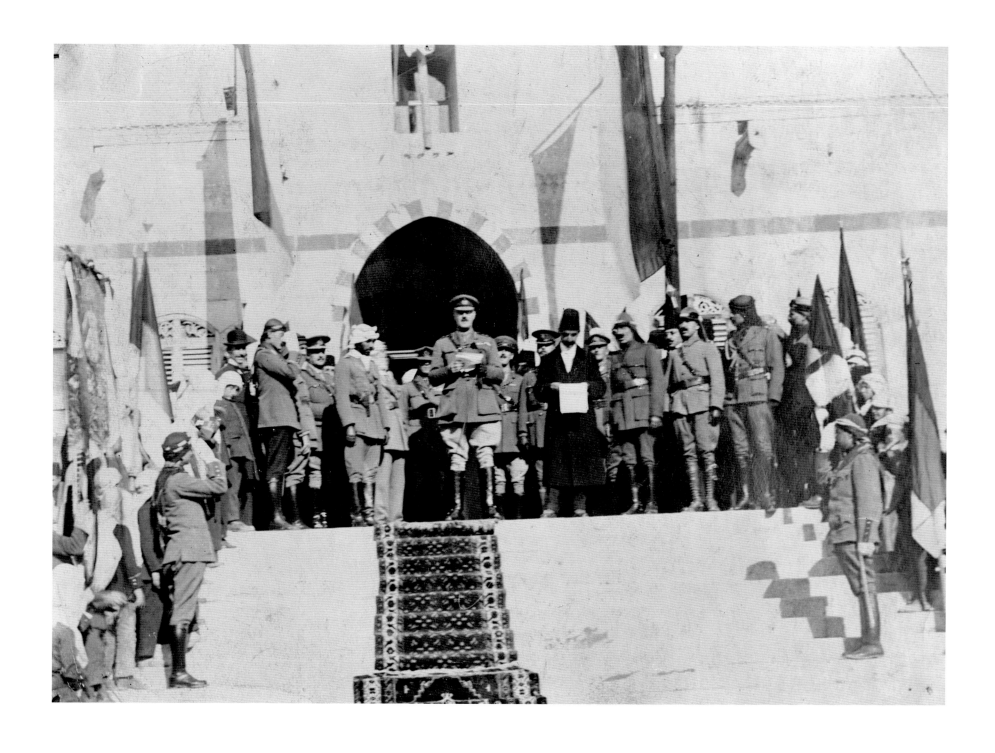

Left: Unknown photographer, Egyptian Expeditionary Force
The Proclamation of Martial Law in Jerusalem issued by General Sir Edmund Allenby, Commander of the Egyptian Expeditionary Force in Palestine, 10 December 1917
Allenby proved to be dynamic and successful, sweeping aside Turkish resistance to enter Jerusalem in December 1917

Above: CAPTAIN J. R. H. CRUICKSHANK, King's Own Lancers, Indian Army, personal photograph
General Sir Edmund Allenby declares martial law, Jerusalem, 10 December 1917
Allenby's proclamation was published in seven languages, an acknowledgement of the complexity of life in the Holy City

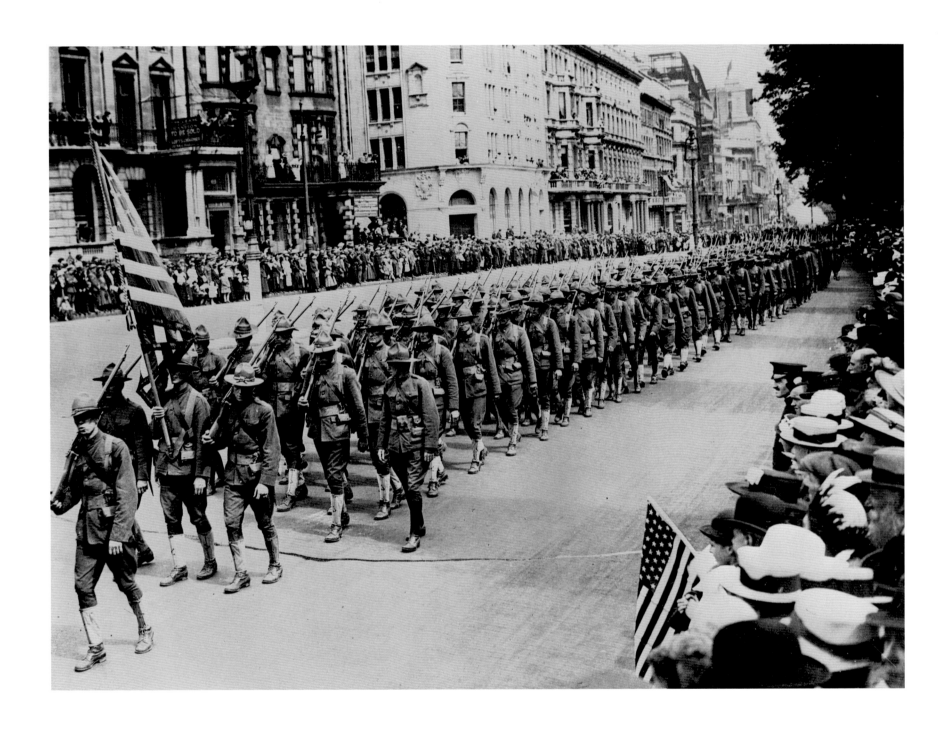

Unknown photographer, Sport & General commercial news agency
Soldiers of the American Expeditionary Forces march down Piccadilly, London,
16 August 1917
Germany's resumption of unrestricted submarine warfare and her intention to seek
an alliance with Mexico in the event of a war with the United States caused President
Woodrow Wilson to abandon his policy of neutrality. The US entered the war with
Germany on 6 April 1917

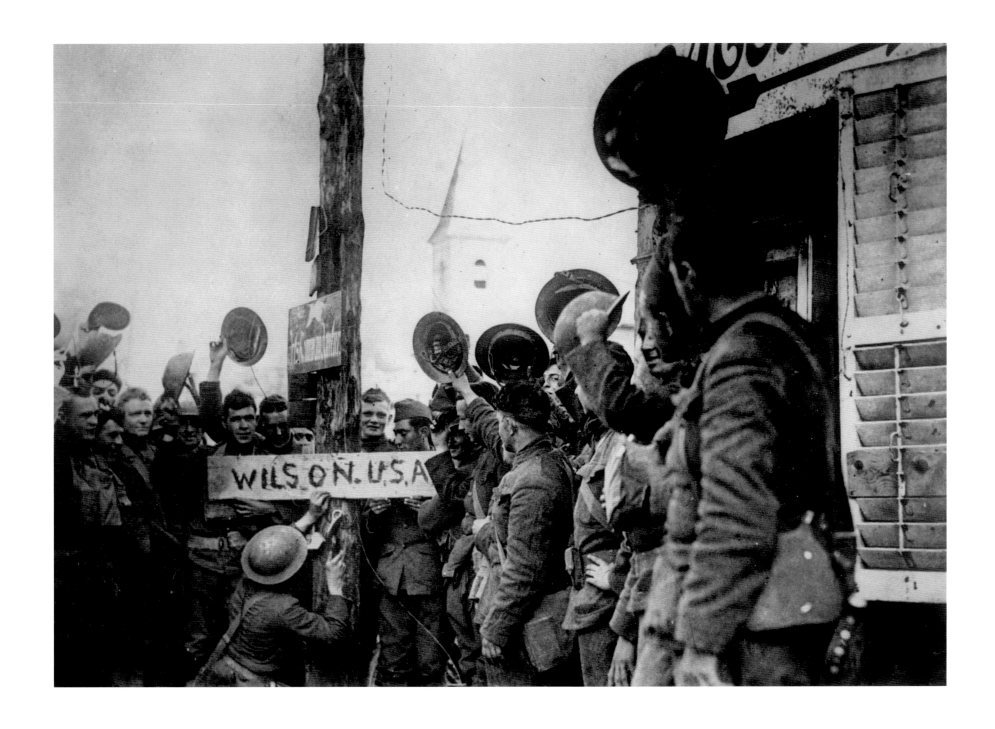

Unknown photographer, US Army Signal Corps
American troops replace a German street sign with their own version, St Mihiel Salient,
France, September 1918
American troops began to arrive on the Western Front in October 1917, but were not
'battle-hardened' until the Battle of St Mihiel, a year later

Right: LIEUTENANT GEORGE TURNER, Royal Naval Air Service Armoured Car Division, personal photograph
Russian troops break and run during the Kerensky Offensive, Galicia, Austria-Hungary (now Ukraine), July 1917
War on the Eastern Front had taken a massive toll on Russia. Disaffected Russian soldiers
and sailors mutinied and joined forces with revolutionaries in Petrograd to overthrow
the Tsar on 8 March 1917. A Provisional Government under Alexander Kerensky
resumed the offensive in July, but was compromised by transferring officers' control to
soldiers' committees. When troops refused to obey orders, the offensive collapsed

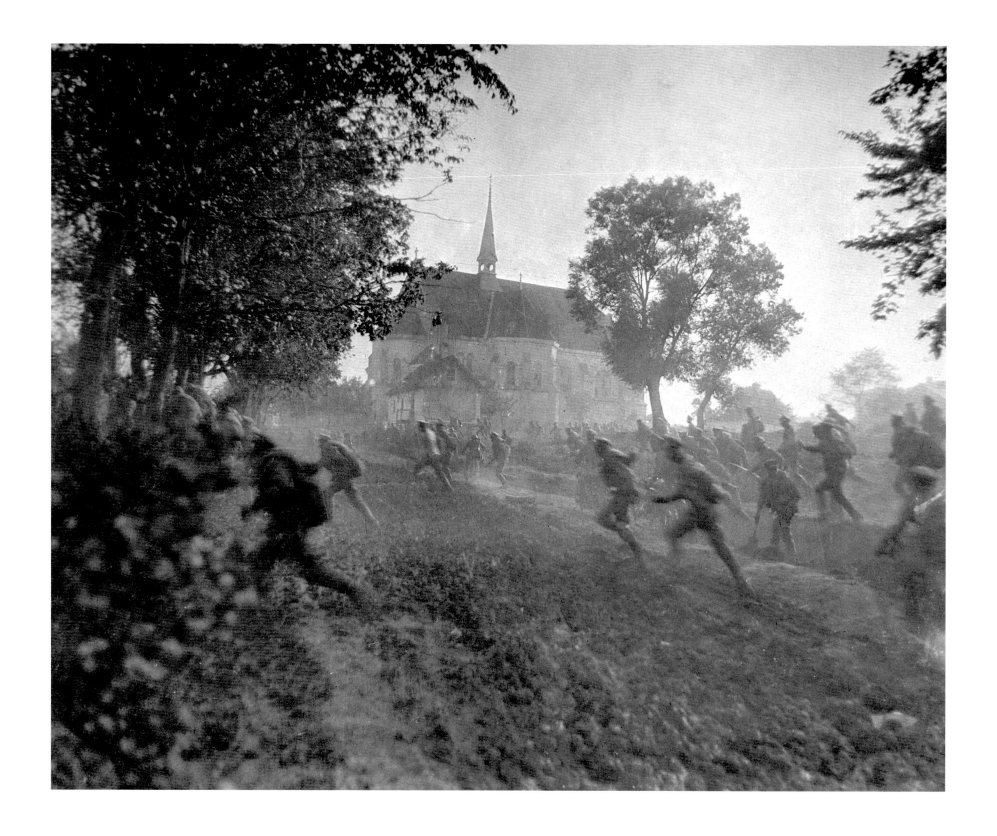

Page 416: VIKTOR BULLA of Bulla & Sons (presumably), St Petersburg
A Russian revolutionary soldier breaks into a government building to search for supporters of the Tsar, Petrograd, Russia, March 1917

Page 417: VIKTOR BULLA of Bulla & Sons (presumably), St Petersburg
An hour after the Tsar's actual abdication, signs bearing the Imperial coat of arms lie on the ice of the Fontanka Canal after being torn from a shop front, Petrograd, Russia, 13 March 1917

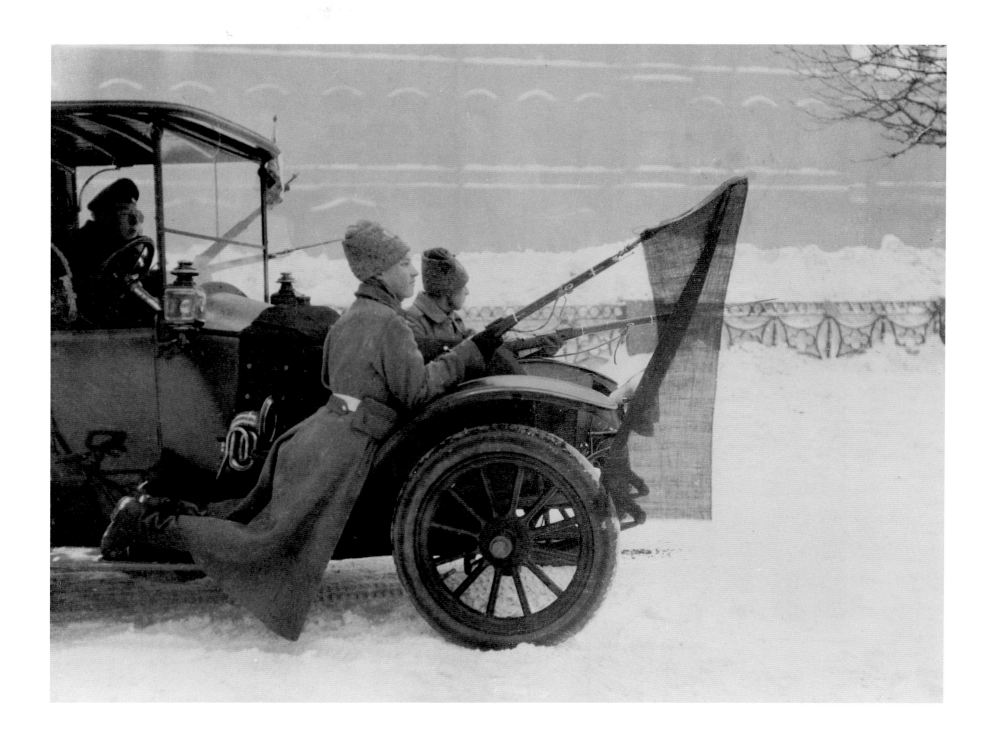

Above: VIKTOR BULLA of Bulla & Sons (presumably), St Petersburg
Russian revolutionary soldiers escort a car through the streets of Petrograd, Russia, March 1917

Right: Unknown German press photographer
A German civilian displays a newspaper headline announcing the end of hostilities on the Eastern Front, Berlin, Germany, 1918
In a second revolution, the Bolshevik faction of the Social Democratic Labour Party overthrew Kerensky and formed a communist government on 7 November 1917. Vladimir Lenin, the Bolshevik leader, signed a Decree of Peace initiating Russian withdrawal from the war the following day

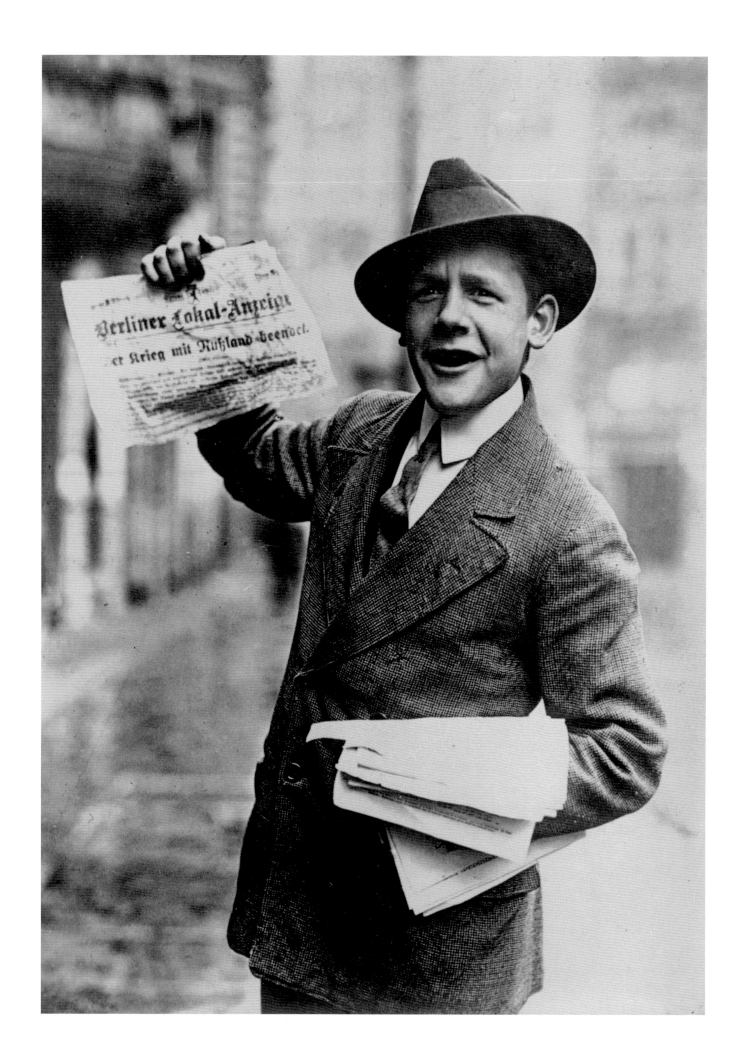

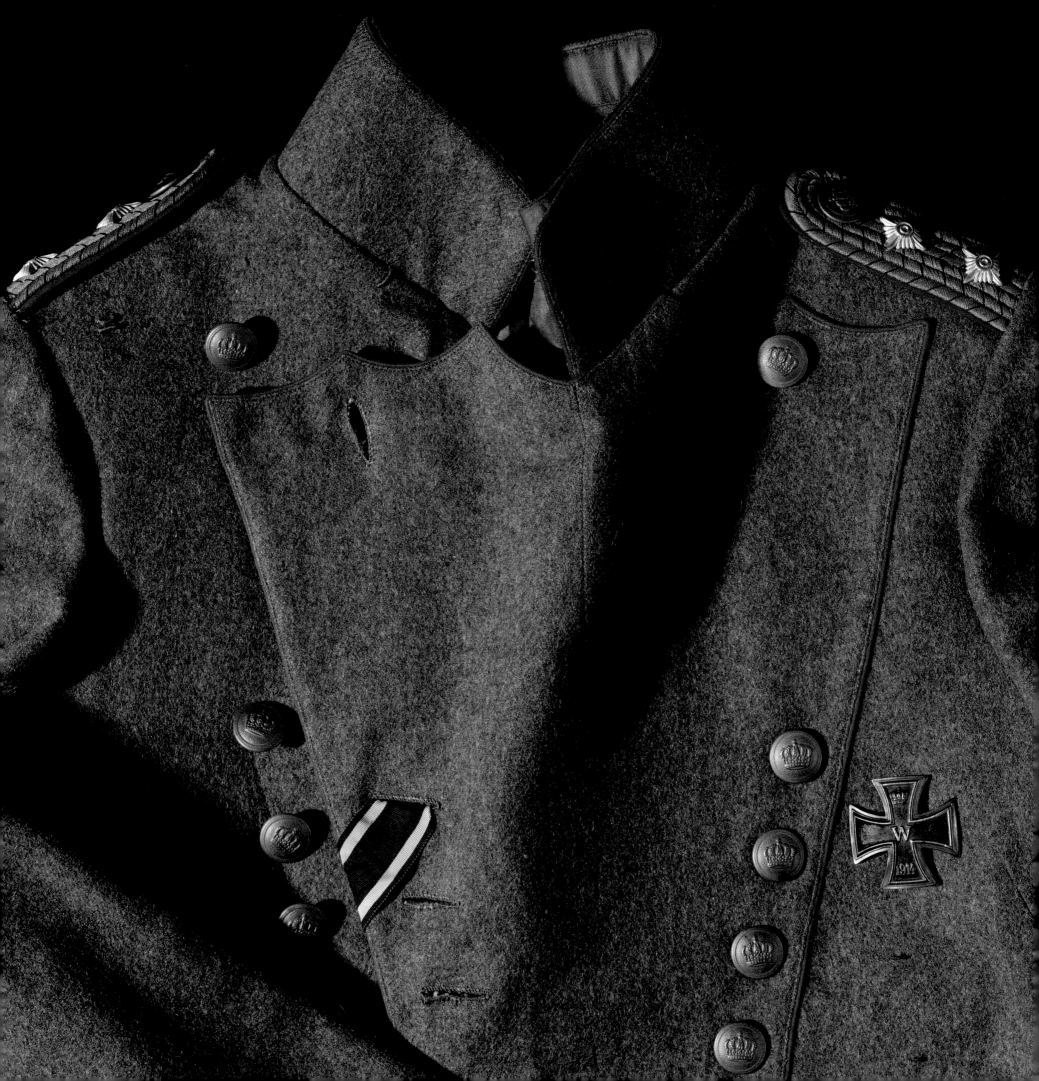

JANUARY 1918 – NOVEMBER 1918

YEAR	MASS MEDIA AND TECHNOLOGY	WAR PHOTOGRAPHY	WORLD EVENTS
1918 JANUARY	• US War Department rescinds its decision not to accept Kodak's offer to host a school of aerial photography at Rochester • Press strike in Berlin, Germany	• David McLellan, Thomas Aitken and Armando Console are commissioned as British official photographers on the Western Front in an attempt to provide more coverage by British photographers • In Palestine, Hurley uses Finlay process to generate colour images. Linking up with the AFC, he also takes aerial photographs. • Lowell Thomas and Harry Chase arrive in Egypt to report the war. They meet T. E. Lawrence in Cairo	• 8 January: Woodrow Wilson draws up 14 Points as a basis for any peace agreement
1918 FEBRUARY	• Foreign Office appoints Lord Northcliffe as Director of Propaganda. John Buchan appointed Director of Intelligence, Britain. Both appointments end after one month • US Press and Censorship Division launches *Stars and Stripes*, a weekly newsletter for American troops at the front • George Eastman agrees that Kodak should assist the US Navy in devising an effective camouflage scheme for warships	• US Army School of Aerial Photography, directed by Captain Charles Betz, (succeeded on June 30 by Major James Barnes), established at Kodak, Rochester, United States. Instructors are Kodak civilian workers. School trains over 2,000 US Army photographers. Its first graduates reach Europe three months later	• 6 February: Representation of the People Act. Right to vote gained by women over 30 and many previously ineligible men, Britain • 25 February: Rationing introduced in London & southern England
1918 MARCH	• British Department of Information converted to Ministry headed by Lord Beaverbrook, Britain. Propaganda outlets centralised and brought under MoI control. Lord Northcliffe given responsibility for propaganda in enemy territories. Integration of Fleet Street into British propaganda effort, which increasingly overwhelms that of Germany • *Pravda* becomes official press outlet of the Soviet Government • General Ludendorff appeals in vain for the establishment of an Imperial Ministry of Propaganda, Germany	• Armando Console posted to Western Front • Viktor Bulla covers Russian Civil War • Career of Albert K. Dawson (now serving with the US Army Signal Corps) is destroyed when a former manager of the American Correspondent Film Company is found guilty of smuggling goods to Germany. US Army charges Dawson with embezzling photographic supplies and dismisses him	• 3 March: Germany and Russia sign Treaty of Brest-Litovsk, ending war on Eastern Front • 21 March: Start of German Spring Offensive • 26 March: General Foch assumes overall command of Allied armies in France • Spanish flu breaks out in military establishments, United States

YEAR	MASS MEDIA AND TECHNOLOGY	WAR PHOTOGRAPHY	WORLD EVENTS
1918 APRIL	• Commissariat Général de la Propagande established in France	• Lt Armando Console's car is hit by a shell, killing his driver and destroying his cameras, shortly after he arrives on the Western Front. Console loses his right leg and suffers severe shell shock. Other photographers at the Front are deeply shocked. Lord Beaverbrook decides Console should receive some of the revenue from a special exhibition at Grafton Galleries in London as compensation • British official photographers brought under the control of the Ministry of Information on a salary of £600 a year • Ernest Brooks loaned to the Admiralty and deployed to HMS *King George V* while covering the Grand Fleet • Australian official photographer Frank Hurley granted London exhibition	• 1 April: Royal Air Force formed • 7 April: Meat rationing introduced, Britain • 9–29 April: Battle of the Lys, Western Front; WAAC renamed QMAAC in recognition of their conduct during German offensive • 17 April: US troops sent to fight alongside French armies, Western Front • 21 April: Manfred von Richthofen shot down and killed, Western Front • 23 April: Royal Navy raid against ports of Zeebrugge and Ostend • Spanish flu spreads to Europe
1918 MAY	• American Expeditionary Force establishes press headquarters at Neufchâteau, subsequently moving to Paris. Issues accreditation to 29 civilian photographers and artists, allocating at least one to each division and granting them use of military transport	• MoI requests Admiralty to release Ernest Brooks so that he can replace Armando Console on the Western Front	• 19 May: Final raid by German aircraft on London; 49 killed • 27 May–6 June: 3rd Battle of the Aisne, Western Front
1918 JUNE		• Hubert Wilkins, Australian official photographer, awarded Military Cross for gallantry in rescuing the wounded during Battle of Passchendaele, Western Front • Ernest Brooks deployed to Italian Front	• 9–14 June: Battle of the Matz, Western Front • 15 June: Battle of the Piave, Italian Front • Spanish flu spreads to India
1918 JULY		• Hubert Wilkins appointed officer commanding No. 3 (Photographic) Sub-section of the Australian war records unit, Western Front	• 15–18 July: 4th Battle of Champagne, Western Front • 17 July: Bolsheviks execute Tsar Nicholas II and his family, Russia • 18 July–7 August: 2nd Battle of the Marne, Western Front • 26 July: Major Mick Mannock, RAF, shot down and killed
1918 AUGUST			• 5 August: Last German airship raid on Britain • 8 August–11 November: Battle of Amiens, Western Front

YEAR	MASS MEDIA AND TECHNOLOGY	WAR PHOTOGRAPHY	WORLD EVENTS
1918 SEPTEMBER	• German GHQ appoints officer to supply news stories direct to press, Western Front	• RFC produce 14,678 aerial photographs and distribute 347,000 prints • Armando Console is recommended for medical discharge and requests employment in a 'sedentary occupation' at MoI Photographic Bureau, Britain • Hubert Wilkins awarded a Bar to his Military Cross after assuming command of a group of US soldiers who had lost their officers during the battles for the Hindenburg Line, Western Front	• 12 September: British and French advance to the Hindenburg Line; Battle of St Mihiel: debut of American Expeditionary Force as an independent army • 15 September: French and Serbian offensive against Bulgarian forces, Salonika Front • 18–24th September: Battle of Monastir-Doiran, Salonika Front • 19 September–24 October: Battle of Megiddo, Middle East • 26 September–15 October: Franco-American Meuse-Argonne Offensive begins, Western Front • 27 September–9 October: Battle of the Canal du Nord, Western Front • 28 September–10 October: Battle of the Flanders Ridge, Western Front • 29 September–2 October: Battle of St Quentin Canal – breach of Hindenburg Line, Western Front • 30 September: Bulgaria agrees armistice
1918 OCTOBER	• Lord Beaverbrook, frustrated by his limited role, resigns as Minister of Information, citing ill health, Britain. Lord Downham replaces him	• Lt Ernest Brooks returns to Western Front where he remains with Warwick Brooke, McLellan and Aitken until the end of the war • Major Jean-Baptiste Tournassoud appointed director of the Section Photographique et Cinématographique de l'Armée, France	• 1 October: Allied forces capture Damascus, followed by Beirut, Homs and Aleppo, Middle East • 3 October: Prince Max von Baden becomes German Chancellor; German Government seeks armistice • 14 October: Turkey seeks armistice • 17 October: Battle of the Selle, Western Front • 24 October: Battle of Vittorio Veneto, Italian Front • 26 October: General von Ludendorff resigns • 27 October: Austria-Hungary seeks armistice with Italians • 30 October: Turkey signs armistice

YEAR	MASS MEDIA AND TECHNOLOGY	WAR PHOTOGRAPHY	WORLD EVENTS
1918 NOVEMBER	• Australian official photographer Frank Hurley returns to Australia	• F. J. Mortimer publishes *Gate of Goodbye* photomontage in *Photogram*. The image, often mistaken for genuine, becomes a popular icon of the First World War and an early exhibit in the Imperial War Museum • 1st Lt E. R. Estep, US Army Signal Corps official photographer, killed in action	• 1 November: Serbian forces recapture Belgrade • 3 November: German Naval Mutiny, Kiel • 4 November: Revolutionary outbreaks begin in German cities • 9 November: Kaiser Wilhelm II abdicates and enters exile in the Netherlands • 11 November: 5 a.m. Germany accepts Allied Armistice conditions • Canadian forces recapture Mons • 11 a.m. Armistice comes into effect, ending fighting on the Western Front • 21 November: German High Seas Fleet enters internment at Scapa Flow; German submarine fleet interned at Harwich, Britain • 25 November: German forces in East Africa surrender undefeated

Page 420: IWM collection
Imperial German Army service dress tunic, which was worn by an unknown cavalry captain of a Ulanen-Regiment and holder of the Iron Cross (1st & 2nd Class) on the Western Front in 1918

Page 427: LIEUTENANT WILLIAM RIDER-RIDER, Canadian Army photographer
Soldiers of 3rd Canadian Division advance through the ruins of Cambrai during the Hundred-Days Offensive, Western Front, France, 9 October 1918
The departure of Russia and the entry of the United States into the war brought the stagnation of trench warfare to an end on the Western Front in 1918

Germany sought to capitalise on Russia's collapse by launching a major spring offensive on the Western Front with the aim of defeating Britain and France before US forces arrived. The offensive, of unprecedented proportions, was launched on 21 March against a weak sector of the British Front. In what became known as the Kaiserschlacht (the Emperor's Battle), the British 5th Army was driven back almost 40 miles. German forces, augmented by troops from the Eastern Front, launched further attacks, advancing to the Marne and threatening Britain's hold on Flanders. Field Marshal Haig issued a Special Order of the Day, urging British troops to fight to the very last man.

The offensive, which lacked strategic focus, ultimately faltered in the face of sustained British and French resistance in July. Coordinated by General Foch and supported by the United States, the Allies launched a series of counterattacks known collectively as the Hundred Days. An Allied offensive at Amiens combined aircraft, armour, artillery and infantry to achieve total success. A renewed British attack on the Somme was similarly successful. The exhausted German Army could no longer mount a response and thousands of German soldiers were taken prisoner. In September, British and Dominion troops breached the Hindenburg Line in the north while the Americans began offensive operations at its southern extremity.

The Allies also began to gain the advantage in the air war. The Royal Flying Corps, renamed the Royal Air Force, was now equipped with aircraft capable of challenging the Imperial German Air Force. A strategic bombing campaign was launched on Germany, while the death of Manfred von Richthofen, shot down in a dogfight over the Somme, represented another blow to German morale. Meanwhile, the Royal Navy supported land operations with a series of dramatic raids on the German-occupied ports of Zeebrugge and Ostend.

As the tide of war turned against Germany on the Western Front, Britain, France and their allies gained ground elsewhere, most notably in the Middle East. Threatened by starvation and internal disorder, Bulgaria, Turkey and Austria-Hungary all sued for peace. As Germany was left isolated, the Kaiser and the German High Command recognised that the war was lost. Amidst growing domestic unrest, the German Government forced the Kaiser to abdicate and negotiated an armistice. On 11 November 1918 at 11 a.m., the guns finally fell silent.

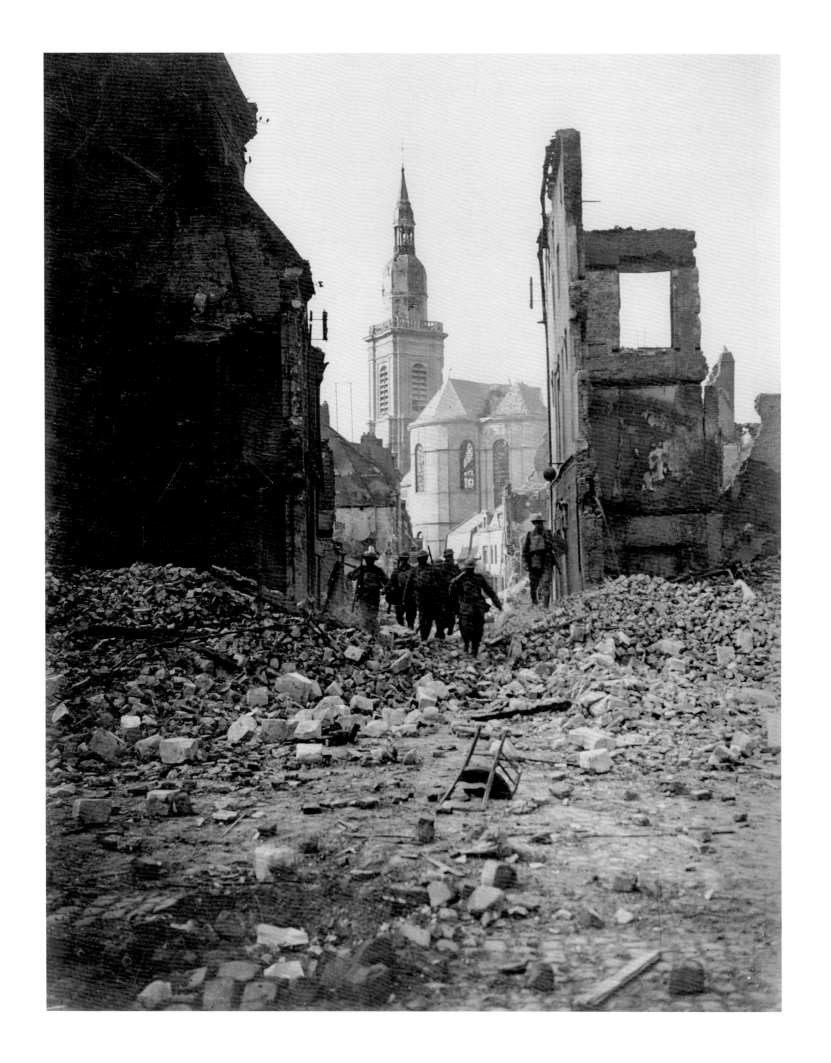

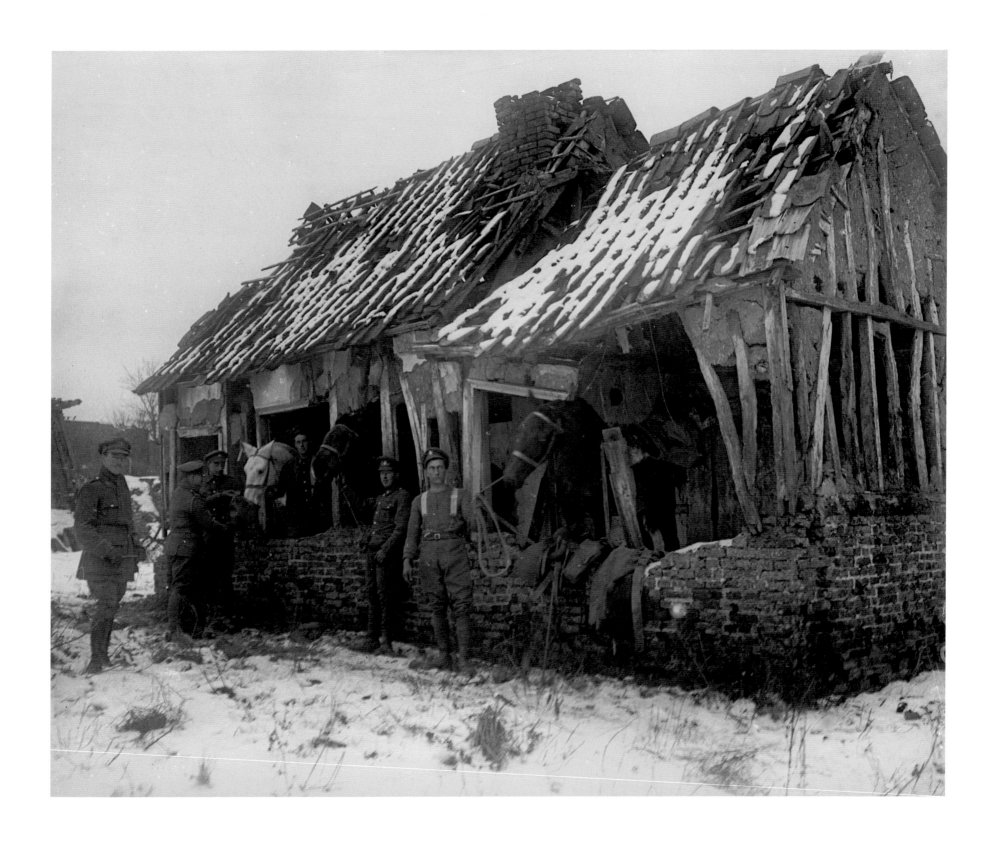

2ND LIEUTENANT THOMAS K. AITKEN, British Army photographer
A cottage damaged by shellfire provides winter shelter for horses of the Northumberland
Hussars, Étricourt, France, 1 January 1918
The first weeks of 1918 were quiet on the Western Front

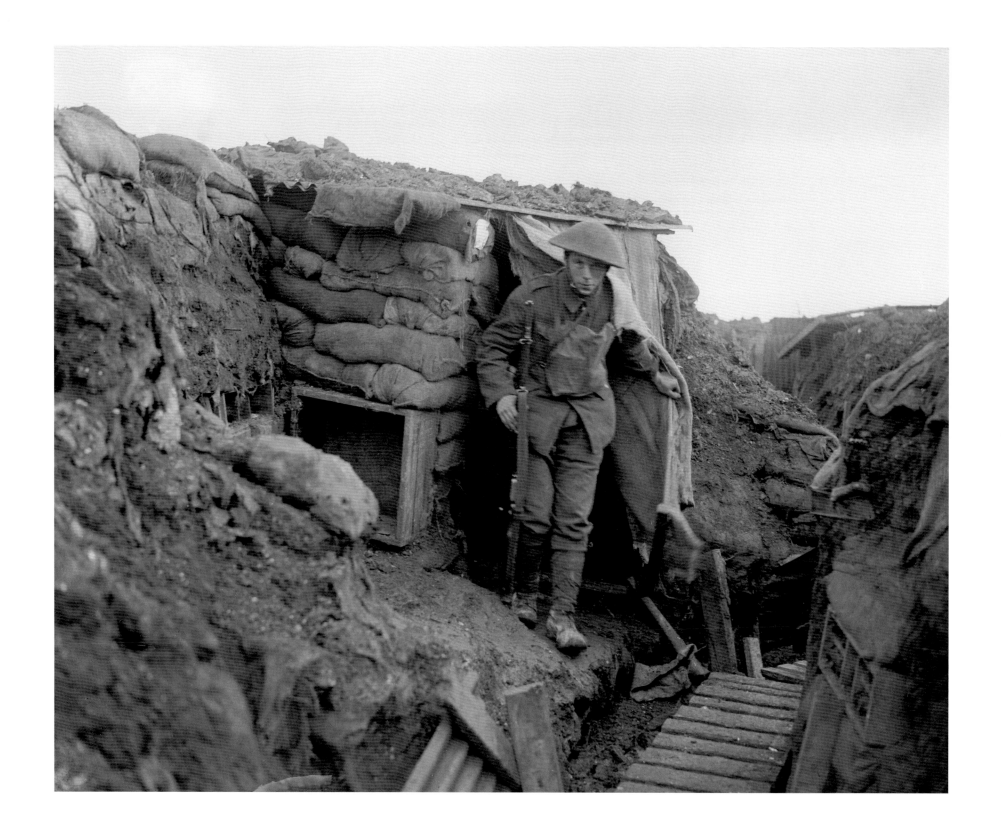

2ND LIEUTENANT THOMAS K. AITKEN, British Army photographer
**A British sniper of 6th York and Lancaster Regiment leaves his post in the trenches,
Cambrin, France, 6 February, 1918**

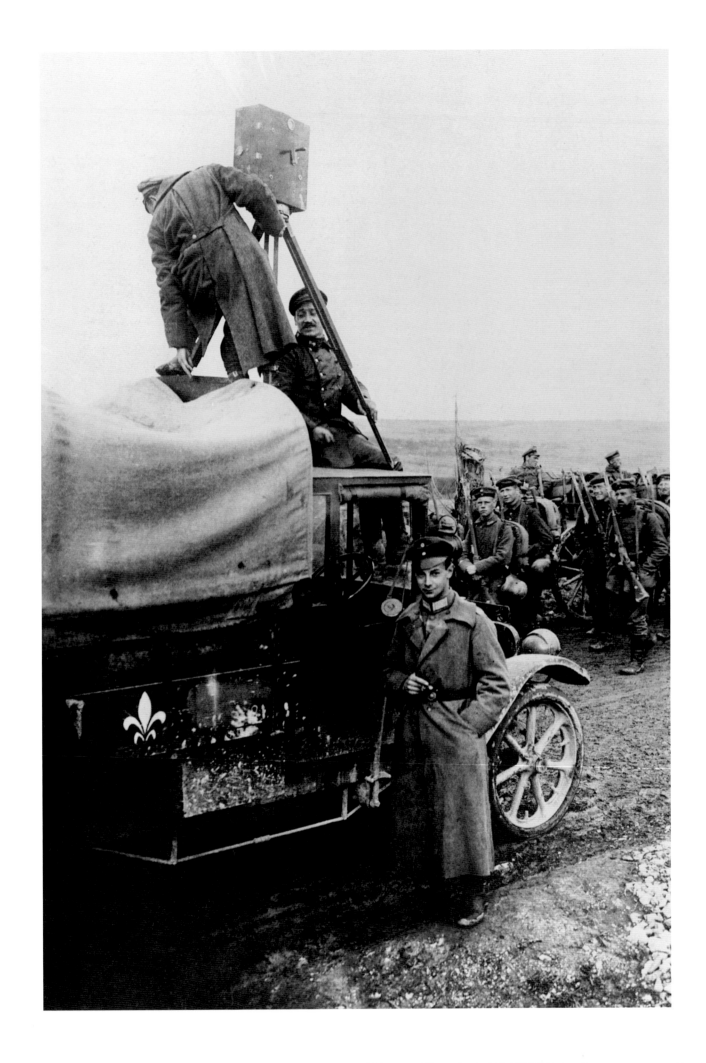

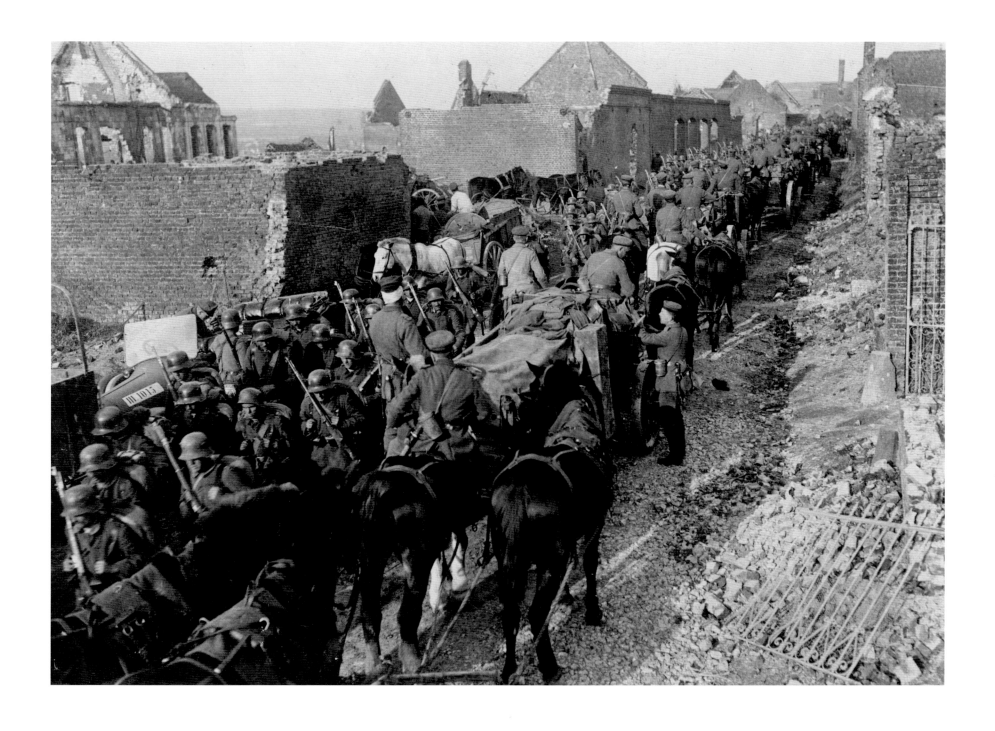

Left: Unknown German Army photographer, Bild und Film Amt (Bufa)
A cinematographer of the German Army's Bild und Film Amt (Bufa) films the German advance from the roof of a van near Albert during the Ludendorff Offensive, Somme, France, April 1918
By 1918 all the major nations had established an infrastructure for official photography and cinematography on all fronts, but demand for pictures continued to exceed supply

Above: Unknown German Army photographer, Bild und Film Amt (Bufa)
German forces, moving between the front line and the rear areas during the Ludendorff Offensive, squeeze through a narrow street in the ruined village of Templeux, Picardy, France, March 1918
Hoping to end the war before US troops deployed in force, Germany launched a major offensive on the Western Front on 21 March 1918. The German Imperial Army, reinforced by troops from the Eastern Front, advanced to the Marne, retaking much of the ground it had lost since 1914

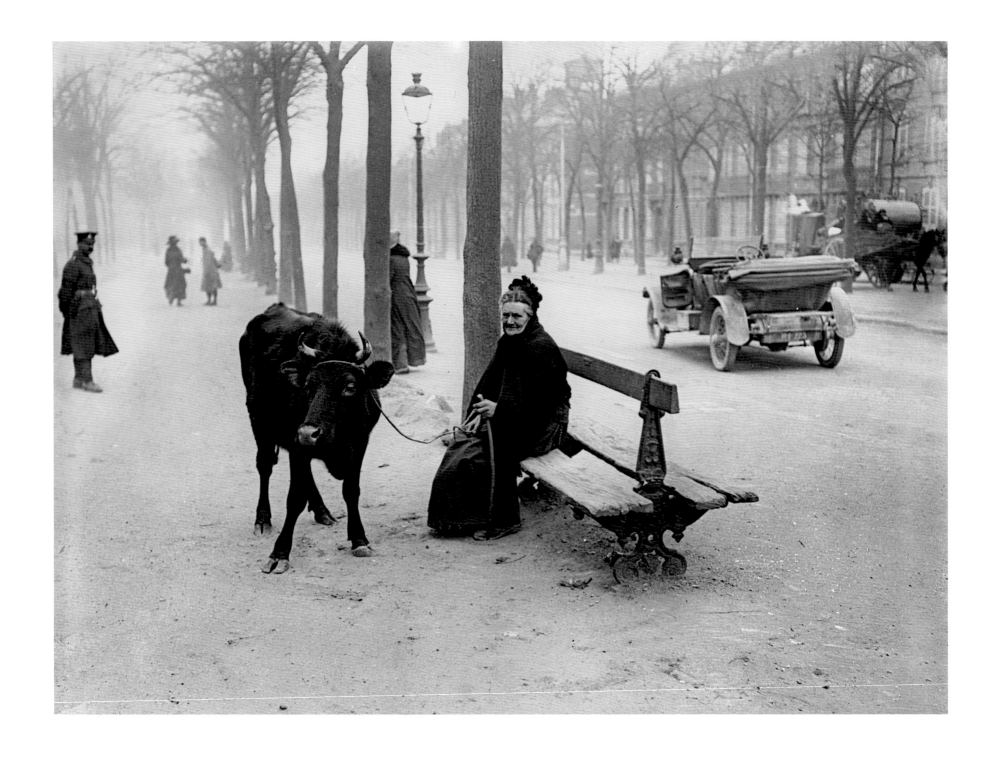

Page 432: Unknown German Army photographer, Bild und Film Amt (Bufa)
British prisoner of war, March–April 1918
German official photographers compiled a memorable series of poignant studies of
British prisoners of war

Page 433: Unknown German Army photographer, Bild und Film Amt (Bufa)
A soldier of the Royal Irish Rifles shortly after being taken prisoner, March–April 1918

Above: 2ND LIEUTENANT THOMAS K. AITKEN, British Army photographer
An elderly French refugee guards her only possession, a cow, after fleeing the fighting,
Amiens, France, 28 March 1918
Once again, French civilians living behind the Allied lines were forced to flee their homes

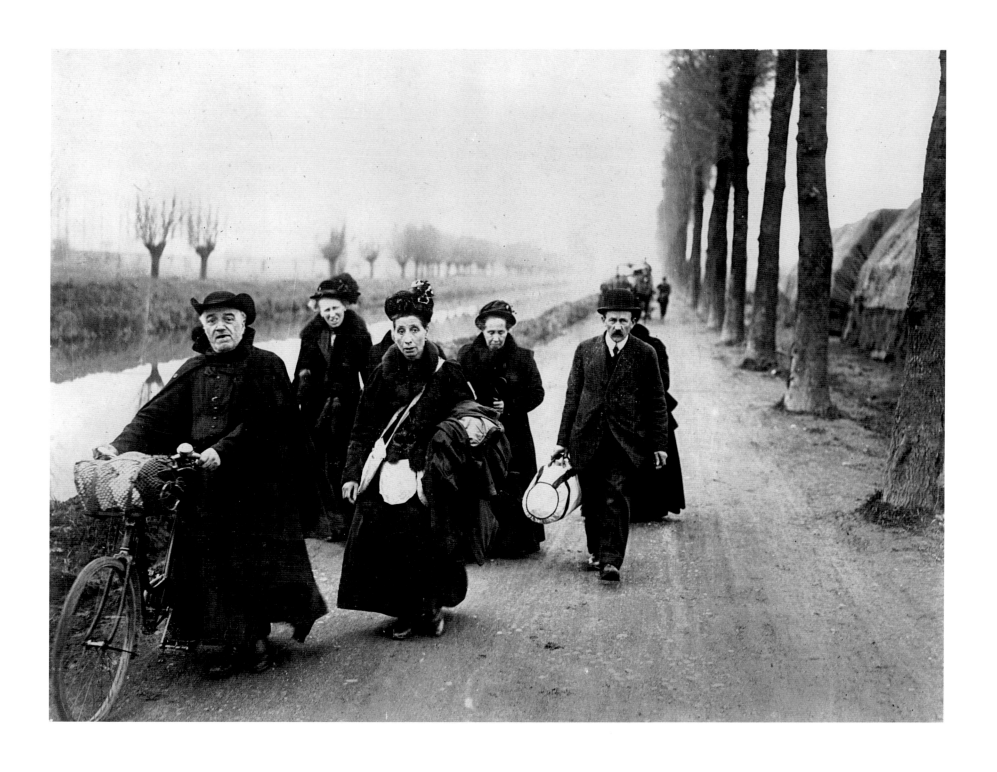

2ND LIEUTENANT THOMAS K. AITKEN, British Army photographer
French refugees flee after German forces occupy Merville, France, 12 April 1918

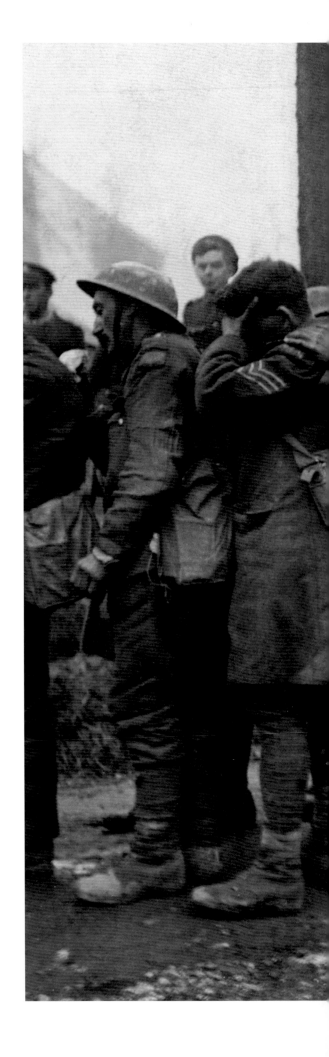

2ND LIEUTENANT THOMAS K. AITKEN, British Army photographer
British soldiers queue for treatment at an advanced dressing station after being blinded by mustard gas during the Battle of Estaires near Béthune, Pas de Calais, France, 10 April 1918
Iconic photographs and paintings captured the impact of widespread use of mustard gas during the German offensive

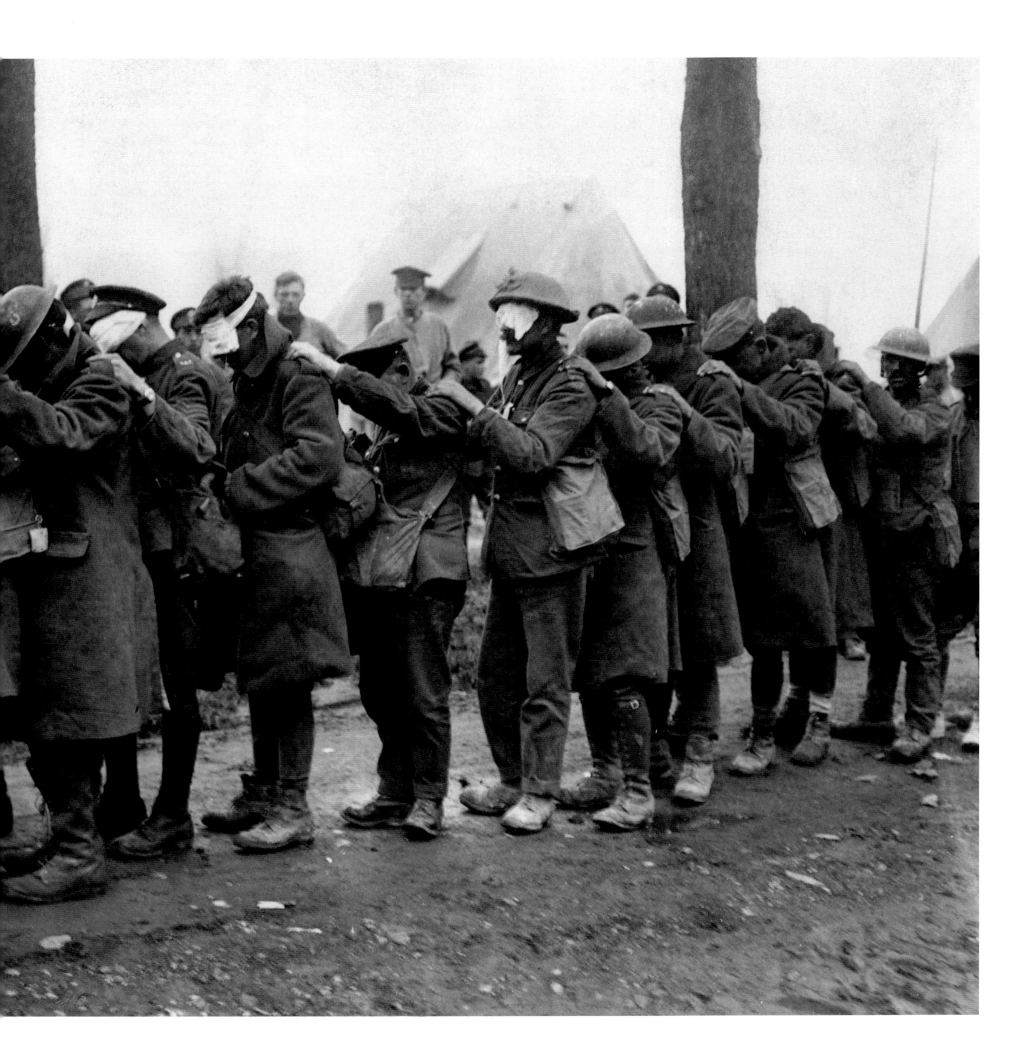

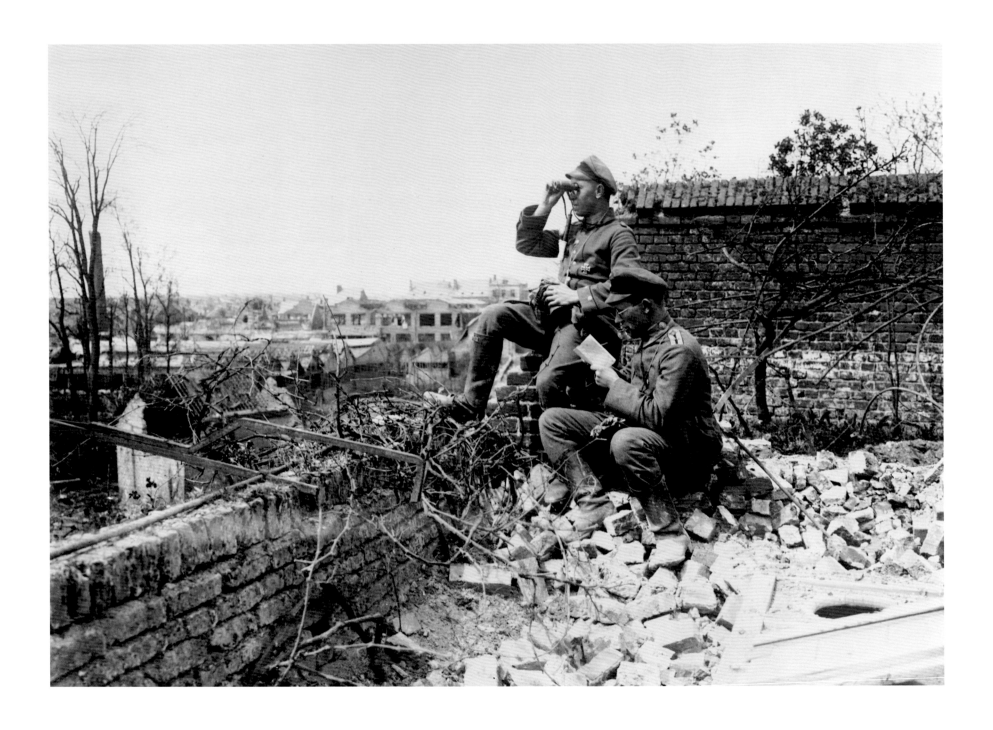

Unknown German Army photographer, Bild und Film Amt (Bufa)
**Observers from a German artillery unit survey British positions from the roof of a
ruined house in front of Albert, Somme, France, May 1918**

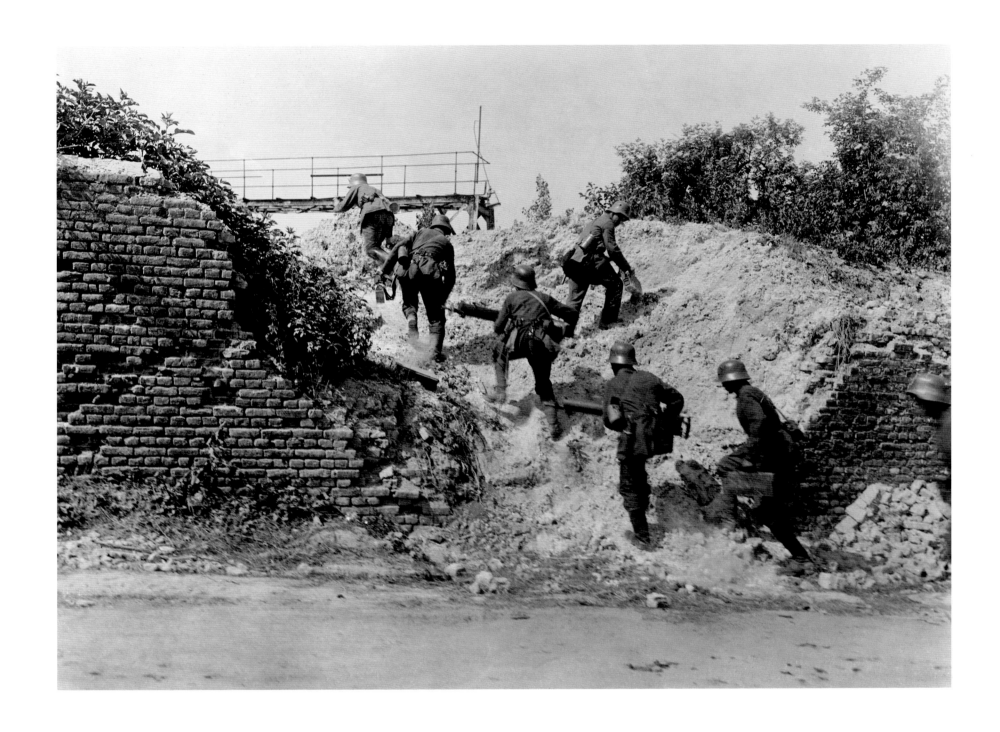

Unknown German Army photographer, Bild und Film Amt (Bufa)
**A German machine-gun section moves to a new position in the ruins of a house on the
Montdidier–Noyon sector of the front, France, June 1918**

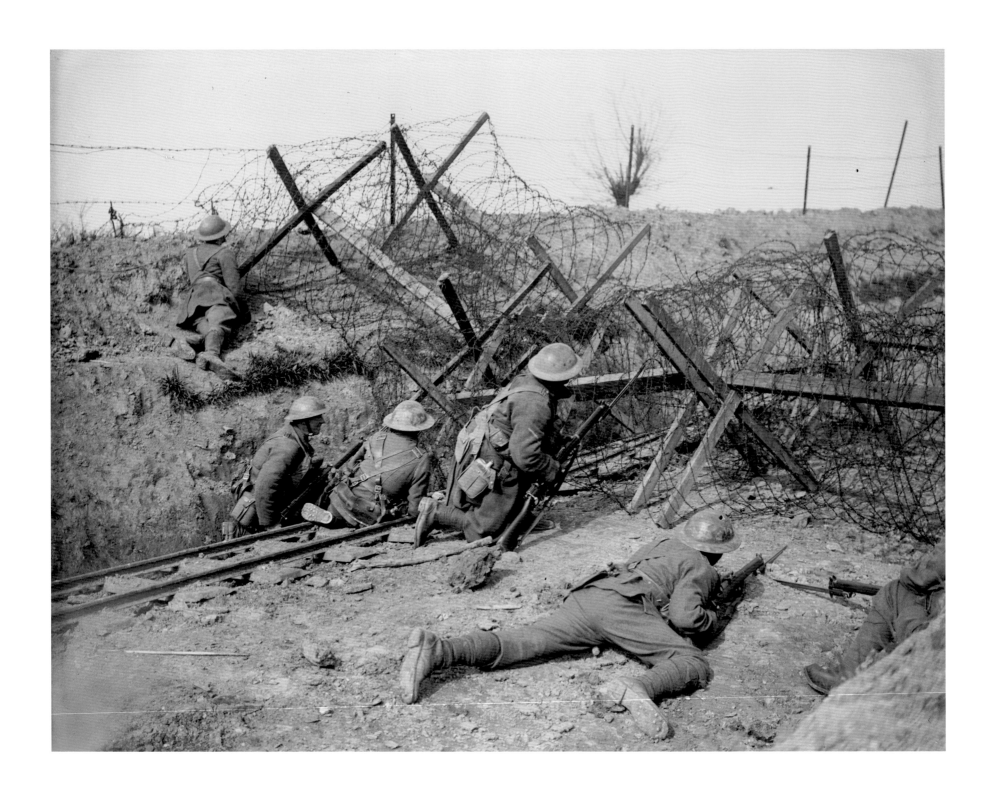

LIEUTENANT JOHN WARWICK BROOKE, British Army photographer
Soldiers of 10th Queen's (Royal West Surrey) Regiment defend a flimsy wire barricade
during the Fourth Battle of Ypres, St Jean, Belgium, 29 April 1918
Facing the possibility of utter defeat, British troops fought desperately to defend the line

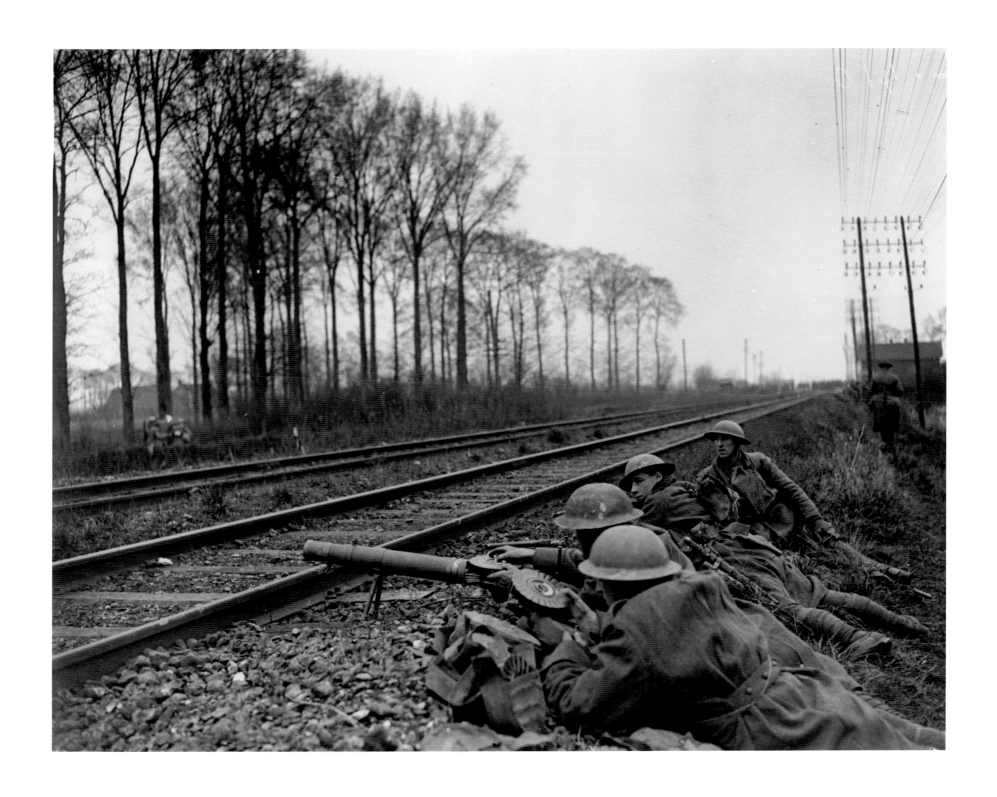

2ND LIEUTENANT DAVID McLELLAN, British Army photographer
During the Fourth Battle of Ypres British soldiers equipped with Lewis guns defend the
railway at Merris near Hazebrouck, Belgium, 12 April 1918

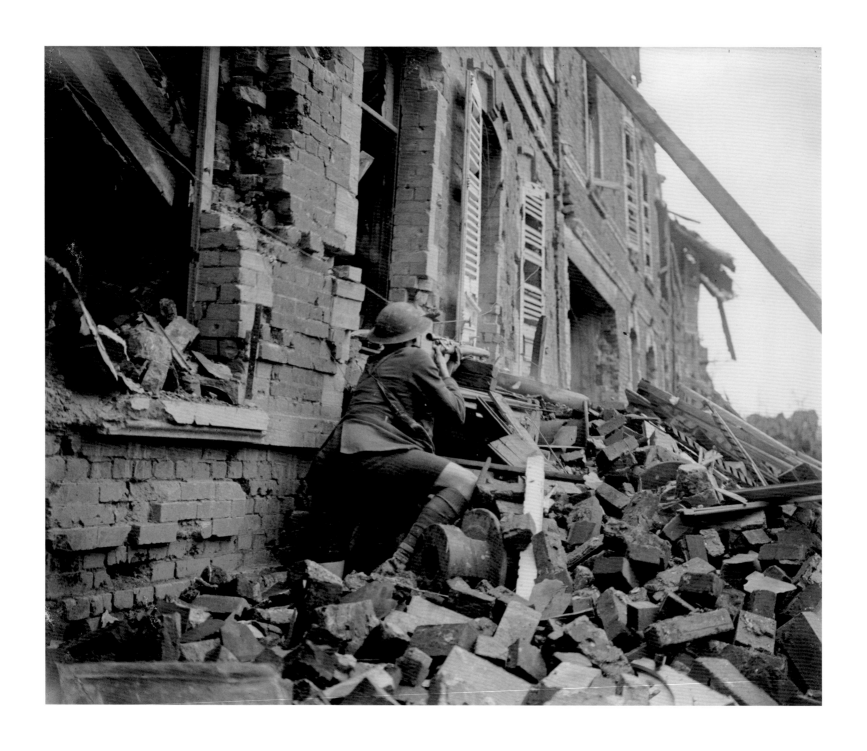

LIEUTENANT JOHN WARWICK BROOKE, British Army photographer
A sniper of the London Irish Rifles engages in a duel with an enemy sniper in the ruins of Albert, Somme, France, 6 August 1918

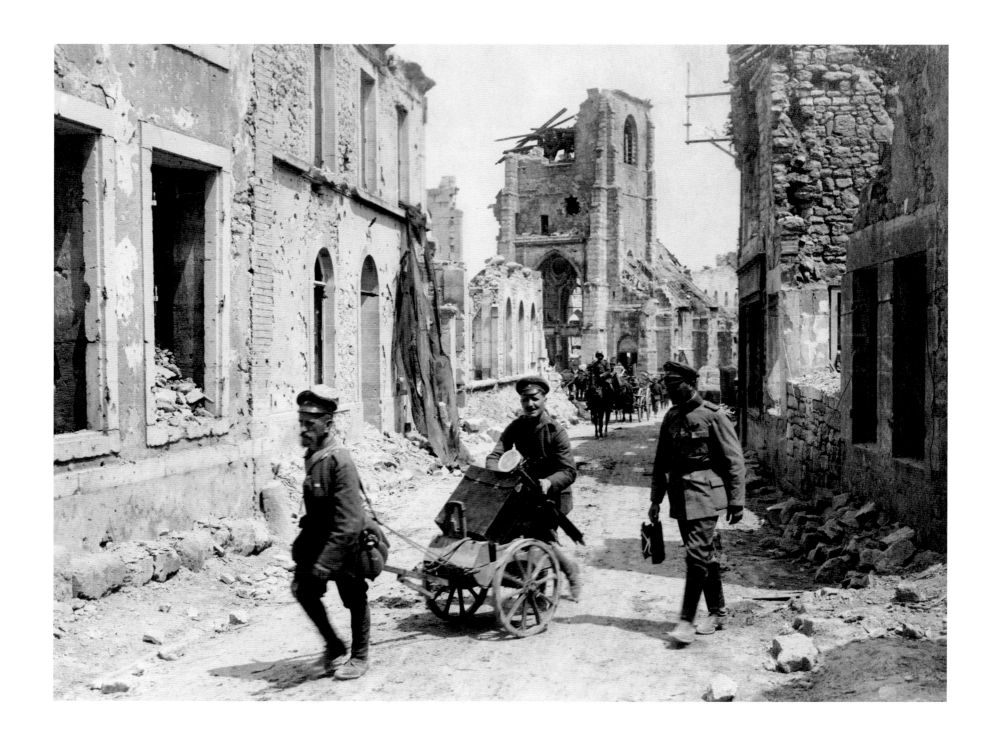

Unknown German Army photographer, Bild und Film Amt (Bufa)
Leutnant Schaffer, a photographer (right), and orderlies of the German Bild und Film Amt at work in the streets of Soissons, which had been captured by the Germans during the Aisne battles on 29 May, Picardy, France, June 1918

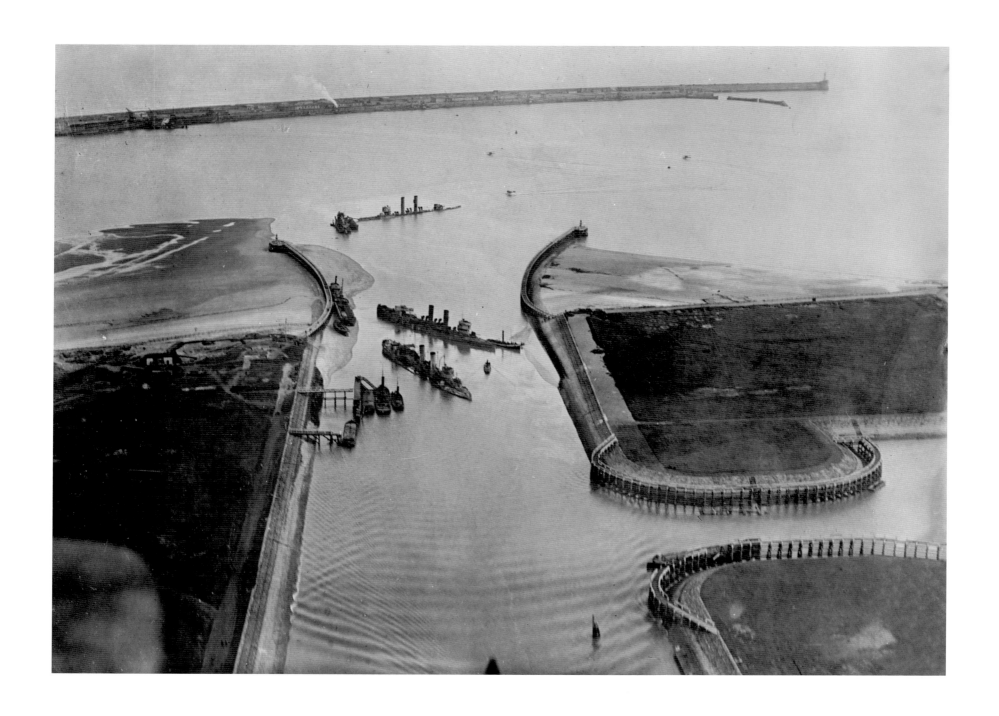

Unknown photographer, German Reichsmarine
Three British ships, HMS *Thetis*, HMS *Intrepid* and HMS *Iphigenia*, which were scuttled in an attempt to block the mouth of the Bruges Canal to German shipping at Zeebrugge, Belgium, April 1918
Meanwhile the Royal Navy launched a series of daring raids on German-occupied Belgian ports

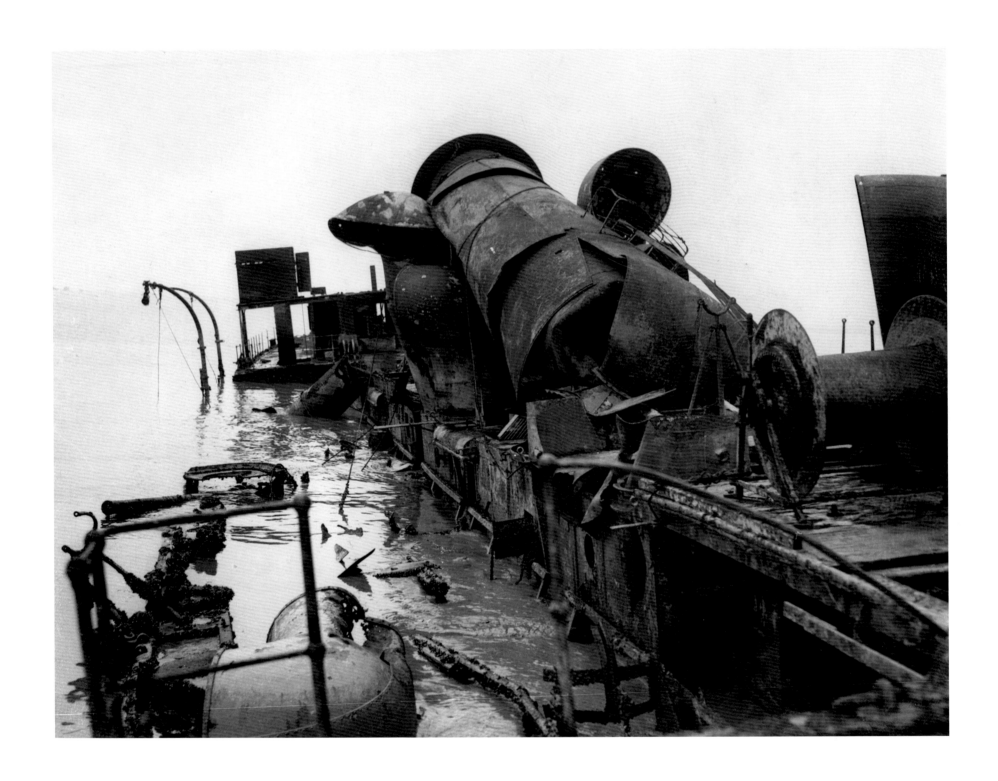

Unknown photographer, German Reichsmarine
**The sunken remains of the British blockship HMS *Thetis*, in the mouth of the Bruges
Canal, Zeebrugge, Belgium, 1918**
German defences prevented HMS Thetis *from scuttling in the correct position,
so allowing German ships to resume use of the canal after a few days*

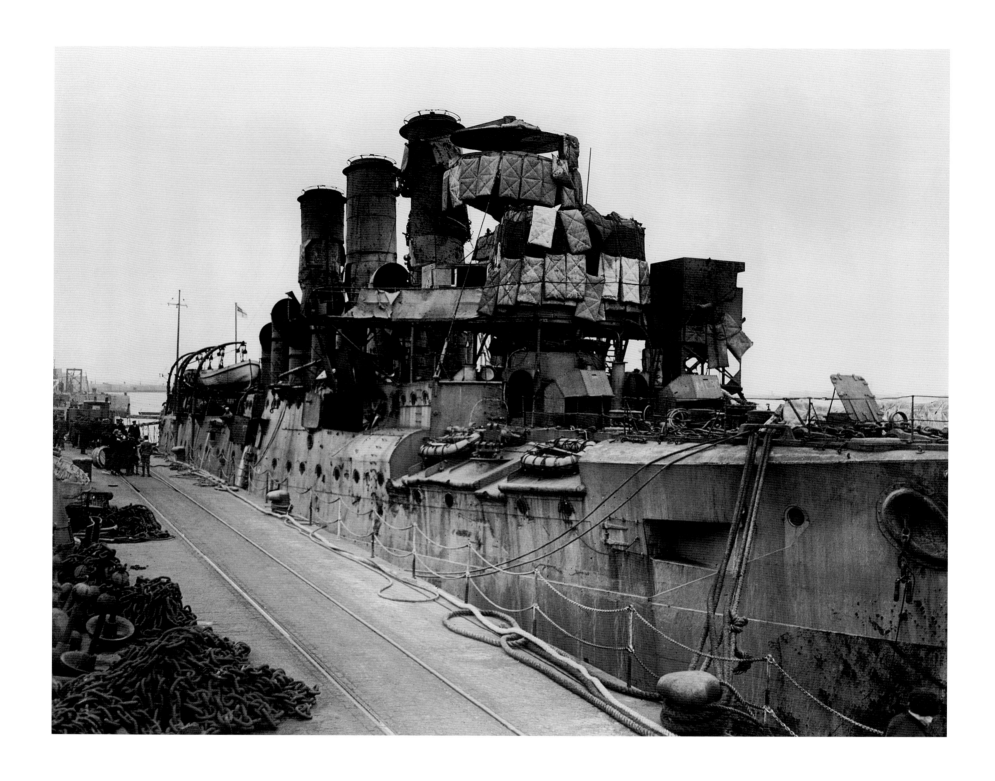

Unknown British press photographer
HMS *Vindictive* on returning to port after her diversionary attack on the Zeebrugge
Mole, Dover, Kent, Britain, April 1918
The raids, although costly, provided valuable photographic propaganda for both sides

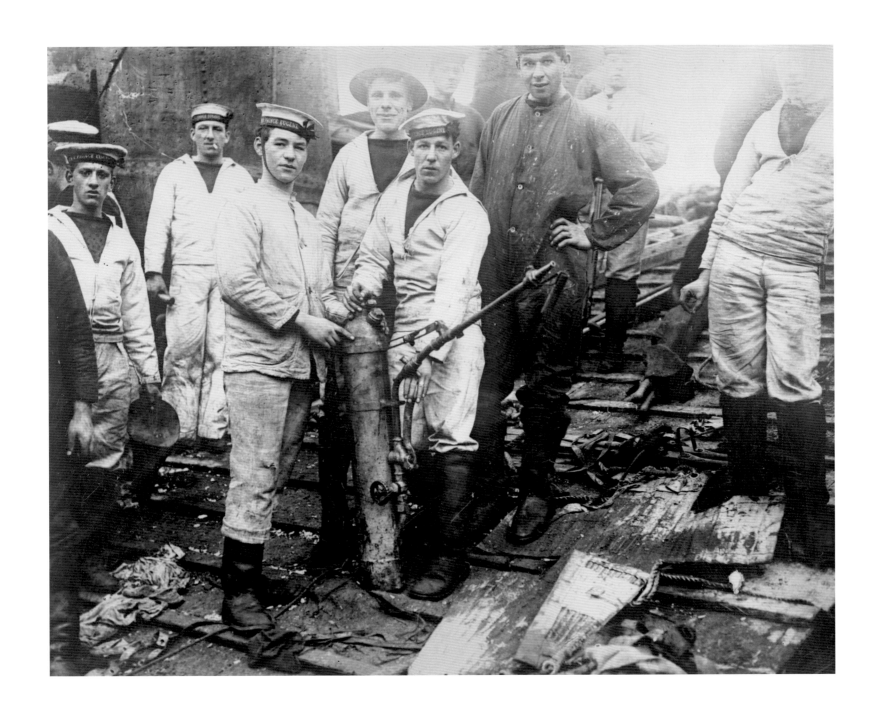

Unknown British press photographer
Sailors on board HMS *Vindictive* display a Hay flamethrower, which was used by
the RNAS Experimental Party during the diversionary attack on the Zeebrugge Mole,
Dover, Kent, Britain, 24 April 1918

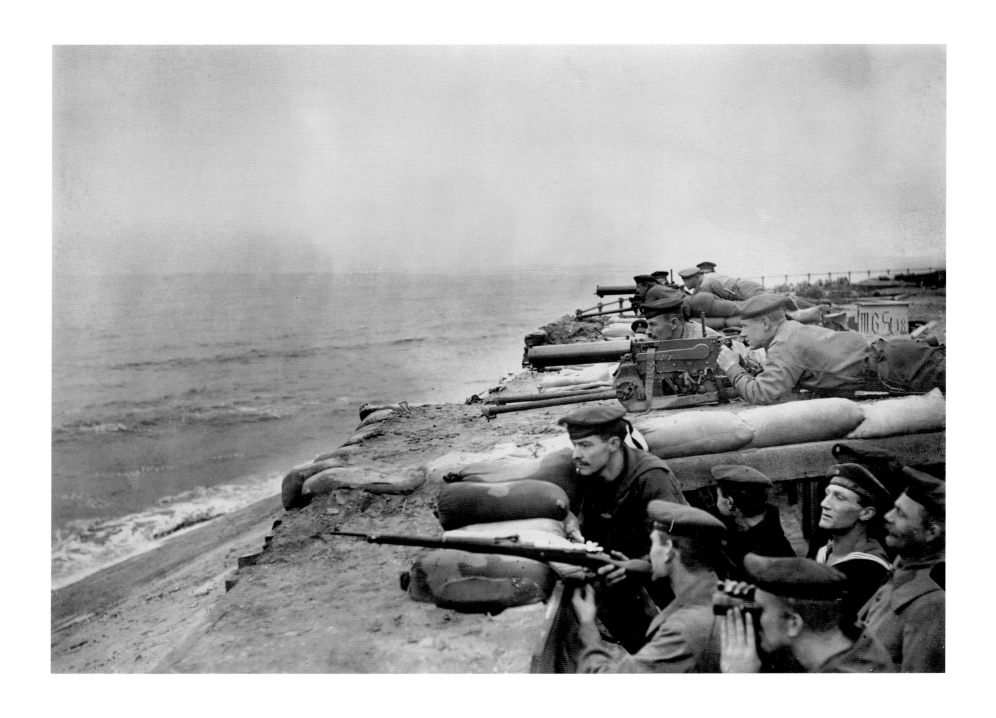

Unknown photographer, German Reichsmarine
Marines of a German Marine-artillery regiment defend the Belgian Sea Wall after
British raids on Ostend, Belgium, May 1918

Above: 2ND LIEUTENANT DAVID McLELLAN, British Army photographer
Royal Air Force Handley Page O/400 bombers, Coudekerque airfield, near Dunkirk, France, 20 April 1918
In 1918, the Royal Flying Corps, now renamed the Royal Air Force, finally established air superiority over the Germans and, using its recently acquired fleet of heavy bombers, launched a strategic bombing campaign over Germany

Right: 2ND LIEUTENANT DAVID McLELLAN, British Army photographer
SE5A Scouts and officers (including Major Mick Mannock) of No. 85 Squadron, Royal Air Force, St Omer Aerodrome, France, 21 June 1918
McLellan drew on his experience as a Royal Flying Corps photographer to convey the power and confidence of the newly formed RAF

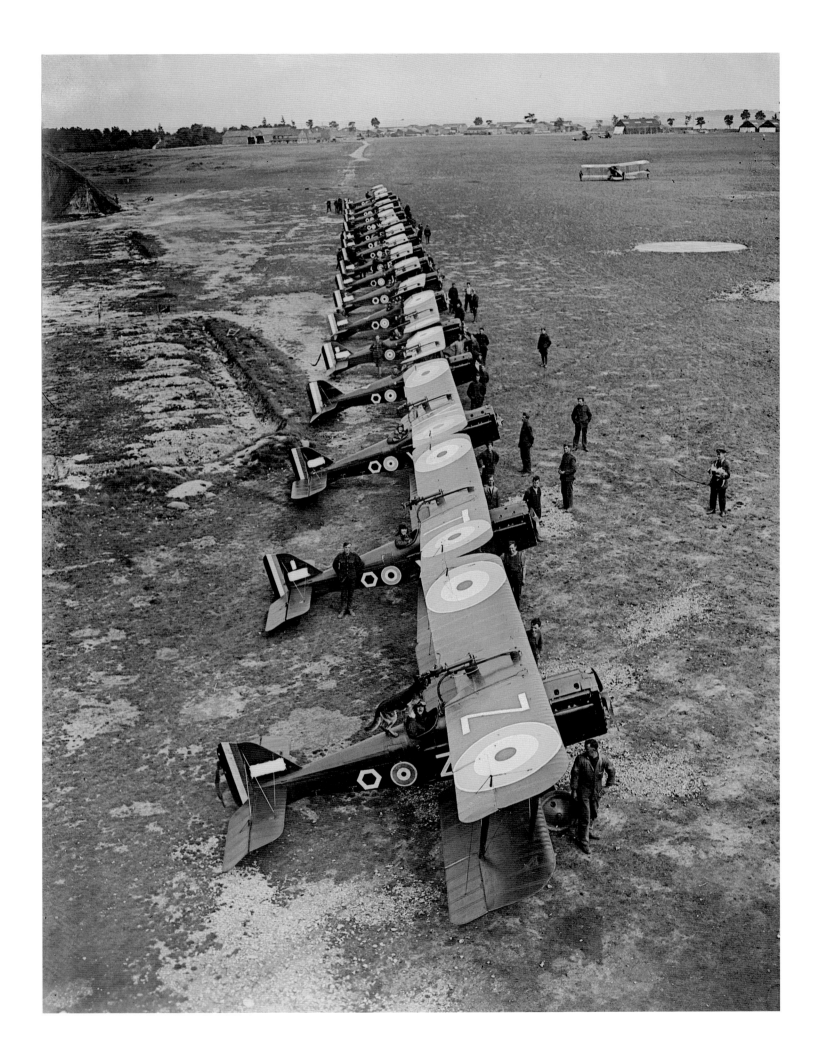

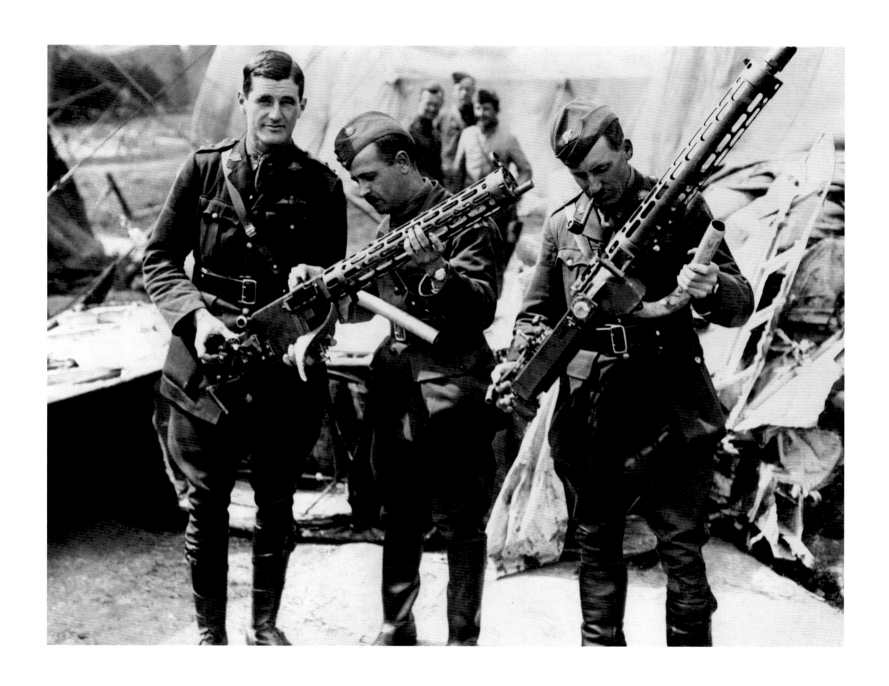

2ND LIEUTENANT THOMAS K. AITKEN, British Army photographer
Officers of No. 3 Squadron, Australian Flying Corps, examine Spandau LMG 08/15 machine guns retrieved from the wreckage of Rittmeister Baron Manfred von Richthofen's Fokker Triplane, Bertangles, Somme, France, 22 April 1918
The fame of von Richthofen was such that the aftermath of his death in aerial combat, subsequently credited to No. 3 Squadron, Australian Flying Corps, was covered in detail by photographers

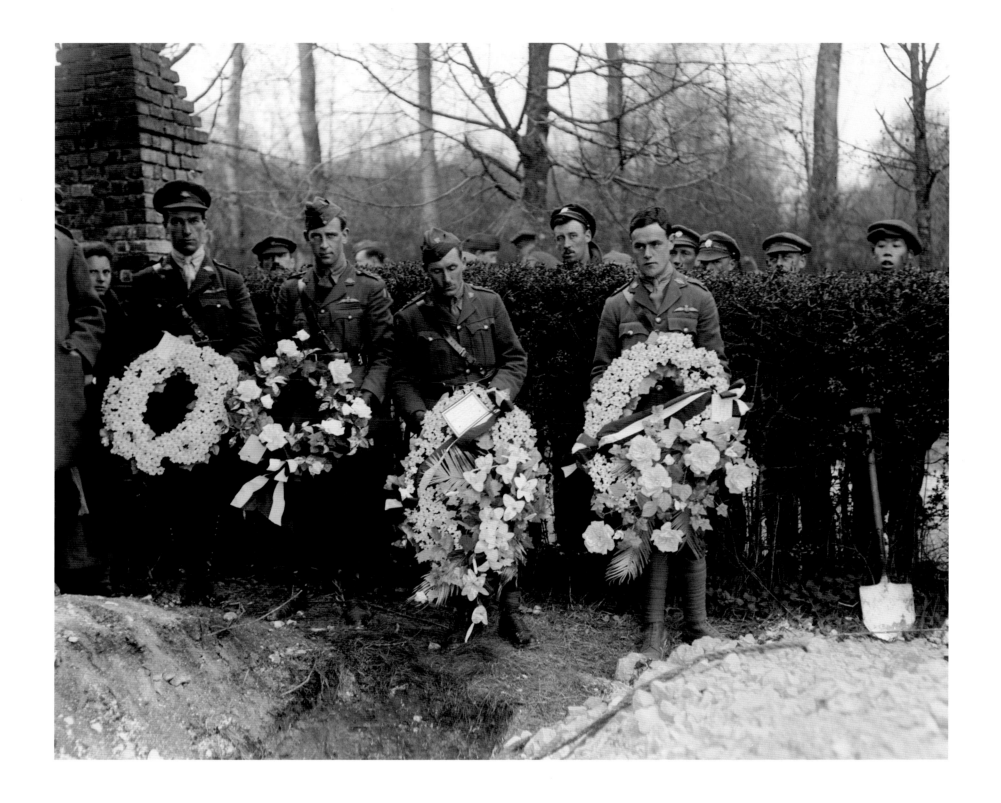

2ND LIEUTENANT THOMAS K. AITKEN, British Army photographer
Officers of No. 3 Squadron, Royal Australian Flying Corps, with wreaths from British
squadrons during the funeral of Rittmeister Baron Manfred von Richthofen, Bertangles,
Somme, France, 22 April 1918
*Their photographs served simultaneously as news, trophies, propaganda and an
expression of the respect in which he was held by all pilots*

Above: CAPTAIN HUBERT WILKINS, Australian Army photographer
Camouflaged dumps of 18-pounder shells stockpiled at the edge of a wheat field in readiness for transport to the front line during the Battle of Hamel, Somme, France, 7 August 1918
The power of the aerial camera had now developed to the point that uncamouflaged military equipment was vulnerable to attack from the air

Right: Unknown photographer, No. 205 Squadron, Royal Air Force
An ammunition truck explodes (bottom right) after being hit by a bomb dropped by No. 205 Squadron, Royal Air Force, Chuignolles, Somme, France, 1 July 1918

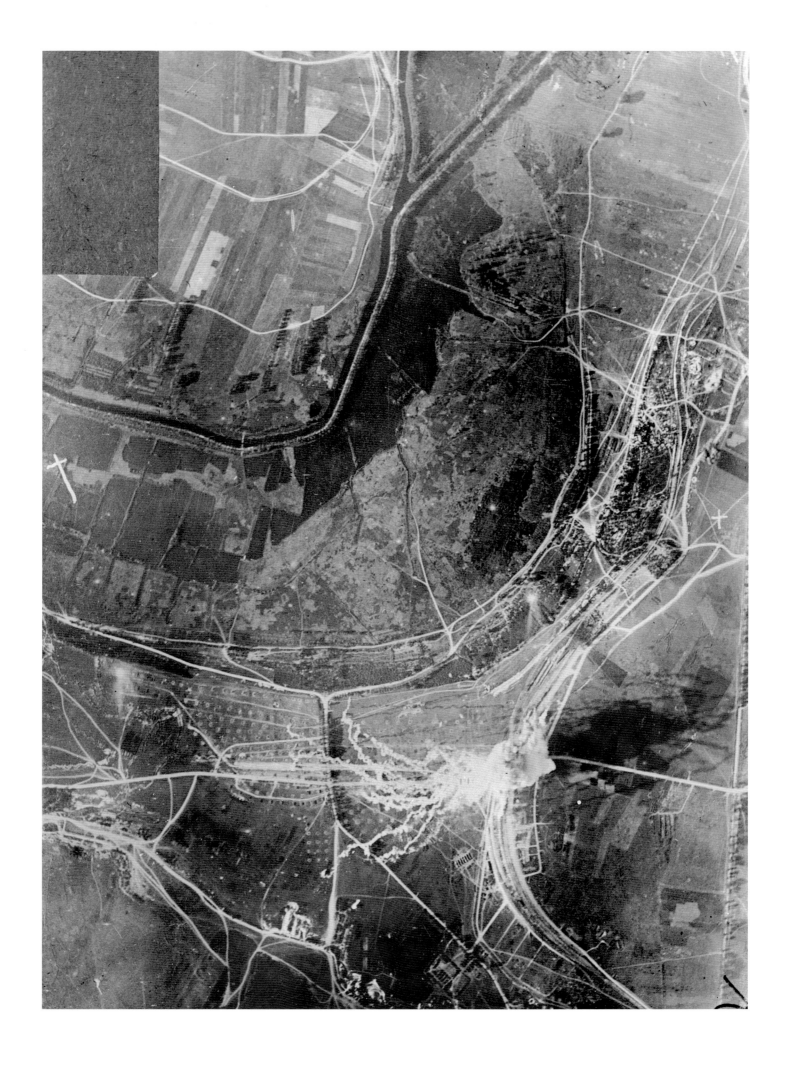

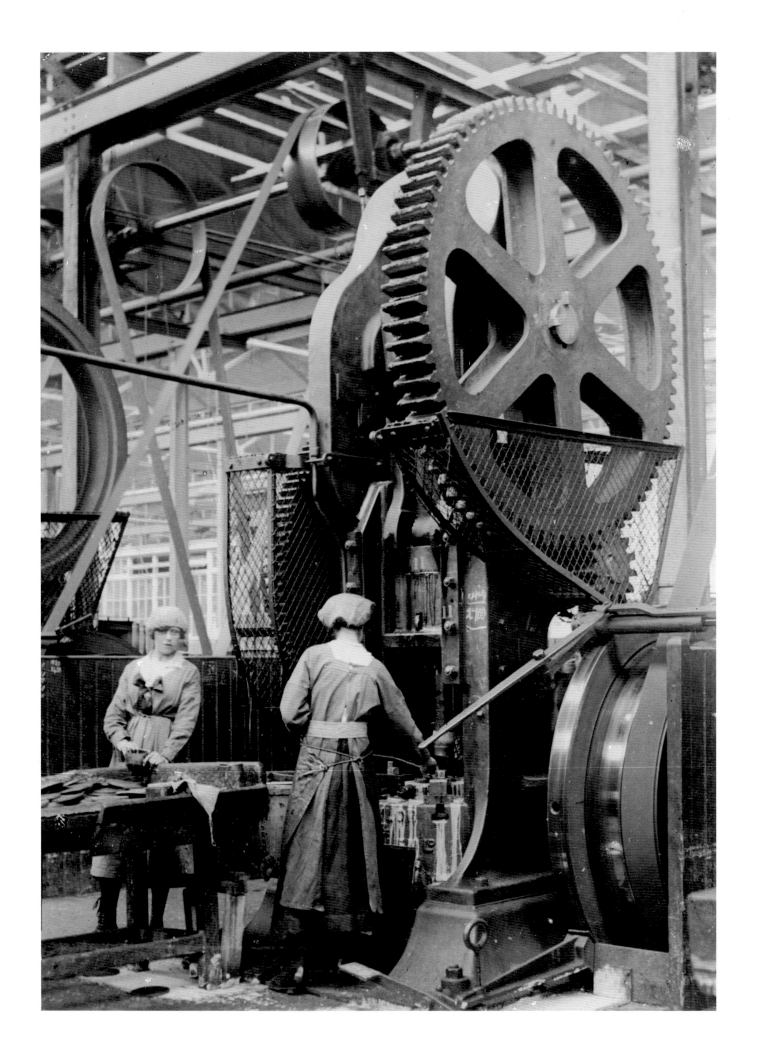

Left: GEORGE P. LEWIS, Ministry of Information photographer
Two women munition workers operate a shell case-forming machine at the New Gun Factory, Royal Arsenal, Woolwich, London, May 1918
In Britain official photographers such as Horace Nicholls and George Lewis set new aesthetic standards for industrial photography

Above: Unknown photographer, Royal Navy
A British submarine under construction, Fairfield West Yard, Govan, River Clyde, Scotland, 1918

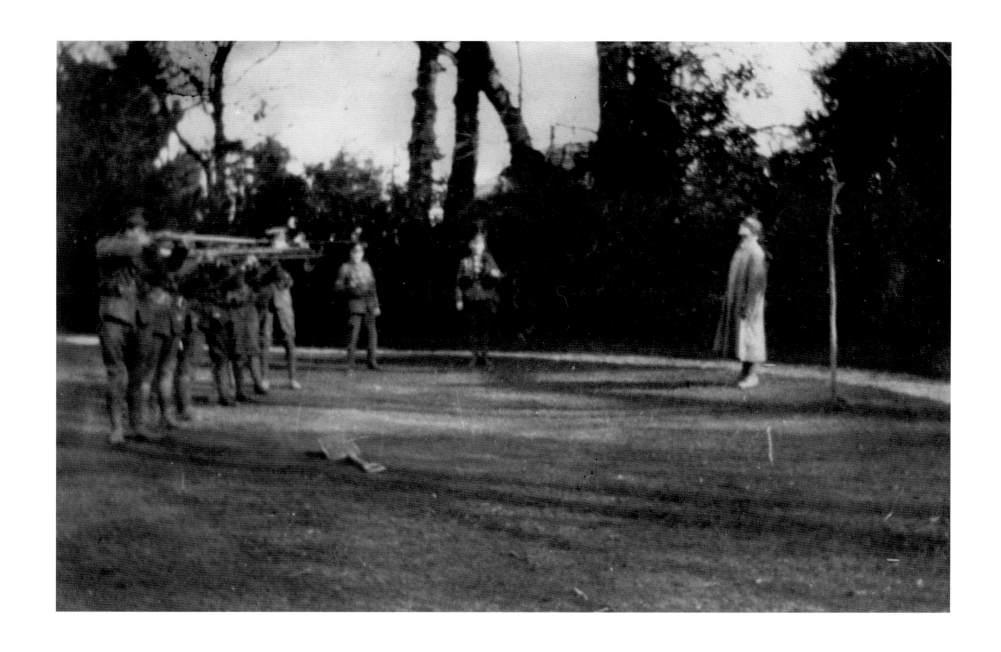

Unknown photographer, personal photograph, from the collection of Alan Grace
A photograph purporting to show a British Army firing squad about to execute a blindfolded prisoner wearing a greatcoat, possibly in the summer of 1915
Trophy photographs of purported atrocities, often snapshots of dubious authenticity, circulated amongst soldiers on all fronts. Those convicted of espionage, desertion or other serious military offenses faced death by firing squad. The execution of 304 British soldiers remains controversial today

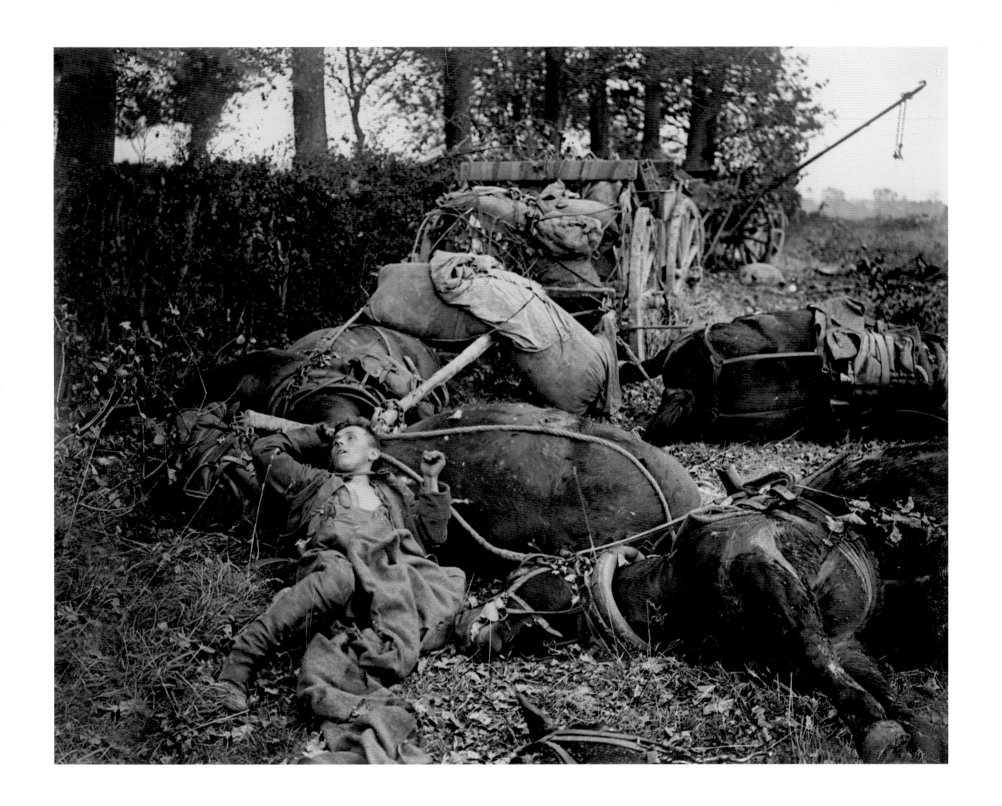

LIEUTENANT JOHN WARWICK BROOKE, British Army photographer
**The bodies of soldiers and horses lie in the remains of a German ammunition column
that was hit by British shellfire, Le Quesnoy, 27 October 1918**
*Hardened by war and aware that their work would form part of their nation's
permanent record, the work of the longest-serving official photographers became
increasingly graphic*

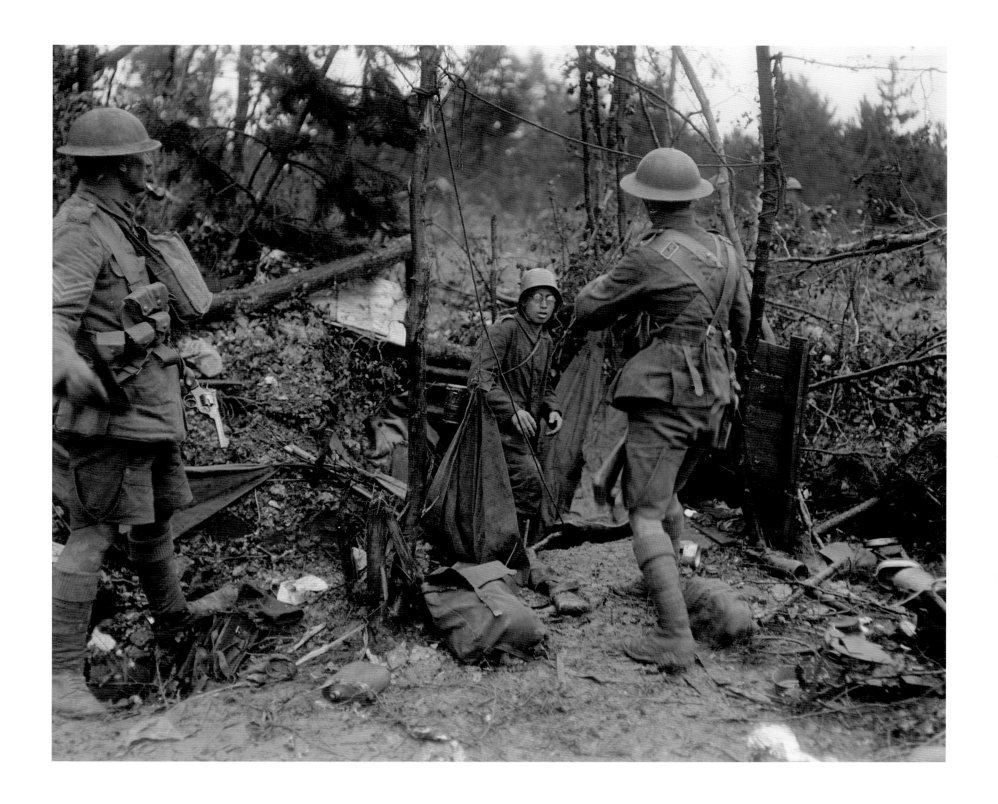

2ND LIEUTENANT THOMAS K. AITKEN, British Army photographer
Soldiers of 5th Devonshire Regiment capture a German soldier during the Battle of the
Tardenois, Bois de Reims, Marne, France, 24 July 1918
By the summer the German offensive had been halted, but at heavy cost

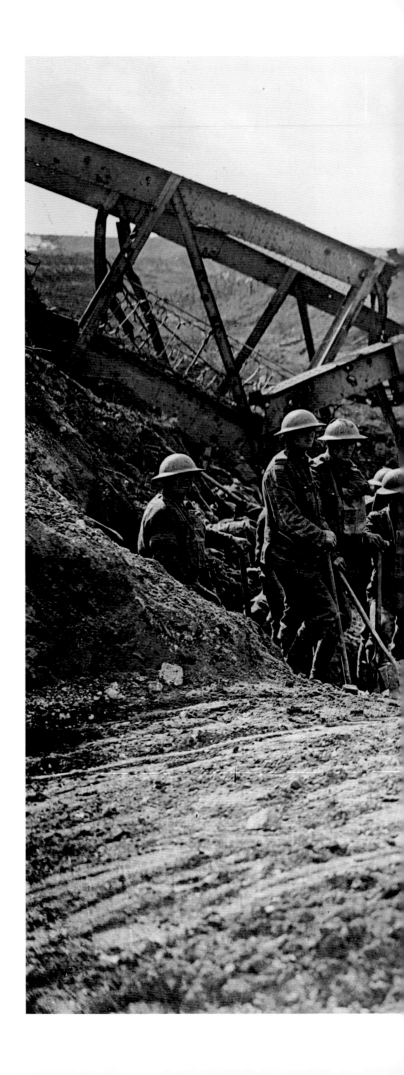

2ND LIEUTENANT DAVID McLELLAN, British Army photographer
A British Royal Field Artillery 18-pounder field-gun team crosses the Canal du Nord near Moeuvres, west of Cambrai, France, 27 September 1918

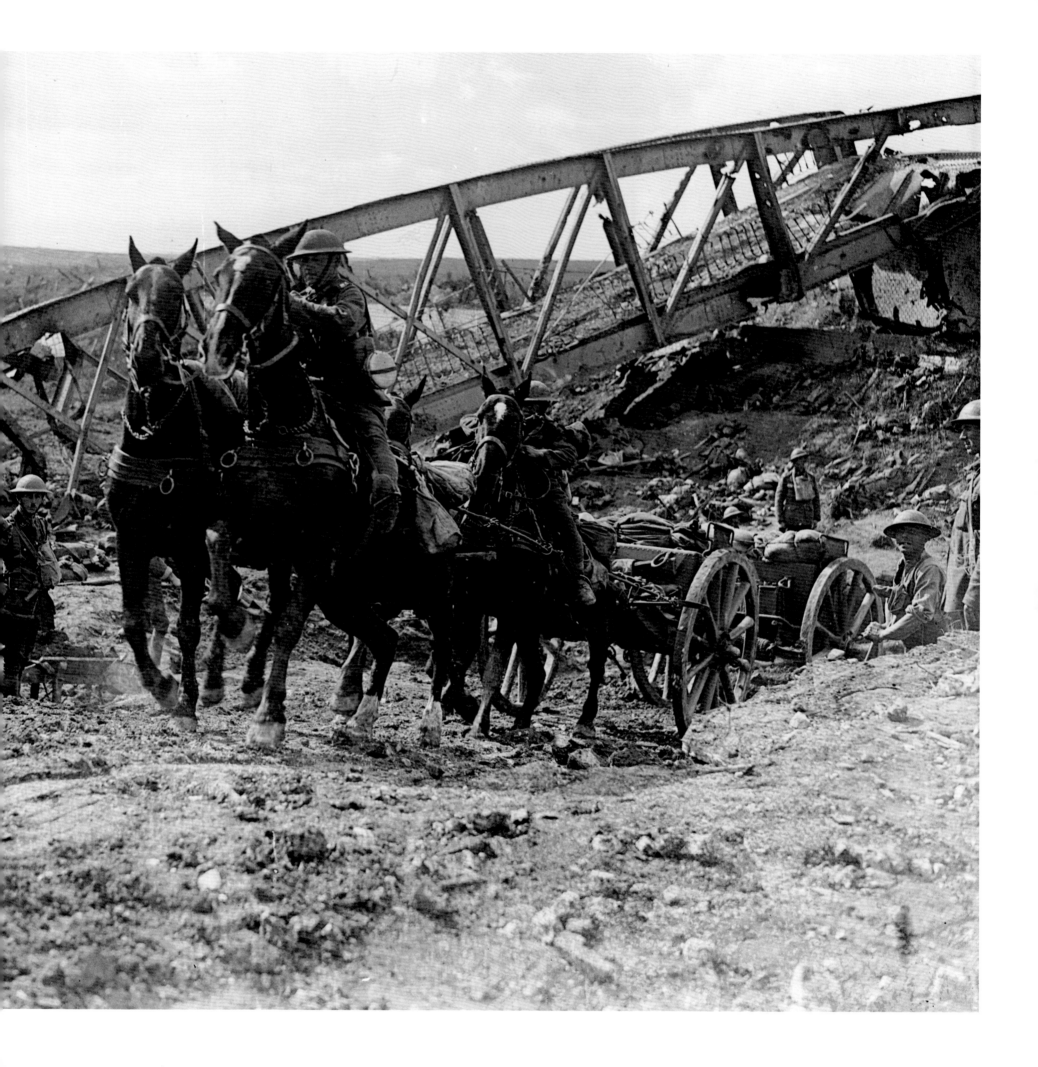

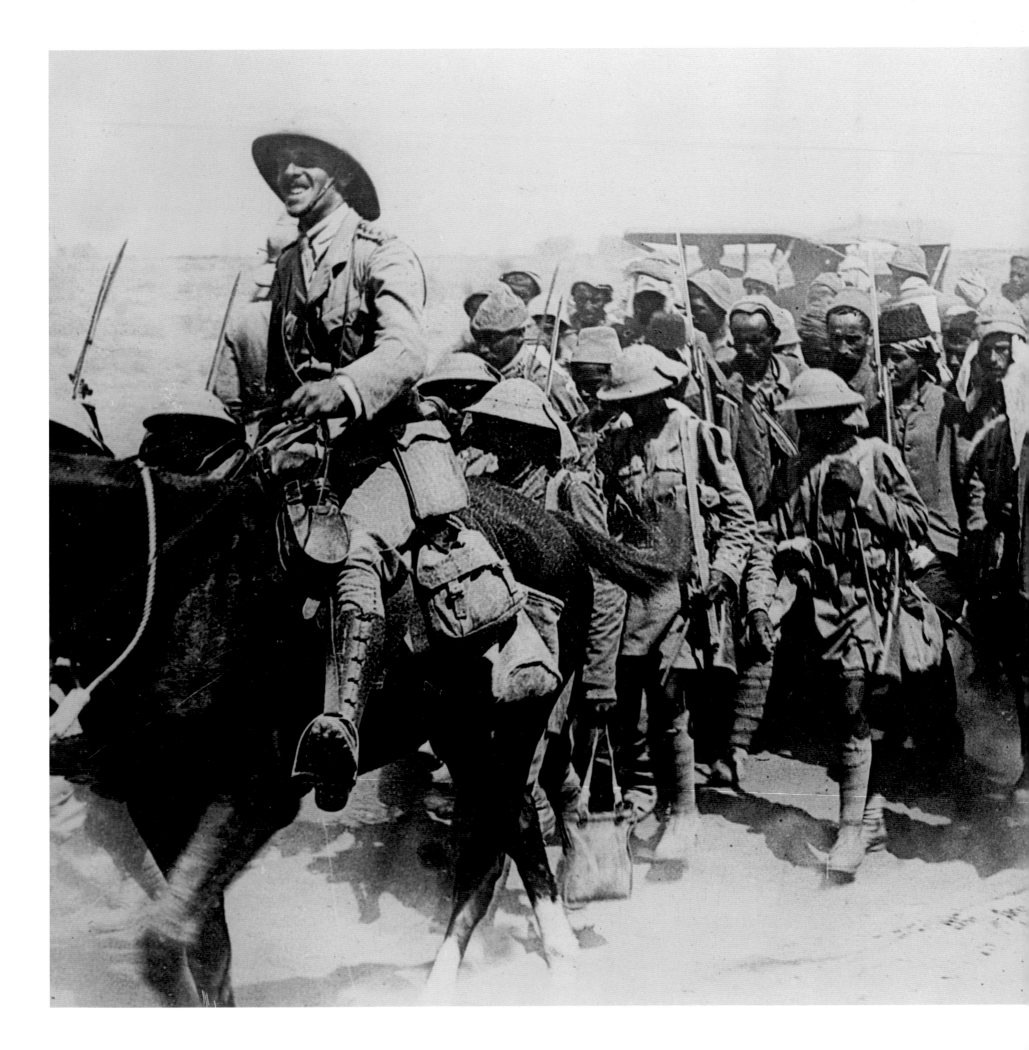

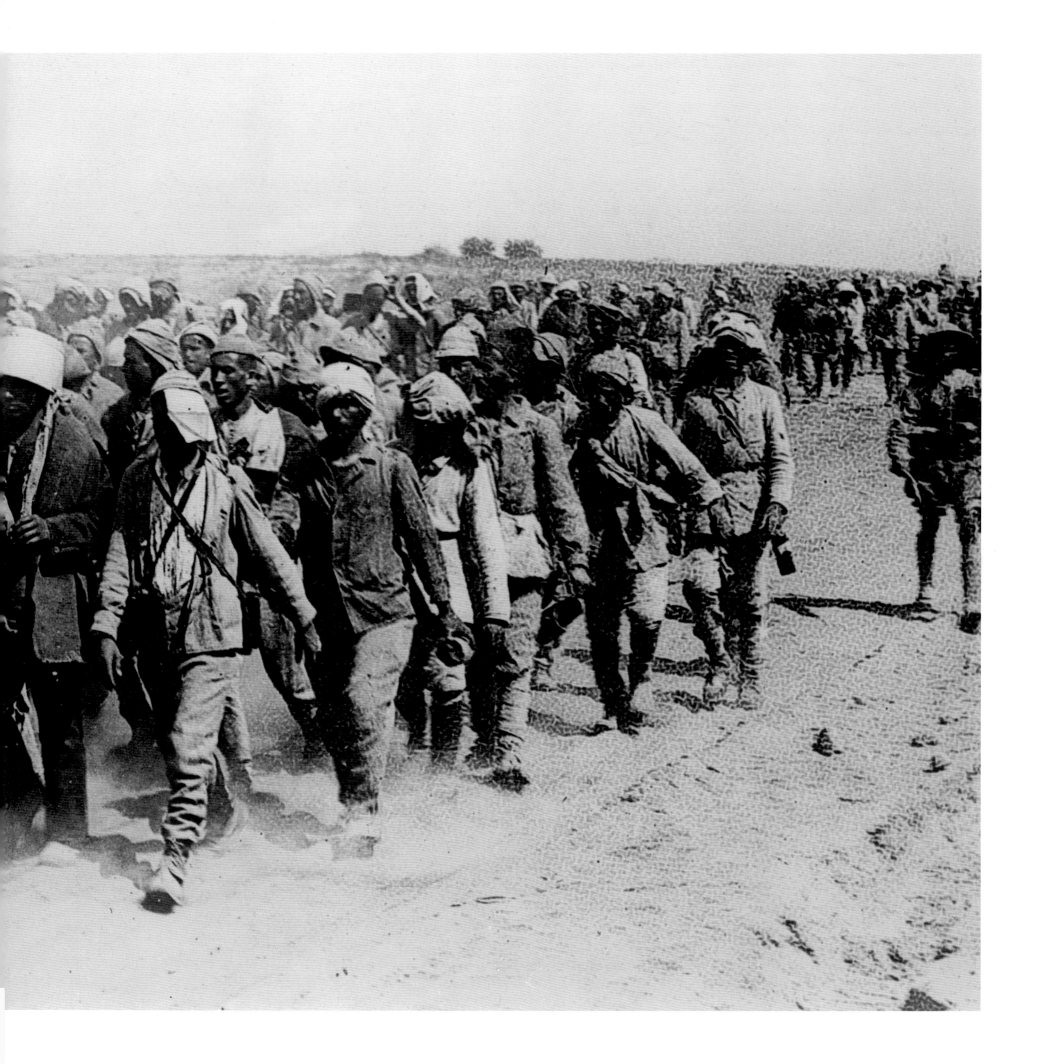

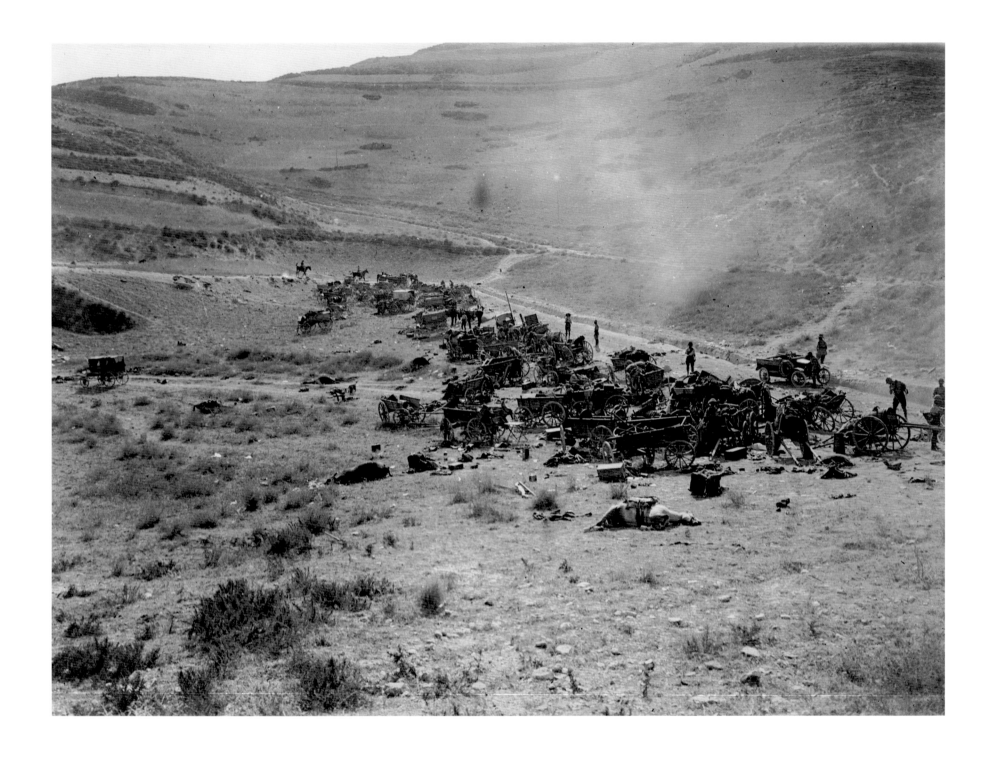

Pages 464–5: GEORGE WESTMORELAND, Ministry of Information photographer, Palestine Front
A column of 1,200 Turkish prisoners, captured by the Desert Mounted Corps at the Battle of Sharon, en route from Karkur to Tulkarem, Palestine, 22 September 1918
Fighting on the Western Front delayed the Allied assault on Ottoman forces in the Middle East. Reinforced by Jewish, Armenian and British Empire troops, the Allies launched their final campaign, known as the Battle of Megiddo, in September 1918

Above: GEORGE WESTMORELAND, Ministry of Information photographer, Palestine Front
The remains of Turkish transport destroyed by British aircraft on the Nablus–Beisan Road during the Battle of Megiddo, Palestine, 20 September 1918
Air superiority in the Middle East theatre passed from the Central Powers to the Allies in early 1918. Aerial photography provided vital intelligence about the disposition of Turkish forces

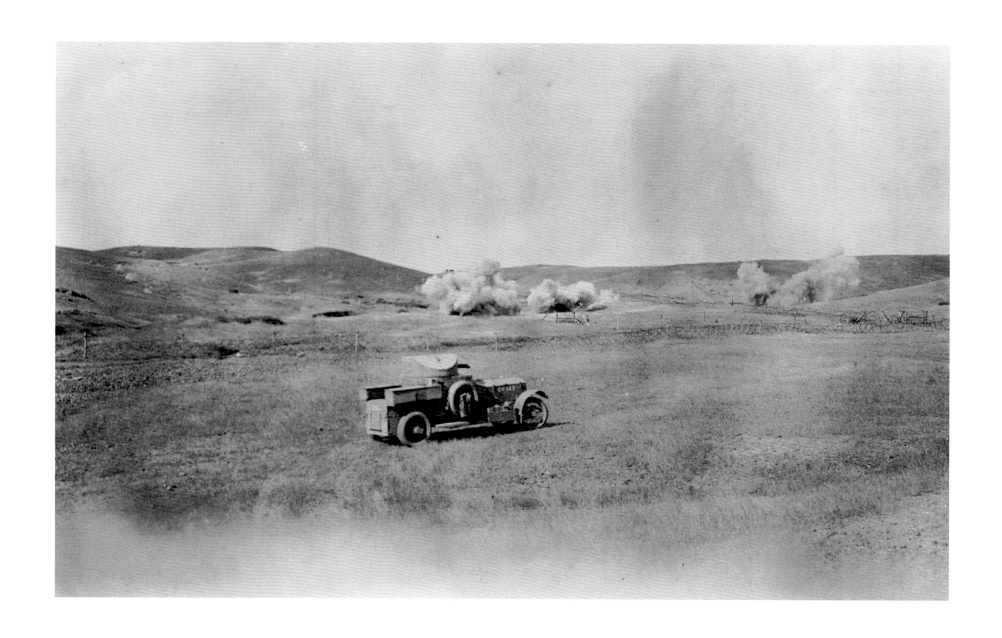

ARIEL VARGES, Mesopotamian Expeditionary Force photographer
**Turkish shells burst near a Rolls-Royce armoured car of 14th Light Armoured Motor
Battery during the Battle of Sharqat, north of Baghdad, Mesopotamia, 28–30 October 1918**

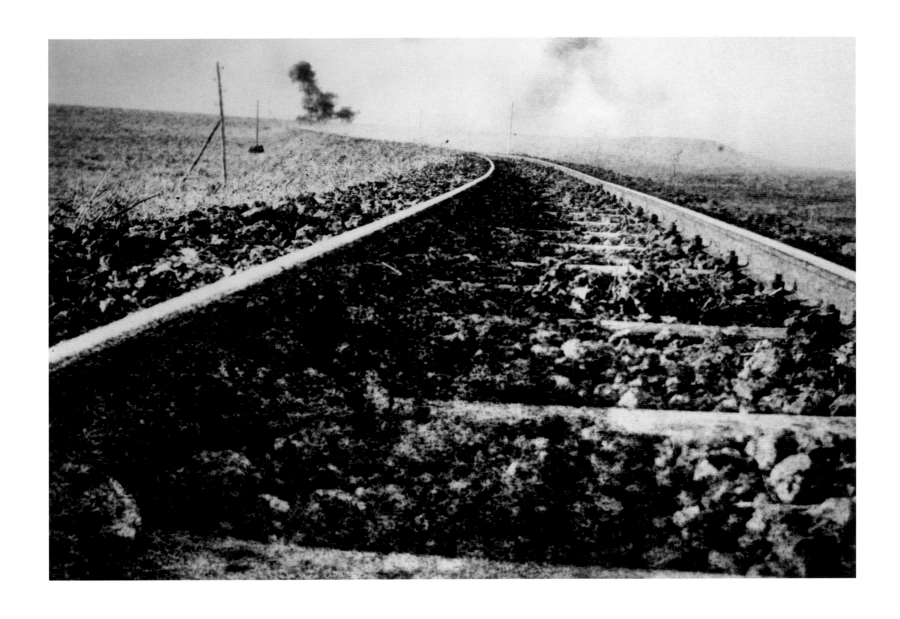

COLONEL T. E. LAWRENCE, personal photograph
**A Tulip bomb, planted by Arab forces under the command of Colonel T. E. Lawrence,
explodes on the Hejaz railway near Deraa, Syria, 1918**
*Sabotage by Arab irregular forces led by Colonel T. E. Lawrence and Emir Feisal
further undermined Turkish infrastructure*

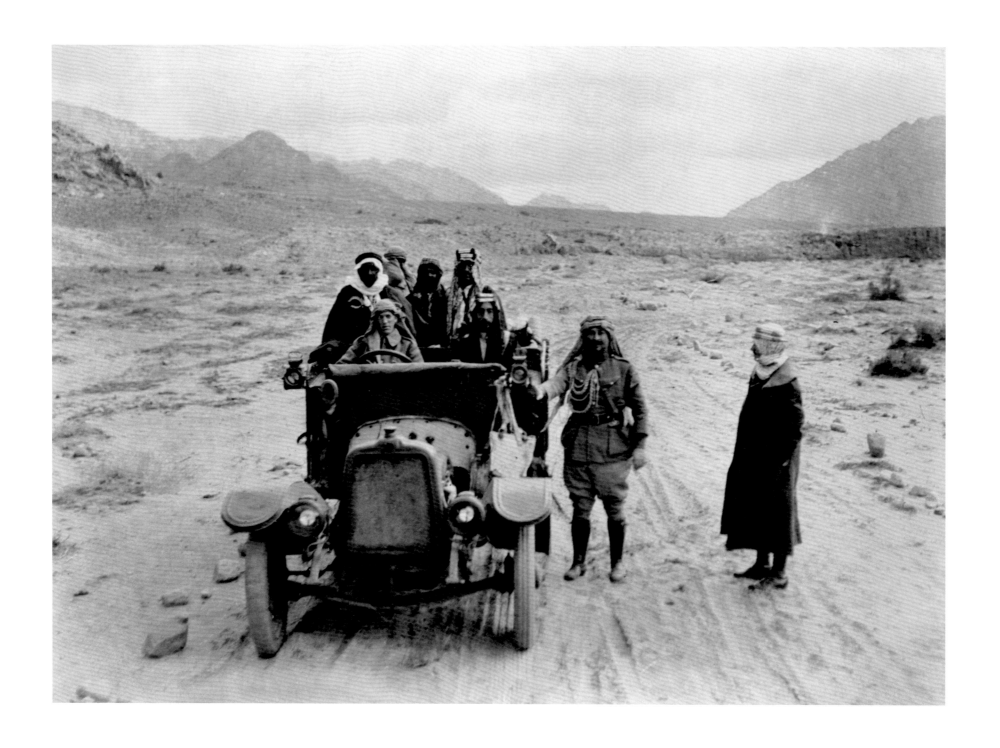

CAPTAIN RAYMOND GOSLETT (presumably), personal photograph, from the collection of Colonel T. E. Lawrence
Lowell Thomas, US war correspondent, transports leaders of the Arab Revolt by car in Wadi Itm *c.* September 1918. Emir Feisal bin Husain al-Hashimi seated front, next to Lowell Thomas (at the wheel). Auda Abu Tayi, leader of the Howeitat tribe (behind), and Ferid (standing)

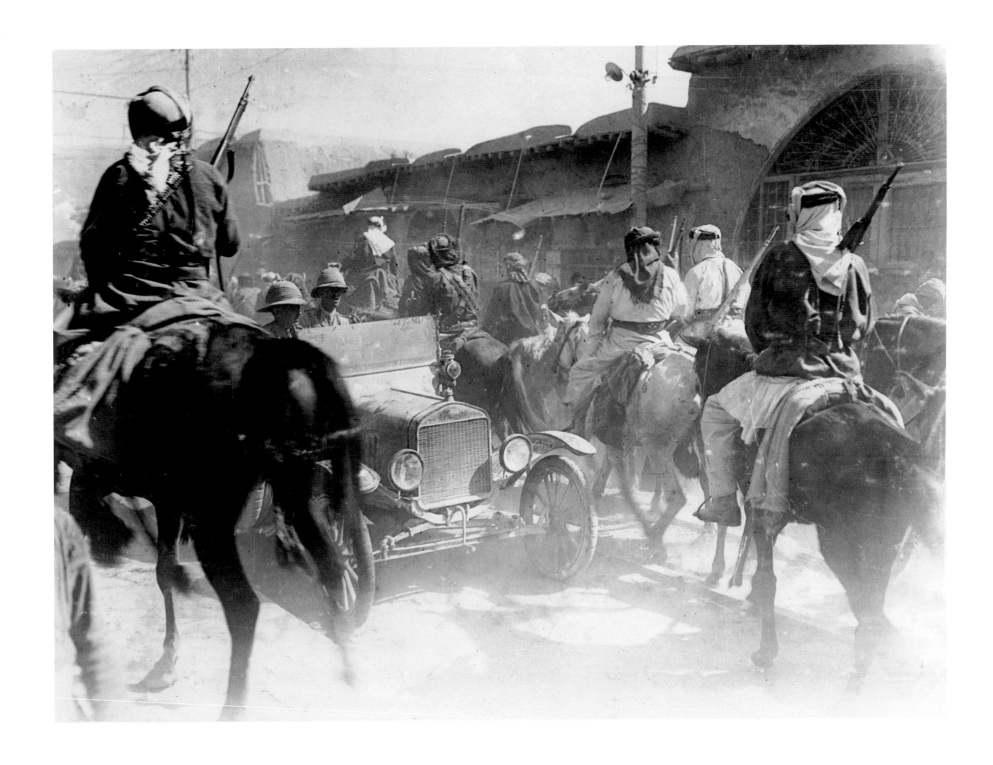

GEORGE WESTMORELAND, Ministry of Information photographer
Emir Feisal's Arab force enter Damascus, Syria, 1 October 1918
Regular and irregular Allied forces united to capture Damascus. The story of Colonel T. E.
Lawrence and the Arab insurrection came to the attention of official photographers

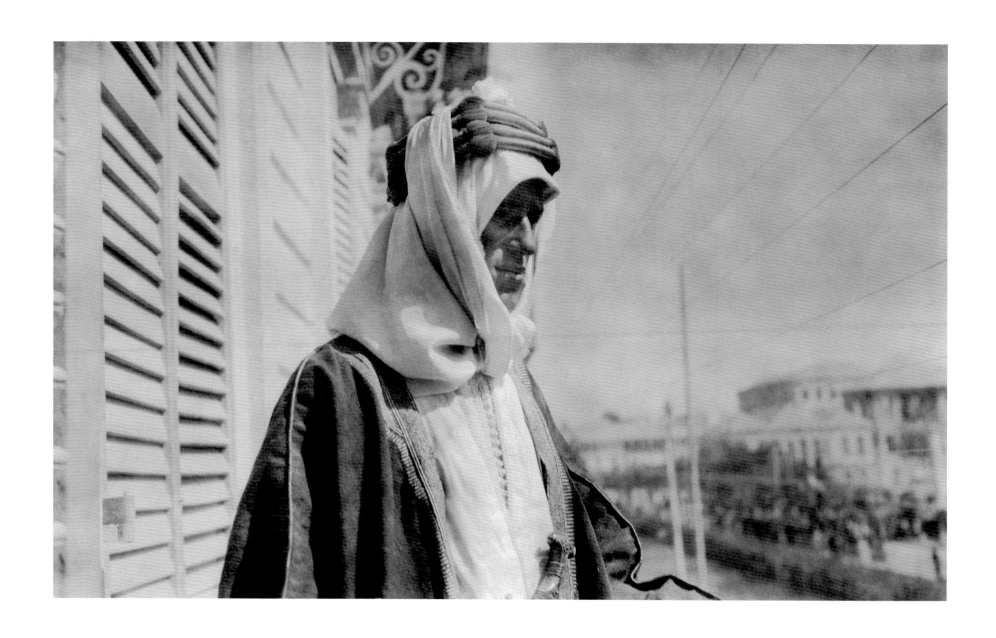

HARRY A. CHASE, photographer accompanying Lowell Thomas, US war correspondent
**Colonel T. E. Lawrence on the balcony of the Victoria Hotel in Damascus, half an
hour after he had resigned his position in the Arab Army, 3 October 1918**
*Chase took a series of romantic portraits of Colonel Lawrence at the request of Lowell
Thomas. The photographs, combined with Chase's reports and Lawrence's own desire
to publicise the Arab cause, gave birth to the legend of Lawrence of Arabia*

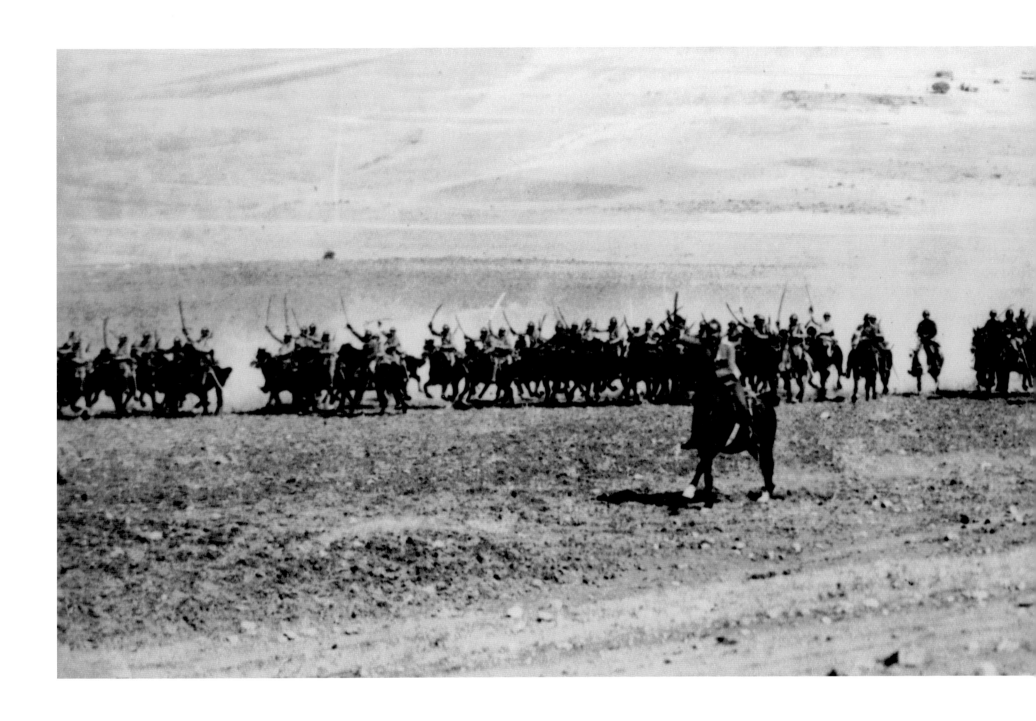

Unknown photographer, from the collection of Mrs D. Stankovic
Serbian cavalry charge with drawn sabres in Macedonia, September 1918
*Despite extreme vulnerability in the face of modern weapons, cavalry charges still
featured occasionally as a shock tactic, particularly in the Middle East theatre. One of
the last cavalry charges, by the Australian Light Horse during the Battle of Megiddo,
helped secure victory at Samakh in September 1918*

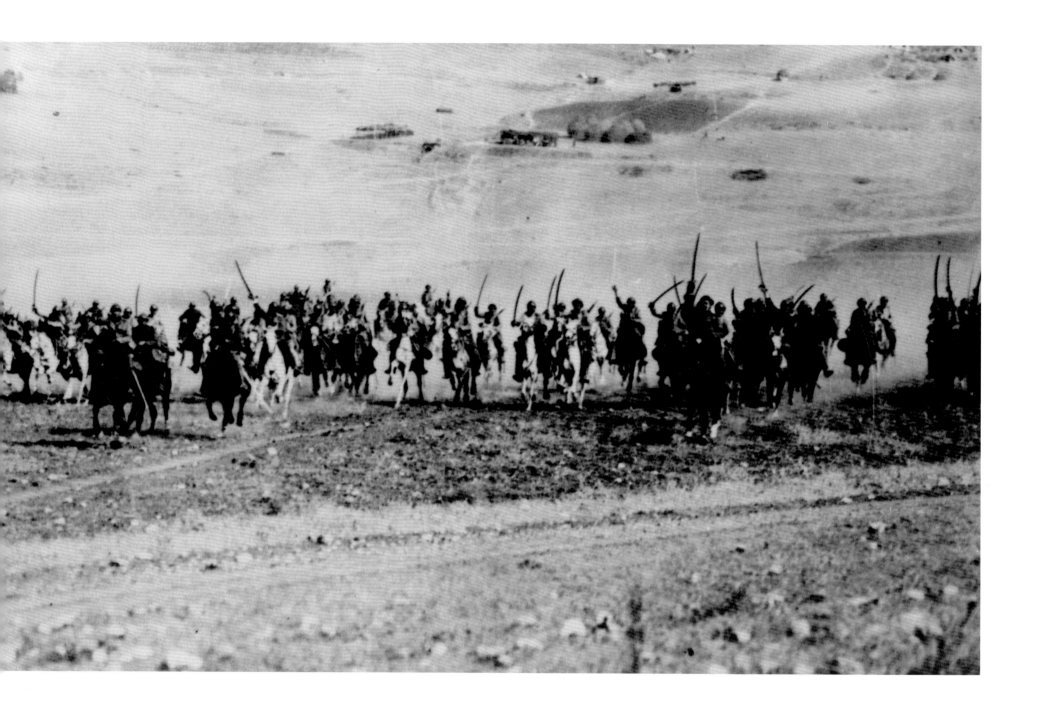

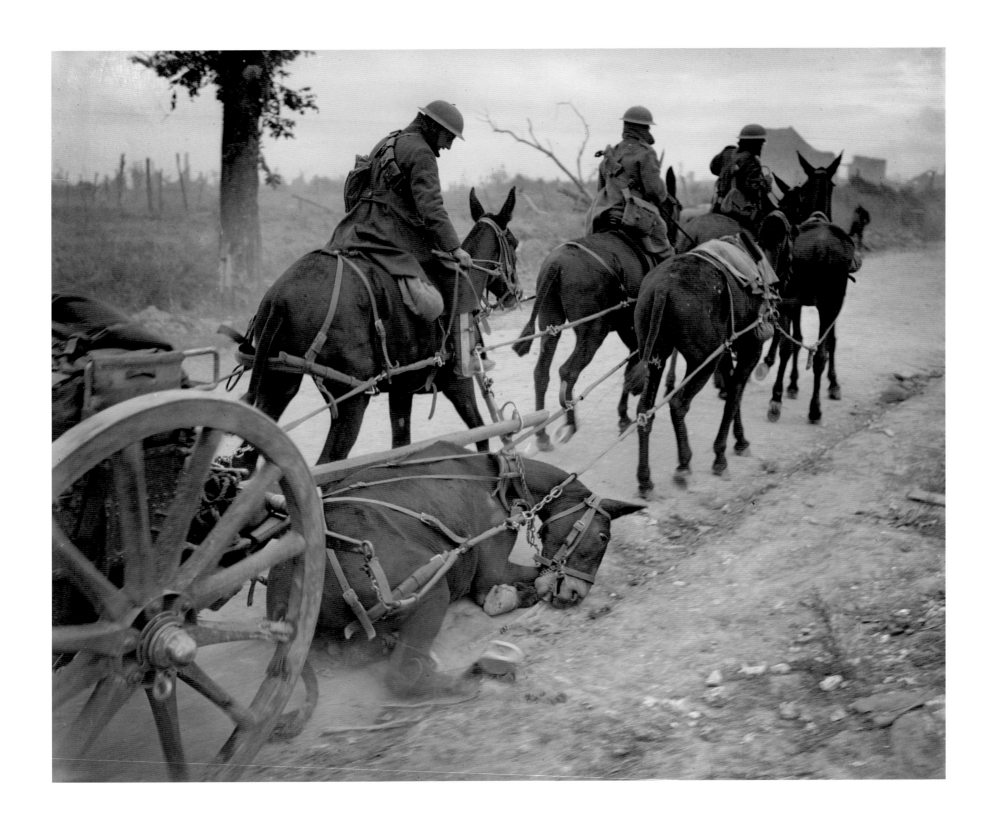

LIEUTENANT JOHN WARWICK BROOKE, British Army photographer
A mule harnessed to a British limber falls in the traces after being injured by a shell splinter during the Battle of the Drocourt-Quéant Line during the Allied Counter-Offensive, Remy, France, 2 September 1918
By the summer the German offensive had been halted on the Western Front. The Allies, led by the French, then counterattacked

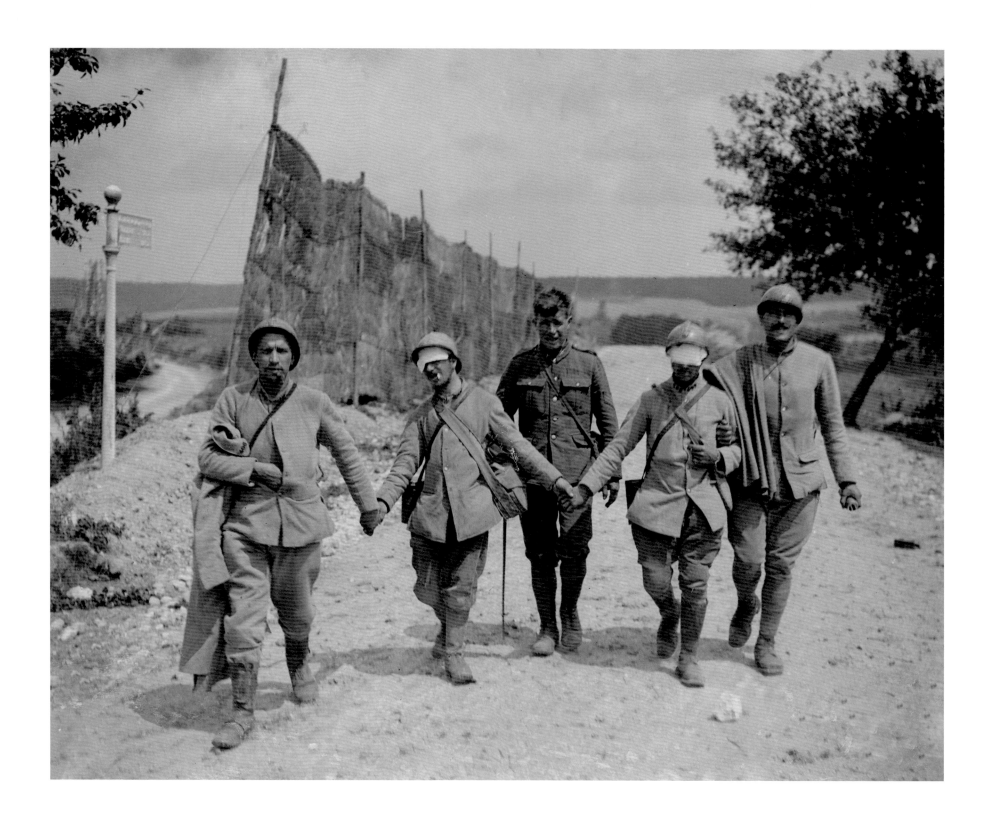

LIEUTENANT JOHN WARWICK BROOKE, British Army photographer
French soldiers are led towards an advanced dressing station after being blinded,
probably by mustard gas, during fighting on the Marne, France, *c.* July 1918

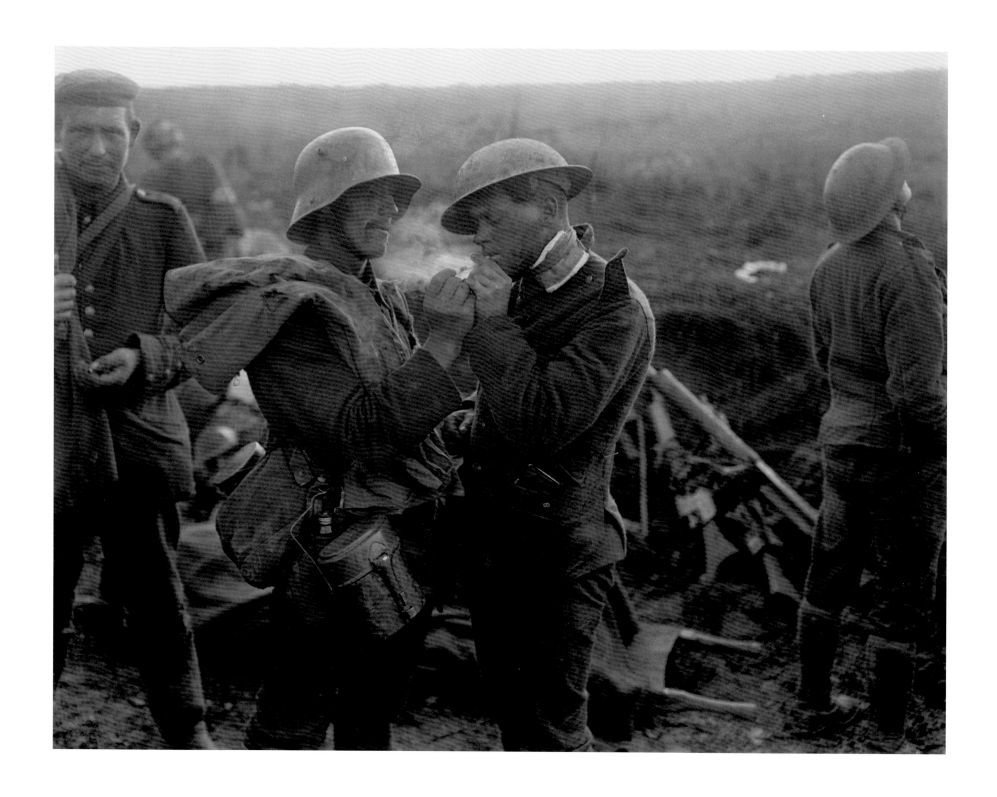

2ND LIEUTENANT THOMAS K. AITKEN, British Army photographer
British and German wounded at a British advanced dressing station during the Battle of Épehy, Nord, France, 18 September 1918
On 8 August 1918, the Allies, supported by now-seasoned US troops, launched a series of offensives, known collectively as the Hundred Days Offensive, on the Western Front

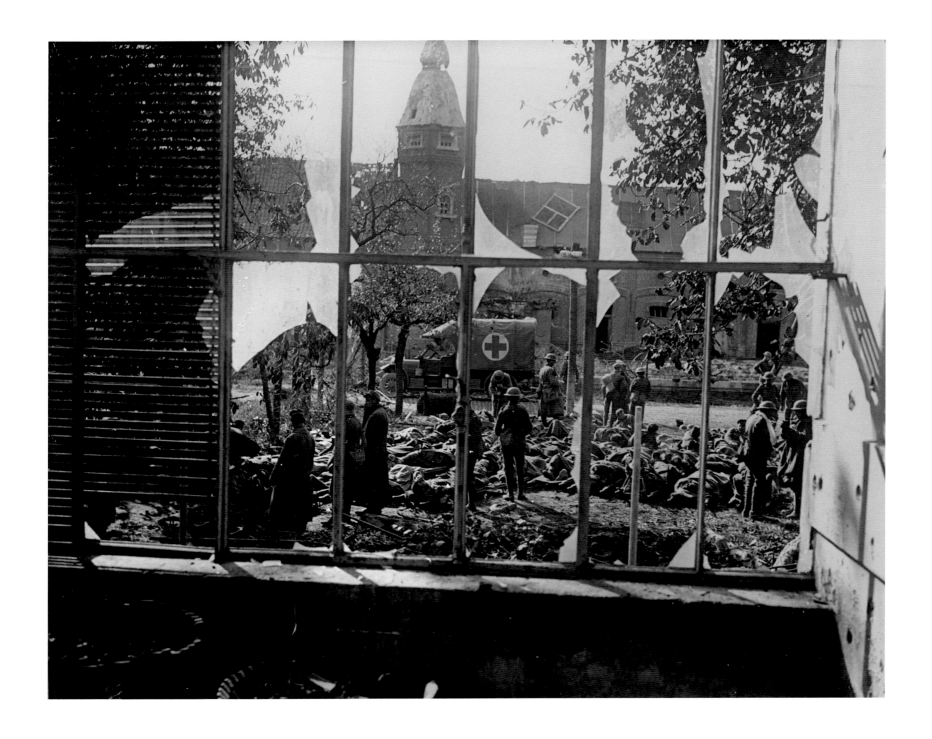

Above: 2ND LIEUTENANT DAVID McLELLAN, British Army photographer
A view of Allied stretcher cases outside a British dressing station in the courtyard of a French chateau near Noyelles-sur-Escaut during the Battle of Épehy, Nord, France, 8 October 1918

Right: 2ND LIEUTENANT DAVID McLELLAN, British Army photographer
German prisoners bring in Allied wounded on stretchers as Mark V tanks equipped with crib fascines advance near Bellicourt during the Battle of St Quentin Canal, France, 29 September 1918
The battle became a turning point in the war when British, Australian and American forces finally breached the Hindenburg Line

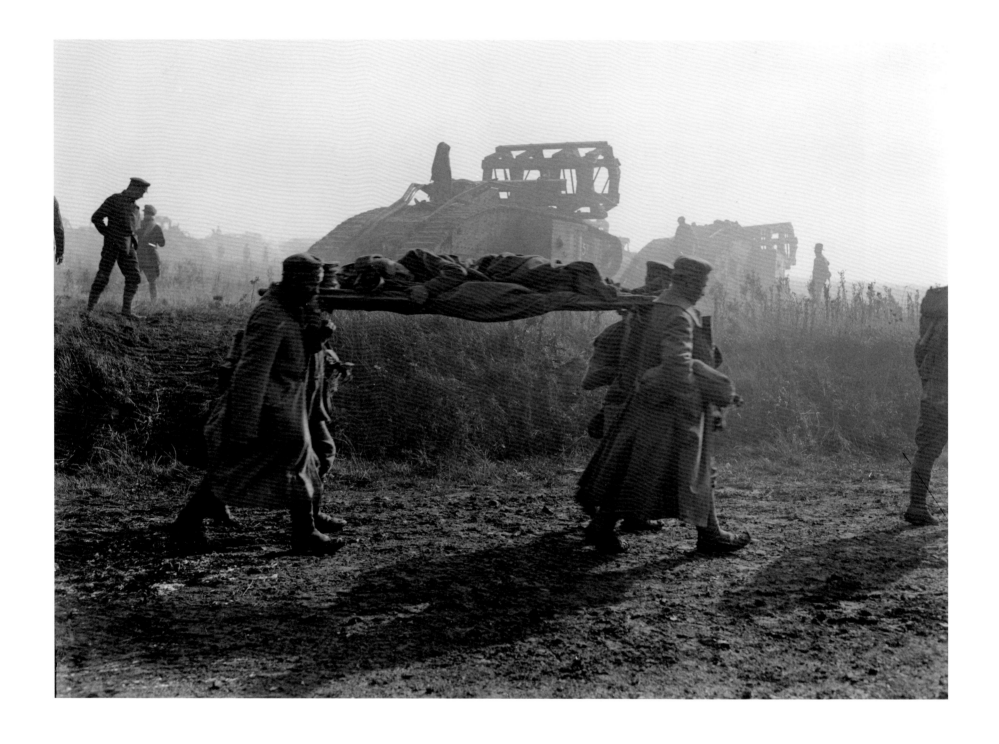

Page 480: 2ND LIEUTENANT DAVID McLELLAN, British Army photographer
German prisoners, captured during the Battle of St Quentin Canal, at a clearing depot, Abbeville, France, 2 October 1918
Vast numbers of German troops fell into Allied hands, compounding losses incurred in the spring. The Imperial German Army was forced to retreat and recognised that the war was lost

Page 481: 2ND LIEUTENANT DAVID McLELLAN, British Army photographer
The Hindenburg Line was finally breached on 29 September. Brigadier General J. C. Campbell, VC, addresses 137th Brigade from the entrance to the Riqueval Tunnel on the St Quentin Canal near Bellicourt, France, 2 October 1918

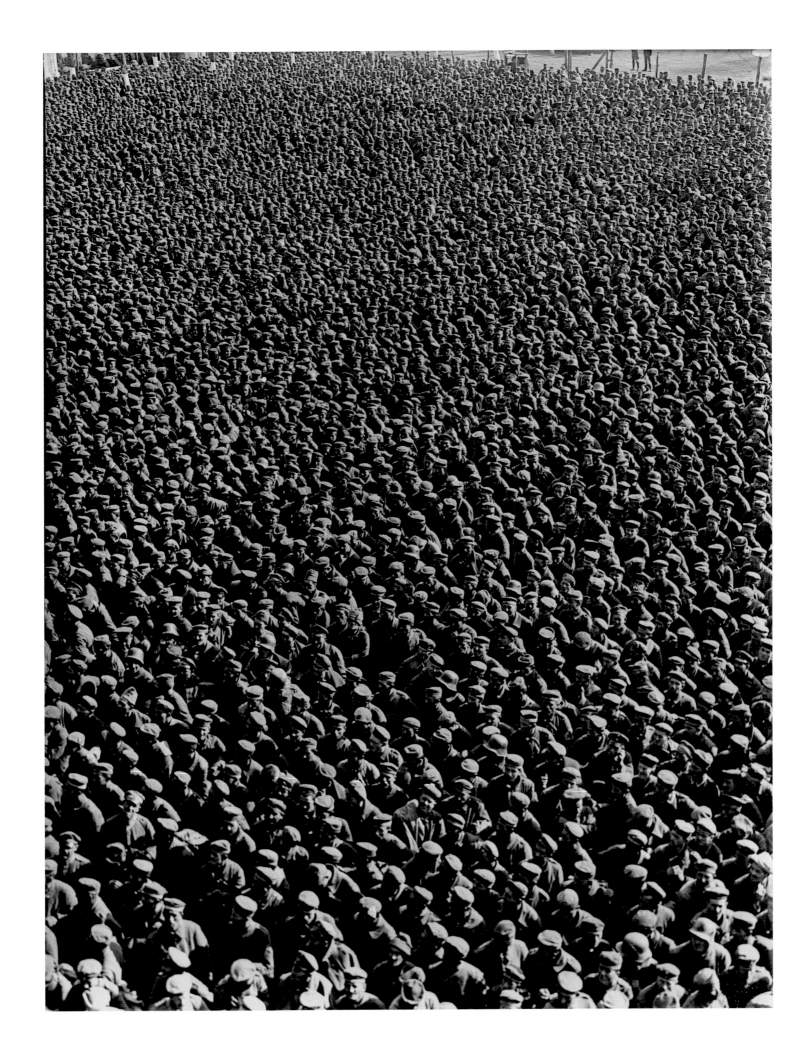

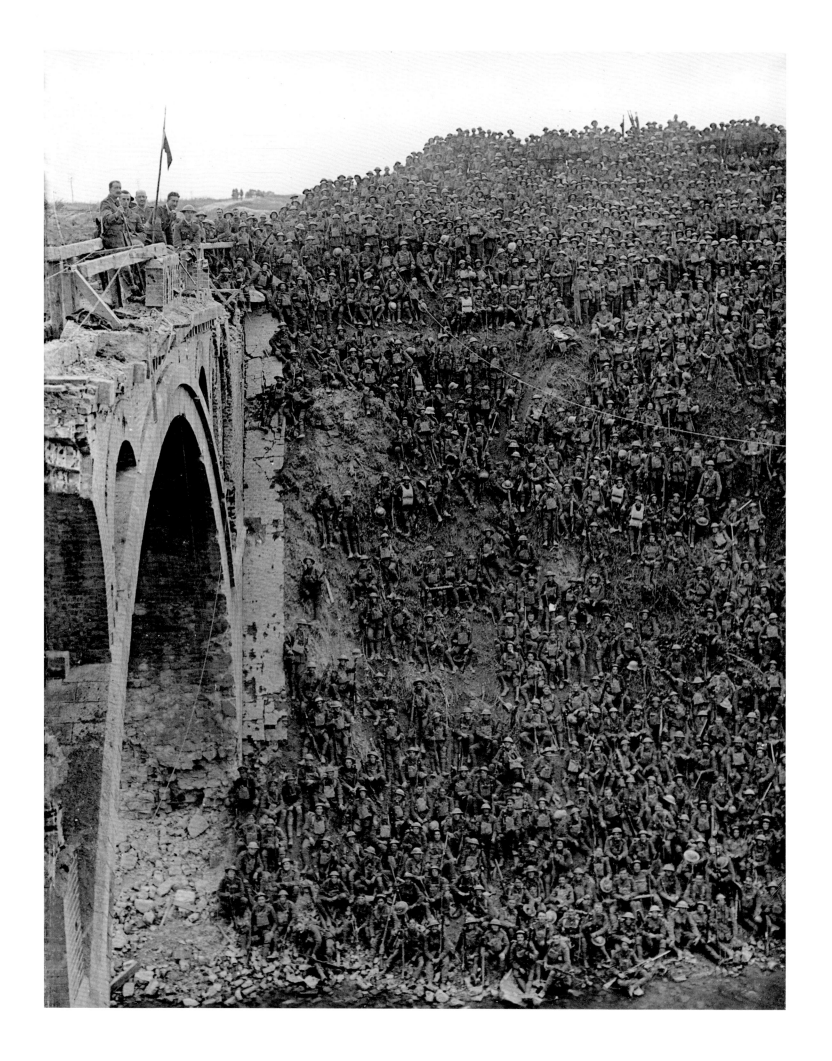

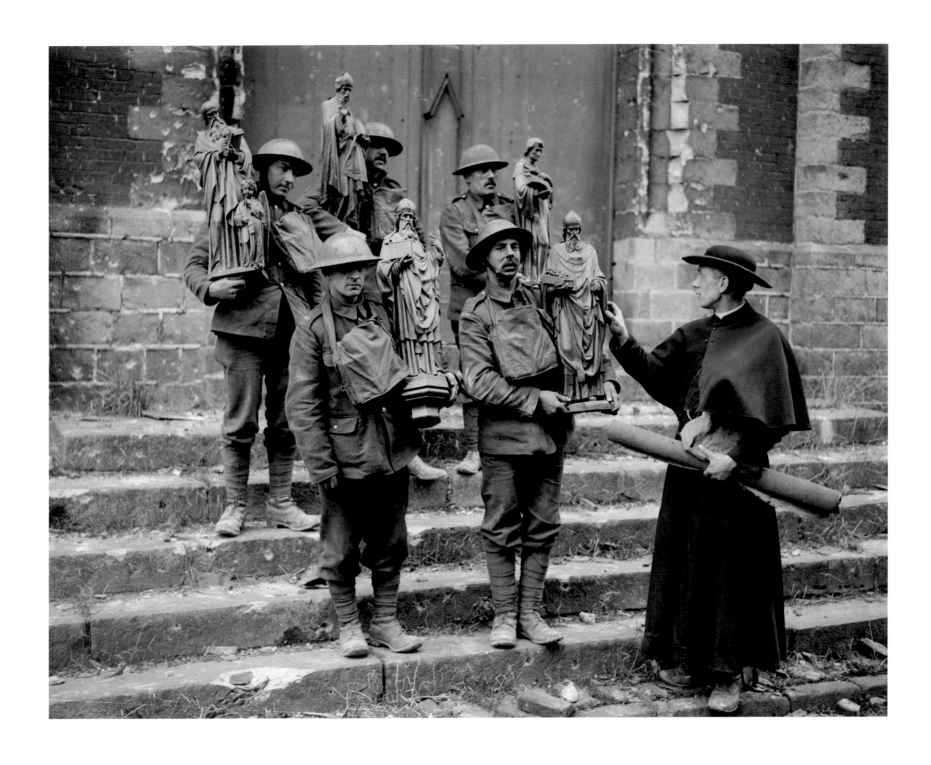

2ND LIEUTENANT DAVID McLELLAN, British Army photographer
British soldiers help a French priest to remove statues from a church that has been damaged by shellfire, Armentières, France, 26 February 1918

482

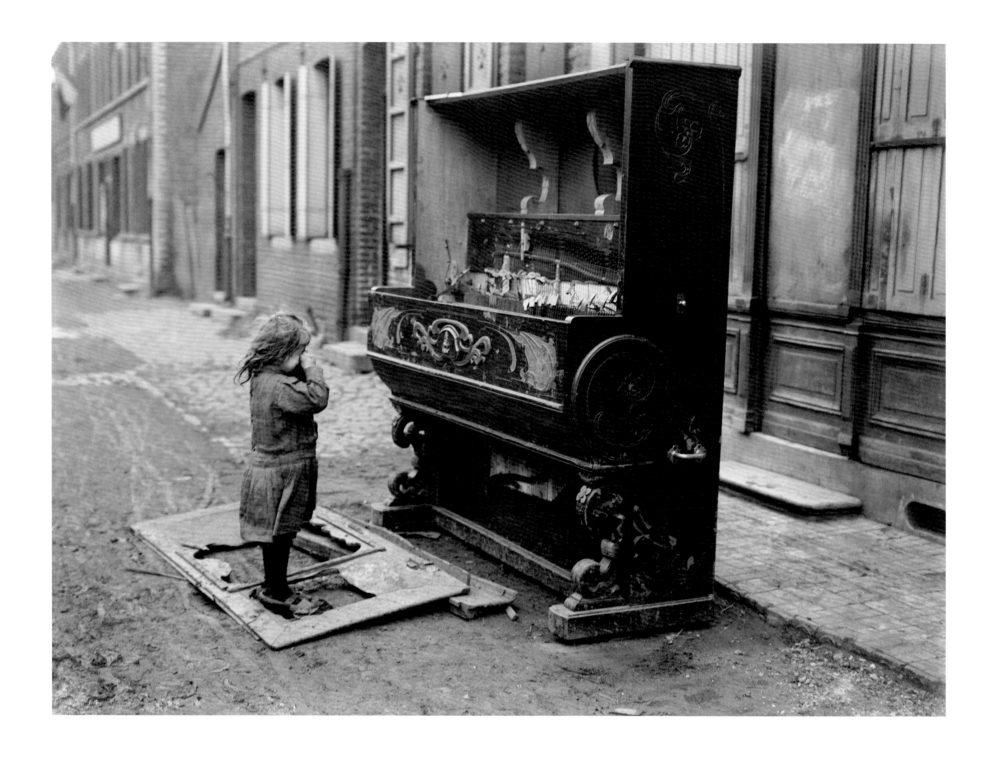

LIEUTENANT ERNEST BROOKS, British Army photographer
Denain, France, 25 October 1918

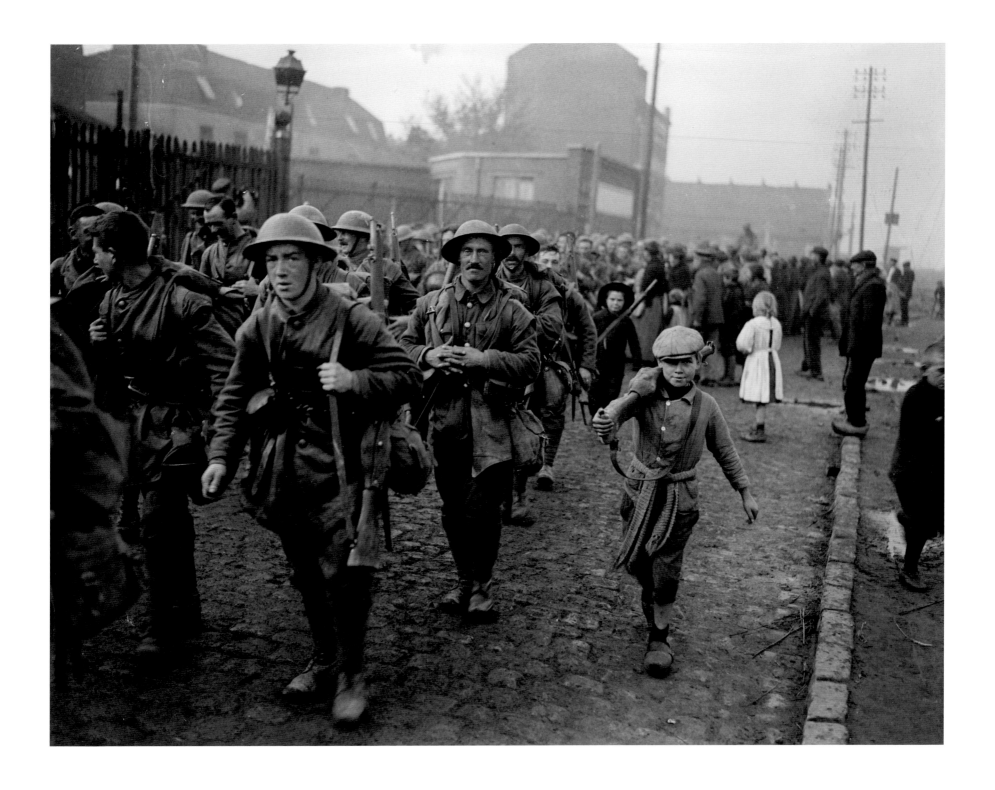

2ND LIEUTENANT DAVID McLELLAN, British Army photographer
57th Division, accompanied by a small boy, march through the outskirts of Lille after
its liberation from German occupation, France, 18 October 1918

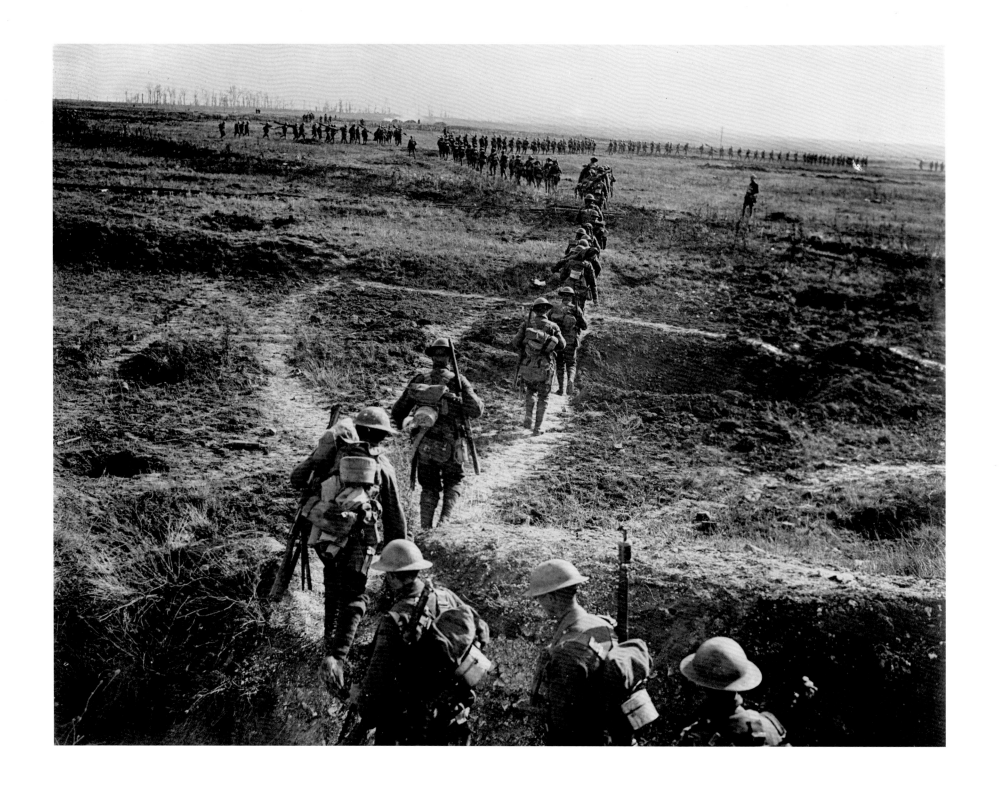

2ND LIEUTENANT DAVID McLELLAN, British Army photographer
Canadian troops advance during the Battle of the Canal du Nord, France, 27 September 1918

WILLIAM J. BRUNELL, Ministry of Information photographer, Italian Front
An Austro-Hungarian prisoner captured by British troops, Italy, September 1918

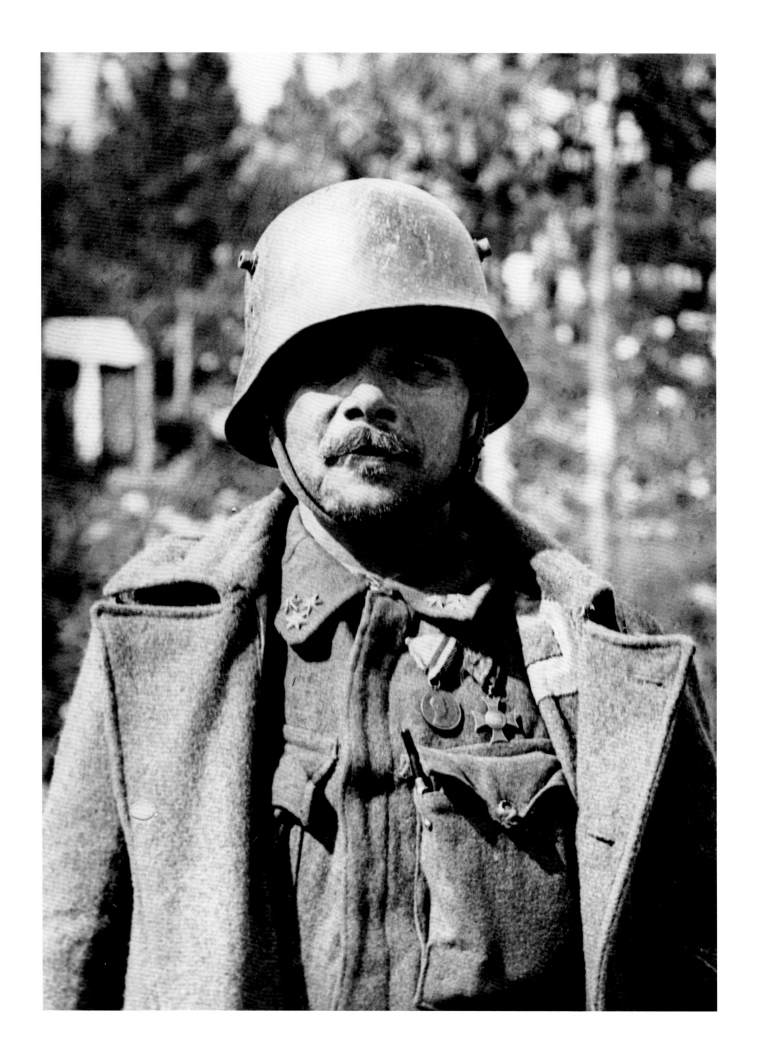

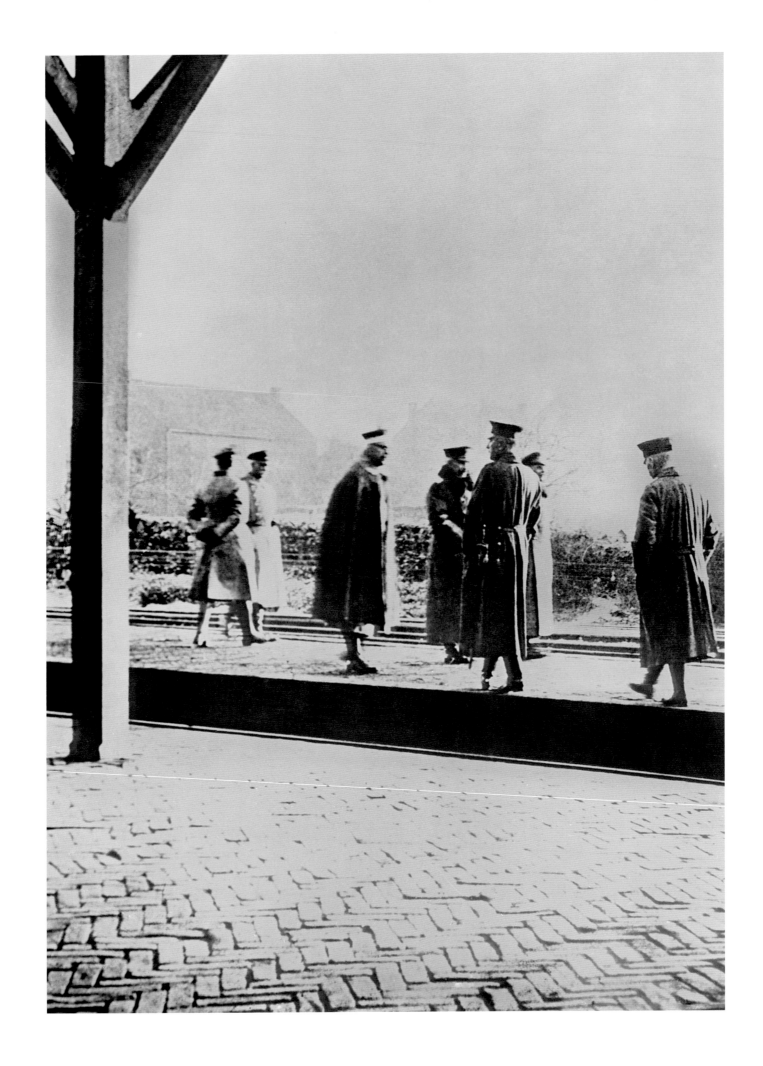

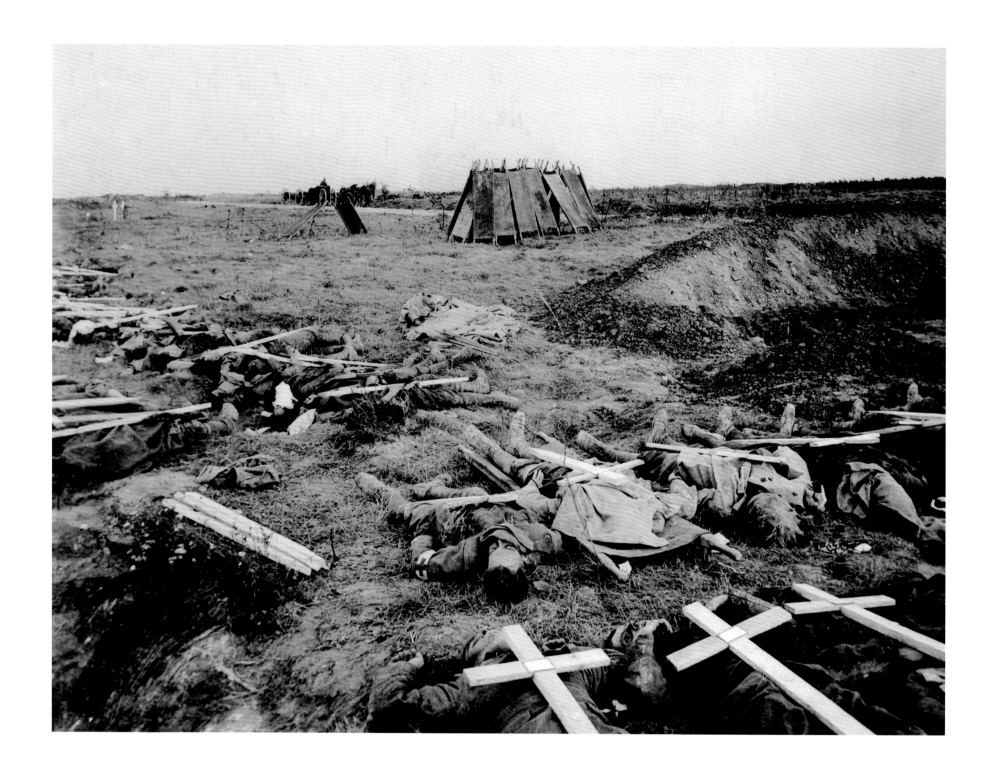

Left: Unknown photographer, personal photograph
**Kaiser Wilhelm II (fourth from left) leaves Germany for exile in the Netherlands.
Major van Dyl of the Dutch Army receives the Kaiser at the Dutch frontier near
Eysden, Netherlands, 10 November 1918**
*As the prospect of defeat grew close, the governments of Germany, Austria-Hungary
and Turkey faced political crises triggered by social and political unrest. On 29 October,
German sailors mutinied at Wilhelmshaven, triggering a chain of events that culminated
in the abdication and exile of Kaiser Wilhelm II*

Above: CAPTAIN GEORGE HUBERT WILKINS (presumably),
Australian Army photographer
**Bodies of Australian and American soldiers, killed during the final battles on the
Western Front, are gathered for burial at a new cemetery, Gillemont Farm, Picardy,
France, 3 October 1918**
*Photographers, professional and amateur, rarely photographed the dead of their own
side. This photograph, which forms part of a triptych, is a rare exception and was
probably intended as a record of cemetery construction on the front*

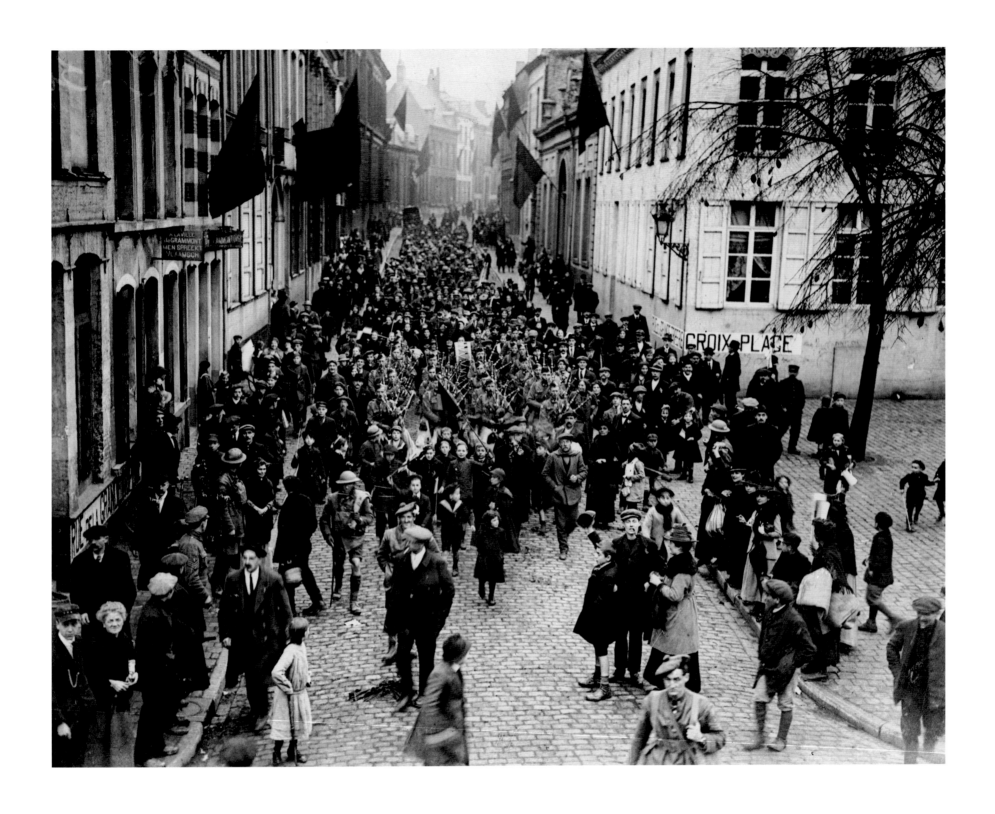

LIEUTENANT WILLIAM RIDER-RIDER, Canadian Army photographer
As the Armistice comes into effect, Canadian troops march through Mons, Belgium,
11 November 1918
An armistice brought fighting to a close at 11 a.m. on 11 November 1918. When hostilities
ended, the Allied line was located at Mons, scene of the first encounter between British
and German troops in 1914

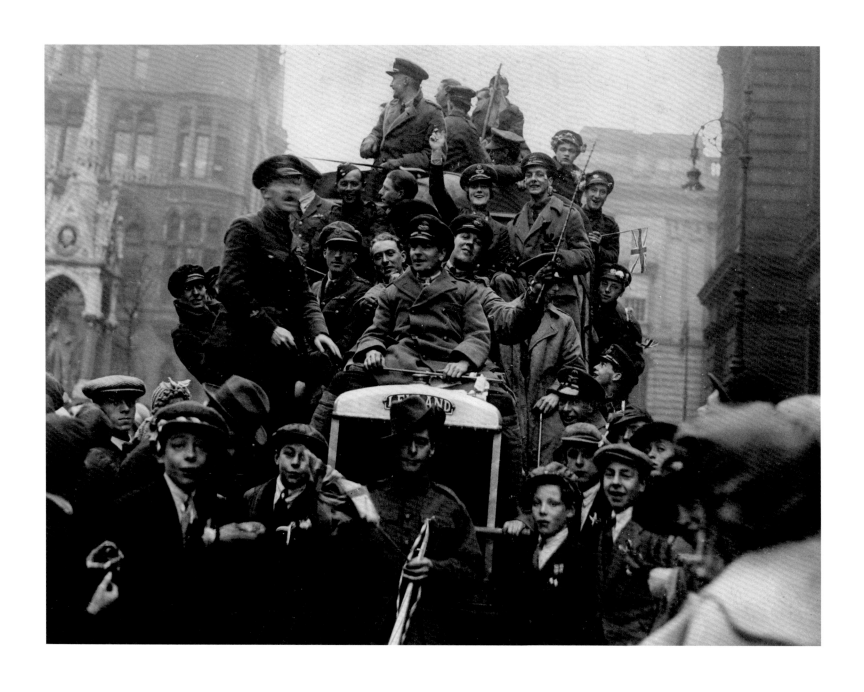

JOHN L. LYNE, personal photograph
Crowds take to the street on Armistice Day, Birmingham, 11 November 1918

Unknown naval photographer, Royal Naval Air Service
HMS *Queen Elizabeth*, flying the flag of Admiral Sir David Beatty, preceded by HMS *King George V*, HMS *Ajax*, HMS *Centurion* and HMS *Erin*, sails out to escort the German High Seas Fleet into Scapa Flow, Orkneys, Scotland, 21 November 1918
After the Armistice, seventy-four ships of the German High Seas Fleet were interned in the harbour of Scapa Flow while negotiations took place about their future

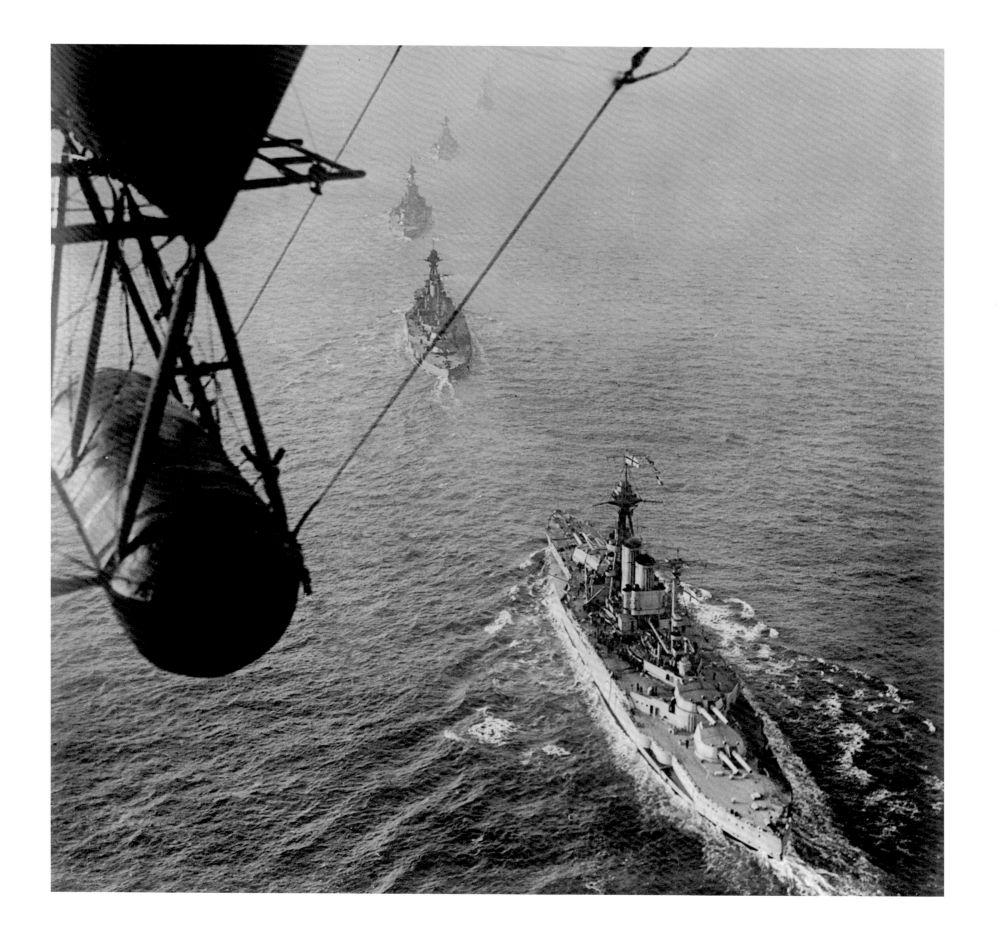

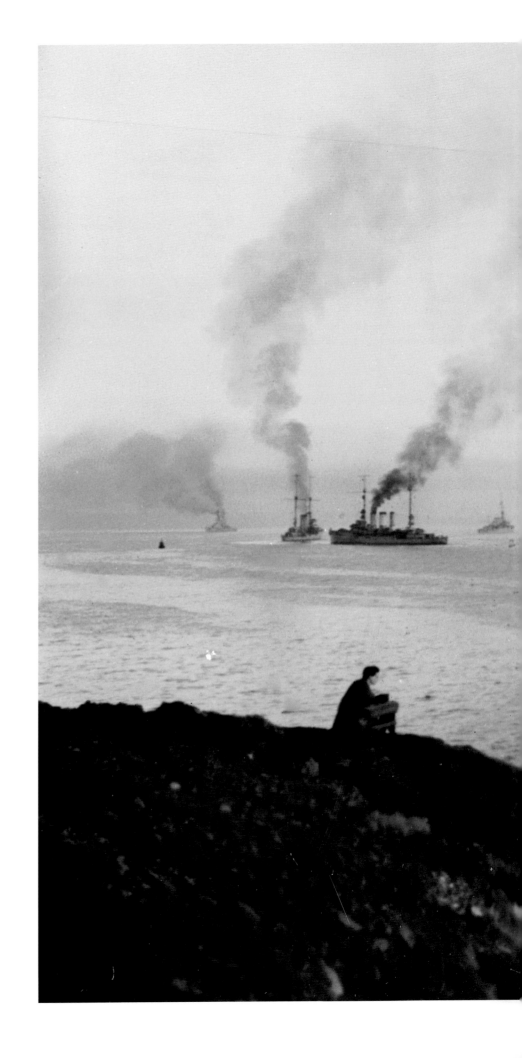

Unknown photographer, from the collection of Surgeon Oscar Parkes
Three German cruisers, SMS *Emden*, SMS *Frankfurt* and SMS *Bremse*, enter internment at Scapa Flow, Orkneys, Scotland, 24 November 1918
The interned fleet immediately became a popular British tourist attraction. For German sailors, rebellious and confined to their ships, conditions were poor

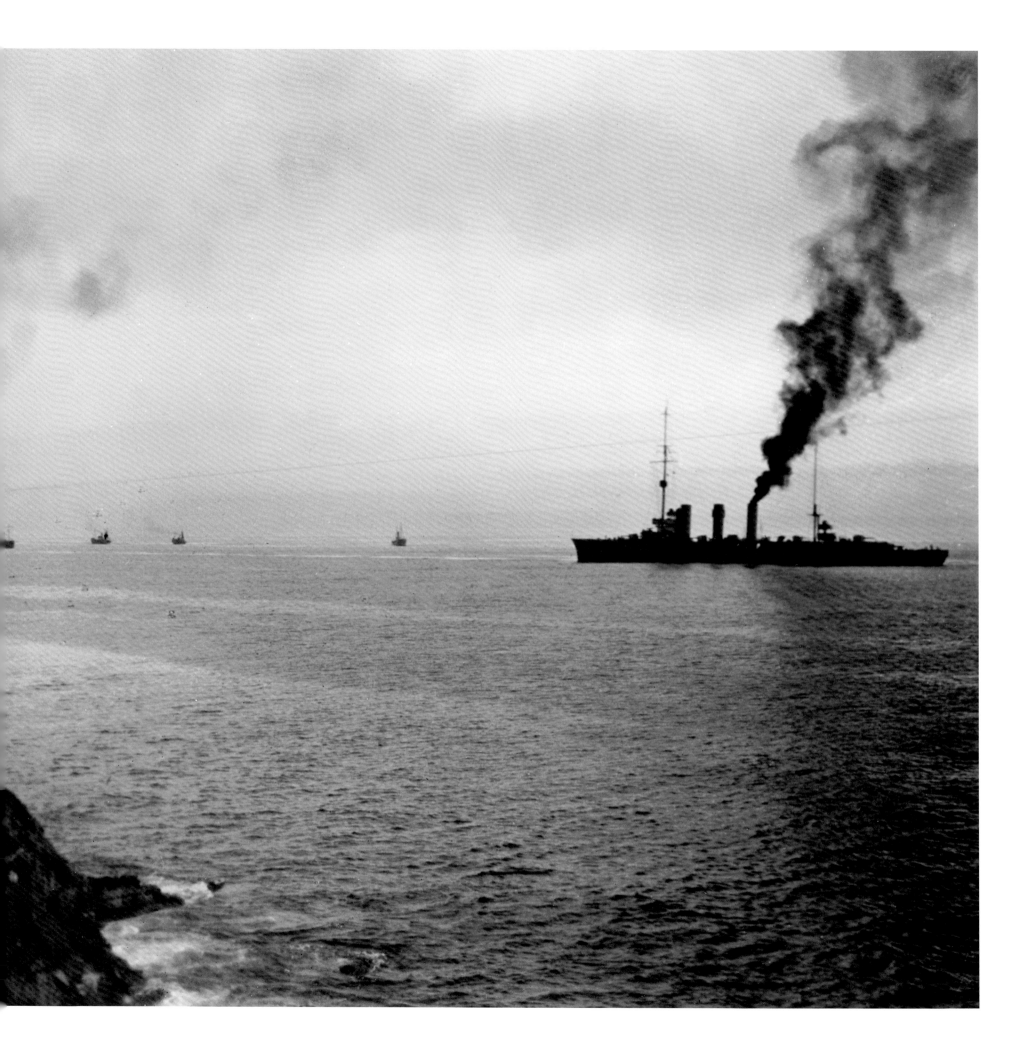

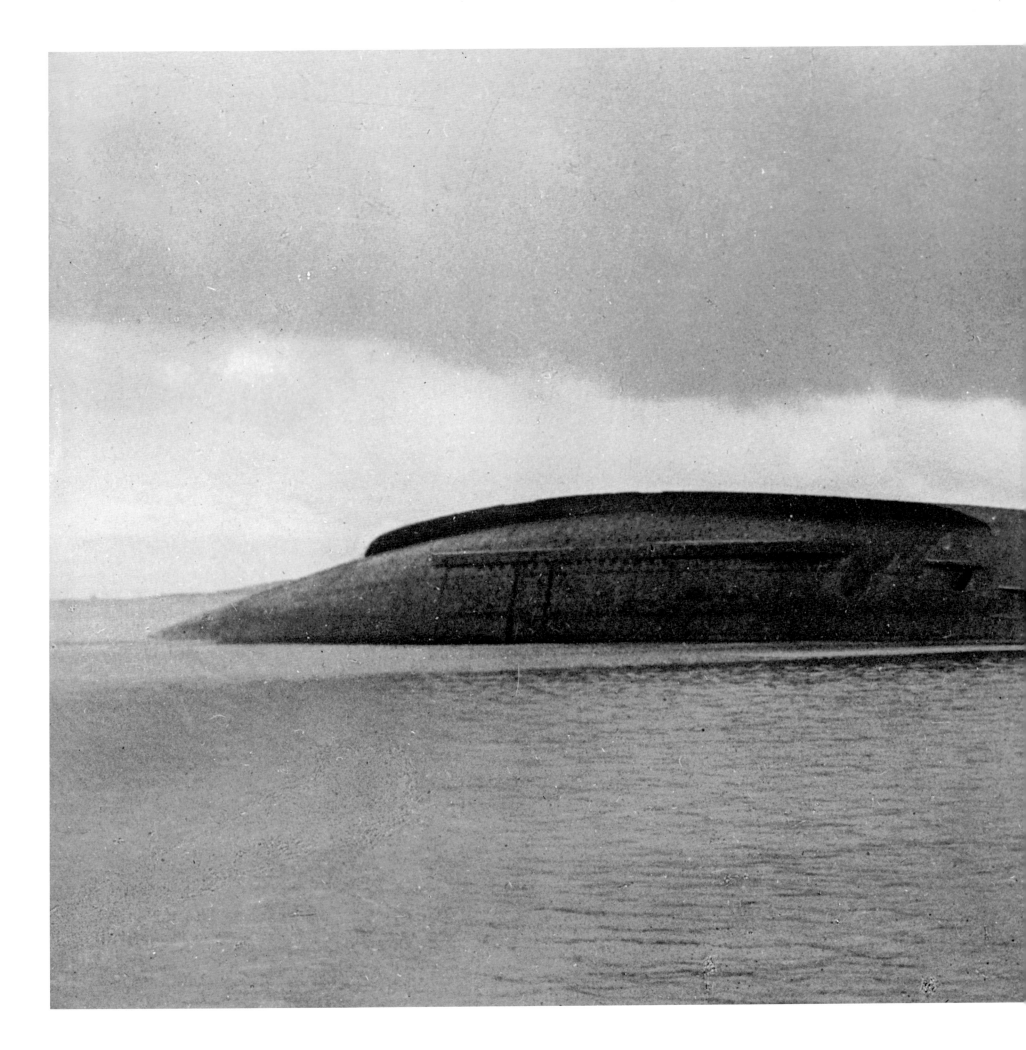

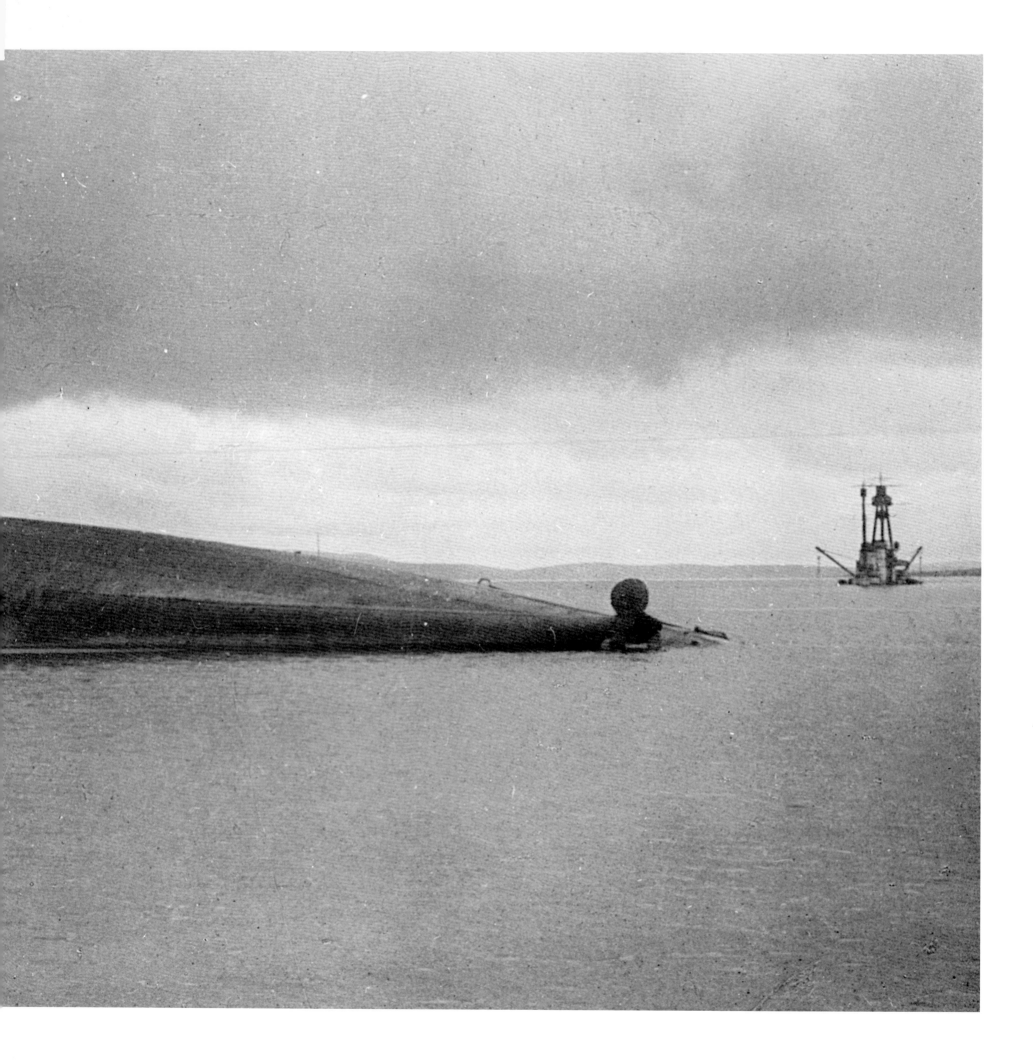

OVER 70 MILLION MEN WERE MOBLISED.

45 MILLION OF THEM BECAME CASUALTIES AND 9 MILLION DIED.

IT IS ESTIMATED 230 SOLDIERS, SAILORS OR AIRMEN DIED EACH HOUR.

19,240 BRITISH SOLDIERS WERE KILLED ON A SINGLE DAY, 1 JULY 1916.

TWO MILLION BRITISH AND EMPIRE SOLDIERS WERE WOUNDED.

240,000 OF THEM SUFFERED TOTAL OR PARTIAL AMPUTATIONS.

MORE THAN SIXTY PER CENT OF THE WOUNDED RETURNED TO THE FRONTLINE.

Pages 496–7: Unknown photographer, from the collection of Surgeon Oscar Parkes
The hull of the German battle cruiser SMS *Seydlitz* lies capsized and exposed after being scuttled at Scapa Flow, Scotland, on 21 June 1919
The Versailles Peace agreement was signed on 21 June 1918. As peace negotiations were concluded, the Allies prepared to seize the German ships, but were pre-empted when the German Fleet scuttled itself on the same day

Right: HORACE NICHOLLS, Imperial War Museum photographer
A coffin containing the body of an unknown British soldier in Westminster Abbey shortly before interment in its final resting place, London, 11 November 1920. The date on the photograph is that on which the remains of the unknown soldier were selected on the former Western Front
Britain's national memorial to the dead of the First World War, the Cenotaph, was dedicated on the second anniversary of the Armistice in 1920. In tribute to the many soldiers with no known grave, it was also decided that an 'Unknown Warrior' should be laid to rest with all due ceremony in Westminster Abbey on the same day. Britain's example was subsequently adopted by other countries

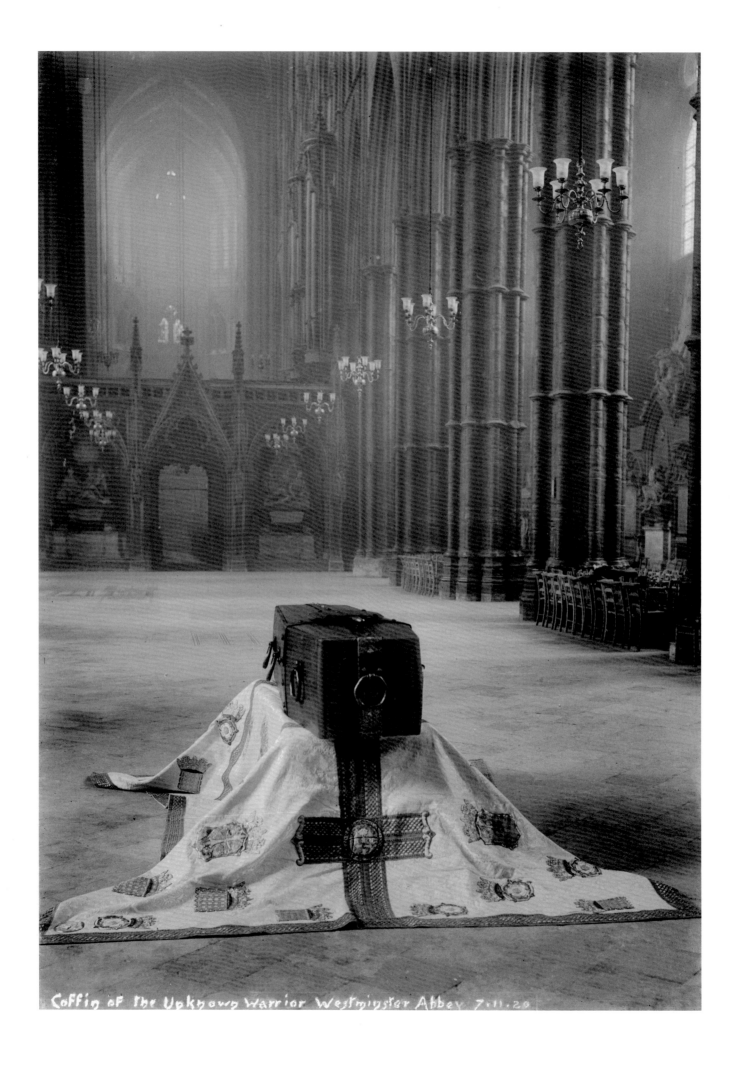

Coffin of the Unknown Warrior Westminster Abbey 7.11.20

499

PHOTOGRAPHY IN THE GREAT WAR
Hilary Roberts

The reign of Kaiser Wilhelm II of Germany, between 1888 and 1918, coincided with a watershed in the history of photography. Technological change fed creative innovation at an unprecedented rate. Documentary photography, photojournalism, popular, artistic and scientific photography all became established genres. Art photography forums flourished. Even colour photography was possible following the invention of the autochrome process in 1907. However the genre of war photography developed most, due to the First World War.

When war broke out, most of the resources required to photograph the conflict were already in place. Servicemen and civilians had access to small, lightweight, roll-film cameras such as Kodak's Vest Pocket Autographic camera, introduced in 1912, but marketed as 'The Soldier's Camera' from 1915 onwards. Professional photojournalists were now attached to major newspapers and magazines and many of them had already covered major conflicts. They used glass-plate cameras designed for the press, such as the 1904 Goerz Anschütz. Military photographers, in particular those of the British Army's Royal Engineers, had accumulated years of experience in conflicts around the world.

It is a surprise to discover that the war was not photographed more extensively from the outset and that the overall body of work from the first global conflict is so small, even by the standards of the day. The Imperial War Museums house what is probably the world's most extensive collection of professional and amateur First World War photography, generated by all the participating nations, yet it numbers fewer than a million images. Some subjects, such as the war in Africa, were barely covered at all.

The reason for this lack of coverage lies in the management of photography during the war. Government ministers, civil servants and senior military commanders of the belligerent nations had failed to broaden their understanding of the nature and potential of photography in line with the technological advances. In 1914, those in a position of authority generally regarded photography as a threat rather than an opportunity. The Kaiser was a rare exception, authorising nineteen court photographers to accompany the Imperial German Army as it launched its assault on Belgium and allowing a relaxed approach to personal photography by servicemen, provided they did not use cameras while in combat. Otherwise, civilian photojournalists were kept away from the front line until 1918, when General Pershing granted them access to the American Expeditionary Force on the Western Front. Lord Kitchener, British Secretary of State for War in 1914, was particularly hostile to photographers of any description, invoking the 1911 Official Secrets Act and threatening court martial for any serviceman caught carrying a camera.

The only professionals allowed in the front line throughout the war were military photographers, charged with documenting the battlefield and military equipment for operational purposes. They also produced numerous panoramic views of the battlefield. Aerial photography

was considered so important that armed fighter aircraft were developed to protect those carrying out photographic reconnaissance missions. Even though air sections of the major navies carried out aerial photography, professional photographers did not form part of a ship's regular complement, due to space limitations as well as the pervading hostility to photography.

A policy of exclusion was neither enforceable nor sustainable. The public was accustomed to taking photographs and expected the press to publish photographs. Commercial publishers and the news media needed pictures of the war. Restrictions on personal cameras were ignored or flouted to the point that some servicemen were able to supplement their pay by selling copies of their photographs. News organisations regularly published personal photographs, most notably of the unofficial Christmas Truce on the Western Front in 1914. They also responded to the shortage of authentic imagery by misattributing or even faking photographs when required.

Demands mounted for photographers to be granted access as part of a campaign for general improvements in the quantity and quality of information from the fronts. After eighteen months, the major powers began to recognise that a change of approach was necessary. The need to engage those at home in the war effort and to contradict negative messages of failed offensives and mounting casualties led to the utilisation of photography in the propaganda war. Between 1915 and 1917 the belligerent nations, with the exception of Russia, appointed official military photographers to work in the front line, generating photographs for propaganda, public information and the historical record. Censorship controls and distribution infrastructures were put in place. France and India were the first to sanction official photography in 1915. The Battle of the Somme provided the incentive for Britain, Canada and Australia to do likewise in 1916. Germany, realising that it was falling behind, introduced official photography in 1917, as did the United States when it entered the war that year. Russia, afflicted by pervading social unrest and the difficulties of communication over vast distances, was unable to put a coherent structure in place and continued to depend on the coverage of individuals such as the Bulla family.

First World War official war photography relied heavily on the input of experienced professionals of the international press and photographic industry. Such dependence could cause conflicts of interest and, in some cases, the boundary between official roles and commercial interests barely existed. A lack of official training facilities meant that the photographers themselves had to be experienced as well as fit and battle-hardened. Ernest Brooks, John Warwick Brooke, Frank Hurley and Hubert Wilkins were all exceptionally tough, courageous men as well as outstanding photographers. They received minimal acknowledgement, but carried the legacy of their experiences for the rest of their lives. Despite many shortcomings, the photographers of the First World War created an enduring legacy of work and laid the foundations for the photography of subsequent conflicts. We owe much of our understanding of the nature of war to their achievements.

Special thanks are due to the following for their support and work on this book:

Richard Bayford, Martin Boswell, Elizabeth Bowers, Paul Cornish, Bodo von Dewitz, Gudrun Muller, Alison Nordstrom, Abigail Ratcliffe, Roger Smither, Nigel Steel, Alan Wakefield and the staff of the IWM Photograph Archive.

File Numbers from the IWM Photograph Archive

Front jacket Q 11538, Back jacket Q 4316, Case wrap Q 1471, page 1 HU 81073, page 4 UNI 12422, page 6 UNI 12422, page 7 Q 81794, page 11 RP 2062, page 12 SP 3127, page 13 HU 68385, page 14 HU 68418, page 15 HU 68473, page 16 Q 81723, page 17 Q 81803, page 18 HU 68459, page 19 HU 68469, page 23 Q 69871, page 31 Q 81755, page 32 Q 81828, page 34 Q 81739, page 35 Q 81832, page 36 Q 81760, page 37 Q 81840, page 38 Q 81780, page 39 Q 81724, page 41 Q 81728, page 42 Q 81781, page 44 Q 51128, page 45 Q 51472, page 46 Q 53234, page 47 Q 67397, page 48 Q 53275, page 49 Q 53311, page 50 Q 53298, page 52 Q 53426, page 53 Q 53581, page 54 Q 81766, page 55 Q 45771, page 56 Q 114886/documents, 5020, page 57 Q 66196, page 58 Q 53446, page 60 Q 51214, page 61 Q 60695, page 62 Q 51489, page 64 Q 53248, page 66 Q 50704, page 67 Q 53231, page 68 Q 53320, page 70 Q 53431, page 71 Q 56325, page 72 Q 57214, page 73 Q 53437, page 74 Q 53348, page 76 Q 53386, page 78 Q 51159, page 79 Q 53238, page 80 Q 57283, page 81 Q 57328, page 83 Q 57287, page 84 Q 57194, page 85 Q 57253, page 86 Q 57380, page 87 Q 51524, page 88 Q 53400, page 89 Q 53416, page 90 Q 51550, page 91 Q 51542, page 92 Q 53476, page 93 Q 53459, page 95 Q 50992, page 96 Q 45913, page 97 Q 20896, page 98 Q 45916, page 99 Q 45920, page 100 Q 20894, page 102 Q 53468, page 105 Q 11718, page 106 UNI 1053, page 113 Q 58452, page 114 Q 53585, page 115 Q 53591, page 116 Q 53573, page 118 Q 53637, page 119 Q 53549, page 120 Q 22687, page 122 Q 51569, page 123 Q 51588, page 124 Q 53666, page 125 Q 48966, page 126 Q 53603, page 127 Q 53620, page 128 Q 53731, page 130 Q 61565, page 131 Q 50446, page 132 Q 115273, page 133 Q 53770, page 134 Q 17399, page 135 Q 51886, page 136 Q 53781, page 137 Q 53785, page 138 Q 20220, page 139 Q 48349, page 140 Q 53498, page 141 Q 13783, page 142 Q 103604, page 143 Q 46430, page 145 Q 50473, page 146 Q 112876, page 147 HU 50621, page 148 Q 61099, page 150 Q 13503, page 151 Q 13497, page 152 Q 13400A, page 154 Q 13622, page 155 Q 13315, page 156 Q 13448, page 157 Q 14340, page 159 HU 53364, page 161 Q 67644, page 162 Q 45735, page 164 Q 69222, page 165 Q 58422, page 166 HU 3277B, page 168 Q 49296, page 169 Q 17390, page 170 Q 30166, page 171 Art.IWM PST 12217, page 172 Q 53564, page 173 Q 70238, page 174 Q 24446, page 176 HU 51408, page 177 Q 92658, page 178 Q 55130, page 179 Q 69144, page 180 Q 29057, page 181 Q 29056, page 182 Q 13679, page 184 UNI 10830, page 191 Q 27736, page 192 Q 107237, page 194 Q 27308, page 195 Q 56809, page 196 Q 79438, page 197 Q 79446, page 199 Q 55499, page 200 Q 20902, page 202 Q 18121, page 203 SP 2469, page 204 SP 2156, page 206 SP 1708, page 207 SP 2470, page 208 SP 1594, page 209 SP 1592, page 210 Q 20794, page 211 Q 20704, page 213 Q 23760, page 215 Q 73774, page 216 Q 55066, page 218 Q 669, page 219 Q 670, page 221 CO872, page 222 Q 716, page 223 Q 743, page 224 Q 1247, page 225 Q 1375, page 226 Q 36, page 227 Q 113, page 228 Q 1293, page 229 Q 1471, page 230 Q 91, page 231 Q 23, page 232 Q 4307, page 233 Q 814, page 234 Q 738, page 237 Q 59, page 238 Q 115, page 239 Q 754, page 240 Q 85, page 241 Q 67, page 243 Q 42261, page 245 Q1, page 246 Q 774, page 249 Q 800, page 250 Q 4245, page 251 Q 4015, page 253 Q 3970, page 254 Q 757, page 255 Q 1208, page 256 Q 751, page 259 Q 815, page 260 Q 5817, page 261 Q126, page 262 Q 872, page 263 Q 871, page 264 Q 4180, page 265 Q 4210, page 266 Q 55197, page 267 CO 827, page 268 Q 4242, page 269 Q 4361, page 270 Q 1456, page 271 CO 851, page 272 Q 4205, page 273 Q 56558, page 274 Q 1071, page 275 Q 3990, page 277 Q 1201, page 278 Q 23761, page 279 Q 56577, page 280 Q 1534, page 281 Q 2488, page 282 Q 1540, page 283 Q 2041, page 284 HU 98286, page 285 CO 219, page 286 Q 1158, page 287 E(AUS) 5, page 289 Q 1163, page 290 Q 4593, page 291 Q 887, page 293 Q 27633, page 295 Q 27637, page 296 Q 27639, page 298 Q 58481, page 300 HU 83640, page 302 UNI 3683, page 309 SP 843, page 310 SP 455, page 311 SP 2053, page 312 SP 813, page 314 Q 54569, page 315 Q 108452, page 316 PD-CRO 30, page 317 PD-CRO 31, page 318 Q 2438, page 319 Q 4669, page 320 Q 2676, page 321 Q 2966, page 322 Q 44170, page 323 Q 6420, page 324 Q 5098, page 325 Q 5100, page 326 Q 6418, page 327 Q 2050, page 328 Q 2054, page 329 Q 2049, page 330 Q 24087, page 331 Q 55022, page 332 CO 1146, page 333 CO 1189, page 334 Q57764, page 336 Q 2062, page 337 Q 2393, page 338 CO 1414, page 339 Q 50649, page 340 Q 2548, page 341 CO 1973, page 342 Q 2293, page 343 Q 2290, page 344 HU 89482, page 345 HU 88193, page 346 Q 86552, page 348 HU 94400, page 349 HU 96966, page 350 HU 58890, page 352 Q 11980, page 353 HU 67786, page 354 CO 1744, page 355 Q 23917, page 356 Q 42284, page 357 Q 52781, page 358 Q108846, page 359 Q 108954, page 360 HO 65, page 361 HO 81, page 363 E (AUS) 1175, page 364 Box 11 1 82 1917, page 365 Box 121 564 1917, page 366 Q 2764, page 367 Q 2907, page 368 CO 1636, page 369 Q 3117, page 370 Q 5941, page 371 Q 6236, page 373 Q 5935, page 374 E (AUS) 661, page 375 E (AUS) 714, page 376 Q 2729, page 377 Q 2863, page 378 Q 5979, page 379 Q 6003, page 380 E (AUS) 3864, page 381 CO 2212, page 382 Q 2890, page 384 Q 2901, page 385 Q 2891, page 386 Q 2860, page 387 Q 3067, page 389 E (AUS) 1220, page 390 CO 2241, page 391 CO 2246, page 392 Q 3178, page 394 Q 86080, page 396 HU 89191, page 397 Q 115126, page 398 Q 6297, page 399 Q 6284, page 401 Q 24318, page 402 Q 58908, page 403 Q 60212, page 404 Q 58877, page 405 Q 58863, page 406 Q 105642, page 407 Q 59193, page 409 Q 12841, page 410 Q 55530, page 411 Q 48460, page 412 Q 53994, page 413 HU 56409, page 415 Q 81095, page 416 Q 69402, page 417 Q 69404, page 418 Q 69408, page 419 HU 92907, page 420 UNI 3679, page 427 CO 3369, page 428 Q 10603, page 429 Q 8454, page 430 Q 55252, page 431 Q 55226, page 432 Q 23838, page 433 Q 23839, page 434 Q 10836, page 435 Q 358, page 436 Q 11586, page 438 Q 55281, page 439 Q 55349, page 440 Q 6595, page 441 Q 8689, page 442 Q 6902, page 443 Q 87926, page 445 Q 49164, page 446 Q 22841, page 447 Q 18887, page 448 Q 55569, page 449 Q 49185, page 450 Q 12033, page 451 Q 12051, page 452 Q 12163, page 453 Q 10923, page 454 E (AUS) 3888, page 455 Q 12218, page 456 Q 27846, page 457 Q 18524, page 459 HU 76248, page 460 Q 7156, page 461 Q 11086, page 462 Q 9347, page 464 Q 12326, page 466 Q 12310, page 467 Q 24758, page 468 Q 60020, page 469 Q 60048, page 470 Q 12393, page 471 Q 73534, page 472 HU 94332, page 474 Q 7031, page 475 Q 6864, page 477 Q 11538, page 478 Q 9631, page 479 Q 9370, page 480 Q 9353, page 481 Q 9534, page 482 Q 8544, page 483 Q 3308, page 484 Q 9586, page 485 Q 9326, page 487 HU 89219, page 488 Q 47933, page 489 E (AUS) 4945, page 490 CO 3660, page 491 Q 63690, page 493 Q 20616, page 494 SP 428, page 496 SP 1636, page 499 Q 31514, page 504 Q 47886

Published by Jonathan Cape in association with Imperial War Museums

2 4 6 8 10 9 7 5 3 1

First published in Great Britain in 2013 by
Jonathan Cape
Random House
20 Vauxhall Bridge Road
London SW1V 2SA

In association with Imperial War Museums

www.vintage-books.co.uk
iwm.org.uk

The Random House Group Limited Reg. no. 954009

A CIP catalogue record for this book is available from the British Library

ISBN 9780224096553

Design by Jesse Holborn, Design Holborn
Production by Simon Rhodes
Printed and bound in China by C&C Offset Printing Co., Ltd

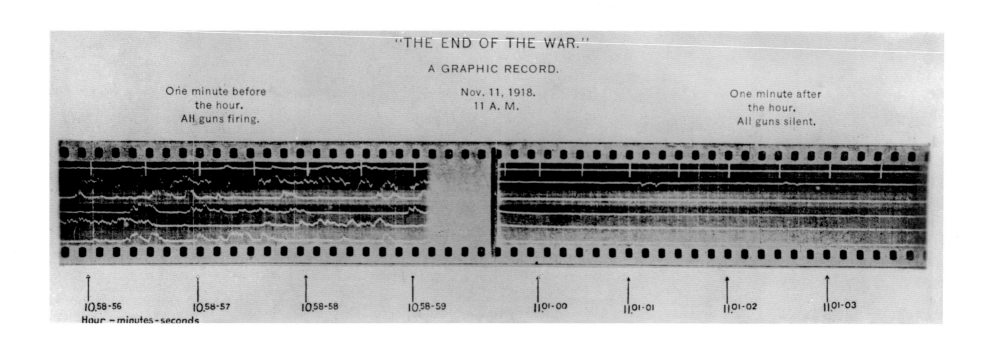

Official sound recording: source unknown
A sound trace recorded by artillery sound-ranging equipment on 35mm film provides a
visual record of the moment when guns fell silent on the Western Front, 11 November 1918